Tactical Biopolitics

Leonardo

Roger F. Malina, Executive Editor

Sean Cubitt, Editor-in-Chief

The Visual Mind: Art and Mathematics, edited by Michele Emmer, 1993

Leonardo Almanac: International Resources in Art, Science, and Technology, edited by Craig Harris, 1993

Designing Information Technology in the Postmodern Age, Richard Coyne, 1995

Immersed in Technology: Art and Virtual Environments, edited by Mary Anne Moser with Douglas MacLeod, 1996

Technoromanticism: Digital Narrative, Holism, and the Romance of the Real, Richard Coyne, 1999

Art and Innovation: The Xerox PARC Artist-in-Residence Program, edited by Craig Harris, 1999

The Digital Dialectic: New Essays on New Media, edited by Peter Lunenfeld, 1999

The Robot in the Garden: Telerobotics and Telepistemology in the Age of the Internet, edited by Ken Goldberg, 2000

The Language of New Media, Lev Manovich, 2001

Metal and Flesh. The Evolution of Man: Technology Takes Over, Ollivier Dyens, 2001

Uncanny Networks: Dialogues with the Virtual Intelligentsia, Geert Lovink, 2002

Information Arts: Intersections of Art, Science, and Technology, Stephen Wilson, 2002

Virtual Art: From Illusion to Immersion, Oliver Grau, 2003

Women, Art, and Technology, edited by Judy Malloy, 2003

Protocol: How Control Exists After Decentralization, Alexander R. Galloway, 2004

At a Distance: Precursors to Art and Activism on the Internet, edited by Annmarie Chandler and Norie Neumark, 2005

The Visual Mind II, edited by Michele Emmer, 2005

CODE: Collaborative Ownership and the Digital Economy, edited by Rishab Aiyer Ghosh, 2005

The Global Genome: Biotechnology, Politics, and Culture, Eugene Thacker, 2005

Media Ecologies: Materialist Energies in Art and Technoculture, Matthew Fuller, 2005

Art Beyond Biology, edited by Eduardo Kac, 2006

New Media Poetics: Contexts, Technotexts, and Theories, edited by Adalaide Morris and Thomas Swiss, 2006

Aesthetic Computing, edited by Paul A. Fishwick, 2006

Digital Performance: A History of New Media in Theater, Dance, Performance Art, and Installation, Steve Dixon, 2007

MediaArtHistories, edited by Oliver Grau, 2007

From Technological to Virtual Art, Frank Popper, 2007

META/DATA: A Digital Poetics, Mark Amerika, 2007

Signs of Life: Bio Art and Beyond, edited by Eduardo Kac, 2007

The Hidden Sense: Synesthesia in Art and Science, Cretien van Campen, 2007

Media Ecologies, Matthew Fuller, 2007

Closer: Performance, Technologies, Phenomenology, Susan Kozel, 2008

Video: The Reflexive Medium, Yvonne Spielmann, 2008

Tactical Biopolitics: Art, Activism, and Technoscience, edited by Beatriz da Costa and Kavita Philip, 2008

Tactical Biopolitics

Art, Activism, and Technoscience

**edited by Beatriz da Costa and Kavita Philip
with a foreword by Joseph Dumit**

The MIT Press
Cambridge, Massachusetts
London, England

For information about special quantity discounts, please email special_sales@mitpress.mit.edu

This book was set in Garamond 3 and Bell Gothic by SNP Best-set Typesetter Ltd., Hong Kong. Printed and bound in the United States of America.

Library of Congress Cataloging-in-Publication Data

Tactical biopolitics : art, activism, and technoscience / edited by Beatriz da Costa and Kavita Philip; foreword by Joseph Dumit.
 p. cm.—(Leonardo books)
Includes bibliographical references and index.
ISBN 978-0-262-04249-9 (hardcover : alk. paper) 1. Biology–Social aspects. 2. Technological innovations—Social aspects. 3. Biotechnology—Social aspects. 4. Biopolitics. 5. Art and science. I. Da Costa, Beatriz. II. Philip, Kavita, 1964–
QH333.T33 2008
306.4′5—dc22

 2007032375

10 9 8 7 6 5 4 3 2 1

Contents

Series Foreword

The arts, science, and technology are experiencing a period of profound change. Explosive challenges to the institutions and practices of engineering, art making, and scientific research raise urgent questions of ethics, craft, and care for the planet and its inhabitants. Unforeseen forms of beauty and understanding are possible, but so, too, are unexpected risks and threats. A newly global connectivity creates new arenas for interaction between science, art, and technology, but also creates the preconditions for global crises. The Leonardo Book series, published by the MIT Press, aims to consider these opportunities, changes, and challenges in books that are both timely and of enduring value.

Leonardo books provide a public forum for research and debate; they contribute to the archive of art-science-technology interactions; they contribute to understandings of emergent historical processes; and they point toward future practices in creativity, research, scholarship, and enterprise.

To find more information about Leonardo/ISAST and to order our publications, go to Leonardo Online at http://lbs.mit.edu/ or e-mail leonardobooks@mitpress.mit.edu.

Sean Cubitt
Editor-in-Chief, Leonardo Book series

Leonardo Book Series Advisory Committee: Sean Cubitt, *Chair*; Michael Punt; Eugene Thacker; Anna Munster; Laura Marks; Sundar Sarrukai; Annick Bureaud

Doug Sery, Acquiring Editor
Joel Slayton, Editorial Consultant

Leonardo/International Society for the Arts, Sciences, and Technology (ISAST)

Leonardo, the International Society for the Arts, Sciences, and Technology, and the affiliated French organization, Association Leonardo, have two very simple goals:

1. To document and make known the work of artists, researchers, and scholars interested in the ways that the contemporary arts interact with science and technology
2. To create a forum and meeting places where artists, scientists, and engineers can meet, exchange ideas, and, where appropriate, collaborate.

When the journal *Leonardo* was started some forty years ago, these creative disciplines existed in segregated institutional and social networks, a situation dramatized at that time by the "Two Cultures" debates initiated by C. P. Snow. Today we live in a different time of cross-disciplinary ferment, collaboration, and intellectual confrontation enabled by new hybrid organizations, new funding sponsors, and the shared tools of computers and the Internet. Above all, new generations of artist-researchers and researcher-artists are now at work individually and in collaborative teams bridging the art, science, and technology disciplines. Perhaps in our lifetime we will see the emergence of "new Leonardos," creative individuals or teams that will not only develop a meaningful art for our times but also drive new agendas in science and stimulate technological innovation that addresses today's human needs.

For more information on the activities of the Leonardo organizations and networks, please visit our Web sites at http://www.leonardo.info/ and http://www.olats.org.

Roger F. Malina
Chair, Leonardo/ISAST

ISAST Governing Board of Directors: Martin Anderson, Michael Joaquin Grey, Larry Larson, Roger Malina, Sonya Rapoport, Beverly Reiser, Christian Simm, Joel Slayton, Tami Spector, Darlene Tong, Stephen Wilson

Foreword: Biological Feedback

When I first looked over *Tactical Biopolitics,* I was excited by the array of authors and the fact that this was not a book retheorizing biopolitics or talking about intervening. These were accounts by interveners, reports on practices. Most important, these were conversations between scientists, artists, theorists, and activists; conversations in the field, struggling over new practices of life. Talking across these divisions of life is not easy at all; at best it is usually what Deleuze approvingly calls a resonant encounter in which "one discipline realizes that it has to resolve, for itself and by its own means, a problem similar to one confronted by the other."[1] I like Deleuze's image here, but it is a solitary endeavor. *Tactical Biopolitics* is oriented differently, toward a shared set of problems that do not require discovering because they are in the face of practitioners. These include the recognition that the multiplicities of life have their own designs, even if, especially when, we try to manipulate them on micro and nano scales. These multiplicities also include the increasing entanglement of all practices—science, art, activism, writing—with corporate capital and mass media, and the belated admission that these problems cannot be handled alone, but require cross-species tactical coordination.

The choice to call the volume *Tactical Biopolitics* is intriguing because it resists the urge to come up with another name for the present that would spin us off into lexical appreciation and distract us from the tasks at hand: where to put a hazardous bioengineering lab, how to manage corporate sponsorship of bioart, how to decide the social limits of a research practice, how to know when animal research goes too far, how to teach about race and biology when students have learned their ancestry through online genetic testing services, how much biology artists or activists need to learn, and how much social theory should biologists acquire. In other words, how to be a biological citizen today. As a foreword, I offer a few take-home tactics that I acquired while reading:

Microbiopolitical tactic: Never think you know all of the species involved in a decision. Corollary: Never think you speak for all of yourself.

Foucault identified the biopolitical as the shift to population and territory as key problems for society: how to control and secure the multiplicity of men as living bodies, as populations, as global mass; modulating rates of life through birth control strategies or death through epidemic preventions. These were ways of anticipating, modeling, and intervening in generalities conducted from expert and managerial levels.

But life, it seems, doesn't react so much as invent responses, appearing like a mold in the interstices of plans and models. Drug-resistant tuberculosis, for instance, is not simply an evasion of epidemic management, but a new type of threat that thrives on prevention strategies. From AIDS to Mad Liberation movements, the problem of man in his environment has been overwritten by the problem of man as environment. Equally, stem cells are not simply a technical solution to organ shortages, but reconfigure how we think of both research and the future of humanity. I am reminded of Heather Paxson's study of artisan cheesemakers in the United States. Focusing on what she calls the "microbiopolitics . . . human encounters with the vital organismic agencies of bacteria, viruses, and fungi," she described how "cheesemakers . . . take quite seriously the fact that they work with a potential biohazard."[2] Feedback here traverses bodies at multiple scales. From SARS to the long history of dog-human co-living, life's multiplicities are more than scientific management can handle. Even discussing our future requires more than gathering diverse humans to a table. Microbes, etc., become not just allies to be enrolled, but subjects in their own right, enrolling humans in their projects. As this *TB* volume makes clear, if before population was posed as a political and biological problem, today biology itself is a political problem.

Cosmopolitical tactic: Expertise confines problems as much as it defines them. How ever hard the homework, we all need to become biologists, activists, artists, and theorists. It is possible and imperative.

The implosion of biology as science into politics is a symptom of a larger entanglement: a doctor treating AIDS, a patient taking a pill, a scientist in a lab, a new professor buying a house, breathing polluted air are part of relations that create new allies and mutate the notion of expert at the same time. In these pages, a biologist repeats that biology is just as political as anything else. At the same time, artists, activists, and writers confront the problem of politics requiring biology. Bioartists articulate life to make biology an object of recognition and concern for all; activists reconfigure lines of authority, knowledge, and regulation to change how concern about life operates. This reformatting of expertise invents a do-it-yourself (DIY) science, and it can be DIY Big Science too: from ancestral

DNA testing to bioterrorism to bioengineering. But it can also be infrastructural science as when Beatriz da Costa works with pigeon-machine hybrids to gather data on lived air pollution at levels that current state instruments don't gather. She is simultaneously artist, activist, scientist, and science studies scholar.

The multiple layers of response in all of these projects require a suspicion of science as usual, but also activism, art, and theory as usual. The requirement is to explore relations across species and scales. However, flourishing with some species—dogs, mice, microbes— demands entanglements that also work against other species. This problem cannot be formulated as life versus the state or capital, but which lives, which biodiversity? As Isabelle Stengers points out, one must put oneself at risk.[3] The only choice that is off the table is allowing questions of liveliness and diversity to be seen as technical, to be decided off-stage.

Bioremediation tactic: Never assume that facts can speak for themselves, and that a reasonable position won't require a hard sell, especially if it is scientific.

Engaging across these levels and relations raises immediate, in-your-face practical issues of tactical media as well. Almost every actor in this book emphasizes the need to format their facts via public relations, and the need to struggle with the constant pressure on these facts from corporate, governmental and other corners. Popularization and commercialization, entertainment and intellectual property, inhabit art, science, activism, and scholarship. This is a shared problem of how to manage hype and how to comprehend and take responsibility for the complicities that financial allies bring with them. Financial security is often at odds with financed security.

At the same time, the bio-hype and the hyper-real fear of biohazards are not wrong. The security model that depends on modulating rates and ensuring against randomness must treat events as regular occurrences against a background of noise. But the very premise of bioengineering is that events are disruptive of prior systems; viral mutations as well as activism can transform whole ecologies. Microbes and viruses are bioengineers too.

In addition to these tactics, what I learn from *Tactical Biopolitics* is that it is imperative to talk across expert lines, and perhaps more important, to learn across them. The compelling conclusion of this book is that biologists and biology students need to learn art and politics, social science, and feminism as well as law and business. Politicians and business majors need to learn biology and art and feminism and sociology. It sounds like a lot of homework, but this book is a great start on the learning and makes clear that home and work have both been seriously mutating during the past few decades. Artists, sociologists, scientists, activists, science fiction writers, historians, all find that their worlds have thoroughly infected each other. There is quite simply no space outside the laboratory, no space

that isn't kin to a lab, and no part of the lab that isn't a site of social, political, and artistic regulation and invention. It is no longer a question of what to know, but how to handle the increasing demands that everyone must get their hands dirty, pay more attention, and do it yourself.

Joseph Dumit

Notes

1. Deleuze, Gilles, "The Brain Is the Screen: An Interview with Gilles Deleuze," translated by Marie Therese Guirgis, in 2000, *The brain Is the Screen: Deleuze and the Philosophy of Cinema*, edited by Gregory Flaxman (Minneapolis: University of Minnesota Press, 1986), p. 367.

2. Paxson, Heather, "Post-Pasteurian Cultures: The Microbiopolitics of Raw Milk Cheese in the United States," *Cultural Anthropology,* 23(1)(2008).

3. Stengers, Isabelle, "Cosmopolitiques, 7 tomes" (Paris: La Découverte & Les Empêcheurs de Penser en Rond 97, 1996).

Acknowledgments

This book grew out of a conference on BioArt and the Public Sphere at the University of California Irvine in October 2005, and, more generally, out of collaboratively taught classes and research discussions between the editors. We thank the ACE program for the stimulating institutional context which we were able to collaborate, and the funders of the original conference, who made it possible for us to draw together a widely interdisciplinary group of people in a provocative conversation that continued to stimulate, trouble, and inspire us through the making of this book.

For conference funding and support, thanks to the University of California Humanities Research Institute, and to David Goldberg and the amazing UCHRI staff (especially Irena Polic and Rosemarie Neumann); Bill Parker and UCI's Division of Research and Graduate Studies; Sue Bryant and the UCI School of Biological Sciences; Ngugi wa Thiong'o, Colette Atkinson, and the International Center for Writing and Translation at UCI; the California Institute for Information Technology & Telecommunications; UCI's Arts Computation Engineering Graduate Program and Claire Trevor School of the Arts.

Thanks to all of the conference participants who stayed with the project over two years of edits and revisions. As the project grew and became more ambitious, we issued several new contributor invitations, and special thanks go to those authors who enlarged and deepened this conversation with these contributions. Many thanks to Joe Dumit who was as excited as we were by the emerging book, and who generously wrote a foreword.

We are grateful to Roger Malina for his early interest and encouragement, Sean Cubitt, Charles Taylor, and an anonymous reviewer for enthusiastic support, and Gwen D'Arcangelis, who brought editorial support and a keen understanding of the politics of biology. At MIT Press, thanks to Alyssa Larose, Katherine Almeida, and copy editor Beth Wilson, who steered this large project to completion with good cheer in the face of numerous unexpected obstacles. And finally, we couldn't have done this without our overlapping networks of kinship and friendship, which kept us intellectually and personally nourished.

Introduction

Beatriz da Costa and Kavita Philip

"Tactical biopolitics" is a creative terminological misappropriation, drawing its inspiration from, but not mapping directly onto, two formations: the assembly of resistant cultural practices referred to as *Tactical Media*, and the intellectual ferment around the history of biopolitics. This book, thus, is a hybrid, made possible by two recent histories: the enormously creative practices at the intersection of technoscience, activism, and art; and the explosion of cross-disciplinary conversations following Michel Foucault's articulation of biopolitics.

Tactical Media practices and their associated conceptual framings emerged within the political climate of post–Cold War Europe. The sudden availability of cheap "do-it-yourself" media, public access to the Internet, and reports about tactics of underground information exchanges formerly employed in communist Eastern Europe provoked intellectual and experiential exchanges between programmers, artists, activists, and theorists in the search for new approaches to media activism.

Inspired by de Certeau's *Practice of Everyday Life*, theorists and practitioners developed a framework favoring tactical uses of media and activism, which served as a point of reference for tactical media groups and collectives initially located in both Western and Eastern Europe and the United States. Garcia and Lovink's (1997) publication of the "ABC of Tactical Media"[1] was an attempt to outline specific approaches inherent in this loose confederation of practices:

Tactical Media are what happens when the cheap "do it yourself" media, made possible by the revolution in consumer electronics and expanded forms of distribution [. . .] are exploited by groups and individuals who feel aggrieved by or excluded from the wider culture. Tactical media do not just report events, as they are never impartial they always participate and it is this that more than anything separates them from mainstream media. [. . .] Tactical media are media of crisis, criticism and opposition. This is both the source of their power, [. . .], and also their limitation.

A semi-regular conference called The Next Five Minutes[2] emerged out of informal meetings held in the early nineties. Hosted by cultural organizations such as Paradiso, de Balie and the de Waag Society in Amsterdam, this conference allowed for broader international inclusion of media activist practitioners from all five continents and thereby for the ongoing questioning and reformulation of Tactical Media practices and its goals. The conference maintained an informal structure throughout the years and had little resemblance with its academic counterparts. Technical skill exchanges, open-mic fora, and reports of locally conducted activities and their outcomes were just as much part of the agenda as were formal panel discussions.

While Tactical Media clearly defined itself as a cultural, decentralized, non-institutionalized formation, it has also found creative ways to explore temporary alliances and funding sources within institutionalized academic and public contexts. Over time, it has also built increasing ties with larger strategy-based movements such as the anti-globalization movement.

Tactical Media activities continue to be performed in many parts of the world, although not always under the sign of the same term. The initial conceptual framing power of Tactical Media and its associated exchanges appear to be on the decline. The last Next Five Minutes took place in 2003 and currently no plans exist to continue this forum for international exchange.

While *Tactical Biopolitics* does not see itself as the successor of Tactical Media, it does share some of its convictions regarding the importance of interdisciplinary knowledge-making in the context of resistant practice. We believe it remains crucial to investigate, critique, and create forms of collective production, distribution, and deployment of knowledge that engages with history and culture, academia and the public, technoscience and everyday life.

In *Tactical Biopolitics*, we examine the possible recuperation of one of the movement's strongest aspects: the inter- and "(un-)disciplinary" exchanges among practitioners and theorists from various backgrounds, always privileging collaboration and coordination with larger strategy-based movements of resistance to hegemonic forces. In addition to re-calling technology practitioners, artists, activists, and theorists, we now call for the inclusion and cooperation of the scientific community. Such an intellectual/political/artistic/technoscientific community is a potentially resistant formation in the heart of postmodern transnational technospheres. The corresponding politics and activities can be understood, however, not only in their most recent contemporary contexts, but also in a much longer historical framework. We owe our understanding of this context to numerous scholars and intellectual developments, many of them drawing on the terms "biopolitics" and "biopower."

Foucault argues that the exercise of biopower made possible the "adjustment of the accumulation of men to that of capital, the joining of the growth of human groups to the expansion of the productive forces and the differential allocation of profit."[3] Biopower has

Beatriz da Costa and Kavita Philip

been fundamental to the development of modern capitalism and to the formation of the society of the "norm." Emerging coevally with modern liberalism, biopower operated through two forms, anatomic and biological. The first worked via the individual; the second through the species. Disciplinary forms of optimization, coercion, and control centered on the body as a machine, integrating the body into systems of control via its (trained) docility and utility. Regulatory forms of control focused on the species body— monitoring, encouraging, and managing biological processes such as procreation, health and mortality. Since the eighteenth century, Foucault shows, Western knowledge has legitimized particular forms of rationality via its links to state power, sovereignty, juridical truth, political peace, and social order. Conventional histories of order, peace, and continuous scientific progress obscure the ways in which truth itself is established through a struggle over its enunciative conditions.

Struggles over truth, can, in a Foucauldian sense, be traced within the laboratories of scientists, cultural producers and media makers "in accordance with the intelligibility of struggles, of strategies and tactics."[4] It is not just a question of tracking how funding follows political trends, or showing that particular hegemonic groups control the dissemination of particular facts (although it helps to understand these); we must also track the ways in which modes and periods of scientific investigation work according to their own "internal regimes of power."

Tracking what it is that governs scientific statements, their thinkability, and their relationship to each other and to the discursive regime of truth, remains a task that this book's participants challenge us collectively to undertake. Order and conflict, theory and practice, life and art, science and culture: this volume is committed to subverting these distinctions and to exploring the tactical practices that bring disparate publics into engaged conversations. Foucault's investigations of power/knowledge remind us, as we investigate science/art/politics, that the difficult intersectional, interdisciplinary work to be done includes within one frame the spaces of the political economic and the ontological, the battles of the activist and the epistemologist, the tracings of the historian and the artist.

The twenty-first century has been dubbed the Biological Century because the advances in the biosciences have begun to change our understanding of life itself, in ways that recall, and go beyond, the ways in which the atom bomb, physics, and engineering defined the twentieth century. Life sciences have not remained the sacred domain of the bioscientists, however. Information and computer sciences are fundamental to the ways in which biological information is produced, stored, and analyzed. Computational and digital media studies now think the biological and the informatic together. Science and technology studies, a field that grew rapidly in the late twentieth century, catalyzed a shift in the ways humanities and social science academics understood the role of science and technology in everyday life.

Artists have actively taken part in scientific, political, and technical controversies, forging modes of representation and intervention that synthesize practices from science

and engineering, and producing fields such as biological art. Each of these fields of practice and theory has experienced a decade or two of exceptionally vigorous growth producing rich bodies of work, each with paradigmatic exemplars, methods, and figures. At the same time, interdisciplinarity has boomed. Controversies in genomic medicine, biotechnology, biodiversity, racial genetic markers, stem cell research, public anxiety, national security, biological terrorism, science fiction, and transnational public health bring together experts from numerous fields because the complexities in their constitution demand creative analysis. While we welcome this interdisciplinary explosion, we pause here to consider its challenges and limitations. To be successful, interdisciplinarity demands both intellectual rigor and expansiveness. Too often, scientists, artists, scholars, and critics bring their own complex expertise to the table but take away little that is new. Discussions often run aground because terms, categories, and concerns are perceived as incommensurable across disciplinary paradigms. *Tactical Biopolitics* takes up the challenge of speaking across these barriers.

Many people have come together here who, despite the explosion of academic interdisciplinarity, have rarely engaged with each other's work over a sustained period of time. Subsets of them—for example, the artists groups Critical Art Ensemble, subRosa, and Tissue Culture and Art, and the theorists Troy Duster, Donna Haraway, and Paul Rabinow—have long known each other's work. Others met each other in Irvine at the 2006 conference on BioArt and the Public Sphere, and still others, living and working across four continents, have been brought, via this book project, into remote but intimate engagement with new interdisciplinary fields.

Tactical Biopolitics approaches the numerous intersections of life, science, and art via specific topics that are too often analyzed in singular disciplinary rubrics, and sets out to recalibrate problematics, historical understandings, and resistant strategies. Some chapters return to classic formulations of biopolitics and bring fresh interventions into their frame. Others highlight the most controversial or experimental tactics of the 1990s. The book brings together academic research with public concerns, transnational politics, and artistic interventions. Public and expert discourses have converged at the ethical and creative challenges that lie at the intersections of life, science, and art. Popular culture feeds proliferating representations of the fears, anxieties, and hopes around the life sciences, at a time when basic concepts such as scientific truth, race and gender identity, and the human itself are destabilized in the public eye. What do inquiring, curious, or anxious publics need to understand about biology and its current research frontiers? How might scientists assess myriad, often contradictory, concerns about informed publics, national priorities, and academic freedom? How can historians, anthropologists, and philosophers contextualize the intersections of concerns about biological research, personal choice, social freedom, and civilizational progress? *Tactical Biopolitics* explores:

Beatriz da Costa and Kavita Philip

- Epistemological questions that emerge at the intersection of biology, art, and the public sphere
- Political questions that emerge at this historical moment, at the beginning of the Biological Century
- Models of interdisciplinary engagement that facilitate rich public participation in scientific discourse
- Practices that allow for experiential hands-on experience, and that facilitate deep and broad public understandings of the formulation of research questions

We open the book with two frames that take up the intersection of theory and practice in public enactments of biology and art. Particular forms of biology and art have been critical shapers of public perceptions of the Biological Century. Two biologists with extensive records of public engagement occupy our biology frame; and a curator, an artist, and a social scientist write the section on "Curating the Book of Life." Six topical sections follow.

"The Biolab and the Public" introduces key thematics in the field of bioart. "Race and the Genome" reintroduces a classic essay on the ethical and policy implications of genome research, and brings into dialogue a historian of science who addresses popular Indian and U.S. responses to genetic testing, a biological anthropologist whose work brings science, ethics, and race together, and a media artist who works with DNA.

"Gendered Science" brings into dialogue feminist work on biopolitics from the directions of fiction, media art, and critical theory. Each feminist author in this section brings to this task significant experiences in scientific laboratories, and approaches the task of critical technoscience conversation with no time for the popular canard that women and technology are inherently opposed.

"Expertise and Amateur Science" questions more sacred boundaries, blurring the lines between scientific experts, artists engaging in science, activists, and the law. This section brings together perspectives from art, anthropology, critical theory, and activism.

"Biosecurity and Bioethics" takes on the hot-button issues of post 9/11 biosecurity, bringing together essays by an artists' collective, an anthropologist and Foucauldian scholar, a biologist reflecting on the scientist's role in public resistance to the current politics of biosecurity, and a transnational feminist scholar concerned with public health and China–U.S. relations.

"Interspecies Co-Production" stages a dialogue among people who work with animals. A feminist science studies scholar, a media artist, and a philosopher–veterinarian approach the question of cross-species work with assumptions refreshingly free from the binary frames of human-animal domination and/or consumption.

This volume, then, uses the lens of a biopolitical discourse to develop a politicized framework composed of contributions from the arts, sciences, and cultural/science studies.

The book is intended not as the last word in this debate, but as an introduction to the field for newcomers, as a textbook for those long familiar with it, and, perhaps most significantly, as an experimental space in which we engage with each other over the meanings, histories, futures, and critical potential of tactical biopolitics.

Notes

1. http://www.nettime.org/Lists-Archives/nettime-l-9705/msg00096.html

2. http://www.next5minutes.org/

3. Michel Foucault, *History of Sexuality*, vol. 1 (New York: Vintage Books, 1990), p. 263.

4. Michel Foucault, "Truth and Power." In *Power, Essential Works 1954–1984*. James Faubion, ed. (NY: The New Press: 2000), p. 116.

Theory and Practice: Biology as Ideology

Although the twenty-first century is justifiably crowned the Century of Biology, the sciences of life have long been understood as irreducibly political. This section includes personal narrative histories from two activist intellectuals who have worked creatively at the intersections of biology and society.

In opening the book with this section, we remind a new generation of activists at the borders of life, science, and activism that we do not come to this field *ex nihilo*; the biosciences were not a blank, apolitical slate before the bioartists, science studies scholars, and new media hackers interrogated them. Rather, the sciences of life have long been politically contested and produced. Feminist, antiracist, and leftist scholars have documented the ways in which the biology of life was always already inscribed with the racial, classed, and gendered contours of Renaissance and Enlightenment Europe and its colonies. Some of the key insights for scholarly critiques from the so-called margins have emerged in collaboration with scientists at the centers of bioscience research in the twentieth century. Levins and Lewontin stand, here, as inspiring instances of politically committed intellectuals who have lived through tremendously turbulent political and intellectual times, managing to combine their intellectual passion for scientific research with their ethical commitment to political and social justice.

Richard Levins and Richard Lewontin are well known as biologists and as public commentators on biology and society. Working in the fields of theoretical population biology and molecular evolutionary biology, they have challenged and rewritten some of the foundational assumptions of their research fields while being involved in the social movements that shaped a generation of American students in the second half of the twentieth century, including the anti–Vietnam War protests and student movements in solidarity with labor, antiracist, and anti-imperialist struggles.

In these contributions Lewontin and Levins reflect on their lives in biology and in politics. How does one practice everyday science, and hope to get access to "truths" about nature, while being convinced of the irreducible historical and political shaping of scientific knowledge? How does one participate responsibly in local social justice movements when the scope of science and economics grows daily more globally imbricated? How can scientists address the complex ways in which even well-intentioned research can be taken up to serve political causes that may be antithetical to their own beliefs? What is the role of a democratic lay public in an era in which increasing scientific specialization is accompanied by increasingly dramatic effects of science on the practice of everyday life? What challenges lie ahead in the area of biosecurity and governmentalized life, and what lessons can we take with us from twentieth-century struggles over the politics of bioscientific research?

1

Interview with Richard Lewontin

Interview by Gwen D'Arcangelis, Beatriz da Costa, and Kavita Philip

Personal Background

Tactical Biopolitics (TB): How did you first get interested in population genetics, and how has this interest shifted over time?

Richard Lewontin (RL): Well, I got interested in population genetics by accident, the way one gets interested in anything. As an undergraduate I worked in the laboratory of a person who had been a student for his Ph.D. of the most eminent experimental population geneticist, Theodosius Dobzhansky, who was a professor at Columbia. So I met Dobzhansky. At one point I had a very bad undergraduate record, and I despaired of getting into graduate school. I thought a way to get in was go to Dobzhansky and he'd take me, which he did. So when I got my degree here [Harvard], I then went to Columbia to work with this famous population geneticist. I had second thoughts about it when I got there. Dobzhansky was not around—he'd gone off to do fieldwork—and I went up to another professor, who was a psychologist, with an idea for an experiment that would determine at what stage in the cell cycle DNA would be replicated. And he said, "Oh, that sounds like a very good experiment; I think it would be an excellent experiment, but if I take you as a student, Dobzhansky will never speak to me as long as I live. So go back where you came from." So I went back downstairs and stayed as a student of Dobzhansky. And that's how I came into it.

I also thought, foolishly, that population genetics, studying fruit flies and so on, had absolutely no consequences for human sociopolitical issues. And I was looking at that time to retreat somewhat from my previous political work. I thought, okay, I'll get into this. And of course that was stupid, because it turns out that it's very relevant.

TB: Would you describe yourself as passionate about population genetics? Do you feel the same way now as before?

RL: Well, I got into it . . . and it's my professional life.

TB: When did you first become involved in politics?

RL: When I was about thirteen. When I was in high school, the woman who is now my wife and I were founders of a left-wing political group in our high school, but I didn't think of it as having to do with science; it was just, politics came first. When I was in college, I hung out with people from the Communist Party, the John Reed Society—which was the Harvard undergraduate Communist Party—and I was always arguing with people about politics and stuff like that, but I didn't think about it in terms of science. And as I said, I decided I would sort of put that aside for the moment, and that's why I went into population genetics. But as human genetics developed . . . it became clear that population genetics was just as political as anything. I pretty well gave up any political activity when I was in graduate school; I became pretty careerist. And then I came back to it within a few years. I was involved with the [Black] Panthers.

TB: You've been talking about political groups, but were there some science and politics groups?

RL: There was a thing called Science for the People, which started out as Scientists and Engineers for Social and Political Action (SESPA). It was started by a couple of people who were academics. And I was in that from its early days. We would go to national meetings and challenge people like Teller and. . . . Yeah, that was part of life.

Science for the People finally went under for financial reasons. Science for the People was a completely anarchist group; it had no membership, you were just part of it. We didn't have any offices. But we did publish a journal, *Science for the People.* What happened was that the people in *Science for the People* had particular interests and particular issues like racism, or like environment, or something like that. And what developed over the years, after the sixties—during the seventies, mostly—were single-issue groups. For example, local people interested in safety and health, or environment, like MassCOSH, the Committee on Safety and Health, and the local environmental, Greenpeace, and all that stuff. So people, instead of working within this general-purpose organization which dealt with all kinds of things—we dealt with workers' health and safety, sociobiology, racism . . . I mean, *Science for the People* had articles written on all kinds of stuff—instead of that, people went to their single-issue organizations, and that left *Science for the People* with nothing.

And so it finally folded. But there are offspring groups. For example, we now have in Cambridge the headquarters of a thing called Council on Responsible Genetics. [See chapter 23 in this volume.] Council on Responsible Genetics was originally the human genetics study group of Science for the People. Science for the People was divided into study groups; I was a member of a couple of them. And the people interested in racism and stuff like that all belonged to the human genetics or the sociobiology study group. Well, the human genetics study group evolved into Council on Responsible Genetics,

which is what we have now, an independent organization with a full-time director and a journal, and [it] gets funding from the Ford Foundation. So, what I'm trying to say is that Science for the People had the politics of the sixties—nonhierarchical, non-official membership, no officers, no central committee—it was a truly participatory, democratic sixties-ish organization. But as the sixties disappeared and people went back to more conventional political organizations, Science for the People disappeared, and in its place arose a number of special groups.

There are certain kinds of political consciousness, some of which last a long time. You have, for example, the Revolutionary Communist Party, which is still Maoist and has [as] its leader Bob Avakian, who is in exile and has been in exile for thirty years or so, and they're on the edge somewhere. We have a number of Trotskyists—for example, the Workers' World, a more conventional party. But then we have a lot of these organizations which are not along the lines of parties because people don't have that kind of political consciousness. They don't want a central committee; they don't want a line that you have to stick to. That, I think, is a major effect of the sixties on radical politics in America. The pushing to the background of organized, disciplined political parties on the Left, and their replacement with a more anarchistic, or more participatory democratic, point of view. For example, I was a member in Chicago, when I was a faculty member, of what you would call the faculty branch of Students for a Democratic Society [SDS]. Now I wasn't really a part of SDS, but it was the equivalent of SDS for faculty members, and we had that same politics—there were no officers; there was no discipline. I once said, "I don't know why you guys are all kidding yourselves; this is a Marxist group." And they really got very annoyed with me. They didn't want to be identified as a particular . . . although they were all Marxists. So that was the change in political attitude which the sixties brought in, and which is still with us.

Science and Politics

TB: Usually most scientists will call things universal in a certain way; and you've been heavy on talking about the historical specificity or the contingency of science. How do you respond to critics who claim that your politics taint your science?

RL: Well, my response is very specific. We can take an example: my struggle with sociobiology. Sociobiologists, Ed Wilson in particular, say, "Well, you just have your attitude about the lack of rigid human nature because that's against your politics, and you're politically committed to a kind of open, changeable world, a revolutionary attitude, and you just don't like any science that is the opposite of that." And my response to that is that that's got the situation upside down. I've spent a lot—now I speak personally—I've spent a lot of my life, a lot of energy . . . I've put myself in difficult positions, some of them dangerous, some of them illegal . . . that's part of my political work. Why? Because

I would like to change the world in certain ways. Now, wouldn't I be a goddamned fool to do that, to go to all that trouble, to put myself in difficult positions, and so on, unless I really thought the world could be changed? It'd just . . . it'd be stupid.

You have to distinguish: well, there's a world I would like, but I'm not a utopian. There are lots of worlds I would like, but I can't have them because I don't think they're possible; I don't think we can get there from here. So whatever political things I've engaged in have been in pursuit of something that I thought was possible. Which means I think that ideas of rigid human nature and so on are baloney. So I have a very, very deep stake in the scientific correctness of that view. If that view is scientifically incorrect, I've been spending my life doing something stupid. So I want to know what's true about nature. It's not that I do the politics and therefore I lay it on Nature. I have to be sure that Nature really allows that.

The opposite is true for people like Ed Wilson, who want to say . . . who are happy with the way the world is. They don't have to know the truth about it, because suppose it's true that people are changeable. Even if they're changeable, they don't *have* to change. So you can make a perfectly consistent argument that the world we have now is the best we can do: "I wanna keep it that way . . . the fact that we could make a different world doesn't interest me . . . I wanna keep it *this* way." So . . . politics—the politics of "keep things the way they are"—in this respect, with respect to human society, does not depend on what is true about human nature; it doesn't have to be true . . . humans could be changeable or not changeable. But the politics which says "I want to change and I insist on change, and I work for change" has got to be based on the assumption that change is possible. So I think they have the argument upside down.

TB: What you were saying about taking a world as fixed versus changeable makes a lot of sense scientifically as well.

RL: Let me give you an example. I wrote a paper, which has been very widely referred to, on the amount of genetic variation within and between human races. Now, I wrote that paper on a bus going from Chicago to Urbana, Illinois. I had a table of logarithms and some big books of data, and I just sat there and did the calculations. I had no idea how that was going to come out. I did not write the paper with the intention of demonstrating that most human genetic variation was within races. In fact, I had the same prejudices that everybody had. Namely, that probably most human genetic variation is between geographical races; after all, skin color, and hair form, and that stuff is pretty obvious, so . . . it's probably gonna turn out that way . . . I was just curious. So I wrote the paper and it came out a particular way. That's an example of what I'm talking about.

TB: Right, you were open.

RL: I even had the initial prejudice that it would come out the other way. I was surprised.

Race

TB: Did it have a lot of implications for race?

RL: It had a lot of effects on people's thinking about race. But you have to decide on what you mean by implications for race. Suppose it turned out that most genetic variation was between races. Not all genetic variation is between races. Indeed, most of the human genome doesn't vary from individual to individual. The question is what you want to use race for . . . is race for you a social construct or a biological one? What this showed is that race is not a very useful biological construct, but I can still make a social construct out of it. I can still say God meant people like that to be slaves, even if they were genetically almost identical. I can say that racism in a social sense or the construction of social racial categories is independent of the truth of that question about genetic variation within and between races. And that applies in the other direction; even though eighty-five percent of human variation is within any local population, that doesn't tell me anything about some particular gene. Even though eighty-five percent is within a population, there must be genes in which most of the variation is between races; and there are a few, like the Duffy blood group, in which nearly all of the variation is between whether you're an Asian or an African or a European. Those are in the minority, but I can't prove any generality. I can't prove by the generality what's true in the specific case until I look at the specific case. So you have to be careful how you use that kind of information.

TB: Did you have a definition of race that you came up with when you did that experiment?

RL: You've asked exactly the right question. To ask how much genetic variation exists between races, you have to decide what a race is. . . . And that was not clear. That calculation has been done by other people based on DNA data and other data. They came to the same value of eighty-five percent within individuals within a local population, but the fifteen percent left over is between populations within a race and between races. And how do you decide which populations belong to which race? And different people got different answers depending on how they defined a race. A local population, you have no problem there. So, for example, when I wrote my paper, I had to decide are the Turks Asians or Europeans? How about the Finns? Everybody says Finns are Europeans, but they talk an Asian language—Finno-Ugric. And Hungarians, for that matter. Finno-Ugric and Turkish belong to the same Ural-Altaic group of languages, radically different from the Indo-European languages that Europeans speak. So where do you put people who come from India? What race are they? Are they Asians? How about people of the South Pacific?

So what I had to do is make up my mind about what I was going to do. So . . . it's just arbitrary . . . I made more races than usual, that's what I did. I took people of Southeast Asia, of the Indian subcontinent—Urdu and Hindi speakers—and then put them in a separate group. I made a group of Oceanians, all those people in the Pacific. Then I

made mainland Asians—Chinese, Japanese, Koreans. Then Africa, I pulled all the people in sub–Saharan Africa into one race called African black. All Native Americans into one group, and so on. I mean, you have to do something. And it came out that if you do it that way, about six percent of all the variation among humans is between those big groups. But when other people pooled them in different ways, they got nine percent, because race doesn't have a clear definition. The fact is that, in the United States at least, the social definition of race goes very close to the "one drop of blood" rule. Are you white or black? Well, I'm black. Well, how do you mean you're black? You look white to me. Well, I had a great-grandfather . . . Why isn't a person with one European ancestor and one African ancestor white instead of black? They're just as white as they are black. But under social definitions they're black. There is no definition of race.

Tracing Ancestors

TB: With the Human Genome Project, race is being defined in particular ways. People are trying to trace ancestry back to particular parts of the world . . .

RL: If you wanna do that, you could try to do that. We have a group here. Skip Gates, from the African–American Studies program, has a program to trace ancestry back to particular tribes.

. . . Why do they want to do that? I don't need to be a scientist to know that Oprah has African ancestry, or that Skip Gates has African ancestry. I didn't have to test your blood to know that you have Asian ancestry. So why do I wanna trace it back to a particular place, which is what genomics studies are doing? It's the same nuttiness, if I might say, that pushes people to want to know all about their family trees. Somehow your identity for people depends . . . for those people, not for me! I have my identity . . . One of my favorite stories is about one of Napoleon's marshals, who was asked by a nobleman who his ancestors were. And he said, "I am my own ancestor." "I am the ancestor." You know, you make your life, whatever it is. But I confess that the world is full of people who try to get credit or something or identity according to their ancestry. I think it's crazy. I think it's crazy, for example, when people who are adopted children wanna know who their real parents are. What do you mean, who your real parents are? Your real parents are the ones who brought you up. What do you gain from that knowledge? Except this very funny sense that you don't know how to express your own identity, and that it helps you. But it's irrational, from a scientific point of view.

TB: It could give one a sense of solidarity with a group . . .

RL: But what kind of a crazy solidarity do you get from that? Look, we all came out of Africa; it's just a question of more or less recently. My ultimate ancestors were African, just like yours. People are always doing that, but it doesn't mean that it has some independent, scientific importance or validity. The studies of the genetics of the caste system

in India go all the way back to the 1950s, before anybody heard of DNA. I had a fellow graduate student in Columbia, from India, who . . . found evidence that the different castes were genetically different . . . but of course, they're different . . . because they're isolated genetically from each other because they're not allowed to marry across caste lines. Of course . . . but [so] what?!

TB: But you don't see political utility, though?

RL: No, I think political disutility. I think it substitutes . . . it reinforces an arbitrary division of people along lines which don't correspond to most genetic variation and which have almost a . . . in the end a bad effect because people who are in power, whoever they are . . . I mean, look at the situation in Africa today, where tribalism is producing murdering people everywhere. My tribe is . . . I'm in power, and you're different . . . you're an out-group. It's the biologicization of historical variation that gives people an excuse. Because, look, let me try it from a completely different standpoint so you see where I'm going. There are people in the gay community who want very much to prove that being gay is biological. When I talk to them about it, they say, "Well, we don't want people to say that you're gay because you chose to be gay, because then they can say that you can un-choose." We wanna say to people, "We don't have a choice in the matter; that's what we are. We're biologically gay and there's nothing that can be done about it, so knock it off! It's like having wavy hair."

What they don't understand is, for the political and social forces who want to expunge homosexuality, can't stand it, for whom it's horrible, if they become convinced that it's biological . . . how do you get rid of something that's biological? You kill people. We have the Nazis as the classic example. They said, Gypsies, Jews, it's in their blood; they don't belong to the pure race. How can we purify the world? We have to kill all the bad ones. We can't convert them. So I think that the people in the gay rights movement who are pushing the biological unchangeability and necessity of sexual identification, gender identity, are doing a very bad thing for themselves.

Biological Determinism

TB: So let's talk a little more about genetic determinism.

RL: Look, we need a little history here. Geneticists since the beginning of genetics, in the twentieth century, have been biological determinists. It goes with the job. Geneticists are the ones who keep talking about "genes determine this" and "genes determine that," and "genes make this" and "genes make that" . . . all kinds of biologically wrong things. But they say it all the time. And geneticists are in the everyday business of looking at DNA or doing crosses between organisms and seeing which kinds come out. And they can't . . . they don't want to fool around with issues of physical and social environment; I mean, that just makes life complicated. There are some books over there on the top shelf

which—they're now online, but they used to issue them. There's a big red book there which is all the mutations of *Drosophila* [fruit fly], and there's thousands of those, and descriptions of them. And if you look in there, you will see that every mutation has got the notation RK1 or RK2 or RK3. Those are the rank mutations; every mutation is ranked. A rank 1 mutation is a mutation which, if you've got it, you are absolutely distinguishable from individuals who don't have it . . . the white eye mutation in *Drosophila*. If you're homozygous for the white eye mutation, you have a colorless eye and it doesn't matter what the temperature is, it doesn't matter how old you are, it doesn't matter anything.

A rank 5 mutation is a mutation which, if you've got it . . . under exactly the right environmental circumstances, if you look at the right age, maybe twenty-five or thirty percent of you show the trait but the rest don't. *Drosophila* geneticists don't like rank 5 mutants, because *Drosophila* geneticists want to make a cross of this individual with that individual and see the result and know and be able to identify by the look of the organism what its genes are. If you have a rank 5 mutation, just because you look normal doesn't mean you don't have the mutant gene. So they avoid those. They're listed in the book, but no sensible *Drosophila* geneticist will work with rank 5 mutants, despite the fact that most mutants are not rank 1. Rank 1 mutants are special mutants. And what they never tell you is that before a *Drosophila*-ist would start to do crosses with a particular mutant, they would go to a lot of trouble to make sure that any other genes that might interfere with the expression of that mutant are gotten rid of.

So what I'm trying to say is that if you're a geneticist, you're in the business of studying genes, not phenotype, and the trouble is, until there was DNA sequencing, the only way to study genes was to look at the organism, or maybe its proteins. Then along came proteins, and I spent a certain part of my life looking at proteins. But for most of genetics, between the beginning of modern genetics early in the twentieth century—1910 or so—until 1970, geneticists studied genes by studying organisms. So they have a strong commitment to the view that the organism is made by its genes. Because if you don't believe that, then how can you study the genes by looking at the organism? And they narrowed their investigations down to those cases where there was no ambiguity.

Now, they study DNA, but they've inherited that. So geneticists say that genes are self-replicating. Genes are not self-replicating. DNA can't do anything. The cell makes new DNA by copying old ones. They say genes make proteins. No, genes don't make proteins. The cell makes protein out of amino acid, using information in the genes. But the genes don't make anything. But that constant reiteration of genes are self-reproducing, they make the organisms—that's what geneticists have always talked about. The social consequence of that has been from the early days that almost all geneticists were strong racists and believed that every aspect of human behavior was caused by genetic difference. Almost all famous geneticists were one kind of racist or another, even those who were antiracist, so to speak. Look, a famous geneticist like Fisher, who founded population

genetics, he was a real racist. Most British geneticists were racists. Even people like H. J. Muller, who politically started out as a Marxist, and who would not be called politically conservative, nevertheless believed that genes determined just about everything, and he was a very strong eugenicist.

So, eugenics was a very important part of genetics for a long, long time. There were some anti-eugenics movements around the time of the Second World War when it became known what the Nazis were doing by their racial theories. But that lasted about ten years after the war, and along came Jensen's famous article "IQ and Race," and the thing started up again. So what I'm trying to say is that the people who study DNA, most of them, believe that the genes determine the organism. And you have to struggle against that concept.

TB: So not much has changed, is what you're saying.

RL: That's right. What the Germans did was to make it politically unpopular to be a eugenicist and a racist, but then people have short memories.

TB: In your book *It Ain't Necessarily So*, I saw the same; you were going back and forth with someone that had this revamped version of the brain size argument, except some variables were taken out, put in. It was the same thing, and I was thinking, "Isn't this from a hundred years ago?"

RL: Yeah, so those people still exist. But eugenics is not big stuff now.

. . . Well there's not a big movement to prevent people from marrying or having children based on their genome. It's been replaced by a medical predictive form of genetics, which is where they look at your genes and say, "Well, look, if you have a kid, it's likely that your kid will blah-blah . . . so be careful." But there they're sticking pretty closely to diseases rather than anything else. Nevertheless, you know Mr. Shockley, the famous physicist, supported for years a sperm bank in which people with high IQs would donate the sperm—men with high IQs—and women would say, "Oh I want a smart kid" But I would say—although I don't know that they admit it, so it's a guess on my part—but my guess is the majority of geneticists, of working geneticists, believe that genetic differences are pretty important in determining whether you have high IQ. I bet they wouldn't come out and say it, but I still have a feeling that they do.

Using Science

TB: How do you feel about the prevalent use of animal models?

RL: An awful lot of human behavior is analogized through animal behavior. So you talk about rape in animals, all that kind of stuff that was in sociobiology; you take human behavior and you lay it on animals. An interesting case is—I'm not gonna say this is generally true, because we don't have enough knowledge—the maze-bright and maze-dull rats. It is the case that you can select by selectively breeding a strain of rats that will learn

much more rapidly to go through a maze and another strain that will learn rather poorly. When those rats were looked at, however, a funny thing was discovered; . . . the maze-bright rats, the ones who learned quickly, were partly deaf and partly blind. So it turns out that the reason they are maze-bright is not because they are any smarter, but because, being partly deaf and partly blind, they're not distracted by all kinds of irrelevant cues from outside, so they can pay attention to what they're doing. So you haven't selected for intelligence; you've selected for not being aware of the world around you.

You can select for animals that would be better at doing some job . . . mice, you can select mice to run mazes . . . maze-bright and maze-dull rats . . . that's been used for a very long time to imply that differences in human behavior are consequences of differences in genes. So we don't have any new evidence, better evidence; it's always the same thing. You take some rats; you get them to perform some task; you breed from those who successfully perform the task and from those who don't successfully perform the task. And you keep doing that, and pretty soon you get a strain of rats that are successes and a strain of rats who are not. The question is what have you selected for. And what that has to do with what you and I are doing now. I mean, we're going to make it up. I mean, you say there's smart rats and dumb rats. I don't know what it means to be a smart rat or a dumb rat.

. . . Did you ever take an IQ test?

TB: Yes.

RL: How old were you?

TB: In third grade, really young.

RL: Okay, there you are. I don't know whether it was third, but I took it in elementary school. Anyway, I was sitting in a classroom, sun's shining in the window, the kid are fidgeting, the kid next to you hasn't had a bath, there are noises, little noises, and you are supposed to concentrate on meaningless, contentless questions. Now I had a thought that if most of your senses were dull—you didn't hear too well and you didn't smell very well—you'd do a much better job at it because you wouldn't be distracted by all those senses, things that are coming in. So I think kids who did well, had a high IQ test, were kids who didn't hear too well, and didn't have good olfactory sense, and stuff like that. Well, I just made that up, but that's all I'm trying to say: that the senses are competing with each other for information.

. . . Look, the one thing you have to understand about scientists is that they do what they know how to do. They can't do what they don't know how to do. So they do what they know how to do, and they try to pretend that what they've done is an answer to the question they had.

. . . What else are they gonna do? Say "I don't know"? Scientists hate saying "I don't know."

. . . And what they hate even more than saying "I don't know" is . . . "I don't know how to find out" or . . . "Not only do I not know how to find out, but no one will ever

find out." Scientists by their training are brainwashed to believe that if you work at it enough, you can know everything.

. . . Scientists are not allowed to say, "You know, there's a lot about the world no one will ever know." Not because it's mystical or spiritual, but because we have not enough of time in the world. Look, our species has been on Earth for . . . I don't know, a million years. So we have a few million years left to go, and we have only a certain amount of time and energy and money to do scientific work, and I can well believe that we will never understand the human nervous system, central nervous system. Not because it's intrinsically impossible to understand. We don't have the time; we don't have the money; we don't have the energy; we're not smart enough. I don't know how to put it. But the belief that everything will be found out about the world is just stupid.

TB: So the last thing I want to ask you, do you see any positive role for the Human Genome Project?

RL: I can't actually think of many, except the possibility of finding markers that will be useful for diagnosis.

TB: For disease?

RL: For disease. Other than that . . . As a geneticist, if I were just interested in studying the evolution of the human genome or something like that, then the Human Genome Project is very useful for me. But if you mean useful as humanly useful, I don't see it. Look, I thought the HGP was a general waste of time. But if suddenly we got it for free, I wouldn't be against it. The *Drosophila* . . . I'm perfectly happy to know the comparative genomics of different species of *Drosophila*, because I can make use of that in a certain number of experiments. They provide me with experimental tools. But I don't have to know the whole genome. Now we're getting to a deep political issue about science, which is that an awful lot of what scientists do is of no use to anybody, and never will be, and is positively bad for people.

What about anthropology? What has anthropology ever done for the people that it's studied? If I were a Brazilian Indian, why in hell would I want to tell anthropologists . . . and the anthropologists say, "Ah, well, we can tell you your origins," . . . and I said, "What do you mean you can tell me my origins? I know my origins; I got a story; I'm perfectly happy with my story. Why do I want your story?" This belief . . . that to know everything about the material world is necessarily—except for pure intellectual interest and joy of doing it—useful in some other sense is nonsense. Most of what scientists do will never be of use to anybody.

TB: Rarely said.

RL: You know, we've got a museum here where people are doing taxonomy and trying to get the correct relationships between different species . . . Who cares? I mean, I care about the relationships among *Drosophila*, because then, if I know the relationships, I can

use the differences between the genes to make inferences about certain evolutionary processes. But that's not to say that it's of any benefit to people.

TB: Right, personal interest.

RL: Purely intellectual.

TB: So what about gene therapy? Do you think that it's too sketchy?

RL: Two things to say about gene therapy. You know that we do not yet have a single case of success with gene therapy?

TB: I didn't think so.

RL: No, we don't. One of the reasons is an everyday reason, and that is that if you change the genes in a certain number of cells . . . you haven't done it in all of the cells . . . cells are turning over in the body all the time. They're turning over and dying and being replaced by other cells. Now what's happening with these people who have to get re-treated every six months or every year is that the small group of cells that did get transformed don't have any progeny cells anymore. They died, and the other cells took over, and now they're back where they started from.

TB: Oh, I didn't know that.

RL: One thing we know is that cells are dying and being replaced constantly. And if the successfully changed cells die and don't replace . . . for a while they do, but the random chance is that they'll disappear, that cell line will disappear. . . . The other problem for human gene therapy is that we do not have in humans the technology to insert genetic material into a place in the genome that I decide in advance that it is going to go. It is a very important point that has to do not just with human gene therapy, but has to do with so-called genetic engineering, with plants and so on. There are few organisms in which I can put the gene, the introduced DNA, exactly where I want it, using viruslike particles and so on. In that case, I can stick the good gene exactly in the right place, so that the controlling elements are controlling, but if I throw genes at random into the gene, they'll pop in anywhere, they'll pop in the middle of some other gene and destroy that gene's activity. That's the chief danger of genetic engineering. . . .

How do I know when I put a gene in you to solve some problem, it doesn't wind up in the middle of your hemoglobin gene?

TB: Yeah. So how do you specifically place? You can't?

RL: Not in humans, you can't. You've gotta have just the right kind of viral setup and so on. We couldn't do it in *Drosophila* until a few years ago, when a special method was invented. So that now you can in fact. . . . no, I'm sorry, you still cannot put a gene in *Drosophila* anywhere you want. What you can do, is you can arrange to put a piece of DNA in and it'll go someplace, and then you can take out part of it, and you can take out different parts of it so you can see what the effective . . . all in the same place . . . but

in *Drosophila* I cannot have site-specific insertion. Very, very few organisms—in bacteria you can do site-specific insertion. You cannot do site-specific insertion on any higher organism that I know of . . . not in people, not in mice, not in *Drosophila*. So there's a big chance you'll screw up the organism. That's the second reason why gene therapy is bad.

But the main political reason why gene therapy is bad is that only very rich people can afford it.

TB: As usual . . .

RL: But it's worse than most cases. It's the kind of therapy that is extremely expensive, so it diverts possible resources from the real things we should be spending resources on, the things that are killing—well, making most people sick—just for the benefit of one person. And secondly, a lot of it is not gene therapy; a lot of it is trying to make your kid prettier or smarter or something like that. . . . tailor-made babies, right? That's the propaganda! Now, it's not actually being done. But a lot of the propaganda is, make babies to order. Wanna blue-eyed baby? We can arrange that. So, for all those political reasons, the diversion of resources, and for scientific reasons it won't work anyway. And finally there's an ideological problem, which is that it reinforces the notion that we can cure everything, you can live forever . . . It just gives a false notion of a kind of physiological utopia which is not possible and again diverts attention from what we should be doing.

TB: Regular disease, chronic diseases . . .

RL: AIDS . . .

TB: Well, the whole Human Genome Project seems that way . . .

RL: But that's just a way to get money. You have to have money.

Biosecurity

TB: Let's talk about biosecurity.

RL: What is biosecurity?

TB: How do you think the national security climate post 9-11 is affecting how biology is practiced?

RL: Well, I don't think they're having much effect on most of biology. Now, of course, I'm not privy to those particular branches of biology, but generally speaking . . . Look, I go back to think about the way in which a whole variety of security issues and fear of the Communists and so on . . . what effect they had on science in the sixties and fifties, and few people were severely hurt by that. It had almost no effect on scientists in the lab. It really didn't. I know that it's not a fashionable thing to say, but the fact of the matter is that the House Un–American Activities Committee and McCarthyism and all that did ruin some people's lives, but they had no effect on science in general. I mean, I sent for my Freedom of Information Act file, most of which is completely blacked out so I can't

read it. But all the time when the FBI was watching me, I was getting money from the Atomic Energy Commission to do my scientific research. One of my Professors, L. C. Dunn, was a member of almost every so-called fellow traveler group that existed in America, and he was completely supported by the Atomic Energy Commission.

America was lucky, and we're still lucky, I think, that the people that are doing this are not very . . . that we don't have a uniformly integrated State apparatus of the fascist kind. We have individuals who are making political hay by doing . . . but the state is not organized in such a way that there's much constraint on people's freedom to do whatever the hell they want. And that's a fact. I'm not saying it couldn't be . . . but we just don't have that . . . we didn't have it in the heyday of the anticommunist movement, and we don't have it now. So that's one thing.

Now, much of this simple security stuff is a product of the military itself. And so why do we have smallpox in laboratories? If we don't have any out there, then . . . We have it because we're afraid that other people will attack us with smallpox, so we need to develop defenses, and also because we would like to be able to threaten them. So it's part of the counterweaponry that the problem arises in the first place. Anthrax, I mean, why does anybody have anthrax in a laboratory? Anthrax is not a public health problem. Again it's because, on the one hand you want to protect yourself in case somebody else has it; on the other hand you want to be able to threaten them. So most of the simple biosecurity business is a product of the military itself. I mean, I don't want to say we shouldn't have people working at the CDC or even Fort Dietrich on how to protect me against smallpox, because there might be some nitwit out there who wants to use it against me. So I'm in that funny position. If I could get rid of it on a world scale, I would. But if I can't get rid of it on a world scale, why would I not want to develop vaccines and so on to prevent it? I think that's one of those contradictions that have no solutions. You cannot unilaterally disarm from biological weapons unless you are willing to become a tiny corner of the world, which the United States is not willing to become.

TB: Do we need biodefense?

RL: I don't know. This is all secret work. We know nothing about it. If I could rule the world, I'd get rid of it all. But I can't rule the world, and I don't know how to make judgments about it. I don't know how much laboratory space, and money, and time are required to keep up on smallpox . . . or anthrax protection . . . I just don't know. And nobody outside of that system knows, either. We were going to have a very high-level containment facility here many years ago. A bunch of us went and testified. I testified against it; they, in favor of it. They pulled the usual . . . they arrived in their white coats, with test tubes, and said, "We're scientists; you can trust us." And my main claim to the City Council was that you can't trust scientists because they only do what's interesting to them and pay no attention to anybody; so if you really want to be careful, don't let them do it.

Look, this raises a very interesting issue. Suppose Cambridge is going to have regulations about what science of DNA-level technology can be done. Who's going to make the decisions? You're not going to let the scientists make the decisions, even though they said, "You can trust us, after all we're . . ." So you say okay, well, we have to let the public make the decision. So we have to form an outside group. Who are you going to put on the committee? Are you going to walk down to the central square and point at people at random and say, "You're on the committee"? You can't do that because people have to be highly educated in this material before they can make decisions. So therefore you take academics or biologists, but they already have a vested interest. And this is a long-standing legal problem in the United States or anywhere. When you want to have a regulation of something, who do you make the regulators? You have to make the regulators people who understand the technology. Who are the people who understand the technology? People who already have a vested interest in it.

TB: The government.

RL: Or industry. We don't know . . . look, let me just diverge a little bit and tell you a story. Fifteen years ago or so, I can't remember anymore, a group was formed in California using a public interest law firm to sue the University of California because of all the money they put into agricultural research that was a benefit only to very rich farmers, to corporations who were involved in processing food, and stuff like that. And the claim of this group, which I was a participant in, was that the legislation which set up the agricultural experiment station system in California, the State University agriculture school at Davis, was, according to the law, to benefit farmers, farmworkers, consumers. Our claim was that all the research that was being done, did not benefit farmworkers—on the contrary they exploited farm workers, did not benefit consumers, was only a benefit to farmers, and to the richer farmers. And we wanted that to change. That was a wonderful trial. We could so easily demonstrate that the agricultural experiment station, the whole agricultural experiment station system in California, was rigged against labor, and against a huge constituency. And we won the case. And you might be interested to know that the judge in the case was the father of Bob Avakian.

TB: Who's that?

RL: Bob Avakian? He's the head of the Revolutionary Communist Party. But his father, Sparky Spurgeon Avakian, was a judge in California. At any rate, the University of California lost the case. Then came the problem. Okay, the court judges in favor of the plaintiffs: the University of California must be required to do research that benefits consumers, farmworkers, and small farmers. Since we cannot look at every research proposal which would interfere with academic freedom, among other things, we have to have some group that will generally oversee the direction of work. It's up to you, the plaintiff . . . to tell us how we should form this group. We couldn't do it. How did we make the remedies? We couldn't make a remedy which said that we, in particular, will oversee. First of all,

every state in the Union had got some interest in it . . . they filed amicus briefs because they didn't want anybody interfering with the agricultural research they did in North Dakota, or Kansas, or Iowa. And that's where we failed. We won the case, but we failed to suggest sensible remedies because we could not invent a way of forming a judgment . . . a town . . . that would not contain people who were not already deeply interested in the issue. The result was that the judge ruled that it would have to stay in his hands, and he would himself make the judgment. Well, it was simple, . . . and so the whole movement failed in that sense, and nothing changed.

TB: So what do we do?

RL: Well, I mean, now I just have to go back to old politics. When you live in a hierarchical and class society, you're stuck with some aspects of that hierarchical society. We're going back to that whole political issue which I told you about, which we had in Chicago . . . if you had a participatory democracy, that would be one thing; but we don't. There are models. I'll tell you an example of a model at work. The chicken slaughterhouse workers in Canada were getting all kinds of warts and other kinds of bad things from handling chickens. They were getting viruses. They were getting other viral diseases. They went to public health school at the University of Quebec in Montreal, and got a group of the public health people to start giving evening classes to which the workers went to learn all the science necessary for this particular question. They weren't trying to give them Ph.D.s. They were teaching them the science they would need. And they succeeded in doing that, and the result was that the slaughterhouse workers' union was then able to negotiate with the owners of the slaughterhouses along lines that would protect their health.

That's what you need. What you need are interested parties who will be educated on the specific issues, will spend enough time to learn what they have to learn for their own benefit, and then go there and demand . . . Labor unions, . . . when they were powerful, were a very important source of that kind of stuff for industrial health. Workers themselves would oversee their own health, provided they were educated. And so what you need to do is set up workers' schools. Now of course the unions are less and less powerful in America, and I don't know what to do about that. But you see it's part of the whole system.

Let's talk about these containment labs. The head of the lab doesn't do any work in the lab. The head of the lab sits in his office. The workplace remains the place to organize. There are scientific workers in every laboratory. There are people who just do everyday technical work. They are exposed to all of these germs. They should be organized. And they probably know a lot about it; they don't have to be educated. They should organize. It'd have to be organized from the inside. You have to have small participatory groups not from the outside, picked at random from the public. It's important from the standpoint of what you're doing to look at the makeup of government advisory committees on

scientific issues and see who they are. They're almost always presidents of universities, heads of technological companies. They don't go into the lab and ask some lab worker to be on the committee, do they? It's always the people who are running the world who are on those committees. And that's where the real politics is. The real politics is to get people from the bottom of the hierarchy into . . . power, to make those decisions. That's a very heavy political question.

There was a time when unions were strong. But even then . . . when I was in Chicago, I tried to get Walter Reuther, a name which you're probably not familiar with. He was perhaps the most famous and powerful union leader. He was head of the United Auto Workers when they were really big stuff. I tried to convince Reuther and his brother to deemphasize at the next go-round of negotiations an increase in hourly wage and instead make demands about pollution, because the workers were in fact living side by side with the factories in workers' housing around Chicago, over the Indiana line. There were big steel mills and auto plants.

Those workers were getting poisoned heavily by stuff coming out of the chimneys. I wasn't getting poisoned; I lived far away. But they were getting poisoned. And I said, "Look, what you got to do is get the organizing, the negotiating team, and demand investment in pollution control for the health of the workers themselves. Reuther wouldn't buy it, because he regarded wage demands as the easiest thing to do . . . it's not that he was against it in principle . . . he just thought it wouldn't go.

TB: Right, priority.

RL: So we need more; at that time we needed more consciousness-raising among the general public, among the workers and the people, about the dangers of pollution. Fortunately we're not in that position now, because that work's been done. The American public is conscious about pollution. Unfortunately, we no longer have a powerful labor movement.

TB: What about the people representing science to the public? For example, artists, journalists, and corporations?

RL: I wouldn't be too vulgar in my explanation. . . . but it's too easy to say that it's being pushed by the corporations and the scientists are not responsible. They *are* responsible. And the artists are responsible. The artists are participating in that same consciousness. After all, I'm not a scientist; I'm an artist, right? I have to believe what the scientist tells me. Who am I going to believe if I don't believe the scientist? Look, I think this has much broader implications than just the art world. It has to do with the feature articles, and the reporting, and the writing, and the press, and the TV, and so on about science in general. It has to do with science journalism. The New York *Times* has a lot of science journalism. They even have a weekly science section. And the stuff in there is terrible.

I mean, really terrible. Nicholas Wade and Gina Kolada . . . they're awful. They're really awful. They vulgarize everything. They love it when some scientist makes an

announcement, "Scientists today have announced the discovery of a gene which may one day lead to a possible cure for . . ." And they, they're . . . so I think that brainwashing of the public goes on very, very successfully and constantly through . . . the public media. And, question, what is to be done about it? Now, having bad-mouthed Gina Kolada and Nicholas Wade and their friends, I have to take a step back. I have had for some years active participation, not in the last couple of years, but . . . with . . . the Knight Fellowships at MIT, which are fellowships for science writers. They come to MIT, they study science . . . and I used to go there and give them talks and discussions.

And what I found was that science writers are actually very sophisticated about science. The problem is not what's in their heads. The problem is this: science articles, in newspapers, magazines, radio, and so on, are in competition for space with other kinds of news. If I'm a science writer and I write, "Well, a scientist today claims to have found the gene that . . . may one of these days lead to some blah blah blah, but you know, they really don't know much about it, and it's all very complicated because the environment is important and genes don't determine anything," I can't get that article in the paper. If I want column inches, I have to have something dramatic. And so, by the very nature of print publications and radio and TV, where space and/or time slots are at a premium, if you don't say something dramatic, you don't get in.

So our problem is not with those stupid science writers; our problem is their profession is bound by a larger constraint. I don't think they need to be any more educated than they are; I think they need to be freed from . . . Now we have models. They don't happen to be American models, but we have models. For example, we have what's called the *feuilleton* . . . French newspapers have sections called the *feuilleton* section—Italian newspapers have the same thing—in which serious articles of some length are written about intellectual and scientific issues. I write for *Corriere della Sera*, for *La Stampa*, for *Le Monde*. I don't write often for them, but my friends ask me if I'll—I don't write them in Italian—I write them and then they translate them. You talk about the books I've written . . . some of that stuff appears in *Le Monde*, which is a daily newspaper in France, one of the big daily newspapers. I mean, these are not little, . . . *Le Monde* is a big paper. *Corriere della Sera* is the largest-selling newspaper in Italy . . . and so on. But they have a tradition of getting people to write seriously about serious scientific issues.

TB: I am interested in your article *Applied Biology in the Third World*. Could you talk a bit about biopiracy?

RL: Some kinds of biopiracy could benefit countries which have very little money to spend on science.

TB: What do you mean?

RL: Well . . . it depends what you mean by piracy. If you believe in the patent system, then if I use something that you have a patent on in my own country without paying for it, isn't that a form of piracy? The issue is the role of property and private property and

patenting, and the problem again is a historical one. Patents were put into the Constitution of the United States. Why? Well, a very sensible argument. Namely, we want to have innovation, but nobody will innovate if they can't get something out of it. So we have to invent a system which, on the one hand, will allow them exclusive rights for some period of time but not forever, and they're certainly delicately balanced. And if you have a system of private property, . . . then you do have to guarantee to innovators the fruits of their innovation, or something, and I don't know any solution to that problem except . . . to get rid of private property.

The issue is what the right balance is between encouraging innovation and making sure that it doesn't prevent any . . . for example, how will Third World countries get it? . . . Well, the way they should get it is to steal it. I'm a great defender of that. . . . The real dangers to Third World countries are not by marching off with plants and things like that. The real danger is in biotechnology and with putting genes into plants that grow here to make it unnecessary to buy crops from foreign countries. For example, genes that allow soybeans to produce palmitic acid oils, so-called palm oils, which have been put into them. So now you can grow palm oil in the middle of Iowa, but that means that the Philippines, which depends tremendously—a huge fraction of Philippine oil workers depending on harvesting and processing palm oil—have gone out of business. I mean, Third World agricultural economies are being destroyed by . . . Look, much of Third World agricultural economies, except for the food they grow, is for the world market for specialty crops. If I grow a specialty crop in Iowa, I don't need them. So that's what the whole tropical oil thing is happening.

They put the genes for caffeine production in soybeans. Now, it doesn't taste like coffee, but there is caffeine in it. And caffeine itself is a very important industrial product in the United States. It goes into all kinds of soft drinks . . . all got caffeine in them. It used to be that you had to buy coffee from Central America and get the caffeine out of the coffee, but you don't have to do that anymore. So a very important pressure in biotechnology by the seed companies, and in universities, is to develop strains of commercial domestic varieties . . . soybeans . . . which will be able to produce all kinds of specialty stuff, which will destroy tropical infrastructure . . .

So I'm much more concerned with that kind of an issue, than of going to tropical countries and grabbing a plant. That's been going on for a long time. The advantage that these tropical countries had at one time was that those plants only grew well in the tropics, so nobody can . . . the rubber countries didn't care where their rubber trees grew . . . what do they care? And they tried, you know, substituting guayule for rubber during the war, but. . . . it didn't work very well, and now anyway rubber is out of the picture. Nobody's into rubber; it's all synthetic. See, that's the other threat to Third World agricultural economies: the substitution of petroleum-based synthetics for natural products.

TB: Okay, so you view that as harmful because of the economic issue.

RL: Well, yeah. If you're not Venezuela selling oil to the United States, and you're Guatemala, or Brazil, which doesn't have any oil, and you used to grow a lot of rubber and you don't grow it anymore . . . it's an important source of income. It's not a source of income anymore. It's also true in Indonesia. Indonesia was a very important source of rubber. Dead. So Third World countries depended a lot on the export of agricultural commodities, which have slowly but surely been either replaced by synthetics or by inserting the genes for important types of production into domestic products.

TB: What kind of audience are you targeting, or are you trying to create, for your work? In other words, what is your ideal of a well-informed layperson engaging with science?

RL: Well, we're really talking about my limitations. My limitations in the ability to communicate are such that I can only communicate with people with a fair amount of education. Now we're talking about not what I would like to be able to do, but what I know how to do. Almost everything I write is only seen by people with a lot of education. All that stuff I write in the *New York Review*, all those books we talked about, *It Ain't Necessarily So,* or *Triple Helix* . . . who reads that stuff? I mean, only college people, college-educated people. Now what I try to do is to at least internationalize it, so it reaches out to other countries. A lot of those books have . . . been translated into a lot of languages. But I'm not kidding myself. I'm not J.B.S. Haldane writing a column on science that the daily worker can really read. It's not true. For one thing, I don't know how to do that, because I don't know where the outlets are. Who's gonna publish science for the citizen, so to speak? *New York Times*? It has its own science writers and its own thing they wanna do. Writing *feuilleton* columns for European papers? But look, *Le Monde*, who reads the *feuilleton* section of *Le Monde*? Not every . . . most people. No, I mean that's a contradiction that I have no way of . . . no solution for. I really don't. For one thing, you would have to crack TV. TV is everything. I don't think the newspapers matter that much. Well, what TV do you have to crack? Not public broadcast. But those other stations don't do that kind of stuff.

. . . So, I don't have an answer. Look, I mean there are some contradictions that exist for me because the society won't . . . they're not changeable . . . without a revolution, it's not a revolution. I mean, there could be a filtered-down effect, I suppose, if you could convince enough people with a certain level of education that what's been given to them is bullshit, that might themselves have some spreading effect . . . But look, I come back to what I said before: the greatest force possible for education of working people was the trade union movement. The destruction of the trade union movement in America is a very great catastrophe in many respects, including that one.

TB: What you're saying about the trickle-down does make sense because one of my friends has just now entered biology grad school and has read your works and was very excited that I was going to come interview you. And he is—in terms of practicing responsible science or trying to negotiate some of these contradictions—he's at least aware. He

doesn't have a solution. He does have that same contradictory impulse; he just likes doing science, the research. . . . He also wants to change things politically. But he has that pull; he knows that a lot of what he's doing is just his own thing. But I have this hope that he'll figure something out; something he'll do will somehow . . .

RL: There's another issue buried there which we didn't talk about. And that's the question of legitimacy. If you write and speak about things that are not part of your professional work, you have to have a certain legitimacy. Now people use that legitimacy to spread all kinds of ideas. Ed Wilson used his legitimacy as an ant professor to spread sociobiology. I use my legitimacy as a geneticist to spread other things. So legitimacy is very important. The only way to maintain that legitimacy is to keep producing science. My metaphor is the metaphor of the bank account. Every time you write something for the general public, you withdraw something from the bank account. And you gotta put something back. If you stop putting something in, pretty soon you're going to go bankrupt. And that's true even for people whose bank accounts are immense. Not me; I don't have such an immense account. But you take people, people who have Nobel prizes. If they don't keep doing science, their bank accounts become empty, because they decide, "Oh, I have a Nobel Prize, so I can talk about anything." And so they talk and they talk, and pretty soon people pay no attention. So that's a very important reason for the politically active person in science to continue to do the scientific work. I do. I'm retired, but I still do my science.

Living the Eleventh Thesis

Richard Levins

Philosophers have sought to understand the world. The point, however, is to change it.
KARL MARX, "ELEVENTH THESIS ON LUDWIG FEUERBACH"

When I was a boy, I always assumed that I would grow up to be both a scientist and a Red. Rather than face a problem of combining activism and scholarship, I would have had a very difficult time trying to separate them.

Before I could read, my grandfather read to me from Bad Bishop Brown's *Science and History for Girls and Boys*.[1] He believed that as a minimum, every socialist worker should be familiar with cosmology, evolution, and history. I never separated history, in which we are active participants, from science, the finding out how things are. My family had broken with organized religion five generations back, but my father sat me down for Bible study every Friday evening because it was an important part of the surrounding culture and important to many people, because it was a fascinating account of how ideas develop in changing conditions, and because every atheist should know it as well as believers do.

On my first day of primary school, my grandmother urged me to learn everything they could teach me—but not to believe it all. She was all too aware of the "racial science" of 1930s Germany and the justifications for eugenics and male supremacy that were popular in our own country. Her attitude came from her knowledge of the uses of science for power and profit, and from a worker's generic distrust of the rulers. Her advice formed my stance in academic life: consciously in, but not of, the university.

I grew up in a left-wing neighborhood of Brooklyn where the schools were empty on May Day and where I met my first Republican at age twelve. Issues of science and politics and culture were debated in permanent clusters on the Brighton Beach boardwalk, and were the bread and butter of mealtime conversation. Political commitment was assumed; how to act on that commitment was a matter of fierce debate.

As a teenager I became interested in genetics through my fascination with the work of the Soviet scientist Lysenko. He turned out to be dreadfully wrong, especially in trying to reach biological conclusions from philosophical principles. However, his criticism of the genetics of his time turned me toward the work of Waddington and Schmalhausen and others who would not simply dismiss him out of hand in Cold War fashion, but had to respond to his challenge by developing a deeper view of the organism/environment interaction.

My wife, Rosario Morales, introduced me to Puerto Rico in 1951, and my eleven years there gave a Latin American perspective to my politics. The recent various left-wing victories in South America are a source of optimism even in these grim times. FBI surveillance in Puerto Rico blocked me from the jobs I was looking for, and I ended up doing vegetable farming for a living on the island's western mountains.

As an undergraduate at Cornell University's College of Agriculture, I had been taught that the prime agricultural problem of the United States was the disposal of the farm surplus. But as a farmer in a poor region of Puerto Rico, I saw the significance of agriculture for people's lives. That experience introduced me to the realities of poverty as it undermines health, shortens lives, closes options, and stultifies personal growth, and to the specific forms that sexism takes among the rural poor. Direct labor organizing on the coffee plantations was combined with study. Rosario and I wrote the agrarian program of the Puerto Rican Communist Party, in which we combined rather amateurish economic and social analysis with some first insights into ecological production methods, diversification, conservation, and cooperatives.

I first went to Cuba in 1964 to help develop their population genetics and get a look at the Cuban revolution. Over the years I became involved in the ongoing Cuban struggle for ecological agriculture and an ecological pathway of economic development that was just, egalitarian, and sustainable. Progressivist thinking, so powerful in the socialist tradition, expected that developing countries had to catch up with advanced countries along the single pathway of modernization. It dismissed critics of the high-tech pathway of industrial agriculture as "idealists," urban sentimentalists nostalgic for a bucolic rural golden age that never really existed. But there was another view: that each society creates its own ways of relating to the rest of nature, its own pattern of land use, its own appropriate technology, its own criteria of efficiency. This discussion raged in Cuba in the seventies, and by the eighties the ecological model had basically won, although implementation was still a long process. The Special Period, that time of economic crisis after the collapse of the Soviet Union when the materials for high tech became unavailable, allowed ecologists by conviction to recruit the ecologists by necessity. This was possible only because the ecologists by conviction had prepared the way.

I first met dialectical materialism in my early teens through the writings of the British Marxist scientists J. B. S. Haldane, J. D. Bernal, Joseph Needham, and others, and then moved on to Marx and Engels. It immediately grabbed me both intellectually and

aesthetically. A dialectical view of nature and society has been a major theme of my research since. I have delighted in the dialectical emphasis on wholeness, connection and context, change, historicity, contradiction, irregularity, asymmetry, and the multiplicity of levels of phenomena, a refreshing counterweight to the prevalent reductionism then and now.

An example: after Rosario suggested I look at *Drosophila* in nature, not just in bottles in the laboratory, I started to work with the *Drosophila* in the neighborhood of our home in Puerto Rico. My question was How do *Drosophila* species cope with the temporal and spatial gradients of their environments? I began examining the multiple ways that different *Drosophila* species responded to similar environmental challenges. I could collect *Drosophila* in a single day in the deserts of Gúanica and in the rain forest around our farm at the crest of the cordillera. It turned out that some species adapt physiologically to high temperature in two to three days, and show relatively little genetic differences in heat tolerance along a three thousand-foot altitude gradient (about twenty miles). Others had distinct genetic subpopulations in the different habitats. Still others adapted to and inhabited only a part of the available environmental range. One of the desert species was not any better at tolerating heat than some *Drosophila* from the rain forest, but were much better at finding the cool, moist microsites and hiding in them after about 8 A.M.

These findings led me to describe the concepts of cogradient selection, where the direct impact of the environment enhances genetic differences among populations, and counter-gradient selection, where genetic differences offset the direct impact of the environment. Since on my transect the high temperature was associated with dry conditions, natural selection acted to increase the size of the flies at Guánica, while the effect of temperature on development made them smaller. The outcome turned out to be that the flies from the sea level desert and the rain forest were of about the same size in their own habitats, but the Guánica flies were bigger when raised at the same temperature as rain forest flies.

In this work I questioned the prevailing reductionist bias in biology by insisting that phenomena take place on different levels, each with its own laws but also connected. My bias was dialectical: the interaction among adaptations on the physiological, behavioral, and genetic levels. My preference for process, variability, and change set the agenda for my thesis.

The problem was how species can adapt to an environment when the environment isn't always the same. When I began thesis work, I was puzzled by the facile assumption that, faced with opposing demands—for example, when the environment favors small size some of the time and large size the rest of the time—an organism would have to adopt some intermediate state as a compromise. But this is an unthinking application of the liberal bromide that when there are opposing views, the truth lies somewhere in the middle. In my dissertation, the study of fitness sets was an attempt to examine when an intermediate position is truly an optimum and when it is the worst possible choice. The short answer turned out to be that when the alternatives are not too different, an intermediate position

is indeed optimal, but when they are very different compared with the range of tolerance of the species, then one extreme alone, or in some cases a mixture of extremes, is preferable.

Work in natural selection within population genetics almost always assumed a constant environment, but I was interested in its inconstancy. I proposed that "environmental variation" must be an answer to many questions of evolutionary ecology, and that organisms adapt not only to specific environmental features, such as high temperature or alkaline soils, but also to the pattern of the environment—its variability, its uncertainty, the grain of its patchiness, the correlations among different aspects of the environment. Moreover, these patterns of environment are not simply given, external to the organism: organisms select, transform, and define their own environments.

Regardless of the particular matter of an investigation (evolutionary ecology, agriculture, or, more recently, public health), my core interest has always been the understanding of the dynamics of complex systems. Also, my political commitment requires that I question the relevance of my work. In one of Brecht's poems he says, "Truly we live in a terrible time . . . when to talk about trees is almost a crime because it is a kind of silence about injustice." Brecht was of course wrong about trees: nowadays when we talk of trees, we are not ignoring injustice. But he was also right: scholarship that is indifferent to human suffering is immoral.

Poverty and oppression cost years of life and health, shrink the horizons, and cut off potential talents before they can flourish. My commitment to support the struggles of the poor and oppressed, and my interest in variability, combined to focus my attention on the physiological and social vulnerabilities of people.

I have been studying the body's capacity to restore itself after it is stressed by malnutrition, pollution, insecurity, and inadequate health care. Continual stress undermines the stabilizing mechanisms in the bodies of oppressed populations, making them more vulnerable to anything that happens, to small differences in their environments. This shows up in increased variability in measures: blood pressure, body mass index, and life expectancy as compared with more uniform results in comfortable populations.

In examining the effects of poverty, it is not enough to examine the prevalence of separate diseases in different populations. While specific pathogens or pollutants may precipitate specific named diseases, social conditions create more diffuse vulnerability that links medically unrelated diseases. For instance, malnutrition, infection, or pollution can breach the protective barriers of the intestine. Once the barrier is breached for any of these reasons, it becomes a locus of invasion by pollutants, microbes, or allergens. Therefore nutritional problems, infectious diseases, stress, and toxicities cause a great variety of seemingly unrelated diseases.

The prevailing notion since the 1960s had been that infectious disease would disappear with economic development. In the 1990s I helped form the Harvard Group on New and Resurgent Disease, which rejected that idea. Our argument was partly ecological—the

rapid adaptation of vectors to changing habitats: to deforestation, irrigation projects, and population displacement by war and famine. And the equally rapid adaptation of pathogens to pesticides and antibiotics. But we also criticized the physical, institutional, and intellectual isolation of medical research from plant pathology and veterinary studies which could have shown sooner the broad pattern of upsurge: malaria and cholera and AIDS, but also African swine fever, feline leukemia, tristeza disease of citrus, and bean golden mosaic virus. We have to expect epidemiological changes with growing economic disparities and with changes in land use, economic development, human settlement, and demography. The faith in the efficacy of antibiotics, vaccines, and pesticides against plant, animal, and human pathogens is naïve in the light of adaptive evolution. And the developmentalist expectation that economic growth will lead the rest of the world to affluence and to the elimination of infectious disease is being proven wrong by events.

The resurgence of infectious disease is but one manifestation of a more general crisis: the ecosocial distress syndrome, a pervasive, multilevel crisis of dysfunctional relations within our species, and between it and the rest of nature. It includes, in one network of actions and reactions, patterns of disease, relations of production and reproduction, demography, our depletion and wanton destruction of natural resources, changing land use and settlement, and planetary climate change. It is more profound than previous crises, reaching higher into the atmosphere, deeper into the earth, more widespread in space and longer-lasting, penetrating more corners of our lives. It is both a generic crisis of the human species and a specific crisis of world capitalism. Therefore it is a primary concern of both my science and my politics.

The complexity of this whole world syndrome can be overwhelming, yet to evade the complexity by taking the system apart to treat the problems one at a time can produce disasters. The great failings of scientific technology have come from posing problems in too small a way. Agricultural scientists who proposed the Green Revolution without taking pest evolution and insect ecology into account, and therefore expected that pesticides would control pests, have been surprised that pest problems increased with spraying. Similarly, antibiotics create new pathogens, economic development creates hunger, and flood control promotes floods. Problems have to be solved in their rich complexity; the study of complexity itself becomes an urgent practical as well as theoretical problem.

These interests inform my political work: within the Left, my task has been to argue that our relations with the rest of nature cannot be separated from a global struggle for human liberation, while within the ecology movement my task had been to challenge the "harmony of nature" idealism of early environmentalism and to insist on identifying the social relations that led to the present dysfunction. On the other hand, my politics have determined my scientific ethics. I believe that all theories which promote, justify, or tolerate injustice are wrong.

A leftist critique of the structure of intellectual life is a counterweight to the culture of the universities and foundations. The antiwar movement of the sixties and

seventies took up the issues of the nature of the university as an organ of class rule and made the intellectual community itself an object of theoretical as well as practical interest. I also joined Science for the People, an organization that started in 1967 with a research strike at MIT as a protest against military research on campus. As a member, I helped in the challenge to the Green Revolution and genetic determinism. Antiwar activism also took me to Vietnam to investigate war crimes (especially the use of defoliants), and from there to organizing Science for Vietnam. We denounced the use of Agent Orange (used as a defoliant in the Vietnamese jungle), which was causing birth defects among Vietnamese peasants. Agent Orange was one of the worst uses of chemical herbicides.

The Puerto Rican independence movement gave me an anti-imperialist consciousness that serves me well in a university that promotes "structural reform" and other euphemisms for empire. My wife's sharp working-class feminism is a running source of criticism of the pervasive elitism and sexism. Regular work with Cuba shows me vividly that there is an alternative to a competitive, individualistic, exploitative society.

Community organizations, especially in marginalized communities, and the women's health movement, raise issues that academia prefers to ignore: the mothers of Woburn noticing that too many of their children from the same small neighborhood had leukemia. The hundreds of environmental justice groups that noted that toxic waste dumps were concentrated in black and Latino neighborhoods. The Women's Community Cancer project and others, who insist on the environmental causes of cancer and other diseases while the university laboratories are looking for guilty genes. Their initiatives help me maintain an alternative agenda for both theory and action.

Within the university I have a contradictory relationship with the institution and with colleagues, a combination of cooperation and conflict. We may share a concern about health disparities and persistent poverty, but are in conflict about corporations funding research for patentable molecules and about government agencies such as AID[2] promoting the goals of empire.

I never aspired to what is conventionally considered a "successful career" in academia. I do not find most of my personal validation through the formal reward and recognition system of the scientific community, and I try not to share the common assumptions of my professional community. This gives me wide freedom of choice. Thus, when I declined to join the National Academy of Sciences and received many supportive letters praising my courage or calling it a difficult decision, I could honestly say that it was not a hard decision, merely a political choice taken collectively by the Science for the People group in Chicago. We judged that it was more useful to take a public stand against the Academy's collaboration with the Vietnam–American war than to join the Academy and attempt to influence its actions from inside. Dick Lewontin had already tried that unsuccessfully, and resigned along with Bruce Wallace.

Most of my research has objectives at two levels: the particular problem at hand, and some major theoretical or polemical issue. The study of temperature adaptation in fruit flies was also an argument for multiple levels of causation. Niche theory was also a foray into the interpenetration of opposites (organism and environment). Biogeography was about multiple levels of ecological and evolutionary dynamics. Ecological pest management was also a claim for whole-system strategies. Work on new and resurgent infectious diseases combined biology and sociology. We examined why the public health community was caught by surprise when infectious diseases would not go away. It therefore was an exercise in the self-examination of science.

I have always enjoyed mathematics, and see one of its tasks as making the obscure, obvious. I regularly employ a sort of midlevel math in unconventional ways to promote understanding more than prediction. Much modeling now aims at precise equations giving precise prediction. This makes sense in engineering. In the field of policy, it makes sense to those who are the advisers to the rulers who imagine they have complete enough control of the world to be able to optimize their efforts and investments of resources. But those of us who are in the opposition have no such illusion. The best we can do is decide where to push the system. For this, a qualitative mathematics is more useful. My work with signed digraphs ("loop analysis") is one such approach. Rejecting the opposition between qualitative and quantitative analysis and the notion that quantitative is superior to qualitative, I have mostly worked with those mathematical tools that assist conceptualization of complex phenomena.

Political activism of course attracts the attention of the agencies of repression. I have been fortunate in that regard, having experienced only relatively light repression. Others did not fare as well: lost careers, years of imprisonment, violent attacks, intense harassment even of their families, and deportations. Some, mostly from the Puerto Rican, Afro–American, and Native American liberation movements, as well as the five Cuban antiterrorists arrested in Florida—are still political prisoners.

Exploitation kills and hurts people. Racism and sexism destroy health and thwart lives. Studying the greed and brutality and smugness of late capitalism is painful and infuriating. Sometimes I have to recite from Jonathan Swift's "Ballad in a Bad Temper":

Like the boatman on the Thames
I row by and call them names.
Like the ever-laughing sage
In a jest I spend my rage
But it must be understood
I would hang them if I could.

For the most part, scholarship and activism have given me an enjoyable and rewarding life, doing work I find intellectually exciting and socially useful, with people I love.

Acknowledgments

I am grateful to Rosario Morales for her assistance in conceptualizing and editing this chapter. This is based on a talk at the International Society for the Study of the istory, Philosophy and Society for the Study of the istory, Philosophy and Social Science of Biology conference 2004 in Guelph, Ontario at a panel "Combining the Scholarly and Activist Life."

Notes

1. John Montgomery Brown, a Lutheran Episcopal bishop of the Missouri Synod, was excommunicated when he became a Marxist. In the 1930s he published the quarterly journal *Heresy*.

2. AID, the Agency for International Development, carries out programs on health and development in strategically chosen Third World countries. Its separate programs are sometimes helpful, and their participants, motivated by humanitarian concerns. But the agency is also a terrorist organization, supporting counterrevolutionary groups in Venezuela, Haiti, and Cuba. It once sponsored the LEAP (Law Enforcement Assistance Program), which taught torture methods to Uruguayan and Brazilian police.

Selected Bibliography

Evolutionary Ecology

Levins, R. 1968. *Evolution in Changing Environments*. Princeton, NJ: Princeton University Press.

Levins, R. 1969. Thermal acclimation and heat resistance in *Drosphila* species. *Amer. Nat.* 103(933): 483–499.

Levins, R. 1995. Preparing for uncertainty. *Ecosys. Health* 1(1).

Levins, R., M. L. Pressick, and H. Heatwole. 1973. Coexistence patterns in insular ants. *Amer. Sci.* 6(4): 463–472.

Lewontin, R. C., and R. Levins. 2001. Schmalhausen's law. *Capitalism, Nature and Socialism* (March).

Agriculture

Awerbuch, T., C. Gonzalez, R. Levins, S. Sandberg, R. Sibat, and J. L. Tapia. 2004. The natural control of the scale insect *Lapidosaphes gloverii* on Cuban citrus. Inter-American Citrus Network, *IACNET Newsletter* 21/22.

Levins, R. 1973. Fundamental and applied research in agriculture. *Science* 181: 523–524.

Levins, R. 1986a. Science and progress: Seven developmentalist myths in agriculture. *Month. Rev.* 38(3): 13–20.

Levins, R. 1986b. Seven developmentalist myths in agriculture. *Month. Rev.* 38(3): 13–20.

Levins, R. 2005a. How Cuba is going ecological. *Capitalism, Nature, and Socialism.*

Levins, R. 2005b. A "left" critic of organic farming. *New Internat.* 13: 169–181.

Levins, R., and J. Vandermeer. 1984. The agroecosystem embedded in a complex ecological community. In R. C. Carroll, J. Vandermeer, and P. Rosset (eds.), *Agroecology.* New York: Wiley.

Health

Karpati, A., S. Galea, T. Awerbuch, and R. Levins. 2002. Variability and vulnerability at the ecological level: Implications for undertanding the social determinants of health. *Am. J. Pub. Health* 92(11): 1768–1772.

Levins. R. 1995. Toward an integrated epidemiology. *Trends Ecol. Evol.*

Levins, R. 2001. The future of schools of public health. *J. Bio. Law and Business*, spec. suppl., Global genomics and health disparities, 40–41.

Levins, R., and C. Lopez. 1999. Toward an ecosocial view of health. *Internat. J. Health Serv.* 29(2): 261–293.

Wilson, M. E., R. Levins, and A. Spielman (eds.). 1994. Disease in evolution. *Ann. NY Acad. Sci.* 740.

Philosophy

Levins, R. 1966. The strategy of model building in population biology. *Amer. Sci.* 54: 421–431.

Levins, R. 1996. Ten propositions on science and anti-science. *Soc. Text* 14(46/47): 101–111.

Levins, R. 1999. Dialectics and systems theory. *Sci. and Soc.* 62(3): 375–399.

Levins, R. 2000. The butterfly ex machina. In R. S. Singh and C. Krimbas (eds.), *Evolutionary Genetics: From Molecules to Morphology.* New York: Cambridge University Press.

Levins, R. 2004. Sorpresas, errores y dudas. *Rev. Cubana de Salud Pub.* 2004(3).

Levins, R., and R. C. Lewontin. 1985. *The Dialectical Biologist.* Cambridge, MA: Harvard University Press.

Other

Kriebel, D., J. Tickner, P. Epstein, J. Lemmons, R. Levins, E. Loechler, M. Quinn, R. Rudel, T. Schettler, and M. Stoto. 2001. The precautionary principle in environmental science. *Env. Health Perspec.* 109(9): 871–876.

Levins, R. 1988. Mistaken development. In *An Agenda for Our Common Future: Implications of the Brundtland Report.* New York: Friedrich Naumann Foundation.

Levins, R. 1996. A view from the through. *Month. Rev.*

Levins, R. 2005. Progressive Cuba Bashing. Socialism and Democracy.

Interview with Richard Levins

On Philosophy of Science

Interview by Abha Sur

AS: In one of your seminars you said, "All science is class science, yet science also finds out real truths about the world." Would you elaborate on this thesis, particularly in terms of race, gender, and colonialism?

RL: Science is informed by gender, class, locality, and microlocations—the kinds of institutions one is working in and so forth. Everybody looks at the world from somewhere. This is true of our perceptions. What we deem important and what we obscure in the world. We are constantly bombarded by sensory inputs. Learning what to ignore is not unique to humans. All organisms abstract relevant sensory information from the world.

Organisms of different sizes see the world very differently. For instance, because the ground is rough . . . an ant does not see very far. It depends on its chemical senses for its orientation. Marx observed that our senses are our first theoreticians screening the input from the surroundings for relevance. The fact that all science is socially located does not by itself make it true or false.

Every social location has its blindness and its insights. Farmers tend to have a sophisticated, detailed knowledge of the particulars of their circumstances, but only of objects in the size range of everyday experience. There is no reason to expect peasants to have a traditional understanding of the Krebs cycle. They are also limited by their own locality and do not necessarily have comparative knowledge. On the other hand, scientists would enter into that community with general knowledge but not of the particulars that may produce results quite opposed to what their science will predict.

The science of animal behavior has been transformed by the entry of women in this field. Earlier male observers had looked at social organization of the animals with adolescent boys' fantasy. Therefore we cannot strive to find a place outside the world from a neutral vantage point. Rather, the best we can do is to understand our own biases that

come from our own location in the world and try to look at them critically from the perspective of other communities.

AS: Does it imply science is merely ideology, a false consciousness?

RL: No, it does not. All knowledge comes from experience and reflection on that experience in the light of previous knowledge.

AS: Do you believe in the primacy of experience, then?

RL: Certainly.

AS: Would not that lead us to subscribe to a kind of postmodern relativism?

RL: Postmodern understanding of relativism stops at the insight that all ideas come from some perspective. We go beyond that in asking where that perspective comes from, and therefore what it shows us and what it blinds us to. By looking at as wide a range of perspectives as possible, we can protect ourselves from those blindnesses that vary from community to community, but not those which are shared by all of us.

Because we are visual animals, we see objects in the world as having sharp boundaries, but organisms that orient by sound or smell see things blurring into each other. We all look at the same sky and identify with those objects which send us light . . . only recently have astronomers paid attention to what happens between the sources of light—the "empty space." On the other hand, looking at the same sky, all traditions came up with the year's length that is about the same, and had rules for navigating by the stars even when these stars had different names and origin stories.

AS: How do you see the role of science and of scientists in this era of neoliberal economics and increasing surveillance of people in the name of "national security"?

RL: In the course of history the task of the production of knowledge has been organized differently. Chinese science was largely developed by administrators concerned with getting things done. Mesopotamian science was centered on priesthood. Victorian science was a luxury of gentlemen of leisure. In the feudal context a court astronomer, like the court fool, was a trophy for display. The outstanding feature of contemporary science is that knowledge is increasingly a commodity produced by a knowledge industry to satisfy the goal of the owner of that industry, and therefore concerned with profitability, power, hegemony, and display. Since this determines the institutional arrangements, the agenda, the recruitment into science, and the criteria for satisfactory solutions, scientists must either understand the social determinants of their disciplines or be subjected to forces outside their understanding. This self-reflective quality is the task of philosophy of science. It can look at other scientific traditions with the respect due to the product of intellectual labor, but without the sentimentality which pretends that "the more ignorant the person, the wiser" or "the older an idea, the truer." Thus, the phrase "the ancients say" is not a strong recommendation. We have to ask which ancients, why did they say it, and how come it was preserved for us against other things that other ancients may have said.

Abha Sur

AS: Do you think that critical self-reflection is possible, given that knowledges are increasingly compartmentalized and specialized?

RL: Commodification of science and its institutional organization works against self-reflectivity and produces contempt for philosophy. This contributes to the narrowness of contemporary science even when there are pleas for complexity, interdisciplinary methodologies, and wholeness. So far the appeals to complexity tend to live in the introductory chapters of books, while the main text is still fragmented and narrowly focused. Scientists are evaluated mostly by their contributions within the bounds of their department's definitions. Funds are awarded according to bounded programs. All too often the right to look at philosophy is a reward for having survived to tenure. In order to offset the biases of the academic world, it is necessary to have one foot in and one foot outside that community.

In the university, our relationship with colleagues is partly cooperative and partly conflictive. In public health I share the excitement of colleagues unraveling the behavior of mosquitoes or the transformation of nutrients while we conflict over the assumptions about the market, the legitimacy of a private pharmaceutical industry, or the willingness to collaborate with the World Trade Organization or USAID. Outside academics I live in communities committed to liberating social change, but often with a sense of urgency that regards theorizing as a luxury. The experience of these communities is different from that of academics. It was the women of Woburn, Massachusetts, who discovered that a chemical dump was causing leukemia among their children while academics were more prone to discuss their experience as a statistical artifact. Philosophers might debate the ethical basis for feeding the hungry, but food is not a philosophical problem for those who don't have it. Therefore, when asked . . . how I can reconcile scholarly and activist work, I have to answer that I cannot imagine keeping them separate. Each informs the other, and within each community I struggle for the recognition of the insights that come from the other.

A third dimension is that scientists are for the most part also workers. There is a process of proletarianization of intellectual labor which was experienced two centuries ago by the weavers of Lancashire, but which catches academics by surprise because of their sense of professionalism. Increasingly scientists are losing job security as they work on temporary contracts. They have to teach at more than one institution at a time, and are regarded as interchangeable units of human capital. This condition of workers would orient us toward the labor movement as natural allies, but we are also unlike other workers. Our labor is not completely alienated from us. We enter our field of work in part for the intellectual excitement and the sense of doing some good in the world, while workers in an ammunition factory do not seek these jobs because they love killing people. The nonalienated part of our existence can be a rich addition to the consciousness of the labor movement, while the history of labor struggles can help us cope with the conditions of our employment.

So . . . the most fruitful way of existence for the academics is as scholar activists and workers.

AS: Scientists do not control the utilization of the knowledge they produce. As a result, the "intellectual excitement" of doing science can have deleterious consequences. What do you think is the responsibility of scientists in this regard?

RL: We Marxists have been much better as analysts than as prophets. The way of looking at the future is to understand the contradictions that are at work and decide on the direction of our agitations. As scientists we can be, and are, engaged in struggles over the uses of science, over access to science, over the agenda of science, and over the ways in which science is used for purposes of profit, power, and hegemony. Some of these struggles are external to our institutions and others are within. Scientists have to defend the integrity of science against its manipulation by the regime. We must challenge the uses of science to justify inequality and aggression. We have to resist the incursions of creationism and religious obscurantism. In every regime, no matter how oppressive, there are things that are allowed and things that aren't—there is a boundary between them, even if fuzzy—and part of our task is to push that boundary back.

Depending on our own social location within the system, we might struggle to expand the scope of our research, we might look critically at the research from the point of view of community organization, or we might decide that the boundaries of our job are incompatible with our social commitment and choose, to leave academia to work in people's organizations where scientific work can be put to good use. But no matter what we choose, we cannot allow the boundaries of our job to be the boundaries of our actions or the boundaries of our discipline to be the boundaries of our minds.

AS: As a geneticist, do you think the Human Genome Project is a way for eugenics to make a comeback?

RL: The Human Genome Project is a logical and necessary outcome of the emphasis on genetics that is always present in our biology, the political economy of genes as commodities, and the real problem of improving our understanding of development. The greatest achievement of the HGP has been the refutation of its initial premises. It has shown ways in which the genes are important, but not determinant, elements of an organism's development—that we cannot talk of "a gene for" any old trait that interests us. So there is now a struggle over the interpretation of the new discoveries. For instance, there are too few genes that differentiate us from other species to account for all aspects of human behavior and organization. There are far too few genes to "program" the network of the brain. So advances in genetics and in neurobiology are constantly showing us that our organism is much more fluid, labile, and complex than the simple determinists would like. The capacity of neurons to regenerate in the brain undermines the old telephone exchange model of the nervous system and gives hope for new strategies of recuperation from injuries.

Most of the important changes in our understanding of the organism have been in the direction of recognizing it as a living material—spinal disks are not only passive shock absorbers; the circulatory system is not only a plumbing system which can get rusty; the neuron system is not the executive board of the body—social experience impinges on the endocrine and the immune systems through pathways we are beginning to understand. The internal development of our sciences is pushing us toward a more dialectical understanding while the political economy and institutional structures for the production of knowledge are militating against it.

AS: How do you reconcile the production of knowledge—even people's knowledge— and its appropriation by the powers that be? What can scientists do to prevent misuse of their work?

RL: In some cases the answers are fairly obvious, such as doing military research or research sponsored by the military. In other cases it is not possible to disentangle innovations and discoveries that are now described as dual use. As warfare becomes more total, more kinds of knowledge become relevant. The medical study of stress can inform the work of torturers. The control of tropical diseases allows invading armies to intrude into more habitats. The struggle has to be directed against the military more than against the knowledge that they might find useful. There are some fields which create fewer opportunities for malign use, for instance, the development of ecological agriculture against the high-tech system which facilitates corporate control. This leaves us with three categories:

1. Directly noxious research which we can refuse to participate in, and expose
2. Multiple-use research where we can struggle against its destructive uses
3. Research that arms popular movements through exposure and alternative pathways of development.

AS: Some people have argued that large-scale science and industry, by its very nature, is antidemocratic. Do you agree?

RL: The argument for large, sophisticated industrial enterprise is that it is more productive and safer. Neither is true. Peasant farming is more productive per unit area than industrial agriculture. A power plant or an oil refinery has more safety devices, but also more things that can go wrong. Each has a vanishingly small probability of failure. But vanishingly small probability multiplied by infinite opportunity equals inevitability. The failures of large systems may be less frequent, but [they are] also much more disastrous. The ownership of these facilities by giant corporations and [the] military guarantees the exaggeration of benefit and the covering of the harm. In agriculture the growing awareness of the harm of industrial farming has led to a sentimental endorsement of "small is beautiful." But both perspectives are wrong. Planning has

to take place at many levels, with the unit of planning being larger than the unit of production.

For instance, agricultural planning has to embrace a complete watershed—it has to look . . . for the available inputs, available labor throughout the year, production for consumption throughout that region and some export to other regions. This is a large area, but the individual fields should be much smaller. What is needed is a mosaic of land uses with forests modulating the flow of water, reducing wind speed, and modifying the microclimate around the edges, as well as providing direct products. It is a refuge for beneficial birds, bats, and insects. Pastures have meat and diary products, but also provide manure that retards erosion, have flowers that pollinate fruit crops and support beneficial insects. Within a field, mixed crops suffer less pestilence disease damage and are a hedge against uncertainty.

Decision-making must be local, to take into account the heterogeneity of the land and the variability of the weather. It is also a way of combining the physical and mental labor of the producers. Therefore, we have to avoid easy formulae which are mostly the inversions of our deeply felt dissatisfactions. Neither small nor big, but mixed. The same applies to top down and bottom up. There will always be some tension between the needs of the whole society and the producers in any one place, which must be constantly worked out and renegotiated.

AS: How about the energy industry?

RL: The giant hydroelectric products were regarded by developers as a giant step forward. It is now realized that they have a short life expectancy; they disrupt the ecology and the lives of people where they are built; they fail less frequently than small rural dams, but are so much more devastating when they do fail. Similarly, nuclear power has turned out to be not so clean. Even when working normally, there is contamination by radiation on the surrounding environment, demand for enormous quantities of water for cooling, and inevitable domination by large corporations who are prone to covering up potential problems. This does not mean that wind or solar power is inherently democratic, but they are less vulnerable to large-scale disasters.

The other side of the quest for more resources of energy is the reduction of consumption. Improved fuel efficiencies of cars will allow for longer-distance commuting unless urban planning places the sites of employment closer to residential areas. But this means redesigning of the industries themselves, since we don't want to create more Bhopals to save oil. As long as land use is determined by real estate values and community is dominated by the auto industry, improvements in fuel efficiency will not protect the environment. Electric cars and hybrids may be less polluting per unit, but are not likely to protect the atmosphere. More generally, I would argue that technological research has to be guided not by shortsighted notions of efficiency or the bottom line, but by an integrated perspective on development.

Life.science.art:
Curating the Book of Life

When art publicly presents life science discourses, what ethical and aesthetic challenges emerge? Artistic creations are never neutral. Implicitly or explicitly, they take a stance positioning themselves in one way or the other within current artistic, cultural, and political discourses. Thus, artistic projects contribute to the shaping of public opinion regarding a particular topic. Given the impact of recent developments in the life sciences and their associated rhetoric on the agricultural, pharmaceutical, and medical domains, the stakes are particularly high when presenting "life science art." What types of meaning is being conveyed to visitors experiencing these works in a public or institutional context? What types of relations are being drawn between existing public rhetorics promoting a variety of economic and political interests? How does the context of a particular venue influence the overall perception of the exhibition? Curators, art producers, and funding organizations dedicated to the support of artistic creations operating at the nexus between art and science carry the responsibility of negotiating these meaning-creating conditions and of offering the public a coherent experience of the work.

This section opens with an essay by political scientist Jacqueline Stevens examining genetic iconography. By placing the causes of public health and agricultural problems into the genetic domain, rather than into the political-economic domain, genetic iconography has sensationalized rather than elucidated contemporary bioethical crises. Stevens elaborates on artistic creations that all too often reinforce genetic determinism and other dominant ideologies. She uses three recent museum exhibitions as case studies to unveil the influence of biotech corporations on the types of works being shown, as well as on the context in which these works were being presented. In some cases artists were unaware of their own ideological positioning and were carried away by an uncritical admiration of scientific discovery. In other cases, the artists clearly intended a different read of their creations, but lost control over the way their work was being presented to the public.

Following Stevens's chapter is artist Rachel Mayeri's account of an artist taking on the role of a curator in sci-art documentary-making. Analyzing the role of science documentary as science's "public ambassador," she has compiled a DVD collection of artists' videos mocking the authoritative nature of science documentary by putting the genre through the scrutinies of subversion and creative appropriation. Mayeri also describes the motivations and related research of her own widely screened video project *Stories from the Genome*.

Curator Jens Hauser concludes this section with an essay examining the phenomenological nature of "bioart." Hauser reminds us that most people interested in the phenomenon of bioart have never experienced the artworks directly, but have only had access to secondary representations. Even experts often conflate medium-driven, formalist biomedia art with topical and political approaches in the field. How might curators and critics assess the impact of the emergent field of bioart, given these confusions over meaning, politics, and form? Hauser explores the affective relations between bioartists and their living media, audiences and the living works, and the pasts and futures of the works themselves, in and out of the museum/lab. Bioart in its most productive manifestation, he suggests, is a rematerialization and epistemic interrogation of art and the "whole of life" itself.

Biotech Patronage and the Making of Homo DNA

Jaqueline Stevens

Timeline

On August 6 and 9, 1945, two bombs developed by the Manhattan Project were dropped on major cities in Japan. Immediately after the explosions, the military sent in researchers to measure the impact of the radiation by collecting epidemiological data on the health status of survivors, and several other waves of research teams continued in their wake, most notably the Atomic Bomb Casualty Commission.[1] In 1984 the U.S. Department of Energy (DOE) announced it would begin a new endeavor to represent DNA for the purpose of understanding heritable mutations caused by radiation, so that the DOE could more clearly track the effects of the bombings of Hiroshima and Nagasaki by studying the genetic mutations in descendants of survivors.[2] From the Manhattan Project was born the Human Genome Project. In the late 1980s and early 1990s, pharamaceutical companies were successfully hyping the potential of recombinant DNA research to potential stockholders and venture capitalists,[3] and by 1997, Richard Klausner, director of the National Cancer Institute, announced that almost all the Institute's funding would be spent on genetic research.[4] During this period, gene research began to yield results that lent themselves to new forms of molecular representation, and genetic iconography exploded.[5] Alas, the result was neither a utopian nor a Frankensteinian future, but relentless propaganda reducing human beings to inert matter as stupid and unable to control themselves as molecules of rice protein.

The harms of this genetic iconography—distracting from the actual political-economic roots of most health problems, including the racism that led to dropping the gene-damaging atomic bombs in the first place—were furthered by a curious alliance of artists, curators, and biotech advocates. Caught up in the excited debates over new ways to define human nature, and the nature of other organisms as well, artists were quick to contribute.

Perhaps more relevant to their success, major museums and other public institutions were eager to support these artists' endeavors, meaning that capitalism's process of natural selection led to the proliferation of banal work on genetics, and proved far less hospitable to themes engaged with nongenetic forms and content. This chapter reviews the funding and aesthetic commitments behind major gene art shows and catalogs since 2001, and discusses their broader impacts. Political theorist Murray Edelman writes:

Though only a fraction of the population may experience particular works of art and literature directly, the influence of these works is multiplied, extended, and reinforced in other ways through variations and references in popular art and discourse; through "two-stage flows," in which opinion leaders disseminate their messages and meanings in books, lectures, newspapers, and other media; through networks of people who exchange ideas and information with each other; and through paraphrases that reach diverse audiences.[6]

Biotech firms and their public relations consultants grasped Edelman's point. Consistent with a deliberate propaganda effort on the part of some individuals and corporations, and at odds with even the overt intentions of many of the artists, the effect of these gene art shows has been to convince the broader public that genetic representations of disease, behaviors, and even human beings are the ones that are both inevitable and truthful. The result is of a piece with the genetic narrative, the tragic genre of our age. The gene art images in these shows, regardless of content, show us at the mercy of a code we did not create and that, individually, we cannot control. Although some of these stories may hold out a utopic promise of perfection, even the so-called hopeful representations are fraught with catastrophic possibilities: everyone knows what happened to poor Icarus.

The message that we are on the threshhold of entering the Brave New World and must decide only if we want to embrace the new age or behave as Luddites, is hard not to avoid, especially in the United States. One possible reason for the ubiquity of this framing is that the choice is aptly put. In fact, this feeling some have is not the result of any actual sweeping changes in medical treatments, or even their foreseeable potential. Public health experts caution that gene therapies may never come to fruition. If they do, the Centers for Disease Control states that they will be helpful only for a handful of odd diseases: over 90 percent of our diseases have largely environmental and behavioral causes; 99 percent of people are most affected by these, and not inherited diseases.[7] Financial investors hoping to cash in on gene therapy also are regularly disappointed.

In 2001, a "Motley Fool" financial columnist wrote, after pointing out that years of research had produced just one gene therapy treatment, affecting a very small number of people: "There's no reason why the average investor should be invested in biotechnology companies. None." Five years later the situation was the same. Companies still had not made good on their promises: "Investors who had been enchanted by biotechs were soured by the sorry performance of some experimental drugs," one journalist wrote, after noting

that despite the stock market's overall increase of 5 percent that year, biotech stock values in 2006 had dropped 4 percent.[8]

Yet in 2002 the American Museum of Natural History (AMNH) exhibit "Genomic Revolution" announced, "By the year 2020 it is highly possible that the average human life span will be increased by 50 percent; gene therapy will make most common surgery of today obsolete; and we will be able to genetically enhance our capacity for memory." Though the claims about gene therapy in the AMNH show were especially enthusiastic, even overtly critical installations unintentionally reinforce the cause of scientists and corporations that see money to be made in selling dreams. The common ground all these shows share is that they propagate supposedly scientific results that scientists themselves have not been able to obtain. These exhibits are an important venue for scientists, and especially biotech firms, to gain converts to their faith in their work on DNA, the "Book of Life," to redeem us from such sins as smoking or the fate of living in pollution.[9] Through attracting visitors for in-person spectatorship, but perhaps more through the public relations blitzes in the towns the exhibits tour, and the print and online media that cover the exhibits, curators are creating the Genomic Age that they claim to be discovering.

Major Exhibits

"Paradise Now: Picturing the Genetic Revolution," Gallery Exit Art in Downtown New York City, September 9 to October 15, 2000

"Paradise Now" was a blockbuster exhibition of works by thirty-nine artists that toured to at least five major cities and published a widely marketed catalog.[10] The installations ranged from those eagerly celebrating new venues of potential beauty, such as Helen Chadwick's luminous colored photograph *Nebula* (1996), to the tongue-in-cheek *Genomic License #5 (Alison Knowles Properties), 1992–97,* Larry Miller's portrait of a woman's clothed body alongside images of her blood, skin, hair, and fingernail samples. Though Affymetrix, Orchid BioSciences, Variagenics, and Noonan/Russo Communications—the last a biotech public relations firm—were among the exhibit's sponsors, the "man behind the curtain," as one artist called him, was Howard Stein. Stein, who led the Dreyfus Corporation and whom some credit as the father of the mutual fund, told me, "My luck in the world is being aware of things that have a future. Things like Haloids. Later changed their name to Xerox."[11] One of the show's organizers, explaining Stein's foresight, said that he "knew to invest in biotech stocks because he always put his money where he sees the government investing."[12]

Not only did Stein fund two giant billboards promoting "Paradise Now" in lower Manhattan, spaces usually occupied by jeans companies or rock stars, he also funded full-page color advertisements for the show in the *New York Times* and hired a publicist, devoting about $500,000 to the show. According to the "Paradise Now" brochure, "The

major benefits of sequencing the human genome are yet to come. Medicine will be transformed, diagnoses will be refined and side-effect-free drugs will target specific diseases, working the first time they are administered." Not only that, "Biotechnology will be . . . increasing the nutritional value of crops and making them easier to grow."[13]

Natalie Jeremijenko, an artist and scholar, called "Paradise Now" a "corporate snow job and an embarassment." Of her *One Tree* installation in the show, she said, "It doesn't serve my piece to be framed in this way." Jeremijenko was showing six trees cloned from the same source but revealing significant differences in their appearance. Even when raised under conditions far more similar than those humans encounter, these simple, genetically identical organisms vary quite distinctly in size, health, texture, and so forth. However, the show's signage and pamphlet framing the experience, Jeremijenko said, had led viewers to infer that the trees were different because they were raised in different environments. Indeed, this was exactly how Stein characterized the piece when he spoke with me: "She cloned them and they're all identical and now she's going to plant them and see how they're affected by the environment. Over time I'm sure they're going to grow differently."

In fact, Jeremijenko was making a far more interesting point that the show's funder missed: due to randomness, two organisms cloned from the same source will differ, even when their environments are identical. Jeremijenko was planting *pairs* of cloned trees in various locations in the San Francisco Bay area, and all the cloned trees in the Exit Art show had been raised together but had strikingly different characteristics. After the curators Marvin Heiferman and Carole Kismaric heard that Jeremijenko had organized a panel questioning the corporate sponsorship of "Paradise Now," they informed her that her installation would not be included when the show toured.

Stein's funding of "Paradise Now" was of a piece with his earlier and subsequent support for gene art. Indeed, he had sponsored one of the first exhibits on the theme in Santa Barbara's Museum of Art in 1998.[14] Stein does this through a nonprofit run by himself and his family, Joy of Giving Something, Inc. (JGS). JGS owns many of the photographs in the shows it supports, and as of 2004 it had an art collection valued at close to $27 million.[15] Among subsequent major projects that JGS funded are "The Art of Science" (2004),[16] and further curatorial work by Heiferman and Kismaric. Stein's JGS also was a major sponsor of the Gene Media Forum at Syracuse University, with donations of at least $500,000.[17]

In a telephone interview Stein told me that he supported these shows because he wanted to ensure that biotech firms in the United States would avoid the hostility they generate in Europe: "I don't think they [the biotech industry] presented all the facts to the public. Had they presented all the facts and had they participated in doing what they should have been doing, then there might not have been so much of a problem for Monsanto."[18] Stein compared the bad press of genetically modified foods with President Clinton's sex scandal, offering that "open discussion" was more likely to decrease hostility "than if someone is

saying here it is, take it or leave it. Once the information about Clinton's activities was in the open, the public had the feeling 'but I don't want the president to be impeached.' " Stein also told me he agreed with the lukewarm reviews by art critics. "I think the critiques in the *New Yorker* and *Times* were on target. The show's really, you know, a mishmash." He also complained that his favorite, a work by Helen Chadwick from his personal collection, was "hung badly."

"The Genomic Revolution" at the American Museum of Natural History, May 26, 2001, to January 1, 2002

The exhibit begins in a dark room aglow with video loops of talking heads refracted through Plexiglas, seemingly coming from nowhere. But the signage stealing one's attention repeats text from the brochure indicating biotech's ability to enhance life expectancy and conquer disease. "You may be born with your genes, but that doesn't mean you can't change them," one sign announces. "Fixing genetic malfunctions by repairing 'flaws' in the DNA code—using a technique called gene therapy—is no longer science fiction," says another. But when I asked Bruce Alberts, president of the National Academy of Sciences, to comment on gene therapy breakthroughs, he said dryly, "I didn't know there'd been any."[19] Dr. Robert DeSalle, a molecular biologist and the exhibit's curator, agreed that while there are several hundred ongoing experiments, not a single one has proven that human gene therapy can offer permanent relief without side effects.[20]

DeSalle said he was familiar with gene-therapy research failures, including the 1999 death of eighteen-year-old Jesse Gelsinger in a study at the University of Pennsylvania and the aggressive and irreversible advance of Parkinson's disease among patients in a clinical study who had holes bored in their heads, followed by injections of fetal tissue cells into the holes, an account of which appeared in *The New England Journal of Medicine* two months before his exhibit opened.[21] Dr. Paul Greene, at the Columbia University College of Physicians and Surgeons and a researcher in that study, told the *New York Times* of the awful symptoms the therapy caused. The people injected with the test formula "chew constantly, their fingers go up and down, their wrists flex and distend." Dr. Greene continued, "It was tragic, catastrophic . . . a real nightmare."[22] When asked why the exhibit avoided these alarming examples, DeSalle said they were "too complicated."[23]

Art historian Mary Coffey points out that the presentation of information in digital displays recalls the work of Jenny Holzer, who mocked this type of sign in her 1990 takeover of the Guggenheim. DeSalle told me he did not believe the signs' statements, including one claiming "In the near future humans will live 150 years." He explained that the signs with text he knew to be false were not installed to be factual, but were "designed to get people to turn the corner."[24] Coffey takes issue with that intention: "When you're presenting an exhibit under the pretense of scientific accuracy, you have an ethical responsibility to be careful. The American Museum of Natural History is an authoritative institution of knowledge and research. Entertainment is never supposed to

eclipse its educative values."[25] Singling out the phrases on the LED signs as especially worrisome, Coffey said, "That type of sign is an authoritative medium that you associate with information and statistics, like the Dow Jones and Nasdaq, and there was nothing in the exhibition that critiqued or problematized the statements."[26]

Dr. George Annas, chair of the Department of Health Law at Boston University, said he disliked what he called the show's "rah-rah" tone. "Genetics have nothing to do with enhancing life expectancy," he said, adding, "Public health advances have increased life expectancy seven hours a day for the last hundred years. Clean air, clean water, not smoking—all those things really have an impact. When it comes to longevity, nurture is much more important than nature."[27]

DeSalle said the text was "balanced." To prove this to me, he quoted from the exhibit: "Gene therapy is a young science and right now, it cannot cure all genetic diseases; in fact clinical trials can be risky." I told DeSalle the statement implied that gene therapy, while not curing "all" diseases, might be curing some right now, and perhaps all of them down the line. He told me that I had misunderstood the text. Annas believes the term "gene therapy" is itself misleading, since to date no one has received any benefits from the trials, and hence no therapeutic use has yet been demonstrated: "These are *gene transfer* experiments. There are no recognized genetic *treatments* for anything, nor is there likely to be for a while."[28]

Referring to studies documenting the birth defects and adult maladies besetting cloned animals, Annas said, "The cloning exhibit didn't talk about the problems every cloned animal has had. People have known for quite some time about the problems with cloned animals, but the exhibit only leads you to think that the idea is a little strange and raises ethical questions," without mentioning the widespread practical difficulties of cloning. Andrew Imperato, president of the American Association of People with Disabilities, referred to the exhibit's claims as a "classic example of overpromising what science is able to deliver to increase excitement and acceptance of what amounts to a very expensive and unproven experiment that is making it easier to discriminate on the basis of genetic information."[29]

Some installations were interactive computer screens with survey questions. As you finished, the screen displayed your responses and compared them with those of other museum visitors as well as with the general public. With brilliant marketing savvy the show situated the broader public's revealed opposition to biotech in a context that told the survey-takers in the exhibit that their fellow citizens are non-museumgoers who deserve to be educated so they see things the way they are seen by the AMNH.

The AMNH does not usually have art in its exhibits, but it made an exception so it could commission work that would force people to see themselves as no more than their DNA.[30] The installation by Camille Utterback (*Drawing from Life*, 2001) takes its last shot at telling the audience that they are their genes. Upon leaving the exhibit, one's image is captured by a hidden camera and rendered on a life-size screen by the exhibit's

omnipresent As, Cs, Gs, and Ts, the first letters of the proteins in our DNA. Though presented as "art," the exhibit space itself credits no artist and provides no title, so that the installation was merely one more medium for the show's instruction that we are our genetic proteins.

DeSalle explained the reasoning for the Utterback commission: "We always have specimens. We didn't have that luxury. The art pieces became specimens for us."[31] The art was conceived and contextualized as an extension of the scientific journey. We, the audience, are the specimens of DNA. Were that piece framed as an artwork, the installation might invite our speculation about this representation as one possibility among others, but as it is, spectators leave with one more announcement of the reductive finality of their genomes.

The AMNH show was sponsored by the Richard Lounsbery Foundation, a secretive group headed at the time by perhaps the most notorious science spinmeister of the 1990s, Dr. Frederick Seitz. Seitz had been funding marketing research on European public attitudes to genetic research since the early 1990s, and credited himself with having the vision and, one might add, the financial wherewithal, to press for the show. "I was on the board of the museum for many years and said you need to have a good exhibit on DNA," he said. The reason? "Enthusiasm for [genetic research] needed to be boosted a bit."[32]

Seitz also was chairing the corporate-sponsored George C. Marshall Institute (GCMI), founded in 1984 to support Reagan's Star Wars. As the Lounsbery Foundation president, Seitz directed funds to industry-friendly science causes, including his own GCMI. He had been denounced by his colleagues on various occasions, especially for a report he had formatted to misleadingly imply sponsorship by the National Academy of Sciences (NAS). Readers would think that the NAS did not believe global warming merited restrictions of carbon dioxide emissions, but the NAS was on record as holding the opposite.

Seitz also wrote a 1996 *Wall Street Journal* opinion piece falsely claiming that a international scientific report cautioning about global warming had been altered to misrepresent the conclusions.[33] In response, the Executive Committee of the American Meteorological Society and the trustees of the University Corporation for Atmospheric Research jointly rebuked Seitz:

There appears to be a concerted and systematic effort by some individuals to undermine and discredit the scientific process that has led many scientists working on understanding climate to conclude that there is a very real possibility that humans are modifying Earth's climate on a global scale. Rather than carrying out a legitimate scientific debate through the peer-reviewed literature, they are waging in the public media a vocal campaign against scientific results with which they disagree.[34]

While the GCMI is an obvious right-wing operation and Seitz is a known industry hack, the profile of the Richard Lounsbery Foundation and its ties to conservative causes

have been deliberately left in the shadows, with assistance from none other than the AMNH itself. Just as banks discreetly look the other way for their more lucrative clients, the AMNH, in violation of standard policies regarding funding attribution, omitted mention of the Lounsbery Foundation in its 1999 credits of major funders for "Epidemic! The World of Infectious Disease," and was instructed to do so for the "Genomic Revolution" exhibit as well.

So accustomed to secrecy is the organization that the Lounsbery Foundation's executive secretary, Marta Norman, interrogated me as to how I knew the Foundation contributed to "The Genomic Revolution." She was incredulous when I told her the AMNH credited the Lounsbery Foundation as the show's major funder, since Norman had asked AMNH President Ellen Futter not to mention the Foundation, and in the past Futter had obliged.[35]

When I asked DeSalle, the AMNH curator for both "Epidemic!" and "The Genomics Revolution," about the Lounsbery Foundation, he implied the foundation was a garden variety philanthropy with no special agenda: "Lounsbery is a benefactor, a guy who wants to give his money away to benefit science."[36] But Richard Lounsbery had died in 1967, after having established a trust in his name in 1960. The focus on biomedical research occurred when the fund began disbursements in the 1980s, several years after Vera Lounsbery, Richard's wife, had died.

The AMNH exhibit included one more Lounsbery Foundation–sponsored item: a free glossy magazine geared to the one audience even more gullible to scientific authority than the adult public: their children. *The Gene Scene* comic book asks, "What makes you YOU? What makes me ME? A lot is due to heredity. Your genes control/ What makes you YOU, from the color of your hair/ To the size of your shoe."

"Gene(sis): Contemporary Art Explores Human Genomics," Seattle, Henry Art Gallery, University of Washington, April 6 to August 25, 2002

This show follows the approach taken by "Paradise Now," packaging art as "education" for a general audience and offering a curriculum for elementary and middle-school students. "Gene(sis)" includes genetically themed pieces contributed by over fifty artists, many of whose work also appeared in "Paradise Now." It has toured to Berkeley, Minneapolis, and Evanston, Illinois.[37] Once again, an art show is conceived as the key component in an educational program using the authoritative discourse of science and the subconscious saturation of the mind through artist renderings so that the audience cannot avoid the message that, love it or hate it, theirs IS a genetic age. An article describing the show in a student newspaper at the University of Minnesota follows the show's script: "Gene(sis) is an art exhibit that raises questions and provides commentary about the ethical and social implications of genomics, one of the most compelling issues of modern times."[38]

But what is the evidence for this claim that genomics is a "compelling issue" outside the hoopla these shows create? There is no mention of the fact that the major challenges

and breakthroughs affecting world health in the twenty years since the Human Genome Project began have had little to do with genetics. It is true that scientists are using insights from molecular biology to shape their hypotheses for developing drugs, but it is still the case that the impact of even these related projects is minuscule in the context of public health problems and solutions. Between 1965 and 1995, asthma doubled,[39] obesity became an epidemic,[40] and AIDS went from a death sentence to a managed illness.[41] The Human Genome Project has been irrelevant to these problems and will play no role in their solutions for the foreseeable future. The only reason genomics is "one of the most compelling issues of modern times" is that art and museum shows repeatedly insist this is the case.

The show itself states: "Gene(sis) came into inception as a response to the Human Genome Project (a government funded research project). Artists, scientists, historians, the biotech industry, museum professionals, educators and bioethicists created Gene(sis) to aid the understanding of how genomic research will affect human life." This is an over-statement, but perhaps only for a short time, and not because our genomes will suddenly be able to do things we never imagined. Pablo Picasso, when told that his portrait of Gertrude Stein did not resemble her, is said to have replied, "No matter; it will."[42] The main way genetic research will affect human life will be by teaching us to be passive, accept scientific authority, and ignore the effects of politics on changing our environment and health, not by substantively changing our health status.

This show not only received major funding from biotech firms, but the texts and informational materials were prepared with guidance from the employees of Seattle-based ZymoGenetics, whose Web page announces that it "creates novel protein drugs with the potential to significantly help patients fight their diseases."[43] There are no public health officials included in the working group assembling the show, and hence no voices such as that of Dr. Annas to question the show's premise that the genetic age is anything more than a state of mind.

"Ecce Homology," 2003, University of California, Los Angeles, Fowler Museum of Cultural History, November 6, 2003, to January 4, 2004

This exhibit is one of numerous efforts to forge working relationships in the university among artists and scientists, an ambition that seems especially prominent in some of the programs at various campuses of the University of California, including those of Los Angeles, Santa Barbara, Santa Cruz, and San Diego. In "Ecce Homology," at UCLA, the collaborators designed software to display, as they put it, "genetic data as luminous pictographs that resemble Chinese or Sanskrit calligraphy. Five projectors present Ecce Homology's calligraphic forms across a 40-foot-wide wall." The installation invited participants to create, through their movement in front of a screen capturing their shadows, projected lingering recorded fragments of their motion that are matched with images from samples of a rice genome. The result is a supposedly "scientifically accurate"

simulation of Basic Local Alignment Search Tool (BLAST), a Web-based data-mining technology used to match similar DNA fragments, one that requires exactly the high-speed computing technologies sold by the exhibit's main funder, Intel.

The exhibit text states that it was "named after Friedrich Nietzsche's *Ecce Homo*, a meditation on how one becomes what one is," then elaborates that the project "explores human evolution by examining similarities—known as 'homology'—between genes from human beings and a target organism, in this case the rice plant."[44] The curators lack both originality—Mark Lesney's "Ecce Homology" (2001), published in the trade journal *Modern Drug Discovery*,[45] offers the same claims that the UCLA curators make in 2003—and their invocation of Nietzsche might be classified as a crime against philosophy. The genetic homologists do not stop at flattening the differences between humans and rice, but perform their ignorance by ignoring the specificities of intellectual history, importing a pun from the roots homo- and hom- that suits them from an author whose ideas certainly do not.

"Ecce homo" is the Latin phrase for "behold the man!", attributed to Pilate when Jesus, bleeding and wearing a thorn crown, was presented to the crowd seeking his crucifixion. The text Nietzsche titles "Ecce Homo" is an artfully bombastic self-presentation by Nietzsche as himself to be martyred, along with Jesus, by the evolutionary discourse overtaking his colleagues in the humanities.[46] Those who had been consistently misreading Nietzsche's parodies of the social Darwinians and took them literally were about to have their errors pointed out yet again. Nietzsche brags in "Ecce Homo" about how he "attacked David Strauss."[47] Nietzsche's attack on Strauss is specifically on Strauss's efforts to appropriate from evolutionary theory observations about natural selection for use in political theory. Criticizing Strauss sixteen years earlier in *Untimely Meditations* (1873), Nietzsche had overtly mocked the ancestors of the artist–scientists who presented "Ecce Homology."[48] He calls Strauss an "ape genealogist" for his attempt to erase the historical, cultural differences among groups distant in time and place, and pretend we are the same.[49] Nietzsche mocks Strauss for ignoring the many differences among humans based on their histories, and would presumably object to homologizing humans with rice.

In "Ecce Homo," Nietzsche writes: "[S]cholarly oxen have suspected me of Darwinism."[50] He said of his audience, "I have always recognized who among my readers was hopeless—for example, the typical German professor—because on the basis of [a parodic] passage they thought they had to understand the whole book as a higher Réealism."[51] Nietzsche is making a pun, playing on the name of Paul Rée, his former friend who was a philosopher enamored of sociobiology's potential to put philosophy on an objective—or, as Nietzsche put it, a more Réealistic—footing.

Despite the low quality of science education in this country, it is more likely that a student would be able to notice flaws in the exhibit's presentation of scientific data than its inaccurate claim to roots in Nietzsche. The pun "Ecce Homology" plays on the fact that *homo-* is from a Greek root that means "earth," and means "man" (in contrast with gods); and *hom-* is from a Greek root meaning "same." To understand this, one would

have to look for history, meaning, and difference, all of which BLAST destroys. Indeed, Nietzsche himself started out as a philologist and believed that it was to the written codes of history, not blood, that scholars should look for insight, not to mention health and happiness.[52]

The Political Economy of Gene Art

Before exploring how these episodes in gene art shows reveal symptoms of underlying dynamics in art exhibitions, it is important to stress that the people organizing these shows, and the artists contributing their installations, are not hired hacks conspiring to trick citizens into ignoring their need for more clean air legislation and less funding for gene research on asthma. Most of the people working on these shows are earnest curators and artists fascinated by genetic iconography and curious about engaging in a range of relations to it, from laudatory to loathing. The problem is that the industries that benefit from public support for genetic research and genetic myths are easily able to control the public's categories of imagination, whereas those working in other fields must fight for attention and comprehension. Fortunately, some of these other individual efforts are successful, and are discussed below. Before turning to these, the motives among the three major sources for the large genetic exhibits are considered: corporations, gallery and museum boards, and artists.

Corporate Strategies

In a memorandum Greenpeace obtained in 1997 by crashing a conference organized for the industry group EuropaBio, Burson-Marsteller—the world's largest public relations firm—discourages the biotech industry from using traditional PR techniques: "In order to effect the desired changes in public perceptions and attitudes, the bioindustries must stop trying to be their own advocates."[53] The memo explains, "All the research evidence confirms that the perception of the profit motive fatally undermines industry's credibility on these questions." Art and museum shows are crucial because they allow the firms to stay off what B-M terms the "killing fields" of rational debate, and to use "Symbols—not logic: symbols are central to politics because they connect to emotions, not logic."[54] In particular, bioindustries should proliferate "symbols eliciting hope, satisfaction, caring and self-esteem."[55] No one is going to believe Monsanto when it tells people to trust it, but if its message comes across through an art gallery or prestigious museum, then the public will be convinced.

B-M's strategy was employed by the public relations firm NoonanRusso in its work for Stein and the biotech firms backing "Paradise Now." Edelman explains, "Contrary to the usual assumption—which sees art as ancillary to the social scene, divorced from it, or, at best, reflective of it—art should be recognized as a major and integral part of the transaction that engenders political behavior."[56] How can we assess the impact of the

"Paradise Now" show, or any other art exhibit, on the public imagination? Edelman points out that these effects are insufficiently studied, even though what we "know about the nature of the social world depends on how we frame and interpret the cues we receive. . . . Art teaches us to see the world in new ways, and the creation of categories provides one kind of aesthetic lens through which conception and vision are constituted or reconstituted."[57] Stein may not be able to provide a quantifiable measure of the success of his investments, but the guy who bet on Haloids and ran the Dreyfus Fund for decades is probably not making a lot of bad business decisions.

At their most instrumental, biotech proponents self-consciously use their economic levers of control, as did Stein, Seitz, and the biotech firms sponsoring these gene art exhibitions, to create the visual and discursive languages they desire. Through their foundations, direct funding, and contributing content appearing in museum shows, biotech advocates are creating the public's genetic imagination while stunting more lively and creative modes of self-understanding. Those exposed to these messages, reflective creators in the Human Being Project, have been coopted as organisms into the Human Genome Project.

Such an enterprise is enabled by the public's low level of semiotic sophistication, a failure of this materialist culture's citizenry to see the materiality, and hence the efficacy, of work done by signs, i.e., images that are phenomenologically separate from what they are imagined to signify. It is a common myth that signs are not things, and therefore exert less positive or negative consequences than the effects of so-called reality, a place of material disease, genomes, and molecular proteins. Generally unrecognized is that words and all other symbols are every bit as material as the objects of scientific study: there is no idea that can exist without the compression of air when one speaks, the ink on the page, the electrons in the computer display, for instance.[58] The combination of public relations experts with acumen on the ways they can shape the material culture of genetic discourse and the naïveté of the general public makes for an uneven playing field in the competition of ideas, a chess match between a person who knows the rules and another who thinks the queen may move only one square at a time.

Museum and Gallery Strategies

In addition to the high-profile shows initiated by biotech boosters, less overtly instrumental nonprofit board members seek funding in many places, and have been known to develop shows they think will find financial support, either from blockbuster ticket sales or from corporate sponsors. In these cases the decision to mount a gene art show and seek funding from Monsanto seems no different from one to mount a Fabergé egg exhibit and seek sponsorship from the cosmetics firm of the same name.[59] Just as cosmetic sales depend at least as much on the brand image as on the quality of the item marketed, biotech firms' ability to attract investments depends on their ability to sell the brand of mesmerizing "potential" and astronomical profits, and not their actual meager and largely negative

revenue flows. Hence, nonprofit arts organization boards are likely to find in biotech firms the funders and collaborators interested in branding their field with hype that cannot be sustained by their clinical research.

Artist Strategies

In addition to biotech firms and nonprofit boards, artists and curators have their own reasons for making gene art. The artists who began displaying genetic imagery in the early 1990s—such as Suzanne Anker, Steve Miller, Dennis Ashbaugh, and Helen Chadwick—situate themselves as immersed in a new representational landscape of the human being that invites artistic engagement. Their object of fascination is the gene. The novelty of genetic portraits alone seems to inspire their fascination and output. The authors of a book on gene art describe the gene artist Iñego Manglano-Ovalle who, as a present for a patron's spouse, "devised an unusual way to capture the man's true likeness. He conspired with the patron's barber to pluck some hair from his customer's head, and sent the sample to a forensic laboratory, which extracted the DNA."[60] The image from this became a piece Ovalle called *Clandestine Portrait*.[61]

Others have of course joined their ranks since then, and are using media such as animals or other organisms to materialize their take on genetic research as a new and magical field of possibility. Eduardo Kac's transgenic fluorescent green rabbit is the best-known of these, and Kac himself is the Damien Hirst of gene art. These works are the ones most likely to be praised by scientists and biotech firms.[62] Some artists are myopic and can do little more than reproduce the culture mass-produced in front of them. When those who have produced these images come to see their own reflections in these shows, they praise artists for their "vision." About four-fifths of the exhibits in "Paradise Now" and "Gene(sis)" reflect this perspective.

Of course gene art is also the occasion for biting social critiques, especially through parody. This appears to be the second most common type of gene art. Several of the works in "Paradise Now" and "Gene(sis)" display these qualities. For instance, Karl Mihail and Tran T. Kim-Trang exhibited *The Creative Gene Harvest Archive* (1999). The label text said the test tubes with human hairs had been "harvested by Gene Genies Worldwide©" from artists, and that these specimens would be used to genetically engineer creative individuals. Alexis Rockman's famous painting *The Farm* (2000), exhibited in the "Paradise Now" show and on the giant billboards promoting, it has similar overtones, presenting a familiar present showing hints of an emerging dark future. Rockman writes of the animals in various states of "normalcy": "The flora and fauna of the farm are easily recognizable; they are, at the same time, in danger of losing their ancestral identities."[63]

For a related commission from Creative Time to develop an on-line genetically themed game, conceived and funded by Howard Stein,[64] Natalie Bookchin launched Metapet (2002) (http://www.metapet.net). To play Metapet, called the "World's First Transgenic Pet Game," one controlled a worker/pet strategizing to evade the controls of biotech firms and

workplace social Darwinism. Workers gained extra points if they were randomly allowed genetic improvements so that they could work longer and harder, for instance. All of these works seem intent on unsettling the trajectory the biotech industry wants us to follow by issuing giant warning signs about bioengineers' ability to change life as we know it.[65]

The insights are biting and provocative, but nonetheless their political effect is at least as likely to work in ways the artists oppose. The problem goes to the very essence of parody. Insofar as an image materializes reality, the artist's intentions do not change the effects of the visualization. If I am breathing a toxic gas that I am told will heal me or, breathing the same air, and cautioned of its dangers, I will suffer equally, provided the warning does not lead me to alter my breathing. The dark images offered by the satirists resemble these toxic fumes, permeating our psyches as relentlessly as, if not more than, the same images delivered by those exclaiming their benevolence. The installations are meant to provoke resistance and questioning, but their substance is that on the horizon one can see that the enemy within us has already won. This is at least as likely to demoralize people and lead to passivity as it is to inspire action.

Highlighting the difficulty is the challenge to stay ahead of the biotech industry curve. Each day brings new and shocking discoveries. Even if they eventually turn out to be hype or hoax, the images in the *New York Times* of a cloned pet cat costing $50,000 would challenge any gene parodist's imagination.[66] Also among gene art installations are those that eschew parody and instead directly confront the political economy they want to question, as Christy Rupp does in her clear plastic sandwich container labeled in large letters "TELL US what we are eating" and titled *New Labels for Genetically Altered Food* (1999–2000). This and other pieces overtly name their perception of harms biotech firms are causing, and challenge them to do something about this (i.e., "TELL US").

Remaining among the gene art contributions are the ones by people who truly understand art's power to create new truths and not simply affirm the dominant ones, to disrupt complacency, or to offer more and less obvious critiques. These are works that use their media to do something different from what the clichés say are possible. Examples include projects by Beatriz da Costa, Natalie Jeremijenko, and Critical Art Ensemble.[67] These are all prolific artists, and I limit myself here to some suggestive illustrations of what their work accomplishes.

Da Costa's *PigeonBlog* is a technologically impressive interface that integrates pigeons, GPS software, pollution detection sensors, cameras, and the Internet to allow people to see maps with indexed levels of air contaminants wherever the pigeons equipped with these devices fly.[68] The Web site where people may view the results of the pigeon travels states:

By using homing pigeons as the "reporters" of current air pollution levels we are hoping to achieve two main goals: 1) to re-invoke urgency around a topic that has serious health consequences, but lacks public action and commitment to change; and 2) to broaden the notion of grassroots scientific

data gathering while building bridges between scientific research agendas and activist oriented citizen concerns.[69]

This project rejects the gene art premise that human beings are primarily victimized or advantaged by our genes, and instead performs an alternative reality. Da Costa assumes our ideas shape our environments, holding out the promise that new ways of visualizing data might empower citizens to learn and to participate differently in shaping the conditions of their health.

Jeremijenko also offers new technologies for humans to interact with their environments. As is the case with da Costa, Jeremijenko's projects are not comments on someone else's experiment, but her own interventions. Through *OneTrees*, described above, and her many other similarly conceived projects, including the *Feral Robotic Dogs*, *OOZ*, and the *Biotech Hobbyist*,[70] Jeremijenko uses the interactions she stages among animals, humans, and technologies to offer refreshing and astute reconceptions of the banal "nature/nurture" debate. If people are like other organisms, then that is only because the other creatures also have their own lively communities and cultures that shape their health and environments. And if genes do determine who we are, then that means our only hope of self-change is through what we do with and to our environments. She shows these are much more effective ways to change what ails us than second-guessing the noise that inevitably emerges in genetic programming.

The collective Critical Art Ensemble has done many projects that are clear parody, ratcheting up the stylized apocrypha of geneticists to the next level, perhaps just after the scientists have done this themselves. But their commitment to a language of "reverse engineering" and efforts at community outreach in various venues means their interventions are creating something new and teaching the aesthetics of what this looks like. The outcome of a collaboration among Critical Art Ensemble, da Costa, and Shyh-Shiun Shyu, *Free Range Grain*,[71] has mobile labs people can visit if they have suspicions that their food labeled as free of genetically modified organisms is filled with genetically modified organisms. Such a direct action challenges the barrier between artists and scientists, marking the former not only as efficacious as the latter, but also much more thoughtful and creative.

Acknowledgment

Portions of this chapter appeared in some of the content "PR for the Book of Life," posted November 26, 2001 at www.nationmagazine.com.

Notes

1. M. Susan Lindee, *Suffering Made Real: American Science and the Survivors of Hiroshima* (Chicago: University of Chicago Press, 1994), p. 17.

2. Robert Cook-Deegan, "The Alta Summit, December 1984," *Genomics*, 5 (1989): 661–663.

3. Louis Galambos and Jeffrey Sturchio, "Pharmaceutical Firms and the Transition to Biotech: A Study in Strategic Innovation," *Business History Review*, 72 (1998): 250–278.

4. Richard Klausner, director of National Cancer Institute, Keynote Address, Annual Meeting of the American Society for Biochemistry and Molecular Biology, Washington, DC (1997), personal notes.

5. For an intellectual history of the trend's significance, see Evelyn Fox Keller, *The Century of the Gene* (Cambridge, MA: Harvard University Press, 2000). For an account of genetic iconography in popular culture, see Dorothy Nelkin and M. Susan Lindee, *The DNA Mystique: The Gene as Cultural Icon* (Ann Arbor: University of Michigan Press, 2004).

6. Murray Edelman, *From Art to Politics* (Chicago: University of Chicago Press, 1995), p. 2.

7. The data cited on gene therapy prognosis and the contribution of hereditary mutations to disease are from material that appears in Jacqueline Stevens, "Racial Meanings and Scientific Methods: Policy Changes for NIH-funded Publications Reporting Human Variation," *Journal of Health Policy, Politics and Law,* 28 (2003): 1033–1098.

8. "Biotech Stocks in the Doghouse," CNN Online, October 3, 2006, http://money.cnn.com/2006/10/02/news/companies/biotech/index.htm. The other explanation was that some biotech stocks had risen sharply the previous year. This is in keeping with the overall pattern of biotech firms, cyclically luring and then disappointing new waves of investors.

9. For more on the public health futility of genetic research, see Jacqueline Stevens, "Racial Meanings and Scientific Methods: Changing Policies for NIH-sponsored Publications Reporting Human Variation."

10. The venues and dates were as follows: Ann Arbor, University of Michigan, March 17–May 27, 2001; Saratoga Springs, NY, Skidmore College, September 16, 2001–January 6, 2002; Pittsburgh, Carnegie-Mellon University, October 25–December 15, 2002; New Orleans, Tulane University, March 13–June 15, 2003; and Baltimore, University of Maryland, January 29–March 13, 2004.

11. Howard Stein, telephone interview (fall, 2000), personal notes.

12. Anne Pasternak, director at Exit Art, telephone interview (fall, 2000), personal notes.

13. "Paradise Now" pamphlet, Exit Art, New York City, September 9, 2001.

14. "PhotoGENEsis: Opus 2 Artists' Response to the Genetic Information Age."

15. IRS, form 990 (2004).

16. At the International Center for Photography, New York City (2004).

17. Howard Stein, telephone interview (fall, 2000), personal notes.

18. Ibid.

19. Bruce Alberts, telephone interview (fall, 2000), personal notes.

20. Robert De Salle, telephone interview (June 19, 2001), personal notes.

21. "Transplantation of Embryonic Dopamine Neurons for Severe Parkinson's Disease," *New England Journal of Medicine* 344 (2001): 710–719.

22. Gina Kolata, "Parkinson's Research Is Set Back by Failure of Fetal Cell Implants," *New York Times*, March 8, 2001, p. A1.

23. Robert De Salle, telephone interview (June 19, 2001), personal notes.

24. Ibid.

25. Mary Coffey, telephone interview (June 28, 2001), personal notes.

26. Ibid.

27. George Annas, telephone interview (July 10, 2001), personal notes.

28. Ibid.

29. Andrew Imperato, telephone interview (June 27, 2001), personal notes.

30. Robert De Salle, telephone interview (June 17, 2001), personal notes.

31. Ibid.

32. Frederick Seitz, telephone interview (June 28, 2001), personal notes.

33. " 'Global Warming': A Major Deception," *Wall Street Journal*, June 12, 1996, p. A16.

34. Special insert, "Open Letter to Ben Santer (July 25, 1996), available at http://www.ucar.edu/communications/quarterly/summer96/insert.html.

35. Marta Norman, telephone interview (July 27, 2006), personal notes.

36. Robert De Salle, telephone interview (June 19, 2006), personal notes.

37. Berkeley Art Museum, August 27–December 7, 2003; Frederick Wiesman Museum of Art, Minneapolis, January 25–May 23, 2004; and the Mary and Leigh Block Museum, Evanston, Illinois, September 10–November 28, 2004.

38. "Gene(sis) Weaves Art and Science," UMNews on-line (February 5, 2004). Available at http://www.umn.edu/umnnews/Feature_Stories/Genesis_weaves_art_and_science.html.

39. David Mannino et al., "Surveillance for Asthma—United States, 1960–1995," *Morbidity and Mortality Weekly Report*, 47 (April 24, 1998): 1–28, available at http://www.cdc.gov/mmwR/preview/mmwrhtml/00052262.htm.

40. C. Ebbeling, D. Pawlak, and D. Ludwig, "Childhood Obesity: Public-health Crisis, Common Sense Cure," *The Lancet*, 360 (2002): 473–482.

41. R. A. Zabinski, "Evidence-Based Health Benefits Management: Strategies to Optimize Anti-retroviral Medication Adherence and Outcomes in HIV/AIDS," *Journal of Managed Care Pharmacology*, 12 (2006): 12–16.

42. Edelman, *From Art to Politics*, p. 12.

43. Available at http://www.zymogenetics.com.

44. Available at http://insilicov1.org.

45. Mark Lesney, "Ecce Homology," *Modern Drug Discovery*, 4 (November 2001): 26–38, 40, available online at http://pubs.acs.org/subscribe/journals/mdd/v04/i11/html/11lesney.html#auth.

46. Nietzsche, *Genealogy of Morals and Ecce Homo*, trans. Walter Kaufmann (New York: Vintage, 1989).

47. Nietzsche, *Ecce Homo*, "Why I Am So Wise," p. 232.

48. "David Strauss, the Confessor and the Writer [1873]," in Nietzsche's *Untimely Meditations*, trans. R. J. Hollingdale (Cambridge: Cambridge University Press, 1997), pp. 51–125.

49. For specific citations and analysis of Nietzsche's rejection of sociobiology, see Jacqueline Stevens, "The Morals of Genealogy," *Political Theory* 31 (2003): 558–588.

50. Nietzsche, *Ecce Homo*, "Why I Write Such Good Books," p. 261.

51. Ibid.

52. Nietzsche, *The Gay Science*, trans. Walter Kaufmann (New York: Vintage Books, 1974).

53. Available at http://www.intekom.com/tm_info/geleak1.htm. A spokesman for Burston-Marsteller confirmed the document's authenticity for me. In a telephone call Peter Himler, Executive Vice President and Managing Director for B-M Media Relations, did not dispute the document's authenticity.

54. Burson-Marsteller, memo, available online at http://users.westnet.gr/~cgian/leak1.htm.

55. Ibid.

56. Edelman, *From Art to Politics*, p. 2.

57. Ibid., p. 109.

58. The consequences of this are explored more fully in Jacqueline Stevens, "Symbolic Matter: DNA and Other Linguistic Stuff," *Social Text* 20 (2002): 106–140.

59. For example, the "Faberge in America" shows in San Francisco and Cleveland in 1997.

60. Suzanne Anker and Dorothy Nelkin, "Reductionism: The Body as 'Code Script' of Information," in *The Molecular Gaze: Art in the Genetic Age* (Cold Spring Harbor, NY: Cold Spring Harbor Laboratory Press, 2004), pp. 9–46.

61. Ibid., p. 33.

62. For instance, a prestigious science journal published a profile of Eduardo Kac. Stephan Herrera, "Profile: Eduardo Kac," *Nature Biotechnology* 23 (2005): 1331.

63. A Web site of the artworks is available at http://www.genomicart.org.

64. Creative Time is a public art organization that arranged for the billboards promoting the "Paradise Now" exhibit at Exit Art.

65. http://www.genomicart.org/rockman-pn.htm.

66. Gina Kolata, "What Is Warm and Fuzzy and Furry Forever?," *New York Times* (February 15, 2002), p. A1. The announcement that a company had cloned a pet cat generated worldwide news, exciting hopeful pet owners and inciting ethical hand-wringing. Both sides made converts to the

apparently overwhelming power of genetics. Paul Elias, "California Company Sells Cloned Cat, Generating Ethics Debate," AP, December 22, 2004. Far less publicized was the announcement, two years later, that the corporation was going out of business because they were unable to "develop the technology to the point where it was commercially viable." "Pet Project Fur-closure," *Newsday*, October 12, 2006, p. A38.

67. Critical Art Ensemble has constructed installations and staged performances in a genre closer to parody.

68. http://www.pigeonblog.mapyourcity.net.

69. http://www.pigeonblog.mapyourcity.net/statement.php.

70. Jeremijenko's projects can be viewed at http://xdesign.nyu.edu and http://environmentalhealth clinic.net.

71. Available at http://www.critical-art.net/biotech/free/index.html.

Soft Science

Artists' Experiments in Documentary Storytelling

Rachel Mayeri

The call for entries for *Soft Science*, sent to artists' listservs and electronically transmitted around the world, was intended to cast a wide net:

Videos for the *Soft Science* program should walk the line between objective and subjective, scientific and cultural, factual and fictional. These could include: science videos that can be considered artful or soft: psychological, cultural, personality-driven, or aesthetic; documentation by scientists or artists who are the objects of their own research; conceptual work whose methods could be called scientific; videos that investigate the voice of authority as it has been constructed through science education and documentary; imaginary, historical, or marginal scientific theories; experiments in visualization of information and the minuscule; the creation of new life forms.

As a media artist in the shadow of Hollywood and a professor of media studies at a college for scientists and engineers, I wanted to see creative responses to developments in genetics, pharmacology, and ecology—voices and methods of inquiry not commonly represented by mass media. The curatorial idea aimed at examining science as a cultural construction—an imaginative enterprise, influenced by economic and institutional realities. While the call was intentionally broad, it did reflect a certain point of view on the emerging field of sci-art: there is a tendency for projects that combine artistic and scientific practices to create in the viewer an uncritical sense of awe. The final selections, for the most part, did not contain beautiful artifacts of scientific experiments or glorified tales of Progress and Invention. *Soft Science*, the resulting DVD, playfully dissects the authority that science holds in society, through experimentations with one of scientists' primary means for educating the public: the documentary.

I introduce the essay with an analysis of one avenue in which science comes to be appreciated in the public sphere: television's science documentaries. Despite their curious

hybrid forms, combining soap opera with zoology and dinosaur animations with paleontology, these documentaries construct truth claims through form, visual style, and cultural niche. Reviewing media and science studies, I show how theorists reposition both documentary and science as storytelling practices. Having introduced the documentary fallacy, I discuss artists' experimental documentaries in the *Soft Science* collection, which reframe science as human speculation and provide a counterpoint to popular science media. *It Did It*, *The Bats*, and *Stories from the Genome* contain commentaries on medicine, animal behavior, and genetics, blurring the boundaries of science and art.

Science and Documentary Storytelling

Venerable, liberal, government-subsidized science documentaries are science's public ambassador. Documentaries translate the expert knowledge of scientists into information comprehensible to the public. Like a diplomat from a foreign government, the documentary medium creates a formal relationship between scientists and the people who stand to benefit, suffer, or risk indifference to their work. In a sociological sense, documentaries open a path of communication between the institutions in which science is practiced—universities and corporations—and their funders. People pay for scientific research, whether through taxes, which support state-funded initiatives, or by paying for products and services such as electricity from nuclear power plants and doctor visits. For this citizenry, the voting public, documentaries teach the significance of scientific developments, whether about stem cell research, global warming, space exploration, or new reproductive techniques.

Science documentary teaches through a simple, standard format: illustrative visuals and explanatory voice. The traditional visual style for documentary is photographic realism: the camera records footage of the world, whether it is of tissue colonies, scientists' talking heads, or migrating animals. That which cannot yet be filmed, graphics and animation illustrate. Scientists or professional actors explain how therapeutic cloning works, perhaps reenacting the story of its invention, and speculating as to its significance and future. In documentaries, the admixture of video, still images, graphics, and animation coheres into a linear essaylike structure through a voice-over narration. The representation of reality, as opposed to the telling of a story, traditionally distinguishes the documentary genre from narrative, fiction filmmaking.

Yet, this ambassadorial programming contains more than mere science education. The process of translation, elucidation, and explanation of scientific developments through documentary carries with it ideological messages. The nature of sex roles, the rationale for gene patenting, an answer to famine, the value of space exploration—despite the best intentions of documentary producers, science education is never value-neutral. Whether through word choice or content selection, through lack of multiple viewpoints, or through collusion between media producers' and scientists' agendas, science documentaries convey

political views. Because of documentary's past nonprofit investigations of social realities, viewers may be more trusting of its messages. But beyond the critique of documentaries as ideological, media theorists stress the way in which documentaries essentially do tell stories about reality, just like narrative fiction filmmaking.

In the 1930s John Grierson defined documentary as "the creative treatment of actuality." Promoting impressionistic portrayals of labor in Britain, Grierson affirmed the fabricative tendency in the history of documentary. Since *Nanook of the North* in 1922, documentary has involved collaborations between filmmakers and subjects (Robert Flaherty, the filmmaker, living for years with his subjects), subjects "acting" as idealized versions of themselves (contemporary Inuit men reenacting their grandfathers' lifestyle), the staging of scenes (the killing of a walrus by harpoon instead of by gun), chaotic events organized through editing into story structures (man against nature). Despite what the historian and theoretician of documentary film Bill Nichols calls its "discourse of sobriety," documentary has entertained audiences, like fiction films, with spectacles of the exotic, the primitive, and the rare. Documentary has advocated for causes and painted the world poetically, as much as it has pronounced to represent the world neutrally and objectively.

Science, like documentary, is a form of representation historically bound up in truth claims. Both science and documentary trade in positivism, positing a distanced, objective view of reality. Yet, science studies has examined how the establishment of scientific facts in the laboratory employs storytelling techniques. Scientists' explanations of their data are compared to "audiovisual spectacle" by the sociologist of science Bruno Latour: scientists attempt to persuade skeptics through exuberant arguments illustrated with realistic imagery. Scientific experiments are highly controlled portrayals of real phenomena, but to be convincing, they must read as untrammeled, preexisting truths. Scientists play the role of the "modest witness" to their findings, embodying a posture of objectivity, which Donna Haraway has problematized. Denying the spectacle, curiosity, or entertainment value of their data, they avoid the role of the entertainer, magician, or quack. Scientists are the sagacious narrators of their own documentaries, whether presented as journal articles, conference presentations, lectures, or grant applications.

On a profound level, science itself has been conceived of as an imaginative practice, creatively employing metaphor, projection, visualization, and other cognitive practices to produce knowledge. Storytelling—the sequencing of events in cause-effect relationship— is arguably a psychological compulsion that has much in common with logical explanation. Visualization—speculating about how things look or work with images—is often referred to as a crucial part of the process of scientific discovery. Narrative and visualization, both sitting at the intersection of art and science, are generally coded as fictional. Speculative data produce soft science. Yet, while contemporary science documentaries are teeming with fiction, they remain coded as hard evidence of the truth—as representations of reality.

Science documentary has become a grotesquerie of imagined alien species, intrauterine blood baths, cavemen prosthetics, and prehistoric catastrophes. Documentary itself has hybridized with other genres—police procedurals (*Animal Cops*) and soap operas (*Meerkat Manor*), and has grown increasingly entertainment-oriented, with reality television and numerous box office hits produced on comparatively low budgets. Three-dimensional animation renders speculations about dinosaur society into plastic reality in *Walking with Dinosaurs*. Performance artists sing and dance a rendition of an orgy of hermaphroditic sea hares for *Dr. Tatiana's Sex Advice to All Creation*. Ironically, the wonders of science have become too spectacular for certain media critics, who decry the denigration of the quality of science documentary programming, and claim that visual entertainment is substituting for the transmission of scientific knowledge.

In reaction to this criticism, José van Dijck argues that despite the important implications of the new digital visual styles, these "postmodern, 'fictionalist' " documentaries return to a "realist paradigm." Whether reconstructing prehistory or speculating about physical theories, "postmodern" documentaries such as *Walking with Dinosaurs* or *The Elegant Universe* ultimately ground fictionally coded reenactments and animation to scientific objectivity by means of words, which van Dijk argues are more powerful than images. Voice-overs by scientists, intercut with professional narrators, convey "authenticity" and authority to speculative imagery by linking apparently artificial and constructed scenarios to the real prestige of the scientist.

Scientists' stories of discovery—transforming confusion into clarity, creating solutions where there are problems—are readily absorbed into the narrative structure of documentaries. Scientists produce spectacular imagery and powerful stories, which they cleverly narrate for the public. Scientists have good reasons to be invested in the meanings that they co-produce, with documentary-makers, for the public. Thus, to analyze science documentary is to unpeel layers of stories within stories. Artists' experiments with documentary form can highlight ideological messages and the mechanisms by which traditional science documentaries persuade.

Experimental Documentary in *Soft Science*

"Experimental documentary" describes videos that reflexively blend the traditional visual styles and discursive structure of documentary with those of narrative films. *It Did It*, by Peter Brinson, Jim Trainor's *The Bats*, and my own video, *Stories from the Genome*, are experimental documentaries in the Soft Science compilation which critique both documentary's and science's claims to truth. *It Did It* expands both narrative and documentary forms and visual styles, blending the two, and experiments with art and medicine to "contain" the cultural-biological phenomenon of depression. *The Bats* cleverly reveals what happens to the documentary voice of authority when it shifts from the third person omniscient to the first person, while describing the life history of a species of bat. What sounds

authoritative in the third person, becomes poetic in the first, showing the imaginative leap required to understand "what is it like to be a bat." *Stories from the Genome* blends science fact and fiction, placing contemporary gene science within a history of defunct theories of genetics. Parodying a science documentary, the video decodes the ideological meanings of the emerging image bank on the Human Genome Project and stem cell research.

In each case, videomakers humorously mimic the documentary's claim to certainty and truth. Satire, as Jonathan Sawday explains in his book on Renaissance dissection, is related in root to the term "anatomy": taking things apart to understand how they work. Artists use documentary exposition to explain complex phenomena, just as documentarians do. Yet the very act of explanation is shown to activate a power dynamic: I know more than you/let me educate you. In a sense, these experimental documentaries are a reaction to the didactic power that science exerts in society. Parodying documentary form, artists show how documentaries tend to work. Unlike the "postmodern" documentaries, which unironically combine "fictionalist" visual styles with traditional voice-over, these experimental documentaries code visual style and voice-over as both scientific and artful.

Peter Brinson's *It Did It*

In Peter Brinson's video *It Did It*, a depressed character conducts what appears to be a scientific experiment with Prozac, with the investigator/videomaker as the sole test subject. As in many a mad scientist movie plot, he imbibes chemicals in film noir-ish lab sessions. But instead of unleashing a beastly libido or perfecting the antidote to an alien virus, Brinson's movie documents the failure of medical discourse to answer his ontological question: "If I am always happy, will I still be me?"

The video expands conventional ideas of documentary and narrative form by using scientific method as a form of storytelling. Brinson structures his video through scientific method, inviting the viewer to consider relationships between scientific method and narrative. Each section in the video corresponds to the scientific method stated below, as in the video:

Ask question
Formulate hypothesis
Conduct research
Experiment
Record data
Formulate conclusion
Revise

While it initially seems strange to structure a diary according to scientific method, the video exposes the story structure found in many science documentaries: a narrative of

Figure 5.1 The artist turns the camera on himself in this still from the video *It Did It* by Peter Brinson. The narrator explains: "the smile on the left is instinctual, and the one on the right is conscious, and they originate in different parts of the brain. You can tell the real from the fake by the way the smile tapers. I'm conscious on the one on the right, therefore it's not genuine. But actually, now they both seem fake."

probing for knowledge, conducting an experiment, and finding the answers. Yet this story is plagued by uncertainty. Instead of leading the viewer to a resolution with objectivity and authority, the voice of the doctor-patient is self-reflexive, tentative, and questioning. Rationality itself is rattled by the subjective mind-set of depression. The scientist cannot be distanced and dispassionate when the object of study is his own self. Ultimately, the video critiques positivism and the scientific method by collapsing the subject and the object of study (figure 5.1).

If Brinson's hypothesis is correct—that is, if Prozac cures his depression—the video should have a happy ending. But the central question is not posed in such a way that there can be a simple resolution. Brinson's introspective drama is, rather, a series of existential questions—whether to live with depression, whether to take drugs for his depression, whether to continue to take the drug when it changes his outlook and artwork, and how to assess the experience when he decides to stop taking the drug. Scientific method and medical technology prove inadequate for Brinson's quest.

As scientist and video artist, Brinson's character searches for a satisfactory lens through which to regard his condition. Playing with medicine's representations of depression, Brinson finds a paucity of means for self-expression. Imagining himself an object of science, he animates his lackadaisical serotonin pathways. While depressed, he portrays flaccid neurotransmitters, asking, "Is this what I look like?" (see figure 5.2). Yet, he is dismayed: "I don't like to think of my thoughts and feelings as nothing more than chemi-

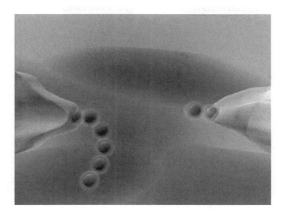

Figure 5.2 A portrait of the artist's neurotransmitters, from the video *It Did It* by Peter Brinson.

cal combinations. It makes me seem so simple." Brinson's camera scans the circles and words of a psychological assessment test like a flat wall. In another segment, Brinson's character (as scientist? artist?) observes an emu which has managed to jump out of its cage. The lone emu shrinks from the outside world, turning toward the flock, which pecks at him in return. Brinson notes, "All he seemed to want was to get back in." The emu, apparently all too human, seems to be in a Nietzschean struggle to break free of the herd. This scene might stand for the protagonist's attempt to circumvent the hegemony of medical discourse.

With the documentary-maker both doctor and patient, video creates meaning simultaneously as scientific evidence and as artistic expression, reminding the viewer of the camera's place at the fulcrum of reality and fiction. In Brinson's video, self-expression, whether overtly constructed as animation or as casual photographic observation, becomes symptom. The camera records the depressed subject's point of view: "Happy people have their eyes closed. Feeling bad is a symptom of seeing things for what they are." As a cinematographer, Brinson projects symptoms of despair unique to Southern California—labyrinthine housing developments, UFO sightings, roses desiccating in the sun, the sanctuary of the apartment interior (figure 5.3). The video alludes to a history of artistic representations of alienation, melancholy, and depression while creating its own original vocabulary.

It Did It begs the question of whether the romantic old language of artistic expression can compete with the technologies of medicine as a salve for depression. The video contrasts medical and artistic languages for describing, expressing, and knowing depression. Medical epistemology—diagnosis, technology, the clinic—is presented as genuinely powerful. The video shows how medical discourse is inextricable from real action: the taking of a pill—in addition to dispensing serotonin reuptake inhibitors—represents a whole

Figure 5.3 Brinson videotaping an unidentified flying object crash landing in a Southern California suburb, from the video *It Did It* by Peter Brinson.

worldview. But Brinson puts medical objectivity in question: the modern idea of depression, he reminds us, sprang from melancholy, or black bile. Our personal understanding of depression might spring from Dürer's famous illustration of the affect (see figure 5.4), and its literary representations, as much as from its medical description. Cultural and artistic discourses contribute to contemporary understanding of depression as much as medical language and technologies do.

Artists have enjoyed a privileged relationship to despair. Artistic expression, synonymous with subjectivity, provides both a contrast and a contest with medical ways of knowing. Expression and catharsis, telling the story of one's life, and witnessing the world are the therapies of a more romantic, Freudian episteme. In a moment in which pharmaceuticals are clearly ascendant, Brinson experiments with both. The artist explores science as an approach to life and as a narrative structure. The scientist analyzes self-expression as symptom. The pill makes him happy—"it did it"—but limits the range of his expression and response to the world. Finally, it appears that self-understanding is more important to the artist-scientist than mere contentment.

Jim Trainor's *The Bats*

Thomas Nagel's 1974 philosophical essay "What Is It like to Be a Bat?" explores the limits and potentials of strategies for understanding phenomena outside of our personal experience.

Our own experience provides the basic material for our imagination, the range of which is therefore limited. It will not help to try to imagine that one has webbing on one's arms, which enables one to fly around at dusk and dawn, catching insects in one's mouth; that

Figure 5.4 *Melancholia* by Albrecht Durer, 1514. Brinson's video suggests that the viewer compare the historical conception of depression as black bile with the contemporary medical explanation as serotonin deficiency.

Figure 5.5 The "next-to next-to high pitches" are depicted in this still from *The Bats* by Jim Trainor.

one has very poor vision, and perceives the surrounding world by a system of reflected high-frequency sound signals; and that one spends the day hanging upside down by one's feet in an attic. Insofar as I can imagine this (which is not very far), it tells me only what it would be like for *me* to behave as a bat behaves. But that is not the question. I want to know what it is like for a *bat* to be a bat.

Nagel's essay has been used to deliberate about scientists' ability to hypothesize about consciousness in other animals. It predates discussions about the importance of embodiment for cognition. According to Trainor, he learned of the famous essay only after he produced his tale of the inner world of *The Bats*. On a certain level, it appears that Trainor and Nagel are interested in the same thing: the scientific imagination. Whereas Nagel exposes the fallacy of objectivity, Trainor reveals its unconscious.

Jim Trainor's felt-tip pen animation (see figure 5.5) seems inspired by 1950s science educational films, those 16mm reels produced with orchestral scores that swell with the glory of nature. Trainor's subtle twist is to narrate the bats' natural history from a "first-person" perspective instead of from the familiar, paternal voice of postwar documentary. What would be a matter-of-fact description of mating habits and competition among species becomes a journey of sexual discovery. Instincts, aroused by scents and the moon, form the basis of one bat soul's metaphysical contemplation—instead of examples of evolutionary theory. What would have been comfortably descriptive in the distant observer's third-person narration becomes, in the first person, a shameless confession of sexual perversion. (See figure 5.6.)

Figure 5.6 "That spring I had intercourse with 42 different girls," explains the narrator of *The Bats* by Jim Trainor.

Nature documentaries of the 1950s were often thinly veiled affirmations of the nuclear family, monogamy, and normative gender roles. Trainor's attention to bat behavior seems located in their spring affairs, the eating of each other's young, their echolocative abilities, and their sensual feeling for rain. The parts of anatomy most carefully rendered are the trachea and sexual organs. In a sense the audience witnesses a truth about science education: that human curiosity, prurient and otherwise, always focuses our studies. Trainor's strategic anthropomorphism reveals the inescapable tendency to interpret animals through human morality, and our lust to imitate their apparent "self-actualization."

Rachel Mayeri/*Stories from the Genome: An Animated History of Reproduction*

Around the year 2000, when the rough draft of the human genome was close to completion, and there was a public debate about its meaning and portents, I was studying Baroque theories of reproduction and heredity. Strangely enough, I found parallels. Current discoveries in gene science seemed as bizarre as its history: the idea that stem cells contain the capacity to synthesize all sorts of adult tissues, that we are genetically nearly identical to other primates, that we share important developmental processes with flies, that complex phenomena such as intelligence or race might be mapped to base pairs.

Each new proposition resonated with disturbing, historical beliefs or with science fiction. *Stories from the Genome*, in retrospect, was a response to shifting notions about human potential and identity produced by recent discoveries in genetics and biotechnology.

In the fifteen-minute experimental documentary, a geneticist both narrates a history of theories about reproductive biology and divulges his doubts about his own experiment in therapeutic cloning. Motion graphics animate the visual evidence of scientific theories, from seventeenth-century anatomical engravings, to nineteenth-century natural history, and to twenty-first-century press kits. The Internet provided a database of stories and images about genes: the University of Wisconsin's spectacular images of stem cells generating heart tissue and neurons; the Department of Energy's Genomes to Life Program, proclaiming an end to global warming through the engineering of new life forms; the Canadian cult leader Raël's announcement of a divine human cloning program; biotechnology corporations' promises of antidotes to diseases produced by aging. Recombining these narratives and illustrations, the video holds a mirror to the creation of meaning and value out of the emergent science of genetics.

Stories from the Genome places genetics within a history of speculative theories about human heredity and reproduction. History clearly frames contemporary scientific theories as stories—provisional, imaginative, and unaware of their own blind spots and biases. The video contains mini-documentaries on genetics history: one on the seventeenth-century homunculus theory, which cast God as the creator of the bloodlines of aristocrats and peasants. Another is on the nineteenth-century artist-zoologist Ernst Haeckel, who popularized Darwin in Germany and planted the seeds for the eugenic interpretation of his theories. Both theories, now for the most part defunct, were immensely popular and withstood what now seems to be obvious evidence to the contrary.

Ideas like homunculus theory and "ontogeny recapitulates phylogeny" had an attractive narrative symmetry and far-reaching explanatory power. Their beauty, as Stephen Jay Gould describes, came in part from their narrative logic: a sequence with a beginning, a middle, and an end, linking actions in a causal, teleological chain. The stories about reproduction gave meaning to life, connecting birth, reproduction, and death into a master plan. In homunculus theory, God placed all the generations of human history into Adam or Eve. Each human life would unfold, generation by generation, until the Last Day. Aristocrats would beget aristocrats, and peasants would beget peasants. Moreover, this story, like any good documentary, was illustrated with fascinating images: the newly discovered realm of the microscopic yielded the observation of a miniature man folded inside the head of a spermatozoon. The story of a little man, or "homunculus," packed inside man, satisfied religious beliefs and appeared to be backed by visual evidence (see figure 5.7).

Haeckel's theory, that ontogeny recapitulates phylogeny, held a similar beauty in its day, two hundred years later. Visually, the development of the human embryo resembled the history of our development as a species. From fish to reptiles to man, the species or the individual grew continually refined. The story also made sense: The perfection of

Figure 5.7 Baroque homunculus theory is pictured as an egg within an egg, in a still from *Stories from the Genome* by Rachel Mayeri.

species and of individuals proceeds sequentially toward a predetermined goal. Human beings developed and evolved like other animals, yet their place at the highest branch of the evolutionary tree was undeniable, recalling another beautiful theory, the Great Chain of Being. Adults were superior to children; men were superior to women; whites were superior to blacks; and human beings were superior to dogs. Despite the fact that Haeckel seemed to revel in the diverse adaptations of organisms to the environment, drawing beautiful images of radial symmetry in marine life, his theory attractively affirmed social prejudices (figure 5.8).

To regard contemporary genetics within the history of theories of reproduction is to be skeptical that we have the final facts of the situation, to see the emergent science as yet another story in the making. With the recent revolutionary changes in genetics, much is still unknown: Why do we have only 25,000 genes? How do these genes produce the diversity and intelligence that our species appears to have? How does our genetic heritage combine with environmental and cultural factors to produce individuals?

In light of gene science's recent eugenic past, a concerted effort was made at *Science* magazine to herald the publication of the Human Genome Project as a celebration of diversity.

Looking at the February 16, 2001, cover of *Science* (figure 5.9), we see the completion of the Human Genome Project represented as a vertical ladder, reminiscent of a DNA molecule, connected by people of different races, ages, and sexes. A hierarchical sequence of the sort imagined by eugenic theory was somewhat avoided, despite the fact that a black man holding a white baby occupies the bottom rung, and an elderly white man is

Figure 5.8 An animated college of images by Ernst Haeckel, the artist-biologist who brought Darwin to Germany, in a still from *Stories from the Genome* by Rachel Mayeri.

on top. Nevertheless, the publication's text proclaimed that human individuals are 99.9 percent the same, genetically speaking. Certainly, any one individual genome could represent the entire species. Yet, a public announcement by Celera Genomics, the corporation that would co-publish the HGP, proclaimed that the genetic material would be drawn from twenty anonymous donors representing five different ethnic groups. The choice of genes, like the choice of subjects on the magazine cover, was intended to shape the public perception of the large-scale science project—as a celebration of diversity rather than as the first wave of a tide of genetic determinism.

Despite these efforts by *Science*, in 2002 news emerged that Craig Venter, the head of Celera Genomics, had scandalously used his own genetic material as the basis for the Human Genome Project; in fact, he was already using the information to take drugs to counter a gene associated with the development of Alzheimer's. (See figure 5.10.) Clearly, the choice of genes for the HGP was a minor social issue in comparison with Celera and other corporations' stakes in gene patenting. With this symbolic public act, Venter personified a stereotype of a "mad scientist," common to science fiction, whose selfish desires dangerously rank personal interest over public gain.

As "Darth Venter" or San Diego surfer, Craig Venter certainly plays a role in the public imagination of gene science. In an episode of the PBS documentary *Nova*, "Cracking the Code of Life," Venter's public persona dramatizes the story of creation of the Human Genome Project as a tortoise-and-hare fable, with Venter the hare to his rivals, Francis Collins and Eric Lander. Using spurious methods—shotgun sequencing—Venter threatened to win the race to decode the genome first. As a character in the story of genetics, Venter's "Miss Piggy"

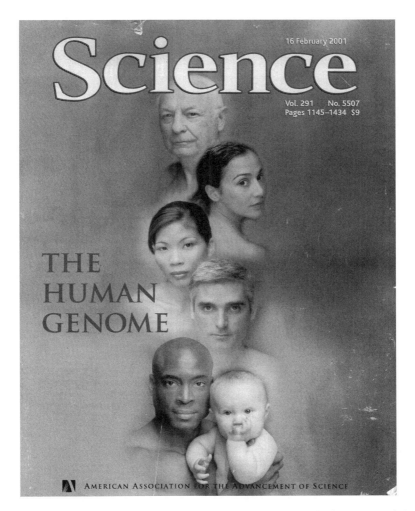

Figure 5.9 The February 16, 2001 cover of *Science* magazine, signaling the historic completion of the Human Genome Project (vol. 291; no. 5507). Photography by Ann Cutting. Printed by permission of *Science* magazine and Ann Cutting.

Figure 5.10 One entrepreneurial geneticist's genome stands in form humanity's genome. The geneticist, here, is played by Robby Herbst in a still from *Stories from the Genome* by Rachel Mayeri. The geneticist is also played by Marc Herbst.

actions stand in for corporate science, whereas Collins's and Lander's prudence and generosity represent public science. As scientists, they provide stories about the triumphant production of knowledge in the face of constraints of time and money, of doubt and incertitude, and of national pride. There are tours of their laboratories and demonstrations of their labor: Venter displays to the documentary narrator a room full of machines churning without people; in Lander's case, the documentary-makers present a room full of researchers celebrating after reaching a hard-won milestone, gene by gene. Scientists cleverly collaborate in playing their roles with the media; they understand the value of their spectacular imagery and the power to shape public interpretations of their work.

Stories from the Genome undermines traditional documentary authority by using the same narrator to expertly explain science history and to candidly disclose the progress of his own research in cloning. Much like Craig Venter, the narrator reveals himself to be a geneticist and CEO who admits to using his own genes as the basis for the map of humanity's genome. The protagonist identifies a marker for Alzheimer's in his genes, and he creates clones of himself as researchers and specimen, and sets them to work on a cure. The narrator experiments with the "production" of his clones, giving one group of test subjects love without education; another group, education without love; and the third, both education and love. When the developing clones are not doing research on themselves, working out, or playing video games, they psychoanalyze the scientist. Played by identical twins, the geneticist becomes the subject of his own experiment. (See figure 5.11.)

With the Human Genome Project, the subject of the study is us. Casting the geneticist as participant-observer emphasizes the circularity of scientific enterprise. How do we

Figure 5.11 Robby Herbst and Marc Herbst as young clones in a still from *Stories from the Genome* by Rachel Mayeri.

create distance and criticality in laboratory practice? How can we evaluate stories about genomics as they emerge in the middle of history? How are we modifying the categories of life—old age, development, and personhood? Venter's use of his own genome for the Human Genome Project represents a simple form of narcissism. More deeply, scientists' interest in heredity, intelligence, shyness, and race has historically belied self-interest and self-construction. With the drawing of family trees, love and fear, inclusiveness and exclusion, inhabit the study of genes.

Conclusion

The beginning of this essay is intended to argue that state-funded science documentary should not be viewed as separate in form or content from other media: it is only one of several media that represent science in the public sphere, but it may be the most insidious because it is received uncritically, as neutral information conveyed to viewers as a public service. Put another way, science museums, magazines, state-run and private Web sites, feature films, and advertisements all offer persuasive messages about the significance of scientific discoveries. While documentary is science's ambassador, feature films and television advertisements, for instance, may be equally influential in shaping individuals' interpretations of genetics, medicine, and biotechnology.

Examinations of fears and desires around DNA testing in the film *GATTACA* are contrasted with newspaper representations of the emerging technology in a comprehensive study of how the Human Genome Projected transformed the material substance of genes into cultural meanings, conducted by groups at Lancaster and Cardiff universities. In another example, science studies scholar Joseph Dumit studied pharmaceutical advertisements' sunny solutions to allergies and social anxiety. Biotechnology corporations such as Monsanto routinely produce their own Web-based documentaries, explaining the value of their products to potential investors, consumers, and critics. While it is abundantly clear that feature films tell stories about science, and that advertising is intended to sell products, television documentary tends to be viewed less critically. Artists' experiments with documentary, in contrast to science's popular media, can contribute to the public sphere by opening up questions about developments in science and technology, and the stories by which science comes to be "appreciated" by society.

Soft Science DVD is distributed by Video Data Bank, 112 S. Michigan Ave., Chicago, IL 60603 (http://www.vdb.org). Additional information is at http://www.soft-science.org.

References

Farley, John. *Gametes and Spores*. Baltimore: John Hopkins University Press, 1977.

Gould, Stephen Jay. *Ontogeny and Phylogeny*. Cambridge, Mass.: Harvard University Press, 1977.

Rachel Mayeri

Haran, Joan, Jenny Kitzinger, Maureen McNeil, and Kate O'Riordan. *Human Cloning in the Media.* London: Routledge, 2007.

Haraway, Donna. *Modest_Witness@Second_Millennium. FemaleMan©_Meets_OncoMouse*[a]: *Feminism and Technoscience.* New York: Routledge, 1997.

Latour, Bruno. *Science in Action: How to Follow Scientists and Engineers Through Society.* Cambridge, Mass.: Harvard University Press, 1987.

Mayeri, Rachel. "Call for Videos by Artists and/or Scientists. Soft Science Film and Video Screening." October 12, 2003. http://www.redproject.org (accessed February 26, 2007).

McKie, Robin. "I'm the Human Genome, Says 'Darth Venter' of Genetics." *Guardian Unlimited*, April 28, 2002. http://www.guardian.co.uk/Archive/Article/0,4273,4403109,00.html (accessed February 26, 2007).

Mitman, Gregg. *Reel Nature.* Cambridge, Mass.: Harvard University Press, 1999.

Nagel, Thomas. "What Is It like to Be a Bat?" Reprinted in *The Mind's I*, composed and arranged by Douglas Hofstadter and Daniel Dennett. New York: Basic Books, 1981.

Nichols, Bill. *Representing Reality: Issues and Concepts in Documentary.* Bloomington: Indiana University Press, 1991.

Nova. "Cracking the Code of Life." Paula Apsell, senior executive producer. Broadcast on PBS, April 17, 2001.

Paabo, Svante. "The Human Genome and Our View of Ourselves." *Science* 291, no. 5507 (2001): 1219–1220.

Rael. "Intelligent: Design—Message from the Designers." http://www.rael.org (accessed February 26, 2007).

Sawday, Jonathan. *The Body Emblazoned: Dissection and the Human Body in Renaissance Culture.* London: Routledge, 1995.

Shapin, Steven, and Simon Schaffer. *Leviathan and the Air-Pump: Hobbes, Boyle, and the Experimental Life.* Princeton, N.J.: Princeton University Press, 1985.

University of Wisconsin-Madison. "Embryonic Stem Cells Research at University of Wisconsin-Madison." http://www.news.wisc.edu/packages/stemcells (accessed February 26, 2007).

U.S. Department of Energy. "Genome Programs of the U.S. Department of Energy." http://genomics.energy.gov (accessed February 26, 2007).

van Dijck, José. "Picturing Science: The Science Documentary as Multimedia Spectacle." *International Journal of Cultural Studies* 9, no. 1 (2006): 5–24.

Observations on an Art of Growing Interest

Toward a Phenomenological Approach to Art Involving Biotechnology

Jens Hauser

Although the research work of the artist is rarely as systematic as that of the scientist they both may deal with the whole of life, in terms of relationships, not of details. In fact, the artist today does so more consistently than the scientist, because with each of his works he faces the problem of the interrelated whole, while only a few theoretical scientists are allowed this luxury of a total vision.
—LASZLO MOHOLY-NAGY[1]

Art that uses biotechnology as its means of expression is currently addressed less as art and more as a discursive and often instrumentalized form of contributing to ongoing public debates beyond the aesthetic realm. Despite the aspect described by Moholy-Nagy that artists as seismographs "may press for the sociobiological solution of problems just as energetically as the social revolutionaries do through political action,"[2] art that typically operates on the level of presence of biological process rather than on its representation loses its particularity and its complexity when being grasped only through its popular agenda-setting potential. The holistic view of art that Moholy-Nagy suggests, in which "not only the conscious but also the subconscious mind absorbs social ideas," depends on the capacity of the arts to transform weltanschauung into emotional form, and "with means largely comprehensible by sensory experiences on a nonverbal level. Otherwise any problem could be successfully solved only through intellectual or verbal discourse."[3] Art involving biotechnology needs to be analyzed in its characteristic phenomenological oscillation between meaning effects and presence effects,[4] without neglecting the latter, as it is dissimilar from other forms of information-centered new media art.

 The growing interest in art forms that deal with the biological disciplines at large has created a niche for a proliferating murky and woolly generic term: *bioart*—a catchword to describe a still unclear postdigital paradigm and its specific metaphors—which stands for both biomedia and biotopics, and tends to abolish their ontological differentiation.

On the one hand, art in which the use of biological metaphors and symbols serves to fuel biopolitical discussion and which can get along fine with conventional techniques; on the other hand, art that utilizes biotechnology but does not necessarily, address thematically linked issues. The medium can, but does not necessarily meet the message. Of course, biology's ascent to the status of the hottest natural science has generated not only an inflationary use of biological metaphors within the humanities, but also and above all, a range of biotech procedures that provide artists with new means of expression that they appropriate. These two sides need to be ontologically differentiated.

What is new? New media transform artistic expression in the very McLuhan sense that to the blind, all things are sudden. Today new media are not necessarily about digital media anymore, and the newness factor itself is very old, as technological flux is intrinsically dynamic. It is more significant how the use of biotechnological processes in art semiotically and somatically changes the relation between the artist, his or her displays, the recipient, and the socioeconomic context in which this art intervenes. Artists today incorporate diverse fields and their related methodologies, such as cell and tissue cultures, neurophysiology, transgenesis, synthesis of artificially produced DNA sequences, controlled Mendelian cross-breeding of animals and plants, xenotransplants and homografts, and biotechnological and medical self-experimentation, among others. But it is less relevant whether

... network art, computer art, video art, pigment art, oil art, painting art or sculpture art is art or not, but rather how the production technologies and the physical-chemical, biotechnological and mediated procedural modes of conception and execution enable, hinder, modify and characterize those products that, in accordance with a particular society's view of certain methods and objects, are referred to as *art*. ... Art in the focal point of mediatization is of interest as a specifically inspired capacity to tie together vision, knowledge and the world of everyday life."[5]

A Taxonomy

While *bioart* that involves biotechnological methods and/or manipulation of living systems has become a process-based art of transformation in vivo or in vitro that manipulates "biological materials at discrete levels (e.g., individual cells, proteins, genes, nucleotides),"[6] and creates displays that allow audiences to partake of them emotionally and cognitively, it might seem at first glance paradoxical that artists in this field even ascend to the level of socially respected epistemological commentators. So far, only a very restricted audience has even had the chance to experience such artistic displays directly in exhibits or performance situations.[7] One of the reasons for the limited exhibition record of wet art might lie in the fact that this art is very difficult to display live. Also, at a time when the life sciences are driven largely by commercial and free-market logic, this art often appears as suspect and unethical in the eyes of more traditional art circles. These rematerialized forms

of art that collide with real life so literally clearly generate, for instance, more interest outside than inside the realm that one may refer to as "the art world."[8]

Nevertheless, with the increasing impact of technoscientific discourses on the economy and belief systems, bioart—if we accept the use of this mutant term as a polysemic placeholder that includes its own evolution—is coveted by multiple sociopolitical actors for its ability to influence discussion on biopolitical and ethical issues. But, like a book that hardly anybody has read but everybody is talking about, wet biological art[9] is mainly presented via, and judged upon, secondary texts, documentation, and other mediated paratexts.[10]

A typical way of presentation ex post is documentation. Boris Groys, without treating the special case of bioart, describes the larger framework of this tendency and helps us to understand the environment in which it is located.

Art documentation as an art form could only develop under the conditions of today's biopolitical age, in which life itself has become the object of technical and artistic intervention. In this way, one is again confronted with the question of the relationship between art and life—and indeed in a completely new context, defined by the aspiration of today's art to become life itself, not merely to depict life or to offer it art products."[11]

The problem here is that museum-friendly art documentation then becomes again a representational sign that refers to "art as life itself." Therefore, despite the technical and institutional difficulties in displaying bioart live, more and more artists manage to stage real biological processes that appear to the viewer as "living," or are suggested at least to be organically authentic—since this art relies in its essence on this organic authenticity. By transgressing the semiotic procedures of representation and metaphor,[12] it goes beyond them to produce presence in a face-to-face situation which cannot be mediated without reducing it to a purely heuristic placeholder of discourses.

As a short case study, the particular oscillation between the previously mentioned meaning effects and presence effects[13] can be exemplified through Eduardo Kac's transgenic art installation The Eighth Day:[14] it presents itself as a self-contained artificial ecology under a Plexiglas dome illuminated with blue light, evoking the image of Earth as seen from space, under which living transgenic life forms that strongly glow green can be contemplated with the naked eye through wavelength filters that are fixed to the dome. The life forms are GFP plants, amoeba, fish, and mice that have been obtained through the cloning of a gene which codes for the production of green fluorescent protein, and selective breeding to amplify the glowing effect. The display also contains a robot piloted by an active biological element within its body—GFP amoeba cells within a transparent bioreactor. When the amoebal colony moves, the biobot moves in the same direction. This heralds the potential of biological agency within the performative process. The biobot also has an integrated camera whose images can be accessed by Web participants in order

to remotely gain a "first-person perspective" of the environment. An additional camera is fixed above the installation, thus completing the artificial biotope with a "bird's perspective" from which visitors experiencing the dome now also appear to be part of that universe, as they can see the terrarium from both outside and inside the dome.

On its metaphorical level, the setting can be interpreted with the classical hermeneutic tools: according to the Judeo-Christian Scriptures, it refers to the bioindustrial "creation" of a transgenic environment in which green fluorescent organisms become the visualizing Geiger counters of "a circumstance that escapes us because of the fact of a too large physical scale, and a too slow time scale,"[15] a concept corresponding to Moholy-Nagy's reflections on space-time problems.[16] The bioluminescence may also stand for the need for a renewed Enlightenment "at a time when much of the public is relegated to a state of minority and dependence vis-à-vis the experts whose white labcoats have superseded black habits"[17] while biopolitical decisions are being made.

But the efficiency of the *The Eighth Day* largely relies on emotional factors that meaning does not convey: the fully green glowing mice signify less than they are; they have less a metaphorical function than a presence in the work. The direct encounter with them is a striking and, especially for the less science-literate audience, disturbing experience of empathy and co-corporal projection. The effects of presence both condense and dramatize. Furthermore, the mediated images of the "transgenic environment," when being transmitted by the camera via the Internet, provide only a black-and-white scope in which the emotional presence effects disappear: the representation and mediation via digital visual information do not give the full picture. At the same time, the filters through which one looks to see the glowing with the naked eye emphasize more general issues linked to the phenomenology of perception. As in performance art, the remaining traces of the installation are photos, video documentation, and a book[18]—in which, significantly, only two of the eight contributions on the artist's strategy are based on direct experience of the work in the gallery that is described.

In the light of this synecdochic example, this chapter focuses on the following:

· The phenomenon of rematerialization
· Artistic biomedia and their mediation
· The relation between presence and representation
· Performativity and co-corporal projection
· The role of documents, physical traces, and paratexts
· Context dependency and its consequences

Rematerialization

Bioart is a phenomenon of increasing rematerialization in art that uses contemporarily available new media. This is to be understood neither as progress nor as regression, but

rather as a culmination of a long period of generalized dematerialization in art and culture. The former fascination with the "codes of life" in computer art inspired by biology is receding and making way for a phenomenological confrontation with wetwork. Art dealing with biological systems may have followed the hyperbolic career path of the genohype launched by technoindustrial special-interest groups in the 1990s, which, in the wake of its zenith in conjunction with the media frenzy surrounding the Human Genome Project, has been slowly subsiding in the last few years. Art has picked this up,[19] and has not itself developed in accordance with prescribed master codes of a determinant postavant-garde manifesto; instead, it has been subject to a process of social drift and diverse influences from its aesthetic and political environment.

For a long time, new media art circles suggested that bioart was purportedly synonymous with genetic art, and focused on so-called genetic algorithms, visualizing data, aestheticizing computer simulations of biological processes, culminating in "autopoietic systems, virtual creatures, Artificial Life software, genetic images, synthetic life, evolution and the ecology of digital organisms, interactive evolution and the algorithmic beauty of nature,"[20] as computer culture promoted "the shift of paradigms from defining life as substance, material hardware or mechanisms to conceiving life as code, language, immaterial software, dynamical system."[21] Indeed, even artificial life as life-as-it-could-be ought not to be understood as a simulation only, but rather as a preliminary stage of potential materialized visions. With the emergence of artistic strategies such as transgenic art[22] or tissue culture art,[23] the earlier term genetic art[24] has changed its meaning in light of wetwork. After the demystifying abnegation of the primacy of the genetic paradigm as the ultimate Jacob's Ladder, the proclaimed centrality of the code is being confronted with concrete carbon-based physical reality.

But neither does rematerialization imply a return to the art object, moreover living and teratological, nor the animation of creature-objects flowing from fascination for yesteryear's automatons—where in retrospect technology was indeed hidden away. Rematerialization is enriching because it epistemologically opens up parallels in art, beyond the information-only paradigm of the last decades. It can establish links to other biological disciplines, such as ethology or biorobotics, and at the same time draw parallels to land art and eco art, in which the continuum of life balances a predominantly cognitivist approach. More historically, it might even refer to the age of anthropomorphic landscapes, to still life and, because of its ephemeral nature, to Vanitas paintings that share their paths with early materialist philosophy, such as Julien Offray de la La Mettrie's,[25] that mocks Cartesian concepts of logo- and phonocentrism that have been systematically deconstructed by Jacques Derrida.[26]

Rematerialization is not limited to the arts; in architecture as well, the interplay between simulation, information, and materiality is being discussed as complementary modes of wet grid and dry grid modeling, or analog computing and soft constructivism.[27] Artist-architects such as Zbigniew Oksiuta illustrate this transdisciplinary shift: his

gelatin architectures and isopycnic systems[28] use direct material systems (a mix of liquids and solids) for calculating form, instead of imposing simulated geometrical concepts on a material, thus inverting the direction of thought.

Art, Biomedia and Mediation

Telecommunications and information theory-based notions of media fall back into digi-centrism and fail to properly reflect the diverse possibilities of utilizing biotechnological processes in art. If, for example, the encoding of visual icons or text fragments into DNA is still relevant for art emerging within the genetic paradigm—such as Joe Davis's *Micro-venus*[29] or Eduardo Kac's *Genesis*[30]—then the artistic practice of tissue culture, for example, may demand a media definition that is not based primarily on information theory, as too many parameters of biological interaction are necessary to inform matter. Although "the biological and the digital domains are no longer rendered ontologically distinct, but instead are seen to inhere in each other," Eugene Thacker, in his definition of biomedia, insists that they must not

. . . be confused with *technologization* generally. Biomedia is not the *computerization* of biology. Bio-media is not the *digitization* of the material world. Such techno-determinist narratives have been a part of the discourse of cyberculture for some time, and, despite the integration of computer technology with bio-technology, biomedia establishes more complex, more ambivalent relations than those enframed by technological-determinist views.[31]

And, in spite of the development of new areas of research such as biocybernetics and synthetic biology, which strive to design new functions for living organisms, artists are not just seeking to illustrate a suggested programmability of life mechanisms; they are neither concentrating on "making a chimerical product, nor on obtaining a result . . . but on the *media* that help obtain a result," thus implying, "according to a definition suggested by Peter Weibel, the change from *world contemplation* to *media contemplation*."[32] In addition, in contrast with technologies deployed in digital media art, biotechnologies as artistic implements are not yet widely democratized,[33] even if biotech home studios as new mani-festations of pop culture may soon be upon us.[34] Unlike Software or Net Art, where the transmission of data and their translation into a more or less sensorial vector are central, artists using biomedia do not necessarily access, control, or emphasize the biological information in the displayed systems. Bioart is about intermediality. On the one hand, biotechnological processes, organic material, or living systems allow one to perceive bio-media in McLuhan's sense, as possible extensions of the body. On the other hand, artists conceive and mediate their displays, enabling audiences to partake of them emotionally and cognitively in various multimedia forms and with largely different intentions, ranging from autotellic museable pieces and performative installations to public political activism that is directly related to concrete socioeconomic reality.

Beyond Representation: The Production of Presence

In an age in which the technosciences themselves have increasingly become potent producers of aesthetic images,[35] the use of biotechnological processes as a means of expression in art has no prime depictive function. This art uses a priori nonimage-producing biotechnological processes, and turns the representation of physicality into its organically constructed and staged presence. We must ask whether artists here even want to make rival use of the epistemological power of the image, or whether they see their role instead in the subversive questioning of dominant concepts and dogmas—and thereby also of their modes of representation. It is striking that wetwork-centered artists almost use visualization technologies such as GFP-protein localization or gel-electrophoresis by subverting their actual purpose and turning them against themselves.[36]

Are these only "living images"? Facing, physically, the "semi-living" organic sculptures by the Tissue Culture & Art Project, spending time in the greenhouse that is hosting Marta de Menezes' asymmetric butterflies whose wing patterns she has modified for her installation *Nature?*,[37] or experiencing the live displayed green fluorescent living organisms in Eduardo Kac's *The Eighth Day* is radically different from any concept of referential representation, visualization, or illustrative simulation. Bioart is, then, to a large degree based on the staging of presence, in which "the reality of presentation (the world of art creation) is replaced by the presentation of reality (creation of the world), thus reducing to nothing the difference between an originally artificial model and the actual world."[38] This takes place simultaneously, both through imparted knowledge of the underlying processes and through the organic presence, with which the viewer comes into contact and with which he can sensually or multisensorially accomplish an affective corporeal projection.

The need to produce effects of presence in our oversemanticized culture has been discussed by Hans Ulrich Gumbrecht in his critique of the central position of interpretation and his hypothesis that "any form of communication implies such a production of presence, that any form of communication, through its material elements, will 'touch' the bodies of the persons who are communicating in specific and varying ways."[39] He underlines the fact that this has been "bracketed (if not—progressively—forgotten) by Western theory building ever since the Cartesian *cogito* made the ontology of human existence depend exclusively on the movements of the human mind." Indeed, this resistance against the generalized culture of interpretation articulated by the affirmation of a corporeal substantiality does not mean that the interest in the materiality of communication,[40] in the nonhermeneutic and in the production of presence, would

. . . eliminate the dimension of interpretation and meaning production. Poetry is perhaps the most powerful example of the simultaneity of presence effects and meaning effects—for even the most overpowering institutional dominance of the hermeneutic dimension could never fully repress the presence effects of rhyme and alliteration, of verse and stanza."[41]

This oscillation between the effects of presence and the effects of meaning can be found centrally in bioart. In contrast to the now uncountable exhibitions focusing on the relations between art and the sciences, artists here seem to distance themselves from the assumption made on the heuristic comparability of scientific and artistic images as proclaimed in the context of the *iconic turn*.[42] There might be other indicators of how contemporary art has reacted to oversemanticization in the last forty years: the massive practice of performance art, but also the physical presence of live animals in contemporary art[43] which not only have a symbolic function but also generate presence by their corporeal alterity.

Performativity and Co-corporality

The oscillation between the effects of presence and the effects of meaning may change according to eras and people's media experience. In digital media art, the production of presence has been approached through the introduction of haptic stimuli and noninvasive biofeedback, real-time participation, and, more generally, of interactivity, in which often the temporal simultaneity of interaction suggests a physical proximity, up to more sophisticated telepresence. In bioart, the spatial proximity seems to be crucial, in accordance with the Latin *prae-esse*. Could bioart then be able to be interactive, to a point of even physically affecting the viewer/experimenter? Theoretically, yes. Practically and ethically, it might be problematic. Neal White,[44] in his concept of invasive aesthetics, proposes to make the substance-absorbing body of the beholder into a site for art and asks: "Is it possible to create an object that has an immediate pathological/neurological/physical basis of impact for the viewer?"

The French group Art Orienté objet has created *Artists' Skin Cultures*, biotechnological self-portraits destined ideally to be grafted by collectors onto themselves. In *Disembodied Cuisine*, the Tissue Culture & Art Project offered "victimless frog steaks" grown in bioreactors to the audience.[45] Self-experimentation in which a process is not seen, but potentially felt, is staged in the *Melatonin Room* built by Décosterd & Rahm, a nonrepresentational hormonal stimulation space in which electromagnetic rays suppress, and ultraviolet rays increase, endogenous melatonin production. When secreted, this hormone provides information associated with tiredness and sleep. The architects/artists wish to directly, but discreetly, create a "physiological impact on human metabolism" in a "space that reduces the medium between the transmitter and the receiver to the greatest possible extent and acts on the chemical mechanisms of things *inter se*."[46]

Bioart, as a consequence, is also attracting the interest of performance artists and those specializing in body art; structural relationships connect the two fields. This brings about a situation in which artists are again increasingly attempting to use bodies, including their own, as a battlefield for the confrontation with themes and issues that have arisen in connection with the life sciences. It is not surprising that Stelarc and Orlan, two of the seasoned pioneers of body art, have approached SymbioticA, the Art and Science Collab-

orative Research Laboratory in Perth, in order to utilize cell cultures to grow an *Extra Ear 1/4 Scale*[47] and a patchwork-like mantel made up of hybrid skin cultures of diverse donors and cell lines representing a variety of different ethnic origins, and human and animal cell lines. These works can be meant as satellite bodies, so to speak, designed to effectuate the reshift of the modifications Orlan performed on the level of virtuality in her *Selfhybridations Africaines* into the domain of real, customized physical design, thus completing the dialectical cycle pointing back to her earlier surgical operations.[48]

Bioart shares with live art the dialectical relationship between real presence and representation. Whereas the theatrical actor still metaphorically embodies a role—let's make an honorary exception for Antonin Artaud—the performance artist brings his own body and his own real biography into play. What this gives rise to for the spectator is a realm of emotional tension and interplay between the two possible modes of perceiving the action. Likewise, the viewer who is experiencing bioart may switch back and forth between the symbolic realm of art and the "real life" of the processes that are being put on display and are being suggested by organic presence. These processes draw their significance not only as semiotic cultural signs, but also through their own performativity, which suggests a bodily co-presence. It has to be asked if this performative aspect can ultimately confer an agency to the biological entity, whether it is an animal, living tissue, or smaller organic components.

Documents and Traces from A/live Art

Other aspects that body art and bioart have in common are the preservation, presentation, and mediation a posteriori of frequently ephemeral projects: they survive as film, photo, or video documents, as traces such as posters or flyers, or in the form of material remnants or fetishized relics.[49] In gallery spaces, bioart is generally displayed in three interrelated forms:[50]

1. As a live installation that has to be maintained over the period of the exhibition, sometimes involving biotechnological devices. Examples are Martha de Menezes' greenhouse with the living modified butterflies in *Nature?*; the *Free Range Grain*[51] GMO testing laboratory set up by Critical Art Ensemble (CAE), Beatriz da Costa, and Shyh-Shiun Shyu; the *Genesis*[52] installation containing transgenic bacteria by Eduardo Kac; *Disembodied Cuisine*,[53] by Tissue Culture & Art; Paul Vanouse's *Relative Velocity Inscription Device*;[54] or Adam Zaretzky's *Workhorse Zoo*.[55]

2. As physical traces that refer back to the process in the manner of a synecdoche. Examples are Eduardo Kac's *Transcription Jewels*,[56] containing purified "Genesis DNA" powder; the cleared and stained specimen following Brandon Ballengée's *Species Reclamation* frog-breeding project,[57] or the half-chewed "frog steaks" that dinner guests spat out and that are part of TC&A's post-performative installation *The Remains of Disembodied Cuisine*.

3. As documents, mainly photographs, videos, drawings, and sketches. Examples are the photographs documenting George Gessert's breeding program of irises and strepto-carpuses,[58] and the *Free Alba!* photographs in which Eduardo Kac presents the press coverage related to the ongoing *GFP Bunny* discussion.

Even if "art documentation is by definition *not* art, it merely refers to art," contemporary art at large "has shifted its interest away from the artwork and towards art documentation."[59] According to Boris Groys, this tendency paradoxically demonstrates the increasing aliveness of art in general:

For those who devote themselves to the production of art documentation rather than of artworks, art is identical to life, because life is essentially a pure activity that does not lead to any end result. The presentation of any such end result—in the form of an artwork, say—would imply an understanding of life as merely a functional process whose own duration is negated and extinguished by the creation of the end product—which is equivalent to death. It is no coincidence that museums are traditionally compared to cemeteries: by presenting art as the end result of a life, they obliterate this life once and for all. Art documentation, by contrast, marks the attempt to use artistic media within art spaces to refer to life itself. . . . Art becomes a life form, whereas the artwork becomes non-art, a mere documentation of this life form. . . . *Pure* art thus established itself on the level of the sign, the signifier. That to which the signs refer—reality, meaning, the signified—has, by contrast, traditionally been interpreted as belonging to life and moved from the sphere in which art is valid."[60]

What Groys calls "pure art" here seems to be similar to what Allan Kaprow, who coined the term "happening" in the late 1950s, once called "art art," which he considered getting trapped by the upcoming blurring of art and life:

Art art's greatest challenge . . . has come from within its own heritage, from a hyperconsciousness about itself and its everyday surroundings. *Art art* has served as an instructional transition to its own elimination by life. Such an acute awareness among artists enables the whole world and its humanity to be experienced as a work of art."[61]

How can we know for sure these days that the truck driver repairing his exhaust at the crossroads in your neighborhood is not a silent conceptual artist engaging you in a thought-through performative experience? Or a farmer in a white lab coat releasing bacteria in the botanical garden? Groys sees art today getting "biopolitical, because it begins to use artistic means to produce and document life as a pure activity."[62]

A recent project by the Critical Art Ensemble illustrates these logics at work. Although the group is most known for its activist strategy, participatory performances, and field-work, *Marching Plague*,[63] which addresses the issue of U.K.-U.S. biological warfare research and the paranoia surrounding bioterrorism, is presented as a video shot on location on the

Scottish Isle of Lewis. While the CAE carried out a live germ-testing performance on site, no audience was conveyed, and the documentation hence becomes the piece itself.

Here the question of "unpresentability" of this art that is difficult to curate in a traditional museum setting, arises: bioart defies reproducibility; on the other hand, it postulates the importance of direct presence. One of the consequences is that it is often read and interpreted via a secondary text or paratext, which means a heuristic device which at this level cannot be clearly differentiated from other representational metaphors and images anymore—and therefore gets into direct concurrence with representational art that deals with biotechnology only thematically.

Paratexts: Parasitism or Biocenosis?

In order to understand the discrepancy between the limited exposure that audiences, for instance, have had to bioart displays in a nonmediated way and the large and visceral public interest in this field, the grid of paratextual analysis by Gérard Gennette offers some keys to identifying the components of a work and how a work relates to its context by instances of mediation that are appendices to the text itself. Of course, Genette is interested in the relationship between books and readers and how paratexts stand in between, but the grid can well be transposed onto a complex, intermedial concept of work beyond that of a text in the narrower sense of the word.[64] Paratexts act as a threshold between text and off-text; they are liminal devices mediating the relations between the content and the receiver, "a privileged place . . . of an influence on the public . . . at the service of a better reception for the text and a more pertinent reading of it," destined "to make present, ensure the text's presence in the world."[65] Genette defines paratexts as an equation of two categories:

Paratext = peritext + epitext.

The peritext includes elements inside the confines of the aesthetic object; the epitext denotes elements outside the aesthetic object. Transposed to art, the following paratexts could be considered as peritexts: artist's name (individual or collective, pseudonym), work title, artist's statements and notes of intention, didactics, gallery size and type (art or science museum), dedications, epigraphs (external quotations), parallel actions or displays that act like "footnotes," and so on. As epitexts, the following could be considered: public epitexts such as reviews and interviews, public responses, media coverage, and symposia; or private epitexts such as letters and correspondences that are integrated into the work itself. It is evident that this grid could be applied to any art form, but here it reveals that the reception of "wet" bioart very strongly dominates through peritexts such as artists' discourses, declarations of intent, and "footnote"-like additions. This can be explained by the facts that biomedia primarily do not transmit information and that the presence of the works cannot be accessed though the interpretive approach only.

The other dominant paratexts are public epitexts, generated by commentators attracted by the thematic exposure but who often have not experienced the works themselves, as this art form has only rarely been made available institutionally—and because of the ephemeral-processual character—for short periods of time. Artists construct an often inscrutable substructure of paratexts on multiple levels of reception—as peritexts—or react to external, public epitexts and integrate them in turn, so that the paratextual organization significantly determines the aesthetic object itself.

A good example is the video *Evidence*, by the Critical Art Ensemble, which appropriates an external document (epitext) and turns it into a peritext, thus linking it closer to the art strategy itself. The document shows FBI officers investigating the presence of bacterial cultures and materials in Steve Kurtz's home, and the traces they left. The footage itself does not refer concretely to any of the tactical art projects that the CAE develops, but to a contextual event that was unforeseeable and that reflects, in a post-situationist spirit, the threat of an artistic position as such.

Although with very different intentions, Eduardo Kac's well-known *GFP Bunny* project has also become totally context-dependent, to a point that even the "failure" of the initial proposal by the artist to live with a transgenic glowing rabbit in an art gallery, due to the refusal of the French laboratory to give away the rabbit in question, transformed the project into an open communication art piece[66] that could not have been planned. Its failure is part of its actual success: "It's to say that had everything gone [according] to plan, there would have been less to learn from the work, and from how it slipped from the artist's control. It is in this, its goings-wrong, that it remains, for the present, Kac's most compelling project."[67] In its context dependency, bioart is exemplarily brought up as a wild card in public discourse.

The Medium Is Not Always the Message—nor the Other Way Round

Probably never in recent art history have we witnessed a case in which questions of content, public utility, or epistemological and educational value are asked so directly and in real time to an emergent, marginal art form, which bioart is. Benefiting from the attention that this formally new art has gotten by manipulating living systems for real, the attention is shifted from an aesthetic and philosophical debate to that of the topics at stake. But should art be analyzed based upon the content it deals with? Biofictional manifestations such as chromosome paintings or mutant-depicting digital photo tricks are no more examples of bioart than Claude Monet's impressionistic paintings could be classified as "water lilies art" or "cathedral art." And even in practices that involve living material or biotechnological processes, the focus on biotechnology as subject, by providing the most useful examples in the context of a broader cultural discussion in which art is referred to as political agency, has accessorily led to a certain aesthetic monoculture: no longer can one establish an overview of how many "DNA portraits" or "genetic certificates" have been elaborated during the last years. The use and display

of HeLa cells[68] as a cultural signifier also proliferates in art installations. Works are often identified as culturally relevant mainly when the expressive medium meets the message.

Yet, it is all but evident that this needs to be the case. Even a crucial piece from the beginning period of bioart, *Microvenus* by Joe Davis in collaboration with the biologist Dana Boyd, uses external references. *Microvenus*[69] is a graphic icon symbolizing the female sexual organ that has been encoded as a DNA sequence, synthesized as a DNA molecule, and inserted into a plasmid DNA, which has then been transformed into laboratory strains of *E. coli* and grown in laboratory culture. The piece had been conceived as a reaction to what Davis felt to be acts of censorship on the part of NASA, carrying out attempts to communicate with extraterrestrials by means of a plaque inscribed with line drawings of male and female human figures and sent into outer space, but in which the female external genitalia were lacking. Since the sequence can be analyzed but not seen with the naked eye, Davis's piece also more conceptually questions the primacy of visual representation in art in general, and the authenticity we grant to what we see.

As George Gessert argues, the challenge of this art is also that it is based on unverifiable claims:

The significance of this work lies almost entirely in what viewers cannot validate: its aliveness, and the process by which it was created. Most of us must take these things on faith. . . . We are of course free to dismiss any work of art that requires too much knowledge or faith. However, we have more to gain by engaging such work on its own terms whenever possible."[70]

Another example is Wim Delvoye's major piece *Cloaca*. He employed, on his own initiative and outside of any institutional sci-art program, scientists and engineers to help him build a large-scale digestion machine that administrates various enzymes and replicates the workings of the human gut. Although this piece technically qualifies as bioart—it manipulates living bacteria and enzymes at least systemically[71]—Delvoye feels such labeling to be reductionist in regard to this multilayered work of an absurd "shitting machine," making digestion "scientifically" transparent, commenting on brand name business, advertising, food distribution, and the mechanisms of the art market by selling the ambiguous physical results and enabling buyers to speculate on it via the issue of shares, in a real economy.[72] The manifold angles of access to Delvoye's work and its relative flexibility in regard to different social contexts establish a level of complexity that serves as insurance against a monothematic reading—which often precedes instrumentalization.

Context Dependency

While trying to define contextual art, Paul Ardenne lists several characteristics,[73] some of which have already been mentioned.

- It establishes direct relationships with the concrete material world beyond distant representation, Duchampian subversion, or conceptual and tautological autoreflection.
- It questions the primacy of the visual by integrating other perceptual modes, such as smell, touch, and taste.
- It inherits from socially engaged revolutionary nineteenth-century realism, inspired by the French libertarian social theorist Pierre-Joseph Proudhon,[74] and his sharp divide into past art of metaphysical idolatry, and art to come that is to be used as a social tool.
- It brings about a complex situation for the artist between simultaneous association with and dissociation from the social tissue. While his or her action emphasizes the values of sharing, his or her own condition as artist asserts a position of social exception.

One of the questions we may ask is whether artists engaging with biotechnologies can still choose the appropriate context for their action, or if they fulfill the context's expectations of usefulness that can become a slippery terrain.

Biomedical foundations like the U.K. Wellcome Trust support sci-art programs,[75] help produce art in the context of medical research, and serve as a model for other institutions, such as the newly founded Arts and Genomics Centre in the Netherlands, dedicated to bringing together artists, genomics researchers, and art historians to investigate the interactions and intersections of arts and genomics. Here, a topic-centered agenda emphasizes the assumed "unique role that the visual arts can have in the critical evaluation and dissemination of the results of genomics research. . . . A major assumption is that visual art, through its specificity of *medium* and *content*, may contribute to public debate and the *dissemination of scientific knowledge*[76] in ways that substantially differ from other forms of debate and dissemination. As such, the visual arts may contribute to a broad cultural *embedding*[77] of genomics."[78] Transdisciplinary symposia are popping up internationally to enable, often with explicit references to bioart, exchange between scientific experts, policymakers, and the nontechnical public. The recent "Genetic Policy and the Arts" working group generated ideas ultimately passed on to policymakers in a briefing to the U.S. Congress. "As a lawyer involved in creating social policies for the governance of biotechnologies," writes one of the organizers, Lori Andrews, "I am fascinated by the ways that, *beyond its aesthetic value*,[79] life science art can help society to: confront the social implications of its technology choices, understand the limitations of the much hyped biotechnologies, develop policies for dealing with biotechnologies, and confront larger issues regarding the role of science and the role of art in our society."[80]

While generally artists working in this field are often suspected of collaborating with the "bioindustrial complex," at a time when life sciences are driven largely by commercial and free-market logic, one may also ask what the price of social utilitarianism for the arts is. Beyond aesthetic monoculture, it happens that artists now write directly into the funding lines to their applications fit perfectly with the requirements of targeted foundations that are external to the "art world." Some experience that voices too critical of agendas of "embedding" those topics through art are not welcome.[81] Searching for opportunities

outside of the much-blamed "contemporary art system" also provides artists and curators with the insight that in the framework of science or natural history museums, educational aims prevail and "cultural sensitivity" can be evoked to justify content censorship.[82]

Cultural Determinism

Political contexts have a large influence on the development of bioart, which aims to be contextual. All "contestational biology" projects by Critical Art Ensemble have been context-based: at a time when divergent U.S. and E.U. policy approaches regarding traceability regulations were disputed, *Free Range Grain*[83] allowed participants to screen standard food products for genetic modification in a mobile GMO testing laboratory in the gallery. Also, CAE, in collaboration with Beatriz da Costa and Claire Pentecost, initiated an experiment attempting to reverse engineer the genetic modifications made to Monsanto's genetically modified crops, which has made them supposedly resistant to the weed killer Roundup Ready, and has been seeking to develop a biological agent able to undo the effects of biotechnical modifications.

Advocates of an activist approach and participatory public performances seek to propose a critique of corporate biotechnology by tactical models of engaging wetware in order to disrupt the course of profit back to biotech main players. However, despite these clear intentions, one might worry about the way that such work tends to be misinterpreted in alarmingly shallow and unreflective coverage, even in supposedly serious mainstream media such as the *New York Times*: "Mutant bacteria, genetically altered mice, cactuses with curly hair: Step this way to enter the danger zone of bioart."[84] The cliché of the mad scientist is shifted toward the cliché of mad artists, thus uncritically keeping in place an untouchable authority of overall systemic technoscientific reliability. Indeed, CAE clearly foresees this danger:

We do not want to make it easy for capitalist spectacle to label resisters as saboteurs, or worse, as eco-terrorists. These terms are used very often and generously by authority and tend to have the profound effect of producing negative public opinion, which in turn allows state police and corporate posses to react as violently as they desire while still appearing legitimate and just. Escaping these labels completely seems nearly impossible; however, we can at least reduce the intensity and scope of these forms of labeling, and hopefully escape the terrorist label altogether.[85]

As during the Bush era, public liberties have been restricted, these artistic positions have become even more directly involved in the mechanisms of political agenda-setting in the sensitive context of the post-9/11 Patriot Act. As Anna Munster puts it:

North America's various artistic communities have been subjected to both targeting and censorship for the political beliefs they have personally espoused and for the subject matter of their artwork. From the deliberate targeting of members of the film, television and radio industries through the

compiling of blacklists indicting those named as communists or sympathizers under McCarthy's directives, the NEA pornography and censorship debates of the late 1980s to the more recent controversy surrounding the exhibition of the show *Sensation: Young British Artists of the Saatchi Collection* in 1999, U.S. artists have felt their very livelihood threatened by government surveillance and sanctions. The zealousness of the FBI investigation into Kurtz's art practices—involving the use of biological material and techniques for the purposes of questioning the current directions, data and outcomes of the mainstream biotech industries . . . reeks of a familiar fanatical odor. . . . It is clear that the policing of America means the confinement of people, knowledge, resources and cultural production to their proper spheres. Artists using materials that are authorized for scientific research cannot possibly be conducting research as well.[86]

According to Munster, this leads to a specific situation "in the broader sphere of public culture in the U.S." where "the political status of art is no longer determined by recourse to the politics of the artist or to the platform promoted by the work's content. Art now becomes political when it catches the attention of a policing agency."[87] Artists with an activist approach measure the success of their efficiency less in gallery prices at the New York Chelsea art market than in its impact, prompting reactions from targeted, but also from randomly encountered, authorities: "the French culture minister was offended," "the German beer police intervened," "the museum director prohibited the performance."

So, is bioart overall dependent on its social and media contexts? Are the paratexts becoming the art itself? Artists in this field are actively shaping the modes of perception of their highly mediated work—looping, programming, and inducing feedback to it, which on its own becomes part of the artistic practice. The displacement of the territory of action beyond conventional places for art, vaporized into everyday life, is a great opportunity to be explored in the "biopolitical age." But the seasonal topocentric interest that induces a narrow reading of the works may not last long. We can assume that bioart, whose epistemes and/or aesthetic qualities are notable enough for their multidiscursive and multisensorial complexity will then have a longer life span—especially when they are not purely reduced to effects of meaning.

Acknowledgment

This chapter is based on a contribution to the "Genetic Policy and the Arts" project at the Los Angeles Museum of Contemporary Art in November 2005, and organized by the Institute for Science, Law & Technology, the Institute on Biotechnology and the Human Future, and the Jefferson Institute.

Notes

1. Laszlo Moholy-Nagy, "The Function of Art," in Richard Kostelanetz, ed., *Esthetics Contemporary*, rev. ed. (Buffalo, N.Y., 1989), pp. 65–68. Reprinted from *Vision in Motion* (Chicago, 1947).

2. Ibid, p. 12.

3. Ibid, p. 12.

4. See Hans Ulrich Gumbrecht, *Production of Presence: What Meaning Cannot Convey* (Stanford, Calif., 2004), p. 2.

5. Hans Ulrich Reck, *Mythos Medienkunst* (Cologne, 2002), pp. 20, 93.

6. Eduardo Kac, ed., *Signs of Life: Bio Art and Beyond* (Cambridge, Mass.: 2007), p. 12.

7. For example, *Life Science* (1999) and *Next Sex* (2000), two of the Ars Electronica festivals in Linz, Austria, dealt explicitly with the challenges of biotechnology and reproductive technologies. The exhibition "Paradise Now: Picturing the Genetic Revolution" at Exit Art in New York City (2000) presented installations with biological components, with which were mixed thematic pieces by artists working with traditional methods. In contrast, both exhibitions staged by the Biennale of Electronic Arts Perth (BEAP)—"BioFeel" (2002) and "BioDifference" (2004)—as well as "L'Art Biotech' " in Nantes, France (2003)—focused on artists who had all worked with biotechnologies and physical intervention as their methods.

8. There are already significant indications that the contemporary art system with its commercial mechanisms becomes involved in this field. The Spanish art fair ARCO in Madrid presented biotech art and identified this field as one of the future key sectors. An international two-day conference, "Biotechnological Art," was organized by Ángel Kalenberg. See *ARCO, 25 Years*, vol. 2 (Madrid, 2006), pp. 944–947.

9. Similar terms are used, including vivo arts (Adam Zaretzky), moist media art (Roy Ascott), life science art (Lori Andrews), and biotech art (Jens Hauser). Whereas live art emphasizes the relation to the performing arts, transgenic art (Eduardo Kac) and genetic art (George Gessert) point to more specific areas.

10. According to Gérard Genette's formula, originally designed as a philological tool (Paris, 1987). The English version is *Paratexts: Thresholds of Interpretation* (Cambridge, 1997).

11. Boris Groys, "Art in the Age of Biopolitics. From Artwork to Art Documentation," in *Documenta 11_Plattform 5* (Ostfildern, 2002), pp. 108–114.

12. On biotech-related metaphors, see Suzanne Anker and Dorothy Nelkin, *The Molecular Gaze: Art in the Genetic Age* (Cold Spring Harbor, N.Y., 2004).

13. Gumbrecht, *Production of Presence*.

14. *The Eighth Day* was shown from October 25 to November 2, 2001, at the Computing Commons Gallery at Arizona State University, Tempe. For a more complete description of the work, see http://www.ekac.org/8thday.html.

15. Eduardo Kac, in *Le Huitième Jour*, a film by Jens Hauser (2002).

16. Laszlo Moholy-Nagy, "Space-Time Problems," in Richard Kostelanetz, ed., *Esthetics Contemporary* (New York, 1989), pp. 69–74.

17. See Jens Hauser, "Gènes, génies, gênes," in Hauser, ed., *L'art biotech* (Nantes, 2003), pp. 9–15.

18. Sheilah Britton and Dan Collins, eds., *The Eighth Day: The Transgenic Art of Eduardo Kac* (Arizona State University, Institute for Studies in the Arts, 2003). The author had the privilege of being one of the few persons outside Arizona to have experienced this installation.

19. An illustration for a critique of the "genohype" that artists identified in the public relations strategies surrounding the Human Genome Project is *Pig Wings* by the Tissue Culture & Art Project. See Oron Catts and Ionat Zurr, "Big Pigs, Small Wings: On Genohype and Artistic Autonomy," *Culture Machine* (on-line journal), Biopolitics, no. 7 (2005). http://culturemachine.tees.ac.uk/Cmach/Backissues/j007/articles/zurrcatts.htm.

20. See the table of contents of "Genetic Art—Artificial Life," *Ars Electronica* (Linz, Austria, 1993).

21. Peter Weibel, "Life—The Unfinished Project," In "Genetic Art—Artificial Life," *Ars Electronica* (Linz, Austria, 1993), pp. 9–10.

22. Eduardo Kac, "Transgenic Art," in *Leonardo Electronic Almanac*, 6, no. 11 (Cambridge, Mass., 1998).

23. The most prominent example is the Tissue Culture & Art Project, http://www.tca.uwa.edu.au.

24. The artist George Gessert, who is breeding irises, poppies, streptocarpuses, and other flowers for artistic purposes, appropriated the term genetic art from computer artists and prefers to speak about art involving DNA: "A Brief History of Art Involving DNA," *Art Papers* (September/October 1996). Revised and reprinted as "A History of Art Involving DNA," in "LifeScience," *Ars Electronica* (Vienna and New York, 1999), pp. 228–235.

25. Julian Offray de La Mettrie, *L'Homme-Plante* (1748). English version is published in *La Mettrie: Machine Man and Other Writings*, edited by Ann Thomson (Cambridge University Press, 1996).

26. Jacques Derrida, "L'Animal que Donc Je Suis (à Suivre)," in *L'animal autobiographique. Autour de Jacques Derrida*, Marie-Louise Mallet, ed. (Paris, 1999). Published in English in *Critical Inquiry* 28, no. 2 (Winter 2002).

27. See: "The Structure of Vagueness," in Lars Spuybroek, ed., *NOX: Machining Architecture* (London, 2004), pp. 352–359.

28. "An isopycnic system is a physical phenomenon which describes the behaviour of bodies of the same density." See Zbigniew Oksiuta, *Breeding Spaces* (Cologne, 2005), and *Spatium Gelatum* (Wroclaw, 2003).

29. *Microvenus* is constructed from synthetic molecules of DNA that contain a coded visual icon representing the external female genitalia and an ancient Germanic rune representing the female Earth. See Joe Davis, *Microvenus*, "Contemporary Art and the Genetic Code," *Art Journal* 55, no. 1 (Spring 1996): 70–74.

30. *Genesis* is a transgenic art installation in which the key element is a synthetic gene that was created by translating a sentence from the biblical book of Genesis into Morse code, and converting the Morse code into DNA base pairs according to a conversion principle developed by the artist

for this work. See Eduardo Kac, *Genesis*, in Gerfried Stocker and Christine Schopf, eds., in "Life Sciences," *Ars Electronica* (Vienna and New York, 1999): 310–313.

31. Eugene Thacker, *Biomedia* (Minneapolis, 2004), p. 7.

32. Dmitry Bulatov, "Ars Chimera. Structural Aspects and the Problems," in Bulatov, ed., *BioMediale. Contemporary Society and Genomic Culture* (Kaliningrad, Russia, 2004), pp. 378–379.

33. Interest in acquiring lab skills to handle wet biology in hands-on art and biotechnology workshops is increasing exponentially. See the contributions by Oron Catts and Gary Cass in this volume.

34. Eugene Thacker and Natalie Jeremijenko, *Creative Biotechnology: A User's Manual* (Newcastle, U.K.: 2005).

35. Kristian Köchy, "Zur Funktion des Bildes in den Biowissenschaften," in Stefan Majetschak, Ed., *Bild-Zeichen. Perspektiven einer Wissenschaft vom Bild* (Munich, 2005), pp. 215–239.

36. On subversive approaches toward gel-electrophoresis, see the contribution by Paul Vanouse in this volume.

37. In *Nature?* the artist created live butterflies with modified wing patterns by interfering with the normal developmental mechanisms of the butterflies. See Marta de Menezes, *Nature?*, in Gerfried Stocker and Christine Schopf, eds., "Next Sex," *Ars Electronica* (Vienna and New York, 2000), pp. 258–261.

38. Bulatov, "Ars Chimera."

39. Gumbrecht, *Production of Presence*, pp. 17–18.

40. H.U. Gumbrecht and K. Ludwig Pfeiffer, eds., *Materialities of Communication, trans. William Whobrey* (Stanford, Calif., 1994).

41. Gumbrecht, *Production of Presence*, p. 18.

42. This concept is discussed mainly in the German *Bildwissenschaften*, following what is also known as the pictorial turn in the American context. It implies that the deluge of images is a sign of a fundamental cultural change which has a growing influence over our modes of meaning in all disciplines.

43. See Steve Baker, *The Postmodern Animal* (Chicago, 2000).

44. http://www.nealwhite.org/self-experiment.html.

45. For an analysis of *Disembodied Cuisine*, see Jens Hauser, "Taxonomy of an Ethymological Monster," in Gerfried Stocker and Christine Schöpf, eds., *Ars Electronica, "Hybrid—Living in Paradox," Ars Electronica* (Ostfildern-Ruit, 2005), pp. 182–193.

46. Jean-Gilles Décosterd & Philippe Rahm, *4.09 E. Melatonin Room*, in *Physiological Architecture* (Basel, 2002), pp. 306–307.

47. http://www.tca.uwa.edu.au/extra/extra_ear.html.

48. See Orlan, "Harlequin Coat," in Jens Hauser (ed.), *sk-interfaces. Exploding Borders-Creating membranes in Art, Technology and Society* (Liverpool University Press, 2008) pp. 83–89.

49. For example, Orlan has created her *Petits Reliquaires* with fat and tissue residues of her surgical art interventions.

50. On the complex interrelationship between performance art and the image, see Christian Janecke, ed., *Performance und Bild—Performance als Bild* (Berlin, 2004).

51. http://www.critical-art.net/biotech/free/index.html.

52. http://www.ekac.org/geninfo2.html.

53. http://www.tca.uwa.edu.au/disembodied/dis.html.

54. http://www.contrib.andrew.cmu.edu/~pv28/.

55. http://emutagen.com/wrkhzoo.html.

56. http://www.ekac.org/genseries.html. In *Transcription Jewels*, Kac ironically commodifies the genetic code by exhibiting purified DNA powder from the "Genesis" bacteria in a "genie bottle," a relic decorated with a "protein" in solid gold. We would assume that he refers to the earlier denunciation of genetic fetishism by Donna Haraway: "It takes little imagination to trace commodity fetishism in the transnational market circulations where genes, those 24-carat-gold macromolecular things-in-themselves seem to be themselves the source of value." See Donna Haraway, "Deanimations: Maps and Portraits of Life Itself," in Caroline A. Jones, and Peter Galison, eds., *Picturing Science, Producing Art* (New York, 1998), p. 187.

57. http://greenmuseum.org/content/work_index/img_id-232__prev_size-0__artist_id-19__work_id-38.html.

58. http://www.viewingspace.com/genetics_culture/pages_genetics_culture/gc_w02/gc_w02_gessert.htm.

59. Groys, "Art in the Age of Biopolitics".

60. Ibid.

61. Allan Kaprow, "The Education of the Un-artist, Part I" (1971), in Jeff Kelley, *Essays on the Blurring of Art and Life: Allan Kaprow*, 2nd ed. (Berkeley, 2003), p. 102.

62. Groys, "Art in the Age of Biopolitics," p. 108.

63. *Marching Plague* centers on Critical Art Ensemble's re-creation of some of the secret sea trials conducted by the UK government in the 1950s off the coast of Scotland, which investigated the airborne distribution of bacterial agents including plague. The film seeks to expose the relative ineffectiveness of germ warfare compared with more conventional terrorist weapons, and to highlight the diversion of resources from pressing medical research to high-cost bioweapons research programs in the current climate of fear of terrorist attacks. See: http://www.artscatalyst.org/projects/biotech/caeplague.html.

64. See Georg Stanitzek, "Text and Paratexts in Media." *Critical Inquiry*, 32 (2005): 27–42.

65. Genette, *Paratexts*.

66. Kac's *Alba Headline Supercollider* picks up and reverses the absurd and distorting mirror effect of news media reporting about the *GFP Bunny* project. http://www.ekac.org/alba .headlinesupercollider.html.

67. Steve Baker, "Philosophy in the Wild?," in Sheilah Britton and Dan Collins, *The Eighth Day: The Transgenic Art of Eduardo Kac* (Tempe, Ariz., 2003), p. 37.

68. The HeLa cell line is grown from the cervical cancer tumor of a young African-American woman, Henrietta Lacks. HeLa cells were the first immortalized human cells to be continuously grown in culture.

69. Marek Wieczorek, "The SmArt Gene (or, Are We Not Alone in the Aesthetic Universe?)." See http://web.archive.org/web/20050310071959/www.gene-sis.net/essays/wieczorek_essay.pdf

70. George Gessert, *Unverifiable Claims in Genetic Art*. Unpublished manuscript.

71. For a complete discussion of *Cloaca*, see Jens Hauser, "The Grammar of Enzymes," in Wim Delvoye, *Cloaca 2000–2007*. Casino Luxembourg—Forum d'Art Contemporain (Luxembourg, 2007) pp. 26–35.

72. See http://www.cloaca.be. "We're sorry to inform you all Cloaca-feces are currently sold out. Many happy customers have secured their shit and are now experiencing the richness that Cloaca has to offer. The remaining 100 feces have been held back for future capitalisation."

73. Paul Ardenne, *Un Art Contextuel*. Paris, 2002; pp. 9–38.

74. Pierre-Joseph Proudhon, *Du principe de l'art et de sa destination sociale* (Paris, 1865). Published in English as *The Principle of Art and Its Social Destiny*.

75. See: http://www.wellcome.ac.uk/doc_WTD003251.html.

76. Italics added.

77. Italics added.

78. See the New Representational Spaces research program, at http://www.artsgenomics.org.

79. Italics added.

80. Lori B. Andrews, "Life Science Art: A New Tool for Assessing Biotechnology," in Oron Catts, ed., *The Aesthetics of Care? The Artistic, Social and Scientific Implications of the Use of Biological/Medical Technologies for Artistic Purposes*, symposium papers from the Biennale of Electronic Arts (Perth, 2002); 2nd ed. (Perth, 2004), p. 2.

81. See the example described by Oron Catts and Ionat Zurr in "Big Pigs, Small Wings: On Genohype and Artistic Autonomy."

82. A recent example is the decision of the Western Australian Museum in Perth to condition the exhibition "Still, Living" as part of the Biennale of Electronic Arts Perth to a veto over any exhibit which was felt to be inappropriate for presentation in the Museum. This content censorship was motived by "the risk of considerable negative publicity" especially relating to work by French body artist Orlan, who addresses cultural hybridity as a topic. As a consequence, the exhibition had to be moved to the Bakery Artrage Complex in Perth, four months before the opening.

83. *Free Range Grain*, produced in collaboration with Beatriz da Costa and Shyh-Shiun Shyu, is documented at http://www.critical-art.net/biotech/free/index.html.

84. Randy Kennedy, "The Artists in the Hazmat Suits," *New York Times*, July 3, 2005.

85. Critical Art Ensemble, *The Molecular Invasion* (Brooklyn, N.Y., 2001), pp. 98–99.

86. Anna Munster, "Why Is Bioart not Terrorism? Some Critical Nodes in the Networks of Informatic Life," *Culture Machine* (online journal), Biopolitics, No. 7 (2005). http://culturemachine.tees.ac.uk/Cmach/Backissues/j007/articles/munster.htm.

87. Ibid.

The Biolab and the Public

This section examines the relationship between laboratory practices and the public. How can a nonexpert public gain access to scientific laboratories and develop a nuanced familiarity with the type of knowledge production occurring in these environments? What happens when artists start venturing into the scientific realm and merge scientific inquiry with a studio art practice? What is the political and economic context of life science research today, and how does this context influence any artistic production that attempts to bridge the two fields? Approaches to these questions are provided by three artist-theorists and one biologist.

Artist Claire Pentecost opens this section with an analysis of the cultural, political, and economic conditions under which "bioart" is being produced today. She uses the works of four well-known practitioners in the field who employ very different strategies in negotiating their existence as hybrid creations developed in response to a political ecology under the influence of a neoliberal ideology. Pentecost exhorts us to pay attention to the ways in which the arts/science nexus works within new modes of neoliberal capitalism, and the possible positionings of the (bio-)artist within that framework. The "bioart" she is most interested in refuses the role of propaganda for the biotech industry, taking up, instead, everyday problems that attempt to contest the oppressive and exploitative practices that shape "the world where most people live."

Tissue Culture & Art Project founders Ionat Zurr and Oron Catts provide compelling case studies of the incorrect use of scientific terminology found in curatorial statements and other bioart-related writings, which often confound developments in tissue engineering with molecular biology and other genetic-based subfields of the life sciences. Careless use of scientific language, they warn, only furthers the public misunderstandings of science, and all too often plays right into the rhetoric promoted by the biotech industries and other funding beneficiaries which have lots to gain by equating the field of biology

with the (sub-)field of genetics. Zurr and Catts make a strong call for eschewing "geno-hype," outlining the dangers of equating biology with genetics. Instead, they argue for the "ethical, cultural and political importance of experiential engagement with life manipulation as it can be an effective methodology to confront the complexities and contest dominant ideologies regarding the life sciences."

Also by Oron Catts, in collaboration with the biologist Gary Cass, is the closing article of this section. Catts, Cass, and Zurr are members of SymbioticA, the art and science collaborative research laboratory at the University of Western Australia. SymbioticA has developed a series of hands-on biotech workshops for artists. The workshops consist of introductory labwork in molecular biology as well as plant and animal tissue culture. One of the most important aspects of the workshops is the construction of custom-made laboratory equipment. This included, for one workshop, the assembly of a laminar flow cabinet made from parts available at any home improvement or similar store. The cost for a piece of equipment that would usually be thousands of dollars was suddenly reduced to about a hundred dollars. In addition, Cass and Catts show the participants numerous bioartworks, and hold discussions evaluating this art as well as addressing the ethics of contemporary life science research.

Outfitting the Laboratory of the Symbolic

Toward a Critical Inventory of Bioart

Claire Pentecost

In the year 2000 the artist Eduardo Kac made network television news with an announce-ment that he had commissioned the "creation" of a transgenic bunny named Alba. The PR campaign included a picture of Kac holding a white rabbit and another, iconic image of a rabbit photographically enhanced to appear green. The green fluorescent protein expressed by the DNA extracted from the jellyfish *Aequorea Victoria* and spliced into the zygote of one of Alba's forebears shows only when illuminated by a special spectrum of light. Kac claimed as his work, known as *GFP Bunny* (GFP for green fluorescent protein), all the discussion that would arise from this act of guaranteed controversy, as well as the social integration of the rabbit via his family (composed of himself, his wife, and his daughter).

The controversy and dialogue are selectively documented in a number of ensuing works, all widely publicized. The proposed social integration was transmuted into a cam-paign to "free Alba," as France's Institut National de la Recherche Agronomique, where the rabbit was produced, refused to let it leave the premises, amid some dispute as to the nature of the agreement.[1] The details of this bit of controversy do not seem to have been claimed by the artist in his book on the subject, in his photographs of Alba-laden news-papers being read in glamorous settings, or in his interactive screen piece in which audi-ences can collide Alba headlines to make recombinant biotech buzz texts.[2]

Alba was not the first transgenic rabbit, nor the first with a code for green fluorescent protein added to its genome. Transgenic animals and plants incorporating GFP DNA have a long service record in biotech laboratories, as this fluorescent feature quickly estab-lishes whether or not the target organism has indeed taken up the genetic modification. Rabbits, homogenic or transgenic, are a staple of laboratories, along with mice, frogs, fish, flies, worms, bacteria, yeast, viruses, other microorganisms, and plants. The most favored ones are called "model species" for their usefulness in research. Such utility is measured

by questions of interest to the humans doing the research, and range from similarity to humans in effects of cholesterol and the progress of cancers to the brevity of generations when producing mutations or engaging in selective breeding.

In a project called *Workhorse Zoo*, Adam Zaretsky and Julia Reodica installed a portable clean room in the Salina Art Center in Salina, Kansas, and stocked it with a selection of "the industrial workhorses of molecular biology."[3] The large glass windows of the eight-foot-square unit gratify the ritual of looking for which art spectators are trained, but the fishbowl their gaze invades here showcases the creatures most subjected to the professional gaze of science. The artists state: "These are the organisms whose genomes have been sequenced and partially annotated. These are the evolutionary templates with whom we search for homologies to assess our own inherited pains. Much of the public has little or no idea how much the deadly study of these select strains affects their health and potential physical future."[4]

For the first week of the exhibit, Zaretsky and Reodica, having included *H. sapiens* in the workhorse menagerie, lived in the HEPA-filtered enclosure equipped with a refrigerator and Porta John. The other cohabitating species were not caged, but each had some version of a hospitable habitat replica (tanks for the fish, burrowing materials for the mice and worms, etc.). Each day the artists impersonated figures familiar to the popular imagination (e.g., biotech scientist, bioterrorist, anthropologist, medical doctor, patient, mother, and/or infant), and entertained college students, children, lawyers' luncheon groups, church groups, and local farmers.

After completing a master's degree in fine arts, Zaretsky had spent a year as a bench scientist in the Arnold Demain Laboratory of Microbiology and Industrial Fermentation at MIT, where he conducted his own experiments on the effect of music on the growth of engineered *E. coli* used in the development of pharmaceuticals. This unconventional but not trivial practicum furnished him an insider's experience of the technology, methods, and culture of research biology, but he has not assembled these to assume the authority of a scientist, or to pursue the kinds of research a qualified scientist might. A few moments at the emutagen.com Web site make clear that he is much more interested in lining up these tools to skew them with patent irrationality, exhibitionism, aesthetic experimentation, humor, emotional attachment, the flat-footed layperson's question, and a well-pondered transparency bordering on the confessional. These are hardly the attributes invested in scientific confidence, but one may assume that the work in question has a different mission.

The artist Brandon Ballengée has maintained considerably more sobriety in his appropriation of scientific methods. For over a decade, he has conducted serious field research in wetlands and other ecosystems, to make contributions to scientific institutions, ecological reclamation efforts, and environmental education through innovative visual forms of documenting and communicating his findings. Some areas of special interest include toxic algae blooms, amphibian population decline and deformities, and the legacies of atomic

and chemical pollution. Using selective breeding in controlled genetic colonies of a dwarf African clawed frog of the Hymenochirus family, he has been working for almost the entirety of his professional career to reestablish one species currently believed to be disappearing (if it has not already disappeared). All of Ballengée's work proceeds through a network of collaboration with scientists and institutions. Although he exhibits his work for the art-seeking public in the relevant institutions, he also integrates contact with other populations into phases of the research and production of his projects. To this end he designs and teaches workshops in ecology, field biology, evolution, genetics, and digital imaging for schools and the general public at urban and rural parks, museums, zoos, pet stores, and fish markets, and holds artist residencies in various locations.[5]

Natalie Jeremijenko has literally brought biotechnology to the streets in a long-term project called *One Trees*. From one genetic source she cloned 1000 trees and had over 200 of them planted along sidewalks and in parks throughout San Francisco, a city notorious for microclimates owing to dramatic changes in elevation and the weather patterns conjured by the proximate ocean, bays, and not-too-distant Sierras. As in most cities, the distribution of its hazardous environmental conditions correlates pretty well with its geography of wealth and poverty. The rhetoric of cloning perpetuates images of multiple cookie-cutter organisms, but as these trees grow to maturity, urban travelers can witness for themselves the same variety we expect from genetically nonidentical trees. The role of the environment in producing phenotypic variety is adumbrated, not only to complicate simplistic formulas of genetic determination, but also to register immediately local conditions.[6]

In another project, *Feral Robotic Dogs*, Jeremejinko has worked with groups of students to upgrade and repurpose commercially available robotic pet dogs. Drawing on electronic and engineering basics, she works with university design students or untrained teenagers to equip the dogs with all-terrain locomotion, wireless communication systems, and sensors for detecting toxins. The hacked toys are then released as "packs" in mediagenic events at sites where the public has reason to be concerned about persistent toxic histories. It turns out that a disturbing number of new schools and parks are built on toxic waste sites. A workshop of teens in the Bronx, New York, made their own pack and set them loose at the local park to call attention to what a fifty-page technically worded report couldn't advertise adequately.

Since then, these teens have been invited as consultants to every public meeting on what to do about the park. Their relationship to toys and electronics is changed, offering new exits from passive consumption. Their relations to power and their role in their own environment is reengineered to create expectations of participation and the wedge of autonomy.[7]

For many people in the general public, owing to its successfully tendered media campaign, *GFP Bunny* may have been their first exposure to the concept of bioart, much less transgenic bioart, but the subgenre had been extant for some time in various more and

less technologically mediaphilic forms well before Y2k. The reorganization of value that has accompanied the social and psychic disruptions of the twentieth century has accustomed the public to the continuous migration of art onto unexpected terrain. It is not surprising that the first exodus of artists from the landscape-bearing canvas and into the natural environment itself occurred just as the planet's inhabitants were becoming aware of Earth as Spaceship Earth, a mother ship needing parental stewardship.

The wave began to swell in the 1960s when artists such as Robert Smithson and Michael Heizer applied the tenets of conceptual and minimalist art to the field, but its crest was filled out by the first-generation environmental movement, feminism, and the utopian perspectives of the 1970s. Now the contemporary art corresponding to the earthworks of a previous generation integrates new technologies, cognizant that technology, as much as anything, sets the terms of the human relationship to the natural. Nothing makes this clearer than the biotechnologies elaborating the meteoric rise of the life sciences in the years since the first Earth Day in 1970.

The question of this chapter is, given the volatized identity of art, how do we evaluate bioart? The category itself has various definitions, each implying a criterion, e.g., bioart uses the imagery of contemporary medicine and biological research; or true bioart should actually use, and not merely represent, biological material. It may follow the imperative that it perform activities loosely recognized as scientific; this requisite may be met by using scientific equipment and/or procedures, and/or making a hypothesis and testing it (no matter how inconsequential the motive question), or the project may be designed to further an inquiry usually considered the province of the life sciences. Or it may aspire to address a controversy or blind spot posed by the very character of the life sciences themselves. What are the problems that come with that turf?

What Is the Context for the "Bio" That Informs Bioart?

The explosion of well-funded specializations in biology, notably under the rubrics of genetics, bioinformatics, and biotechnology, is very much a function of the ways biology has been adapted to the mechanics of the hegemonic doxa of our time, neoliberalism. As a political economic theory, neoliberalism maintains that individuals and society flourish best when government confines its function to the guarantee and protection of private property, free markets, and free trade. This ideology has achieved extraordinary influence through its association with moral notions of individual freedom and human dignity, especially vis-à-vis their perceived enemies: the totalitarian regimes of communism and, since the end of the Cold War, Islamic fundamentalism. Promoted this way, the universal human desire for such a system is taken to be self-evident. The necessity of enforcing free markets and free trade through U.S.- and European-controlled supranational bodies such as the World Trade Organization and the International Monetary Fund, and even by means of preemptive war, is noted as a contradiction by protesters characterized as anti-

globalists. From Seattle to Genoa, suppression of protests against the global enforcement of neoliberal rules is only one recent phenomenon that has made the interdependence of market fundamentalists and state power obvious.[8]

Via this ideology, anything humans value becomes legally articulated as something to be owned by one party literally at the expense of another: not only real estate, material products, and technological inventions, but also the basics of life, health and safety: knowledge, creativity, nutrition, sanitation, medicine, water. Consequently (and certainly not only in the sciences), we have seen a transformation of the living world into limitless possibilities to stake legal property and an inalienable right to profit. Add to this a jurisprudence that grants corporations the rights and protections of individuals and a de facto privilege for that status when held by a corporation as opposed to actual individual persons. Situate this in a system of public research and educational institutions that, again in accordance with neoliberal principles, has been gradually defunded and so relies increasingly on corporate partnerships and the generation of patentable, marketable knowledge products.[9] Then drive this entire system around the globe via brutal trade agreements in which intellectual property regimes are enforced by the world's military and economic superpower.[10] This is the context of the life sciences today.

Under neoliberalism, the governance of the vitality and fertility of whole populations is arrogated by market forces. Looking primarily at the social welfare directives of France in the 1970s, Foucault conceptualized "biopower,"[11] managed by the state in a concert of rational, statistical, and behavioral studies, models, and incentives. It works through public health, health and life insurance, pension funds, retirement planning, vaccination programs, and similar phenomena. However, in the United States, and now more than ever, pension funds and retirement plans, proper diet and sanitation, vaccination and antibiotics, managed fertility and extended longevity are transferred to the domain of the private under the primacy of the right to property and individualized prospects. The rhetoric of the personal—personal responsibility, personal choice, and personal opportunity—delineates a model self-reliant citizen who does not expect these functions from the state, or any democratically constituted macro subject.

Foucault poses the norm as the element that circulates between the disciplinary and the regulatory, applicable to both the individual body and the multiple factor of the population at large.[12] In the discourses of both neoliberalism and biotechnology, the availability of the norm, whether in matters of health, beauty, or performance, is sold through the device of the success story. We hear, above the hum of generalized inconsistency, carefully edited narratives such as the rebirth of New York City through tough neoliberal policy after the manufactured fiscal crisis of the 1970s; a study in which a breakthrough genetic therapy appears to retard the progress of an incurable disease; or the always-in-the-pipeline food crop that will end hunger in the global South. The promotional apparatus of both biotech research and the market economy promises access to an idealized norm of a continually improved human existence. Obtained at the level of the individual

body, it is sold at the level of the mass media, and decisions for the entire population are made on the premise of its widespread availability. However, if it comes through at all, it will be available only to those with the means to purchase it on the market. And a public discourse including any serious reference to a common good quickly gives way to one reminiscent of social Darwinism.

This is the context in which I set out, a little while ago, to formulate a criterion for bioart. I wanted to establish some measures of evaluation that were not about trying to make a case for bioart as art in the conventional, vexed, socially exhausted definition of art. The bioart that I am interested in does not want to become propaganda ware for the biotech industry. I make the assumption that it wants to address a kind of problem in the world where most people live.

I conceived the problem this way: science in the service of neoliberalism alienates the nonspecialist whose life is profoundly affected by its commercial application. I am not making a case against specialized knowledge per se, which will continue to prove authoritatively recondite to the nonspecialist in many contexts. It is the refiguration of science, still vested with traditional claims to truth and service to the public good, while shaped to narrow market agendas, that requires a new enfranchisement by a broader scope of society. Current mechanisms of alienation function to extend the status quo and thwart public contestation. These operations can be sorted into three principal categories: (1) abstraction and mystification; (2) the ambiguous nature of funding (i.e., whether public or private), which effectively obscures the interests involved; and (3) legal instruments designed to protect knowledge as trade secrets or private intellectual property. These include patents and material transfer agreements (MTAs), which govern the use of biological research materials as intellectual property. In my schema, I presumed that the artist is a person who creates various forms of interruption of these barriers on behalf of herself and other members of an alienated public. Figure 7.1 is an example of one of the diagrams I created in this process.

As the diagram shows, I organized possible methods used by the artist into categories loosely corresponding to the categories of alienations: staging of scientific procedures in participatory theaters can provide experiences of the materiality of science; participation across specialized knowledge fields enfranchises nonspecialists to author new narratives with a perspective on the real stakes involved; playing the amateur, the artist takes pains to find collaborators within scientific fields and/or consents to become a "thief" of privatized knowledge in order to politicize or at least problematize this sequestering (see the case of Steve Kurtz for an example of an artist who built a relation of trust with a collaborating scientist, only to be indicted by the federal government as a thief).[13]

I presented my schematic a couple of times and then put it away to do a variety of other things. When I returned to it a few months later, I found it haunted by questions issuing from the part I had left unexamined. If I were going to base this criterion on a contextualization of the life sciences, perhaps I should do the same for the category of art.

SCIENCE UNDER NEOLIBERALISM
barriers or
mechanisms of alienation
serving to maintain or extend the status quo

abstraction fetishism mystification	funding: corporate/ private sector sponsorship is behind the scenes. public dimension increasingly ambiguous	intellectual property: MTA's patents trade secrets

ARTIST
strategies of interruption
forms of contact/experience

materiality of science: staging of scientific procedures in public places	initiation v. division of labor or division of knowledge: sense of the stakes	amateur challenge: artist/citizen becomes either welcome collaborator or thief

AUDIENCE (PUBLIC SPHERE):
visitors to museums and other venues, students,
consumers, scientists, artists

Figure 7.1 Schematic criteria for bioart considering the conditions of science under neoliberalism.

What Frames the "Art" in Bioart?

The canonical art of the late modern period in Western democracies had a peculiar mandate: to be democratic and yet difficult; to be a nondiscursive form of communication in a highly diverse society; to be universally recognized as authentic but to offer semantic legibility only to the initiated.[14] Such authenticity is founded on persistent mutations of Kantian disinterestedness. As much as art and science are played as opposite kinds of human endeavor, they are both burdened with disinterestedness, especially in the affairs of the world. In science it is the idea of institutionalized objectivity. In art it serves the institutionalization of the art act or product, which has no integrated role in daily life. The scientist suppresses personal opinion to voice the truths of nature. The artist delivers her truths through a hypertrophied individualism presumed to be nonconformist.

By now we have many credible accounts for the confounded mandate of art: under a regime of rational instrumentalization, artists asserted the value of the irrational, the

useless, and the perverse; artists needed to distinguish themselves from the predatory message machines of marketing and mass media, which were all about being accessible; artists have been caught up in the avant-garde game of offending the conventional values of the bourgeoisie, who prove their own nonconformity by validating the artists, who are in turn supported by the ensuing patronage of their works.

Whatever account we prefer, I want to note the extent to which the harmony between art and the institutions of art's validation has been challenged from within art practice by the artists themselves. In wave after wave, the aim or the temporary effect of these challenges has been to make art more relevant to a broader or more diverse population. One recurring feature of these efforts is a radical reorientation of the mechanisms, routes, and inclusions of distribution. When I speak of distribution, I am referring to the varieties of institutional interfaces that constitute audiences for artists and/or their product: museums, galleries, art press in the form of professional reviewers and specialized publications, as well as the collectors whose subjectivities and imaginations are captivated by these distribution systems and whose dollars essentially sustain them.

Most of the major discursive and practical interventions in standardized fine art practice that have been historicized as movements have implied or explicitly pursued new or altered strategies of distribution, as the innovations of artists throw curves into this reception device. One may think, for example, of the Impressionists and the Salon des Refusés, Dada and surrealist artists exhibiting in cafés and dance halls, circulating posters and experimental publications; Fluxus artists, the magazine inserts of conceptual artists, performance art, mail art, cable-access and activist video, community-based art, net.art, and so on. However, what is retained at the level of the canon, what is retained at the level of permissible, transmissible DNA, is purged of the disturbance to authorized forms of creativity and unidirectional, centralized distribution.

The problem is not just that change in these arrangements destabilizes the investment of billions of dollars, but that change in these arrangements requires validation of other forms of art, artists, and creative practice. This in turn destabilizes the charge of the existing distribution system to produce a firm distinction between the professional artist and the amateur. In a society built on democratic ideals, this takes a lot of energy to sustain, and may be one of the reasons why the fine arts are marginalized even as "creative industries" charge ahead.

To put it another way, since the invention of photography and the development of cheap handheld cameras with cheap available films; the intermittent flowering of Super8 film; the invention of video and the proliferation of consumer video equipment, digital technology, home computers, desktop printing, and Internet methods of exposure; and since the availability of formal education (for those with money or credit) and the incessant visual education of the public by ubiquitous media presence, the value-added forms claiming inheritance of the historic lineage of the fine arts need more and more rhetorically intricate support to maintain their rarified qualification.

Claire Pentecost

Most gallery artists perform to the expectation of their distinction by filtering the semantically obdurate or highly personal gesture through references to the everyday in materials and content. The larger perspective on these dynamics is further complicated when we take into account another development of the concept of biopower which relates it to the well-promoted phenomena of the knowledge economy, also referred to as the information economy, the experience economy, and/or the creative class.[15] Under this economic paradigm, the individual invests in herself, in her cultural and creative capital—with the immaterial assets of education, cultural adaptability, teamworking, affective and communication skills, signifiers of interpersonal mastery—all toward the goal of optimum performance in the high-end marketplace. Here the same novel forms of self-expression that qualify artists, when integrated with a socially skilled, business-minded interface, command high remuneration.

Not long ago, ambitious artists had little to gain from higher education. Now, more than ever, art school is considered obligatory for learning the system, making contacts, and establishing a pedigree. While it is unclear to what extent terminal degree art programs are about developing any particular standards, they are clearly expected to consolidate the human cultural capital specific to art world success. If we assume that both are part of the project, how might they relate to each other?

Take this example: a graduate student in a prestigious art school makes work based on popular television shows. She is also very engaged with the fan world, an extensive realm of people who watch the shows, tape the shows, and make their own Web sites, images, video, music, and texts based on their favorite shows, characters, and stars. These include remakes, remixes, rewrites, and collages, some playing with transgression, many highly subjective, some acknowledging the role of the fan, others not. Overall, the spectrum can absorb the work of the graduate student. At a critique with a group of faculty at the art school, the student is asked what makes her work different from the work of any other fan. Specifically, she is asked, "Where's the criticality?"

Would that be criticality of the relevant television show? Of the other fans? Of their products? Of the production value of their products? Of the fact that millions of Americans sit in their homes watching TV shows and using their creative energy and consumer equipment to add to television reality while other realities are ignored? Even if they are all real artists, all brilliantly "critical" of the television show itself, according to what values do we evaluate the experiences or second-order perspectives they provide? The trouble with criticality, even to the limited extent that artists embrace it, is that it is rarely grounded by a well-defined ethical referent.

I select this example to indicate the currently deracinated status of criticality. Presumed to be one of the possibilities for marking the ontological distinction between art and popular culture, criticality has become a legitimating effect lingering from the highly intellectualized art practices of the 1980s and early 1990s, informed by feminist, postcolonial, Marxist, neo-Freudian, and queer critical theory. These intellectual platforms were

explicitly related to more politicized art, and briefly offered something like an ethical structure for meaning in elite cultural production. The undermining of those politicized art practices came about only remotely through the "culture wars" in which elected officials capitalized on moral outrage over indecency in order to eviscerate public funding for the arts (a change in public spending policy consistent with neoliberal principles). Arguably more fatal opposition came from within the art world itself, from critics such as Peter Scheldahl and Dave Hickey, in favor of a "return to beauty," coinciding with the 1990s stock market bubble and a boom for investing in beautiful art.

The lasting effects of that moment of political receptivity, like many previous efforts to rearrange the terms of representation and access to resources, will be most felt wherever they have been absorbed in cultural practice beyond the high-profile, high-investment art world. The system that sustains the fine arts as an exclusive professional realm continues to reward those artists who trade on insider knowledge and can best pull off the mystification of their own relation to specialized creativity, without threatening actual social relations.

In some obvious ways, artists face many of the same challenges scientists do in relation to an alienated public. Blockbuster museum shows apart, contemporary "fine art" is a small, misunderstood subculture. Unless its practitioners are willing to radically change the nature of art itself and the apparatus of its distribution, it is hardly a good candidate to significantly redefine the public's relation to science. Moreover, professional artists interested in the life sciences and subject to career pressure for visibility and the command of resources, tend to select projects according to the same biases driving professional scientists, who must command resources to do any science at all. Understandably, artists want to address the controversial issues raised by the commercialized life sciences. Unfortunately, this can reinforce Big Science's deformation of all meaningful biological inquiry into profit-yielding questions (e.g., genetics) while the urgent project of understanding the stunningly complex field of ecology is being starved. This is often the downside of current ideas of criticality: it becomes another capture device for creative energy that could be redefining value itself at a more vital intersection.

By this time my schema required a double to address its compound object (see figure 7.2).

Criteria in the Ecology of Reception

If the reader were to scan again my account of the examples opening this text, I'm sure my biases would be even more apparent than on the first take. Still, it is only just that I should revisit those works now, with my criteria in play. What I have proposed is not a point system or checklist, but rather a set of guidelines intended to expose the unique causes and outcomes of artistic efforts, which by their very nature steer us into the territory of the unquantifiable. When we closely examine the supposed members of a category,

ART UNDER NEOLIBERALISM

barriers or
mechanisms of alienation
serving to maintain or extend the status quo

opacity, fetishism, mystification, denial of function or purpose	funding: government, corporate, private sector sponsorship reserved for certified professionals	intellectual property maintained through elite institutions and financial speculation

ARTIST

strategies of interruption / forms of contact/experience

communicability of art: collaboration connection to groups operating in the political	inclusive projects v. division of labor and knowledge: stakes are democracy	amateur challenge: non professional is either welcomed collaborator or thief

AUDIENCE (PUBLIC SPHERE):
culturally unenfranchised, students, consumers, scientists, including specific groups

Figure 7.2 Schematic criteria for bioart considering the conditions of art under neoliberalism.

we often find that no one specimen attains all of the attributes of the category. Similarly, I imagine that neither a provisional nor even a more evolved schema will be adequate to the range of situations we are invited to consider.

Among other things, *GFP Bunny* is about publicly forming a respectful self-to-other relationship with a transgenic animal (in a footnote on his Web site, the artist refers to the work of Martin Buber, most famous for his concept of I-Thou relations). In his quest to have us accept chimerical monsters by bringing a transgenic animal into his family, Kac provides on his Web site a long essay on the history of human tampering with animals through selective breeding. Unfortunately, he does not explain the controversies that may have prompted the scientists at the Institut National to withdraw their participation from the project, nor any of the economic and environmental downsides of genetic engineering, or even how many failures—dead animals—would have gone into the production of one Alba.

Along with playing the piece for sensationalism, the press seemed happy to correlate the bold image of the artist as creator—whose materials now include life itself—with

forward-looking industry. One may conjecture that it is just this connection, and the possible impression of irresponsibility engendered therein, that the scientists at the Institut National wanted to avoid in the wake of the mad cow and the foot-and-mouth disease scandals that had recently shaken public confidence in the United Kingdom and Europe. The precise nature of the collaboration is obscure; the "ownership" of Alba is not transparent; the discrepancy between the accounts given by the Institut National and the artist are not addressed. For all its availability to a general public, the project does little to demystify either the artist or the complex, embedded status of biotechnology in oligarchic corporate structures.

The Web site archives comments from the general public on the destiny of Alba. The opinions collected there are overwhelmingly in favor of the artist getting to keep his rabbit, of the rightness of Alba going home to where she belongs. This archive testifies to the failure of the piece to communicate the complexity of the issues, displacing the controversy to a battle between the individual (artist) and the authority (insensate institution). Having generated this well of sympathy, the artist's handling of the controversy appears at best a missed opportunity to engage the public in a higher level of debate on questions of proprietary technology, safety, the public sphere, and how to apply these innovations. However, the notoriety of *GFP Bunny* does offer a useful starting place for discussion between more and less informed people. Even the amount of text devoted to it in this chapter testifies to its seduction as an object of pedagogy!

A striking number of the archive entries repeat the sentiment best distilled as "How can I get one?" This suggests another outcome: adding one more niche of desire, now for transgenic pets, which a public may decide it is their right to demand. Where most successful (in the desire of parents for genetically advantaged children, in the desire of farmers for products they have been led to believe will arm them against brutal economic odds), the acceptance of experimental genetic technologies is achieved through creating consumer demand for something which defers scientific, social, and ethical controversy. In itself, *GFP Bunny* is a well-executed fetish object sustaining the mystification of creativity and the opacity of partnerships, ownership, knowledge partitions, and stakes in the life sciences.

While the staged laboratory of *Workhorse Zoo* is patently fictionalized and does not attempt to replicate the microbiology lab in a naturalistic fashion, it is based on an informed index of the materiality of scientific practice. The conflation of the arcane and rational laboratory with the spectral spaces of the gallery and the zoo (emphasizing the metaphoric use of "zoo" as a sort of madhouse) is unexpectedly transgressive. And yet these species and their routine serviceability are indeed the foundations of scientific practice. The artists' relation to authority figures is one of burlesque, although they have commanded at least enough resources—intellectual and material, specifically with the support of the Daniel Langlois Foundation[16]—to pull this off. They fully inhabit the figure of the zany artist even while they present a wealth of information about their subject.

Introducing more information than it is likely to explain, the piece may engage a public but not satisfy previously held convictions, as abbreviated news forms are likely to do.

While not on the scale of a national news share, the audience appears to have been fairly diverse. As often happens, the exchange of broadcast coverage for hands-on immediacy may press the viewers who actually do confront this peculiar menagerie farther toward contemplating the peculiar basis of our scientific truths than would be possible through consumption of a syndicated digest. The fact that Zaretsky has spent time as a bench scientist at a prestigious institution somewhat elides the need for collaboration with a credentialed scientist. But more precisely, construction of the work requires no specialized access—anyone could put it together—so the question of proprietary tools is moot. The utter transparency of the source of everything in the piece, from the animals to the foods, puts the question of ownership onto the ground of routine: Does acquiring living organisms through conventionalized routes allow anyone to do anything with them?[17]

The audience is induced to question just what relation the artists' antics bear to an actual lab, but the very encounter with this vaudevillian theater of scientific and other personas is likely to lodge questions about scientific procedure persistently in the minds of viewers. I venture that doubts engendered in a setting constructed by credible, specific elements and experienced in a direct, theatrical way are a possible strategy of making the pieces of abridged information that come to the nonscience public on a daily basis more meaningful. Warranting new points of entry, these experiences could begin to turn such sound bites into the basis for further questions, to explore what goes on in research labs, why it does, and for whom it does.

Creating points of access, not so much to laboratory as to field methods, is the foundation of most of Brandon Ballengée's projects. Equipped with a formal education in the arts and not in science, he models the tradition of the amateur naturalist who has much to contribute to the field. Nowhere does this continue to be more germane than in the still young, complex, and underserved discipline of ecology,[18] which requires hours of observation and data collection in the field. Shortly after its rise in the 1970s with the awareness of the effects of man-made environmental pollutants, it began to lose ground in university biology departments as the boom in biotechnology and changes in patenting and technology transfer laws made genetics the hub of revenue streams in research.[19] While Ballengée's assiduous fieldwork in amphibian populations and algae blooms is unlikely to attract the media attention of an Alba, it does excellent pedagogical service in the range of workshops and participatory processes he has pioneered in various institutional settings.

If he does achieve the recovery of an extinct species by "reverse breeding," Ballengée will be sure to have his day in the general press. The media scene one pictures in such an event is much closer to that surrounding a hopeful shred of news from the environmental front, rather than a gesture replicating "the unique phenomena of a distance" that Walter Benjamin once attributed to the cult object,[20] in this case the cult being art, science, or

both. It is significant that Ballengée's work has developed through working partnerships with scientists and scientific institutions, and that the field he entered without the conventional credentials obviously takes him seriously.[21] It is also significant that he is not a professional scientist and has contributed something different from what that vocation is structured to include, namely, the visual, symbolic, and communication skills of an artist. Consistent with another tradition of artists, one that may not be favored in "the marketplace of ideas," Ballengée creates and adjudicates socially determined notions of value. The model he offers us is one of self-motivated acquisition of knowledge, committed to values that market-driven science has increasingly abandoned.

Although her proficiencies cover a different terrain, Natalie Jeremijenko's work shares with Ballengée's a dedication to pedagogy and the reorientation of values in the life sciences. Formally educated in both neuroscience and engineering, she has amassed a great deal of expertise—not toward establishing herself as an expert in those fields, but in order to do projects that experts would not do for the realistic fear of jeopardizing their authority. What she retains throughout her endeavors is a feel for the nonexpert: the artistic deftness of *One Trees* and *Feral Robotic Dogs* is to make scientific "data" legible to nonscientists. Legibility is understood as a complex phenomenon including attraction, relevance to common experience, engagement of the senses, and adroit interface with popular media.

Projects like these and many others of Jeremijenko's depend on the cooperation of teams of people, not only students but also public employees and all manner of interested participants. The collective effort may serve to expand the scope, bring the design through levels of testing and refinement, extend the time frame, distribute investment, or all of the above. She consents to continue learning and experimenting in a shared arena, preventing mystification of her process.

Neutrality in Perspective

"I don't want it to be too political," I often hear my students say about a project they are working on. "I'm not a political artist." "I don't want to be too didactic." "I don't want to hit people over the head." "I don't like things to be obvious."

Perhaps I should begin to catalog all the forms of disavowal of the political I hear from practitioners in every field. I'm beginning to think what I really need to understand is how resistance to something called the political has been so well accomplished in a democratic society. Because democracy, the concept and structure which ostensibly does legitimate our government's power over our lives (and deaths), is not a democracy if the people in it are allergic to all forms of political life.

What interests me is the fact that every discipline has a good reason not to be overtly political. In the sciences, including the social sciences, to be perceived as having a politics is to suggest that you cannot easily step from yourself to the objective position of the

scientist and back again, a move which is apparently the basis for the field's credibility. In almost any profession with an expectation of responsible decision-making, to have a politics is to jettison good judgment, to lose perspective. In the arts—where expectations for the most part have not included responsible decision-making—being passionate, personal, and opinionated are assets, but being political is considered the end of creativity. It is having an opinion that might be collective, that might not be individual, that might not be private, and that might not be free. Because, like all values in our particular liberal democracy, freedom is understood as private, and one of the jobs of the artist is to perform freedom—but altogether too much in the terms by which our society is most conditioned to recognize it.

As artists we can start formulating the unrecognizable, first by refusing to perform a freedom increasingly defined by conditions that legitimate primacy of the private: private expression, private feelings, private experiments, private intellectual property, private losses, private giving, private destinies. Especially as it becomes undeniable that such a "private" guarantee of freedom is rank privilege accorded to fewer and fewer people, those who already enjoy the lion's share of security and aesthetic enhancement. In the overweening neoliberal psychology of public life, the rhetoric of privatization has falsely pitted the liberty and the functional diversity of individuals against all forms of collective endeavor. If the artist aims to make an impact on the use of science and related biotechnologies to concentrate resources in the hands of a very few, she must creatively refigure both scientific and artistic practice.

Notes

1. Christopher Dickey, "I Love My Glow Bunny," *Wired*, 9.04 (April 2001).

2. See http://www.ekac.org/gfpbunny.html (accessed September 30, 2006).

3. http://www.emutagen.com/wrkhzoo.html (accessed September 30, 2006).

4. Ibid.

5. http://www.greenmuseum.org/content/artist_index/artist_id-19.html (accessed October 31, 2006).

6. http://www.onetrees.org/ (accessed September 6, 2006).

7. http://xdesign.ucsd.edu/feralrobots/ (accessed September 6, 2006).

8. David Harvey, *A Brief History of Neoliberalism* (New York: Oxford University Press, 2005).

9. As some readers have pointed out to me, publicly funded science brings its own problems (e.g., when civilian access to classified research pursued under military auspices is denied or deferred). Any combination of funding sources for scientific research raises essential questions regarding the purposes of science and the beneficiaries of what are considered its contributions (or threats) to human and other life. When science is funded by a public tax base in a democracy, those questions are hypothetically up for debate and oversight; the more that labs and personnel once

considered publicly oriented become dependent on corporate funding, the more those questions are directed by corporate entities unaccountable to a public. For an excellent overview of the influence of corporations on universities, see Jennifer Washburn, *University Inc.: The Corporate Corruption of Higher Education* (New York: Basic Books, 2005).

10. For a continually updated source on the details of bilateral trade agreements being negotiated far from the public spotlight, see www.bilaterals.org. Under "Key Issues, Intellectual Property," is the following:

Through FTAs [free trade agreements], BITs [bilateral investment agreements] and other forms of direct agreements between countries, the US and Europe are insisting that the partner country adopt their standards of IPR protection and enforcement. For many countries, and many peoples, these propositions are nothing short of revolutionary. Because it means they have to
- extend protection for branded drugs and limit parallel imports, hampering the availability of affordable generic medicines
- start patenting plants and animals, which means farmers cannot save seed or reproduce fish breeds or livestock
- get rid of screen quotas that give preference to the showing of local films
- start patenting computer software, to the detriment of local programmers and the creative open source movements now mushrooming up across the world as a cheaper alternative to Microsoft
- extend copyright protection, which already causes serious problems for students, libraries and educational institutions
- clamp down on piracy of popular consumer goods like digital products, clothing and music
- make IPR infringements criminal offences, even though IPR is part of civil law.

11. Michel Foucault, lecture, (March 17, 1976), in Mauro Bertani and Alessandro Fontana, eds., *"Society Must Be Defended": Lectures at the Collège de France 1975–76*, trans. David Macey (New York: Picador, 2003).

12. Ibid.

13. For more information on this case, see http://www.caedefensefund.org/ (accessed November 20, 2006).

14. For an especially clear articulation of this paradox, see Grant H. Kester, "The Eyes of the Vulgar," in Kester, ed., *Conversation Pieces: Community and Communication in Modern Art* (Berkeley: University of California Press, 2004).

15. The concept of a knowledge-based economy was developed by Peter Drucker, who coined the term "knowledge worker" in 1959, in the context of the need for new thinking in industrial management and organization. Drucker elaborated his ideas in numerous books and articles. See Peter Drucker, *The Age of Discontinuity: Guidelines to Our Changing Society* (New York: Harper & Row, 1969). The "experience economy" is just one example of theories placing the value in the evolution of the locus of "value added" (in goods and services) in the consumer demand for an experience or memory created by a concert of aesthetically produced directives. See B. J. Pine and James Gilmore, *The Experience Economy* (Boston: Harvard Business School Press, 1999). See also Virginia Postrel, *The Substance of Style: How the Rise of Aesthetic Value Is Remaking Commerce, Culture, and Consciousness* (New York: Harper Perennial, 2004). The idea of the creative class has been most associated with

the sociologist Richard Florida, who is credited with coining the term. His identification of an economically powerful, emergent class includes scientists, academics, architects, designers, writers, artists, software engineers, health care professionals, and many others whose jobs are knowledge-intensive, draw on creative, transferable skills, and are performed best under flexible, nonhierarchical management structures. See Richard Florida, *The Rise of the Creative Class: And How It's Transforming Work, Leisure, Community and Everyday Life* (New York: Basic Books, 2002).

16. The project received funding from the Daniel Langlois Foundation for Art, Science, and Technology. "The Foundation seeks to nurture a critical awareness of technology's implications for human beings and their natural and cultural environments, and to promote the exploration of aesthetics suited to evolving human environments." http://www.fondation-langlois.org/html/e/page.php?NumPage=96 (accessed October 31, 2006).

17. *Workhorse Zoo* is similar to *GFP Bunny* in the generous provision of background text on the Web site documenting the piece. Here Zaretsky and Reodica emphasize bioethics and animal rights, and each section of their text is followed by a long list of philosophical and other questions to the viewer, each ending with "Why is this your belief?" Unfortunately, no answers to the questionnaires are posted. Correspondence with Zaretsky revealed that none were archived, but also that these questionnaires continue to be used by educators employing documentation of the work in the classroom.

18. Although many forms of ecological thinking can be found throughout history, ecology as a discipline is regarded as a new science, especially given our increasing awareness of its complexity.

19. Jennifer Washburn, *University Inc.*

20. Walter Benjamin, "The Work of Art in the Age of Mechanical Reproduction," in Hannah Arendt, ed., *Illuminations: Essays and Reflections*, trans. Harry Zohn (New York: Schocken Books, 1969), p. 222.

21. Ballengée has contributed specimens to the collections of the American Museum of Natural History, the New York State Museum, the Peabody Museum at Yale University, and the Museum of Vertebrate Zoology at the University of California at Berkeley. He has collaborated with Dr. James Barron, Ohio State University at Lancaster, and Dr. Stanley Sessions, Hartwick College, in Oneonta, New York; and researchers at the Natural History Museum in London, the Woods Hole Oceanographic Institution in Massachusetts, and many others. He is a field observer for the U.S. Geological Survey's North American Reporting Center for Amphibian Malformation, and has participated in and instigated numerous wetlands surveys throughout North America. In 2001, he was nominated for membership into Sigma Xi, the Scientific Research Society.

The Ethics of Experiential Engagement with the Manipulation of Life

Oron Catts and Ionat Zurr

Recent developments in the life sciences have had a fundamental effect and affect on individual and communal perceptions of life. Some of these developments present a profound departure from cultural (and, some might say) biological perceptions of what life is and what can be done with it. The ways in which these developments are being presented to the wider community play into current socioeconomic and political agendas. The ability to manipulate life not only creates new forms of life and partial life, but also forces us to reevaluate different understandings of life and the dissolving boundaries in the life continuum.

The technological application of knowledge in the life sciences created a wide array of responses from non-biologists who comment on the various aspects of the manipulations of living systems. Among them are a growing number of artists who engage with different levels of manipulation of living systems. This work draws a considerable amount of criticism. Ethicists, philosophers, writers, and fellow artists respond to the so-called biological art phenomena as well as to the larger issues concerning research, development, and application of the life sciences, biotechnologies, biomedical research, and agriculture. Much of the critique is valid and warranted; this includes questioning the motivations of artists and funding bodies who support biological arts, issues concerning the responsibilities of artists toward life-forms that are presented in artistic contexts, and the risk that works of art that are intended to warn about and critique trends in the application of the life sciences will instead end up normalizing and domesticating these developments. However, in many cases this critique is being marred by the misunderstandings of the different levels of engagement with life, overwhelmed by the complexities of life processes and outcomes, and the subscriptions to prevailing hyperbole discourses.

We would like to argue for the ethical, cultural, and political importance of experiential engagement with life manipulation, as it can be an effective methodology to confront

the complexities and to contest dominant ideologies regarding the life sciences. For the scope of this chapter, the narratives we would like to question with our "wet hands" are the narratives of life as a coded program—"biology as information"—and the way it serves the ideology and rhetoric of Western society advancing toward a false perception of total control over life and the technologically mediated victimless utopia.

Life Is not a Coded Program, and We Are not Our DNA

The mainstream discourse regarding the life sciences in the popular media, social sciences, the arts, and even, to a certain extent, the biological sciences themselves, seems to focus on genetics and molecular biology—even when the processes discussed have little or nothing to do with that level of biological intervention.

There is a direct relationship between this type of discourse and cybernetics and information theory. This correlation is partly based on a linear technological/historical narrative; biological revolution follows the digital revolution. This linearity can be seen as following a path of least resistance by applying established narratives to new phenomena, as much as the will to emulate the high-tech bubble (to do with success rates and short-term return on capital investment), rather than as following scientific findings. Applying the metaphors of the digital age to the life sciences acts (partly) as reinforcement of established power dynamics; the familiar and successful metaphors of "the dot com boom" draw a direct correlation from the digital revolution to the biological one while concealing some fundamental differences between the two. This way, the same economic model and market-driven product development is being used in connection with life and software/hardware.

For example, intellectual property laws as they apply to software are very different when applied to living entities; economic benefits from software/hardware are usually much more direct, and the revenue is earned faster, than when they are applied to biotech; risk assessments concerning software/hardware are shorter-term and different in nature from the risks associated with new biomedical and agricultural products. Recent investments and developments in genome mapping techniques may have advanced the knowledge of gene mapping; however, the promised utopian scenarios of understanding life and curing diseases are slow to follow. This is not to underestimate the advance in molecular knowledge, but rather a critique of the DNA mania (André Pichot)[1] or genohype (Neil Holtzman).[2] Furthermore, looking at life under the constraint of the metaphor of the code may lead to misunderstandings about the mechanisms of life, and certainly will limit the potential for different understandings which are not compatible with this metaphor.

Also, the mechanisms of life are enormously complex, and it is easier for us, who are "locked" within our own physiology, to try and make sense of life through simplistic cause-effect formulas. "We are our DNA" is one of these simplistic and misleading rhetorical statements.

Oron Catts and Ionat Zurr

The problem is that many of the developments in biomedical research do not adhere so neatly to information theory, and the origin of their development and the conceptual framework that brought them about are often neglected and ignored. However, many people from different disciplines are consciously and unconsciously conforming to this pervasive discourse.

Case Studies

We are concerned with the many examples of critiques of the life sciences which are based on what can only be described as sloppy research and misunderstandings of basic biological concepts, such as the difference between genetic engineering and tissue engineering (molecular manipulation and its effects versus cellular intervention). There is a need for correct terminology rather than careless use of generic terms in order for a meaningful dialogue to occur.

A report presented at the Wellcome Trust Biomedical Ethics Summer School at St. Annes College, Oxford, in September 2005 suggests that while the debate between scientists and social scientists and other humanities scholars may be fruitful, the latter are "intimidated by the complexity of the science, . . . This suggests a training need: To find ways to familiarise social scientists and humanities researchers with neuroscience, and to equip them to liaise with neuroscientists in a competent manner."[3] The same can apply to other streams of the life sciences as much as it should apply in reverse; scientists who would like to comment seriously about social and cultural issues should engage with the relevant discourses or at least get factual details correct. As will be outlined below, the main frame of reference concerning developments in the life sciences, and in particular their applications (whether technoscientific or cultural-philosophical), tend to be monodimensional in focus. This seems to be the case in which a narrow band is used to discuss the entire array of complex interrelationships between different aspects and levels of manipulation of life. Ironically, both the proponents and the opponents of biotechnological developments are mostly promoting one narrative—a reductionist view that manipulation of life through modern biology happens only at the molecular (genetic) level. As a result, shared discourses tend to have the same frame of mind and use the same metaphors concerning genetic manipulation to deal with other forms of biological engagement.

An example this common phenomenon is Carol Gigliotti's article in *AI & Society*.[4] Social scientists discussing bioart in this magazine is the first associative connection between biology and information theory. Gigliotti titles her article "Leonardo's Choice: The Ethics of Artists Working with Genetic Technologies." However, the body text discusses two main case studies. One concerns the transgenic work of Eduardo Kac; the other, the Tissue Culture & Art Project—the authors—who do not work with genetic technologies at all, but rather with tissue technologies. Furthermore, key words suggested for the

article are "Animals—Biogenetics—Ethics—Aesthetics—Ecocentricism—Anthropomorphism—Animal rights—New media." Biogenetics? Somehow, we do not think that her article deals with the debunking of the notion of spontaneous creation of life; it seems that it is more a combination of two buzz words: "bio" and "genetics."

Throughout the article Gigliotti uses various terms in regard to both case studies, such as "genetics," "transgenic," and "biotechnology," as well as the awkward term "biogenetic art." There is no apparent logic to the use of the different terms in the different contexts, which leads the reader to suspect that Gigliotti may not know, or may not be careful in her use of, general terms among the different terminologies involved with the life sciences. It seems that in this article everything biological is genetic (it might be true, if one holds a very reductionist view that life is only about origin or development),[5] and the author is not considering that genetics or transgenic procedures are different from other levels of engagement with life, such as the cellular, the tissue, or the organ level.

These kinds of factual inaccuracies make it very difficult to engage in the very important and relevant issues raised by Gigliotti which question the anti-anthropocentric intentions of artists who use animals or parts of animals for their artistic research. (Unfortunately, the scope of this chapter does not allow a further discussion of this issue.)

The same pattern of "genohype"[6] (using the terms "biology" and "genetics" as if there are synonymous) occurs in the following discussion by two social scientists with interest and previous writing in regard to bioart, Steve Baker and Carol Gigliotti:

Abstract: This dialogue concerns the nature of ethical responsibility in contemporary art practice, and its relation to questions of creativity; the role of writing in shaping the perception of *transgenic art* and related practices; and the problems that may be associated with trusting artists to act with integrity in the unchartered waters of their enthusiastic engagement with genetic technologies. *Keywords:* Art practice, Transgenic art, Ethics, Aesthetics, Genetics, Postmodernism.[7]

Furthermore, Gigliotti is very much aware of the power of metaphors and the effect of metaphors on further thinking and conceptualization. Referring to her statement "we are all transgenic," she writes:

I wanted to throw the reader, the artist, the writer, the techno-theorist, the student, who appreciated my very specific points in earlier parts of the essay, a *metaphoric hook upon which they might begin or continue their own thinking.* The fact that there is a vast amount of genetic similarity between organisms, including humans, and we are all related by a shared evolutionary history, is the basis for the idea that we are all transgenic, and the basis, as well, for notions of a bio-centric compassion. *What current transgenic technologies are doing, however, is based on a flawed application of this similarity by reducing complex behaviours to single genes completely apart from the context of the formations of those behaviours. The problem with using what might be construed as an ambiguous metaphor is that it, too, might be misread and misapplied.*

Oron Catts and Ionat Zurr

Here is an example of either misunderstanding or sloppy use of terms. "Transgenic" is a technical and specific term that relates to the transfer of genes from another species or breed to another. The fact that organisms share "a vast amount of genetic similarity" is what makes the practice of transgenics possible. It can be argued that we are all transgenic through horizontal gene transfer via viruses and other biological agents, but it seems that is not what Gigliotti is referring to. It is also peculiar that Gigliotti is herself conducting a reductionist analysis by grouping all biological art under the umbrella of genetic art.

Gigliotti does not follow what she advocated: *"the idea that a confrontation with the complexity of a topic or issue precludes the necessity of confronting ethical choices embedded in that complexity."*[8] She critiques the ethics of artists working with tissue culture, without looking at the complexities within the relations between tissue culture and ethical treatment of animals. Furthermore, she is falling into the trap of genohype and the reductionist view of biology and biological art. To some extent, biological art that deals with other nongenetic forms of manipulation can be used as a way to counterbalance the view of life as determined solely by the DNA code. This is done by presenting the complexity of life and its interdependent relations with the environment; the development of living or semi-living entities is affected by and is effecting its surroundings rather than a "coded program" imposed on the environment.

Also, these artists remind us, in a way, how our understanding of life is not only limited but also filtered by our biology—by our anthropocentric makeup. Examples range from the authors' practice as part of the Tissue Culture & Art Project[9] (see figure 8.1), in which we are using tissue technologies as a medium of artistic investigation, to artists who are working at the level of the organism and ecologies, such Phil Ross[10] and Brandon Ballengée.[11] Another example is the artistic work of Paul Vanouse, who does work with DNA, but with the intention to disprove genetic determinism, as in the piece *The Relative Velocity Inscription Device.*[12]

Genohype or DNA mania rhetoric is playing into the hands of the discourse Gigliotti opposes. When one reduces life to the code or abstracts the complexity into its chemical components, the visceral sentient life is being pushed farther away. As Noble notes: "What the genes do is to contain the database from which the system can be reconstructed. They are the 'eternal' replicators. They don't die, but outside of organism they also don't live."[13] (. . . and react, and respond, and bleed, and may experience suffering and pleasure).

This inability to distinguish genetic engineering from tissue culture/tissue engineering leads to the following example and, as will be discussed later, presents an opening to an interesting case in which technology helps to obscure its victims even from the eyes of the most avid watchdogs.

In her essay Gigliotti identifies the correlation between developments in genetic engineering and the increase in the use of animals in biomedical research, mainly through the use of knockout mice:

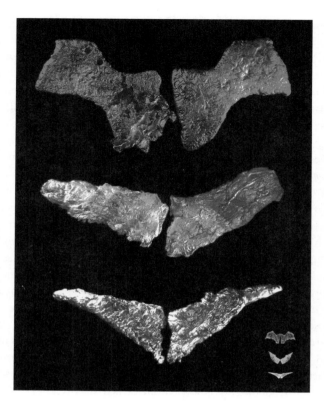

Figure 8.1 *Pig Wings,* by Tissue Culture and Art Project, 2000–2001. Pig mesenchymal cells (bone marrow stem cells) and biodegradable/bioabsorbable polymers (PGA, P4HB), originals 4 cm × 2 cm × 0.5 cm each.

. . . though the use of animals in experimentation has decreased slightly over the last 40 years due to the diligence and commitment of a vast network of animal welfare and animals rights organizations, ". . . the impact of genetic engineering on animal use should be carefully monitored, given its potential to reverse the decreases in animal use seen during the 1980s and 1990s (Salem and Rowan, 2003)"[14]

What she fails to mention is that one important way to reduce the "use of animals in experimentation," a method that has been endorsed and promoted by "a vast network of animal welfare and animals rights organizations," is the use of tissue culture as a model, rather than the full-bodied animal.

The European Coalition to End Animal Experimentation Web site[15] puts cell and tissue culture as the first example of nonanimal research techniques recommended by the

Coalition. The case is similar with the People for Ethical Treatment of Animals' fact sheet titled "Alternatives: Testing Without Torture,"[16] in which cell and tissue cultures are offered as an important substitute for animal testing.

The work we produce as the Tissue Culture & Art Project employs the very same techniques recommended by animal rights organizations, and yet Gigliotti accuses us of following paths "which are littered with the bodies and lives of millions of animals."

This example represents the problem of discussing all forms of biological manipulation in the context of genetics. As we will demonstrate below, there are animal welfare issues concerning tissue culture, but they are not the same as these presented by Gigliotti. By clustering tissue culture with genetics, Gigliotti and others keep missing the opportunity to discuss and expose the multitude of issues that we as a society need to address. Furthermore, by subscribing to and promoting the "biology as genetics" view, non-biologist scholars, critics, and artists are complicit in the creation of the mythology and metaphors that serve to obstruct the victims and lead to a narrowing of the concerns that society and decision-makers take into account in forging the paths ahead.

The Hidden Victims of Tissue Culture

In the course of our work we were approached by the People for the Ethical Treatment of Animal (PETA) to collaborate on a project that involved growing "victimless meat" (figure 8.2). In a correspondence with one of PETA's members in 2003, he wrote in regard to the latest research project by the Tissue Culture & Art Project, *Disembodied Cuisine* (figure 8.3):

You have extended the boundaries of what is considered natural and given new appreciation to the complexities and paradoxes of life. We are extremely intrigued by the poignant issues you raise regarding the sanctity of human life and the artificial demarcations humans have constructed between human life and all other forms of life and life that has yet to be classified as such.[17]

As part of our practice we employ irony as an artistic and philosophical response to technological determinism. We are very aware of the paradoxical statements of artists using certain technology while critiquing its use. We are also facing the dilemma of the artist working with emerging media as being "employed" (willingly or against her will) by the media or other invested institutions as an agent in promotion and normalization of various developments. Irony is one device to avoid self-righteousness, and it can be used as an attempt to keep the critical aspects of artistic expression once it is out of the studio (or laboratory) and into the "free market." Yet even irony can sometimes be too subtle to be noticed. In the *Disembodied Cuisine* installation we ironically offered the possibility of eating meat without killing animals, creating a victimless meat. The idea is to

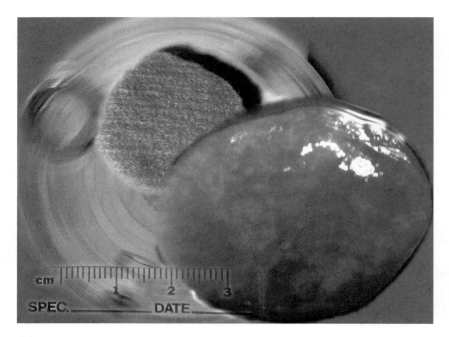

Figure 8.2 *Tissue Engineered Steak No. 1,* by Tissue Culture and Art Project, 2000–2001. Prenatal sheep skeletal muscle and biodegradable PGA polymer scaffold. This was the first attempt to use tissue engineering for meat production without the need to slaughter animals. Part of the Oron Catts and Ionat Zurr Research Fellowship in Tissue Engineering and Fabrication, Massachusetts General Hospital/Harvard Medical School.

take a biopsy from an animal and proliferate the cells in vitro and over a matrix—hence growing/constructing a tissue-engineered meat for consumption as food.

The first steak we grew was made out of prenatal sheep cells (skeletal muscle). We used cells harvested as part of research into tissue engineering techniques in utero. The steak was grown from an animal that was not yet born. In theory, this work presents a future in which there will be meat (or animal protein-rich food) for people who reject eating meat based on animal welfare considerations, and the killing and suffering of animals destined for food consumption will be reduced. Furthermore, ecological and economic problems associated with the food industry (such as growing grains to feed the animals and keeping them in basic conditions) can be reduced dramatically.[18]

However, current methods of tissue culture require the use of animal-derived products as a substantial part of the nutrients provided to the cells, as well as an essential part of various tissue culture procedures.[19] This point about tissue culture seemed (until recently)

Figure 8.3 *Disembodied Cuisine* installation, Nantes, France, by Tissue Culture and Art Project, 2003. Photo by Axel Heise.

to go unnoticed by the advocates of its use as a replacement for animal experimentation. The abstraction of these animal products in the technology associated with tissue culture served to obscure the very real victims from the eyes of organizations such as PETA and the European Coalition to End Animal Experimentation. For example, as a rough estimate (based on our experience with growing in vitro meat), growing around 10 grams of tissue will require serum from a whole calf (500 ml.), which is killed solely for the purpose of producing the serum.

The Art History Narrative

As mentioned above, Gigliotti is not alone in her "biology = genetics" view. In the context of the emerging area of biological art, much of the discussion of biological art seems to follow a neat, but problematic, linear historical narrative. This narrative is not so different from the general genohype in its outcomes, but its intentions are specific to the field. Nevertheless, it can illustrate the problems associated with the patterns that lead to the

limited public engagement with biology, and focus on only one aspect of the biotechnological story.

Many scholars draw a direct line from genetic art (use genetic algorithms to generate artificial life entities and/or computer-generated objects and forms) to biological art.[20] In order to rationalize this leap from computer-generated art to art that involves the manipulation of biological life, the proponents of such narratives take the view of biological life as being all about the code; that the artists and the work involved with biological art deal with the "code" of life. One can speculate that the combination of genohype and the need for cohesive narrative leads to ignoring the complexity of the different levels of engagement with life.

This proposition leads to an assumption of a linear, controlled, and progressive history of biological art that seems to be the line of choice of art historians, curators, and theorists who cannot cope with the multiplicity of sources, concerns, motivations, backgrounds, and references of biological art. The need to create a seemingly coherent, yet simplistic, narrative to explain the somewhat abrupt appearance of biological art created an array of swiftly forced postulations regarding the origins and progression of the field.

Even though practitioners in the field have diverse backgrounds ranging from formalist and conventional art through eco-art to body art, in the eyes of published art historians, biological art seems to be linked to, and to have originated from, digital art, possibly in an attempt to draw a deterministic lineage of progression in technologically based art. This line propagates a capitalist ideological stance that sees knowledge production and utilization as an inevitable, deterministic, and unstoppable progression of unidirectional growth. One example is the curatorial premise of the upcoming exhibition titled "Genesis! Creation in the Age of Electronics":

. . . it was not before the development of air pumps that we could say that "the heart pumps blood." Before the age of information, we could not understand that the genome was a program, . . .

Is creation a haphazard construction shaped by accidents and contexts or does it require a program, with defined sets and rules? How has information, program and other concepts from the age of computer sciences structured how we think of creation? And what are—if any—alternative ways of creating in art and science? This is what the exhibition Genesis! is about.[21]

Fox-Keller warns of the discourse of "genetic program": "in identifying genetic continuity and change as the sole fundament of evolution, it contributed powerfully to the polarization of debates over the relative force of genes and environment in such highly charged arenas as eugenics and the "hereditability" of intelligence and other behavioral attributes."[22]

"Bioart" is far from being a coherent movement with a common origin. Most artists who work with the manipulation of living systems seem to dislike the term "bioart" and

would rather distance themselves from being bunched with the other so-called bioartists. The art historians' and curators' desire to cluster these discrete modes of operation under a unifying banner is understandable, but the forced fitting of a common history and lineage is inappropriate.

Community Versus Data: Cells Versus DNA

DNA never acts outside the context of a cell. And we each inherit much more than our DNA. We inherit the egg cell from our mother with all its machinery, including mitochondria, ribosomes, and other cytoplasmic components, such as the proteins that enter the nucleus to initiate DNA transcription. These proteins are, initially at least, those encoded by the mother's genes. As Brenner said, "the correct level of abstraction is the cell and not the genome."[23]

Contra Oyama: I want to argue that taking the cell rather than the gene as a unit of development does make a difference: not only does it yield a significant conceptual gain in the attempt to understand development, it also permits better conformation to the facts of development as we know them.[24]

The issue is that many of the developments in biomedical research do not so neatly adhere to information theory, and the origin of their development and the conceptual framework that brought them about are often neglected and ignored. We argue that the developments in regenerative medicine (such as therapeutic cloning, stem cell research, tissue engineering) can be traced back to early cell theory and to the work of Alexis Carrel in 1912, rather than to that of Watson and Crick in 1953.

We would like to emphasize the importance of the issue. As explained by Noble:

. . . at this stage of our exploration of life, we need to be ready for a basic re-think. . . . It requires that we develop ways of thinking about integration that are as rigorous as our reductionist procedures, but different. This is a major change. It has implications beyond the purely scientific. It means changing our philosophy, in the full sense of the term.[25]

Decisions that are made now in regard to the type of application of biomedical research tend to conform to the reductionist view of life. In many cases these decisions (and more often the critique of these decisions) are being made from a conceptual and ontological framework that is not relevant to the actuality of the processes and outcomes.

This chapter does not underestimate the importance and significance of the field of molecular biology. Also, as discussed by Thacker, the relationships between information theory and cybernetics, and the field of molecular biology, are closely related, but the two niches mutated their respective meanings. Thacker continues to argue that genomics rematerialized the information rather than virtualized the biological material. It is interesting to note that although he discusses the problems associated with the concept of

information and the concept of life, he himself, when discussing regenerative medicine, feels compelled to insert it into the "Decoding" section of his book,[26] but not as a technology that "debugs" the information/cybernetic analogy. We would prefer to relate regenerative medicine to fragmenting, mixing, and reconstituting life. For example, fragmenting can be seen as isolating cells or tissues; mixing involves culturing/coculturing; and reconstitution refers to embodying the result either in a new host body or in a new kind of "body" or vessel (bioreactor/technoscientific body).

As a critique of the reductionism of much genomic-based research, Thacker quotes Canguilhem:

. . . these relationships [organism and its environment] are not simply a matter of information processing, but of informatic-based understandings of biological life that is inseparable from the material, meaning-making process of the organism: Biology must therefore first consider the living as a meaningful being. . . . To live is to spread out; it is to organize a milieu starting from a central reference point that cannot itself be referred to without losing its original meaning.[27]

Thacker also offers Lewontin's new view of genetics as a "triple Helix" of genes, organism, and the environment.[28] However, the problem that rises from that metaphor is that it is still rooted in the code/informatics view of life. It is not the double helix that interacts with the environment, but rather a whole organism (or part of an organism) that exists, grows, and changes together with its environment. Noble goes further, arguing that ". . . the statements suggest that organisms are defined only by their genes; whereas in truth they are also defined by the very varied ways in which genes actually operate within a living cell, and these gene expression patterns are most certainly influenced by the outside world.[29]

It seems that even in the field of genetics we are witnessing some fundamental problems with conceiving life in relation to the metaphors of information and cybernetics. The situation becomes even more acute when this conceptual frame of mind is applied to regenerative medicine, stem cells, and therapeutic cloning: not only by the biologist who works in the field but also by people supporting the field, such as engineers and biomaterial scientists. The "language" of the code not only perpetuates misunderstanding regarding the processes involved; it also severely limits the development of new understandings which are "true" to the biological materials involved. This is becoming apparent in the growing field of synthetic biology, which attempts to develop genetically modified organisms as building blocks for engineering ends, using the logic of engineering to create these biological circuits:

"You write the same software and put it into different computers, and their behavior is quite different," Mr. You said. "If we think of a cell as a computer, it's much more complex than the computers we're used to."

For that reason, some scientists say, it might be difficult ever to make biological engineering as predictable as bridge construction.

"There is no such thing as a standard component, because even a standard component works differently depending on the environment," Professor Arnold of Caltech said. "The expectation that you can type in a sequence and can predict what a circuit will do is far from reality and always will be."[30]

Tissue engineers, who are working mostly at the level of cells and tissue, seem to be just as aware of the problems of applying engineering logic to living systems:

The cell is at the center of the developmental world. Truth be told, we cannot, as tissue engineers, actually claim to engineer tissues. We can only engineer an environment for cells that might induce, enhance, or mediate their developmental processes. But progress has been buoyed by biomimetics—lifting recipes from nature for the design of tissue engineering systems.[31]

As some of the current major developments in the life sciences are concerned with cell development (rather than only genetics), it is worthwhile to look at cell theory and tissue culture at the beginning of the twentieth century. These theories are concerned with the materiality of "life" and the environment in which it is grown. Rather than on code, there is an emphasis on communal interrelationships as a reference point.

In Canguilhem's discussion of the early formation of cell theory, there are a couple of narratives concerning ideas and research on cellular formation. The first is the narrative of individuation and its relation to the bigger "whole," and the second is of the community. Metaphors of community, labor, and the nation-state have been attached to the conceptual understandings of the way cells, tissues, and organs are operating within and without a body:

In fact, the cell is both an anatomical and a functional notion, referring both to a fundamental building block and to an individual labor subsumed by, and contributing to, a larger process. What is certain is that affective and social values of cooperation and association lurk more or less discreetly in the background of the developing cell theory.[32]

H. G. Wells, Julian Huxley, and G. P. Wells refer to cells in organs as individuals in a city (by extension the body is a nation-state), and to cells in vitro as individuals with no purpose and structure:

Naturally, when they are parts of a living body the cells are disciplined, they do not wander about where they like, growing actively and reproducing themselves, as the cells in culture do. An organ such as the brain or liver is like the City during working hours, a tissue culture is like Regent's Park on a Bank Holiday, a spectacle of rather futile freedom.[33]

Animal cells are a complex system which behaves and multiplies according to its environment and the signals it receives from its surrounding cells. Hence the same cells will behave differently in the body and in a dish because of their context. In the case of embryonic stem cells, which have the ability to differentiate to any cell type, they receive many of their "differentiation instructions" from surrounding cells. This is especially relevant to cells grown in culture.

In a way, while the metaphors surrounding information theory and the code refer to some sort of a central processing unit (or a control mechanism that operates on the materiality), cell theory allows autonomy to parts which can operate, evolve, and mutate independently and in direct relation to their surrounding. Oken anticipated the theory of degrees of individuality. This was more than just a presentiment; it anticipated that techniques of cell and tissue culture would teach contemporary biologists about differences between what Hans Peterson called the "individual life" and the "professional life" of cells.[34]

As always, metaphors are a fruitful source for new understandings and misunderstandings. What is unique to the dominant metaphors developing in cell biology is that they tend to be more morphic and adaptive to their environment, yet at the same time they tend to become anthropomorphic in their individual and communal "behavior." Hence, cells' "behavior" is receiving (almost) the same level and type of agency as the individual cell of a social organism.

Getting Close to the Victim and the Need for Informed Experiential Engagement

As demonstrated above, much of the perception of development in the life sciences is marred by misappropriation of prevailing metaphors, ideologies, and hype. Working in laboratories with living materials, we were faced with the complexity of life in its multi-levels. How living entities (whether genes, cells, organs, organisms, or populations) cannot be separated from their environmental factors, and are always in flux.

In Fox Keller's words: "To be sure, the concept of program has changed considerably since the 1960s, but it has not lost its facile assimilation with information, or, more generally, its disembodied aura."[35] One way to understand the different concerns and the complexity of the different levels of engagement with life, as well as a way to reveal the obscured casualties of the new technologies, is by hands-on experiential engagement. By working hands-on with tissue technologies, we were confronted with the "hidden victims" of this field: the animals from which the tissues are obtained, and animal-derived ingredients in the nutrient media as well as the waste created (mainly in the form of plastic labware), which has a lasting effect on the environment. To use another metaphor, being in the lab is akin to going to the slaughterhouse rather than to the supermarket to obtain beef. This approach can be, and has been, utilized by artists who are working with biology;

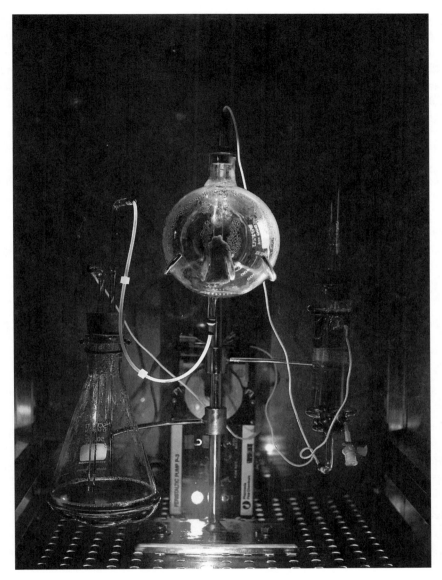

Figure 8.4 *Victimless Leather*, a prototype of a stitchless jacket grown in a technoscientific "body," by Tissue Culture and Art Project, 2004. Biodegradable polymer connective tissue and bone cells, original dimensions variable.

for the non-scientist, the "wet" experience in the laboratory involving some degree of life manipulation can be seen not only as an ethical conduct but also as a political act. A political act that goes beyond the democratization of the technology, to the act of breaking down dominant discourses, dogmas, and metaphors to reveal new understandings of life and the power structure it operates within. This experiential engagement can sometimes reveal that critique leveled against some biological art is embedded within the dominant dogma (figure 8.4).

Notes

1. Quoted in Denis Noble, *The Music of Life: Biology Beyond the Genome* (Oxford University Press, 2006), pp. 3–6.

2. A term coined by Neil Holtzman to describe the discourse of exaggerated claims and overstatements concerning DNA and the Human Genome Project (1999), pp. 409–410.

3. Quoted in http://www.lancs.ac.uk/fss/sociology/events/showevent.php?ID=620, CSS, CSEC, & CESAGen Conference, "Getting Underneath the Fact."

4. For the whole issue (vol. 20, no. 1 [2006], see http://www.eciad.bc.ca/~gigliott/gtanimal/TOC.htm.

5. The *American Heritage Dictionary* defines "genetic" as follows:

1. a. Of or relating to genetics or genes.
 b. Affecting or determined by genes: genetic diseases.
2. Of, relating to, or influenced by the origin or development of something.
3. Linguistics. Of or relating to the relationship between or among languages that are descendants of the same protolanguage.

6. For more, see Oron Catts and Ionat Zurr "Big Pigs, Small Wings," *Culture Machine* (on-line journal), Biopolitics, no. 7 (2005). http://culturemachine.tees.ac.uk/Cmach/Backissues/j007/Articles/zurrcatts.htm.

7. Steve Baker and Carol Gigliotti, "We Have Always Been Transgenic: A Dialogue," *AI & Society*, 20 (January 2006), special issue, *Genetic Technologies and Animals*.

8. Ibid.

9. http://www.tca.uwa.edu.au.

10. http://www.philross.org.

11. http://greenmuseum.org/artist_index.php?artist_id=19.

12. http://www.beap.org/2004/index.php?z=exhibitions/bio_arti&h=bio&h=bio.

13. Denis Noble, *The Music of Life*, p. 21.

14. Carol Gigliotti, "Leonardo's Choice: The Ethics of Artists Working with Genetic Technologies," *AI & Society*, 20 (January 2006), special issue, *Genetic Technologies and Animals*.

15. http://www.eceae.org/english/alternatives.html.

16. http://www.peta.org/mc/factsheet_display.asp?ID=87.

17. PETA correspondence, February 10, 2003.

18. The president of PETA has contacted the authors to inquire about collaborating with the TC&A on a project in which a biopsy will be taken from her body to grow a semi-living steak. She will consume this steak as an act of (self) cannibalism to highlight that from her perspective, any consumption of meat can be considered cannibalism.

19. From the chief executive officer of the Australian Association for Humane Research, Inc. (AAHR):

Fetal calf serum (FCS) . . . is commonly used in cell and tissue cultures as a source of nutrients, hormones and growth factors. Many researchers however, may not be aware of the ethical and scientific concerns regarding its use.
Methods of collection:
 After slaughter and bleeding of the cow at an abattoir, the mother's uterus containing the calf fetus is removed during the evisceration process . . . and transferred to the blood collection room. A needle is then inserted between the fetus's ribs directly into its heart and the blood is vacuumed into a sterile collection bag. This process is aimed at minimising the risk of contamination of the serum with micro-organisms from the fetus and its environment. Only fetuses over the age of three months are used otherwise the heart is considered too small.
 . . . Australian authorities have confirmed that fetuses here should have already died from anoxia prior to serum collection, however according to scientific literature this is not likely to be the case.
 . . . It has been estimated that around half a million litres of raw FCS is produced each year worldwide which equates to the harvesting of more than one million bovine fetuses annually. Some sources have suggested that the actual figure may be closer to two million fetuses per year. 30 June 2006.

20. Some examples can be found in the writings of scholars such as Gerfried Stocker, Suzanne Anker, Ingeborg Reichle, and others.

21. An attachment to an e-mail sent to us on December 12, 2006.

22. Evelyn Fox Keller, "Beyond the Gene but Beneath the Skin," in Eva M. Neumann-Held and Christoph Rehmann-Sutter, eds., *Genes in Development: Re-reading the Molecular Paradigm* (Durham, N.C., 2006), p. 292.

23. Denis Noble, *The Music of Life*, pp. x–xi.

24. Quoted in Fox-Keller, "Beyond the Gene but Beneath the Skin," p. 294.

25. Denis Noble, *The Music of Life*, p. 41.

26. Eugene Thacker, *TheGlobal Genome: Biotechnology, Politics, and Culture* (Cambridge, Mass., 2005).

27. Idid., p. 89.

28. Ibid.

29. Denis Noble, *The Music of Life*, p. 19.

30. "Custom-Made Microbes, at Your Service," http://www.nytimes.com/2006/01/17/science/17synt.html?emc=eta1.

31. Gordana Vunjak-Novakovic, "Transplants Made for Order," *The Scientist.* http://www.the-scientist.com/article/daily/24539/ September 2006.

32. Quoted in François Delaporte, ed., *A Vital Rationalist: Selected Writings from Georges Canguilhem*, trans. Arthur Goldhammer (New York, 2000), p. 162.

33. H. G. Wells, Julian Huxley, and G. P. Wells, *The Science of Life: A Summary of Contemporary Knowledge About Life and Its Possibilities*, vol. 1 (London), p. 29.

34. Quoted in Delaporte, *A Vital Rationalist*, p. 169.

35. Fox Keller, "Beyond the Gene but Beneath the Skin," p. 306.

Labs Shut Open

A Biotech Hands-on Workshop for Artists

Oron Catts and Gary Cass

Through the arts, SymbioticA seeks to take science beyond scientists and the laboratory to inform and encourage the broader community to develop a critical awareness of the (life) sciences and new biological technologies. As our knowledge and abilities to manipulate life increase, so does the need to make sense of where we are going. Art can play an important role in creating cultural meaning and informed involvement that are needed in order for our society to comprehend the very significant changes we are facing. Among other activities, such as hosting research residencies, producing exhibitions, and running academic courses, SymbioticA developed a unique biotech art workshop.

The SymbioticA Biotech Art Workshop is organized by SymbioticA, the art and science collaborative research laboratory at the University of Western Australia. Originally commissioned in 2004 by the Experimental Art Foundation of Adelaide as a part of the "Art of the Biotech Era" exhibition, the workshop has since mutated and been taken up by other organizations, including the Biennale of Electronic Arts Perth, the University of Wollongong, and Kings College London. The fifth workshop was at the University of California-Irvine.

The workshop's target audience is people who have a professional interest in the life sciences and biotechnology, but have never had an opportunity to engage hands-on with the tools and protocols of contemporary biology. In our workshops we have had artists, theorists, philosophers, writers, ethicists, architects, designers, curators, and engineers participate. The workshop provides hands-on experience and knowledge that enables them to engage with the issues of biotech from an informed and experiential basis. Many of the participants are interested in questioning the motivations, agendas, and possible impact of new developments in the life sciences. We hope that their practice will be informed by the workshop and that they will make provocative cultural gestures that bring into a

wider context the ethical, philosophical, and cultural ramifications of scientific discovery and technological application.

Our intention is to introduce the life sciences to the participants and to expose them, through hands-on experiences and discussions, to as much biotech as a week will permit. This knowledge will, hopefully, inspire new thoughts, discussions, and projects. We attempt to give the participants enough information to develop an interest in, and provide them with tools to continue their engagement with the life sciences; to demystify and democratize some aspects of biotechnology by direct engagement with its fundamental processes. By demystifying science, we hope that participants' future practice will be informed and influenced by their workshop experience.

This five-day intensive workshop deals with hands-on exploration of biological technologies and issues stemming from their use. It introduces participants to concepts and techniques relating to contemporary art practices dealing with the manipulation of life. Emphasis is placed on developing critical thought, discussing ethical issues, and exploring cross-disciplinary experimentation in art. Current and historical practices dealing with the manipulation of living systems are traced through exploring art, culture, and biotechnology. The tools of modern biology are demonstrated and used through artistic engagement, which in turn opens discussion about the broader philosophical and ethical implications of the extent of human intervention with other living things.

The workshop is structured in a way that allows for phenomenological and reflective interrogation of the broader aspects of application of the knowledge generated by research in the life sciences. Each day involves a theoretical component that presents art projects that involve the use of the procedures and organisms employed in the practical session of the day.

Microscopes and Microbes

Day one of the workshop is seen as an easing into the culture of biological lab work. As the workshop participants' backgrounds are so diverse, an overview and brief presentation reviewing SymbioticA and biological art is essential to bring everyone to an even footing.

It would appear that the start time must be no early [*sic*] than 10 a.m. Many of our bleary eyed workshop participants (and workshop coordinators) are certainly not the early birds!*

Most participants have never experienced the inside of a lab, and this day is, hopefully, the first of many more to come. The lab coats are distributed and put on. For most, the wearing of the lab coat acts as an ego equalizer, and changes the group dynamics.

Figure 9.1 Kings College London workshop participants getting their hands wet before getting them dirty.

Everyone sized up each other's height, status and prominence; egos were scrutinized.

I remember the camera's flash and for the next, what seemed to be several hours, a photo session breaks out. "Me, take one of me!" The voices repeat.*

Since most of the participants are in a foreign environment, the group has to be subjected to an extremely important but incredibly tedious occupational health and safety talk which encompasses all facets of lab protocols (figure 9.1). Stories are told of laboratory explosions, dealings with possible mutagenic agents, hazardous chemicals, the threats of microbial infections and radioactive contamination. Stringent regulations must be followed to prevent the escape of any genetically modified (GM) material, thus averting a potential environmental disaster. No laboratory deaths are discussed, at least no human deaths! "The participants had been warned" (Fargher 2005).

Lunch, which is inspected with suspicious eyes, is followed by the first of many hands-on biotechnological experiments throughout the week. The afternoon concentrates on learning how to use microscopes and studying microorganisms—two types in particular, bacteria and fungi. Macroscopic and microscopic details of these organisms are examined. The participants experience the proper handling, culturing, and identification techniques which can lead to the microbes' exploitation, and thus the production of a bioart work. *Fibre Reactive*, by Donna Franklin (figure 9.2), is a bioart piece that uses the fungus *Pycnoporus coccineus* to produce a living garment.

Microscopes are an essential part of microbiology which shows the participants a whole new world: the land of the small, the very small. Part of the practical experience engages

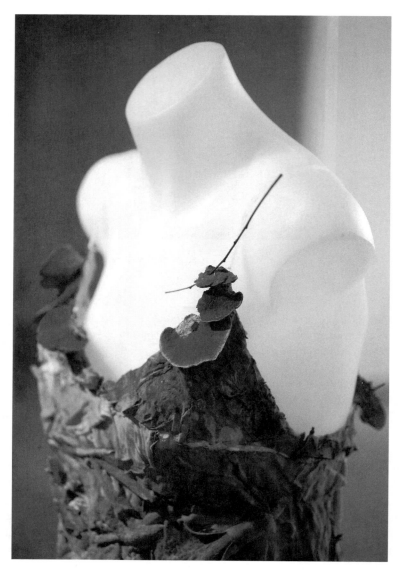

Figure 9.2 Fibre Reactive, by Donna Franklin, a living fungal dress. Photograph by Robert Frith. Biennale of Electronic Arts Perth (BEAP), "BioDifference: The Political Ecology" (2004).

with culturing germs from the body and the environment. Participants are encouraged to swab body parts (within reason!) and observe what grows over the coming days. Participants also leave the laboratory to take samples of the surrounding world.

Note to self for future workshops: Tell participants that restaurant owners do not appreciate unannounced people in white lab coats entering their premises and swabbing cookware.*

The use of microorganisms for artistic ends is becoming one of the main areas of biological art. From the culturing of neutrally occurring (airborne and site-specific) bacteria and fungi, as in the work of Polona Tratnik and Peta Clancy (bacteria) and Donna Franklin (fungi), through the use of bacterial by-products (such as the Bioalloy Group's work), to the manipulation of microorganisms by means of genetic intervention (more on that to follow). In general, working with these organisms is relatively easy, and the work can be performed in a nonspecialized environment, using easily obtained, off-the-shelf items. Given the accessibility of some of these organisms and the straightforwardness of their propagation, participants have been alerted to potential hazards that some of these organisms represent.

To end the first awe-inspiring day, all the participants and coordinators sit down to reflect on the day's events. A group discussion commences—which continues sporadically for the entire week—in relation to what has been accomplished and everyone's personal reactions to what they have experienced. Moral codes and belief systems are reevaluated. But this is just the start; by the end of the week, with several more life science experiments and encounters, many participants will further question their ethical stance.

Genes and Hype

Day two starts with the statement "You are about to be implicated in genetic engineering. Are you sure you want to go on?" This is the molecular biology day, the day on which we will delve deep into the cell and reduce life to a molecule. DNA is extracted from plants and visually compared to the DNA extracted from each participant's cheek cells (figure 9.3).

How can our DNA which is believed to control the mechanisms of a Supreme Being, look and be similar to that of a common old pea plant! Maybe this can be seen as the ultimate in life's nakedness. The confrontation of staring at the molecule that we are led to believe, along with our personal space, makes us who we are! Maybe if we can reduce life down to a single molecule and see there is no difference, then and only then will we be able to tolerate each other's diversity!*

From the fairly straightforward DNA isolation—which includes a demonstration of performing this procedure using items and materials found in the kitchen (which yielded

Figure 9.3 Richard Pell, an American artist at the University of California, Irvine, workshop with a specimen of his own DNA, extracted from his cheek cells.

substantial amounts of nonpurified DNA)—we move to have a glimpse of high-end molecular biology. These experiments include DNA fingerprinting and gene mapping. They provide a very tangible example of the tools molecular biologists use to learn about and manipulate life at the molecular level (which range from the use of electrophoresis equipment to the use of enzymes), as well as the need for mathematical skills. The highlight of the day is a bacterial transformation, hands-on genetic engineering. The participants are given the green florescence protein (GFP) gene (originally obtained from a jellyfish) and a culture of bacterial cells (a weakened strain of *E. coli* bacteria). When successful, the participants genetically engineer the bacteria with the jellyfish gene to create fluorescent bacteria.

Some of what is starting to be seen as seminal pieces in the emerging area of biological art (sometimes known as bioart) involves the genetic manipulation of organisms and, in particular, bacteria. Joe Davis's *Microvenus* is widely accepted as the first artwork to be produced by inserting a novel strand of "artistic" DNA molecule into a living organism (figure 9.4). However, the first such piece to be exhibited was *Genesis*, by Eduardo Kac (Ars Electronica, 1999), and another piece that used similar techniques is *GeneTerra* by Critical Art Ensemble. This area of artistic engagement seems to parallel, and in some

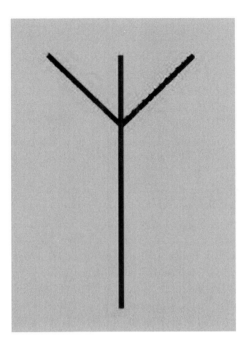

Figure 9.4 One of the original pieces of transgenic bioart is Joe Davis's *Microvenus*. Joe transformed a simple image into synthetic molecules of DNA.

cases to critique, the hyperbolic discourse concerning molecular biology; genehype seems to dominate public discourse about modern biology to the degree that often everything biological is presented as synonymous with genetics. The practice of molecular biology in the context of art also makes a neat (but mainly false) linear progression from digital art to biological art, as they both involve some form of manipulation of code. Some artists have even coined specific terms to describe this type of work: for example, "geneaesthetics" (Joe Davis), "transgenic Art" (Eduardo Kac), "geneart," and more.

The day's practical sessions end with a final question: "You have created these transgenic GFP-expressing organisms. Do you feel morally responsible to destroy them?" The following day the concerned participants are invited to observe the destruction of the GM bacteria in an autoclave (a giant pressure cooker).

The Hobbyist/Amateur Biologists

As the workshop is run in a scientific laboratory, many of the practical sessions are very scientifically oriented. Much of the equipment accessed is similar to that used in research

and industry laboratories. One of the major goals of this workshop is to inform and teach the participants about alternative methods which can be used for many of these biotechnological experiments. For instance, DNA extraction, culture media preparation, and tissue engineering can be completed at home, and many of the ingredients and much of the equipment used in laboratories can be sourced from the kitchen, the household, the supermarket, and the local hardware store.

I'm starting to believe that the scientific laboratory may be just an overelaborate kitchen designed by scientists to mystify the sciences behind closed doors.*

The aim is to develop an inexpensive tool kit for non-biologists who are interested in pursuing research and development of biological projects at home or in the studio. One of reasons for the inhibiting costs of scientific equipment is their need to be as precise as possible. This is not always the need of artists or hobbyists. Therefore, developing non-scientific biological tools can be done at a fraction of the costs usually associated with research in the life sciences. By presenting these alternatives to the workshop participants, we hope to help in the formation of a community of hobbyists and to share an open source ethos of biological research. By making this type of research more accessible and affordable, we hope to foster a democratization of the knowledge of life and to open avenues of investigation that are now accessible only to a selected privileged few.

For example, sterility is all-important for all the biotechnological sciences. To achieve this, many of the experiments are completed in a sterile laminar flow cabinet or a biological safety cabinet. The coordinators demonstrate how to build a sterile hood quickly and cheaply. Many of the parts are now commercially available, especially HEPA filters that have, ironically, dramatically come down in price after the first Iraq war and the fear of a biological attack.

Fragments of Complex Beings

Before *day three* commences, the participants are asked to bring in a piece of meat from the butcher, the fresher the better. The aim of this day is to introduce the participants to animal cell culture and tissue engineering. This area of investigation presents some tantalizing questions, such as whether the cells from a piece of meat ready for human consumption are still living. The workshop's intensity is beginning to rise, and emotions are on edge.

At what point can a mass of cells be classified as nonliving?*

An anecdote from the workshop we conducted with Arts Catalyst at Kings College in London can illustrate the point. Prior to the animal tissue culture experiments, José

Good morning, the worm, your Honour,
The Crown will plainly show,
The prisoner who now stands before you,
Was caught red-handed showing feelings,
Showing feelings of an almost human nature.
This will not do.

Call the schoolmaster!

—Pink Floyd, *The Wall*, 1979

Figure 9.5 Verena Kaminiarz in the Kings College London workshop holding the worm that held the art-science world in judgment.

Eugenio Marchesi, a Spanish artist, brought in a worm from the surrounding gardens as a possible specimen for the animal culture experiment (figure 9.5). The worm was put in the fridge to hibernate until its fate was decided. A group discussion followed, debating the use of the worm, and soon became an ethical dilemma for the group.

As the week goes on, the group starts to bond. Friends gel and foes oppose, all of which is leading to the formation of excellent and intense group discussions.*

In the absence of the worm, the discussion was somewhat hypothetical. "It is just a worm—let's just get some tissue out of it," one participant suggested. "No, we should not use any living animals," another responded (somewhat hypocritically, as we were about to use meat from the butcher). Then a suggestion for a compromise came about: "What if we use one half of the worm for culturing and let the other half go free?" (The vital half of a worm will survive the other half's amputation.) "But if we let the worm go, it will probably be eaten by a bird!" was one response. The discussion went on for some time, to the astonishment of the local scientists and technicians. "If it was a group of medical students, the worm will be chopped without a second thought" one of them told

us afterward. By the end of this phase of the discussion, the consensus seemed to favor the Solomonic[1] proposal of cutting the worm in half. But when the worm was removed from the fridge, it lifted one of its ends and seemed to scan the room, "looking" at the participants. The presence of the worm shifted the balance, and it was set free unharmed.

In a sense this story illustrates one of the important aspects of the workshop and of biological art in general. While the worm was hidden, the discussion could have been seen as academic, bearing no phenomenological or direct involvement with the worm itself. The apparent shift in the group's resolve to harm the worm could have been brought about only by the very real existence of the worm in front of participants. The need to look the subject "in the eye" might be one of the most important aspects of the emerging area of artistic exploration involving the use, manipulation, and display of living biological systems.

Each participant begins the process of tissue engineering from the piece of meat he or she has purchased from the butcher. All sorts of animal and tissue types are present, from a T-bone steak to a pig's hock and a frozen chicken. Scalpels start mincing the meat into smaller samples, and the bone saw's blade cuts through the bone, exposing the marrow as its high-pitched resonance rings around the room. Dissected and disassociated fragments of both the steak sample and the marrow are placed into the culture media and incubated overnight.

As the freezing process applied to the frozen chook would have lysed (split open) all the cells hence rendering it unsatisfactory for tissue culturing; it was raffled off for dinner.*

The participants also work with cell lines. These cells are considered to be immortal, in that they have the potential to divide forever, as opposed to primary cells (cells that are taken directly from healthy tissue, usually by means of biopsy), which have a finite number of divisions (up to approximately fifty-six). Cell lines, either derived from cancerous tissue or transformed in vitro, can be considered as a renewable resource, and can be mail ordered from several tissue banks around the world. The workshop participants learn how to subculture the cells by splitting the cell population from one dish into two dishes. By using enzymes and the lab equipotent, the participants experience cell and tissue culture techniques and are exposed to the basic workings of maintaining and growing fragments of complex organisms. One lesson involves understanding the makeup of the nutrient solution (media) used to feed the cells. It is important to find out that much of the media includes animal-derived components. It is interesting to contrast this fact with the call by animal rights organizations to use tissue culture as an alternative to animal experimentation.

The day also involves a detailed lecture on the history of tissue culture and tissue engineering, and their artistic use. The work of Paul Perry, the Tissue Culture & Art

Oron Catts and Gary Cass

Project, and other artists is used to show the potential of this type of work to generate alternative discourses and narratives. The discussion also covers some other uses of these technologies for nonmedical ends—such as meat and leather production using muscle and skin cells, sensors using liver cells, actuators using muscle fibers, and componential devices using neurons.

Tissue Engineering and Plant Culture

Day four. After a long, anxious night reflecting on whether the animal cells have been successfully cultured, mixed results are discovered. Some of the cultures are contaminated with microbes; these cultures are disposed of. However, several of the cultures show potentially living animal cells. The proud animal cell culturists now face the daunting reality that their cultures of living cells are their responsibility, and they now either spend much more time and expense keeping these cells alive or they destroy the cultures.

The participants are taken through a demonstration on tissue engineering and scaffold fabrication for the animal cell culture. Animal cells usually grow in a monolayer, so to generate a 3-D sculpture of animal cells, a structure must be built. This structure is prepared using biodegradable polymers which the animal cells will adhere to. The participants are shown how to build the scaffold used in artworks from the Tissue Culture and Art Project.

I noticed that at this stage of the workshop, the participants were experiencing the dreaded brain overload. Rather then [*sic*] envisaging brains exploding over the lab (which is a bugger to clean up), we reduced the stress load.*

To slow things a little, group discussions and conversations about possible bioart projects become high on the agenda. This is achieved on the lawn, if weather permits, or over a refreshing beverage—anywhere other than the laboratory.

The afternoon's practical experiment back in the lab involves plant tissue culture. Many aspects and techniques applied in plant tissue culture differ from animal cell culture. These include the media ingredients, culture conditions, and growth habits. It is the three-dimensional growth habit of plant cells, and the fact that each plant cell is totipotent (will generate a clone of the mother plant), that artists can take advantage of. This capacity to grow undifferentiated plant cells in a 3-D shapes gives the ability to form plant cell sculptures (figure 9.6).

Most of the participants didn't seem to become as emotionally attached to their plant cultures as they did their animal cultures. Is this the mammalianism effect; that emotions are more connected to living matter that belong to the same animal kingdom?*

Figure 9.6 Janet Osborne's living apple plant tissue sculpture, which was part of a poster—"The Explant (r)Evolution: The Use of Plant Tissue Culture for Artistic Purposes," presented at the Plant Tissue Culture and Biotechnology Conference, University of Western Australia (2005). The parts of the sculpture spell out "Ceci n'est pas une pêché"/This is not a sin).

Both sexual and asexual techniques for propagating plants are examined in this practical session. Clones from the mother plant are generated through lateral bud excision (asexual reproduction), and an embryo rescue is performed on a pea seed (sexual reproduction). Participants are encouraged to take their plant cultures home and are taught how, once matured, these plants can be planted in the garden for further enjoyment.

Working with plants is one of the oldest forms of human interventions into biological processes; however, contemporary art has seemed to keep the manipulation of plants largely untapped. One of our hopes is that the artists will explore the potential of this area as less threatening engagement with the life science that holds a promise for much poetic output.

The Field Day

Day five. The last day of the workshop is the most important. This day hopefully puts the rest of the week into context. The stakes are raised, and the participants have become comfortable with familiarity in a science teaching lab environment, visited a working conventional science research laboratory in the university. In going into a working lab armed with the knowledge and experience from the workshop, the participants can understand better not just what the lab is researching but also how it is being done. This enables them to engage with the research scientist and appreciate, as well as critique, the work in the lab from a much more informed position.

In every workshop we endeavor to expose participants to a scientific setting where "real" biological science is being conducted and where the participants can tour a working research lab and engage with scientists. These sites include molecular biology venues at the University of Adelaide and the National Institute for Medical Research in London, as well as scientific research labs at the University of New South Wales Graduate School of Biomedical Engineering and at the University of California-Irvine. The experiences validate some of the knowledge gained during the workshop and also highlight the breadth of information yet to be fully comprehended. The general consensus of the participants in the SymbioticA Biotech Art workshop has been positive, with most believing that the opportunity to participate was a unique and privileged experience.

The "us and them" feeling between the arts and sciences does exist, but this workshop may be a small step toward chipping away at these barriers. Successful art-science collaboration can be valuable for both parties only if both cooperate equally. We believe that the discussions and decisions emanating from such an alliance will have significant implications for interdisciplinary practice within the arts and science.

One more thing that makes these workshops succeed is the participants. The groups have been diverse, enthusiastic, and open to new sets of knowledge, and each has brought opinions and beliefs to be shared. The workshop by no means can convey the complexities

of biology within five days, but it informs the participants—as per the graduating certificate—"Now you know how much you don't know."

Notes

* Extracts from Gary's personal diary detailing his five-day workshop journey—lost in time, science, and art.

1. Although Solomon was young, he soon became known for his wisdom. The first and most famous incident of his cleverness as a judge was when two women came to his court with a baby whom each woman claimed as her own. Solomon threatened to split the baby in half. One woman was prepared to accept the decision, but the other begged the king to give the baby to the other woman. Solomon then knew the second woman was the mother. From http://www.jewishvirtuallibrary.org/jsource/biography/Solomon.html.

References

Fargher, C. (2005). "Bio-art: Adventures in Ethics." *Realtime + OnScreen* no. 65 (February–March 2005).

Pink Floyd. (1979). *The Wall*. CBS Studios, New York City.

IV

Race and the Genome

All the contributors to this section bring their knowledge of theoretical genomics and the history of the experimental sciences of race to bear on the politics of contemporary state and corporate discourses of racialization. This section's analytical registers include the sociology of science, the history of science, bioart, and biological anthropology.

Sociologist Troy Duster leads us through the complex set of paradoxes that appear to emerge when genetic research claims the non-existence of race as a biological category while social life remains strongly racialized. In order to parse the promises and threats of the new "transparent" technologies of racialization, we must understand the claims and legacies of at least two hundred years of biology, history, sociology, philosophy, law, politics, and laboratory methods. Duster constantly weaves together the philosophical and the practical, and shows that these are skills that must not be confined to the academic sphere; they are absolutely essential for all of us who live through and negotiate the Biological Century. That's easy to say for a scholar trained in biology, sociology, history, and activism, we might argue; but how might the lay public unpack such a complex, contradictory racialized legacy?

Underscoring the serious and playful ways in which the public might engage with the essentialized narratives of DNA, media artist Paul Vanouse teases cultural stories out of esoteric laboratory methods. Like Duster, Vanouse is concerned with the legacies of eugenics, but cautions that the cultural narratives of DNA are both more complex and more pernicious. His artwork engages the enunciating conditions of DNA truth discourses by having public conversations with their culturally coded representations. The role of the artist here is much like the role of the sociologist in Duster's chapter. Understanding the internal and technical claims of biology is not an end in itself; rather, it is an opportunity to engage with the terms of the discourse in political, artistic, and public ways.

Biological anthropologist Fatimah Jackson and her research assistant Sherie McDonald critique the deployment of anthropological genetics in contemporary America. Genetics lacks historical context, yet people seek to retroactively read their ancestral histories into their DNA. Jackson and McDonald are sympathetic to people's desires for cultural affiliations, and even fictive kinship relations, but warn that the mainstream genetic stories available to most of us are based on "old, dysfunctional, and often racist models." They are particularly concerned that the common practice of assigning African American DNA to contemporary African ethnic groups is ahistorical and exploitative, as well as simply bad science. They describe an alternative approach to genomic modeling, in which historical, ethnographic, demographic, and genetic data are read interactively. Jackson's collaborative interdisciplinary research team is at the forefront of constructing alternative genomic models robust and powerful enough to displace the racialist models that still dominate U.S. biological and political paradigms.

Historian Abha Sur and medical student Samir Sur track the biological and social meanings of genomics into the transnational spheres of caste politics. If genomic narratives reify difference, is resistance possible only through deconstructive techniques? Abha and Samir Sur provoke us to consider not only pernicious uses of DNA narratives, but also the strategic appropriation of essentialized DNA identity narratives. How and why have oppressed people adopted the language of the master molecule? They, like the other contributors to this section, bring both scientific and historical concerns to their treatment of a vexed political question.

Selective Arrests, an Ever-Expanding DNA Forensic Database, and the Specter of an Early Twenty-First-Century Equivalent of Phrenology

Troy Duster

We can all celebrate the use of DNA technology to free more than 200 wrongly convicted prisoners, some of whom were on death row and others who served decades for rapes they did not commit.[1] Similarly, when law enforcement can score a cold hit and catch a rapist because his DNA is on file, there are reasons to applaud. The use of this technology in high-profile cases has led to a full set of arguments for widening the net of the DNA database, so that more and more samples can be included, ranging from those from convicted felons to those from arrestees—from those of suspects to those of the whole population.[2] There are currently about 1.5 million profiles in the national database, but in early 2002, the attorney general of the United States ordered the FBI to generate a plan that is supposed to expand this to 50 million profiles. What more objective way could there be of exculpating the innocent and convicting the guilty? However, such an argument conflates three quite distinct strategies and practices of the criminal justice system that need to be separated and analyzed for their disparate impact on different populations.

The first is the use of DNA after conviction to determine whether there has been a wrongful conviction, the kind of situation that would help to free the innocent. The second is the collection of DNA from suspects or arrestees in pretrial circumstances to increase the DNA database, which in turn is designed to help law enforcement determine whether there are matches between the DNA samples of those suspects or arrestees and samples left at the site of some unsolved crime: the net to catch the guilty. The third is the advocacy for increasing the collection of DNA from a wider and wider range of felons and misdemeanants in the postconviction period, so that their DNA profile is on file in the event of recidivism. Much like the current situation in which police can stop a driver and determine whether he or she has outstanding warrants or traffic tickets that have piled up, the new technology would permit authorities to see if the DNA

of the person stopped and arrested matches the DNA on file from an unsolved crime scene.

This is not just hypothetical. In early 2000 the New York City Police Department began a pilot project experimenting with portable DNA laboratories.[3] The police take a buccal swab—some saliva from inside the cheek—of a person stopped for a traffic or other violation and place it on a chip the size of a credit card. They then put this chip through a machine no larger than a handheld compact disc player, which reads the DNA via a laser in two minutes, isolating about thirteen DNA markers to create a profile of the individual. When this task is completed, the police transmit these data to a central database, which currently requires about twelve minutes to determine whether the profile matches that from any sample on file.

Who could possibly be opposed to the use of these technologies for such crime-fighting purposes? The answer is a bit complex, but it has to do with (1) some hidden social forces that create a patterned bias determining that certain populations will be more likely subjected to DNA profiling and (2) the resuscitation of some old and dangerously regressive ideas about how to explain criminal behavior.

It is now commonplace to laugh at the science of phrenology, once a widely respected and popular research program in the late nineteenth century that attempted to explain crime by measuring the shapes of the heads and faces of criminals. Yet the idea that researchers begin with a population that is incarcerated, and then use correlational data from their bodies in an attempt to explain their behavior, is very much alive and well as a theoretical and methodological strategy in the contemporary world. When researchers deploy computer-generated DNA profiles or markers and correlate them with those of people caught in the grip of the criminal justice system, the findings take on the imprimatur of the authority of human molecular genetics.[4] Despite the oft-chanted mantra that correlation is not causation, the volatile social and political context of such correlations will require persistent vigilance and close monitoring if we are to avoid the mistakes of the past.

To provide the context for this chapter's discussion of expanding DNA databases, I begin by pointing out yet again the systematic bias, by race, of a full range of behaviors displayed across the criminal justice system, from the decisions by police at the point of stop, search, and arrest, through the sentencing guidelines and practices, to the rates of incarceration. I then turn to empirical evidence that documents recent developments in the literature of forensic science that claim to be able to predict "ethnic affiliation" from population-specific allele frequencies. It is the relationship between these two developments that is the source of my final point: the looming danger of easily crafted DNA-based research programs and the consequent misattribution of genetic causes of crime. I conclude that such research could easily segue into the moral equivalent of a new phrenology for the twenty-first century, something we need to acknowledge, intercept, and avert.

Troy Duster

Phenotypical Expression at the Point of Arrest: The Selective Aim of the Artillery in the War on Drugs

Since the 1970s, the war on drugs has produced a remarkable transformation of the U.S. prison population. If we turn the clock back no more than sixty years or so, whites constituted approximately 77 percent of all prisoners in America, and blacks accounted for only 22 percent.[5] This provides a context for reviewing figure 10.1 and the astonishing pattern it reveals in the evolution of general prison incarceration rates by race in recent history. Note the striking increase since 1950 in the incarceration rate for African Americans in relation to that for whites, as shown in figure 10.2. In 1933, blacks were incarcerated at a rate approximately three times that of whites (table 10.1). In 1950, the

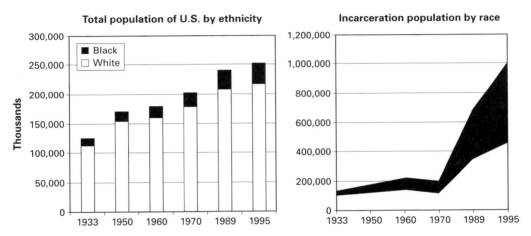

Figure 10.1 Total population of U.S. by Ethnicity, and incarcerated population by race.

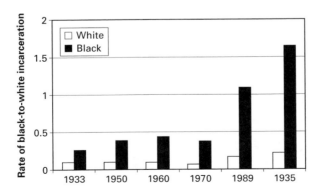

Figure 10.2 Incarceration rate by race.

Table 10.1 Incarceration Rates by Race

Year	Population[a]			Incarceration[b]			Rate (%)[c]			Approximate Ratio
	Total	White	Black	Total	White	Black	Total	White	Black	Black to White
1933	125,579	112,815	12,764	137,997	102,118	31,739	.11	.09	.25	2½ : 1
1950	151,684	135,814	15,870	178,065	115,742	60,542	.12	.09	.38	4 : 1
1960	180,671	160,023	19,006	226,065	138,070	83,747	.13	.09	.44	5 : 1
1970	204,879	179,491	22,787	198,831	115,322	81,520	.10	.06	.36	6 : 1
1989	248,240	208,961	30,660	712,563	343,550	334,952	.29	.16	1.09	7 : 1
1995	263,168	218,149	33,095	1,126,287	454,961	546,005	.43	.21	1.65	8 : 1

[a]Total population of the United States by ethnicity (in thousands).

[b]Total prison population by ethnicity (estimated).

[c]Percentage of total population, white population, and black population incarcerated.

Sources: For population: "Series A 23–28: Annual Estimates of the Population, by Sex and Race: 1900–1970," in *Historical Statistics of the United States, 1976* (Washington, D.C.: Bureau of the Census, Department of Commerce, 1976), pp. 9–28; "No. 19: Resident Population—Selected Character-istics: 1790–1989," in *Statistical Abstract of the United States 1991*, 111th ed. (Washington, D.C.: Bureau of the Census, Department of Commerce, 1999), p. 17, and in *Statistical Abstract of the United States 1997*, 117th ed. (Washington, D.C.: Bureau of the Census, Department of Commerce, 1997), pp. 9, 19. For incarceration: "Characteristics of Persons in State and Federal Prisons," in Margaret W. Cahalan, *Historical Corrections Statistics in the United States* (Washington, D.C.: Bureau of Prison Statistics, Department of Justice, 1986), p. 65, and in *Correctional Population in the U.S., 1995* (Washington, D.C.: Bureau of Justice Statistics, Department of Justice, 1997), p. 91.

Troy Duster

ratio had increased to approximately four times; in 1960, it was five times; in 1970, it was six times; and in 1989, it was seven times that of whites. These figures are dramatic, yet incarceration is but one end of the long continuum of the criminal justice system that starts with being stopped by the police, arrested, held for trial, and convicted.

The war on drugs has played the dominant role in this story. Whereas racial profiling seems often to be characterized as a local police practice, the phenomenon of young minority males being "just stopped by the police" was actually a national strategy first deployed by the Reagan administration. In 1986, the Drug Enforcement Administration initiated Operation Pipeline, a program designed in Washington, D.C., that ultimately trained 27,000 law enforcement officers in forty-eight participating states over the ensuing decade. The project was designed to alert police and other law enforcement officials to "likely profiles" of those who should be stopped and searched for possible drug violations. High on the list were young, male African Americans and Latinos driving cars that signaled something might be amiss. For example, a nineteen-year-old African American driving a new Lexus would be an "obvious" alert, because the assumption would be that neither he nor his family could have afforded such a car, and the driver must therefore be "into drugs."

According to the government's own statistics, during the height of the drug war, blacks accounted for only 15–20 percent of the nation's drug users,[6] but in most urban areas, they constituted half to two-thirds of those arrested for drug offenses. Indeed, in New York City, African Americans and Latinos constituted 92 percent of all those arrested for drug offenses.[7] In Florida, the annual admissions rate of blacks to the state prison system nearly tripled between 1983 and 1989, from 14,301 to nearly 40,000.[8] This was a direct consequence of the war on drugs, since well over two-thirds of the crimes of which these Florida blacks were convicted were drug-related. The nation gasped at national statistics reported by the Sentencing Project in 1990 that revealed that nearly one-fourth of all young black males twenty to twenty-nine years of age were either in prison, in jail, on probation, or on parole on any given day in the summer of 1989.[9] This figure has been recited so often that (relatively) a collective yawn greeted an announcement in mid-1992 that a study had revealed that 56 percent of Baltimore's young black males were under some form of criminal justice sanction on any given day in 1991.[10] Indeed, of the nearly 13,000 individuals arrested on drug charges in Baltimore during 1991, more than 11,000 were African Americans.

The explanation for this extraordinary imbalance between patterns of drug consumption by race and arrest statistics derived from the point-of-sales transaction is not difficult to find. It is the selective aim of the artillery in the drug war. Interviews in 1989 with public defenders in both the San Francisco Bay Area and Atlanta revealed that over half of their caseloads involved young, overwhelmingly black males arrested through "buy-and-bust transactions" by the police.[11] Most of these transactions involved quantities of cocaine valued at less than $75.00. In contrast, even at the height of the drug war, drug

sales in fraternity houses or "in the suites" routinely escaped the net of the criminal justice system.[12] It is the street sales of drugs that are most vulnerable to the way in which the criminal justice apparatus is currently constituted and employed.

Some judges began to throw out cases in which there was obvious racial bias in administering drug laws so unevenly across the population. A white Manhattan judge allowed crucial evidence to be suppressed in a drug arrest case at the New York Port Authority bus terminal, on the grounds that drug enforcement efforts in the terminal were aimed exclusively at minorities.[13] It is a well-known and accepted police practice in many areas to intercept citizens who fit a "profile" of a likely offender. That profile increasingly took on an overwhelmingly racial dimension as the war on drugs escalated. When a Superior Court judge in Los Angeles was informed in 1990 that 80 percent of all illegal drug transactions involved whites rather than blacks or other minorities, he replied in astonishment that he thought it was exactly the opposite.[14]

The drug war affected the races quite differently with regard to their respective incarceration rates. The most striking figure showing this is the shift in the racial composition of prisoners in Virginia. In 1983, approximately 63 percent of the new prison commitments for drugs were white, with the rest minority. Just six years later, the situation had reversed, with only 34 percent of the new drug commitments being whites, and 65 percent minority. It is not just the higher rate of incarceration, but the way in which the full net of the criminal justice system, all the way through mandatory sentencing, falls selectively on blacks. For example, powder cocaine is most likely to be sold and consumed by whites, whereas blacks are more likely to sell and consume crack.[15] Moreover—and, I would argue, not coincidentally—federal law is not race-neutral on these two very much related chemical substances. Possession with intent to distribute five grams of powder cocaine brings a variable sentence of ten to thirty-seven months, but possession with intent to distribute five grams of crack cocaine brings a mandatory minimum five-year sentence.[16]

A study by the Federal Judicial Center revealed that the mandatory minimum sentencing in drug cases, enacted as part of the war on drugs, has had a dramatically greater impact on blacks than on whites.[17] In 1986, before the mandatory minimum sentences became effective, for crack offenses, the average sentence was 6 percent higher nationally for blacks than for whites. Just four years later, the average sentence was 93 percent higher for blacks.[18] Although the figures for crack are the most shocking, the shift toward longer sentences for blacks includes other drugs. In the same time period (1986–1990), the average sentence for blacks vis-à-vis whites (for offenses related to powder cocaine, marijuana, and opiates) increased from 11 percent greater for blacks to 49 percent greater.[19]

The charge that police profile by race those whom they subject to stops and searches reached the highest circles of government. Attorney General John Ashcroft, no crusading hero of civil liberties, went on record as opposing the practice, and has promised to root it out and end it as he uncovered and discovered remnants of racial-profiling policies. But some still contest that there has ever really been something called "racial profiling" (related

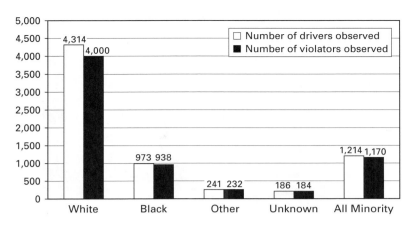

Figure 10.3 Number of traffic violations observed, by race.

to the "offense" of "driving while black"). So it is instructive to present some compelling data on the topic gathered by the Maryland State Police. The data reflect the way in which the Maryland State Police stopped drivers, by race, along the Interstate 95 corridor in that state from January 1995 to September 1996 (see figure 10.3). Note that although drivers in all categories had a high percentage of violations that could be the source of being asked to pull over (from lane changing without signaling to speeding), as shown in figure 10.3, minority drivers were stopped at much higher rates, as shown in figure 10.4, with the difference certainly pronounced enough to support a reasonable conclusion of selective profiling.[20]

Background to "Ethnic-Affiliation Markers" at the DNA Level

At the level of DNA, we have been told repeatedly by the mappers and sequencers of the Human Genome Project that all humans are 99.9 percent alike. However, there is an unacknowledged eight-hundred-pound gorilla hovering around the FBI's national DNA database for forensic investigation. That gorilla has a name, "race" (although it has recently applied for, and received, a name change and now prefers to be called, more politely, "ethnic estimation based upon allele frequency variation"). The official line from the disciplines of molecular biology, physical anthropology, hematology, the neurosciences, and a dozen other scientific fields is that "the concept of race has no scientific meaning, and no scientific utility."[21] On the surface, this is of course correct. There are no biological processes (circulation of the blood, patterns of neurotransmission) that map along any system for classifying humans that we can dredge up from the past or invoke from the present. And, as I shall show, the future belongs to a whole newly evolving nomenclature.

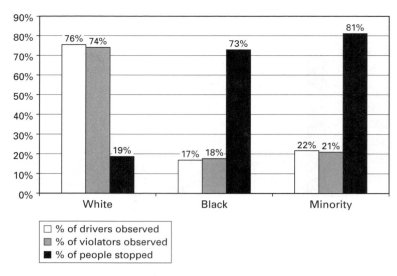

Figure 10.4 Percentage of drivers stopped, by race.

But if humans are 99.9 percent alike and "race" is purportedly a concept with no scientific utility, what are we to make of a group of articles that has appeared in the scientific literature since the 1990s, looking for genetic markers of population groups that coincide with commonsense, lay renditions of ethnic and racial phenotypes? It is the forensic applications of such markers, if they can be shown to exist, that have generated much of this interest. Devlin and Risch made the following statement in "Ethnic Differentiation at VNTR Loci, with Specific Reference to Forensic Applications," a research report that appeared prominently in the *American Journal of Human Genetics*:

The presence of null alleles leads to a large excess of single-band phenotypes for blacks at D17S79.[22] . . . This phenomenon is less important for the Caucasian and Hispanic populations, which have fewer alleles with a small number of repeats. . . .

[I]t appears that the FBI's data base is representative of the Caucasian population. Results for the Hispanic ethnic groups, for the D17S79 locus, again suggest that the data bases are derived from nearly identical populations, when both similarities and expected biases are considered. . . . For the allele frequency distributions derived from the black population, there may be small differences in the populations from which the data bases are derived, as the expected bias is .05.[23]

When genetic researchers try to make probabilistic statements about which group a person belongs to, they look at variation at several different locations in the DNA—usually from three to seven loci. For any particular locus, the frequency of a particular

allele *at that locus, and for that population*, is examined. In other words, what is being assessed is the frequency of genetic variation at a particular spot in the DNA in each population.

Occasionally, these researchers find a locus at which one of the populations being observed and measured has, for example (let's call them) alleles H, I, and J, and another population has alleles H, I, and K. We know, for instance, that there are alleles that are found primarily among subpopulations of North American Indians. When comparing a group of North American Indians with a group of Finnish people, one might find a single allele that was present in some Indians but in no Finns (or present at such a low frequency in the Finns that it is rarely, if ever, seen). However, it is important to note and reiterate—again and again—that this does not mean that all North American Indians, even in this subpopulation, will have that allele.[24] Rather, we are referring to the probability of the appearance of that allele in the subpopulation. Indeed, it is inevitable that some North American Indians will have a different set of alleles, and that *many of them will be the same alleles as some of the Finns have*. Also, if comparing North American Indians from Arizona to North American Caucasians from Arizona, we would probably find at least some level—probably a very low one—of the "Indian allele" in the so-called Caucasians, because there has been "interbreeding." Which leads to the next point.

It is possible to make arbitrary groupings of populations (geographic, linguistic, self-identified by faith, identified by others by physiognamy, etc.) and still find statistically significant allelic variations among those groupings. For example, we could simply pick all the people in Chicago, and all the people in Los Angeles, and find statistically significant differences in allele frequency at *some* loci. Of course, at many loci, even most loci, we would not find statistically significant differences. When researchers claim to be able to assign people to groups based on allele frequency at a certain number of loci, they have chosen loci that show differences between the groups they are trying to distinguish.

The work of Devlin and Risch, Evett et al., Lowe et al., and others suggests that only about 10 percent of DNA sites are "useful" for making such distinctions.[25] This means that at the other 90 percent of the sites, the allele frequencies do not vary between groups such as "Afro-Caribbean people in England" and "Scottish people in England." Even though we cannot find a single site at which allele frequency matches some phenotype that we are trying to identify (for forensic purposes, we should be reminded), it does not follow that no grouping (of four, six, seven) can be found that will be effective, for the purposes of aiding the FBI, Scotland Yard, or the criminal justice systems around the globe in making highly probabilistic statements about suspects and the likely ethnic, racial, or cultural populations from which they can be identified—statistically.

So when molecular biologists assert that "race has no validity as a scientific concept," there is an apparent contradiction with the practical applicability of research on allele frequencies in specific populations. It is possible to sort out and make sense of this, and even to explain and resolve the apparent contradiction—but only if we keep in mind the

difference between using a taxonomic system with sharp, discrete, definitively bounded categories and using one with categories that show patterns (with some overlap) that may prove to be empirically or practically useful. When representative spokespersons from the biological sciences say that "there is no such thing as race," they mean, correctly, that there are no discrete categories of "race" that come to a discrete beginning and end; that there is nothing mutually exclusive about our current (or past) categories of "race"; and that there is more genetic variation within categories of "race" than among them.

All this is true. However, when Scotland Yard, or the Birmingham, England, Police Force, or the New York Police Force wants to narrow the list of suspects in a crime, it is not primarily concerned with tight taxonomic systems of classification with no overlapping categories. That is the stuff of theoretical physics and of logic in philosophy, not the practical stuff of helping to solve crimes or the practical application of molecular genetics to health care delivery via genetic screening—and all the messy overlapping categories that will inevitably be involved with such enterprises. That is, some African Americans have cystic fibrosis, even though the likelihood is far greater among Americans of North European descent; and in a parallel if not symmetrical way, some American whites have sickle cell anemia even though the likelihood is far greater among Americans of West African descent. But in the world of cost-effective decision-making, genetic screening for these disorders is routinely done based on commonsense versions of the phenotype. The same is true for the quite practical matter of naming suspects.

The July 8, 1995, issue of *New Scientist*, titled *Genes in Black and White*, makes some extraordinary claims about what it is possible to learn about socially defined categories of race from reviewing information gathered using new molecular genetic technology. In 1993, a British forensic scientist published what is perhaps the first DNA test explicitly acknowledged to provide "intelligence information" along "ethnic" lines for "investigators of unsolved crimes." Ian Evett, of the Home Office's forensic science laboratory in Birmingham, and his colleagues in the Birmingham Metropolitan Police, claimed that they had developed a DNA test that could distinguish between "Caucasians" and "Afro-Caribbeans" in nearly 85 percent of the cases.

Evett's work, published in the *Journal of the Forensic Science Society*, draws on apparent genetic differences in three sections of human DNA. Like most stretches of human DNA used for forensic typing, each of these three regions differs widely from person to person, irrespective of race. But by looking at all three, Evett and his fellow researchers claimed that under select circumstances, it is possible to estimate the probability that someone belongs to a particular racial group. The implications of this for determining, for practical purposes, who is and who is not "officially" a member of some racial or ethnic category are profound.

A year after the publication of a statement by the United Nations Educational, Scientific, and Cultural Organization purportedly buried the concept of "race" for the purposes of scientific inquiry and analysis,[26] and during the same time period that the American

Anthropological Association was deliberating on and generating a parallel statement, an article in the *American Journal of Human Genetics*, written by Evett and his associates, was summarized in the article's abstract as follows:

Before the introduction of a four-locus multiplex short-tandem-repeat (STR) system into casework, an extensive series of tests were carried out to determine robust procedures for assessing the evidential value of a match between crime and suspect samples. Twelve databases were analyzed from the three main ethnic groups encountered in casework in the United Kingdom: Caucasians, Afro-Caribbeans, and Asians from the Indian subcontinent. Independence tests resulted in a number of significant results, and the impact that these might have on forensic casework was investigated. It is demonstrated that previously published methods provide a similar procedure for correcting allele frequencies—and that this leads to conservative casework estimates of evidential value.[27]

In more recent years, the technology has moved along, and forensic scientists are now using VNTR loci and investigating twelve to fifteen segments of the DNA, not just the earlier three to seven. Recall that in the opening section of the chapter I referred to a pilot program of the New York City Police Department that employs thirteen loci for identification purposes. The forensic research conducted by Evett and his colleagues occurred before the computer chip revolution, which will permit research on a specific population to develop an SNP profile of that group.[28]

Deploying DNA technology in this fashion can be dangerously seductive. Computers will inevitably be able to find some patterns in the DNA within a group of, say, three thousand burglars. But this is a mere correlation of markers, and it is far from anything but a spurious correlation that will explain nothing—but it will have the seductive imprimatur of molecular genetic precision.

The Dangerous Intersection of "Allele Frequencies in Special Populations" and "Police Profiling via Phenotype"

The conventional wisdom is that DNA fingerprinting is just a better way of getting a fingerprint. That "wisdom" is wrong. The traditional physical imprint of one's finger or thumb provides only that specific identifying mark, and it is attached to one individual and one individual alone.[29] Quite unlike an actual fingerprint, DNA contains information about many other things that go beyond simple identification. It contains information about potential or existing genetic diseases or genetic susceptibilities one may have, and information about one's family. These can involve data of interest to one's employer and, of course, to insurance companies. For these reasons, law enforcement officials claim that they are interested only in that part of a DNA profile that provides identifying markers that are not in coding regions. Coding regions account for only 10 percent of the DNA in a DNA sample, and it is in these regions that the nucleotides code for proteins that

might relate to a full range of matters of concern to researchers, from cancer or heart disease to neurotransmission, and thus, for some, to *possible "coding" for "impulsivity" or biochemical outcomes that might relate to violence.* Although the FBI and local and state law enforcement officials tell us that they are looking only at genetic markers in the noncoding region of the DNA samples they take, twenty-nine states now require that tissue samples be retained in their DNA databanks after profiling is complete.[30] Only Wisconsin requires the destruction of tissue samples once the DNA profile has been extracted.

States are the primary venues for the prosecution of violations of the criminal law, and their autonomy has generated considerable variation in the use of DNA data banks and storage of DNA samples. Even as late as the mid-1980s, most states were collecting DNA samples only from sexual offenders. The times have changed quite rapidly. All fifty states now contribute to CODIS. Moreover, there has been rapid change in the interlinking of state DNA databases. In just two years, the CODIS database went from nine states crosslinking "a little over 100,000 offender profiles and 5,000 forensic profiles" to thirty-two states, the FBI, and the U.S. Army linking "nearly 400,000 offender profiles, and close to 20,000 forensic profiles."[31] States are now uploading an average of 3,000 offender profiles every month. If this sounds staggering, recall that computer technology is increasingly efficient and extraordinarily fast. It now takes only five hundred microseconds to search a database of 100,000 profiles.[32]

As we increase the number of profiles in DNA databases, there will be researchers proposing to provide SNP profiles of specific offender populations. Twenty states authorize the use of data banks for research on forensic techniques. Based on the statutory language in several of those states, this could easily mean assaying genes or loci that contain predictive information. Tom Callaghan, program manager of the FBI's Federal Convicted Offender Program, has refused to rule out such possible uses by behavioral geneticists seeking a possible profile for a particular allele among specific offender populations, including especially violent offenders and sexual offenders.[33] It is useful to note here that SNP profiles of violent and sexual offenders are the wedge that opens up the expansion via "function creep" to other crimes and even misdemeanors. Indeed, Louisiana became, in 1999, the first state to pass a law permitting the taking of a DNA sample from all merely arrested for a felony.

Thirty states now require data banking DNA of *all* felons, including those convicted of white-collar felonies. In the fall of 1998, New York Governor George Pataki proposed that the state include white-collar convicts in the DNA database, but the state assembly balked, and forced him to jettison the idea. Perhaps they were concerned that some saliva might be left on the cigars stubs in those back rooms where price-fixing and security frauds occur. Today, nearly half the states include those convicted of certain misdemeanors in the DNA databank. So we can now see that what started as DNA collection from "sex offenders" has now graduated to collection from misdemeanants and arrestees. Although thirty-nine states permit expungement of profiles from DNA databases if

charges are dropped, almost all of those states place the burden on the individual to initiate expungement.

Population-wide DNA Database

It is now relatively common for scholars to acknowledge the considerable and documented racial and ethnic bias in police procedures, prosecutorial discretion, jury selection, and sentencing practices—of which racial profiling is but the tip of the iceberg.[34] Indeed, racial disparities penetrate the whole system and are suffused throughout it, all the way up to and through racial disparities in seeking the death penalty. If the DNA database is composed primarily of those who have been touched by the criminal justice system, and that system has engaged in practices that routinely select more from one group than from others, there will be an obvious skew or bias toward the former group in the database. David Kaye and Michael Smith take the position that the way to handle the racial bias in the DNA database is to include everyone.[35]

But this does not address the far more fundamental problem of the bias that generates the configuration and content of the criminal (or suspect) database. If the lens of the criminal justice system is focused almost entirely on one part of the population for a certain kind of activity (drug-related street crime) and ignores a parallel kind of crime (fraternity cocaine sales a few miles away), then even if the fraternity members' DNA is in the data bank, they will not be subject to the same level of matching, or of subsequent allele-frequency-profiling research to "help explain" their behavior. *That behavior will not have been recorded.* That is, if the police are not arresting the fraternity members, it does not matter whether their DNA is in a national database, because they are not *criminalized* by the selective aim of the artillery of the criminal justice system.

Thus it is imperative that we separate arguments about bias in the criminal justice system at the point of contact with select parts of the population from "solutions" to bias in cold hits. It is certainly true that if a member of one of those fraternities committed a rape, left tissue samples at the scene, and—because he was in a national DNA database—the police could nab him with a cold hit, that would be the source of the justifiable applause with which I opened this chapter. But my point here is that by ignoring powder cocaine and emphasizing street sales of crack cocaine in the African American community, the mark of criminality thereby generated is not altered by having a population-wide DNA database. However, the surface fiction of objectivity will lead to a research agenda regarding the DNA database about which I would now like to issue a warning.

There is a serious threat of how new DNA technologies are about to be deployed that is masked by the apparent global objectivity of a population-wide DNA database. I am referring to the prospects for SNP profiling of offenders. As noted, even if everyone's DNA profile were in the national database, this would not deter the impulse of some to do

specific and focused research on the select population that has been convicted, or who are, in Amitai Etzioni's phrase, "legitimate suspects."

An article in the *American Journal of Human Genetics* in 1997 made the following claim:

[W]e have identified a panel of population-specific genetic markers that enable robust ethnic affiliation estimation for major U.S. resident populations. In this report, we identify these loci and present their levels of allele-frequency differential between ethnically defined samples, and we demonstrate, using log-likelihood analysis, that this panel of markers provides significant statistical power for ethnic affiliation estimation.[36]

As in the earlier work by Devlin and Risch,[37] one of the expressed purposes of this research is its "use in forensic ethnic affiliation estimation."[38] Such a research agenda is likely to produce a significant challenge to the communitarian claim of a common public-safety interest in maintaining a DNA database.

DNA Profiling and the Fracture of "Community"

Perhaps the central thesis of the communitarian movement is that we need to strike a better balance between individual rights and community interests. That is a laudable goal when it is possible to determine a consensus of community interest based on the common health, the commonweal(th), and the common interest. Normally, health is just such an issue. The right of an individual to remain in a community while he or she has a contagious disease such as smallpox or tuberculosis is trumped by the state's right to protect the health of the general citizenry. But molecular biology has played a powerful role in fracturing the public-health consensus.

Whereas we could all agree that it is in our common interest to rid ourselves (more or less) of cholera, yellow fever, tuberculosis, infectious meningitis, and smallpox, this type of communitarian consensus about public-health issues has been dramatically undermined as we have learned that some groups are at higher risk for particular genetic disorders than others. Cystic fibrosis is a genetic disorder that can affect the upper respiratory system in a life-threatening manner, but only those of North European ancestry are at significant risk for developing the disorder. Beta-thalassemia is a blood disorder associated primarily with persons of southern Mediterranean ancestry. Sickle cell anemia is primarily associated, in the United States, with Americans of West African descent. And so it goes. In the 1970s, the public-health consensus about general health screening was disrupted by group interests that began to emerge to demand more funding for research and for genetic testing for the gene disorder most associated with "their group."[39]

If molecular genetics and the emergence of group-based research agendas fractured the country's public-health consensus, we can expect an even more dramatic parallel develop-

ment when it comes to discussions of public safety. It is almost inevitable that a research agenda will surface to try to find patterns of allele frequencies, DNA markers, and genetic profiles of different types of criminals. One could do an SNP profile of rapists and sex offenders and find some markers that they putatively share. As noted above, "ethnic-affiliation estimations of allele frequencies" is high on the research agenda in forensic science. In the abstract, there is a public consensus about the desirability of reducing crime. However, when it comes to the routine practices of the criminal justice system, a demonstration of systematic bias has eroded (and will further erode) the public consensus on how this is best achieved. The war on drugs began with a broad consensus, but the consensus fractured when the practices briefly outlined earlier in the chapter, and thoroughly documented in the literature, came to light.[40] This fracture in the public consensus will be exacerbated by the inevitable search for genetic markers and the seductive ease into genetic explanations of crime.

But like phrenology in the nineteenth century, these markers will be precisely that, "markers," and will not explain "the causes" of violent crime. Even if the many causes of criminal violence (or any human behaviors) are embedded in the full range of forces that begin with protein coding, there is interaction at every level, from the cellular environment, all the way up through embryological development, to the ways in which the criminal justice system focuses on one part of the town and not another when making drug busts. We are bemused today about tales of nineteenth-century scientists who sought answers to criminal behavior by measuring the sizes and shapes of the heads of convicted felons. The newest IBM computers can make 7.5 trillion calculations per second for biological chip analysis. These are sirens beckoning researchers who wish to do parallel correlational studies of "population-based allele frequencies" with "ethnic estimations" and groupings of felons—a recurring seduction to a false precision. A higher and more determined vigilance regarding these and similar developments is necessary if we are to avoid repeating the mistakes of the late nineteenth century.

Acknowledgment

This chapter is a slightly revised version of an article previously published as "Selective Arrests, An Ever-Expanding DNA Forensic Database, and the Specter of an Early Twenty-First Century Equivalent of Phrenology," in David Lazer, ed., *DNA and the Criminal Justice System: The Technology of Justice* (Cambridge, MA: MIT Press, 2004), pp. 315–334.

Notes

1. Jim Dwyer, Peter Neufeld, and Barry Scheck, *Actual Innocence: Five Days to Execution and Other Dispatches from the Wrongly Convicted* (New York: Doubleday, 2000). At the time of Dwyer's report,

the number was less than one hundred, but in the last two years there have been a number of additions.

2. Aaron P. Stevens, "Arresting Crime: Expanding the Scope of DNA Databases in America," *Texas Law Review* 24 (March 2001); Allison M. Puri, "An International DNA Database: Balancing Hope, Privacy, and Scientific Error," *Boston College International and Comparative Law Review* 24 (2001).

3. Kevin Flynn, "Fighting Crime with Ingenuity, 007 Style: Gee-Whiz Police Gadgets Get a Trial Run in New York," *New York Times*, March 7, 2000, p. A21.

4. Dorothy M. Nelkin and Susan Lindee, *The DNA Mystique: The Gene as Cultural Icon* (New York: Freeman, 1995).

5. Andrew Hacker, *Two Nations: Black and White, Separate, Hostile, Unequal* (New York: Scribner's, 1992), p. 197.

6. Timothy J. Flanagan and Kathleen Maguire, eds., *Sourcebook of Criminal Justice Statistics 1989* (Washington, D.C.: U. S. Government Printing Office, 1990).

7. Edna McConnell Clark Foundation, *Americans Behind Bars* (New York: The Foundation, 1992).

8. James S. Austin and Aaron David McVey, *The N.C.C.D. Prison Population Forecast: The Impact of the War on Drugs (F.O.C.U.S.)* (San Francisco: National Council on Crime and Delinquency, 1989), pp. 1–7.

9. Reported in the *New York Times*, February 27, 1990.

10. Jerome G. Miller, *Hobbling a Generation: Young African American Males in the Criminal Justice System of America's Cities: Baltimore, Maryland* (Alexandria, Va.: National Center on Institutions and Alternatives, 1992).

11. Author's interviews with several public defenders in the San Francisco Bay Area and Atlanta regarding their caseloads involving drug charges, 1989.

12. When the police conducted a raid on a fraternity house in Virginia in 1989, it was national news . . . almost a "man bites dog" story.

13. Ronald Sullivan, "Judge Finds Bias in Bus Terminal Search," *New York Times*, April 25, 1990, p. B3.

14. Ron Harris, "War on Drugs Is Charged as War on Black America," *Los Angeles Times*, April 22, 1990.

15. Flanagan and Maguire, *Sourcebook of Criminal Justice Statistics 1989*.

16. 21 U.S.C. § 841 (a).

17. Barbara S. Meierhoefer, *The General Effect of Mandatory Minimum Prison Terms: A Longitudinal Study of Federal Sentences Imposed* (Washington, D.C.: Federal Judicial Center, 1992).

18. Those who defend disparate sentencing policies for crack and powder cocaine argue that crack produces a more violent environment. For a full discussion of these issues, see Craig Reinarman

and Harry G. Levine, eds., *Crack in America: Demon Drugs and Social Justice* (Berkeley: University of California Press, 1997).

19. Meierhoefer, *The General Effect of Mandatory Minimum Prison Terms*.

20. For a full account of the methodology used in the Maryland State Police study, see http://www.aclu.profiling/report/index/html (accessed November, 2003).

21. Solomon H. Katz, "Is Race a Legitimate Concept for Science?," in *The AAPA Revised Statement on Biological Aspects of Race: A Brief Analysis and Commentary* (Philadelphia: University of Pennsylvania, 1995); Luigi Luca Sforza-Cavalli, "Race Difference: Genetic Evidence," in Edward Smith and Walter Sapp, eds., *Plain Talk About the Human Genome Project* (Tuskegee, Ala.: Tuskegee University, 1997), pp. 51–58.

22. B. Devlin and Neil Risch, "A Note on the Hardy-Weinberg Equilibrium of VNTR Data by Using the Federal Bureau of Investigation's Fixed-Bin Method," *American Journal of Human Genetics* 51 (1992): 549–553. As predicted in B. Budowle et al., "Fixed-Bin Analysis for Statist Evaluation of Continuous Distributions of Allelic Data from VNTR Loci, for Use in Forensic Comparisons," *American Journal of Human Genetics* 48 (May 1991): 841–855.

23. B. Devlin and Neil Risch, "Ethnic Differentiation at VNTR Loci, with Specific Reference to Forensic Applications," *American Journal of Human Genetics* 51 (1992): 540, 546.

24. This is a major point that is being made by two sets of statements about race, one from UNESCO and the other from the American Anthropological Association, and it cannot be repeated too often.

25. Devlin and Risch, "Ethnic Differentiation at VNTR Loci"; Devlin and Risch, "A Note on the Hardy-Weinberg Equilibrium of VNTR Data"; I. W. Evett et al., "The Evidential Value of DNA Profiles," *Journal of the Forensic Science Society* 33, no. 4 (1993): 243–244; I. W. Evett et al., "Establishing the Robustness of Short-Tandem-Repeat Statistics for Forensic Application," *American Journal of Human Genetics* 58 (1996): 398–407; Alex L. Lowe et al., "Inferring Ethnic Origin by Means of an S.T.R. Profile," *Forensic Science International* 119 (2001): 17–22.

26. Katz, "Is Race a Legitimate Concept for Science?"

27. Evett et al., "Establishing the Robustness of Short-Tandem-Repeat Statistics for Forensic Application," 398.

28. Hisham Hamadeh and Cynthia A. Afshari, "Gene Chips and Functional Genomics," *American Scientist* 88 (2000): 508–515.

29. Simon Cole has published a book challenging some of the long-held beliefs about the infallibility of the physical fingerprint, but that is another story. Simon A. Cole, *Suspect Identities: A History of Fingerprinting and Criminal Identification* (Cambridge, Mass.: Harvard University Press, 2001).

30. Jonathan Kimmelman, "Risking Ethical Insolvency: A Survey of Trends in Criminal DNA Databanking," *Journal of Law, Medicine and Ethics* 28 (2000): 211.

31. Barry Brown, statement for panel at "DNA and the Criminal Justice System" conference, John F. Kennedy School of Government, Harvard University, November 20, 2000.

32. Ibid.

33. Kimmelman, "Risking Ethical Insolvency."

34. Marc Mauer, *Race to Incarcerate* (New York: New Press, 1999).

35. David H. Kaye, and Michael E. Smith, "DNA Databases for Law Enforcement: The Coverage Question and the Case for a Population-wide Database," in David Lazer, ed., *DNA and the Criminal Justice System: The Technology of Justice* (Cambridge, MA: MIT Press, 2004), pp. 247–284.

36. Mark D. Shriver et al., "Ethnic Affiliation Estimation by Use of Population-Specific DNA Markers," *American Journal of Human Genetics* 60 (1997).

37. Devlin and Risch, "Ethnic Differentiation at VNTR Loci."

38. Shriver et al., "Ethnic Affiliation Estimation by Use of Population-Specific DNA Markers," p. 957; see also Lowe et al., "Inferring Ethnic Origin by Means of an STR Profile."

39. Troy Duster, *Backdoor to Eugenics*, 2nd ed. (New York: Routledge, 2003).

40. Reinarman and Levine, *Crack in America*; Mauer, *Race to Incarcerate*; Jerome G. Miller, *Search and Destroy: African-American Males in the Criminal Justice System* (New York: Cambridge University Press, 1996); David Cole, *No Equal Justice: Race and Class in the American Criminal Justice System* (New York: New Press, 1999).

Discovering Nature, Apparently

Analogy, DNA Imaging, and the Latent Figure Protocol

Paul Vanouse

DNA analysis can now rightly be called "DNA fingerprinting," says Dwight Adams, chief of the scientific analysis section at the FBI laboratory in Washington, D.C. The term "invokes in the mind of the jury that we are identifying one individual to the exclusion of all others."[1]

A "DNA fingerprint" or "genetic portrait" is often understood by the lay public to be a single, unique human identifier. Its complex banding patterns are imagined as an unchanging sentence written by Mother Nature herself that corresponds to each living creature. However, there are hundreds of different enzymes, primers, and molecular probes that can be used to segment DNA and produce banding patterns. These banding patterns tell us as much about the enzyme/primer/probe as the subject of the experiment that they appear to represent. This is because different enzymes cut DNA at different base-pair sequences (e.g., ACCGGT), and different molecular probes bind to different base-pair sequences; it is these two processes that determine the number and location of DNA bands in a DNA image. For instance, figure 11.1 shows three different subjects imaged using three different enzyme combinations but the same molecular probe (the first subject's DNA occupies vertical columns 1, 4, and 7). (See figure 11.1)

To put it another way, DNA exists in the cell as a single long strand. It does not contain "bands"; rather, specific laboratory techniques can cause DNA to be chopped into smaller units that, when imaged, appear as a series of bands at different heights within an image. These techniques exploit the fact that different chemicals can cut specific sequences of base pairs that may differ between individuals in number or strand location. Any individual's DNA can appear in hundreds of different banding patterns, depending upon which chemical combinations are used in the laboratory. Thus the DNA gel image is a culturally constructed artifact (determined by the laboratory, often guided by a given

Figure 11.1 Standard DNA "Fingerprint." From A. J. Jeffreys, V. Wilson, and S. L. Thein, "Individual Specific 'fingerprints' of human DNA," *Nature*, 316 (July 4, 1985): 76–79.

set of standards) that is often naturalized (made to seem as if it existed prior to laboratory intervention).

As an artist, both my critique and my tactics of resistance center on the DNA image and the slippery metaphors that have permeated human genetics and become naturalized. My work cheekily explores this naturalization and seeks to shake audiences' assumptions about race and identity by forcing the esoteric codes of scientific communication to "speak" in a broader cultural language. These works are "self-reflexive"—they engage issues in contemporary technoscience using technoscientific processes and materials as their medium.

This chapter discusses the processes through which DNA images are produced, their relationship to previous identification technologies, their implications in the social milieu, and an experimental scientific protocol designed to lessen their authority.

Figure 11.2 *Paul Vanouse, The Relative Velocity Inscription Device,* Henry Art Gallery, Seattle, Washington, 2002.

DNA Imaging Explained

"DNA fingerprints" and "genetic portraits" are disparate analogies for DNA gel imaging. The former is a comparison to a reasonably accurate authoritative protocol used in criminology. Fingerprints as unique markers of identity were originally proposed by Henry Faulds in 1880. Later Francis Galton, "the Father of Eugenics," and E. R. Henry each developed alternative classification systems. Henry's fingerprinting system was used in India by the late 1890s and first used by Scotland Yard in 1901. Portraits, on the other hand, were historically instrumental to the amplification of social authority but have little or no scientific authority, being artistic representations often referencing the subject's social position, wealth, or profession.

The term "DNA fingerprinting" was coined by the British geneticist Alec Jeffreys in 1985, to describe his method of isolating and imaging sequences of DNA.[2] The procedure begins with the obtaining of a sample of cells and extraction of the DNA. The long strands of DNA are then subjected to an enzyme that cuts each strand at specific locations—a distinct base-pair sequence (for instance, CTTAAG). These DNA fragments are then

separated by size, using a process called gel electrophoresis. Each sample is loaded into the top of its own lane in a porous gelatin and is subjected to an electrical field, which pulls the DNA toward the positive pole; small fragments move the fastest, and larger fragments, more slowly. The DNA is then transferred to a special paper called a membrane and fixed into place.

This membrane is then washed with a radioactive "probe." Probes are essentially DNA or RNA fragments that are complementary (they form bonds) to highly variable regions in human DNA. The bound probe sticks to areas on the long DNA smear produced by electrophoresis. After unbound probe is rinsed off, the membrane, when exposed to X-rays, produces on film the iconic images with horizontal bands resembling a bar code. Since not all individuals will have the same sequence at the same point in their DNA strand, the probe will produce different banding patterns. And, provided the experiment is performed with the same enzymes/probes/gel combinations, the pattern for an individual should never change. Though all human DNA is 99.9 percent the same, Jeffreys's method targeted the locations that are the most subject to variation, VNTRs (variable nucleotide tandem repeats). These locations are predictable (the same in every strand of DNA in each individual), but often vary between individuals. Though Jeffreys developed the protocol during his research on genetics, he quickly recognized its implications for personal identification, patented the technique, and offered it to British police to aid in two rape-and-murder investigations.

DNA fingerprinting and its synonyms, such as DNA forensics and DNA typing, have come to refer to a wide range of techniques—most based on the afore-mentioned procedure—that can be used for identification. There are hundreds of enzymes that can be used to segment DNA, and each can place the VNTRs on different locations on the DNA smear. There are dozens of VNTR regions in our DNA, and different probe combinations will highlight different bands. Thus, thousands of different banding patterns can be produced to represent an individual or to differentiate individuals. Furthermore, several different approaches can change the relative distance between bands in a DNA image, including the electrical field strength of the electrophoresis gel and the concentration/density of the gel.

Why is there not a simple common definition for this procedure (why can my DNA image vary)? Since the advent of the procedure there has been some standardization—for instance, the CODIS project, described below, uses a thirteen-VNTR-site standard. There are dozens of reasons, however, for the slow adoption of standards. The initial procedure was developed for scientific, rather than legalistic, reasons, so its initial design was merely a tool for a specific scientific inquiry. However, its instantaneous entry into criminal law (mostly for the prosecutors) led to a flurry of expedient solutions. Subsequent designs were patented by varied companies, all with financial interests in their own techniques, which forced other companies to investigate different options. Hyperbolic claims of effectiveness permeated varied claims of the different companies. Some companies had really good lob-

byists. Faulty procedures were exposed in criminal trials. Law enforcement agencies began building databases based on certain techniques that would be incompatible with others. Subsequent genome studies found more VNTR regions. Subsequent population genetics studies found some VNTR sites more useful. Certain crime labs found completely new procedures (for instance, PCR amplification rather than enzyme digestion) that were more suited to cases in which there was a smaller sample of DNA. But . . . more in keeping with my argument, one's DNA image can vary so much because nature didn't put DNA in our bodies as a personal identification system.

Both advocates and opponents of increased usage of DNA typing in broader population databases for use in criminal law have objected to the term "DNA fingerprints." For instance, Norah Rudin, in her article "DNA Untwisted," in the San Francisco *Daily Journal*,[3] as well as in a subsequent book, *Forensic DNA Analysis*,[4] details why the term is "in fact a misnomer." Likewise, Jonathan Kimmelman writes in the journal *Nature Biotechnology*[5] that "facile analogies to fingerprints obscure critical differences that warrant ethical solicitude." Rudin goes so far as to suggest a retronym for conventional fingerprinting, "dermatoglyphic fingerprints."[6] My objection to the term revisits some of their arguments while addressing many new ones that are particularly vexing to one working at the crossroads of artistic practice, DNA visualization, and cultural studies of science. Indeed, rather than a mere misnomer, I find the term fundamental to the current implementation strategies of DNA typing and massively revealing in its broad significations. As an artist, both my critique and my tactics of resistance center on the image and the metaphor itself.

The Differences

Unlike a real fingerprint, the DNA fingerprint has no biological stability, as nature did not endow us with a unique two- to twenty-band image for individuation. Images have been formed by varied versions of the aforementioned processes. These processes are cultural: images have been constructed based on the state of our understanding of DNA, and the instantiation of method has been a complex social process.

Furthermore, the images are based on VNTR regions that biologically are the least determining of our physical appearance. Unlike a real fingerprint, which stems directly from the physical patterns on our hands, the VTNR regions are so variable because their direct influence on our development is not yet known. These regions are not "genes," so mutations in these regions throughout evolution have not privileged one individual over another. While this fact is comforting (because it means that conventional DNA fingerprinting doesn't yet provide easy eugenic handles for interpretation), it also distances the images farther from a sense of "self."

Since the image does not represent "us," but rather the process of our identification, we have no rational recourse to its truthfulness. It doesn't look like us, and the protocols

through which it was created are not accessible. It offers a representation of our inner codes in the most authoritarian manner—a representation of self which the layperson could never recognize or differentiate. While DNA evidence has actually been useful for clearing the wrongfully accused—*this is in fact where DNA evidence can be conclusive, since DNA patterns that differ cannot be from the same individual*—prosecution teams have often played the hype of DNA to make false claims of accuracy. Since the inception of the use of DNA evidence in the courtroom, there have been problems with the defense's ability to refute hot new techniques, particularly when the government accuses an individual of a crime. This has led to wrongful convictions and many misguided prosecution attempts.

One often discussed case is that of *New York* v. *Castro*, in which José Castro was accused of murdering a mother and daughter. The Lifecodes Corporation undertook DNA analysis (for the prosecution) of a small bloodstain on his wristwatch. The company reported it had found a match between the DNA in the bloodstain and that of the mother, stating that the frequency of the band pattern was one in 100 million among U.S. Hispanics. However, upon pretrial scrutiny, the actual DNA image showed the wristwatch DNA to contain five bands, whereas the victim's contained only three. Though the company tried to claim the extra bands were the result of contamination, it became apparent that its analysis was biased by seeing what it had hoped to see rather than what an unbiased skilled observer might.[7]

The case also highlights a frequent use of match probabilities by prosecution teams to give weight to their testimony. Marjorie Maguire Shultz discusses a case in England in which the prosecution claimed that a murder/rape suspect's DNA matched that found in a sperm sample recovered from the victim. They stated that the odds that the sperm had not come from the defendant were about 6–8 million to one. Significantly, the probabilistic testimony failed to discover and note that the woman's husband's DNA also matched.[8]

When the chief of the FBI's scientific analysis section states that the term "DNA fingerprinting . . . invokes in the mind of the jury that we are identifying one individual to the exclusion of all others," the metaphor's misleading usage seems intentional.[9] In fact, the actual probabilities of variance across VNTR regions are highly contested. (This is why DNA evidence is scientifically much better suited for falsifying an alleged match than for finding an exact equivalence; that is, it is more useful for defense against false accusations than for prosecution of a specific person.) Shultz notes, "If the individual lacks the resources to balance the disparity of power (the sheer authority of DNA science), the attainment of legitimate outcomes through the competitive process will be compromised."[10]

The DNA image, however, may carry much more sensitive information about us than actual fingerprints do. The VNTR regions are passed on genetically, so the retention of an individual's DNA in a data bank compromises the anonymity of his/her ancestors,

siblings, and progeny. After all, the techniques described earlier were first developed by Jeffreys during work on population genetics.

Last, unlike a real fingerprint, DNA fingerprints offer a much greater possibility for speculative use—such as to determine supposed character and disposition. Though I previously noted that VNTR regions of DNA have yet to be found to code for physical traits, the all too recent history of eugenics and racist science should caution us about the potential for inferential abuse.

The Prospects

Though it is the intent of this chapter to focus on the slippery analogy of the fingerprint, further attention to pressing trends, trajectories, and implications will explain why I believe this issue is so urgent. The points which I summarize below have been fleshed out in publications such as *DNA and the Criminal Justice System* (2004), *DNA on Trial* (1992), and *Documenting Individual Identity* (2001). Authors such as Troy Duster (included in this volume) have addressed many of the following issues in greater depth than it is my purpose to detail.

Today, the fingerprint analogy is crucial to the large-scale implementation of national genetic data registers and expanding a disciplinary agenda. It provides suitable reference to increased means of criminalization while reassuring that its uses will be focused upon the usual suspects. Recent U.S. projects such as the 2004 Justice for All Act accurately fit this description by expanding the Combined DNA Index System (CODIS), begun in 1994 (DNA fingerprints of all convicted felons), while also permitting the retention of DNA data from those simply accused of a crime.

But the implications for this project are hardly complete with the creation of an ever-expanding database of the usual suspects. NIH reports already acknowledge future ethical issues of DNA fingerprinting that dwarf those of traditional fingerprinting. For instance, just as medical uses of genomics have made tentative hypotheses about certain genes making one susceptible to illnesses or addictions, similar claims may follow from prosecutors asserting additional behavioral traits, such as criminality. Indeed, research in the 1960s suggested that males carrying an extra Y chromosome have a genetic predilection to violence,[11] and current research has suggested that Maori (indigenous New Zealander) males have a "warrior gene" which makes them more prone to violent and criminal behavior.[12] Such studies have a potential for stigmatizing entire gene pools. Since the science of DNA interaction, and certainly its links to environmental factors, are far from exact, we will best be able to describe their uses as inferential—based on an assumption that if two things are known to be analogous in certain respects, they must be alike in others.

A database of disproportionately nonwhite subjects, such as CODIS, provides extensive source material for prosecutors seeking to implicate currently free subjects, especially

when they are genetically related to others who have previously been in the criminal justice system. For instance, comparing DNA print patterns of convicted persons with that of a suspect might show genetic similarities that could be used to make correlations—scientized stereotypes—at the molecular level. Financial incentives for such an agenda are enacted in components of the Justice for All Act that allow for the participation of "private DNA labs" (which would complement the existing private prison industry).[13] The CODIS program and the Justice for All Act's provisions for expansion provide, according to Christine Rosen, "an inescapable means of identification, categorization, and profiling, and it does so with a type of information that is revelatory in a way few things are."[14]

An added concern for many critics of national DNA databanks is what has been referred to as "function creep." Function creep describes the process by which (identification) materials collected for one purpose are used for another. Pamela Sankar describes how real fingerprint databases, used to issue immigrant ID cards or to identify dead and wounded military personnel, by the 1930s were added to criminal databases during J. Edgar Hoover's tenure as FBI director. She notes of the expanded database: "What was once a small federal collection limited to fingerprints of convicted felons became, by the 1940s, a vast storehouse of tens of millions of prints taken not only from anyone who had a brush with the law, but from many people who had not."[15] The rules governing boundaries between medical collections, military collections, and suspect collections of DNA are similarly vulnerable to political whim aided by fanciful pronouncements as to the efficacy of DNA typing and reassurances that only criminals would fear expansion. Twice in the last five years, identity records held by the U.S. Department of Veterans Affairs have been stolen from agency computers, so in addition to government-complicit function creep, the probabilities of unintended function creep should be acknowledged.[16]

In the United States, seemingly the strongest protection for those whose DNA is retained without conviction or for nonviolent offenses, and against function creep lies in the Fourth Amendment, which bans unreasonable searches and seizures. Having one's DNA extracted and committed to a database, and potentially used to investigate any infraction, flies in the face of "probable cause," as it lacks any quality of "individuated suspicion." Furthermore, such a database poses risks for relatives of those persons. But, as Amitai Etzioni notes, "Searches lacking individualized suspicion have repeatedly been upheld by the courts if there are other good reasons for them, whether these reasons are said to fall under a 'special needs exception' or a 'public safety exception' to the Fourth Amendment."[17] He uses the examples of sobriety checkpoints to test randomly chosen drivers for excessive alcohol consumption and the use of metal detectors in airports and public buildings as legal exceptions to the rule that will be difficult for opponents of DNA data banking to overcome.[18]

Even Jeffreys, an advocate of national DNA registers, argues against the information being held by police only and finds the retention of suspects' DNA "highly discrimina-

tory." His solution is to "expand the current database to include everyone," and that this database should not be held by police only, but used as a certificate of identity like a birth certificate.[19] (Jeffreys is referencing the English context, which is in many ways farther along in establishing a national DNA database than the United States is.) Though some antidiscrimination advocates might see this as a solution similar to the argument in the United States to establish a military draft to pressure the government to be more cautious about entering foreign invasions, I find it similarly problematic. Having a draft would not ensure that those of lower social status will not be employed in the most dangerous engagements, just as having a universal DNA database will not correct other discriminatory practices when it comes to its application. I find this a cynical tactic, based on trying to correct bad practices with an equally bad (if perhaps more fair) solution.

A last point of clarification for the reader. This discussion has focused on the use of DNA databases, easily searchable numerical data gleaned from conventional VNTR DNA typing (often misnamed "DNA fingerprinting"). Perhaps more troubling is the retention of DNA itself, which is often retained by states pending new methods of evaluating identity. The practice of retaining DNA has much greater potentials for abuse than what I have discussed here, especially because it contains genetic information currently known to reveal medical conditions and otherwise can be easily used for discrimination both inside and outside our legal system.

Critical Tactics

The esoteric nature of DNA imaging and analysis has hampered discussion of the numerous issues raised by its implementation in the social milieu. However, it has been the focus of my artistic practice since 1999. Initially, my concerns and tactics focused upon the slippery yet authoritative analogies of eugenics and similar potentials for abuse in contemporary genomics. *The Relative Velocity Inscription Device* (2002) is a live scientific experiment in the form of an interactive, multimedia installation. The work uses skin color genes from my "biracial" Jamaican/American family members, who literally compete with one another to determine the gene's "fitness" (in an intentionally slippery analogy (i.e., the fittest genes must move the fastest). Jamaica was the site of a high-profile research project conducted by the American eugenicist Charles B. Davenport, and his book (*Race Crossing in Jamaica*) is included in the installation. By inserting DNA from each family member's skin color genes into a lane in an electrophoresis gel and applying voltage, the samples are literally "raced." (See figures 11.2 and 11.3.)

The process is similar to that employed by DNA fingerprinting, but each lane of the gel is limited to a single-size fragment and the experiment is run until the DNA races beyond the gel. As in the procedures described earlier in this chapter, the smaller gene fragments (from some family members) moved faster than larger fragments (from other

Figure 11.3 *The Relative Velocity Inscription Device*, Paul Vanouse, video projection still.

family members). The goal was to build a race about "race" in which the actual bodies of the participants had been "erased," thus begging the question Can racism exist even as the scientific gaze has left the body (eugenics) and gone molecular (genomics)?[20]

Viewers and critics have said that they initially felt intimidated by the authoritative spectacle, but as they engaged with the Davenport book and a touch-screen monitor describing my experiment, they found clues to interpretation. They have noted that it made them reflect on their own beliefs about genetic destiny, encouraged them to become more informed, and revealed ". . . how categorization and data collection methods of current genomics remain embedded in racist notions of difference."[21]

My recent focus on the analogy of the fingerprint is most articulated in my artwork *The Latent Figure Protocol.* This project is intended to force the DNA fingerprint from the position of irrefutable scientific evidence to that of a highly coded cultural representation, and to perform this argument in the space of public display. The work is an actual scientific experiment that takes the form of a one-hour performance in which DNA, processed previously by the artist, is added to an electrophoresis (DNA fingerprinting) gel and voltage is applied until the banding patterns are clearly discernible. A video camera connected to a projector makes each experiment clearly visible to viewers. (See figures 11.4, 11.5, and 11.6.)

Latent Figure Protocol counters the "naturalness" of the DNA fingerprint/genetic portrait by taking advantage of the myriad ways of cutting, amplifying, and re-presenting DNA information in culturally readable terms: using these DNA technologies to create representational images in which there is a tension between what is portrayed and the DNA used to generate it. Unlike a standard DNA fingerprint, *LFP* uses a gel containing DNA sequences cut with enzymes specifically chosen by me to create the correct size DNA fragments to produce a recognizable, quasi-photographic representation. Using

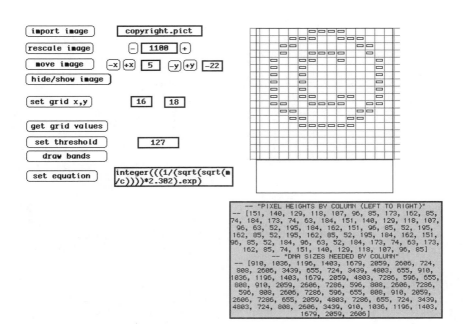

Figure 11.4 Screen grab of Latent Figure Protocol computer program written to determine DNA sizes and proper enzyme combination.

Figure 11.5 Inserting DNA into electrophoresis gel in preliminary development of the protocol (December 2005).

Discovering Nature, Apparently

Figure 11.6 *Latent Figure Protocol*, post-performance discussion with audience at *Human Nature II: Future Worlds*, SoFA gallery, University of Indiana, February 9, 2007.

twelve to sixteen lanes of gel, it is possible to generate iconic images by treating each lane as a row of pixels similar to early computer images that were made using ASCII characters. Inserting DNA of a known size into each lane will allow a sequence of DNA bands to migrate at different speeds when voltage is applied, creating a 2-D grid of DNA bands resembling a low-resolution bitmap image. (See figures 11.7 and 11.8.)

These images will be reflexive of the DNA donor, whether human, plant, animal . . . or some combination. A simple example would be to create an iconic image of the universal copyright symbol (©) using DNA from a transgenic crop (for instance, BT corn, a widely used genetically modified corn variety created by adding genes from a bacteria toxic to insects). Such an image connotes the tensions surrounding private ownership of GMOs and the status of organic life in general. Most instances of the project will use cheek cell DNA from human donors to generate images/portraits that clearly replicate familiar aspects of the individual's cultural signification. In this sense, the project seeks to downgrade the scientific authority of the "DNA fingerprint" to the status of a "portrait" (an association aided by my own status as an "artist" rather than a "scientist").

Figure 11.7 *Latent Figure Protocol,* installation at *Human Nature II: Future Worlds,* SoFA gallery, University of Indiana, February 9, 2007.

I am also interested in confronting the notion of genetic destiny. The notion that DNA somehow provides a template not only for much of our physical appearance but also for our specific relationship to and purpose within the societies in which we live (for instance, determining our income levels or our predilections toward criminality). These ideas were common in the eugenic era and have seen revived interest since the 1990s, particularly since the completion of the Human Genome Project (the recently completed list of every gene in human DNA). *Latent Figure Protocol* images cheekily address this determinist viewpoint, literally reproducing the subjects' cultural significations via their own DNA.

Conclusion

Analogies play an important role in transmitting hypotheses between "expert" and "non-expert" or, more generally, across disciplinary boundaries. They allow us to understand an esoteric system quickly via its similarities to a more familiar system. For example, electrical principles of current, voltage, and resistance are often introduced using analogies to water flow. However, more insidious analogies have occurred in social engineering projects, such as social Darwinism, to naturalize justifications for social inequities. Social Darwinists used the analogy of natural selection and applied it to counter human rights

Figure 11.8 *Latent Figure Protocol,* Figure was produced with the DNA of bacterial plasmid pET-11a. Enzymes used to process the DNA are listed in each column. Image produced December 6, 2006.

sentiments that had emerged in the 1800s. Likewise, convenient misleading analogies were instrumental to racist and eugenic science familiar through the turn of the nineteenth century. For instance, in the imperial wars of conquest, Africans were described as being like animals. Racist science took these analogies to heart, using the study of skull size to prove its point. Since the Africans who were measured reportedly had smaller skull sizes than the sample of Northern Europeans, they were claimed to be less intelligent, more like apes, and/or simply less evolved. And the comparison was sticky, as women's brains were also smaller than men's, thus naturalizing white males' dominant social position in the culture.[22]

The comparison of DNA typing to fingerprinting masks the constructedness of the visual patterns that represent its subjects. It also downplays the serious implications that are raised by DNA cataloging and usage within the criminal justice system. *Latent Figure Protocol* is designed to interrogate such issues and the broader genomic representation of identity. The project also seeks to promote a new type of scientific engagement by other

motivated laypersons and to raise questions about how massive undertakings such as the Human Genome project can be useful to (and utilized by) all of us.

Notes

1. Random Samples, "DNA Fingerprinting Comes of Age," *Science*, 278 (November 21, 1997): 1407.

2. A. J. Jeffreys, V. Wilson, and S. L. Thein, "Individual Specific 'Fingerprints' of Human DNA," *Nature*, 316 (July 4, 1985): 76–79. Note that in the title of the article, the term is within quotation marks, whereas in the text of the article it is not.

3. Norah Rudin, "DNA Untwisted," *Daily Journal* (San Francisco), April 20, 1995.

4. Keith Inman and Norah Rudin, *Forensic DNA Analysis* (Boca Raton, Fla.: CRC Press, 2002).

5. Jonathan Kimmelman, "The Promise and Perils of Criminal DNA Databanking," *Nature Biotechnology*, 18 (2000): 695–696.

6. Other retronym examples include "landline," which is so named to differentiate the word "phone" from the cellular phone. I find retronyms such as this problematic, as they obscure the fact that the original term was meaningful, whereas its replacement is redundant—obviously a "fingerprint" comes from a finger.

7. Eric Lander, "DNA Fingerprinting: Science, Law and the Ultimate Identifier," in Daniel Kevles and Leroy Hood, eds., *The Code of Codes* (Cambridge, Mass.: MIT Press, 1992), pp. 196–200.

8. M. M. Shultz, "Reasons for Doubt," in Paul R. Billings, ed., *DNA on Trial* (Plainview, N.Y.: Cold Spring Harbor Laboratory Press, 1992), p. 26. Shultz is referring here to an article by Brian Sheard, "DNA Profiling," *Medico-Legal Journal* 58 (1990–91): 189, 197.

9. Random Samples, "DNA Fingerprinting Comes of Age," p. 1407.

10. Shultz, "Reasons for Doubt," p. 33.

11. Karen Rothenberg and Alice Wang, "The Scarlet Gene: Behavioral Genetics, Criminal Law, and Racial and Ethnic Stigma," *Law and Contemporary Problems*, 69 (Winter/Spring 2006).

12. Agence France-Presse, "Maori Slam 'Warrior' Gene Study," *News in Science*, August 9, 2006. http://www.abc.net.au/science/news/health/HealthRepublish_1710435.htm.

13. Alice A. Noble, "ASLME Reports: A Summary of the Justice for All Act," Grant no. 1 Ro1-HG002836-01. 2005.

14. Christine Rosen, "Liberty, Privacy, and DNA Databases," *The New Atlantis*, no. 1 (Spring 2003): 39.

15. Pamela Sankar, "DNA-Typing," in Jane Caplan and John Torpey, eds., *Documenting Individual Identity* (Princeton, N.J.: Princeton University Press, 2001), p. 279.

16. Carolyn Mayer, "Records of 26.5 Million Veterans Stolen," *Washington Post*, May 22, 2006. http://blog.washingtonpost.com/thecheckout/2006/05/records_of_265_million_veteran.html.

17. Amitai Etzioni, "DNA Tests and Databases in Criminal Justice," in David Lazer, ed., *DNA and the Criminal Justice System* (Cambridge, Mass.: MIT Press, 2004), p. 205.

18. Ibid.

19. Alec Jeffreys, quoted by Giles Newton, "DNA Fingerprinting and National DNA Databases," *Wellcome Trust*, February 24, 2004. http://genome.wellcome.ac.uk/doc_wtd020879.html.

20. Paul Vanouse, "The Relative Velocity Inscription Device," in Eduardo Kac, ed., *Signs of Life: Bio Art and Beyond* (Cambridge, Mass.: MIT Press, 2007).

21. Anna Kesson, "A Race Against Race," *RealTime Arts.* http://www.realtimearts.net/beap/kesson_relative.html.

22. Nancy Leys Stepan, "Race and Gender: The Role of Analogy in Science," in Gill Kirkup, Linda Janes, Katherine Woodward, and Fiona Hovenden, eds., *The Gendered Cyborg* (New York: Routledge, 2000).

The Biopolitics of Human Genetics Research and Its Application

Fatimah Jackson and Sherie McDonald

Anthropological genetics uses genetic techniques to address topics of anthropological significance, such as human evolutionary origins, contemporary human adaptations, similarities among various primate species, and the genetic basis of human biodiversity. Such studies are infused with biological and political significance, much of it unexamined. The uncritical acceptance of such studies shapes our perspectives on human variation, adaptability, and future potentials. From the ethnical ramifications of non-representative DNA datasets (Jackson, 1998, 1999), to bias in admixture studies (e.g., Parra et al. 1998), to the genetic reconstruction of human evolution in Africa (Lieberman and Jackson, 1995), the biological and political assumptions underlining much of this biological research remain, too often, wedded to static, stratified, mid-twentieth century notions about race and human diversity. New perspectives are needed as we apply ever more sophisticated molecular techniques to the complex issues of human existence.

A number of authors have written insightfully about the perpetuation of nineteenth and twentieth century racial models in genetic studies for epidemiology, public health, and biomedicine (Keita and Kittles, 1997). When genetic studies are applied to African Americans, there are particular issues that, if left unaddressed, can continue to be problematic. In this chapter we focus on three case issues in point. The first concerns the use of genetics to reconstruct African ancestral origins in African Americans. The second case focuses on the problem of the assumptions behind admixture studies, and the third example is the common misinterpretation of evolutionary genetic data on the origins of humanity.

Key Terms and Concepts

It is important to review some of the critical terminology used in genetics.

DNA is a double stranded molecule that is the carrier of genetic information

mtDNA is a small loop of DNA found in the mitochondria in the cell's cytoplasm that is maternally inherited

The *genome* is the sum of the genetic information in an individual or a species

The *genotype* is the genetic makeup of an individual

The *phenotype* is an observable or measurable feature of an organism. The phenotype is the product of gene and environment interactions.

A *microethnic group* is a geographically delineated human group defined in terms of sociological, cultural, linguistic, and biological lineage characteristics.

The *Out of Africa Replacement* model of human evolution is the theory that modern humans arose in Africa around 120,000 years ago and migrated throughout the world, replacing any previous human populations.

Constructed Identities through mtDNA Assessment and Interpretation

As we celebrate the thirthieth anniversary of the widely popular television classic *Roots*, we are assaulted by advertisements claiming to be able to tell us our "true identity" and tell us "who we really are." These entrepreneurial efforts would be acceptable if backed up by solid science. However, new evidence (Ely et al., 2006, 2007) clearly shows that most African Americans have mtDNA types that match multiple ethnic groups in Africa. Furthermore, these mtDNA types are broadly distributed geographically and linguistically (Jackson et al. *nd*). This is because many of the African mtDNA types encountered in African Americans emerged tens of thousands rather than merely hundreds of years ago. They predate the period of the transatlantic slave trade and its aftermath. The assignment of African Americans to specific contemporary African ethnic groups is *ahistorical*, since many of these African groups did not even exist four hundred years ago. Such assignments also are *exploitative*, as they take advantage of the psychological void and vulnerability many African Americans still feel as a result of the detribalization mandated by American slavery and its sequelae. Finally, such assignments are *misrepresentations* of both true ancestry and identity. They are a misrepresentation of ancestry because the mtDNA represents only a very small fraction of the entire human genome and it indicates only one's maternal lineage. In testing for mtDNA ancestral links, we are representing only one individual (our oldest mother) out of the millions of ancestors who contributed directly to our hereditary. Using mtDNA alone, we have no way of knowing if that one ancestor was reflective of the millions of others or not. To tie mtDNA matches to contemporary groups is fine, but to project these contemporary identities back in historical time is ludicrous. Ethnic groups are dynamic, constantly forming and re-forming. Ethnic groups integrate nongroup members, and are themselves integrated into other groups. Ethnic groups regularly become extinct due to warfare, resource depletion, and other stochastic and directed processes. None of that complexity of history is indicated by a mtDNA-limited identity.

Fatimah Jackson and Sherie McDonald

As our databases on the first hypervariable region of mtDNA increase, we see profound overlap of African mtDNA types among contemporary Africans. This tells us that African women were regularly moving around the continent sixty thousand to forth thousand years ago, and for some mtDNA types, over one hundred thousand years ago. As we understand other hypervariable regions of mtDNA, we see a slightly different picture of migration and reproductive interaction. In fact, the more genetic information we include in the analysis, the greater the lineage specificity, that is the more we can tie a particular set of sequences in a number of different genetic systems to particular family lines. But this is not what is being conveyed by the various commercial entrepreneurs in the ancestral identity business. Rather, complex identities are being reduced to single contemporary ethnic identities, their manufacture based upon very limited genetic information. In the words of Al-Hajj Malik Shabazz (Malcom X) the people are being "bambuzzled" once again, sold a bill of goods, and deceived.

A number of factors make African Americans particularly vulnerable to such deceptive genetic interpretations. The first has been alluded to above, our society's fascination with science allows us, on occasion to accept scientific misrepresentations and coincide with our cultural ideals. Clearly, the devastating effects of slavery have also influenced current self-perceptions among African Americans. For many contemporary African Americans there is a continuing amplified need for legitimacy, validity, and authentication.

Original African ethnic identities persisted for some time once an enslaved African arrived in the Americas (Gomez, 2004). However, without the social, political, and economic context to maintain that original ethnic identity, and given the clear penalty associated with retaining an African identity within European American society, each generation of African Americans retained less comprehensive detail about their ancestral past. What we do know from the records is that more African men than women were forced into American slavery, that in many geographical regions of the US Ibo and Wolof women predominated, and that Wolof women preferred to marry Wolof men (probably because most were both Muslim), while Ibo women were more exogamous in their choices (Gomez, 2004). We are just beginning to reconstruct the diversity of African, Native American, and European ancestral origins in contemporary African Americans (Jackson, 1997). At this stage of the unfolding, some individuals misguidedly want shortcuts and simplifications to understanding the past, even if these are largely fabrications.

In addition to the forced detribalization early African Americans faced were the sexual assaults with reproductive consequences perpetuated on many enslaved and oppressed women. High frequencies of conception-resulting rape by European American males on African American women and the shame among the women and their families associated with being "made in the bush" has fueled the tendency to create false ancestries in many African American lineages. The reluctance to acknowledge this European ancestry in the offspring by both the rapist and his enslaved victim also contributed to the reconstruction

of alternative ancestral stories and the disdain many African Americans still feel for scientific studies of admixture.

In certain regions of the United States, interactions with residual Native American groups were quite intense among enslaved and post-slavery African Americans, particularly in the southeastern states. Overall, however, the retention of Native American mtDNA in African Americans is reportedly somewhat lower than would be expected given the pervasiveness of the "Native American ancestor" in most African American lineages. On the one hand, this may reflect a lack of adequate testing by scientists or the use of a regionally inappropriate Native American database for comparative studies. Most southeastern United States Native American databases are fragmentary due to the genocide perpetrated upon the ancestors of these peoples. A lot of hereditary variation may have been lost. Using genetic markers from Native Americans of other regions of the United States to identify Native American ancestry in southeastern United States African Americans is problematic demographially and historically.

The relative paucity of Native American ancestral markers in the many African Americans reporting a "Native American ancestor" may also reflect a confounding of past social and cultural interaction with actual genetic interaction. In other words, individuals and groups, in the formation of their identity, may selectively choose from their history. Important interactions, maybe even life-saving interactions and cultural exchanges, can still take on a "fictive kinship" status in the absence of real genetic exchange. The Seminole Freedmen may share this status with the Seminole Native Americans. Beneficiaries of such deep cultural exchanges become "as one" even though their ancestral lineages are still distinct. It has been said, for example, that more European American southerners claim a Cherokee ancestor than admit to having an ancestor who fought in the Civil War!

In the southeastern United States, African Americans interacted (and for one hundred years were co-slaves) with a broad range of indigenous peoples, yet the scientific community is only beginning to systematically research the residual genetic effects of past gene flow between these groups. Future research will tease out the true magnitude of the Native American presence in African American ancestries, using the correct Native American reference groups (not the Dene or the Hopi peoples, for example, from the southwest United States). Meanwhile, undoubtedly some of the claims of Native American ancestry were made to mask the insertion of European lineages in these ancestries and or to indicate the close cultural relationships that may have historically existed between regional African Americans and certain Native American peoples.

We must remember that in general, genetics lacks historical context. Even though genetic analysis may reveal bits of one's historical genetic identity, it does not tell the entire story. It cannot tell *who, what, where, why* or *when*, under most circumstances. The genetic information must be supplemented with additional genetic data (to provide context), relevant historical data, and keen ethnographic insight. These latter three data sources are often lacking or highly simplified in most current single-gene assessments.

Commercial "identity factories" provide partial and incomplete genetic analysis, little historical context, and no ethnographic honesty. These mtDNA-based "identities" rely on a static view of ethnicity and a typological fix on human variation.

But, of course, they are not the only offenders. In many ancestry studies, genes are dangling out of context with other influencing genetic traits. Clients of many commercial genetic ancestry businesses receive a bogus "certificate of authenticity" that is worthless in the eyes of the ethnic group to whom they've been assigned. Clients are superficially satisfied to be told they are Hausa, Mandingo, Fang, or whatever until they attempt to act on their new "identity" (for example, claim land, tribal privileges). Such studies are presented as a starting point, but they are a false start. Identical matches to a wide variety of mtDNA types are found throughout the African continent, not in one specific ethnic or regional group. The entrepreneurs have collected their fee and duped unsuspecting customers. Science takes a hit.

In their search for an African definition of their ethnic identity, African Americans may tend to confuse their individual cultural identity with their genetic identity. The emergence of the Pan-African movement allowed New World Black people to embrace Africa as their homeland. This Afrocentric ideology was an attempt by African Americans to regain the pride and sense of self they had lost to the domination of White supremacy. Although it was an uplifting time for the Black community, this movement promoted the misinterpretations held by individuals in regard to their genetic background. African Americans at this time were so infatuated by the perceived, often romanticized cultures of Africa, that they began to paint themselves a picture of what their ancestors must have been like. Limiting African history to only kings and queens, many individuals became set on the belief that they too originated from royalty. In actuality, the ancestors of most African Americans were most likely common peasants, as are the majority of the ancestors of most people on this planet.

Furthermore, many of the ideas Black people had held about Africa underestimated the vast diversity within the continent itself. It was a common occurrence to associate Africa with one native tongue, one tribe, one skin tone, one hair texture, one culture. However, there is no homogeneity in Africa. The great genetic diversity of the continent was overlooked by many and thus, many African Americans lacked a mindset to fully comprehend the complexity, antiquity, and integrated nature of their true genetic backgrounds. As a consequence, some individuals allowed an unquestioned acceptance of Afrocentrism to isolate themselves from other ethnicities.

The movement still focuses on only one aspect of the African American identity that describes Blacks as *solely* Africans. Not only does this limit the development of self, but it also perpetuates the narrowness of typological racial thinking. Evidently, no race is purely one ethnicity and African Americans are not limited only to a recent African origin. Even if individual lineages were predominantly African, there is tremendous human biodiversity within continental Africa. The overwhelming majority of human biodiversity

is, in fact, *within* Africa. Our species has spent a tremendously long time just in Africa, our species homeland. Over time genes shift and people cross cultures, protecting the continuation of genetic diversity.

Within some circles, African Americans began to think of themselves as the equivalent of modern day Africans. However, the simple fact is that being African American is not the same as being a continental African, in spite of the important but nonuniform genetic congruence between these groups. African diasporic groups have African ancestral stocks that are a subset of African ancestral stocks. Socio-culturally, the inhabitants of Africa have diverse and ancient histories of their own that are often thousands of years old. Most Black people in the United States can not fully relate to the diverse ecological context of African history or its great time depth. Linguistic incompetence and economic advantages make it quite difficult for the average African American individual to reconcile cultural and historical differences between himself and the modern African. The modern African is not a relic from our four hundred year old past. Modern Africans are the product of their own evolutionary forces. Twenty generations and much poignant history, including differential patterns of gene flow and environmental exposures, separate the modern continental African from the contemporary African American. It is not a bridge that cannot be reconstructed, but that reconstruction must be done with great care and an acknowledgement of the limitations. Cultural and genetic remnants assist in the reconstruction, but we are only at an elementary stage in making such connections.

A great proportion of our identity is based on perceptions. Even the perceptions of racism are distinct across the African continent and among African Americans. Racism in Africa is generally centered around imperialistic colonial rule, the *mzungu* effect, while in the West, racism is associated with color and class discrimination, slavery (*mafaa*), and institutionalized social and economic inequality. The Africans who arrived in the United States hundreds of years ago were forced to create, assimilate, and adapt to an American culture that largely amalgamated the African components and ultimate distanced the African American from specific African roots. African Americans are today an amalgamation of African peoples, predominantly from West and West Central Africa, with modest gene flow from non-Africans, primarily from Western and Northern Europe and from Eastern Native Americans.

Assumptions in Genetic Admixture Studies

Admixture studies are notoriously grounded in typological racial thinking. Without that, researchers would find it difficult to presume that they could determine one's "proportion of European genes" in a non-European. Most admixture studies done in the United States emphasize the monodirectional flow of genes from European Americans into African Americans. Yet converse studies (where genes commonly found in Africa are observed

Table 12.1 Some Heterogeneous Hybrid Microethnic Groups Generally Classified by the U.S. Government as European American or White

Microethnic Group	Geographical Location
Brass Ankles	Coastal Dorchester, Colleton, Berkeley, Orangeburg, and Charleston counties, SC; also Etiwan Island.
Buckheads	Bamberg county, SC
Clay Eaters	Central Piedmont section of GA and SC
Issues	Amherst and Rockbridge counties, VA
Jackson Whites	Ramapo Mts., Orange and Rockland counties in NY, Bergen, Morris, and Passaic counties, NJ
Marlboro Blues	Chesterfield, County, SC
Melungeons	Hancock county, TN (Newman's Ridge, Clinch Mountain, Copper Ridge, Cumberland Range); also Cocke, Davidson, Franklin, Grundy, Hancock, Hawkins, Knox, Marion, Meigs, Morgan, Overton, and other counties in TN and Virginia known as Ramps; found in Giles, Lee, Russell, Scott, Washington, and Wise counties, VA and KY

in individuals claiming to be European American) are rarely reported. The European American geneticist Dr. Mark Shriver is a brave exception in presenting his own lineage in a research context and its African component. In our ethnogenetic layering research we have uncovered a number of groups that are routinely classified as "white" but are clearly mixtures of European, African, and Native American Indian peoples. Some of the groups that come to mind include the Jackson Whites, the Melungeons, the Brass Ankles and others listed in table 12.1. Even more such highly diverse groups are clustered as African American or Black, indicating that there is important population substructure among African Americans.

Misinterpreting "Out of Africa" Replacement Models in Human Evolution

The most accepted model of recent human origin (evolutionary changes within the last two hundred thousand years) is the Out of Africa replacement model (Finlayson, 2005). This model posits that early modern humans first arose in Africa (probably East Africa) and from there, subgroups migrated around Africa and out of Africa to Asia, Europe, Australia, Oceania, and the Americas, to repopulate the world. Where they encountered other human types, they replaced them. No one knows *how* this replacement may have occurred. There is no evidence of sudden mass extinctions of archaic humans in Europe, for example, when modern humans from Africa met indigenous Neanderthals. The Neanderthals just gradually fade out of the fossil record. In Asia, modern humans originally

from Africa replace advanced East Asian *Homo erectus* populations, but there is little archaeological evidence of direct contact between the two groups.

When the "Out of Africa" replacement model of recent human origins hit the public scene, there was much fanfare and, unfortunately, misinterpretation. Some thought it meant that that contemporary Africans were the "parents" of modern humanity, forgetting that contemporary Africans have undergone their own set of evolutionary processes (e.g., natural selection, genetic drift, gene flow) since modern humans first left Africa. Others seem to think that modern humans arriving in Europe, Asia, and Australia tens of thousands of years ago must have looked like contemporary modern Africans, again failing to recognize that contemporary Africans are as "modern" in their looks as are contemporary Europeans, Asians, or indigenous Australians. Still others, mostly scientific opponents of the Out of Africa replacement model, surmised that immigrating modern humans from Africa must have had adversarial interactions with the Neanderthals and advanced *Homo erectus* groups they may have encountered outside of Africa, projecting the own Western biases against African Americans into their interpretations of the fossil record.

What the Out of Africa replacement model actually means in terms of genetics is that all of humanity is connected through Africa. All existing contemporary modern humans are a *subset of African human genetic diversity*. In an evolutionary context, Africa is our collective human homeland, and we are all, genetically, an African people. Gaining a correct perspective on recent human evolution helps to put the issues of identity in a very different framework.

Alternative Approaches to the Race Model

Genetics combined with geographical, environmental, cultural, historical, and demographic information provides us with a fresh database with which to test the classic racial models that too often define our existence in the United States cultural, social, biomedical, economic, and political scenes. Since 1992, the Genomic Models Research Group at the University of Maryland has crafted a novel, sophisticated, and reproducible method for reconstructing and examining the human mosaic for the purpose of predicting disease susceptibility and risk. Our approach, termed ethnogenetic layering (EL), geographically coordinates historic, ethnographic, demographic, and genetic data. EL is based upon the presumption of a monogenic evolutionarily recent common human origin and the premise that all modern humans today are *Homo sapiens sapiens.*

EL incorporates the notion that the expression of an individual's genetic background is modified as it passes through various cultural and environmental filters to produce the phenotype or the expressed genotype. This is an important concept because it places local gene-environment outcomes up front in defining a microethnic group. Figure 12.1 represents these filtering modifiers of the genetic background. Modifying sociocultural, abiotic, and biotic environmental filters are crucial in evaluating most disease susceptibili-

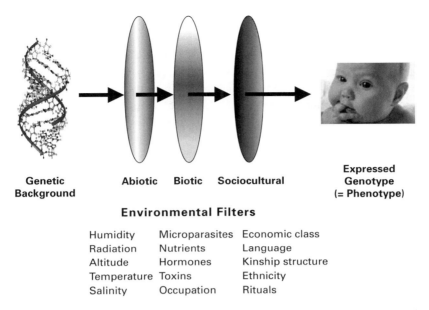

Genetic Background **Abiotic** **Biotic** **Sociocultural** **Expressed Genotype (= Phenotype)**

Environmental Filters

Humidity	Microparasites	Economic class
Radiation	Nutrients	Language
Altitude	Hormones	Kinship structure
Temperature	Toxins	Ethnicity
Salinity	Occupation	Rituals

Figure 12.1 The expression of an individual's genetic background is modified as it passes through various cultural and environmental filters to produce the phenotype or the expressed genotype.

ties and human phenotypic variation because these filters modify *what, when*, and *how* genes may be expressed. For example, in this model, phytochemical exposure through the diet, such as cyanogenic glycosides from cassava (*Manihot esculenta*) modifies the expression of a sickle cell genotype by chemically altering (i.e., carbamylating) the hemoglobin (Jackson et al., 1988; Jackson, 1990).

Quantifying the impact of these filters on the expressed genotype allows us to recognize previously hidden nuances embedded within traditional typological racial groups. In a sense, we are "unpacking" within-group so-called "racial" variation in order to recognize local patterns of contemporary population substructure. As we deconstruct traditional racial aggregates, we are better able to predict regional chronic disease risks for disorders with longstanding health disparities such as hypertension, diabetes, and many cancers. Elsewhere we have begun to report on the applications of EL in specific health disparities (Jackson, 2003, 2006).

EL relies upon geographic information science (GIS) technology to digitize and horizontally layer various data (e.g., genetic, toxicological, historical, demographic) on a particular geographical region for subsequent vertical multilayer analysis at particular sites. Geography is held constant while site- and group- specific data are analyzed statistically at predetermined geographic coordinates. As a result, EL allows researchers to tease out previously hidden substructure and refine local patterns of contemporary biological

variation *within* traditional macroethnic aggregates (i.e., socially constructed racial groups).

In EL, the level of analysis is the microethnic group. Microethnic groups (MEGs) are comprised of related biological lineages usually residing in close geographical proximity. This results in an increase in genetic concordance and cultural similarities within the MEG. Contemporary Americans represent a highly heterogeneous, exceptionally variable subset of humanity. Our recent ancestral origins from often identifiable and well-documented locations elsewhere in the world, our historical patterns of gene flow, and our defined opportunities for genetic drift have produced a geographical mosaic that can be evaluated for biological lineage studies relevant to health and disease and investigations of recent group heritage. This information is also being used to reconstruct regional microethnic groups, the local geographical groupings of biological lineages that provide substructure to macroethnic or social-racial categories.

Given that a microethnic group is a local aggregate of related biological lineages with shared cultural practices, environmental exposures, geographical residence, and historical characteristics, shared cultural practices between microethnic groups are usually the result of reciprocal cultural exchange. Although MEGs are socially constructed, they often exhibit more within-group biological homogeneity than expected because most affiliates are from related biological lineages. Augmenting these within-group genetic similarities are the often shared health related exposures to environmental toxins and communicable disease agents. In terms of health disparities, local aggregates of microethnic groups may have more in common with each other than with their general "racial" cohort residing one thousand miles away. The presence of microethnic groups often complicates the search for race-specific disease markers. As suggested in table 12.1, many groups classified as only one "race" are in fact hybrids.

Applying EL, there can be few, if any, broad sweep generalizations made about "Blacks" and "Whites," for example. With the microethnic groups as the level of analysis, genetic diversity is localized to much smaller units and contextualized by the environment. In this way, genetic misrepresentations at the group level (such as the notions that sickle cell anemia is a "Black" disease, or that cystic fibrosis is a "White" disease) can be reduced. The microethnic group level is also appropriate for first level applications of genetic ancestral studies since different geographical regions of the United States have different ancestral origins and have had different patterns of gene flow, natural selection, and opportunities for genetic drift.

The US has provided the rich geographical, social, and political-economic context for extensive genetic and cultural exchanges among Americans. This process continues with each new wave of immigrants. As the complexity of human genetic diversity increases with these exchanges, we need to develop a more sophisticated approach in genetics that reflects this fundamental heterogeneity. Genetic interpretations based upon old, dysfunctional, and often racist models need to be discarded for more careful and nuanced inter-

pretations of human variation. Only in this way can the public truly benefit from the genetic revolution.

References

Ely, B., Wilson, J. L., Jackson, F., and Jackson, B. A. (2006) African American mitochondrial DNAs often match mtDNAs found in multiple African ethnic groups. *BMC Biology* 4: 34.

Ely, B., Wilson, J. L., Jackson F., and Jackson, B. A. (2007) Correction: African American mitochondrial DNAs often match mtDNAs found in multiple African ethnic groups. *BMC Biology* 5: 13.

Finlayson, C. (2005) Biogeography and evolution of the genus Homo. *Trends Ecol. Evol.* 20(8): 457–463.

Gomez, M. A. (2004) *Exchanging Our Country Marks: The Transformation of African Identities in the Colonial and Antebellum South*. Chapel Hill: University of North Carolina Press.

Jackson, F. L. C. (1990) Two evolutionary models for the interacitons of dietary cyanogens, hemoglobin S, and falciparum malaria. *Amer. J. Hum. Biol.* 2: 521–532.

Jackson, F. L. C. (1997) Concerns and priorities in genetic studies: Insights from recent African American biohistory. *Seton Hall Law Review* 27(3): 951–970.

Jackson, F. L. C. (1998) Scientific limitations and ethical ramifications of a non-representative Human Genome Project: African American responses. *Science and Engineering Ethics* 4: 155–170.

Jackson, F. L. C. (1999) African-American responses to the Human Genome Project. *Public Understanding of Science* 8(3): 181–191.

Jackson, F. L. C. (2003) Ethnogenetic layering: A novel approach to determining environmental health risk potentials among children from three US regions. *J. Child. Health* 1(3): 369–386.

Jackson, F. (2006) Illuminating cancer health disparities using ethnogenetic layering (#L) and phenotype segregation network analysis (PSNA). *J. Cancer Educ.* 21(1): 69–79.

Jackson, L. C., Oseguera, M., Metrano, S., and Kim, Y. L. (1988) Carbamylation of hemoglobin in vivo with chronic sublethal dietary cyanide: Implications for hemoglobin S. *Biochem. Med. Metab. Biol.* 39: 64–68.

Keita, S. O. Y., and Kittles, R. (1997) The persistence of racial thinking and the myth of racial divergence. *Amer. Anthrop.* 99(3): 523–544.

Lieberman, L., and Jackson, F. L. C. (1995)Race, displacement from Africa, afro-european-sapiens, and multiregional continuity: Race implications of competing perspectives on the origins of modern humans. *Amer. Anthrop.* 197: 231–242.

Parra, E. J., Marcini, A., Akey, J., Martinson, L., Batzer, M. A., Cooper, R., Forrester, T., Allison, D. B., Deka, R., Ferrell, R. E., and Shriver, M. D. (1998) Estimating African American admixture proportions by use of ppopulation specific alleles. *Amer. J Hum. Genet.* 65: 1834–1851.

In Contradiction Lies the Hope

Human Genome and Identity Politics

Abha Sur and Samir Sur

[W]hen "race" is used as a stratifying practice (which can be apprehended empirically and systematically) there is often a reciprocal interplay of a biological outcome that makes it impossible to completely disentangle the biological from the social. While that may be obvious to some, it is completely alien to others, and some of those "others" are key players in current debates about the biology of race.

TROY DUSTER

The social stratification of people into nontribal and tribal, and subsequently into various hierarchically arranged castes and subcastes, has been the reality of India for centuries, if not millennia. Caste societies across India show significant regional variation and complexity, especially in the subdivision of the four distinct castes (*varna*)—Bhramins (priests), Kshatriyas (warriors, rulers), Vaishyas (traders), and Sudras (artisans)—into sub-castes or *jatis*. The various *jatis* are endogamous units, often linked to occupational groups and guilds, with each *jati* vying for a higher social status within its *varna*. The Sudra caste is further divided into "polluters" and "non-polluters," based upon their occupation and ritual status. The Dalits (formerly called "untouchables") are considered to be outcastes. In recent years the term *Dalitbahujan* has been coined to refer to the broad spectrum of "lower caste" groups comprising both Dalits and Sudras. Despite the ubiquitous presence of caste discrimination in everyday life, there is little agreement amongst scholars about the origin of the caste system, its stability, its relation to religion, and its sociology and anthropology.

Into this morass have stepped population geneticists with their storehouse of haplogroup frequencies, statistical analysis of DNA markers, and sequence data to weigh in on the issue. The entry of genetics has reinvigorated debates about race and caste in India, bringing the entanglement of the social and the biological to the fore. At the heart of the

controversy is the study by Michael Bamshad of the University of Utah in Salt Lake City and his coworkers in Estonia, India (Andhra Pradesh, West Bengal, and Tamil Nadu), Arizona, the United Kingdom, and New Orleans that resulted in "Genetic Evidence on the Origins of Indian Caste Populations."[1] These studies have been corroborated by more extensive and comprehensive genomic studies by scientists and anthropologists, led by Partha Majumdar, at the Indian Statistical Institute in Calcutta.[2] The central finding of these studies—that the genetic composition of the Indian population shows a significant West Eurasian admixture that is both rank-related and sex-specific—is consistent with the two-race theory of Aryan migration from Central Asia into India around 2000 B.C.E. first proposed by scholars in the nineteenth century. Deeply inflected by biological determinism and racial essentialism, the two-race theory had found widespread acceptance in the caste-ridden Indian society.

Are these recent genetic studies on caste a replay of the racist and Eurocentric worldview as claimed by the ideologues of the Hindu right-wing parties? Or do they reflect a newer perspective in population genetics which eschews stereotyping and sees human populations as complex, labile, and overlapping, where genetic variation is used mainly as a tool to better understand our past migratory histories? Is it even possible to delineate the not so hidden potential for further caste discrimination engendered in the very labeling and description of populations? Ruth Hubbard, the eminent biologist and an incisive commentator on science and society, is rightfully suspicious. She writes that "It is beyond comprehension, in this century which has witnessed holocausts of ethnic, racial, and religious extermination in many parts of our planet, perpetrated by peoples of widely different cultural and political affiliations and beliefs, that educated persons—scholars and popularizers alike—can come forward to argue, as though in complete innocence and ignorance of our recent history, that nothing could be more interesting and worthwhile than to sort out the "racial" or "ethnic" components of our thoroughly mongrelized species so as to ascertain the root identity of each and everyone of us."[3]

In this chapter we will address some of these questions by analyzing the genomic studies in India by Michael Bamshad et al. and Partha Majumdar et al. Dominant theories of race and gender have been predicated on the notion that innate biology of women and people of color was the cause of their marginal position in society. The studies on the genomics of caste mentioned above, however, see genetic differences between populations as necessarily the effect of social norms and historical contingencies. In this respect, these studies signal a departure from the practice of biology and anthropology in the past. Scientific theories and practice have far-reaching implications in the society at large. Thus, we briefly compare the markedly different utilization of these studies by scholars sympathetic to the cause of the Dalits and those who subscribe to ideologies of Hindu nationalism. Such a comparison affords an insight into identity politics and the reification of difference in science. It also helps demarcate affirmative identities of oppressed peoples from coercive identities imposed upon them by their oppressors. Finally, as a way of conclusion

Abha Sur and Samir Sur

we suggest that studies in population genetics engender both hope and apprehension—they enrich our understanding of past and present, but also lend credence to divisive distinctions of race and caste.

Science of Difference

The genomes of any two individuals differ at approximately 0.1 percent of nucleotide sites.[4] Since there are some three billion nucleotide base pairs in the human genome, this minuscule percentage results in differences of approximately two to three million base pairs between each pair of humans.[5] This difference is attributed to errors associated with replications of DNA sequences. Mutations in the noncoding part of the DNA sequence are immune to the pressures of natural selection and can be used to study genetic flows and drifts. Since the mutation rate is extremely low, the extent of genetic variations between different populations is indicative of their genetic heritages. Thus, population genetics research relies upon finding differentially distributed frequencies of certain haplogroups and sub-haplogroups in different caste, tribal, and sociocultural populations to draw inferences about their genetic affinities to and distances from each other, as well as from other adjacent groups. This, in turn, is used to explain paternal and maternal lineages, gene flow patterns, and migration histories—both routes as well as ages of migration.

In their landmark study "Genetic Evidence on the Origins of Indian Caste Populations," Michael Bamshad and his colleagues explored the links between West Eurasian migration into India and the caste system. They compared variations in maternally inherited mtDNA, paternally inherited Y-chromosome, and bipaternally inherited autosomal loci of eight differently ranked caste populations from the state of Andhra Pradesh in South India to populations from Africa, Asia, and Europe. The ranked caste populations were grouped into three caste categories—upper (comprising Brahmins, Kshatriyas, and Vaishyas), middle (Sudras), and lower (Dalits).[6] Their results, remarkably consistent with data obtained from mtDNA, Y-chromosome, and autosomal loci, indicate that in general, genetic distances between the three castes are "significantly correlated with rank; upper castes are more similar to Europeans than are lower castes."

Furthermore, whereas the data from mtDNA analysis show that women from all three caste groupings are more similar to Asians than to Europeans, the Y-chromosome variations in all castes show a greater affinity to Europeans than to Asians. Bamshad et al. report that "contemporary Indian mtDNA evolved largely from proto-Asian ancestors with a Western Eurasian admixture accounting for 20–30% of mtDNA haplotypes." Furthermore, the frequency of these haplotypes varies proportionally with caste; upper castes have the highest frequency of West Eurasian haplotypes, and lower castes, the lowest. Genetic distances between Europeans and caste populations estimated from Y-chromosome studies show the same pattern—the distance is greatest between Europeans and lower castes and smallest between Europeans and upper castes.

The results of the Bamshad study indicate that contemporary Hindu Indians are of proto-Asian origins with West Eurasian admixture. Moreover, this population shows a gender asymmetry in that the proportion of admixture with West Eurasian males is greater than that with West Eurasian females. Bamshad et al. suggest that their results are "consistent with either the hypothesis that proportionately more West Eurasians became members of the upper castes at the inception of the caste hierarchy or that social stratification preceded the West Eurasian incursion and that West Eurasians tended to insert themselves into high-ranking positions."[7] The proto-Asian origin of the Indian population argues against their common ancestry with Europeans that was suggested by some scholars, notably Max Müller, in the nineteenth century on the basis of the shared Indo-European languages. Instead, as the authors of the study maintain, "the transfer of language was mediated by contact between West Eurasians and native proto-Indians."[8]

The findings and conclusions of the Bamshad study are further analyzed by a more comprehensive study by Indian scientists which looked at genetic variation in the larger ethnically, regionally, and linguistically diverse populations of India.[9] In a constructive critique of the Bamshad study, Partha Majumdar noted:

The origins of the castes in India remain an enigma. Many castes are known to have tribal origins, as evidenced from various totemic features that manifest themselves in caste groups. The caste system in northern India may have developed as a class structure from within tribes: As agriculture spread from the Indus River valley to the Gangetic basin, knowledge and ownership of the means of food production may have created hierarchical divisions within tribal societies.[10]

Majumdar further underscored the elasticity of the Indian caste society, in which geographically dispersed tribes took up different occupations and inserted themselves into the caste hierarchies at different levels, and also into different groups within a caste; for instance, the Chitpavan, or Sarasvat Brahmins in Maharashtra, had, in all probability, different origins.

Thus, in "Ethnic India: A Genomic View, with Special Reference to Peopling and Structure," Majumdar et al. studied genomic variation among linguistically different tribal populations—Austro-Asiatic (AA), Dravidian (DR), and Tibeto-Burman (TB)—in addition to social populations spread across India, which they also divided into three caste groups and two language groups (Indo-European (IE) and Dravidian). They describe some of their conclusions as follows:

(1) [T]here is an underlying unity of female lineages in India, indicating that the initial number of female settlers may have been small; (2) the tribal and caste populations are highly differentiated; . . . (6) the Dravidian tribals were possibly widespread throughout India before the arrival of the Indo–European speaking nomads, but retreated to southern India to avoid dominance; (7) formation of populations by fission that resulted in founder and drift effect have left their imprints

on the genetic structures of contemporary populations; (8) the upper castes show closer genetic affinities with Central Asian populations, although those of southern India are more distant than those of northern India; (9) historical gene flow into India has contributed to a considerable obliteration of genetic histories of contemporary populations so that there is at present no clear congruence of genetic and geographical or sociocultural affinities.[11]

The Majumdar study finds that Dravidian speakers, regardless of their social status, are closely related to each other. This finding refutes one of the tenets of the two-race theory, which racially separated the South Indian Brahmins from the non-Brahmins (see below). The study reveals that Dravidian speakers have a high affinity with the Indo-European speakers despite the fact that they currently reside in disjointed geographical regions. The authors of the study suggest:

These findings are consistent with the historical view that the DR speakers were possibly wide-spread throughout India. When the ranked caste system was formed after the arrival of the IE speakers ~3500 ybp, many indigenous people of India, who were possibly DR speakers, embraced (or were forced to embrace) the caste system, together with the IE language and admixture. . . . As the IE speakers, who entered India primarily through the northwest corridor, advanced into the Indo-Gangetic plain, indigenous people, especially the DR speakers, may have retreated southward to avoid linguistic dominance, after an initial period of admixture and adoption of the caste system. As evidenced by their strong genetic similarities, the IE-speaking Halba tribals were most probably a DR speaking tribal group, which is consistent with the IE dominance over DR tribals.[12]

Majumdar et al. further determined proportional contributions of five hypothetical ancestral populations to the four linguistically divided groups and found that the DR and IE speakers are most similar to each other.[13]

Although the Majumdar study corroborates the main findings of the Bamshad study, there are also notable differences between the two, not only because of the much broader sweep of the Majumdar study, but also in the formulation of the research agendas. For instance, in addition to the differences between different caste groups, Majumdar and his colleagues find "stronger geographical sub-structuring of upper-caste populations, compared with populations of other ranks." They note that "there is high genetic differentiation among populations belonging to both caste and tribal groupings, particularly the tribal populations, implying that neither of these two broad groups is genetically homogeneous."[14]

It is undeniable that the Bamshad study, both in its research design and in the language it employs, reinforces (perhaps inadvertently) the connection between race and caste despite its assertions that "human populations share most of their genetic variation and that there is no scientific support for the concept that human populations are discrete, nonoverlapping entities."[15] Furthermore, while the Bamshad study compares genetic distances between caste groups and continental populations, and thus refers to West Eurasian

"admixtures" in the Indian populations, the Majumdar study measures genetic affinities of caste groups with Central Asian populations. However, in a more recent publication, Bamshad and his colleagues "emphasize that any framework that is designed to study the relationship between patterns of genetic variation and notions of race must consider the impact of these relationships on concepts of identity, lay perceptions of race, the application of justice and the development of public policy."[16]

The focus on the regional, social, linguistic, and geographical diversity of the Indian population permits Majumdar and his colleagues to recognize both semblances and differentiations within and across various sub-populations. Their analysis of molecular variance emphasizes that the extent of genetic variation is the highest among individuals within population groups. The tentative tone maintained throughout the Majumdar study indicates that population genetics alone is unlikely to provide incontrovertible evidence either in favor of or against the currently dominant, although contested, understanding of the origin of the caste system. It can only corroborate whether or not its findings are consistent with earlier archaeological, linguistic, and historical studies. The frequent reference to anthropological and historical studies of Irawati Karve, Romila Thapar, and D. D. Kosambi, especially in the Majumdar study, suggests that the research paradigm of these studies is dependent on a particular understanding of history which mediates both data gathering and analyses. The genomic studies, in turn, provide validation for these historical and anthropological works.

Histories are always contentious. The arrival of the Aryans in India and the origins of the caste system remain provocative issues within India, as evidenced by the markedly different reception of these scientific studies among different social groups.

Science and Identity Politics

The questions that scientists ask and answer are rooted in the social and political concerns of their time. Similarly, the reception of scientific findings in the society at large is dependent upon their usefulness to the general public or to special interest groups. The genetics of caste is no exception. Since the 1980s India has simultaneously seen the rise of strident Hindu nationalism and struggle for democratic rights by the Dalits. In this milieu questions about the influx of Aryans into India circa 2000 B.C.E. and its connection to the caste structuring of the Indian society have received renewed importance.

Hindu nationalism subscribes to an exclusionary ideology in which religious minorities, particularly Muslims and Christians, are seen as invaders responsible for the oppression of the Hindus. The ideologues of Hindu nationalism lay claim to India both as the fatherland and as the "cradle-land" of the Hindus. In this formulation Muslims and Christians remain forever the "Other," since their religions are not indigenous to the Indian subcontinent. Preoccupation with origin and authenticity makes the Hindu nationalists hostile to the theory of Aryan migration into India, which posits that Vedic religion as well as the

Indo-Europeans languages may have originated in Central Asia. Despite considerable linguistic and archaeological evidence to the contrary, the Hindu nationalists insist that the Indus Valley civilization, which predates the Vedic civilization by a thousand years, was of Aryan origin and that migration of people was out of India rather than into India. Since the genomic studies by the Bamshad and the Majumdar groups seem to corroborate the theory of Aryan migration into India, they have come under attack from these quarters.

N. S. Rajaram, for instance, takes the Bamshad study to task for using "opaque jargon-filled language" to repackage "the Aryan invasion theory all over again, along with its associated Aryan-Dravidian conflicts."[17] Subhash Kak charges that racism is the primary motivation for the promotion and acceptance of the theory of the Aryan invasion. He writes:

The theory fit the Western or British vision of their place in the world at the time. The conquest of Asian civilization needed a mythical charter to serve as the moral justification for colonial expansion. Convenient, if not consciously acknowledged, was the Aryan invasion by a fair-skinned people, speaking the so-called Proto-Indo-European language, militarily conquering the dark-skinned, peasant Dasa (Dasyu), who spoke a non-European language and with whom the conquerors lived, as Leach puts it, in a "system of sexual apartheid."[18]

Charges of racism notwithstanding, Kak's article is accompanied by articles, such as "India, a Superpower in the 3rd Millennium BC and AD," which extol the superiority of the Hindus. The critique of racism by the Hindu nationalists does not involve a critical examination of the relationship between power and inequality; rather, it is utilized to promote the supremacy of the Hindu civilization over all others. Hindu nationalism thus merely substitutes "white superiority" imbued in the formulation of Max Müller's two-race theory for the superiority of the Aryan Indians.

Comparative philology and ethnology in the late eighteenth and early-to-mid nineteenth centuries had illustrated the linguistic affinity among Sanskrit, Latin, and Greek, and had linked it to racial kinship.[19] The coupling of linguistic evidence and ethnological evidence made sense in the context of the notions of a biblical time period of about six thousand years for human history in which the Indian Vedic civilization was seen as a shining example of the wisdom of the ancients. It was in this context that Max Müller had proposed his two-race theory. The two-race theory posited India as being composed of the Hamites and the Japhites, corresponding, respectively, to the aboriginal peoples and the immigrant Aryans who came from central Asia in 2000 B.C.E. Furthermore, for Müller, the English were the "descendants of the same [Aryan] race, to which the first conquerors and masters of India belonged," and they had now returned "to accomplish the glorious work of civilization, which had been left unfinished by their Arian brethren."[20] Müller subscribed to a nonessentialist theory of race, which nonetheless clung to the notion of white superiority. Here, however, skin color differences were thought to be

due to variations in the climates, and association with a higher civilization could revive moral and physical character.

The two-race theory exerted a profound influence in India even though the West increasingly defined Aryans in much narrower terms, associating only the white population with Aryans and Caucasians.[21] The theory provided a biological basis for the caste differentiation in India, and subsequent ethnological studies in India continued to view the populations in terms of distinct and separate races. The "upper castes," "represented by the Brahmans, Rajputs and Sikhs," were the Aryans, identified by their "tall forms, light complexion and fine noses," with their "general appearance superior to the middle class of Europeans," whereas the aboriginal people had "short stature, dark complexion and snub noses, and approach[ed] the African blacks in appearance."[22]

These ideas had strong currency amongst the Indian intelligentsia. Rabindranath Tagore, whose "Race Conflict" appeared in the pages of *The Modern Review* in April 1913, believed that of all the ancient civilizations, only "India was compelled to recognize this race problem," as Europeans did not have "that physical antipathy between them which the difference in color of skin and in features tends to produce." He further elaborated:

At the beginning of Indian history, the white skinned Aryans had encounters with the aboriginal people who were dark and who were intellectually inferior to them. Then there were the Dravidians who had their own civilization and whose gods and modes of worship and social system were totally different from those of the newcomers, which must have proved a more active barrier between them than full-fledged barbarism.[23]

However, Tagore advocated a "deeper unity," a "higher truth" which would keep Indian civilization vibrant in spite of racial differences.

The "upper caste" elite of India could thus assert their superiority over the "lower castes" and the aboriginal people as well as vie for equality with the upper strata of the Europeans.[24] These ideas percolated in the popular domain. The acceptance was not based upon ignorance about the vitiated characterization of the "Hindoos" by the British and the Whites in general. Rather, they were, in the words of Sucheta Majumdar, racist responses to racism in the West. Indians living in the United States often drew on the notion of "purity of blood" as they repeatedly stressed that they were "high caste Hindu(s) of pure blood" or high caste Hindus of the "Aryan race." Similarly, the Zoroastrians often claimed that Parsees belonged to the white race, while others defended the caste system, claiming that the high price of excommunication for intercaste marriage had ensured the purity of their Aryan blood, which is as pure as that of the Germans, and that there were no "low-caste Pariahs or aborigines" among them.[25]

The two-race theory also articulated "the racial and historical basis of the Aryan-Dravidian divide," contending that the Dravidians had occupied the southern portion of the Indian subcontinent sometime before the Aryan invasion, and were therefore the

pre-Aryan inhabitants of India. It was only well after the invasion that they were subdued by the Aryans. The theory gave rise to the categorization of South Indian Brahmins as Aryans and the non-Brahmins as Dravidians. The subaltern response to the two-race theory was both a celebration of Dravidian culture and the spawning of anti-Brahmin "Self Respect Movement" struggles in the early twentieth century that stressed the admission of Dalits into temples, intercaste marriages, and the uplifting of women.

The "races" of India were conceptualized in a more democratic and thoughtful formulation in the early decades of the twentieth century by the Dalit leader Babasaheb Ambedkar without accepting Aryan supremacy:

The population of India is a mixture of Aryans, Dravidians, Mongolians and Scythians. All these stocks of people came into India from various directions and with various cultures, centuries ago, when they were in a tribal state. They all in turn elbowed their entry into the country by fighting with their predecessors, and after a stomachful of it settled down as peaceful neighbours. Through constant contact and mutual intercourse they evolved a common culture that superseded their distinctive cultures. It may be granted that there has not been a thorough amalgamation of the various stocks . . . But amalgamation can never be the sole criterion for homogeneity as predicated of any people. Ethnically all people are heterogeneous. It is the unity of culture that is the basis of homogeneity.[26]

India, according to Amedkar, had "not only geographical unity, but it has over and above all a deeper and a much more fundamental unity—the indubitable cultural unity that covers the land from end to end."[27]

The discovery of the Indus Valley civilization in 1920 engendered new issues in Indian history. The Aryans now were no longer the forerunners of culture and civilization, but were "foreigners" who had subjugated a highly advanced civilization which was increasingly associated with the "original" Dravidian culture. The Hindu right wing's ideology, whose basis is the claim that India is not only the land of their ancestors but is also their sacred land which has been sullied by Muslim invasions, needs to establish the origin of the Aryans in India. It just won't do if Aryans too were foreigners in India, as corroborated by the recent genomic studies. Thus there have been repeated efforts to link the Indus Valley civilization to the Aryan civilization by claiming that the Aryans were the original inhabitants of the region. Furthermore, the Hindu right wing's defense of the caste system, based on the "nature" of the individual exemplifying the natural division of labor, is also challenged by the above mentioned genomic studies.

In contrast, the reception accorded to the genomic studies of the social structure of caste among Dalit and progressive groups has been cautiously cordial. At the All India Backward and Converted Minorities Communities Employees Federation in New Delhi, in December 2001, an "awakening session" was devoted to understanding the impact of the studies, which were thought to have far-reaching consequences for the *Dalitbahujans*.[28]

Progressive scholars such as Prabir Purkayastha, a member of the Delhi Science Forum, note approvingly that:

The genetic studies are a striking re-affirmation of Irawati Karve and D. D. Kosambi's views on the formation of castes in India. . . . The historical model that best fits the genetic studies is that there was a physical influx of people carrying Eurasian genetic markers. New genetic markers arose in South Asia after this influx, which are not found in significant numbers outside South Asia. The evidence against an efflux is therefore quite strong.[29]

Perhaps mindful that genomic studies might well be read through the lens of race, Purkayastha is quick to point out that "DNA analysis has also exploded the myth regarding races. The genetic variations in the human population within a group account for 85% of all variations; only 9% of all variations are due to different continents while 6% variations are due to differences between groups."[30] Nevertheless, these studies are likely to reiterate a sense of identity based not only on shared oppression but also on migratory histories and shared ancestries. In the popular imagination, race and caste continue to be linked.[31] An article on the Web site dalistan.org by Senthil Veliappa, "Racial Origin of Caste System Vindicated," strongly castigates the "Vedic system of apartheid" but insists that "one's caste is in one's genes" and that "it is indeed foolish to try and deny the fact when a person's caste can be determined from a genetic analysis."[32] Similarly, an exchange posted on the Web site "Race and History" asserted:

Those brainwashed by Aryans and British racism may not know the truth but those who know it well proudly claim their African origins. I have seen it and experienced it in person, right in the Los Angeles area where I have met with both Dalits from India and Australian aborigines who are proud to say that they are part of the Black African Diaspora.[33]

Much as one applauds the notions of political solidarity the above text embodies, its reliance on the essentializing character of DNA remains troubling. Surely, the struggle for an egalitarian and just world cannot be based on either authenticity or biological identity.

Conclusion

Genomic studies on caste by Bamshad et al. and Majumdar et al. seem to confirm the mechanism for social stratification in India elaborated previously by historians and anthropologists, and point to the complex interaction between biology and culture. To the extent that these studies corroborate the origins and mechanisms of caste stratification, their intervention can only be welcomed by those who strive for an egalitarian world. Cressida Heyes suggests that "Identity politics starts from analyses of oppression to recommend,

variously, the reclaiming, redescription, or transformation of previously stigmatized accounts of group membership. Rather than accepting the negative scripts offered by a dominant culture about one's own inferiority, one transforms one's own sense of self and community, often through consciousness-raising."[34] Indeed, the inclusion of the genomic studies in one of the "awakening sessions" of the All India Backward and Converted Minorities Communities Employees Federation Conference affirms Heyes's conclusions. Furthermore, these studies have had a renewed impact upon history and memories of the past, which in this particular instance, at least, are likely to destabilize the basis for the majoritarian, communal identity as forged by Hindu nationalism.

However, it is also the case that the presence of genetic markers not only allows an understanding of the migratory histories of our ancestors, but also signals new ways of classifying humans, even as the scientists decry old racial classifications as racist. As Troy Duster notes, "These new technologies have some not-so-hidden potential to be used for a variety of forensic purposes in the development and "authentication" of typologies of human ethnicity and race. A contemporary update of an old idea of deciding upon "degree of whiteness" or "degree of nativeness" is possibly upon us, anew, with the aid of molecular genetics." Already genomic studies are being used to distinguish European, Afro-Caribbean, and South Asian populations in England even though DNA "differs widely from person to person, irrespective of race."[35] In contrast, however, haplotype maps are also being used in diagnostic medicine with a measure of success. Population geneticists, in collaboration with disease researchers, are studying haplotype maps of people with a particular disease to identify genomic regions that are significantly implicated in the disease mechanism and development. These genome-wide association studies have been particularly successful in the case of type 2 diabetes.[36]

The social world we inhabit is divided along lines of race, caste, and gender. The social and economic consequences of these stratifications are evident in the unequal distribution of power, wealth, and resources across and within these populations. The new technologies of population genetics now make it possible to simultaneously reveal and mark the biological consequences of these divisions as well. How these new technologies function in our world will depend upon whether we choose to live with the inequalities of race, caste, and gender or strive to eradicate these divisive differentiations altogether. For, in the final analysis, it is not science but rather the social world we inhabit, of which science is a part, which will determine whether we will unleash the democratic potential of science or become mired in its dogmatic essentialisms.

Acknowledgments

We thank Ruth Hubbard for her useful comments and criticisms. We also owe special thanks to Kavita Philip and Beatriz da Costa for their insightful reading of the earlier drafts of the essay.

Notes

1. Michael Bamshad, Toomas Kivisild, W. Scott Watkins, Mary E. Dixon, Chris E. Ricker, Baskara B. Rao, J. Mastan Naidu, B. V. Ravi Prasad, P. Govinda Reddy, Arani Rasanayagam, Surinder S. Papiha, Richard Villems, Alan J. Radd, Michael F. Hammer, Son V. Nguyen, Marion L. Carroll, Mark A. Batzer, and Lynn B. Jorde, "Genetic Evidence on the Origins of Indian Caste Populations," *Genome Research*, 11 (2001): 994–1104.

2. Analabha Basu, Namita Mukherjee, Sangita Roy, Sanghamitra Sengupta, Sanat Banerjee, Madan Chakraborty, Badal Dey, Monami Roy, Bidyut Roy, Nitai Bhattacharyya, Susanta Roychoudhury, and Partha Majumdar, "Ethnic India: A Genomic View, with Special Reference to Peopling and Structure," *Genome Research* 13 (2003): 2277–2290.

3. Ruth Hubbard, "Race and Genes," http://raceandgenomics.ssrc.org/Hubbard/

4. "The International HapMap Project," *Nature* 428 (December 2005): 789–796.

5. Lynn B. Jorde and Stephen P. Wooding, "Genetic Variation, Classification and 'Race'," *Nature Genetics Supplement* 36(11) (November 2004): S28-S33.

6. Bamshad et al., "Genetic Evidence on the Origins of Indian Caste Populations." The authors use the term "Panchama" instead of "Dalits" in their classification of the "lower" caste.

7. Ibid., p. 1000.

8. Ibid., p. 1000.

9. Majumdar et al., "Ethnic India."

10. Partha P. Majumdar, "Indian Caste Origins: Genomic Insights and Future Outlook," *Genome Research* 11 (2001): 931–932.

11. Majumdar et al., "Ethnic India," p. 2277.

12. Ibid., p. 2287.

13. Majumdar et al. used structural analysis to distinguish clusters of human populations. In this statistical technique individuals are placed randomly into different clusters regardless of their population affiliation. The number of clusters is preset and somewhat arbitrary and has an influence on the results. Individuals are then reallocated between the clusters to obtain minimum disequilibrium within each cluster. Rosenberg et al. have shown there are several logical ways to accomplish such an analysis, as many of the individuals in the study can be placed in more than one cluster. See N. A. Rosenberg, J. K. Pritchard, J. L. Weber, H. M. Cann, K. K. Kidd, L. A. Zhivotovsky, and M. W. Feldman, "Genetic Stucture of Human Populations," *Science* 298 (2002): 2381–2385. Reference cited in Joseph L. Graves, Jr., "The Empire Strikes Back," *Progress magazine* 1(2) (March 2003).

14. Majumdar et al., "Ethnic India," p. 2284.

15. The quotes are from Jorde and Wooding, "Genetic Variation, Classification and 'Race'," p. S32. Jorde is the senior author of the Bamshad study.

16. Michael Bamshad, Stephen Wooding, Benjamin A. Salisbury and J. Claiborne Stephens, "Deconstructing the Relationship between Genetics and Race," *Nature Reviews Genetics* 5 (2004): 598–609, p. 599.

17. See N. S. Rajaram, "Hot Air and Cold Fusion." http://members.tripod.com/naimisha/new_page_6.htm.

18. See Subhash Kak, "Indology and Racism." http://sathyavaadi.tripod.com/truthisgod/Archives/indology.html.

19. The following few paragraphs are excerpted from my manuscript "Science and Social Stratification: Caste, Gender, and Nationalism in Modern Physics in India."

20. See Thomas R. Trautmann, *Aryans and British India* (Berkeley: University of California Press, 1997), p. 176.

21. See George W. Stocking, "The Turn of the Century Concept of Race," *Modernism/Modernity* 1(1) (January 1994): 4–16. Race was seen as "accumulated cultural differences carried somehow in blood." In this context, "a Hindoo might absorb the learning of Oxford but could not be made an Englishman even though both come from the great Indo-European family."

22. Quoted in Sumit Guha, "Lower Strata, Older Races, and Aboriginal Peoples: Racial Anthropology and Mythical History Past and Present," *The Journal of Asian Studies* 57(2) (May 1998): 423–441, on p. 428.

23. Rabindranath Tagore, Race Conflict," *The Modern Review* (April 1913): 423–426, on p. 424.

24. See Susan Bayley, "Caste and 'Race' in the Colonial Ethnography of India," in Peter Robb, ed., *The Concept of Race in South Asia* (Delhi: Oxford University Press, 1995); and Guha, "Lower Strata, Older Races, and Aboriginal Peoples." Class inequality was almost always mediated by race and gender.

25. Sucheta Majumdar, "Racist Responses to Racism: The Aryan Myth and South Asians in the United States," *South Asia Bulletin* 9(1) (1989): 47–55, on p. 50.

26. Babasaheb Ambedkar, "Castes in India: Their Mechanism, Genesis and Development," paper presented at an anthropology seminar at Columbia University, May 9, 1919. Reprinted in Babasaheb Ambedkar, *Wrtings and Speeches*, vol. 1 (Bombay: Education Department, Government of Maharashtra, 1979), pp. 3–22.

27. Ibid.

28. Information about the convention accessed from http://www.ambedkar.org/News/News111901.htm.

29. Prabir Purkayastha, "Ancestral Echoes in Indian Genes" Delhi Science Forum. Available at http://www.delhiscienceforum.org/index.php?option=com_content&task=view&id=139&Itemid=2.

30. Prabir Purkayastha, "Ancestral Echoes in Indian Genes" Delhi Science Forum, available at http://www.delhiscienceforum.org/index.php?option=com_content&task=view&id=139&Itemid=2.

31. See Ranjit Devraj, *Inter Press Service News Agency*, August 20, 2001, http://www.ipsnews.net/wconference/note26.shtml. Cited in Sharjeel Sabir, "Chimerical Categories: Caste, Race, and Genetics," *Developing World Bioethics* 3(2) (2003): 170–177.

32. Senthil Veliappa, "Racial Origin of caste System Vindicated," *Dalitstan Journal*, 2(6) (December 2000). http://www.dalitstan.org/journal/dalitism/dal000/rac_ocsv.html.

33. http://www.raceandhistory.com/cgi-bin/forum/webbbs_config.pl/noframes/read/1065

34. Cressida Heyes, "Identity Politics," July 18, 2002. http://plato.stanford.edu/entries/identity-politics/.

35. See Troy Duster, "Feedback Loops in the Politics of Knowledge Production," *Technikfolgenabschatzung: Theorie und Praxis*, 13 (3) (December 2004): 40–48. http://www.itas.fzk.de/tatup/043/dust04a.htm

36. See Gene Russo, "Broad Sweep of Genome Zeroes in on Diabetes," *Nature* (February 15, 2007): 688–689.

V

Gendered Science

The feminist media art collective subRosa engages with a long history of critiques of patriarchy, demonstrating how art practice can enable provocation, parody, and critical pedagogy in the public sphere. Capitalism and patriarchy together maintain a heterosexual nuclear family system, whose functionings are not always visible to a disciplined citizenry. subRosa's technologically mediated performances, including *Smart Mom*, *Vulva De/ReConstructa*, and *Yes Species*, are ironic demonstrations of the simplistic ways in which the American public is encouraged to view fertility, pregnancy, assisted reproduction, motherhood, plastic surgery, and genetic research. Drawing on decades of intersex and gay activism, human rights work, and resistance to militarization, subRosa critically and playfully invites us to resist corporate/medical circumscriptions of our bodies and sexualities.

Science studies scholar Kavita Philip explores the nexus of the new biological and informational sciences in contemporary India, against the backdrop of colonial legacies of the Enlightenment and Romanticism. The struggle for indigenous control of intellectual property rights to bioresources is a righteous one, but needs a strategic reassessment in the light of recent history and the transnational geopolitics of technoscience, she argues. Can an antimodernist communitarian ethics fully account for nationalism, patriarchy, and neoliberal capitalism? Can romantic anticorporate activism offer a satisfactory theoretical and tactical analysis of the mutually constitutive relations between West and non-West, urban and rural, masculinist and feminist, scientific and spiritualist? Philip warns that naïve models of science and technology proliferate in the wake of India's software development and outsourcing successes. Well-meaning activists who record "free" knowledge through open source database software appear to be offering a new, transparent technology to cure the old woes of politicized colonial science. While there is reason to celebrate the vigorous activist fields of technoscience in India, there is still room for more creative collaborations among scientists, activists, historians, and cultural critics.

Literary critic Karen Cardozo and women's studies scholar Banu Subramaniam invite us to consider an established, almost traditional, art form—the novel—in its newest hybrid manifestation, as a productive site for a critical, resistant biopolitics. They suggest that the new literatures being produced at the intersection of science fiction and transnational cultural politics offer an untapped resource for activists, scientists, and educators who labor at the intersections of life sciences, art, and multicultural U.S. politics. In reading fiction and science together, Cardozo and Subramaniam are inspired by Donna Haraway's injunction to explore the "very potent join between fact and fiction, between the literal and the figurative or tropic, between the scientific and expressive." Offering a close reading of Ruth Ozeki's "biofiction" along with a critical history of recent anti-GMO activism, the authors argue that activist biopolitics might be most effective if it cultivates political hybridity through "unnatural" alliances that eschew the metaphysical purities of an outdated humanism.

Gwyneth Jones, an acclaimed British science fiction writer, recounts the ways in which an engagement with the practice and content of scientific research radically changed her literary creative practice. Science itself, and the exciting feminist science fiction developments of the 1970s–1990s, were the catalysts that enticed Jones to experiment with fictional tropes beyond the alien invasions, mysterious demons, and piteous female victims that formerly characterized the feminist spaces of science fiction writing. As she describes it, chills went down her spine when she first read Evelyn Fox Keller's biography of Barbara McClintock, *A Feeling for the Organism*, because of the startling parallels between the life of McClintock and Jones's sketch for a fictional protagonist. What followed, in her literary practice, amounts to her independent discovery of the practices of scientific ethnomethodology and the art-science interface.

Like many social scientists and media artists in the 1970s–1990s, Jones initially started reading, and attending lab discussions, and interviewing scientists to assist her literary practice, but became increasingly fascinated with the material itself. She speculates that laboratory life and science fiction writing share a passion for "the addictive stress of novelty, the pride of stepping out onto empty space." Like so many other artists and social scientists in this volume, Jones found that science and art cannot simply be theorized in their abstractions, but are co-constructed through the lived daily discipline and creativity of practitioners' crafts.

Common Knowledge and Political Love

subRosa

. . . the body has been for women in capitalist society what the factory has been for male waged workers: the primary ground of their exploitation and resistance, as the female body has been appropriated by the state and men, and forced to function as a means for the reproduction and accumulation of labor. Thus the importance which the body in all its aspects—maternity, childbirth, sexuality—has acquired in feminist theory and women's history has not been misplaced.
SILVIA FEDERICI (2004, p. 16)

Under capitalism, femininity and gender roles became a "labor" function, and women became a "labor class."[1] On one hand, women's bodies and labor are revered and exploited as a "natural" resource, a biocommons or commonwealth that is fundamental to maintaining and continuing life: women are equated with "the lands," "mother-earth," or "the homelands."[2] On the other hand, women's sexual and reproductive labor—motherhood, pregnancy, childbirth—is economically devalued and socially degraded. In the Biotech Century, women's bodies have become flesh labs and Pharma-commons: They are mined for eggs, embryonic tissues, and stem cells for use in medical, and therapeutic experiments, and are employed as gestational wombs in assisted reproductive technologies (ART). Under such conditions, resistant feminist discourses of the "body" emerge as an explicitly biopolitical practice.[3]

subRosa is a cyberfeminist collective of cultural producers whose practice creates discourse and experiential knowledge about the intersections of information and biotechnologies in women's lives, work, and bodies. Since the year 2000, subRosa has produced a variety of performances, participatory events, installations, publications, and Web sites as (cyber)feminist responses to key issues in bio- and digital technologies. subRosa's projects rethink feminist issues of the body and labor as they are being changed by globalization

of markets, information, and communications technologies, the service economy, migration, trafficking in women, and new biomedical-genetic technologies. The collective's projects range from examining the social, economic, and health effects of ART and the medicalizing of sex and gender, to the worldwide trafficking in organs and stem cells, women's labor in the biotech industries, and the cloning and genetic engineering of animals, plants, and human cells.[4]

Capitalist culture is deeply invested in the compulsory two-gendered, nuclear family system—not least because it guarantees maximum efficiency in the production and reproduction of labor power and the control of biopower. With the rapid advances in reprogenetic, transgenic, and nanotechnologies, the tools are at hand to fully utilize women's (and animals') bodies in the Faustian project of a genetically engineered and human-controlled evolution of new species of cyborg and transgenic organisms. Human and animal bodies have been the most valuable commodity in human culture since primitive accumulation began. It follows, then, that bodies are also primary sites of sovereignty, resistance, and contestation. In this chapter, subRosa begins by tracing a brief history of lay or "common" medical, and healing practices that posed an embodied resistance to religious, medical, and capitalist control of gendered bodies, reproduction, and medical practices—and connects them to current social struggles to create accessible and just public health-care systems, biopolitical autonomy, and knowledge in common. Researching and learning from these histories is fundamental to subRosa's cultural practice.[5]

Using examples from subRosa's performative work, including *SmartMom*, *Vulva De/ ReConstructa*, and *Yes Species*, we illustrate how our work engages a feminist critique of corporate and military control of biogenetic and reproductive medicine, which is imposing new concepts of corporate ownership (through intellectual property agreements and patents) on the bodies and cells of individual women and men (and animals). We also reflect on ways in which practices of sharing "knowledge in common" might effect more just and pleasurable ways of performing health care and "undoing" gender.[6]

Witch Hunts, Healing in Common, and the Struggle for Women's Reproductive and Sexual Autonomy

A study of the witch-hunt also challenges Foucault's theory concerning the development of 'biopower,' stripping it of the mystery by which Foucault surrounds the emergence of this regime.
SILVIA FEDERICI (2004, p. 16)

As Federici sees it, biopower is rooted in the context of the rise of capitalism,

where the promotion of life forces turns out to be nothing more than the result of a new concern with the accumulation and reproduction of labor power. We can also see that the promotion of

population growth by the state can go hand in hand with a massive destruction of life; for in many historical situations—witness the history of the slave trade—one is a condition for the other.

Further, she argues that large-scale violence, torture, and death "can be placed at the service of 'life' . . . and the production of labor-power since the goal of capitalist society is to transform life into the capacity to work."[7]

The fourteenth through seventeenth centuries, the age of witch-hunting in the West, also spanned the decay of feudalism and the rise of early capitalism. Historians speculate that witchcraft may have arisen in part from anti-feudal female-led peasant rebellions after the enclosure of the commons deprived many women of the means of making an independent living.[8] Witch hunts were well-organized campaigns that targeted the most defenseless populations: mostly poor, widowed, and aged females—or those who were considered heretical, sexually deviant, or rebellious. Women accused of witchcraft were often lay healers serving poor and peasant populations. In its persecution of peasant healers, the Church was directly attacking both women as a class, and an emerging "people's medicine" based partly in empirical observation and extensive bodily and herbal knowledge, combined with more intuitive practices (magic, witchcraft) that addressed emotional and spiritual aspects of sickness. The suppression of women healers was concomitant with the rise of medicine as a branch of study for upper-class males. The first male doctors trained during this period were not doctors of medicine per se, but of theology and philosophy. They tended to the aristocracy, the clergy, and the bourgeoisie, not the peasants.

So-called witches, and midwives, were often the only medical practitioners for people who were riddled with disease and afflicted with poverty. While the Church-sanctioned healers mostly employed prayer, alchemy, bleeding, and holy water in their ministrations, many women healers were well on their way to becoming something like the empirical scientists of their time, gathering data from their practices and experimenting with herbal cures, and shared knowledge derived from direct observation through the senses. For example, women healers and midwives discovered the powers of ergot (a fungus) for the inducement of labor and easing of labor pains; belladonna as an antispasmodic after childbirth; and digitalis for heart ailments. Today, many of these plant-derived substances are staples of modern pharmacology and biomedicine. Midwives also used placebo medicine, massage and physical therapy, touching, laying on of hands, herbal infusions, special foods, and baths. Midwives even practiced pelvic massage (masturbation) on their patients to bring on orgasm and relieve pelvic congestion and tension. Clearly, the mass-scale killings of "witches" deprived the world of an extremely valuable "craft" of medical and bodily knowledge, garnered through years of painstaking labor and practice.[9]

The *Malleus Maleficarum* (*Hammer of the Witches*) was a manual used by witch-hunters and the clergy who examined people accused of witchcraft. As defined in this book, the crimes of the witches were religious heresy, being sexually active, organizing women to

rebel, having magical powers of healing and of hurting, and possessing medical and obstetrical skills and knowledge. One could say that "witches" were persecuted because of their knowledge of the body and their refusal to surrender their sovereignty as practitioners. Reading between the lines, it appears that among those accused of witchcraft were people of ambiguous gender, such as hermaphrodites, lesbians, androgynes, and gender rebels. It is also clear that what was chiefly in contestation during the time of the witch hunts was the Church's struggle for the control of women through controlling their sexual and reproductive bodies, as well as their labor power.

A time-honored tactic of workers' resistance has been the withdrawal, or refusal of their labor. For centuries, women, too, have practiced the tactical withdrawal of their sexual services (Lysistrata) and reproductive labor (childfree women, nuns, female mystics) in order to escape patriarchal control. Witches and holy women have used tactics of practicing magic, incantation, and spiritualism as much to escape from allegiance to an unjust system of the gendered division of labor as a means to create an independent living and supply needed services to their communities.

During the Crusades, Europeans came into contact with the Arab world's more advanced scientific and medicinal knowledge; consequently, the thirteenth and fourteenth centuries saw the beginnings of medicine as an empirical science in the West, and gave rise to the university-educated male medical doctor in Europe. Young men of means went to university to study medicine, and soon began to monopolize medical practice and banish women from the healing arts—except for midwifery.[10] In the United States, the rise of medical professionalization started in the early 1800s when the "regular" (university-trained) male doctors became the only legal healers, replacing the "irregulars" or lay healers—many of them women and blacks—with no formal training. Concurrently, the well-organized protofeminist Popular Health Movement arose during the 1830s and 1840s. Organizations such as the Ladies Physiological Societies (often led by middle-class white women) gave public lectures and instruction on female health, hygiene, and anatomy. They advocated frequent bathing, loose-fitting clothing for women, whole grain cereal, and abstention from alcohol and tobacco.

In the Popular Health Movement, feminist struggle and class struggle came together. Yet, however influential and popular this movement was, it could not successfully resist the campaign to professionalize the practice of medicine. Pressure came from the captains of industry who had been trained at elite universities, and from a backlash against the autonomy of women's and people's medicine. Johns Hopkins for example, was the first U.S. medical school to introduce German scientific methods of disease prevention and therapy based on the theory that diseases were caused by germs. But instead of communicating this important information to midwives and lay healers, male-run medical colleges saw an opportunity to exclude them; they refused to admit female and black students, and the practice of medicine became increasingly privatized and professionalized.[11] But by the late nineteenth century, the professional medical monopoly was

so strong that even women doctors trained at female medical colleges began to side with the "regulars" against the "irregulars" to demand a complete medical education for all who practiced obstetrics. By the early 1900s midwives were banned from most American states, and nursing became the only legitimate health-care occupation left for women.[12]

In the 1970s, the Feminist Health Movement (FHM) in the United States became a direct successor to the long-suppressed traditions of people's medicine and lay-controlled health care. Founded by a coalition of amateur health activists and feminist professionals, the FHM organized women's health clinics and rape crisis centers, fought for reproductive and abortion rights, and advocated freedom of sexual choice and women's bodily sovereignty. FHM was integral to "second wave" women's liberation movements of the 1960s and 1970s, which had exploded into public culture, the media, and politics, with campaigns for the liberation of female sexuality and bodily autonomy, abolition of gender discrimination, equal opportunity in the labor market, choice of sexual orientation, and demands for women-centered health care, and reproductive rights.

Since the 1960s, U.S. and European feminists have taken many different positions on the issues of advanced biogenetic and medical technologies, and women's reproductive rights and health care. Though many 1970s feminists celebrated the "natural" creative female body, many more welcomed (apparent) advances in scientific and biomedical technologies such as the contraceptive and abortion pills, ultrasound monitoring of pregnancy, medicalized childbirth, and the development of ART. Other feminists launched strong critiques of the new reproductive technologies, questioning the potential dangers of experimental procedures that necessitate women's taking massive doses of hormones, protesting the constant monitoring and invasion of women's bodies, and critiquing the eugenic tendencies and instrumentalizing of reproduction introduced by ART, doctor-controlled conception, and the separation of sex from reproduction. Currently, there is also considerable feminist debate about the long-term effects on women's health of medical and pharmacological interventions used in the harvesting of multiple donor eggs for embryonic stem cell production, the increased medicalization of menopause, and medically induced cessation of menstruation, particularly in young women.[13] Finally, there is growing concern about the steep rise of aesthetic surgeries such as breast augmentation/reduction, liposuction, and aesthetic surgery of the female genitals (not to mention coerced medical gender reassignment surgery of intersex children and hormonal treatment of sexual "abnormalities").

Many of these medical procedures are marketed to women with the promise of being antiaging or rejuvenating, or enhancing sexual pleasure, as well as serving to raise women's self-esteem. subRosa suggests that the millions of dollars spent by consumers on these "beauty treatments" would be put to better use combating the chief killers of women worldwide: heart disease, AIDS and other infectious diseases, malnutrition, gender violence, poverty, neglect, and war.

Box 14.1 Excerpts from the text on the SmartMom web site

The Problem: Women's Resistance to Cyborg Adaptations

Medical and military research into the adaptation and re-engineering of organic (meat) bodies as platforms for cyborg organisms has been advancing rapidly at least since the 1960s. As is usual, it is the male body that has been used as the standard human template for this research. In "Cyborgs and Space" for example. Manfred Clynes and Nathan Cline write: " Solving the many technological problems involved in manned (sic) space flight by adapting man (sic) to his environment, rather than vice versa, will not only mark a significant step forward in man's (sic) scientific progress, but many well provide a new and larger dimension for man's (sic) spirit as well." (*The Cyborg Handbook*, p. 33)

Historically, women's bodies have been notoriously resistant to machine adaptation or medical regulation. The unpredictable ebb and flow of menstrual cycles, hormones, moods, libido, weight loss or gain, metabolism, ovulation, pregnancy, gestation period, fertility, and natural birth rhythms, have severely tested scientific control and management methods.

The essential female function of reproduction has been the focus of intense medical intervention and control in the West at least since the birth of Christianity. In the last few decades of the 20th century the medical (male) control and advancement of reproductive technologies has been the subject of massive scientific research and development. Using human germ cells manipulated in the laboratory, reproductive scientists are now able to create genetically engineered embryos to implant into human females. But the pregnancy and birth processes are still far less controllable although new methods are continually being tested.

In particular, the problem has been that pregnant and birthing women who are moving freely among the general population are hard to control and surveille at all times. While doctors try to regulate the lives, activities, and diets of their patients, women tend to be resistant to this form of control and many of them habitually disobey doctor's orders and lie about what they have been up to. Add to that the spread of the practice of using surrogate mothers by infertile or older couples, women with health problems, gay couples, single men, and others. Increasingly, those who hire surrogate mothers are seeking the legal right to monitor and prescribe their lifestyles, diets, and activities. But how is this to be done without physically confining the women, or having her followed at all times? Indeed, with declining birth and fertility rates, it is in the interest of all citizens to assist in the surveillance and protection of all pregnancies!

Until now doctors have lacked a foolproof and objective way of constantly monitoring their remote patients, as well as way of treating them if they cannot be there physically. Thanks to exciting new developments in military battlefield medical research however, the technology has now been developed to solve these problems.

The Solution: Smart Mom Pregnancy Technologies

With a combination of the rapid advances in biotechnology, genetic engineering, and smart technology, it seems that at last the tools are at hand to make it possible to include women in the central project of a new kind of technically engineered and assisted biological evolution which holds out the hope of the birth of a new race of cyborg platforms and organisms. While the military will at first be the chief beneficiary of this technology, it also has immediate and far-reaching benefits and applications in civilian society.

It is now possible to control and manipulate reproducing women because new technologies enable the surveillance of women's "natural" pregnancy and birth processes through telepresent obstetrical monitoring and intervention. Henceforth reproducing women will be able to live and give birth in, technological, machinic, or other environments such as space capsules, extraterrestrial environments, remote battlefields, dangerous urban areas, remote rural places, nuclear submarines, and the like, without endangering their offspring, and without altering the biological heredity of their embryonic organic platform which has been genetically engineered to adapt to these environments. Coupled with advanced reproductive technologies that can also be delivered telepresently by Smart technologies, the new remote pregnancy and birth monitoring and manipulation systems represent a major breakthrough in cyborg reproduction. Further, the research also holds the promise of complete telepresent monitoring of surrogate mothers who can be systemically manipulated through Smart biotechnology and telepresent supply and control systems.

Contesting the Control and Surveillance of Women's Bodies

SmartMom

Sometime around 1997, a subRosa member went to buy a toaster at K-Mart and could not find one that was not "smart." With some alarm, she noticed that all the other household appliances were likewise "smart," as were the toys in the toy department. At the same time the cyberfeminist reading group from which subRosa was hatched had been discussing the technologizing of conception, pregnancy, childbirth, and motherhood (as in ART) and cyborg bodies.[14] This research inspired the *SmartMom* Web project as one of subRosa's first artistic responses to the development of the new eugenic practices of ART, and the cyborgification of women's (mothers') bodies through medical surveillance and control of fertility and reproduction.[15]

SmartMom is a detournement (a tactic used by the Situationists to change original meanings of texts or images) of the concept of the Defense Advanced Research Project Agency's (DARPA) Smart T-Shirt technology, and the cyborg engineering of the body for space travel, as described in Manfred Clynes and Nathan Cline's article "Cyborgs and Space."[16] *SmartMom* satirically proposes a civilian adaptation of the technology of the Smart T-Shirt as a new means of surveilling the behavior of pregnant women. (See figures 14.1 and 14.2.) Although the shirt was originally engineered for remote battlefield wound sensing and to facilitate telepresent surgery for soldiers or space travelers, it was not hard for subRosa to imagine "repurposing" DARPA's Smart T-Shirt to control women's productive and reproductive labor.

SmartMom is a discursive, digital work that explores ways in which new biomedical and cyborg body adaptation technologies originally invented and developed by and for military purposes are later converted to civilian uses—thus contributing to an insidious militarization of public health care and private domestic life. *SmartMom* also points to the increased surveillance of civilian life and women's bodies. The project proposes a "solution"

Figure 14.1 Drawing for *SmartMom* Sensate Pregnancy Dress (1998).

to the "problem" of women's notorious resistance to cyborg adaptation and medical control: the Sensate Pregnancy Dress, a "nifty item that uses optical sensors connected to a web of coded fiber-optic lines leading to a radio transmitter provides constant monitoring of body systems and data such as heartbeat, blood pressure, fluid levels, nervous functioning, the mother's fantasy life, sexual and eating urges, and the like."

SmartMom intends to raise awareness of the way women who are pregnant or in childbirth are increasingly subject to behavior control from authorities and members of the public—for example, by forbidding them to drink alcohol, smoke, exercise too much, or in other ways to "endanger" the lives of their unborn children. *SmartMom* implicitly critiques the excessive monitoring and control of women's bodies while it also makes clear that today no one is exempt from constant bodily surveillance and control, and that soldiers are particularly vulnerable. Thus *SmartMom* includes a special "Cyborg Soldier Reproduction Program," an elite "Repro Corps" of women recruited by the military,

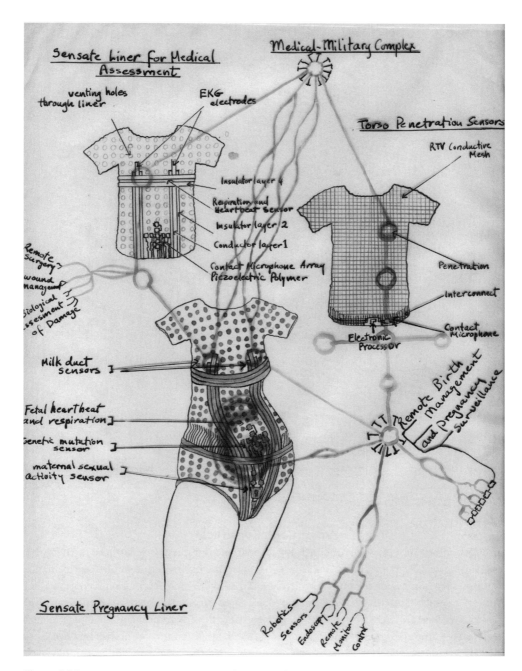

Figure 14.2 Schematic drawing showing adaptation of Smart T-Shirt technology for the *SmartMom* sensate pregnancy dress, 1998.

Figure 14.3 Collage for *SmartMom* Cyborg Soldier Repro Corps Program (1998).

selected through DNA scans, extensive biological and psychological fitness testing, and rigorous physical performance tests (figure 14.3).

Though subRosa's project was intended somewhat ironically at the time, it is sobering to note that many of the procedures we suggested are already in use on both civilian and military bodies. A quick look at projects in development on the current DARPA Web page will readily confirm this.[17]

Vulva De/ReConstructa

In 2000, in response to the surge of Internet marketing of aesthetic surgery of the vulva and vagina, subRosa produced *Vulva De/ReConstructa*, a ten-minute video performance that takes an ironic tour through the virtual and real worlds of "vaginal rejuvenation" and "designer laser vaginoplasty."[18] Perusing these Web sites, we noted that microsurgical medical techniques were being used to pioneer new flesh markets, and that plastic surgeons were capitalizing on women's perennial insecurities about their bodies by "resculpting" their vulvas and vaginas, thus reinforcing the idea that women's bodies can never be perfect enough. As described on one surgeon's Web site: "Designer Laser Vaginoplasty is

subRosa

230

the aesthetic surgical enhancement of vulval structures, such as the labia minora, labia majora and mons pubis."[19] Typical texts on these Web sites suggest that what is lacking or inadequate is the woman's body and the structure of her sexual organs—rather than knowledge and love of her own body, correct medical knowledge of clitoral and vulval structures and function, or informed lovemaking techniques and practices. What is sorely lacking in these Web site texts is any discussion of bodily differences, and of the social construction of beauty and sexual desire.

Amazingly inaccurate, misogynist, and outdated comparative anatomical studies and drawings of male and female genitalia, made by some of the first male doctors and gynecologists, still permeate contemporary scientific and medical literature and practice. In a recent article, Dr. Helen E. O'Connell and her colleagues pointed out that even the nomenclature for the female genital parts is consistently incorrect: "We investigated the anatomical relationship between the urethra and the surrounding erectile tissue, and reviewed the appropriateness of the current nomenclature used to describe this anatomy. . . . A series of detailed dissections suggests that current anatomical descriptions of female human urethral and genital anatomy are inaccurate."[20] The (real-life) reconstructive surgical intern who performs as the "doctor" in *Vulva De/ReConstructa* was horrified when we first called his attention to the Internet advertisements for vulval and vaginal surgeries. He commented that the surgeon's charges were highly inflated, and that the risk of deadening nerves and creating considerable scar tissue in these most sensitive of organs would actually diminish sexual sensation for the woman patient, though this was never discussed on the Internet sites. Instead, the "before" and "after" pictures emphasized the neat, clean, petite, and symmetrical appearance of the surgically redesigned vulva— and glowing testimonies from surgically altered women dwell on their increased self-esteem, sexual pleasure, and how much their husbands are enjoying their new vulvas and vaginas.

Like "cunt art" and other explicitly sexual and erotic art works pioneered by feminist artists in the 1970s, *Vulva De/Re Constructa* was intended to provoke discussion and disseminate knowledge about the still often silenced topics of women's sexuality and orgasmic pleasure, and the resistance, misogyny, and ignorance women may still encounter from medical and health practitioners.[21] Naturally, the financial incentives for these aesthetic surgery and flesh-tech interventions are large, motivating some scientists/doctors to "educate" themselves about the "problems" of women so they can fix them once and for all in the postmodern (posthysterical) way through "science," as this Web site text confirms:

To date there has been no such interest [as that dedicated to the correction of male impotence], let alone research, in vaginal relaxation and its detrimental effects on sexual gratification. . . . The obstetrician and gynecologist is looked upon as the champion of female health care. . . . Your doctor is a scientist. His [sic] knowledge is based upon this science [the science of obstetrics and

Figure 14.4 Vulva resculpting plan, *Vulva De/ReConstructa,* video still, 2000.

gynecological specialty.] This science is founded upon research, biostatistics, established facts [*sic*], theories, and postulates [*sic*]. If there is none of this science pertaining to vaginal relaxation and sexual gratification then it doesn't exist. It won't exist until we look for it. Therefore, let it begin now![22]

Our search of physician Web sites and other medical literature found no mention of the practices of female genital mutilation (FGM), and the connections between this practice and the labia- and vaginoplasty surgical practices, though these doctors must surely be aware of it. In our opinion, these surgical techniques might be put to much better use in trying to help women who are seeking reconstruction and healing of sexual organs damaged by FGM practices, than in making unnecessary "aesthetic" interventions in perfectly healthy women.[23] (See figures 14.4 and 14.5.)

Knowledge in Common: Activism for Gender Justice

Biopolitical production presents the possibility that we do the political work of creating and maintaining social relationships collaboratively in the same communicative, cooperative networks of social production, not at interminable evening meetings. Producing social relationships, after all, not only has economic value but is also the work of politics.
MICHAEL HARDT AND ANTONIO NEGRI (2004, p. 350)

The suppression and devaluing of traditional or common knowledge (women's, people's, non-Western) gained from centuries of inquiry, experimentation, and practice represents one of the greatest losses to the medical and scientific world in history.[24] Currently,

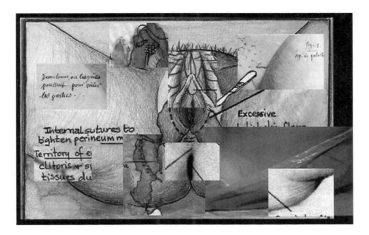

Figure 14.5 Title image, *Vulva De/ReConstructa*, video still, 2000.

however, Western pharmaceutical prospectors and bioprospectors are busy pirating and exploiting this traditional knowledge—often in less industrially developed countries whose populations cannot easily defend themselves against big corporations. Ironically, the patents filed by pharmaceutical companies on plants and drugs "discovered" on bio-prospecting forays have the effect of further suppressing dissemination of common knowledge, and criminalize the sharing and development of indigenous practices and self-care—often with lethal results.

Beginning in the late 1980s, ACT-UP's (the AIDS Coalition to Unleash Power) tactical activists in the United States and Europe began to contest the government and medical establishment's mistreatment of the HIV-AIDS crisis. They merged tactics of direct action learned from civil rights and antiwar activism with those of self-care, community education, and knowledge sharing, learned in part from the Feminist Health Movement, to build an effective and far-reaching social/political/cultural public health movement. Through the use of strategic coalition building, independent media production, founding community clinics and hospices, self-help and educational networks—as well as by launching independent scientific and medical research projects on the causes and treatment for HIV-AIDS—ACT-UP succeeded in changing some governmental public health policies (in the United States) and showed how effective resistant coalition politics can be.

As Mark Harrington (see chapter 19 in this volume) recounts, activist projects, such as the Treatment Action Campaign (TAC) emerging from South Africa, are challenging Big Pharma's patenting and privatization of expensive life-saving retroviral and antibiotic HIV-AIDS medications, and conducting highly visible campaigns to provide affordable treatment for the many millions of infected people by promoting the manufacture and

distribution of generic drug copies from countries such as Brazil and Thailand.[25] In a dark time when public health policies are militarized and medical insurance is unaffordable even for many middle-class people in the United States—let alone most working-class and the poor—ACT-UP and TAC's strategies and tactics are a radical call to widespread action in the public interest. The effective strategy pioneered by ACT-UP, teams of activists, and cultural producers with community health-care workers, chemists, doctors, and lawyers—demonstrate that alternative models for democratic health care are possible if there is the will to act.

Since the 1990s, another strong challenge to the notoriously unjust, racist, and sexist U.S. health care system has come from gender-queer, trans (transsexual) and intersex people who must contend with biomedical practices, human rights policies, and legal institutions in many different ways.[26] The radical body interventions often employed in both freely chosen "trans" and coerced "gender reassignment" surgeries and therapies can involve procedures such as extensive de/reconstructive surgery of sexual organs, mastectomies, genetic testing, hormone and drug therapies, and tissue transplants. Gender-queer and trans activists are contesting a wide array of medical, cultural, and disciplinary systems. Borrowing tactics from the FHM, ACT-UP, and queer activism, intersex/trans activism addresses questions of gender difference, race, and sexual, reproductive, and civil rights that are at the heart of many cultural, political, and human rights struggles. Consequently, trans and queer activists' campaigns for the right to bodily autonomy and choice of gender identification and biological sex could be as significant in bringing about profound legal, political, and societal changes in the twenty-first century as the civil rights, feminist, and gay/lesbian movements of past decades, to which they are intrinsically linked.

In Europe, the campaigns of intersex/trans and gay/lesbian human rights activists have served to put pressure on the European Union to inscribe the right to legally and medically change one's gender and sex as a basic human right into the European Union charter. In Berlin, in 2004–2005, there was a highly publicized campaign to omit any designation of a child's sex on birth certificates.[27] And both in Europe and in the United States, many informational and cultural activities, such as street actions, media campaigns, concerts, performances, and art exhibitions, support full civil and human rights for all gender-queer and minoritarian people.

In 2005, the Neue Gesellschaft für Bildende Kunst (NGBK) gallery in Berlin curated an exhibition and archive project called "Intersex 1-0-1: The Two-Gendered System as a Human Rights Violation." The prospectus for this exhibition read in part:

This archive and exhibition project examines the complex problems of the production of truth & reality especially in regards to the normativity of a bipolar gender system. Through the realities of the so-called Intersexual (Hermaphrodite), the exhibition portrays how culture and society are producing exclusion & demarcation.

subRosa

The medical term Intersexuality describes a spectrum of corporealities, which are anatomically, hormonally and genetically differentiated from what is defined as "man" and "woman." Up until now the concerns of this 0.2–4% of the world population which are affected were mainly left up to doctors and natural scientists. Due to the extreme taboos and disinformation concerning this phenomenon a large number of those concerned are ignorant about their own bodies and the medical operations, which often occurred shortly after they were born.[28]

The goal of the exhibition was to depict a different aspect of the topic than the usual titillating parade of freaks and medical anomalies. Rather, the exhibition was political, aesthetic, and pedagogical, providing, as the catalog stated, "An intensive investigation, negotiation and discussion of information pertaining to this topic . . . because it is not only a question of legal gender justice, but also of physical integrity and human worth. Encroachments on Intersexual human rights are not just the individual's problem, but instead pertain to the whole of society."[29] The work in the show consisted of a great variety of approaches to the topic, some of them displaying humor and anger, others dealing with the social and gender politics of coming out and living as intersex. There were also works about self-transformation in a larger sense, and about different bonds of love, kinship, and family created between intersex and queer people. Historical, medical, and political issues were dealt with in extensive archival and textual displays and installations, and in the comprehensive catalog.

subRosa was invited to present an opening performance and installation for this exhibit. In collaboration with James Pei-Mun Tsang, we produced *Yes Species*, a performative tableau and installation (figures 14.6 and 14.7). Our press text described our intentions:

subrosa and James Pei-Mun Tsang are uncommonly coupled, and will offer every possible explanation of yes species. Redundancy moves in tandem with spiritual healing. The biological body is inspiration.

Imagine . . . a clearing in the forest is populated with a living montage of becomings and unbecomings. Greetings and other exchanges transpire in a semi-digital staging of interruptions.

Imagine . . . in a clearing in the forest a symposium of erotic philosophers exorcises gender sickness. Witches, athletes, herbalists and yes species moan, choking on the silver apples of the moon, the golden apples of the sun.[30]

subRosa's project engaged with the exhibition's mandate to "serve a political purpose to convey knowledge about 'other' worlds" and to defy expectations and definitions about what art about intersex might be. We choreographed a poetic and affective tableau, designed to evoke feelings and ideas by appealing to the senses and imagination through colors, sounds, images, and texts. The tableau was framed by a video projection of a vividly green new-leafing forest creating a "forest clearing" in which performers pursued various

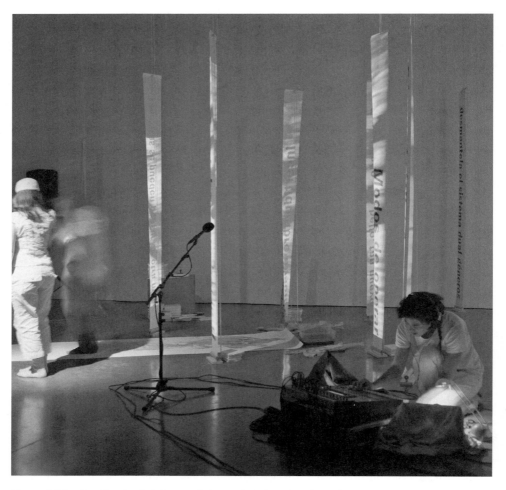

Figure 14.6 *Yes Species* (subRosa and James Pei-Mun Tsang), performance/installation, "Cyberfem: Feminisms on the Electronic Landscape," Espai d'Art Contemporani de Castello, Spain, October 2006.

"ways of operating." Their fanciful costumes defied and confused gender stereotypes: a DJ mixed songs, vocalizations, and sounds from trans, queer, and female vocalists. Brechtian interruptions occurred when a second performer operated bilingual scrolling texts that rose up from the floor declaring, for example: "The human body was the first machine developed by capitalism," "Things could be thought differently," "I love to you," "Andere Handlungsweisen," and "so beautiful, so various, so new." A third performer, costumed like mad King Ludwig of Bavaria, stood with his/her feet in containers of red and green ink, breathing and vocalizing into human-organ-shaped vellum balloons, and later painted

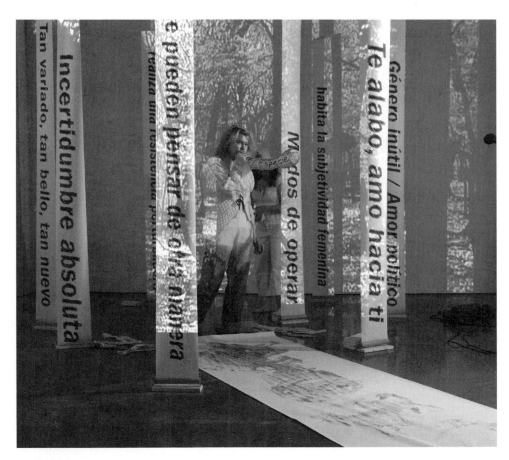

Figure 14.7 *Yes Species* (subRosa and James Pei-Mun Tsang), performance/installation, "Cyberfem: Feminisms on the Electronic Landscape," Espai d'Art Contemporani de Castello, Spain, October 2006.

a long scroll with red- and green-dyed feet and dripping pants legs. Meanwhile, the second performer hand-stamped the cover art for a book of texts written to accompany the performance, and then distributed the books among the audience.

subRosa's desire for the *Yes Species* performance was not to create an entertainment or a literal representation of intersex, but rather to orchestrate a sensuous experience of various bodies engaged in affective and nonalienating work and play, producing the effect of Luce Irigaray's concept of the "spaces between us."[31] Due in part to the collaboration with Tsang, this work marked a departure from subRosa's usual participatory performative biopolitical work in that it attempted to embody theory and research in a poetic and conceptual manner rather than a discursive and pedagogical one.

Conclusion

People today seem unable to understand love as a political concept, but a political concept of love is just what we need to grasp the constituent power of the multitude. The modern concept of love is almost exclusively limited to the bourgeois couple and the claustrophobic confines of the nuclear family. Love has become a strictly private affair. We need a more generous and more unrestrained conception of love. . . . We need to recover today [this] material and political sense of love, a love as strong as death.

MICHAEL HARDT AND ANTONIO NEGRI (2004, p. 352)

We all use our bodies variously as sites on which to inscribe signs of power, desire, gender, beauty, fitness, health, pleasure, and sexuality—and our bodies are also sites of commodification, display, and production. Becoming a noninstrumentalized, noncommodified body is a potent act of resistance very difficult to perform in our global culture of marketing and aggressive accumulation. Today, many people who identify as queer, trans, subcultural, subaltern, and feminist are actively refusing to lend their bodies any further to the inscription of a two-gendered, heteronormative legal, medical, and social system, and refusing to perform the "labor" of reproduction of femininity, masculinity, and nuclear families.[32]

Capitalism has always been deeply invested in controlling bodies, sexuality, reproduction, health, medical care, the affect industry, and the production of knowledge in common. The capitalist war regime is death-dealing, arrogating biopower to itself and controlling all aspects of life. But activist coalitions of the minoritarian and disenfranchised, feminists, the poor and sick, working people, migrants, gender rebels, becoming-women, cultural workers, radical professionals, and activist health workers are refusing to be repressed. They are applying their creative biopolitical powers to producing democratic forms of social production and imaginative life, and resisting market forces of commodification and privatization. So various, so beautiful, so new, in our tactics and life-forms, our anger and joy, we render compulsory gender designation and binary sexual arrangements ridiculous and obsolete in their discrimination, violence, and instrumentality. Moving beyond the unjust two-gender system, disobedient activists are taking up in a new way the radical goals of early feminism: the abolition of the sexist and racist patriarchal state, Church, and nuclear family—and the public health-care system—as we know them. Creating life and knowledge in common, we join with others throughout history who have practiced such acts of political love.[33]

Acknowledgments

This article owes a great debt to two important books: Barbara Ehrenreich and Deidre English, *Witches, Midwives and Nurses: A History of Women Healers* (now long out of print);

and Silvia Federici, *Caliban and the Witch: Women, the Body, and Primitive Accumulation*. In the spirit of knowledge in common, subRosa has freely borrowed ideas and research from these books and mingled them with our own.

Notes

1. In her incisive book *Caliban and the Witch*, Silvia Federici expands on Marx's term "primitive accumulation," which for him "characterize[s] the historical process upon which the development of capitalist relations was premised." Federici departs from Marx by examining primitive accumulation from the point of view of "the changes it introduced in the social position of women and the production of labor power." She explains that this accumulation of labor power is always accompanied by extreme violence—even (or perhaps especially) today. Federici points out that the rise of capitalist society occurred simultaneously with witch hunts and the persecution of women and the degradation of their labor; thus the gendered division of labor became a specific condition of capitalist class relations (p. 12).

2. Under feudalism, the commons were fields, woods, and grazing and agricultural lands open to common usage by landless peasants, many of them women. "Enclosure" was a strategy used by rich landowners and the aristocracy to eliminate communal access to common lands and extend their proprietary holdings. See Federici, *Caliban and the Witch*, pp. 68ff.

3. In *Multitude: War and Democracy in the Age of Empire*, Michael Hardt and Antonio Negri explain "biopower" as a part of the war regime that "rules over life, producing and reproducing all aspects of society. . . . it stands above society, transcendent, as a sovereign authority and imposes its order." By contrast, "biopolitical production" also "engages social life in its entirety," but it is "immanent to society and produces social relationships and forms of life-in-common through collaborative forms of labor" (pp. 94, 95).

4. Like most collectives, subRosa has had several iterations and changes in its membership over the years. Core membership of the collective has typically ranged from two to six people, with occasional one-time collaborators. Current core members are Faith Wilding and Hyla Willis. For more information on subRosa's group history, see Maria Fernandez, Faith Wilding, and Michelle Wright, eds., *Domain Errors! Cyberfeminist Practices. A subRosa Anthology* (New York: Autonomedia, 2003).

5. See www.cyberfeminism.net or the DVD *subRosa: Selected Projects 2000–2005* for documentation of subRosa projects.

6. See Judith Butler, *Undoing Gender* (New York: Routledge, 2004).

7. Federici argues her divergence from Foucault's theory of biopower in great detail throughout her extensive history of witch hunts and the emergence of women's grassroots resistance to capitalist control of the body.

8. "It is in the course of the anti-feudal struggle that we find the first evidence in European history of a grass-roots women's movement opposed to an established order, and contributing to the construction of alternative models of communal life" (Federici, *Caliban and the Witch*, p. 22)

9. Much of this paragraph is drawn from Barbara Ehrenreich and Deirdre English, *Witches, Midwives and Nurses*. Rachel Maines discusses midwives' use of pelvic massage in *The Technology of Orgasm: "Hysteria," the Vibrator, and Women's Sexual Satisfaction* (Baltimore: Johns Hopkins University Press, 1998), p. 68.

10. It was the barber-surgeons, who were not trained medical doctors, who led the final assault on female midwifery and obstetrics. Brandishing the newly created forceps, they worked to displace midwives, who as women were not permitted to do surgery. However, it is notable that mostly thanks to the Feminist Health Movement and obstetricians' rising insurance costs, midwifery has become a growing profession again in the United States (Ehrenreich and English, *Witches, Midwives and Nurses*, p. 20).

11. The practice of excluding of all but white men and a few white women from "regular" medical training was as racist as it was sexist. Like women, black doctors were trained in sectarian medical colleges that were not recognized by the regular medical profession. (See ibid., pp. 32–33.)

12. See ibid., p. 34.

13. See, for example *Period: The Cessation of Menstruation?* a documentary Film by Giovanna Chesler (2006), www.periodthemovie.com; Janice Raymond, *Women as Wombs: Reproductive Technologies and the Battle over Women's Freedom* (San Francisco: HarperSanFrancisco, 1993); Nancy Lublin, *Pandora's Box : Feminism Confronts Reproductive Technology* (Lanham, Md.: Rowman, & Littlefield, 1998); P. Treichler, L. Cartwright, and C. Penley, eds., *The Visible Woman: Imaging Technologies, Gender, and Science* (New York: New York University Press, 1998).

14. For example, Donna Haraway, "A Cyborg Manifesto: Science, Technology, and Socialist-Feminism in the Late Twentieth Century" in Haraway, Donna, *Simians, Cyborgs and Women: The Reinvention of Nature* (New York: Routledge, 1991,) pp. 149–181.; many articles from Chris Hables Gray, ed., *The Cyborg Handbook* (New York: Routledge, 1995); and books such as Robbie Davis-Floyd and Joseph Dumit, eds., *Cyborg Babies: From Techno-Sex to Techno-Tots* (New York: Routledge, 1998).

15. *Smart Mom* was produced by Faith Wilding and Hyla Willis in 1998. It was subRosa's first Web-based project and works well only in older browsers. subRosa is currently seeking resources to update and redo this project. In 2005 it was exhibited in the traveling show: Violencia sin Cuerpos, about violence against women, organized for and by the Reina Sofia Museum, Madrid, Spain. www.cyberfeminism.net/smartmom/html.

16. The Smart T-Shirt was originally developed at Georgia Tech for DARPA (Defense Advanced Research Projects Agency). Soon after subRosa launched *SmartMom*, the DARPA Web page on the Smart T-Shirt was taken down for unknown reasons.

17. The DARPA Web site—www.darpa.mil/dso/thrust/biosci/biosci.htm—lists some speculative new projects that promise to enhance the safety and performance of the "warfighter": for example, a chip that will create an artificial human immune system; smart fabrics that self-clean and self-decontaminate; and a host of new biomedical tools for "maintaining combat performance" through various biotech enhancements of the neural system, injury repair, genetically modified digestive bacteria, and much more.

18. *Vulva De/ReConstructa* was produced in 2000 by Faith Wilding and Christina Hung. It has been screened nationally and internationally, and is available on the subRosa DVD from www. cyberfeminism.net.

19. Laser Vaginal Rejuvenation Institute of Los Angeles, www.drmatlock.com.

20. For information on histories of anatomical genital illustrations, see Terri Kapsalis, *Public Privates: Performing Gynecology from Both Ends of the Speculum* (Durham, NC: Duke University Press, 1997). For the territory of the clitoris, see Dr. Helen O'Connell et al, "Anatomical Relationships Between Urethra and Clitoris," www.twshf.org/pdf/twshf_connell2.PDF.

21. See, for example, Anne Severson, "Near the Big Chakra" (1972), a seven-minute film depicting vulvas of all ages, shapes, and sizes; the "cunt-art" work of Judy Chicago and members of the Feminist Art Program at Fresno and Cal Arts; and art by Carolee Schneeman and Hannah Wilke, among many others.

22. Laser Vaginal Rejuvenation Institute of Los Angeles, www.drmatlock.com.

23. See Faith Wilding, "Vulvas with a Difference" in *Domain Errors! Cyberfeminist Practices* (New York: Autonomedia, 2002) for a discussion of this connection.

24. The patently racist and sexist motivations for such suppression are eloquently chronicled by Vandana Shiva in "Biodiversity and People's Knowledge," in Shiva, *Biopiracy: The Plunder of Nature and Knowledge* (Boston: South End Press, 1997).

25. For an account of ACT-Up's tactical campaigns, and recent AIDS medication activism by TAC, also see Gregg Bordowitz, *The AIDS Crisis Is Ridiculous and Other Writings, 1986–2003* (Cambridge, Mass.: MIT Press, 2004).

26. "Trans" can refer to people who have had transgender surgery, those who are transitioning, and those who are between genders whether they choose medical or surgical interventions or not. "Gender-queer" is a sociopolitical nomenclature rather than a biological one. "Intersex" (biological hermaphroditism) is generally taken to mean various permutations of the presence of both male and female genitalia, tissues, and/or DNA and hormones in one person.

27. Personal communication to author, Berlin, 2005.

28. *1-0-1 {one o' one} Intersex: Das Zwei-Geschlechter System als Menschenrechtsverletzung* (Berlin: NGBK Publishers, 2005), p. 8.

29. Ibid, pp. 8ff.

30. James Pei-Mun Tsang and subRosa, *Yes Species* (Pittsburgh, Pa., and Chicago: Sabrosa Books, 2005), p.5. Also available for free download on-line at www.refugia.net/yes. *Yes Species* was performed again in October 2006 at Espai d'Art Contemporani de Castelló, Castellón, Spain.

31. The spaces between us are explored in several chapters of Luce Irigaray, *I love to you: Sketch of a Possible Felicity within in History*, trans. Alison Martin (New York: Routledge, 1996).

32. See, for example, "Beyond Same-Sex Marriage Statement: A New Strategic Vision for All Our Families & Relationships," which advocates, among other things: (1) legal recognition for a wide range of relationships, households, and families—regardless of kinship or conjugal status; (2) access

for all, regardless of marital or citizenship status, to vital government support programs, including but not limited to health care, housing, Social Security and pension plans, disaster recovery assistance, unemployment insurance, and welfare assistance; (3) separation of church and state in all matters, including regulation and recognition of relationships, households, and families; (4) freedom from state regulation of sexual lives and gender choices, identities and expression. http://www.BeyondMarriage.org.

33. The notion of acts of political love is further discussed by Hardt and Negri in *Multitude*. See especially pp. 350 and 351ff.

References

Ehrenreich, Barbara, and English, Deirdre. *Witches, Midwives and Nurses: A History of Women Healers* New York: The Feminist Press, 1973.

Federici, Silvia, *Caliban and the Witch: Women, the Body, and Primitive Accumulation.* New York: Autonomedia, 2004.

Domain Errors! Cyberfeminist Practices. A subRosa Anthology. Fernandez, Maria, Wilding, Faith, and Wright, Michelle, eds., New York: Autonomedia, 2002.

Gray, Chris Hables, ed. *The Cyborg Handbook.* New York: Routledge, 1995.

1-0-1 Intersex: Das Zwei-Geschlechter System als Menschenrechtsverletzung. Berlin: NGBK Publishers, 2005.

Hardt, Michael, and Negri, Antonio. *Multitude: War and Democracy in the Age of Empire.* New York: Penguin Books, 2004.

Irigaray, Luce. *I love to you: Sketch of a Possible Felicity in History.* Trans. Alison Martin. New York: Routledge, 1996.

Laser Vaginal Rejuvenation Institute of Los Angeles. www.drmatlock.com.

Tsang, James Pei-Mun, and subRosa. *Yes Species.* Pittsburgh, Pa., and Chicago: Sabrosa Books, 2005.

Producing Transnational Knowledge, Neoliberal Identities, and Technoscientific Practice in India

Kavita Philip

The twenty-first century has roared toward the new frontiers of scientific knowledge on the twin turbines of information and biology. After the upheavals of the 1980s and 1990s, including the end of the Cold War and the full flowering of neoliberalism in the developing world, the state, corporations, and activists quickly understood that the battle for control and influence in the new century would occur on the grounds of technoscientific knowledge, intellectual property, and political sovereignty. Analyses of the mutual constitution of knowledge, power, and political economy defined the intellectual preparation required of all actors—conservative, libertarian, and radical—engaged in the struggle to shape the future. Like all millennial transitions, the crisis-ridden dawn of the twenty-first century appeared to shake the very foundations of the worlds it was leaving behind.

In an age of transnational simultaneity, when information appears instantaneously and transparently to manifest everywhere, what can histories of science teach activists about the historical development of underdevelopment, the specificity of regional modernities, the persistent unevenness of information exchanges? About the politics of location of transnational technoscientific centers of professional knowledge, or about the contingencies of truth and power? If the forms of emerging technoscientific knowledge are shaped by the dispersed, electronic, commodified vocabularies of transnational economics, how might activists and scholars engage more effectively with the challenges of bridging history, theory, and contemporary praxis?

To understand the knowledge/power practices we all contend with, it remains useful to recall and reassess the historical frames within which they appear. The rhetoric of radical novelty associated with biology in this century, while understandable in the light of genuinely new intellectual bridges across the disciplines of natural, life, and physical sciences, enables a forgetting of the claims of nineteenth- and twentieth-century science.[1] In this chapter I begin with an intellectual trend that is perpetually pronounced novel and

yet seems already archaic: the invocation of the "environment" and its associated political consequences. Environmental science and ecology appear, in the light of the more commodifiable forms of biological research, to be shifting into the neglected shadows of bioscience (notwithstanding the popular success of Al Gore's cinematic Power Point spectacle, *An Inconvenient Truth*). How might nature's history help us understand the functioning of technoscience in the increasingly privatized transnational spaces of strategically useful knowledge?

As in Al Gore's film, so in much public discourse on the environment. The Earth is often invoked as a fragile entity being consumed by a ravenous population. Statistically, industrialized nations consume a disproportionate share of the world's natural resources;[2] yet, in alarmist environmentalist calls to action, it is usually the Third World populations of China and India, or immigrant populations in the First World, that are held responsible for impacting the Earth in unsustainable ways. Without claiming innocence for any particular population, it is worth noting that racial and regional discourses of population, immigration, and underdevelopment continue implicitly to shape environmentalist virtue. Western critiques of developing countries' growth, although they often identify unsustainable extractive practices, fail to trace the histories of these practices in colonial regimes of resource management, and in their postcolonial imbrication with global economic pressures to provide raw materials and labor in the global marketplace.

Often noted separately from the racial histories of environmental representation, but nevertheless strongly connected, are the intensely gendered tropes of landscape, exploration, and settlement. At least two centuries of colonial representations of gendered landscapes preceded Frederick Jackson Turner's 1893 declaration that the frontier experience provided the foundation for American identity. More than a century later, Turner's tropes remain embedded in U.S. middle-class environmentalism. Constructions of masculinity, nation, class, and race are inextricable from narratives of white expansion into an "empty" West, representations of the American West as virgin territory, and the flight from East Coast urban comforts as the necessary precondition for the formation of authentic rugged American masculinity. The slaughter of Native Americans and the pacifying of the Western landscape then appear, hand in hand, as the precondition for civilization and the restitution of the natural. The enlightened Western settler, having penetrated and tamed the landscape and cleared it of savage weeds, appears as the true custodian of nature.

These historical frames for the emergence of environmental discourses are well known and widely cited among activists. Third World activism around resources, food, biodiversity, agriculture, and biotechnology has been enormously successful in the policy and legislative arenas. Significantly, their arguments have repeatedly deployed these raced, gendered histories in strategic ways. In the next section I track some of the successes of the sort of environmentalism that addresses these historical wrongs. Keeping gender, race, and the emerging politics of information simultaneously in focus has its challenges,

however. I ask, in conclusion, where the silences, gaps, and omissions lie even in the vigorous activist discourses, with a view to investigating where emerging tactical possibilities might lie.

Gender, Environment, Property, Geopolitics

In the volumes of progressive and environmentalist writing on the issues facing environmentalists in the age of globalization, several assertions of absolute difference have long been made. Although they have been strategically successful since the 1980s, it appears that the grounds of their tactical utility might be shifting. Let us take a closer look. Here are three common narratives:

1. Environmentalism represents a fundamental critique of, and resistance to, the WTO model of economic globalization, which represents the homogenization of the world.
2. "Property" is a Lockean, and fundamentally Western, concept, and thus has no appeal for Third World farmers and producers.
3. Third World communities are intrinsically ecofriendly, respectful of nature, and opposed to the ownership of life. In this sense they are fundamentally different from Western, "reductionist," and "Cartesian" cultures of science.

The form of the claims above are essentialist even in their most sympathetic modalities, and in their most extreme formulations they constitute orientalist or condescendingly relativist discourses. Although some of us might be sympathetic to many of the groups who offer these narratives, or find unity with some of their strategic objectives, it would be shortsighted to forgo critique in the interest of solidarity with an imagined subaltern (located in the putative premodern periphery, with its inherently communitarian ecological harmony).

The archetypal scholar/activist associated with romanticized communitarian narratives of ecofriendly indigenes is, of course, Vandana Shiva, whose ideological baggage has been widely critiqued, but whose activist successes continue to grow. The intersections of global economies with the politics of knowledge spawn a set of narratives that merit careful critique, not in order to detract from the radical potential in activist narratives, but in order to better understand the meanings of the radical, the pragmatic, and the neotraditional within the emerging formations of capital, nature, and science.

Shiva argues, for example, that:

Locke clearly articulates capitalism's freedom to build on the freedom to steal; he states that property is created by removing resources from nature through mixing with labour. . . . These Eurocentric notions of property and piracy are the bases on which the Intellectual Property Right laws of GATT/WTO have been framed. . . . It seems that the Western powers are still driven by that

colonising impulse to discover, conquer, own and possess everything, every society, every culture.[3]

We could easily critique the assumptions in this narrative, but it has had demonstrable strategic success—for example, in the overturning of the U.S. Patent and Trademark Office's turmeric patent. Recognizing these strategic histories, then, let us carry out the critical analytical exercise, hoping that a more nuanced critique of the politics of knowledge might inspire more radical tactics.[4] In much of Shiva's work, Western philosophy is represented as the cause of ecological devastation, and Southern indigeneity as antithetical to the very notion of intellectual private property. In her discourse, Southern natures are gendered feminine, while Northern science is gendered masculine. Shiva's ecofeminism advocates an essentialism that leaves little room for a critique of gendered representations of nature. And while there is, of course, evidence to support her assertion that WTO-sponsored economic regulation creates increasing numbers of rich winners and poor losers, it is not clear that this is because of an untempered and pure Lockeanism in the Western legal system. Indeed, the regulatory modifications suggested by Southern environmental activists such as Shiva are often consistent with the public trust and environmentalist legislation that has been effected in Western legal systems over the last several decades.

This is not to suggest that Western environmental law has already solved the ecological problems of developing countries. If it were as simple as countering Lockean influences in environmental legislation, much Western legislation should indeed be judged more ecofriendly than India's. Paradoxically, the global South is represented as the intransigent proponent of Lockean, pro-property, anti-environmentalist ideologies in much U.S. environmental discourse. For example, the legal scholar Anne Dowling sees property rights and sovereignty as obstacles to what she calls genuine international environmentalism. The storm clouds that threaten the dawn of global environmentalism in her discourse are represented by the Southern insistence on property rights and sovereignty:

[P]roperty rights advocates have transformed the idea of *res communes* from the notion of "open to all" into the notion of "property of all." If the latter definition, infused with the notion of ownership, is accepted, "It could . . . be dangerous; if the common heritage of mankind is *owned* it can be *used and abused by the owners*.[5]

Dowling sees hope in the history of American environmentalism and the domestic legislation it has effected, arguing that "it is the developing nations, those same nations concerned with permanent sovereignty, who are advancing [this] property rights definition."[6] Dowling finds evidence for her view in Southern legislative actions—for example, Philippines Senator Orlando Mercado authored a 1994 bill that called for the rejection of the "common heritage principle" in favor of "sovereignty over natural resources."[7]

Kavita Philip

Lockeanism has become a universal epithet that environmentalists fling at each other to describe the other's disrespect for nature, it seems. Instead of reading this as a North versus. South argument, or a Universal Science versus Local Knowledge struggle, perhaps we can read both in terms of their political strategy. Both Shiva and Dowling offer strategically generalized expert narratives. Each accuses very large geographical areas of being inherently, intransigently Lockean and pro-property. Shiva fails to nuance the Indian activist landscape, offering few examples of resistance other than the efforts of her own research foundation. Dowling sees the South as monolithically represented by states in the most recent rounds of WTO negotiations, ignoring the competing narratives within states and the strategic positionings that militate Southern states' claims to sovereignty in the face of Northern attempts to shape global market conditions.

Beneath Shiva's and Dowling's claims of radical difference lie familiar assumptions. Shiva assumes a simple tradition–modernity dichotomy, and opposes urban technoscientific modernity to the idealized communitarian village—narratives rooted in a familiar nineteenth-century romanticism. Dowling's assumptions are rooted in colonial and stagist views of developing countries as yet to rise above parochial and instrumentalist understandings of nature, toward an enlightened appreciation of nature's meaning for the higher aspirations of all humanity. Both fail to read the politics of property in sufficient sociological detail and to analyze the politics of knowledge production in sufficient theoretical detail.

It rather quickly becomes clear that the discourse of incommensurability does not offer us sufficient analytical purchase for a historically complex yet politically useful understanding of technoscientific knowledge/power. The conflict between expert resource management and its ecological peripheries (whether in First or Third World nations) is not really a story of the evolving sameness of modernity versus the inherent difference of the nonmodern. Globalization produces new kinds of heterogeneities and homogeneities as part of the effort to revivify a dynamic yet familiar economic order. In contrast to Shiva's, other subcontinental feminist analyses suggest that we acknowledge the dynamic stratification of gendered, classed, and caste communities, and the ongoing invention of tradition.

Vandana Shiva is one of the most prolific and widely known South Asian environmentalists. Her work has facilitated genuine gains for Indian farmers, such as the setting up of community seed banks and the contestation of corporate intellectual property rights (IPR) to neem (Agadirachta Indica), and this reassessment of tactics is in no way intended to detract from her significant record of strategic successes since the 1980s. However, Shiva's activism and writing have translated into few real advances for feminists. While this might seem surprising from the point of view of Western academia, in which Shiva's articles appear as representative of authentic South Asian feminism in every gender studies anthology, it is less paradoxical from a Southern standpoint. Other feminist South Asianists, particularly Bina Agarwal, Shubhra Gururani, and Gabriele Dietrich, have long

offered critiques of Shiva's environmentalism; but these voices are less often recruited by public sphere technoscience activists. Shiva locates the problem entirely in of colonialism and the intrusion of Western science into an indigenous harmony. Bina Agarwal argues:

> Shiva attributes existing forms of destruction of nature and the oppression of women (in both symbolic and real terms) principally to the Third World's history of colonialism and to the imposition of Western science and a Western model of development. . . . By locating the "problem" almost entirely in the Third World's experience of the West, Shiva misses out on the very real local forces of power, privilege and property relations that predate colonialism.[8]

Bina Agarwal's own 1981 report of the increased number of female suicides in Uttar Pradesh sharply illustrates the conjunction, in contemporary India, of environmental degradation and women's oppression by familial structures.[9] Agarwal reports that suicides among young women in Uttar Pradesh increased sharply by 1981. Soil erosion had made it more difficult to grow enough grain for subsistence; male out-migration in this region was high. Young women were increasingly unable to collect enough water, fodder, and fuel; this caused tensions with their mothers-in-law, who recalled forests of plenty from their youth. Increased fuel-gathering time generally has secondary effects, including decreased agrarian output, since women have less time to spend cultivating crops. In addition, it has an effect on nutrition, which declines because of the need to economize on cooking fuel. Women and children always bear a disproportionate share of decreased nutrition, leading to long-term effects on their health.

To understand the oppression of women in this situation, it is insufficient to posit an ecofeminist thesis alone. Male out-migration must be understood in terms of the national economy and of transnational connectivities; familial relations between women of different ages, and in intrafamily distribution of food, must be understood within the history of patriarchy and the Indian family, which itself has been constituted via the transnational histories of hybrid modernities. Women's work, women's emotional health, forests, fuel, and subsistence agriculture must be understood within an agrarian political economic, as well as a transnational, analysis of the construction of gender and the family.

Agarwal offers the outlines of a "feminist environmentalism"[10] distinct from the "ecofeminism" of Maria Mees, Vandana Shiva, Ariel Salleh, and others. Agarwal adds a political economic analysis and a materialist as well as an ethnographic basis to the ideological analysis that ecofeminism offers. While there is much value in the ideological critique that ecofeminists make (especially in the more historically inflected work), ecofeminism nevertheless tends to posit woman as a unitary category, making it hard to recognize gendered differences along the lines of class, race, caste, and nation.

While Shiva's activist agenda continues to grow in scope and power, her theoretical paradigms have aged poorly. Her critique of the "patriarchal domination" of a metaphysi-

cally valued Earth was a logical outgrowth of a 1970s-style ecofeminism, but its essentialist overgeneralizations and historical inaccuracies have been critiqued by succeeding generations of ever more theoretically sophisticated critics. The critiques have been largely accurate in terms of identifying Shiva's tendency to assume a natural, or inherent, link between women and an anti-exploitative, "nurturing" relationship with the Earth; but their effect has been blunted by the suspicion that marks the relationship of green activists to green theorists. Those who favor action over analysis tend to dismiss the theorists' critique because the language of theory and history appears to them to be inaccessible, specialized, and pretentious. In Shiva's case, two issues seem worrying in practical ways. First, it is not just Shiva's model of womanhood that is static and essentialist; science and technology suffer the same fate, and nature itself is rendered sacred (and thus also static, not to be sullied by profane technology). Second, this "rediscovery" of the authentically indigenous "sanctity" of nature brings Shiva uncomfortably close to a traditionalist religious nationalism, with disturbing implications for the kind of communitarianism she envisions.

Shiva suggests that science and technology, inherently reductionist and unethical, are exclusively a product of Western philosophy, and that, conversely, bioethics is natural to the realm of Eastern thought. Quoting from the Upanishads, the Dalai Lama, and Tagore, she offers their more "holistic" ideas as evidence that "[c]ompassion and concern for other species is therefore very indigenous to our pluralistic culture."

Sinha, Greenberg, and Gururani have argued that Shiva, among other "new traditionalists," offers a revivalist, upper-caste Hindu model for gender and environmental relations.[11] Shiva's silence about the political economy of indigenous hierarchies and patriarchies, when placed in the recent historical context of *Hindutva* patriarchy and antimodernity (where *Hindutva* refers to right wing, essentialized constructions of Hinduism), remains susceptible to, if it is not already complicit with, a neofascist Indian discourse of growing strength. Doug Henwood characterizes eco-traditionalist ideology bluntly when he rejects the "elitist asceticism" of antiglobalizing romantics, saying: "[Their] dream of local self-sufficiency is suffocating and reactionary."[12] Indeed, romantic antiglobalization is often hostile to materialist feminist/activist hopes of transforming modes of production in ways that reject both feudal and capitalist frameworks of patriarchy, both tradition and modernity, both stereotyped "Western" and "Eastern" forms of thought. The desire for a productively hybrid space here is the same desire that invites feminist philosophers and scientists to forge a hermaphroditic science.[13]

Shiva's simple subsistence model, undergirded by a nature ethic that seems transcendentalist and romanticist, leaves little room for a materialist, cultural, historical, or transnational understanding of the shifting relationships among social production, modes of patriarchy, and modes of representing nature. In her narrative, the main villain is "science" per se (rather than a historically specific form of scientific knowledge or technological practice). She advocates a return to a pretechnological existence and a subsistence

model of production, implying that self-sufficient peasant societies insulated from global trade will automatically be egalitarian and respectful of nature. Such a position willfully ignores the patriarchal gender relationships of Indian society that predate colonialism. Moreover, it is reminiscent of nineteenth-century British romanticists and American transcendentalists, who could afford to worship a "mystical" nature only by virtue of accessing it via the enabling privilege of their social positions. A simultaneously theoretical and tactical analysis of the transnational production of cultural identities and scientific assumptions might illustrate the more complex, mutually constitutive, relations between West and non-West, urban and rural, masculinist and feminist, scientific and romantic/spiritualist.

In contrast to romantic antiglobalizers, the South Asian feminist Rohini Hensman cautions against assuming an inherently negative character for technology. Rather, she sees new technologies as a necessary component in defining a better future, for they can potentially be used "to enlarge human choices, combat gender discrimination, and enhace the quality of life."[14] But this would require a sweeping transformation of work in general, and of working conditions for women in particular. Hensman's argument supports activists who advocate an internationalist model of global linkage (developed in dialectical relation with local self-sufficiency) over the dream of antitechnological traditionalist local communities (which absolutize and romanticize self-sufficiency rather than putting it in the context of the historical development of internationalism). Though both romantic and materialist ecopolitics assume a need to forge a different kind of society, they recruit different constituencies. Romantic green politics obscures questions of nation, masculinity, and transnationalism, or simplifies them to mean the addition of women to standard oppositional strategies.

Turmeric and After

The infamous patent on turmeric, granted by the U.S. Patent and Trademark Office to two researchers at the University of Mississippi, was overturned after a legal challenge by the Indian government's Council of Scientific & Industrial Research. Aided by the work of nonprofit groups including Vandana Shiva's agricultural NGO, the Council managed to prove "prior art" by offering ancient and contemporary recorded knowledge and use of the antiseptic properties of turmeric root, rendering the University of Mississippi research nonnovel and nonoriginal.

The case was hailed as a victory not only for Southern activists, but also for a principle: commonly used indigenous and "natural" remedies could not legitimately be patented, and dire claims of the pillage of the commons seemed to recede. But if the specter of multinational pharmaceutical firms suing villagers for applying turmeric paste to a wound or brushing their teeth with neem twigs has receded, more detailed conversations about property have emerged. What form should Southern resistance to patents take? Would

reparation claims be best served by a blanket rejection of so-called bioprospecting, by a case-by-case challenge to multinational patent claims, by an appropriation of property through the proliferation of Southern claims to possess their own indigenous knowledge, by civil disobedience, or by other means? How would authorship be defined within patent law, in the case of ancient or communal knowledge? These and other on-the-ground debates define the emerging spaces of intellectual property discourse, in which the politics of knowledge production are being contested. Given the force of the globalizing narratives and the ways in which states and citizens are interpellated in the end-of-history narratives by which there appears to be no viable alternative to global capital, the space of radical resistance is harder to define, and offers little refuge for those seeking pure indigeneity and the outright rejection of property rights.

Does a critique of Shiva's ecofeminism entail that we abandon the link between gender and environment in the developing world? Despite numerous academic critiques of ecofeminism, activists continue to hang on to its essentialist claims in the belief that they help ground a desire for real, material social change. I would suggest, however, that textual critique of activist discourses should stage not just the ungrounding and delegitimation of claims for justice, but the need for more supple tactics of reading and action.

This is not a call for reinventing the entire field of gendered ecoactivist practice. Several large areas of environmental study have long been identified by feminists as rich areas for gendered analyses that combine historical with contemporary research in environmentalism. In 2002, Melissa Leach and Cathy Green suggested that such a list might include studies of the links among ecology, gender, and labor; changing regimes of tenure and property rights; gender dimensions of institutional arrangements around natural resource usage; changes in gendered uses of products, sites, and techniques in the context of colonial economic trade and policy; and relationships between gender and environmental knowledges and discourses.[15] As Leach and Green note, several environmental studies of the 1980s and 1990s offer us "a variegated picture of conflict, manipulation, and tradeoffs around gender and land rights. Importantly, [such a historical analysis] firmly grafts the relationship between tribal women and natural resources onto a material plane, rather than the spiritual one emphasised in ecofeminist 'histories' of tribal women, land and forests."

Work on African environments, by Sara Berry, Melissa Fairhead, and Jane Guyer, has shown how the spread of a colonial cash-crop economy effectively marginalized women farmers, because colonial management policies targeted chiefs and male "household heads." Postcolonial practices in developing countries have echoed this trend, with both national and international funding agencies, as well as commercial enterprises, privileging the male representatives of local communities. Work by Bina Agarwal, Govind Kelkar, and Dev Nathan has shown how women have historically been displaced from their rights to land by processes including colonial and postcolonial land revenue systems, the targeting of their male kin by development policies, and cultural moves such as accusations of witchcraft. In the early twenty-first century, this pattern continues to play itself out.

Consider a brief example, recounted by the Chattisgarh activist T. G. Ajay. In Chattisgarh, an Indian potter community where women have played a large and active role in the production and marketing of clay pots, they are being systematically marginalized by a growing market economy. Women in these communities have long been active in the collection of firewood, mud, and other materials for the production of pots, as well as in marketing the pots from door to door, activities which afforded them a great deal of mobility through the region, in public and in private spheres, as well as a great deal of bargaining power in household relations. One of the features of the emerging "modern" market is the allocation of physical shop space in officially designated market areas. Ownership of these shops is obtained through governmental channels, and it is the men of the families who are awarded ownership. Women's mobility, now constrained by the decline of door-to-door marketing, is also increasingly regulated by newly popular practices of covering the head and face, and Brahminized cultural practices that include the cessation of formerly free access to divorce and remarriage.[16] Clearly, the move toward a "modern" market economy has not automatically led to the liberation of women, as the standard narrative of free-market democracy holds.

Free Markets, Property, and New Information Technologies

Since 1991, the Indian economy has been through the economic obstacle course (jumping through the hoops of deregulation, structural adjustment, liberalization, and IMF/World Bank consultations) that became common for so many Latin American and African economies in the 1970s and 1980s. Loans from international financial institutions, tied to structural adjustment programs, have trapped developing countries in a cycle of debt while diverting their economies away from a focus on domestic food security and social needs, and toward the "international" mandate that they remain a source of raw materials and cheap labor for Northern markets. The Uruguay Round of GATT, whose conclusions were satified in 1994, finalized the Dunkel Draft, to which India was a signatory. One of its most significant aspects for natural resources was the controversial issue of intellectual property rights as they apply to plant products.

How can we understand different regimes of property rights as they have developed through colonial and postcolonial global economic shifts, and their effect on gendered divisions of labor and access to resources? The most recent developments in property, under the aegis of the GATT and the WTO, have been widely discussed by environmentalists. In table 15.1, drawn entirely from activist organizing materials, we can see the outlines of the main debates.[17]

As a starting point in any historical study of environment, it is clear that the notion of "environmentalism" can be divorced from historical issues of social justice and global equity only if we ignore the ways in which local resource use is tied today to the development of a new stage of capitalist and imperialist transnational geopolitics and cultural/

Table 15.1 Intellectual Property Rights to Nature

What's at Stake?	Northern Perspective	Southern Perspective
Land Races	Land races are "natural." They've developed over millennia, thanks to environmental processes.	Natural processes don't just happen—agency must be attributed to generations of farmers.
Intellectual Property Rights [IPR] for Land Races	Inventions thousands of years old cannot be owned.	Folk knowledge and seeds are no less "modern" than corporate-produced knowledge and seeds.
Inventors	It's impossible to attribute the invention of land races to any particular farmer.	Collective contributions of Southern farmers can be rewarded.
Commerce	Most land races have no commercial value anyway; the expense of monitoring germplasm is not worth the likely compensation.	The same is true of other inventions—only 1 in 1000 patents has great value. Further, a low commercial return for Northern industry may be a huge return for Southern farmers.
Innovation	When a land race is used commercially, breeders extract/adapt a gene complex. The particular genes and their properties may not have been known or expressed in the farmer's field.	Recent biotech patent decisions (e.g., specieswide patents on cotton and Bt) imply that the patent holder need not know everything about the patented material in order to benefit from the patent.
Free Access	Farmers are best served by a free flow of germplasm. Efforts to assign benefits and provide compensation for their raw material will just slow innovation and restrict the spread of future benefits.	Free access would be fine if the principle were applied uniformly. Informal community plant breeders' inventions are unprotected, while formal breeders' are covered by IPR, and awarded recognition and restricted access. The North can't have it both ways—free access must apply across the board.

political economies. We must, then, reject the framework of "pure green" environmentalism, focusing instead on symptomatic issues at the nexus of hybrid concerns in culture, political economy, ecology, gender, and nationalism. The "pure green " approach makes things seem deceptively simple—protect the earth and nature, we are told, and all other good and healthy things will follow. But a hybrid green perspective brings more complicated trade-offs into focus. For instance, gains for "biodiversity" can mean increased influence for Western pharmaceutical firms in Southern nations as well as increased funding

for Southern environmental NGOs. Though international biodiversity preservation interests generously fund local Southern NGOs, they often open up channels for pharmaceutical corporations to access local knowledge of medicinal uses of plants.

The buzzwords "sustainability" and "conservation" are used by corporate deforesters *and* biological crusaders, but the popular circulation of a global discourse of environmentalism simply glosses over political differences among these actors, and obscures the structuring conditions by which the subjectivities of green crusaders are rendered fuzzy-hearted, healthy, and earnest. The legal issues around the patenting of such well-known natural substances as neem, turmeric, and basmati rice have reached public consciousness through the mass media, causing outrage along a wide political spectrum. The ownership of natural entities and the commodification of "life" appear to fly in the face of principles of justice based on anything from spiritualism to socialism. Indeed, the slippage between religious and political grounds for the contestation of intellectual property rights is one of several strategically fuzzy domains in this discussion. This slippage makes for several symptomatically interesting formations around the question of identity and technology.[18]

On the face of it, the patent debate appears to be a straightforward case of conflict between Western industrialized nations, propelled by a multinational pharmaceutical lobby seeking to monopolize ownership of natural resources, and developing nations, seeking an equitable share in the trade of their own natural wealth. This is the conventional representation of the conflict. But several aspects of this debate hint at the ideological questions that lie at the heart of transnational economies and the growth of the software and biotech industries. Implicit in the multinational insistence on tying together property rights, free markets, and progress are historically sedimented assumptions about the ownership and "improvement" of property, and about the capacity of underdeveloped societies/peoples to own and improve. Implicit in Southern activists' opposition to patent claims on their natural resources are claims about historical accountability and the right to demand reparations for past injustices.

For example, the American patenting of modified strains of basmati rice (texmati and kasmati) is undergirded by the assumption that private capital can be spurred to continual innovation only if it is awarded the rights of exclusive ownership of and profits from the physical and intellectual labor expended on its products. The Southern argument suggests that the West had access to its raw material—such as indigenous basmati strains, developed by Indian farmers over centuries of experiments in plant breeding—only by virtue of the force of arms and the power of a colonial state that appropriated tropical resources while postulating inherent native laziness and indigenous incapacity to productively "improve" nature.

Embedded in this debate, then, are historical questions about property, science, and nature, as well as philosophical questions about power and ideology—questions that liberal jurisprudence is ill equipped to handle.[19] When multinationals appeal to "global-

ization" and to the free flow of goods, they gloss over the historical sedimentation of uneven economic development as well as the representational sediment of assumptions about liberal personhood. Southern antiglobalization activists accuse the West of neocolonialism. Though the word is useful in terms of pointing to a historical power differential, it is less helpful when we need to observe the ways in which the neoliberal discourse is new and updated and different from the older forms of North–South relations—for example, in the nature and speed of technology, in the distributed nature of production, and in the necessarily fragmented illusions of consumption-based subjectivities.

The word "neocolonialism" also suggests an exclusive emphasis on North–South relations, which obscures the stratifications and differences within Southern societies themselves. Common among the stratifications thus obscured are gender relations. Patriarchy is conveniently elided in assumptions of a glorious ecological past, so that antipatriarchal, anti-Brahminic feminist environmentalist voices are rarely acknowledged in dominant activist understandings of South Asian environmentalism. The general effect of this simplified anticolonial critique is a grand strategy whose righteous indignation often fuels just victories, but whose categories sometimes obscure the more complex, and difficult, conversations that activists need in order to keep up with the supple nature of transnational economic practices.

Seeing economies and discourses instead as always already historically and transnationally constituted can help us attend to the histories of colonialism and neoimperialism as both connected and dynamic. The mechanisms of corporate globalization and the role of industrialized nations in it entail a sophisticated use of global and local, Northern and Southern, conservative and liberal subjectivities. In resistance, scholars and activists are faced with the need to do more than simply invert the binaries of Enlightenment science or orientalist culturalism. Nationalist antiglobalizers and traditionalist antimodernizers, however, while naming the encroachments of globalizing capital as the new face of imperialism, often believe that resistance resides in the inversion of the "tradition versus modernity" binary. The tracing of historical and contemporary transnational flows, however, problematizes the binary "West versus Rest" models.

Although the identification and inversion of historical "us versus them" narratives have indeed been strategically useful for activists, more supple and nuanced tactics are called for; in a densely interconnected world, it is less plausible than ever to assume separate spheres, civilizational values, or disconnected economic circuits. This is not to say that the economic juggernaut of U.S.-led imperialism must inevitably roll over local alternatives. Rather, it is simply to acknowledge a much more complex historical and contemporary space of lateral interconnections, and to investigate their historical failures as well as their future possibilities. Further, a more complex and adequate historical model might actually lead to more complex and effective activist tactics. It might be time for activists to give up grand strategy games based on monolithic notions of ideological clashes in favor of more nuanced notions of political/technoscientific praxis.

It is useful to note the vigorous feminist debate that exists in India around issues of the law and justice. (The supposedly impermeable boundary between feminist theory and environmental theory has rendered it unthinkable for Shiva and other environmental activists to draw from this rich field.) As an example, consider the scholar of feminism and social movements, Nivedita Menon. In a feminist critique of law and justice, Menon insists that "the experience of feminist politics" shows us that "social movements may have reached the limits of the discourse of rights and of 'justice' as a metanarrative."[20] Menon's critique of the law would be invaluable in analyzing Gupta's hopes for a legal market-oriented solution to the intellectual property conflict.

The intellectual property rights scholar Rosemary Coombe recognizes such a critique:

It has been a longstanding goal of indigenous activists to have tribal court judgments recognized in the federal courts and respected as sources of legal precedent in nontribal tribunals. As indigenous legal activists well understand, this aspiration is fraught with risk; it compels them to speak the languages of dominant others while inflecting the others' categories with unanticipated meanings and stretching them to accommodate injuries suffered by those who bear cultural difference.[21]

Menon's argument is even more explicit about the problems with legal activism. She suggests that "trying to bring about positive transformation through the law can run counter to the ethics [of feminist social transformation]." Through an analysis of specific legal treatments of sex determination technologies, selective female abortion, and rape, Menon shows how the law forces us to speak in terms of a penetrable female body with highly circumscribed agency. She insists that "the law cannot be a 'subversive site' [for feminists] precisely because the regulating and defining force of law is directed towards the creating and naturalizing of specific, governable identities."[22]

Menon invites us "to see the feminist project not as one of 'justice' but of 'emancipation.'" In the debates around rape and abortion, this would mean the challenging of hegemonic conceptions of what it means to be a woman, and of "locating the female self inside the sexually defined body" of the woman: "The attempt then should be to redraw the map of our body to make it accessible to new codes, to new senses of the self, so that at least some of these selves would be free of the limits set by the body."[23] She argues that we need to refigure rights outside the domain of the state and the law, so that rights themselves are unrecognizable in present terms. This would mean, in turn, refiguring political practice so as to be "decentred from the arena of the state and the law."

It is precisely such a gendered critique of the state and patriarchy, of the liberal theory of jurisprudence, and of the history of property and bodies, that suggests the limits of existing discourses on property rights, environmentalism, and Southern nationalisms. As Kumkum Sangari and Sudesh Vaid commented in their introduction to *Recasting Women*, "Patriarchies are not . . . systems either predating or super-added to class and caste but

intrinsic to the very formation of, and changes within these categories."[24] The analogous argument, which we need to apply to the terrain of environmental history and geopolitics, is that we ought not to allow the currently vigorous debate on ecoglobalization to shift the questions of gender to the margins, as if they can be "taken care of" in separation from the "other" parameters of the debate, which include nationalism, caste, and class. Using our training in reading the silences and omissions of colonial history, we must be alert to the gendered contours of the new debates on globalization, even as they are in the process of being articulated by corporations and activists on opposite sides of the struggle. Although tactical intervention in the politics of transnational scientific knowledge is vigorous in India, there remain symptomatic omissions and silences at particular sites: the intersection of law, property, and resistance with gender, caste, and class. These are sites at which technoscientific tactical praxis might draw lessons from decades of feminist theory and activism.

New Technologies of Governance

Let us investigate some newer expert discourses that might, in their contradictory appropriations of property discourses, trouble the easy certainties of localist romanticism and globalist universalism.

Anil Gupta, an academic and activist engaged in recording indigenous environmental knowledge, exemplifies an influential post-1991 discourse of NGO expertise. He combines a politics of engagement with a desire to deploy science and technology at the grass roots. Such discourses carry significant credibility in international circles because of their social base among small farmers and their ability to appear scientific, rational, and amenable to negotiation within the domain of international IPR discourse. After more than a decade of advocating indigenous property rights to so-called traditional knowledge, Gupta found his discourse placed at the center of the post-turmeric patent debate. The U.S. Patent and Trademask Office, apparently embarrassed by its granting of a patent for turmeric, contacted the Indian government. It was unable to verify "prior art" that existed outside of digitized databases, so if India could supply a digitized database of "traditional knowledge," the USPTO would ensure that no further patents would be granted to individuals claiming invention of these facts. The government of India responded by beginning a massive database called the TKDL—the Traditional Knowledge Digital Library. In this context, Gupta publicized his own database, which he calls the "Honey Bee Network"—he had been documenting indigenous knowledge among Gujarati farmers for over a decade, anticipating exactly such an eventuality.

The rush to "database" all knowledge involves an interesting elision of the questions about property that have been floating around the activist discourse for a while. How would one begin to document all "traditional knowledge?" What gets left out, and what kinds of modifications of these knowledges would still be patentable? Would a submission

of such a database to the USPTO render all knowledge absent from it legitimately open to patenting? How would one provide "updates" to traditional knowledge? Traditional knowledge, by virtue of being entered into database fields that fix the "traditional" as static, is detemporalized in a precise recording at a particular historical moment. How are we to include a dynamic understanding of it unless we acknowledge the ongoing construction of tradition? What knowledge status would be then accorded to, say, the patent claims of a University of Mississippi researcher who might now draw extensively upon this database in order to devise new pharmaceuticals or pesticides, but stabilizes these compounds in a lab, and thus satisfies the novelty and originality requirements? What fields should such databases contain? What narratives (of rationality, innovation, usability, testability, repeatability) must be applied to so-called traditional knowledge in order for it to fit the fields? How is authorship attributed, and in what ways does such an attribution cathect a messy contextual system with the bildungsroman narrative of solo scientific discovery and individual genius?

More important, why are these questions so easily elided? One reason is, of course, the status of information technologies. Another reason is the inadequacy of critical perspectives on technoscience, both in so-called grass-roots contexts as well as in well-meaning policy circles. Even at the height of North–South conflicts over the politics of indigenous knowledge, rather simple models of science undergirded the arguments of radical activists as well as institutional policy discourses. The discourse of traditional knowledge creates the site of vigorous inventions of traditions. These processes are rendered invisible in the rush to catalog, rather than being historically observed and analyzed. If the sciences of botanical knowledge appeared radically politicized in the wake of high-profile patent cases, the technologies of information design now appear as the transparent rational solutions to the obstacles of politics and the opacities of international institutions. Politics, externalized via a classic analytical model which sees scientific knowledge as separate and unique, is here "taken care of" by the new apolitical technology of databases.

In a parallel communitarian shift, several calls have recently emerged, in quite different contexts, for the appropriation of "open source" models in bioresource management and pharmaceutical research. Anil Gupta, for instance, says:

There is a very healthy development in the software industry of what is called an open source software, such as Linux. There is a concept of general purpose license. Under this, anybody can use the software without any restriction for one's own use but must share any improvement of the same with the society. However, if there is a commercial use of this software, then they should take commercial license and pay part of the income to the developer. This is precisely the spirit that we have tried to follow . . . at Honey Bee Network.[25]

In a strikingly similar argument the British magazine *The Economist* produced a favorable report on "open source" pharmaceutical research in 2004. The report cited a paper

by Arti Rai et al. proposing the Tropical Disease Initiative, a Web-based database system in which research on low-profit diseases such as malaria will be conducted in a nonprofit, open-sharing environment, supported by governments and universities.

In 2004[26] I interviewed A, an activist programmer at a Bangalore-based NGO whose mission is to bring open-source software (OSS) into the nonprofit sector. The NGO director, B, is the author of a white paper on emerging standards for e-governance, and has published resource materials on the use of OSS in nonprofits, which are being promoted by Richard Stallman. A argued in favor of general public licenses (GPLs). The overturning of the turmeric patent and the challenges to neem patents are fine, he suggested—but: "We should use GPL rather than fight specific patents . . . since we don't have the muscle power and the money power to overturn every Western patent on our bio-resources." A ended the interview by reminding me that "IT is the only thing that can move India from a resource-poor to a knowledge-rich economy."

I interviewed other open-source programmers in Bangalore, India's Silicon Valley, which is home not only to a huge IT software and services economy but also to vigorous domestic activist networks formed of "socially conscious" professionals and long-time activists. C is a techie with a social conscience, an open-source evangelist who believes, like A and B, that OSS is key to India's future as a member of the world economy. C founded an organization that lobbies state and federal government agencies to switch to open-source software, and that offers maintenance and upgrading services at a fraction of the cost of proprietary software. "It's about freedom," he said, "and about affordability, sustainability, and justice for the South." When I asked if he saw these social goals as consonant with India's former commitment to egalitarian growth and distribution of wealth, he reacted strongly against what he called "that old socialist model," distancing himself from the "ideology" of social equality but insisting that OSS would bring freedom to both the nation and its individual citizens.

None of the activists at the new frontiers of bioresources and IT can describe exactly how an open-source community or GPLs on indigenous knowledge would actually work. The analogy with software does not work very well after a first-level approximation. What is the equivalent of code? What qualifies, in this analogy, as modification of code, and the installation of that code on personal machines? What would qualify as commercial use (and what's the analogy to Red Hat?)? And how are so-called indigenous innovators identified and compensated? In August 2006, Red Hat India sponsored a knowledge symposium in New Delhi, attended (by invitation only) by leading IT and ecoactivists.[27] In her talk, "Nurturing India's Traditional Knowledge," Shiva welcomed the connections between software developers and agricultural activists: "What [freely available and IP-unencumbered] open source software is to IT [information technology], open pollinated seeds are to the agricultural commons. These are the same things." Gesturing to the red sari she wore, Shiva concluded by thanking Red Hat India for hosting the event: "Thank you for holding this meeting. There's too little of this happening. And I'd like to tell

Red Hat that this red sari is more than willing to make this happen." Indeed, at present, the link between open-source and indigenous bioresources remains at the level of broad analogy and metaphor.

At the same event, TKDL Director V.K. Gupta spoke about his work with TKDL's team of a hundred persons over five years, documenting "around 70,000 formulations in Ayurveda, and some more in the Unani and Siddha." He argued that "there are about 2,000 patents which have been wrongly issued, in our view." Part of the project involves translating Sanskrit, Arabic, and Persian sources into European languages, so that "ancient" uses of plants are documented in terms accessible to the West. Indigenous knowledge activists are doing enormous amounts of work in the hope that databases in English and French will protect indigenous knowledge, or even that poor Gujarati farmers might grow rich through product patents. The legal scholar Lawrence Liang, skeptical of such enthusiasm, calls this the "cruel promise" of IPR.

Shiva's traditionalist communitarianism and the TKDL's pragmatist model are both important components of local constructions of ideological freedom and subjective autonomy. Yet, their (mis)readings of power as monolithic and as always emanating from "the West," and their readings of the market as global rather than transnational, suggest that we might appreciate their strategies but diverge on tactical considerations. But more disturbing, both these influential schools of environmentalism are conspicuously silent on the issue of nationalism and gender. By this I do not mean simply to suggest that women should be added into the traditionalist and pragmatist models—indeed, their proponents would be only too happy to receive a grant to enable them to hire a few female researchers to collect more data on women's responses to gene banks. But a more fundamental blindness exists in the very constitution of these models, which render intersectional constructions of patriarchy and gender absent from the start.

It is worth noticing that despite the lacunae in activist writing, tactics on the ground are far more tech-savvy and scientifically literate than Vandana Shiva's narratives allow. If Shiva's voice exemplified the resistant discourse of the 1970s and 1980s, the new technological actors exemplify some of the complexity of post-liberalization India. This is not to say that Southern farmers and activists have correctly identified transparent technologies as the key to tactical success. Indeed, a conventional model of "free," "unpoliticized" science has, problematically, long undergirded both Indian and Western policy models. Shiva's writings, strategically useful in the period before full-scale economic liberalization, had concealed much of this underlying discourse, which now leaps out from every activist nook, released by the explosion of world-shaping activities in the wake of the 1991 economic liberalization and, more recently, in the wake of the 2005 amendment to the Indian Patents Act. This emerging discourse is energetic and important, irreverently rejects Shiva's pious traditionalisms, and offers many strategic ways to engage with the ever more subtle interleavings of international and national capital and rural knowledge economies.

Kavita Philip

But naïve models of science and technology continue to proliferate, perhaps with even greater power now than ever before, in the throes of India's software development and outsourcing successes. In the short run, activists who record "free" knowledge through open-source database software appear to be offering a new, transparent technology to cure the old woes of politicized colonial science. Information technology is seen as the technology which Indians truly have control over, as opposed to the old technologies—from railroad to telephone—that carried so much colonial baggage. Communitarian ethics finds a home in the free software narrative, which has echoes in the work of Western intellectuals such as Stallman and Lawrence Lessig, but affirms itself, ultimately, in a model of benevolent capitalism. In this process, both capital and technoscience remain undertheorized.

The theorization of IPR debates within the politics of knowledge and capital is an important project both for science studies scholars and for activists. A crude model of difference and incommensurability is clearly being consigned to the fringes of activism and policy. Rather than being hailed as passive consumers of identical cultures of equivalence, global citizens are recruited to participate in authenticating sameness and regulating difference. "Expertise" with respect to technology and ecology is simultaneously democratized (by involving all citizens in its construction and utilization—farmers in bioknowledge, programmers in OSS)—and specialized (by linking it with a particular narrative of economic systems and giving it a specific directionality). This specialization is what often evades analysis in the celebration of putatively transparent democratizing technologies. The shift to IT metaphors in bioresource activism bears some possibility for strategic successes, but carries much familiar baggage.

However transparent new technoscientific discourse might seem compared to its eighteenth-century antecedents, it remains irreducibly political. "Property" in the late twentieth century was being worked out in relation to organisms and to individuals, as well as to populations. For example, radical markers of new property rights occurred with respect to human individuals (e.g., John Moore's spleen), bacteria (e.g., Ananda Chakravarty's oil-eating bacteria), zoological organisms (e.g., oncomouse), plants (e.g., turmeric and basmati rice), and was also applied to large populations (the Human Genome Project). It also entered large civilizational discourses of modernity and technological citizenship (e.g., software piracy).

The proliferations of property organizations, academic studies of property rights, law school programs in IPR, and WTO negotiations, among others, testify to the attempt to pin down the flux in the meanings of property. A "crisis" (spiritual as well as economic and legalistic) is believed to be generated at the moments of *Diamond* v. *Chakravarty*, the patenting of the oncomouse, the patent on neem, and so on. Oppositions to patenting that give voice to the "sovereignty," "spirituality," or non-ownability of nature in order to resolve this crisis implicitly appeal to juridical models of sovereignty and autonomy that emerged along with modernity (not, as many activists argue, predating modernity),

but do not attempt to address the polyvalent discourses of normalization that constitute the emerging field of property rights. Human and natural subjects were not simply fixed through the Enlightenment; they are constantly in the process of destabilization, and restabilization, reemergence, and resedimentation. In the flux around property discourses today, we can watch the ways in which racialized and regionalized boundaries will define the emerging legal, and illegal, subjects of the new environmental and information technologies.

More than a million people are employed in the allied industries of information technology (IT) and IT-enabled services (ITES) in India. The higher-status IT industry has an approximately 70 : 30 ratio of men to women, which the lower-status ITES industries reverse, with 70 percent women.[28] From journalism to scholarship, a euphoric message pervades reportage; for example, in a 2005 special report on women in IT, the respected news site rediff.com proclaimed, "In the IT industry, women rock!," going on to announce that "India is way ahead of the United States in the empowerment of women in the information technology services arena. . . . The ratio of women in IT services in India is rising steadily, whereas the percentage of women IT workers in the US has been declining over the years."[29]

The anthropologists Chris Fuller and Haripriya Narasimhan find "more empowerment" than "exploitation" in their study of women in the Chennai IT sector. Summing up extended interviews, they comment:

Almost without exception, our informants have insisted that there is no gender inequality in . . . major software companies . . . [and there is] virtually universal agreement that women and men have equal technical skills in software engineering, computer programming and other related fields, which is in turn linked to the assumption that both sexes are equally good at mathematics, science and technology.[30]

There remains, for activists and scholars, much work to be done in thinking through the gender and caste contours of new technological orders. The ways in which discourses of tradition marginalize gender are uncannily repeated in the new technological discourses of freedom and transparency. Claiming radical ruptures with all prior forms of subjectivity, advocates of new computational technologies nevertheless maintain remarkable continuities with eighteenth-century notions of liberal citizenship and subjectivity. Suspecting that one always governs too much, new media liberals render to technological systems the power that until recently lay sedimented in postcolonial bureaucratic systems and corrupt bureaucrats. Watching these processes, we must not forget to ask whether older forms of domination and corruption might occasionally, contradictorily, and messily have been more amenable to subaltern intervention than the slicker, cleaner, and rationalized modes of governance, in which systems of stratification get rewritten as natural modernization.

Kavita Philip

Recent work by Solomon Benjamin and others studies the nationwide project to digitize land records, supported by modernizing impulses ranging from the Ministry for Information Technology to the World Bank's "e-governance" concerns.[31] The Bhoomi (land) Project, implemented in Karnataka and held up as a role model for the nation, moves land records formerly stored in village- and district-level office files to universally accessible databases. The chief minister, corporations, and international donors proudly cite it as evidence of their concern for the rural masses (particularly in response to perceptions that urban high-tech Bangalore gets the largest share of development resources in the state). Benjamin et al. find that corruption and processing times increased; instability grew among small landowners and farmers; and large agricultural businesses, developers of IT corridors and megamalls, and private banks gained from the redefinition of property regimes. In short, land tenure was radically overhauled, dramatically destabilizing small farmers, disempowering *panchayats* (village elected councils), and advantaging big corporate interests by creating huge private real estate benefits via unmarked public subsidies. However, unlike colonial land tenure shifts, these changes are marked not by the force of a coercive government but by the rational functioning of technology.

True, the bureaucratic liberation from paper pushers who sit in Record Offices little changed since 1858 comes bundled with a set of expedient and efficacious practices; but the much-celebrated leap from Victorian to neoliberal forms of power should give us pause. We are witnessing not so much a rupture with the coercive past as a shift in emphasis from disciplining, repressive forms of power to regulating, systematizing technologies of life.[32] The rationalization of insurance, credit, and savings, and the shifts in life practices that go along with Foucault's telling of this shift is usually represented as having already happened, in the past of European societies. Much of the rhetoric of the coming of databases to Indian land regimes celebrates this moment, today, precisely as the delayed but triumphant dawn of modern systems of life. This moment of regularization occurs specifically around agricultural land, and writes in as possible outcomes, specific styles of life always already marked with respect to modernity—the premodern peasant life, the modern developer, the urban pioneer, and so on. Precisely because the database appears rational and transparent, its shaping of modern Indian lives is regularizing in this productive sense. Caste and class become the axes along which is distributed, to different degrees, the freedom to make land productive. It appears that Locke, whom we repressed earlier in this chapter, returns. But our readings must become more complicated.

Historians of the British Empire have commented extensively on the ways in which discourses of property and subjectivity played themselves out in nineteenth-century India. For example, Sudipta Sen summarizes a common claim about civil society and property:

Early colonial commentators on the British Indian political economy believed what would be put forward unabashedly by James Mill in the early nineteenth century, namely, that Indians as subjects

were passive instruments and not full and conscious participants in their own polity. Their lack of liberty, and perhaps also their loss of autonomy in conquest, had reduced the Indians to a state of perpetual unfreedom. Every freeborn Englishman, in contrast, had liberty and the right to property as his birthrights. Indians were hardly capable of apprehending the sanctity and the institution of true property. The absence of these cardinal virtues, liberty and property put together, was indicative of an "uncivil" society in India, making all forms of indigenous rule illegitimate.[33]

It is precisely that which was denied for two hundred years—the possibility of an indigenous civil society, the possibility of indigenous rational subjectivities—that appears to have been magically granted, almost overnight, with the dawning of the new computational technological order. The conjunction of issues that come together here are as profound an intervention as the eighteenth-century Permanent Settlement, which established colonial land tenure systems in Bengal. Amartya Sen notes, in his foreword to Ranjit Guha's classic work on the subject, that the Permanent Settlement in effect produced the new Indian elites who were to take center stage in the next century of Indian nationalism, reminding us that *"A Rule of Property for Bengal* has come from Ranajit Guha's attempt to understand better the roots of [his own] class, and the ideas that led to its emergence."[34] What we are witnessing is a second Permanent Settlement, and the emergence of a reconstituted elite class with its correspondingly regularized citizen-subject. The new contours of this emerging formation remain to be studied systematically, but it is undeniable that technological ways of being must be analyzed with the same cultural and historical nuance with which we have so far studied caste, gender, and liberalism.

Notes

1. The nexus of the new biological and informational sciences could be tracked by recalling a range of historically embedded knowledge practices, including phrenology, eugenics, craniology, population biology, reproductive biology, environmental sciences, cybernetics, ballistics, and programming. Rich historical scholarship exists on each of these, and on the participation of marginalized practitioners of science. The role of scientific practicners and their implications for activist tactics are yet to be fully explored.

2. The American Association for the Advancement of Science reports: "For many resources, the United States of America is the worlds's largest consumer in absolute terms. For a list of 20 major traded commodities, it takes the greatest share of 11 of them: corn, coffee, copper, lead, zinc, tin, aluminum, rubber, oil seeds, oil and natural gas. For many more it is the largest per-capita consumer." http://atlas.aaas.org/index.php?part=2 (accessed April 15, 2007).

3. Vandana Shiva, "The Second Coming of Columbus," *Resurgence* magazine, http://www.resurgence.org/resurgence/articles/shiva_columbus.htm (accessed October 1, 2007).

4. Some of the following discussion is adapted from my article "Seeds of Neo-colonialism? Reflections on Globalization and Indigenous Knowledge," in *Capitalism, Nature, Socialism*, 12 (issue 46, June 2001): 3–47.

5. Anne C. Dowling, " 'Un-Locke-ing' a 'Just Right' Environmental Regime: Overcoming the Three Bears of International Environmentalism—Sovereignty, Locke, and Compensation, 26 *William and Mary Environmental Law and Policy Review* 891, at 893. Emphasis in the original. Dowling is also citing Prue Taylor, *An Ecological Approach to International Law: Responding to the Challenges of Climate Change* (New York: Routledge, 1998), pp. 270–271.

6. Dowling, " 'Un-Locke-ing 'a' Just Right' Environmental Regime," footnote 73.

7. Senate Bill no. 1841, Ninth Congress of the Republic of the Philippines, Third Regular Seccison, see http://www.grain.org/brl/philippines-cirpa-1994.cfm, (accessed September 1, 2003) and http://www.grain.org/brl/?docid=767&lawid=1469 (accessed October 1, 2007).

8. Nividata Menon ed., *Gender and Politics in India* (Delhi: Oxford University Press, 1981), p. 104.

9. Ibid., p. 121.

10. Ibid., p. 105.

11. Subir Sinha, Shubhra Gururani, and Brian Greenberg, "The 'New Traditionalist' Discourse of Indian Environmentalism," *Journal of Peasant Studies* 24, no. 3 (April 1997).

12. Doug Henwood, "Antiglobalization," *Left Business Observer* no. 71 (January 1996), http://www.leftbusinessobserver.com/Globalization.html (accessed October 1, 2007).

13. See Evelyn Fox Keller.

14. Hensman, Rohini, *Impact of Technological Change on Industrial Women Workers. Gender and Politics in India.* N. Menon. (New Delhi, Oxford University Press, 1999), pp. 178–193; p. 192.

15. This list is from Leach, Melissa and Cathy Green. 1997. "Gender and Environmental History," *Environment and History* 3(3): 344–370; pp. 344–345.

16. From a 2002 interview by the author with T. G. Ajay, a Chattisgarh-based filmmaker and activist.

17. This table is adapted from a publication of the activist group formerly known as RAFI, www.rafi.org (accessed January 2002), which has been renamed ETC, www.etcgroup.org.

18. Some of these issues are discussed in Terry Harpold and Kavita Philip, "Party Over, Oops, Out of Time: Y2K, Technological 'Risk,' and Informational Millennarianism," *NMEDIAC* 1, no. 1 (Winter 2002).

19. These histories, along with the current wave of opposition to globalization, do indeed have implications for international law. In other words, historical claims about power can affect the practice of law. For example, Mohammed Bedjaoui, a former president of the International Court of Justice, called for a revolution in international law that would give prominence to "the principle of equity (which corrects inequalities)." Its objective would be "reducing, and . . . even eradicating the gap that exists between a minority of rich nations and a majority of poor nations." Mohammed Bedjaoui, *Towards a New International Economic Order* (New York: Holmes & Meier, 1979), p. 127.

20. Menon, Nivedita, ed., *Gender and Politics in India*, p. 279.

21. Rosemary Coombe, *The Cultural Life of Intellectual Properties: Authorship, Appropriation and the Law.* (Durham, NC: Duke University Press, 1998) p. 381, note 101: "I do not wish to suggest here that artists and authors of First Nations ancestry do not wish to have their works valued on the market, or that they would eschew royalties for works produced as commodities for an exchange value on the market. . . . Instead, I am suggesting that in the debates surrounding cultural appropriation, Native peoples assert that there are other value systems than those of the market . . . Copyright laws, of course, protect only individual authors against the copying of their individual expressions, and do not protect ideas or cultural themes, practices, and historical experiences from expropriation by cultural others."

22. Menon, Nivedita, ed., *Gender and Politics in India*, p. 286.

23. Ibid., p. 290.

24. Sangari, Kumkum, and Sudesh Vaid, eds. *Recasting Women: Essays in Indian Colonial History.* (New Brunswick: Rutgers University Press, 1990), p. 1.

25. The full paper is available at www.sristi.org/papers/new/ Do%20Patents%20Matter,% 20WTO%20and%20Agriculture,%20for%20CMA.doc, (accessed October 1 2007).

26. Interviews conducted by Kavita Philip, Bangalore, July–September 2004. Names and organizational affiliations are withheld to protect the privacy of interviewees.

27. Shiva, Gupta, and others were speaking at an event in New Delhi on August 24–25, 2006. Entitled "Owning the Future: Ideas and Their Role in the Digital Age," it was organized by IIT Delhi and Red Hat and supported by the Software Freedom Law Center, CII and Creative Commons. Key speakers are summarized in the article, "India at the Forefront of Knowledge Commons Debate," by Frederick Noronha, at http://www.asia-commons.net/debate (accessed October 1, 2007).

28. See "India's Top 10 IT Employers," *Rediffusion Report* (2005), and associated updates, http:// www.rediff.com/money/2005/jun/10bspec.htm: "76 per cent of software professionals in software companies are men, whereas 24 per cent are women. However, Nasscom says this ratio is likely to be 65 : 35 (men : women) by the year 2007. This ratio is reversed in the ITES-BPO sector where the ratio of men to women is 31 : 69."

29. http://www.rediff.com/money/2005/jul/27spec.htm.

30. Fuller and Narasimhan, "Empowerment and Constraint: Women, Work and the Family in the Software Industry in Chennai, "unpublished manuscript, pp. 8–9. Quoted courtesy of the authors.

31. See Solomon Benjamin, R Bhuvaneswari, P. Rajan, and Manjunatha, "Bhoomi: 'E-Governance', or, an Anti-Politics Machine Necessary to Globalize Bangalore?" *CASUM-m Working Paper* (January 2007); and Benjamin, Solomon, "Governance, Economic Settings and Poverty in Bangalore." *Environment and Urbanization* 12.1 (2000): 35–56.

32. My reference is to Michel Foucault, *"Society Must Be Defended": Lectures at the Collège de France 1975–76*, edited by Mauro Bertani and Alessandro Fontana, translated by David Mally (New York:

Picador, 2003), chap. 11, pp. 245–246. Foucault dates the emergence of this shift to the seventeenth century in Europe.

33. Sen, Sudipta, "Uncertain Dominance: The Colonial State and Its Contradictions (with Notes on the History of Early British India)." *Nepantla: Views from South* 3.2 (2002): 391–406; p. 394.

34. Guha, Ranajit. *A Rule of Property for Bengal: An Essay on the Idea of Permanent Settlement* (Foreword by Amartya Sen). (Duke University Press; Reprint edition, 1996), p. xii.

Genes, Genera, and Genres

The NatureCulture of BioFiction in Ruth Ozeki's *All Over Creation*

Karen Cardozo and Banu Subramaniam

We need to know where we live in order to imagine living elsewhere. We need to imagine living elsewhere before we can live there.[1]

The main issue is to maintain this very potent join between fact and fiction, between the literal and the figurative or tropic, between the scientific and expressive. . . . When people miss the relations, the whole, and focus only on separate bits, they come up with all sorts of misreadings. . . . All of my metaphors imply some kind of synergetic action at a level of complexity that is not approached through its smallest parts.[2]

Tactical Biopolitics asks, "What do inquiring, curious, or anxious publics need to understand about biology and its current research frontiers? How might scientists assess the myriad, often contradictory concerns about informed publics, national priorities, and academic freedom?" In this chapter, we suggest that imaginative literature offers a unique mode of knowledge production, cultural politics, and activism as it explores the intersections of life, science and art in ways both realistic and speculative. In moving away from the unproductive forms of the sonorous "science wars" and by virtue of having no particular disciplinary allegiance,[3] literature can emerge as a generative site where science, art, literature, culture, and politics can converge, and where the tangled manifestations of gender, race, class, and sexuality can unravel into new and imaginative futures. In its depiction of pressing biological or environmental concerns, fiction may serve a pedagogical function for diverse publics while assembling a constellation of heterogeneous discourses or displaying the "dialogic imagination"[4] that can also enable scientific experts to think through the "contradictory concerns" raised by all manner of contemporary biopolitics.

Unlike academic or political discourses, fictional narratives can raise important questions without necessarily answering or resolving them—such texts can offer a probing

vision without argumentation or judgment, creating a space that opens, rather than reduces, the complexity of the matters at hand. Fictional texts can, and often do, oscillate between realism, or attempts to reflect reality as it seems, and invention, imaginative attempts to remake the world in some different way. In so doing, literature steers between the dual imperatives of understanding the world as it is and envisioning alternative forms of social organization, between empirical and intuitive ways of knowing. In the terms of our first epigraph, such literature can help us meet the need "to know where we live in order to imagine living elsewhere [and] to imagine living elsewhere before we can live there." However, because a literary text signifies in ways beyond the control or intention of its author,[5] it also becomes possible to see and theorize the limits of any given textual universe—its working assumptions, potential blind spots, and historical contingencies. Thus, the act of textual interpretation may fruitfully inform our thinking about the many interrelated concerns of this anthology.

In this chapter, we draw upon the example of Ruth Ozeki's novel *All Over Creation* (2003) to highlight the epistemological, pedagogical, and political possibilities of contemporary fiction. Set in contemporary Idaho, the novel tells the story of the prodigal daughter Yumi Fuller, a runaway at the age of fifteen, who returns home twenty-five years later with three children in tow to care for her aging parents. There she must confront not only the deterioration of their health but also their way of life as potato farmers struggling in the shadow of big agribusiness. From its very first lines ("It starts with the earth. How can it not?"), the novel assiduously forges connections between nature and culture. The child of Idaho native Lloyd Fuller and Momoko, the Japanese wife he brought back after his service in World War II, Yumi sympathizes with the "random seedling, a volunteer, an accidental fruit [that] will most likely be uprooted. . . . That's what it felt like when I was growing up, like I was a random fruit in a field of genetically identical potatoes" (p. 4).

In setting Yumi's mixed-race story in this particular locale, *All Over Creation* explores the themes of capitalism, creation, biodiversity, hybridity, and reproduction in the context of an unfolding drama about the politics of contemporary industrialized agriculture and agribusiness. Thus the novel explores discourses on invasive species, plant breeding, and the genetic engineering of potato crops from multiple perspectives, including that of a group of environmental activists called The Seeds of Resistance. In its insistent attention to the co-constitutive relation of the natural and the cultural, Ozeki's novel enables us to introduce the concept of biofiction as a productive site for "tactical biopolitics."

Defining Biofiction

For us, the term "biofiction" resonates on multiple levels, having genealogical roots in four intellectual traditions: science fiction, literary theory, social and cultural studies of science, and theories of interdisciplinarity.

First and most obviously, "biofiction" refers to creative writing that explicitly thematizes biological and environmental issues (questions of biodiversity, biotechnology, public health, etc.). Such literature owes a big debt to the long history of science fiction and its artistic license to expose the complex politics of science and the technology of life in the past, present, and future. Yet "biofiction" is a more encompassing term than science fiction, in that it includes literature that may be firmly grounded in realism, as Ozeki's is. Thus "biofiction" simply refers to any imaginative text which purposefully and productively engages with contemporary issues of the biological and the environmental. Like Ozeki's well-received *My Year of Meats* (1998), a novel that examines the role of DES in the transnational meat production and the role of contemporary advertising and media in promoting that industry, *All Over Creation* has a deep research foundation. Ozeki's work thus embodies the spirit of biofiction—fiction that is deeply grounded in a scientific understanding of the contemporary world and biological thinking that fictionalizes the real-world consequences of biological invention and innovation. Biofiction dramatizes the consequences of particular forms of biological thinking and imagines alternate modes and forms. It forces us to consider the everyday lives, textures, sights, and sounds of particular biological and scientific interventions of life.

Unlike the tradition of social protest or muckraking novels, however, Ozeki does not aim to present a unified novelistic or political vision, but rather explores a range of competing investments and beliefs. We believe the novel's pedagogical and political potential lies in this open-ended demonstration of heterogeneous responses to contemporary conditions.

Second, literary theory, in its analysis of the cultural politics of form or genre, inspires and informs the concept of biofiction. If Ozeki thematizes the issues of biodiversity and hybridity with respect to questions about the "natural" or "unnatural" reproduction of genera, her work also reminds us that culture often relies on the reproduction of recognizable genres for its intelligibility. At the same time, as in "natural" forms of reproduction, genres of cultural expression evolve and change. Ozeki's novel is remarkable for its own hybridity, mixing as it does epistolary forms, dramatic performances, and explicitly pedagogical lectures with the familiar techniques of fiction. Made up of numerous small sections presented from different points of view rather than extensively developed "chapters" yielding a single or omniscient perspective, the novel's textual "body" is itself an organism made up of many independent cells—or, to scale up the metaphor, an ecosystem in which each part has its own particular function or niche, independent and yet interdependent. Ozeki is well aware of the power of genre to shape or constrain our understanding of the world, a perspective informed by her own experience as the child of a Euro-American father and a Japanese mother:

Maybe it's because [I'm] racially halved and "neither here nor there," but I've always been suspicious of binary oppositions . . . so I guess it makes sense that I'd write a transgressive,

genre-bending novel. It's an outgrowth of my independent film work, too. . . . The juxtaposition of first-person and third-person narrative voices is another transgression of sorts. As a former documentary filmmaker, this question of voice and point of view [interrogates] notions of absolute or objective truth.[6]

In these ways, as literary theory has shown, cultural texts may "speak" not only at the level of content (*what* they say) but also at the level of form (*how* they say it). From this perspective, we see that Ozeki may be pioneering new ground in her hybrid cultural productions, not least by setting her novel in the rural United States. As Michael Pollan has written:

Ruth Ozeki is bent on taking the novel into corners of American culture [where] no one else has thought to look—but where she finds us in all our transcultural and technological weirdness. With a combination of humor and pathos that is all her own, Ozeki brings the American pastoral forward into the age of agribusiness and genetic engineering. The result is a smart and compelling novel about a world we don't realize we live in.

Moreover, as we discuss in the following section, Ozeki's wry division of the novel's 417 pages into seven segments clearly references and interrogates the Judeo–Christian account of creation found in Genesis (i.e., that God formed the world in six days and on the seventh day "he rested from all the work of creation").[7] In resisting closure by fragmenting the novel into multiple parts that do not resolve into a unified totality, Ozeki implies that the work of creation is far from complete. Like the biological diversity championed by the novel's environmentalist activists, Ozeki's biofiction proliferates its own textual and metaphoric diversity.

Third, and most important from the point of view of this chapter, the concept of biofiction has been informed by social and cultural studies of science. This body of work has unearthed the vast textuality and drama of science. Some of it has analyzed science as "text" and pointed to the profound and sometimes irreversible consequences of the metaphoric and rhetorical choices of scientific writing. For example, Evelyn Fox Keller points to the indelible legacy of computer science and its conceptions of "code" for modern genetics; Donna Haraway and Emily Martin explore how metaphors of "war" and "self/ other" animate biological conceptions of the immune system as warrior cells that protect the fort/body from foreigners and enemies;[8] and one of us has shown how xenophobic rhetoric surrounding human immigration traverses into our fears of foreign plants and animals.[9] Others have paid attention to the carefully constructed nature of scientific experiments, which sets the stage for the drama of scientific experiments—for human and nonhuman objects to "act." For example, Bruno Latour, in his analysis on the work of Louis Pasteur, writes:

What is an experiment? It is an action performed by a scientist so that the non-human will be made to appear on its own. It is a special form of contructivism. Who is acting in this experiment? Pasteur and his yeast. More exactly, Pasteur acts so the yeast acts alone. We understand why it is difficult for Pasteur to choose between a constructivist epistemology and a realist one; he creates a scene in which he does not have to create anything. He develops gestures, glasswares, protocols, so that the entity once shifted out, becomes automatic and autonomous.[10]

Fundamentally, the social and cultural studies of science remind us not to take the dichotomies of the fictional/creative/literary and the real/factual/scientific too seriously. While insisting that fiction and science are not the same and while reminding us that each has a different, unique, and important role in our understandings of nature and culture, the field nonetheless opens up the possibilities of an engaged and productive space for biofiction. Centrally, biofiction (especially Ozeki's work) can be read as a social analogy to experiments: don't start with a constituency; rather, start with a problem, assemble the participants needed, and stage the experiment. The result is a novel that carefully examines the natural (human, floral, and faunal; biotic and abiotic) and cultural consequences of our model of industrialized agriculture.

In its linkage of the biological (the natural) and the fictional (the cultural), our coinage of the term "biofiction" highlights the intextricable ways in which natural and cultural life are organized. As Donna Haraway writes:

There are two aspects to emphasize when discussing biology. The first is: *We live intimately "as" and "in" a biological world.* This may seem obvious but I emphasize it to reiterate the ordinariness of [the] quotidian nature of what we are talking about when we talk about biology. And the second aspect, which represents a major gestalt switch from the previous point, is: *Biology is a discourse and not the world itself.* So while, on the one hand, I live materially-semiotically as an *organism*, and that's an historical kind of identity, immersing me—particularly in the last couple of hundred years—in very specific kinds of traditions, practices, and circulations of money, skills, and institutions, I am also inside biology as it is intricately caught up in systems of labor, systems of hierarchical accumulation and distribution, efficiency and productivity. . . . Such a mode of thinking is more than metaphorical. It is a deep way of seeing how the natural-cultural world is constituted.[11]

Haraway further argues that to fully understand biology, one must understand nature and culture not as distinct ontological zones with different and unique histories, but rather as naturecultures (one word), "implosions of the discursive realms of nature and culture" (p. 105). Most obviously, then, our term "biofiction" follows upon Haraway's semantic innovation to represent a particular instance of this "implosion." As feminist scholars have long argued, this co-production and co-construction has meant a dense traffic of meaning between our conceptions of nature and culture. As a result, our conceptions about gender,

race, class, and sexuality are also co-produced and co-constructed as meanings travel between the worlds of natures and cultures.

Ozeki explicitly makes this connection in Yumi's letter to her mother discussing her undergraduate dissertation, "Fading Blossoms, Falling Leaves: Visions of Transience and Instability in the Literature of the Asian American Diaspora." Yumi writes, "Basically, it's about the way images of nature are used as metaphors for cultural dissolution" (p. 42). In its seamless incorporation of such analogies and metaphors into the text for our contemplation, Ozeki's biofiction thus provides an important space in which to explore the intertwined worlds of natures and cultures. Thus, biofiction pays attention to the science of biological connections while tracing their discursive circulation within biology, politics, and culture—showing precisely how "naturecultures" are constituted.

Fourth, biofiction references our own interdisciplinary collaboration, since one of us (Banu) is originally trained in biology and the other (Karen) in literary studies. Thus, we find the form of our collaboration to be as important as the content it has generated—that is, our partnership itself models the interchange of the "natural" and the "cultural" within the academic ecosystem. Interdisciplinarity, then, is a form of intellectual hybridity that may serve as its own kind of "tactic" of resistance: in the terms of the novel under discussion, it may help to guard against the increasing "monoculture" of the corporate university. Or better yet, interdisciplinarity may help pave the path to new kinds of experiments, biologies, economies, literatures, cultures, and politics.

As we see it, the realm of biofiction (like all fiction) is itself a mode of knowledge production, a way of thinking through some of the most pressing problems of our time. It enables us to question not only the nature/culture binary, but also the perceived oppositions between the creative and the critical, fiction and reality, theory and practice, art and politics. As a number of critics have noted, such binary distinctions are part of a Western episteme that negates the different cultural modes in which theoretical acts may take place. Thus, as Joni Adamson has written, novels can be a form of "cultural critique that makes accessible [some] complex ideas about the connections between history, politics, economics, culture, and the environment."[12] Eschewing dichotomous modes of thought or organization, biofiction's nuances can yield what Adamson calls the "middle place" beyond binary thought. These fertile naturecultures can help us imagine and reinvigorate a more robust, complex, progressive, and productive feminist politics of the environment.

Alien and Unnatural: The Biopolitical Context

To appreciate Ozeki's creation, especially as biofiction, one must first understand the complex politics the book investigates. For the purposes of this chapter, we focus on the biopolitics of biological (plant) invasions and genetically modified organisms (GMOs). As an Asian–American writer whose work has always attended to the themes of ethnicity,

hybridity, race, sexuality, and transnationality, Ozeki makes an inspired choice to focus on the politics of invasive plants and GMOs. As with the politics of human migration and immigration, these discourses are replete with questions of native/foreign, alien/resident, natural/unnatural, purity/impurity, and of hybridity, dislocation, and belonging.

Biological invasions and GMOs engage and are engaged by contemporary politics of belonging. Since September 11, 2001, these politics are even more acute, representing the world through stark binaries: good and evil, natural and unnatural, pure and polluted, authentic and inauthentic, native and alien, insiders and outsiders, white and black. From the color-coded threat levels to worries about the safety of our air, food, and water, we see fear and threat everywhere. On the surface, it seems fundamentally ironic that with increased globalization, we see a renewed call for the local and the protection of the indigenous, with a fervent nationalism expressing the need to close our borders to "outsiders." And indeed, these anxieties span the political spectrum, including groups of both the political Right and the political left.

But feminist scholars of science would argue that this should not surprise us. The increased xenophobia and fear of impurity should not be seen as contradictory or ironic, but rather as a symptom of and reaction to a fear of change. For example, Nancy Tomes documents how our panic about germs has historically coincided with periods of heavy immigration to the United States of groups perceived as "alien" and difficult to assimilate. She documents these germ panics in the early twentieth century in response to the new immigration from Eastern and Southern Europe, and in the late twentieth century, to the new immigration from Asia, Africa, and Latin America. "Fear of racial impurities and suspicions of immigrant hygiene practices are common elements of both periods," she writes, noting that such fears "heightened the germ panic by the greater ease and frequency with which immigrants travel back and forth between their old, presumably disease ridden countries and their new, germ obsessed American homeland."[13] This traffic between our conceptions of nature and culture frame the changing contours of our "naturecultural" worlds. Before proceeding with our analysis, it may be useful to briefly summarize the biopolitical contexts of biological invasions and GMOs.

They Came, They Bred, They Conquered![14]

According to the U.S. Department of Agriculture (USDA), "Invasive plants are introduced species that can thrive in areas beyond their natural range of dispersal. These plants are characteristically adaptable, aggressive, and have a high reproductive capacity. Their vigor combined with a lack of natural enemies often leads to outbreak populations."[15] There has been a huge hype about invasive plant species since the 1980s. The frenzied alarm has been sounded by groups of the Right and the Left, environmentalists and nonenvironmentalists alike. There are two main strands of argument on this issue. The first, and by far the more prevalent, is the literature that focuses on the problem of invasive

species—their origins and ecologies, conditions that favor invasions, and strategies curtailing their growth. Conversely, this body of work has also extensively explored the ecologies of native species, the conditions for their inability to thrive and compete with exotic species, and concurrent programs to promote their growth. At the level of research and policy, this is a fertile area. The USDA has an extensive national program;[16] most state governments have additional programs targeting their local geographic and ecological contexts;[17] and the National Science Foundation has targeted funding and programs for projects that deal with invasive plant and animal species, as do environmentalist groups such as the Nature Conservancy's "invasive species initiative"[18] and the Sierra Club's invasive species efforts.[19]

In contrast, the second strand points to the xenophobic language that has pervaded much of this literature and how strategies of binary thinking, such as native/exotic and foreign/local, misplace and displace the problem onto intrinsic qualities of individual species rather than their ecological and economic contexts.[20] Banu's previous work has analyzed how discourses that are squarely focused on alien/foreign species as "problems," and native species as "victims," result in management practices and policies that parallel the "war on terror" and use militaristic language of "waging wars" and "battling" exotic species. Paralleling human immigration, this rhetoric proposes the need to "fence" borders and develop policies to keep alien/exotic species out. One sees local nurseries promote native species, and local environmental groups enlist citizens in campaigns to be "weed warriors"[21] in order to pull out exotic/foreign species and plant native species.[22] A displacement of the problem onto the intrinsic "qualities" of exotic/alien plants, and not on their habitats, results in misguided management policies. Rather than preserving land and checking development, we instead put resources into policing boundaries and borders, and scapegoating foreigners and aliens for the ever increasing problems of late capitalism. As the biologist L. B. Slobodkin points out, course "Good species are native species, and oddly enough, the less one might reasonably call them successful, the better they are."[23]

Attack of the Killer Rice: Frankenfood Strikes Again![24]

Genetically modified organisms (GMOs) or transgenic organisms are created when genes from one species are introduced into another species. For example, a gene from bacteria (Bt) could be transplanted into corn or cotton. Companies argue that the transgenic plant of agricultural importance, corn or cotton, now produces a toxin (Bt) that kills pests. The usefulness of transgenic technology is in making available unique adaptations/properties of one organism to all organisms. There is a huge campaign within the United States to promote genetically modified food. Indeed, due to the lack of labeling of genetically modified food, most of the population consumes GMOs without realizing it. But there is an equally strong campaign emerging against GMOs. The campaign against genetic engineering has two main strands. The first focuses on the "unnaturalness" of the technol-

ogy, and the second is more concerned with the ills of unbridled capitalism in the form of big agribusiness.

In discourses on the "unnatural" nature of transgenic organisms, the fear is largely of the unknown—fear that in embracing this technology, we will unleash monsters, as signified by the term "frankenfood." This rhetoric may take a theological form, focusing on humans losing their place in the world—the fear here is that we, as mortal humans, are usurping divine privilege by playing God. Some of the same fears of miscegenation we saw in metaphorical descriptions of invasive species also permeate the anti-GMO literature. Might the new hybrids escape the GMO fields and infiltrate "nature"? Might the "superplants" cross-pollinate "natural" weeds to create superweeds? By tinkering with nature, humans seem to assume a supreme arrogance, disrupting a co-evolved nature with its own checks and balances and thus risking the unleashing of monsters. The response is to focus on pure seeds that are organic, pesticide- and herbicide-free. The nostalgic rhetoric valorizes the natural, looking back to the past as a "better" time.

The second, often less publicized strand of anti-GMO work focuses not on the inherent unnaturalness of the technology, but rather on the political questions of corporate power versus communal self-determination in late capitalism. Here the critiques are of a weakened FDA and lax safety monitoring standards, the increasing corporatization of agriculture, and the destruction of organic and sustainable farming practices.[25] This body of work focuses on the context of agribusiness, which, through webs of secrecy such as patents and political lobbies, obfuscates the details of the technology, as well as information about the safety of food.[26]

The Natureculture of *All Over Creation*

It is this fraught biopolitical context that Ozeki uses as her backdrop for a cast of zany characters caught in an even zanier plot—all in the heartland of the home of the American potato. Ozeki deliberately and brilliantly weaves into the discourses on invasive species and GMOs the politics of ethnicity and the politics of religion—illustrating how scientific and environmental ideas of "nature," "genes," "earth," and "seed" are caught up in them. For example, in developing a "grammar of genes" or the "story of seeds," she weaves the natural and the cultural into complex questions of identity, globalization, and environmental politics. To trace the complicated web of biofiction that Ozeki weaves, we discuss her treatment of invasive species, GMOs, and finally a politics of the environment.

Celebrating Biodiversity and Hybridity: A Counterdiscourse on Invasive Species

In contrast to the discourses on the "alien and unnatural" described above, Ozeki's novel clearly embraces the migration of humans and plants, and cross-breeding of humans and

plants, with wild abandon and wondrous warmth and welcome. The novel is filled with moments that celebrate hybridity, migration, and immigration. Drawing on an immense literature that tracks the traffic between our discourses of human immigration and of plant and animal migrations, the novel is unflinching in its support of unbridled "natural" plant breeding—suggesting, for example, that "[P]otatoes, like human children, are wildly heterogzyous" (p. 57) and that squash are "promiscuous." Indeed, in contrast to mainstream rhetoric that often uses religion to make a case for the "rightful" place of people and flora and fauna, Ozeki's Christian patriarch, Lloyd, does just the opposite. Lloyd, who is fervently "pro-life," draws on his religious teachings to develop environmental policy and critique xenophobia. Deeply in love with and married to a Japanese woman, he celebrates hybridity. They breed plants with wild abandon, crossing species from all over the world. In the *Fullers' Seeds Newsletter*, they write:

And while we are on the subject of Exotics, there is an idea in circulation that these so-called "aggressive" non-native plants are harmful, invasive, and will displace "native" species. How ironic to hear these theories propounded by people of European ancestry in America! . . . Mrs. Fuller and I believe, firstly, that anti-exoticism is Anti-Life: *God giveth it a body as it hath pleased him, and to every seed his own body* [I Corinthians 15: 38]. Secondly, we believe anti-exoticism to be explicitly racist, and having fought for Freedom and democracy against Hitler, I do not intend to promote Third Reich eugenics in our family garden. (p. x)

Strong words indeed, and perhaps surprising from an ostensibly conservative Christian; yet they remind us of the ways in which political identifications often exceed simple "Red State/Blue State" categorizations. Lloyd's position has no doubt been influenced by his wife, Momoko, who with acute eyes and gentle whispers purposefully cajoles crossbreeding of all kinds of exotic vegetables, fruits, and flowers. Unlike Ozeki's previous novel, her hybrid protagonist here, Yumi, is hyperfertile rather than infertile; she is the mother of three delightful "cross-bred" children. If there is a figure of sterility, it is the icon of the rural American heartland: the white woman, Cassie, who is married to a white farmer—signaling tradition and inbreeding. Repeatedly in the novel, sites of hybridity—of people and plants—are sites of fertile exuberance, and adoptive models of kinship are celebrated, as when Momoko "raises" the seeds of other families and Cassie ultimately adopts the child of an international couple (Frankie and Charmey, who are, respectively, American and French citizens and members of the Seeds of Resistance).

At the Biofictive Limit: Reifying the "Natural" in Anti-GMO Discourse

This overwhelming support of the exotic/foreign species through both religious and secular arguments contrasts with Ozeki's treatment of GMOs, which is at the heart of the novel. In a simple reading of the novel's message in this regard, human tinkering with nature has had profound consequences—barren seeds and barren women. Food engineered

Karen Cardozo and Banu Subramaniam

with poison may kill pests but may well also be poisoning our own bodies. *All Over Creation* thus presents the drama of the small town potato farmer caught in a history of escalating use of pesticides and herbicides that is increasingly unsustainable. The novel presents the publicity onslaught and consistent pressure from companies and their agents to move to the newest product—genetically modified potatoes—that are ostensibly "purer" (and more "natural") because they will require no pesticides; the genetically modified potato itself produces the pesticides.

This parallels arguments on this subject within mainstream culture, as does the novel's portrayal of activist resistance to the corporate position. An anti-GMO flyer distributed by The Seeds of Resistance reads, "Poison testing is being carried out at our dinner tables every day. Our government and the Biotech Industry are conducting a massive experiment on unsuspecting, uninformed human subjects—You. And me. *We Are Their Guinea Pigs*" (p. x). Yumi (you/me) stands in for interchange between activism and this uninformed subject; far from embracing the radical Seeds of Resistance, she moves only reluctantly toward some recognition of their position.

If there is a critique to be made of Ozeki's handling of the issues, it is that while she brilliantly takes apart the problematic discourses of invasive species and GMOs, she continues to hang on to a rather unproblematic notion of "nature" that stops at the door of a simplistic notion of the laboratory. For example, Ozeki clearly celebrates Momoko's experimentation with cross-breeding. In beautifully moving and evocative scenes, Momoko carefully cross-pollinates geographically unrelated seeds. She crosses them, bags them against future pollinations, and watches carefully for the errant bee bent on spoiling her carefully controlled reproductions. She whispers to her seeds in Japanese, "Grow, little ones, grow."

One could argue that these scenes dramatize what scientists do, and undermine the binary of natural and unnatural creation or engineering by enacting in detail the various steps scientists must take in order to breed plants, but with a lyricism that is often absent in scientific retelling. But Ozeki imbues them with a sense of the "natural" in stark contrast to the evil laboratory that produces GMOs. There are no equivalent scenes in the laboratory where transgenic hybrids are lyrically brought to fruition. The novel repeatedly comes down against GMOs—drawing on both strands of critique—corporatized agriculture, and unnaturalness. But nowhere in the novel is any case made for the progressive possibilities of genetic engineering (except by the corporate flaks whom the novel clearly positions as irredeemably corrupt).

In this way, however, *All Over Creation* reveals the contradictions in the rather arbitrary lines activists sometimes draw in ways that shore up the boundaries between natural and unnatural rather than carefully critiquing them. The elaborate scenes where Momoko cross-pollinates her plants remind us that some "natural" plant breeding is in fact quite "unnatural." Yet while both Lloyd and the secular Seeds of Resistance support such plant breeding (even of species that would not "naturally" have access to each other reproductively), for both groups genetic modification of organisms is anathema. Thus Ozeki shows

how conservative/progressive binaries may be inadequate to understand these political dynamics, since Lloyd, who is fervently "pro-life," also draws on his religious teachings to develop environmental policy and critique xenophobia. He draws on the same holy book both to support foreign plants, animals, and humans and to virulently oppose GMOs. In doing so, he brings together the two strands of anti-GMO critique—the discourses on the "unnatural" and the argument against corporate control, as in his speech during a rally organized by The Seeds of Resistance:

Mrs. Fuller and I have always assumed that whatever base corruptions man has inflicted upon nature, there were certain of our Maker's laws, sacred and inviolable, that even man could not breach. In this assumption we have been sadly mistaken. . . . This patent permits its owners to create a sterile seed by cleverly programming a plant's DNA to kill its own embryos. . . . thereby, and in one ungodly stroke, breaking the sacred cycle of life itself. . . . What good does this serve? To make a seed sterile? The answer is, no good whatsoever. Honest farmers, robbed of their God-given right to save their seed, will be forced to purchase these new, blasphemous contraptions every year from corporations that claim to control the patent on life. (pp. 301–302)

Here Lloyd takes on the fundamental outrage of the commercialization of seeds, the patenting of life, and indeed the development of terminator technology—genetically engineered seeds that, if planted, will not sprout—that forces farmers to go back to corporations for their seed supply each year. In an ingenious rhetorical mixture, Lloyd brings together the biological, the economic, and the religious:

Mrs. Fuller and I say this: God holds the only patent! He is the Engineer Supreme! And He has given up His seeds into the public domaind. . . . Our seeds contain our beliefs. That's why we urge you to continue to save them and propagate them and pass them on to others to do the same, in accordance with God's plan. In this way we chose to praise our Lord and to fulfill His design—of which mankind is just one small part. (p. 302)

Ozeki reveals, in effect, a hybrid *political* discourse, showing how religious diatribes mix with progressive notions of secular Left movements to rejuvenate the ideas of the public domain and the "commons."[27]

Genes and Genesis: It's All Over Creation, Procreation, and Re-creation

In a sense, then, as the novel's title suggests, the biopolitical center of the text is all "over," or about, the meaning and responsibility of creation. In multiple ways, Ozeki shows how the biblical roots of the "natural"—of creation as God intended—inhere in contemporary environmental politics, revealing them to be deeply rooted in Judeo–Christian philosophies. This, we believe, is not the novel's own cosmological view as much as the author's attempt to construct an opportunity for the reader to see the similarities in rhetoric

between the religious and the secular. For example, The Seeds of Resistance also echo Lloyd's criticism of GMOs as unnatural. As their leader, Geek, explains, we are

Symbionts. We depend on plants. They depend on us. It's called mutualism. The balance between nature and culture. At least, it used to be. But now the balances are shifting. You see, Frankie, there used to be this line that nature drew in her soil, which we simply weren't allowed to cross. A flounder, she said, cannot fuck a tomato. . . . Until genetic engineering. Go back to language for a moment, Frankie, and think about this: Genetic engineering is changing the semantics, the meaning of life itself. We're trying to usurp the plant's choice. To force alien words into the plant's poem, but we got a problem. We barely know the root language. Genetic grammar's a mystery and our engineers are just one click up the evolutionary ladder from a roomful of monkeys, typing random sonnets on a bank of typewriters. We've learned a lot about letters—maybe our ability to read and spell words now sits halfway between accident and design—but our syntax is still haphazard. Scrambled. It's a semiotic nightmare. (p. 125)

Drawing on metaphors of "balance" and divine and intelligent "nature," the consistent invocation of wondrous design (not godless accidents), Ozeki's prose plays out the similarities between religious and secular rhetoric against GMOs, where "God" and "nature" serve analogous rhetorical functions.

Reminding us of Haraway's point that all forms of biological knowledge are discursively produced, Ozeki's novel shows the Judeo–Christian underpinnings of the "language of life," as when Geek educates a newcomer to the group:

Every seed has a story. . . . Seeds tell the story of migrations and drifts, so if you learn to read them, they are very much like books—with one big difference. . . . Book information is relevant only to human beings. . . . However, the information contained in a seed is a different story, entirely vital, pertaining to life itself. Why? Because seeds contain the information necessary to perform the most essential of all alchemies. . . . They know how to transform sunlight into food and oxygen so the rest of us can survive . . . this is what planting is all about—the ancient human impulse to harness that miracle and to make it perform for our benefit. To emulate the divine author and tease forth a new crop of stories from the earth. (p. 171)

The concept of natureculture perhaps becomes most clear through Ozeki's insistent deployment of the seed metaphor throughout the novel; here the reference to the "divine author" reminds us that "seed" is indeed a key term in the book of Genesis. The semantic links between "genetics" and "Genesis" further highlight this debate over "natural" origins, thereby opening up tensions between notions of creation, procreation, and re-creation.

The question at the heart of the novel is this: Is biological and cultural reproduction to be ordered and controlled, or playful and random? Ozeki's novel works to undermine the binary form of the question itself, suggesting *both* a need for boundaries *and* the importance of playful invention. As postmodern theory has shown, most notably in the deconstructive

thought of Jacques Derrida, in the language of life, "freeplay" is inevitable. In "Structure, Sign and Play in the Discourses of the Human Sciences," Derrida discusses the dissolution of the nature/culture boundary and emphasizes how the "rupture" in the system of linguistic authority, or "structure" predicated on a notion of a controlled and stable center, gives way to the endless play of discourse.[28] For Derrida, this expresses the "monstrous birth" of poststructuralist thought, in which the game has no rules and origins are fictions. Ozeki's trope of "seed," despite its deep etymological linkages to the biblical narrative of ordered boundaries, expresses the necessary play of creativity in all its senses—creation, procreation, and re-creation. Indeed, a deconstructive reading of the biblical account shows how the notion of the work of creation as complete (on the seventh day God rested) exists in tension with the endlessly "creative" capacity of the Earth's life-forms.

Ultimately, the novel reveals that many of the anxieties that surround biotechnology in industrialized agriculture are really anxieties about the profound shifts in our conceptions of sex, gender, and heterosexuality that contemporary biotechnology offers—concerns about whether these new "creations" are monstrous or divine. As Hugh Gusterson notes, "Anti-GM activists are not so much progressive defenders of the environment against the depredations of greedy corporations (thought they may still be that) as they are reactionary defenders of an established order that is threatened by the unlicensed border crossing of migrant genes."[29] Furthermore, as Donna Haraway points out, "It is a mistake to forget that anxiety over the pollution of lineages is at the origin of racist discourse in European cultures. . . . I cannot help but hear in the biotechnology debates the unintended tones of the fear of the alien and suspicion of the mixed."[30]

The conflation of the "native" and the "natural" is hardly accidental. Drawing on the centrality of racial/ethnic and religious underpinning of Western environmentalism, Ozeki weaves them both into a human/plant naturecultural story.[31]

In pointing to the Judeo–Christian roots of the "natural," Ozeki traces the anxieties about the natural and the unnatural in a country filled with reproductive angst—the contentious abortion debates over "unwanted" reproduction and the burgeoning world of "wanted" reproductive technologies, of negative birth rates in rich countries and the "population explosion" in poor ones. In a world where birth and death are increasingly technoscientific objects, Ozeki explores the tensions these have wrought. As feminist theorists of technologies have pointed out, with the increased personification of the fetus, women and their agency in conception, pregnancy, and birth are rendered invisible and even mute.[32] These debates span the political Right and Left as questions of morality and ethics intertwine with discourses of the natural and unnatural. Ultimately, the novel seems to suggest that our endless creativity is both our greatest risk and our hope. For her part, Ozeki's protagonist Yumi seems to grasp this at the end of the novel:

Standing in my mother's greenhouse . . . I felt the brittle coat around my heart crack open at the beauty and fragility and loss of all that is precious on earth. [Geek] was right, we are responsible.

Intimately connected, we're liable for it all. I had to take responsibility for myself and my kids, but also for Geek and Elliot, and for Charmey and Lloyd, too, and yet at the same time I realized I was powerless to forecast or control any of our outcomes. But maybe that was the trick—to accept the responsibility and forgo the control? (p. 410)

Far from the ordered world of Genesis with its tidy notion of a finished work of creation, the complicated work of natureculture that is *All Over Creation* presents us with a biofictive world still seeking the meaning of creative responsibility.

Biofiction as Praxis

In assembling her imaginative collection of strange bedfellows, from the Christian fundamentalist farmer Lloyd Fuller, to his Japanese wife Momoko, to the "hippie" Seeds of Resistance, to the Fullers' farming neighbors Cass and Will, Ozeki illuminates the limits of strict discourses of identity politics. As "multicultural conservativism" and related political phenomena would attest, it is difficult to form and sustain the heterogeneous alliances necessary to gain sufficiently democratic representation and political power.[33] The coalition that emerges in the novel, however fragile, suggests what can happen when diverse kinds of people confront the ways in which their lives are intertwined and impacted by larger forces of capitalism and globalization. Thus, Ozeki's characterization resists the reinforcement of established divisions or neat alignments.

Ultimately, *All Over Creation* suggests that the future success of tactical biopolitics may depend in part upon the *political* equivalents of hybridity and biodiversity. As we saw in the partnership of Lloyd Fuller and The Seeds of Resistance, anti-GMO and antiglobalization activists come from fundamentally different political orientations but gain strength in working together. Yet such alliances cannot be "naturalized," but must be self-reflexively forged: at one point, for example, Yumi warns Geek about his growing alliance with Lloyd: "I can't stop you from doing his action, and God knows I can't stop Lloyd, but please understand that he takes this right-to-life stuff seriously. A lot of people around here do. Don't get him all riled up about it. It's not a joke" (p. 268). Yumi knows this all too well, as her early sexual history and resulting abortion were the reason she fled her father's wrath and the small and ironically named Idaho town of Liberty Falls. Yet, ultimately, she does return. The novel's emotional warmth and compassionate representation of people all along the political spectrum highlight the limitations of Left activism that pontificates and unproductively shames people. Instead, as the communications theorist Sut Jhally once remarked, social change movements also need a theory of play or pleasure in order to foster the psychological renewal needed for long-term investments. The reproduction of social movements depends upon a capacity to harness deeply felt human desires for both personal fulfillment and community.

Furthermore, in modeling an adoptive rather than a biological structure of community, The Seeds of Resistance "queer" the notion of belonging from a model of kinship or heterosexual reproduction to one of elective affiliation. As Siobhan Somerville asks in her incisive reading of "the specific figure of the alien who seeks naturalization":

To what extent has the naturalization process been understood within economies of desire? And to what extent have narratives about naturalization obscured or exposed the state's attachment to particular embodiments of desirable citizenship? How have these narratives been entangled with or detached from questions about sexuality and reproduction?[34]

The novel thus presents both a kind of absolute morality about "monstrous" kinds of reproduction (e.g., the NuLife potato) and a "queer" politics of adoptive models of all kinds of "seeds": whether we are speaking of Cass adopting the baby of a Seeds of Resistance couple, Momoko adopting various seed lineages from all across the world (pp. 113–114) or, by novel's end, hundreds of individuals adopting Momoko's seeds over the Internet (pp. 352–354). Significantly, Cass's infertility (the result of years of chemical exposure) and subsequent forays into reproductive technologies in order to have a child are unproductive. Ultimately, it is only through establishing a new community—a mode of affiliation rather than biological kinship—that she becomes a mother when Frankie, a teenage member of the Seeds, elects to let Cass raise his newborn daughter after the child's mother, another activist, is killed in an apparent accident that may or may not have been an ugly form of political retaliation. Despite the losses endured, in this instance, as in others, the novel suggests that "resistance is fertile!" (p. 416), ending with an affirmation of playful, inventive, and pragmatic alliances. The emphasis is not on shoring up the boundary between natural and unnatural forms of reproduction or hybridity, but rather on asking which forms are "productive." The novel not only points out the ways in which environmental issues impact everyone, regardless of their social location, but also suggests that "tactical biopolitics" depends on the cultivation of political hybridity through the "breeding" of sometimes "unnatural" alliances.

Conclusion

Ozeki's novel *is* the messy naturecultural world we live in—polluted and toxic landscapes, individuals hungry for love and connection, uneasy political alliances, powerful agribusiness conglomerates, and inventive, creative resisters. What her work allows us to do—as we argue the best of biofiction should—is to understand the inextricable interconnections of the natural and the cultural, the personal and the political, in contemporary biopolitics. It presents multiple theories, historical and geographic contexts, global and local connections, as well as the seeds of hope and resistance. One cannot, we have discovered through our endless conversations and e-mail debates, discuss this novel as one does most novels.

Ozeki forces us to confront the dense theoretical—biological and cultural—issues that underpin life in the twenty-first century. Would you eat genetically modified food? Why or why not? Should we really prefer the "natural" potato, which Ozeki argues has been exposed to at least seven cycles of intense herbicide and pesticide treatment, instead of the genetically modified one? Is either really "natural"? Ozeki suggests that there are no easy answers—no easy targets for blame. As she has said, the issues at the heart of *All Over Creation* are "complex and still evolving, so it would be reductive to propose simple answers or solutions."[35]

Transposing the lessons of our excursion into biofiction to academic and activist work, one could say that it is no longer departments, disciplines, or even particular interdisciplinary configurations that should drive knowledge production; rather, our collaborations and priorities should be configured primarily in terms of the social problems that we wish to solve. As Avery Gordon reminds us, quoting Roland Barthes: "Interdisciplinary work [is] not about confronting already constituted disciplines. . . . To do something interdisciplinary it's not enough to choose a 'subject' (a theme) and gather around it two or three sciences. Interdisciplinarity consists in creating a new object that belongs to no one" (Ghostly Matters, p. 7). Gordon adds, "Not owned by anyone yet, this interdisciplinarity is in the public domain, which does not guarantee anything except that there is still some room to claim rather than discipline its meaning into existence" (ibid.). Biofiction is, we suggest, just such a "new object" that, by virtue of belonging to no one, may belong to everyone—curious publics, environmental activists, and the specialists for whom these scientific concerns are professional matters. In an era in which both activism and knowledge production operate in uneven, fragmented, and heterogeneous ways at the local level, it seems important to remain open to the possibility that "the seeds of resistance" may take root in unlikely places. Expressing Gordon's sentiments in her own way, Ozeki has said that "You cannot make a better world unless you can imagine it so, and the first step toward change depends on the imagination's ability to perform this radical act of faith."[34] Although it cannot provide all of the answers, let alone ask all of the questions, biofiction offers up a theoretical and pedagogical space in which we might both come to understand something about where we live now, and begin to imagine how to live elsewhere.

Notes

1. Avery Gordon, *Ghostly Matters: Haunting and the Sociological Imagination* (Minneapolis: University of Minnesota, 1997), p. 5.

2. Donna Haraway, *How Like a Leaf: An Interview with Thyrza Nichols Goodeve* (New York: Routledge, 2000).

3. See Michael Gadamer, "Fictionalizing the Disciplines: Literature and the Boundaries of Knowledge," *College English* 57(3) (1995): 281–286.

4. Mikhail Bakhtin, *The Dialogic Imagination: Four Essays*, edited by Michael Holquist, translated by Caryl Emerson and Micheal Holquist (Austin: University of Texas Press, 1981).

5. For a discussion of the distinction between author and text, along with other theoretical nuances important to understanding fiction, see Wayne Booth, *The Rhetoric of Fiction* (Chicago: University of Chicago Press, 1961; 2nd ed., 1983).

6. "A Conversation with Ruth Ozeki," in Ozeki's *My Year of Meats* (New York: Viking, 1998), p. 9.

7. Stephen Mitchell, *Genesis: A New Translation of the Classic Biblical Stories* (New York: HarperCollins, 1996).

8. See, for example, Evelyn Fox Keller, *The Century of the Gene* (Cambridge, Mass, Harvard University Press, 2002); Donna Haraway, "The Biopolitics of Postmodern Bodies: Constitutions of self in Immune System Discourse," in *Simians, Cyborgs, and Women: the Reinvention of Nature* (New York: Routledge, 1991), pp. 204–207; Emily Martin, "Science as a Cultural System," in *The Woman in the Body: A Cultural Analysis of Reproduction* (New York: Beacon Press, 1992), pp. 25–69. These are but three early examples of a vast literature.

9. Banu Subramaniam, "The Aliens Have Landed: Reflections on the Rhetoric of Biological Invasions," in Betsy Hartmann, Banu Subramaniam, and Charles Zerner, eds., *Making Threats: Biofears and Environmental Anxieties* (Lam ham, Md.: Rowman & Littlefield, 2005).

10. Latour, Bruno, "Pasteur on Lactic Acid Yeast: A Partial Semiotic Analysis," *Configurations* 1(Winter 1993): 129–146, on p. 140.

11. Haraway, *How Like a Leaf*, p. 25.

12. Joni Adamson, *American Indian Literature, Environmental Justice, and Ecocriticism: The Middle Place* (Tucson: University of Arizona Press, 2001), p. 12.

13. Nancy Tomes, "The Making of a Germ Panic, Then and Now," *American Journal of Public Health* 90 (2) (February 2000): 191–199.

14. Section title in Christopher Bright, " 'Invasive Species: Pathogens of Globalization," *Foreign Policy* 116 (Fall 1999): 51.

15. http://www.invasivespeciesinfo.gov/plants/main.shtml.

16. The USDA Web site outlining its invasive species program is http://www.invasivespeciesinfo.gov.

17. On local issues and programs, see http://www.invasivespeciesinfo.gov/unitedstates/state.shtml.

18. http://www.nature.org/initiatives/invasivespecies.

19. http://maryland.sierraclub.org/newsletter/archives/2006/12/a_017.asp.

20. See Banu Subramaniam, "The Aliens Have Landed: Reflections on the Rhetoric of Biological Invasions," in *Making Threats: Biofears and Environmental Anxieties*, Betsy Hartmann, Banu Subramaniam and Charles Zerner eds. (Rowman and Littlefield, 2005); Mark Sagoff, "Why Exotic Species Are Not as Bad as We Fear," *Chronicle of Higher Education* 46 (June 23, 2000): B7; Stephen Jay Gould, "An Evolutionary Perspective on Strengths, Fallacies, and Confusions in the Concept of

Native Plants," in *Nature and Ideology: Natural Garden Design in the Twentieth Century*, Volume 18, Joachim Wolschke-Bulmahn ed., (Washington D.C.: Dumbarton Oaks Research Library and Collection, 1997), pp. 11–19; Johan Peretti, "Nativism and Nature: Rethinking Biological Invasions," *Environmental Values* 7 (May 1998): 183–192.

21. See Maryland's attempt to enlist "urban weed warriors" in: http://www.ci.baltimore.md.us/government/recnparks/conservation.htm

22. Jonah H. Paretti, "Nativism and Nature: Rethinking Biological Invasions," *Environmental Values* 7 (2) (May 1998): 183–192.

23. L. B. Slobodkin, "The Good, the Bad and the Reified," *Evolutionary Ecology Research* 3 (2001): 361–367. Yet others critique the view that the framework of biological invasions invoke xenophobic rhetoric. See, for example, Daniel Simberloff, "Confronting Introduced Species: A Form of Xenophobia? *Biological Invasions* 5(2003): 179–192.

24. http://steelturman.typepad.com/thesteeldeal/2006/08/frankenfood_str.html.

25. George Myerson, *Donna Haraway and GM Foods* (Cambridge: Totem Books, 2001).

26. Chaia Heller and Arturo Escobar, "From Pure Genes to GMOs: Transnationalized Gene Landscapes in the Biodiversity and Transgenic Food Networks," in *Genetic Nature/Culture: Anthropology and Science beyond the Two-Culture Divide*, Alan Goodman, Deborah Heath, M. Susan Lindee eds. (University of California Press, 2003), pp. 155–175.

27. http://onthecommons.org.

28. Jacques Derrida, "Structure, Sign, and Play in the Discourse of the Human Sciences," in *Writing and Difference*, trans. Alan Bass (London: Routledge, 1978), pp. 278–294.

29. Hugh Gusterson, "De-coding the Debate on Frankenfood," in Betsy Hartmann, Banu Subramaniam, and Charles Zerner eds., *Making Threats: Biofears and Environmental Anxieties* (Lanham, Md.: Rowman and Littlefield, 2005), p. 121.

30. Quoted in George Myerson, Donna Harway and GM Foods. (Cambridge: Totem Books, 2001), pp. 60–62.

31. David Arnold, "The Place of Nature," in his *The Problem of Nature* (Oxford: Blackwell, 1996), pp. 9–38.

32. Sarah Franklin, "Postmodern Procreation: A Cultural Account of Assisted Reproduction," in *Conceiving the New World Order: The Global Politics of Reproduction*, Faye D. Ginsburg, Rayna Rapp, eds. (University of California Press, 1995), pp. 323–345.

33. Angela Dillard, *Guess Who's Coming to Dinner Now? Multicultural Conservativism in America* (New York: New York University Press, 2001).

34. Siobhan Somerville, "Notes Toward a Queer History of Naturalization," *American Quarterly* 57 (3) (2005): 659–675.

35. See the conversation with Ozeki at her official website: http://www.ruthozeki.com/creation/conversation.html

36. "A Conversation with Ruth Ozeki," p. 13.

True Life Science Fiction

Sexual Politics and the Lab Procedural

Gwyneth Jones

Science/SF[1]/Feminisn

Science fiction writers and "science" have a dysfunctional relationship. The core audience for science fiction (sf) especially print fiction, tends to be drawn from those in science- and technology-related employment, self-identifying geeks, "anoraks," coders, nerds. Readers have a high tolerance (astonishingly high, relative to the rest of the fiction audience) for details of lab procedures, engineering problems, high-energy physics phenomena, gadget specifications—yet many express indifference to the *content* of these demanding passages. "You wade through that stuff to get to the story and the characters," is a typical comment. Meanwhile, the writers, a group that includes many passionate amateurs, attempt to keep up with the future. Their preoccupation with "science" is an accident of the twentieth century, their *desire* is to be at the cutting edge of everything: dress codes, black holes, radical politics, melting ice caps. Science fiction writing lives poised on the edge of now, always about to be out of date. The vital element that lab life shares with the genre could be that mood: the addictive stress of novelty, the pride of stepping out onto empty space—

The genesis of my novel *Life* was in the 1970s, when science fiction took on the novelty of the Women's Movement.[2] It was a paradoxical meeting. Defining feminist sf texts, notably Monique Wittig's *Les Guérillères* and Joanna Russ's *The Female Man*, were (and remain) lyrical, intellectual, experimental; with passages of theory, a painful naming of parts, at once too alien and too accusing to be ignored. The average recreational sf fan was appalled. Yet the popularizers of this epiphany, the developers who took the goods to market, were Ursula Le Guin and the late Octavia Butler, two U.S. writers whose sheer quality and gravitas had an immense and lasting impact on the genre. A third figure, using the pseudonym James Tiptree, Jr. (later outed as Alice Sheldon, which brought about her downfall), wrote novels and stories that combined startling sexual themes with

devout sf convention, and swiftly collected every honor the community could bestow. It was a Camelot moment, a brilliant anomaly; soon buried.[3]

Iconic female futures speak bitterness. The most famous, Margaret Atwood's mainstream novel *The Handmaid's Tale*, features affluent North American women reduced to the chattel status of Pakistani peasants by an ultraconservative administration. Genre versions anticipated the same theme: women crushed under the iron boot of patriarchy, sometimes dragged-up in role-reversal fantasy, sometimes unrelieved (Suzy Charnas, *Walk to the End of the World*[4]); sometimes in diptych with a sweet Radical Left alternative (Marge Piercy's *Woman on the Edge of Time*). In the last pages a light glimmers ahead, but don't go there, our Utopia will sound as fascist and covertly vengeful as any other; end here, it sounds hopeful. Issues of science and technology permeate these narratives, but the encounter is tragic. Positive feminist sf (Joan Slonczewski, *A Door into Ocean*; Vonda McIntyre, *Dreamsnake*; Kathleen Ann Goonan, *Light Music*)—imagining a ravaged planet restored by the new, experiments in reproduction and posthumanism, gender-neutral societies, high-tech symbiosis with the living world—is far less likely to be known outside the genre or to be recorded in the academic canon. It cannot be read as radical politics; the dissonance is too great, women are not supposed to occupy this space. And yet, as those writers of the 1970s discerned, as we see all too clearly in this hell-bent, regressive young century, embracing futurism, assimilating *les accidents de féerie scientifique*[5] (even if only in art/drama/fiction; it's a start) is our only hope.

I saw Joanna Russ's *The Female Man* (1975) in a bookstore in Singapore, where I was living at the time, and walked past it several times before I picked it up. I found the expression "Female Man" disturbing, and I did not expect to be *disturbed* by the Women's Movement. I expected feminist theory to tell me only things I knew already. Curiosity got the better of me; I bought the book and discovered that Joanna Russ was none other than the writer of "When It Changed"[6]—a new wave sf story, radically feminist yet impeccable science fictional, that I greatly admired.

The Female Man is a hatchet job. It strips feminism of all sentimental illusion; exposes the (sf) writer as a daydreaming schizophrenic; and presents its women-only world as a dazzling high-tech playground where duelists strut and genius IQ is advisable, if not mandatory. I was an immediate convert. Overnight, the veiled women in the novel I was writing (set in a far future Southeast Asia) stopped being piteous victims and became rulers of the hearth, who had abandoned the public sphere to their "studs" of their own free will.

Russ appeared to be a disillusioned fellow traveler of U.S. (regular flavor, not feminist) underground politics; of urban terrorism, secret mail drops, layers of deception—a world I deeply distrusted. She probably ruined my chances of a career in commercial sf, for which I thank her sincerely; and she set me the task of stripping down my own, very different illusions.[7] My writing was a means of naming the parts, reducing what I knew to its components, finding out by trial and error, by building functional models, what happened

when I discarded one unit or another. I produced a series of novels, reiterating in variant forms the only story feminist sf can tell.

But *The Female Man* had shifted my focus. I was no longer describing the battle of the sexes, speaking bitterness and imagining a hopeful outcome. I was investigating the causes. What is femaleness, what is maleness? What, exactly, *happens* in the wiring of human sexual behavior? Is the dominance of a male-ordered culture (supported by the women, apparently of their own free will) one of the great problems of our world? Or am I just deluded? Like Ramone, the perenially angry young woman who shadows the protagonist's career in *Life*, I did a huge amount of reading—at first seduced by the blank canvas of the question, increasingly fascinated by the material itself, the naked equations of sexual difference.

By the mid-1990s my fiction had entered a gender-neutral space which many sf feminists considered positively hostile. I was writing of a future in which the world had divided into two camps: a global low-intensity war between the Traditionalists, fanatically intent on preserving hallowed male/female characteristics, and the Reformers, who were prepared to let the difference go into free fall. A lot of the Traditionalists were women; a lot of the Reformers were men. The don't-knows had a particularly hard time. There were some aliens, too, who had no conception of the sexual other, the either/or, dark/light, active/passive divide: it was the challenge of their arrival that had triggered the gender wars. As I came to the end of this project, I knew it was time to move on from sf feminism; I had nothing more to say.

But before I left town, I wanted to do something with my research. I'd discovered a collection of articles from the first conference devoted entirely to sexual difference, in which I'd read Jennifer Marshall-Graves's original "SRY" paper, among other deipatches from the front line.[8] Drawn by her reputation among feminists, I had encountered Lynn Margulis's endosymbiotic theory and her stubborn fight to break down the establishment's resistance—on point of doctrine completely innocent to laypersons, yet *immediately* recognized by the priesthood as a challenge that shook the pillars of the universe. One meets the same bewildering acuity in all holy wars.

I felt there was a story to be told which would trace the checkered career of a visionary woman scientist, and the equally checkered career of a controversial discovery. It would be a fantasy about something going on in the human sex chromosomes, the impossible made plausible by a wealth of technical detail. But crucially, vitally, this change in sexual molecular biology would turn out to be profoundly important for all life on Earth. And it would be nobody's fault; it would be something inevitable, neither good nor evil, working its way to emergence (it was nobody's fault that Galileo saw the moons of Jupiter).

There would be no alien invasion, no divine or demonic intervention, no mysterious Rapture. No single-sex colony on a distant planet, no Born Again Bronze Age matriarchs, no gender-selective genocide, no sex-linked plague. I would return to the source of all modern folklore, whether or not labeled "sf": science itself, the marvelous in its street clothes.

Shadowing a Scientist

Ideally, science fiction writers should be scientists tossing off best sellers in their spare time. Ideally they should be working in theoretical physics or engineering; astrophysics, astronomy, and of course branches of computer science may also apply. This is our long-established male-typic elite, the standard by which we judge ourselves. (The genre is conservative. Life sciences, until recently considered more suitable for women writers, are coming up fast.) Even now I feel slightly shocked when I hear that one of their number has quit to "become a full-time writer." What a fall! The rest of us are camp followers, groupies, cargo cultists, collectors of antique packaging. I had been writing science fiction for more than a decade without ever going near a lab. For the "Anna Senoz" novel I needed to enlist a scientist, and this was alarming. I had been working with Richard Crane (now the convenor of Creative and Dramatic Writing at the Centre for Continuing Education, University of Sussex), on community writing projects. I asked him to be my matchmaker. Could he find a molecular biologist, preferably female, who would be willing to talk to an sf writer? Who might even let me come into a lab and be a fly on the wall?

My first approaches were not successful. I find an entry in my notebook, written after one phone call in which I'd been given a short, sharp answer. Here's the catch. Women in science are likely to be hard pressed. *Oh dear, I've hit the busy people. This isn't going to work, why should anyone make time for me?*

Eventually, Dr. Jane Davies agreed to see me.

I prefer to do my own research. I read everything I can get my hands on, I do my best to understand, or at least to capture the ambience; and then I make it up. Conformity to today's knowledge base is beside the point in sf. The Higgs boson discourse will no doubt have moved on, two hundred years from now; if anybody cares at all. When I have to call in a specialist, I try to use (and not to abuse) a personal contact. I don't tend to ask questions, because I fear I'm too ignorant to think of the right way to frame them. I tell my story; explain how the device or special effect is supposed to fit into my plot; and the specialist makes objections. I had no list of questions with me, no tape recorder either, when I set out for Sussex University, my alma mater (I had wasted three years of my parents' and my government's money there, once upon a time) one morning in November.

At Sussex, four miles from Brighton, on the edge of the South Downs, the great divide between arts and science is physical and dramatic. Arts is in the green valley; science occupies a concrete hillside. I announced myself at the porter's desk in BIOLS, a building in a part of the campus I had never entered when I was an undergraduate. I approached the corridor lined with office doors expecting very little. I thought I'd state my case, go away, and wait for Dr. Davies's decision. I was concerned because I was going to have to talk about feminism right away, or I'd be under false pretenses, and I didn't know how she would react. In my experience, successful professional women are often very wary of that word. It's demeaning.

Feminism? Special pleading, whiny nonsense. Get out of here!

I saw a woman in a white coat, maybe a few years older than myself (but I'll feel childish until I die), with a warm smile. I stumbled through my intro, and Dr. Davies showed no sign of impatience. Unprepared—and babbling, I'm afraid—I began to tell her my story.

"The important thing to remember is that Anna isn't interested in sexual politics, or politics of any kind. She's not *anti*feminist, she'd say she just wants to be treated like a human being. She's ambitious, secretly and wildly ambitious. When she's an undergraduate, she dreams of finding a missing link—some mechanism to bridge the gaps in evolutionary theory, giving a better model of life itself. But that's a daydream; in real life she's an idealist, she wants to do good. She decides on a career in plant biology, improving food crops (sustainably, of course). Feed the world. . . . But she gets derailed; by bad luck involving a male student who probably resents her talent, she ends up in human fertility studies. There she spots something going on, a tiny change in a sample of male sex chromosomes which she sees at once might have a very weird explanation . . . if it's not an experimental artifact. She checks it out, and is convinced she's on the track of something. I'm not sure how, but in the end this will happen *fast*, become unstoppable *fast*, within a generation.

Is it possible? I know they don't usually, but do the X and the Y ever exchange bases? Would it be obvious, or could it appear and disappear, the way I need—?

At some point she's forced to sacrifice her career to her domestic responsibilities—"

I trembled every time I had to use a technical term. *Mitochondria*, how do you pronounce that? I rambled around, explaining about taking things apart, identifying the basic components, as if that's what's important. I remember Dr. Davies gently prompting me. "Reductionism—?"

"Uh, yes." I was extremely exposed. All I could do was cling to Anna—

"She keeps coming back to the thing she saw, and finding it again, and getting more and more excited. She knows it's the key to a BIG discovery, but she also knows—and it turns out she's right—that the sex angle will be her downfall. It's what happens to women in science in real life. Because they have children; or a husband who doesn't like their long hours; a superior who tacitly, unthinkingly, marks them down; or because they make male colleagues feel insecure (though you can never say that). It's meant to be read doubly: a young woman who wants to be a *pure* scientist, and has a very idealistic notion of what that means, but she keeps being brought up against the sex angle—"

I have pages of scribbled notes from this interview, it was astonishingly successful for me. There are no notes about my state of mind, but I know how I felt. I'd been trying to teach myself molecular biology from half a page of misunderstood notes washed up on a desert island: and was plunged into a master class.

Interview Notes

A transfer of material from the Y to the X, with some selective advantage?

The X and the Y don't usually exchange recombination, they're too different in shape, but there is a small area where this male donation could happen:

A benign mutation, fixed in the population for thousands of years?
A tiny change in the amount of Y (more).
Conveying resistance to our increasingly toxic environment?
What's needed is a horizontal transfer.
Transposons. What about transposons? (This was my big idea.)
What do you **see**? A band changes in size?
Spontaneous change causes transposable elements to mobilize.
At least 10–15 percent of our DNA is made up of transposable elements.
They can act like viruses.
She would note this change, publish a paper in *Trends in Genetics*.
A scientific journalist would pick it up from a database.
Very bad news if your supervisor doesn't know what's in your graduate paper. If it's published without her supervisor's name, that's a crushing blow——.

I had not yet decided *when* my story would start when I walked into Dr. Davies's office. Possibly the near future? But we mapped out Anna's career for her, as if she were setting out now: a game of snakes and ladders that's not going to change, and I made an instant decision. She starts from here.

She knows nothing about 1970s feminism (although she's going to meet a ferocious, defiant young feminist). She's eighteen, proud, and brave, and the Spice Girls have just released "Wannabe." She's *disgusted* by girl power.

She gets a good first degree.
A science department gets a quota of grants.
Your supervisor puts you on a project.
For three years. It's not enough time.
The nature of lab-based science makes it impossible to survive for the fourth year. Industry-sponsored studentships, for top-up grant support. Student works w. industrial partner, but no guaranteed employment.
Many supervisors use their students as technicians, you could end up without much choice of work.
In academic science you can keep going on short-term contracts. But you have to have a permanent job by thirty-five or forty. Teaching, administration, grant organization.
Publish! Publish! Publish!
Her own research is always going to have to give——.

Serendipity: I was very lucky to have encountered someone who was prepared to countenance my proposal: to recognize and nurture what faint resonance it had with her professional knowledge. Perhaps even luckier to meet someone outside science fiction or academic literary criticism, who grasped the idea of a *doubled* narrative, where the information, the sequence of events, is meant to convey at least two meanings at the same time. Or perhaps that wasn't luck. The genome is the original complex, layered, looping, interactive narrative. A gene may "mean" several different things. Depending on the location; depending on the bases upstream and down; depending on the weather in the cells. Simplicity as a result of complexity: this is a historical document. I met Dr. Davies in 1996. The Human Genome Project had begun in 1990. The Y-chromosome would not be sequenced until 2003. In 1996, horizontal transfer of DNA—in a population, between species—was verging on science fiction, to coin a phrase. I was to spend the next few years, as I wrote and rewrote this book, rearranging my fantasy science so that it could live in the chinks between real-world discoveries (conditions, current affairs): my understanding of the science growing more sophisticated, and the surface of my fiction growing sleek as flesh and blood.

Some things didn't change. In 1996 there were initiatives, conferences, workshops, on the "women in science" question. The hemorrhage of female graduates, from both public and private sectors, was being debated. "Everyone" knew about the hoops women had to jump through to get grants; the scandal revealed by blind testing of the funding application process; the dearth of women reaching high-level, role-model, influential posts. And yet, just as now, girls like Anna, talented and liberated, were supposed to be having it all. If Equal Opportunities didn't work for them, there must be something wrong with the girls.

(Once, when I was twenty or so, a fellow undergraduate jumped on me. We were alone in a student rented house, a grimy front room with a mattress on the floor, posters of Ché and Dylan. He was one of the circle of friends, by no means a close friend of mine. What did I do? I fought him off. He came back for more, I kept on fighting. I did not scream, of course I didn't. I went on fighting, silently, until he finally quit. But if he had persisted, I would have had to give in. I would not have called it "rape," not unless he'd actually beaten me unconscious or tied me up or something; and I wouldn't have dreamed of reporting the incident. Girls usually don't. What would you say, in the face of his convinced denial? It's true, I let him do it. He didn't rape my body, he raped my mind. Nah, better keep quiet. Expect to be insulted, understand that you always *have to be careful)*

After about an hour, I took away the ideas I'd been given; the insights into the feudal relationship between a student and (her) supervisor; and the promise that I could have a lab visit. My sense of astonished daring, my feeling that I'd entered a sanctuary, a holy place where I had never expected to tread, was no part of the interview. But it was to become part of Anna.

True Life Science Fiction

She spent the lunch break lurking in the crowd, unmolested. In the middle of the afternoon she presented herself in good time. Professor Reeves of Computer Science, who was running the symposium, greeted her distractedly.

"Who are you?" His grey curly hair fizzed with anxiety.

"I'm Anna Senoz, from Parentis."

"Good, good. Now look, er, Anna, we're running late, it's going to be very unfair on the last group, so could you make it short. Get through your stuff in fifteen minutes, instead of twenty. Can you do that for me, love?"

"Of course."

"Good girl! Now where the hell's Eswin? Anyone here seen Terry Vick?"

She scanned her pages and made instant cuts. It was better this way: hustled, badgered, no time to think. It would be no worse than talking to a nearly empty hall, the way she'd imagined. There was no one here remotely interested in "Transferred Y." This was a rehearsal, harmless as practicing in front of the mirror. Her heart beat wildly, she felt like a half-fledged bird crouched on the rim of the nest: *"Ça, mon âme, il faut partir."* Who said that? René Descartes, as he lay dying. "My soul, we must go." But she was not dying, she was being born. She was about to join the edifice, the organism, thousands of years, to which she had given her life and heart. To speak and be heard. She checked the OHP, made sure her acetates were in order—and saw K. M. Nirmal, sitting erect in the middle of the front row. She hardly recognized him. Her supervisor was wearing a very smart suit. She'd never seen him except in a lab coat or a shabby sports jacket. He hadn't said a word about attending the symposium. Her head started to spin. To speak in front of Nirmal was *completely different*.

She began.

That evolution is still a mysterious process, with many unsuspected byways, and perhaps she had found an example of one of these. That her predecessors in sequencing the Y-chromosome had worked like this.

That she was analyzing samples of DNA from healthy, normally fertile contemporary human males and from recovered medieval tissue.

That her technique was like this (including the tweaked modeling program). That she had repeatedly observed an exchange of the same sequence of bases between the Y- and the X-chromosomes in the modern samples. That she had found no sign of this polymorphism in human male DNA from a similar geographic location at an earlier date (the Huit Bories samples). Further investigation was indicated. Was there a female version of "Transferred Y," passed on by affected males to their daughters?

Meanwhile, here was a distinctive genetic variation, apparently fitness-neutral, that had established itself in a human population in a relatively short time. How

this happened—if it was not disproven by further evidence—and whether there were other instances of the same mechanism, continued studies might reveal.

The previous speaker, Eswin Holmes ("Bacteriostatic Effects of Food Preservation") had overrun his fifteen minutes a little. Therefore, after about thirteen minutes and a quarter, Professor Reeves started making urgent *wind it up!*, signals. Anna wound it up. She was pleased with herself for being in control enough to do that and still more or less make sense. No one was listening, anyway—except presumably Nirmal. She dared, as she delivered her final sentence, to risk a timid glance in his direction. He was staring right at Anna, his eyes blazing with naked fury. As she watched, horrorstruck, he got to his feet, pushed his way along the row, and marched out of the hall.

There were no questions.

The symposium had been on a Saturday. Nirmal kept her waiting for a week before he called her to his office. No one else had mentioned the symposium except Ron Butler (m), who made an attempt to congratulate her on breaking her duck. Anna thought the delay was a refinement of cruelty; she realized later that Nirmal had been giving himself a chance to calm down. The worst part was that Anna hadn't an idea what she had done wrong. He'd accepted her Transferred Y outline without comment, merely telling her to carry on, and she'd been too unsure to ask to talk it over. She'd handed him a copy of her final draft and waited hopefully for his input. She'd been disappointed when he failed to make any response, but it was typical of Nirmal.

The best and worst thing about the interview itself was that everything became very clear very quickly.

"So, Miss Senoz. I gather that the work we have been doing together has been far from worthy of your undivided attention. When I suggested that you give a paper at the Young Scientists' Symposium, I think I had a right to assume that your presentation would focus on the doctoral project you are undertaking with my supervision."

"I'm sorry," she whispered.

"But no. Your mind is elsewhere." He lifted a copy of Anna's "Transferred Y" paper and slapped it down on his desk as if he hoped to break all its bones. "If it cannot be distorted into the service of your much more interesting private preoccupations, your work in this lab does not engage you at all. I trusted you implicitly! It was extremely, extremely unpleasant for me to discover, in public, that you had chosen to present a peculiar hobbyhorse of your own—"

Anna was dumbfounded. It dawned on her that Nirmal had not read her outline or her paper. Of course, he'd assumed he *had* read it. He knew everything she'd been doing on the pseudogenes. He'd assumed she would be going over that

ground. He had not made time to check up on her, or it had slipped his mind, or he'd let it go because he hated one-on-one meetings. She stared at her hands, clasped in her lap to stop them shaking, and wondered, how on earth did someone as allergic to personal contact as Nirmal get to be a postgraduate adviser? It wasn't because she was a girl, he was as distant with the male members of the team. Everybody complained about it.

That's science for you. The better you are at what you do, the more time you're doomed to spend doing things you're no good at. Her terror was strangely dissipated. *No way* was she going to remind him that he'd told her she could do what she liked. *No way* was she going to point out that he'd had every opportunity to find out, and had omitted to make sure he knew what his student was going to say in her first public appearance.

"Until you are free to return to your beloved potatoes," Nirmal was saying, with withering politeness. "I expect you to concentrate *mainly* on the tasks in hand here."

Anna nodded, accepting her lessons. Anything you say in the lab, your supervisor is going to hear. Anything you do, it is your responsibility to make sure your supervisor knows about it. Don't take chances with the natural human vanity of your boss.

"Professor Reeves intends to publish a transcript of the colloquium. Needless to say, *this* will not feature. It will never be published. I cannot consider putting my name to it."

She nodded again. She was no longer devastated. She knew he would not be unfair in his personal record. Neither of them would say it, but he knew he'd been neglectful.

"I'm sorry," she said, standing up. "I got carried away. It won't happen again."

"Good. I hope I can trust you from now on."

She reached for the paper. Nirmal's thin hand came down upon it, the nails almond shaped and calcined, thick as seashells. He didn't speak, so she headed for the door.

"Oh, Anna—"

She quailed. What now?

"This is very good work," said her supervisor dryly, tapping the "Transferred Y" paper. "Wrong-headed, even absurd, in the implications, which you wisely didn't spell out. But bold, original, well-reasoned, and well-presented. Your technical work is also very good. You have a formidable talent, young lady. But you must focus. Focus!"

"Thank you," she muttered. "Thank you, I'm sorry, I will."

"A formidable talent," repeated Nirmal. "Don't waste it!"

{Extract from Life, chapter 2, "Anna's First Paper"}

Box 17.1 Shaking B Polymerase Chain Reaction

28.1.97 Martin shows me round

A biology lab, too warm. Long islands of benches, clutter of equipment, screwtop jars with masking tape labels. Post docs in jeans and T-shirts. Names of the machines: a microwave oven bought from a chain store, vairous devices for long-term shaking of things. A squat pyramid with a rubber cone let into the top vibrates a microfuge (eppendorf) tube. The fridge freezer, the PCR machines, the gel trays linked to a row of transformers. Designed so you can put your hand in the electrophoresis liquid with the current running. For sequencing, the voltage may be very high; today it's not critical. The prep room where tech support staff make up mixes from enzymes and proteins bought in bulk. The fume cupboard, the camera in a closet, Eagle Eye, where people take pictures of their gels. Moments of tension; sometimes no bands appear.

(*I watch the extreme sports programs on late night TV, with my son. I see those young men leaping into the empty air, their preternatural confidence—as if they have an immediate, physical sense of their place in the whole of this state of all states, this state of affairs, a path they follow that will never let them fall. The truth is that they DO fall, crash and burn, smash their elbows, snap their collarbones. But they don't care. I wonder, is that testosterone, or nurture? Is it something I could never learn, or is it something I could find in myself, an atrophied skill? What kind of human being am I?*)

Blots And Gels

Anna wanted to tell them that when she studied a protein separation gel, it was like a negative image of the starry sky. She was an astronomer, a cosmologist, a particle physicist: knowing events by their traces, through a chain of mathematical inference, never able to perceive her quarry directly. She wished she could make her friends understand the vast *distances*, which was far more important than worrying about vanity parenting or whether men or women owned the jargon. It is so far away, you can't imagine how far. We don't exist there. They don't direct us, no more than the stars direct human affairs. We are part of the same system, obeying the same laws, but we hardly begin to understand what the laws are. Maybe we're still waiting for Galileo's telescope. *{Extract from Life, chapter 1}*

Dr. Davies had advised me to listen-in to some lectures. I turned up and snuck in at the back of the theater, for Janet Collet's Eukaryotic Genetics in 1996: Heritability; Genetic Constraints of Selection; Recognizing, Saving, and Using Genetic Resources. The lecturer was a tall woman with a graying braid, dressed in workshirt and jeans; unpretentious and kindly. The students liked her, evidently; so did I. My way had been prepared for me. When I first appeared, someone came up at the end and asked, "Are you the

Box 17.2 Polymerase Chain Reaction #2

The project involves a gene in *Drosophila* called Shaking B that affects nerve/muscle junctions. The object of this exercise is to try and pinpoint the working part of the code. Martin is using a different technique in this reaction—a section of DNA with an added long tail of nucleotide bases that will help him to spot his target. PCR record sheet, check boxes. Use the micropipette to make up the mixture of cutting enzyme, buffers, template, de-ionized water, etc. Add a thin film of oil to prevent evaporation. The enzyme is a special one that is thermostable to 95 degrees centigrade. Shake the tubes, using the machines that shake them, and insert in the PCR machine.

Micropipettes are robust, practical-looking dispensers, disposable tips, use and eject into beaker (bin). Care must be taken to let no part of the pipette beyond the disposable tip touch the microfuge; DNA is everywhere. Names on masking tape, like on food in a student fridge. Post-docs are in their late twenties. Pressures on lab space, supervision hours = many undergrads do no practical work, except by-rote prepared experiments. A few will be lucky enough to do a third-year project.

science fiction writer?" I nervously agreed, and that was all. I copied diagrams, I made adjustments to the ideas formed by my amateur reading. I discovered how fluid, how interactive the genome was becoming, how much unsuspected complexity had been uncovered by the failure of early attempts at "genetic engineering." It's not that the processes aren't predictable—they're just far more intricate, and there are far, far more variables, combinations, feedback loops than had been dreamed possible. I pondered on transposons, viruses, cohorts, methylation, environmental factors.

In the late 1930s (this was before Crick and Watson, before the dramatic revelation of the structure of DNA) something critical happened to genetics, which until then had been a patient science of organisms and cells, where the result of a cytology experiment had to be read in the variegated color of a flower, in the shape of an insect's wing. The technology improved and the physicists moved in, notably Max Delbrück, bringing their mechanistic, reductionist (that word again!) worldview. For more than thirty years thereafter, DNA was the miraculous blueprint (this was what they taught me in school, in the 1960s): changeless as the fixed stars; except when a random mutation, conveying an advantage at some level, propagated through a population via fitness selection. It was a beautiful model, pure and simple and essentially tragic. Every organism, every gene, was an isolated warrior, forging alone through the ages, ruled by arbitrary fate. And it was wrong.

It was wrong, but inescapable. You believed in the physicists' version or you didn't work; or if you worked, you were a crank, unpublishable: you were nobody. The heroes of the resistance (Lynn Margulis, Barbara McClintock) suffered horribly, especially McClintock. It was like being nailed as un-American, except nobody talked about a

blacklist. I was proud of them. Yet if I had been a female biology student in the 1950s, the 1960s, wouldn't I have been *very* careful not to associate with anything cranky? Can't be too careful. Wouldn't I still be wary today? I felt my native caution welling up: if someone is called a crank, there's usually something in it. No smoke without fire. Just because I write sf, it doesn't mean I'm gullible.

But I took comfort—I take comfort—in the big mistakes of science. Sun still going round the Earth, anyone? There's no mystery as to how it happens: as long as the accepted theory works, and still produces good results, a few mavericks can easily be ignored. All human structures protect themselves. The life of the mistake is prolonged by peer pressure, witch hunts, more or less willful blindness; whatever the market will bear. But sooner or later, the cracks begin to show. The bigger and more pervasive the system gets, the more the contrary evidence begins to mount up, too, until a tipping point is reached. Anyone can suppress the truth. You can suppress the truth as often as you like. But there comes a point when you can't suppress the facts, because there they are! All over the place.

The idea that gender is all-important could be simply wrong. Down among the chromosomes, the science is neutral. Every human body (right now, no fantasy intervention required) is a mosaic of male and female cells. The whole idea that humanity is divided into two halves could be a chimera. One day it could just vanish, like the Cold War, like the crystal spheres, like canals on Mars and jungles on Venus. There'd be people who felt themselves to be men, having babies; people who felt themselves to be women, having penises. People who just couldn't see the problem, letting their "sexual identity" go into free fall. And then everyone would—

Be happy?

Nah. Better than that. Everyone would be the same as before, or that's what they'd tell you. Successful revolutions vanish, nobody realizes they happened.

Dark they were, and golden-eyed[9]

Random Lecture Notes

The rule is not "if you have a Y, you're male."

It's 1X + 2 sets of autochromes, and you're male.

2X + 2 sets of autochromes, and you're female.

A molecular mechanism that can distinguish one from two is sophisticated.

Triggered by meiosis sorting X from Y or X from not-X.

Y in flies, not necessary for male identity, is necessary for spermatogenesis.

Environmental cues can also be used to determine sex (e.g., reptilians; temperature). Sea worms—an embryo develops as male if near another embryo that's developing as female.

Genetic determinism = the genotype drives all subsequent behaviors = wants to ascribe all behaviors to one part of a process.

Vast fruit fly chromosomes looking like the Alphabet necklace in *Just So Stories*.

1966 refined specific enzyme assays in plants = wild-type alleles were hugely variant! = we are extraordinarily variable, not only between genes but inside genes, in the coding systems of proteins.

1944 Oswald Avery, Colin Macleod, Maclyn McCarty identified DNA as the "transforming principle," but cautiously hedged their conclusions. It was in the middle of the war but Avery isn't a legend, nobody's heard of him, because he wasn't the alpha male type. Discuss.

You have to be ruthless and driven to get to top, in science as elsewhere, but a woman with full domestic support immediately becomes a man—a man who makes time for his personal life, his family, in the chinks allowed by lab science.

A Feeling for the Organism

In our first interview, Dr. Davies advised me to read Evelyn Fox Keller's biography of Barbara McClintock, *A Feeling for the Organism*.[10] All I knew about Barbara McClintock was that she'd discovered "transposons" in corn—the jumping genes I'd read about, and pounced on as a possible mechanism for my "Transferred Y" idea—and won a Nobel Prize. It took me a while to get hold of the book. When I finally read it, chills went down my spine. The parallels between the story of this dead woman scientist of genius and my "Anna" were startling.

Barbara McClintock was born in 1902, and got her Ph.D. from Cornell when she was twenty-five. There were no careers for women in scientific research in those days. She spent her life on the margins: amassing awards and honors, collecting fellowships that financed her research, never had a chance of being appointed to a post to match her reputation or her achievements. Her gender was "always there, always intruding."[11] Male colleagues knew she was brilliant, they were in awe of her "surpassingly beautiful investigations"[12] but considered her "difficult," if not slightly deranged, when she protested at being passed over for jobs. She became increasingly isolated after the advent of molecular biology, and her discovery of "transposition," announced in 1950, was dismissed as invention. Her results did not fit into the model of the gene as a fixed, unchanging unit of heredity. It would be more than twenty-five years before "transposons" were recognized in bacteria, and the connection with her work was made. She was awarded the Nobel Prize in 1983. The implications of her work are still expanding, still causing controversy. But perhaps—who knows—she'll be remembered as the woman who discovered a new model of life itself.

Most biographical summaries, articles you'll read on the Web, gloss over the "delay" in recognizing her discovery. Actually, you see, McClintock *was* difficult, and more than a little strange. It was no wonder people found her hard to understand. So was Richard Feynman a little strange, by all accounts. So is Albert Einstein hard to understand. Don't get me started on Isaac Newton. Didn't do *their* careers any harm.

"Keep a cobbler's job," Einstein once said. But isolation from the mainstream has its price, especially in lab science. All seeing is perception. By the time Barbara McClintock

announced her "transposition" discovery, her vision was so differently trained, so preternaturally expert in the field of one that she had created, that other scientists literally *could not* see what she was seeing. Even modern molecular biology is a "black art" (the organism fights back!). Samples behave differently in different culture mixes, visual acuity and deft hands make the difference between success and failure. Talented experimenters can produce perfectly genuine results that nobody can replicate. I'd walked into Dr. Davies's office with an idea for a story about a woman scientist. I hadn't intended for Anna to be a "genius." But maybe it's the discovery that makes the genius, and not the other way round: a compelling insight that gets hold of a trained mind, and will not let go, and forces that mind to grow, to become the equal of the thing it glimpsed. Anna had to be extraordinary in the end; and because of Barbara McClintock, and Lynn Margulis, too (and others, the roll call stretches back), the issue of fame had to become a part of my novel.

But Anna was no longer alone. She was part of the ongoing drama in her field: life science riven by passionate loyalties, cold-blooded feuds, vicious disputes. She was a samurai serving her lord, she became the handmaid of a visionary recluse; eventually she was a team leader in a furious, sleepless race to be first past the post, with the proof that everyone in the game was madly chasing—

Coda

At the end of January 1997, I had my last session in the BIOLS building. I sat in on a team meeting in Dr. Davies's office, keeping quiet, taking notes.

Business

JD hopes the building work won't be too disruptive. The radiation area will go, needs a new home at the back of the lab, must have a separate room, nice surfaces.

Martin says he needs to upgrade Word on the PowerMac. Can't defrag the hard drive anymore. Is anybody in charge of the computers?

Work

Trying to make antibodies to shaking B. There's a commercial firm in Belgium that will make them for us. Martin and Lucy have been designing peptides for the antiserum. When David Beckham (not the footballer) came, he was talking about a wonderful new way to couple antibodies. Keyhole limpet hemocyanin.

Unfortunately, he still hasn't sent us the references.

Tanya is still doing hybridization, been doing Southern blots, got v. high background and can't wash it off.

True Life Science Fiction

Do you have enough leech DNA to make another blot?
If you're doing some, give the carcass to Tanya.
It's impossible to grind up that elastic skin—

This is how it sounds, looks; this is how things are done that have never been done before. The shak-B gene, neurogenesis, gap junctions, CNS, wonder if I'll ever find out what happened. Wonder if *any* of these notes will turn up in my book, in any form? I was thinking about an expert system who was almost, arguably, a person (call the Turing police!), and a storming guardian angel who would always be pestering Anna to get radical. I was preparing to take away with me, folded down small, the slightly rank smell of the big, warm lab; the calm atmosphere in here; and a feeling for the vast complexity, the intricacy, and the individuality of the very small. Creatures of another world, speaking to us in their own language. How far away, how far—

I was supposed to go back for an internship, maybe in April, but I didn't. I don't know what happened; perhaps I was too busy. I was on the Committee for Amnesty International UK's Women's Action Network, I'd agreed to help set up a "feminist" Web site (short-lived!) for my local Internet provider. There was always something. I have a last note: not referenced or attached: "You're going to have great difficulty getting this published." True enough. It took years. In 2003, when the latest rewrite was wandering around the West Coast of the United States, passed from hand to hand, my friend Timmi Duchamp contacted me, and asked if she could publish it for her new venture, The Aqueduct Press. In 2004 *Life* won the Philip K. Dick Award. In 2006, I was invited to speak on a panel on women in science at a literary convention; had to field some entertaining questions. I don't actually *know* much about the secondary school science curriculum. I did my best.

I watch my son's friends. How unaffectedly physical the boys are with each other, how easily they relate to the girls; now the segregated years are over. But still the young girls dress up in spike heels and tight little skirts, and though maybe it's meant for dominance display (Spice Girl-style), I think of the Chinese proverb, *binding one's feet to prevent one's own progress.* More than likely there'll be another Women's Movement along soon. Right now there's a war on, that's the main story, and permanent warfare isn't good for women's rights. Or men's rights, really.

The story I told in *Life* is true. I wonder when it will be out of date.

Eppur si muove.

Acknowledgments

With grateful thanks to Dr. Jane Davies, Dr. Janet Collett, and the shak-B team, 1996/1997.

Notes

1. "SF" or "Sci-fi"? Insiders distinguish, passionately, between serious fiction, generally print fiction, which should be called "sf," and the mass-market and TV phenomenon, known as "Sci-fi." The "Sci-fi" label, indiscriminately applied by the general public, is always derogatory—as insiders fully recognize. Serious science fiction novels can be as challenging, complex, and substantial as anything in modern literature, but though I've used "sf" in this chapter, I'm afraid it's a losing battle.

2. The sf feminism of the 1970s and 1980s could trace its lineage in the United States, through crusading women writers and editors of previous decades, to the Utopian New Woman fictions of the early twentieth century (Charlotte Perkins Gilman, *Herland*). But knowledge of this geneaology came after the fact for most of us.

3. Jeanne Gomoll, in her "Open Letter to Joanna Russ," describes the situation and the swift reversion to the status quo that followed. It can be found on-line at http://www.geocities.com/athens/8720/letter.htm.

4. "Only one science fiction book in hundreds manages to convince the reader that it ever could have happened anywhere, and at least that few are worth reading at all. In *Walk to the End of the World*, Charnas has created a future that is at once believable and fascinating" (William S. Burroughs).

5. "Que les accidents de féerie scientifique et les mouvements de fraternité sociale soient chéris comme restitution progressive de la franchise première" Arthur Rimbaud, *Illuminations*.

6. Joanna Russ, "When It Changed," in Harlan Ellison, ed., *Again, Dangerous Visions* (Garden City, N.Y.: Doubleday, 1972), subsequently much anthologized. Text is on-line at http://www.scifi.com/scifiction/classics/classics_archive/russ/russ1.html

7. I've written about this experience. See: http://homepage.ntlworld.com/gwynethann/OSLO.htm.

8. R. V. Short and E. Balaban, eds., *The Differences Between the Sexes* (Cambridge: Cambridge University Press, 1994), is reviewed at http://tracearchive.ntu.ac.uk/frame/freebase/free2/gjones.html.

9. Ray Bradbury, "Dark They Were, and Golden-Eyed," *Thrilling Wonder Stories* (August 1949). A classic sf story on the mystery of cultural evolution.

10. Evelyn Fox Keller, *A Feeling for the Organism* (New York: Henry Holt, 1983), p. 1. Reprinted, San Francisco: W. H. Freeman, 1984.

11. Ibid., p. 76.

12. Ibid., p. xviii.

Expertise and Amateur Science

"Expertise and Amateur Science" examines different configurations in the co-production of knowledge by expert and amateur scientists. The following chapters draw on models from cultural studies, activism, anthropology, and new media art.

Cultural theorist Eugene Thacker opens with a brief historical overview of the notion of the commons and its contemporary manifestations in digital media, such as the creative commons' licensing system, as well as the push for a "biological commons" in the life sciences. Thacker unravels unexpected traveling lives of metaphors, contradicting the regimented, separate-sphere histories of the natural, the social, and the technical. What is the relationship of social resistance to microbial resistance? How do they both inscribe power relationships? How do policy initiatives such as the "drug war" mobilize the calculus of "life itself"? Thacker argues that what is at stake is the social, cultural, political, and biological "life" of the commons.

Activist Mark Harrington's chapter looks back on a classic story of a social movement around the scientific and political conditions of life and death. Harrington was at the forefront of activism that shaped the public discourse about the construction of scientific language, medical facts, and public health policy procedures. In this first-person account of his involvement in ACT-UP and the Treatment Action Group, he recounts the fierce fight for treatment solutions, drug trials, and political change as it was enacted by AIDS activists in the late 1980s. Scientific self-education was one of the crucial tools that provided AIDS activists with the means to exert pressure on the FDA, the NIH, and the drug industry, which ultimately led to accelerated drug approval and development for the treatment of HIV/AIDS.

Anthropologist Gabriella Coleman's article on the psychiatric survivor or "mad liberation" movement is another example of patient-organized self-determination. The biomedicalization of mental health and its related treatment procedures have historically resulted

in forced treatments such as electroshock therapy and nonconsensual drug intake. Coleman traces the political strategies employed by a group of people deemed to be politically impotent and irrational. She is particularly interested in the ways these activists maintained "a strong, unconditional, and institutionally independent critique of pharmaceutical science and psychiatric abuse," in the face of shifting political contexts such as the "transition from the radical political landscape of the 1960s and 1970s to that of neoliberal materialism in the 1980s."

Artist Beatriz da Costa's article examines the role and position of interdisciplinary artists engaged in technoscientific discourses. She traces the emergence of artists' involvement in the technosciences and their shifting responsibilities regarding the shaping of public political discourse and action. da Costa is particularly interested in the place political artists may want to occupy when situated between the academy and a nonacademic public. "How can the artist function as an activist intellectual situated between the academy and the 'general public' in an age where global capital and political interests have obtained an ever-increasing grip on the educational and public environments where technical, scientific, and artistic knowledge production occur?"

Uncommon Life

Eugene Thacker

The Consistency of the Commons

In its traditional sense, the commons is a concept that responds to the problem of "the government of the living," of how best to articulate the relations between the elemental (rock, soil, rivers, lakes), plant and animal life (crops, herds), and human productive labor. It is thus a concept that folds into itself territory and earth, the crop and the plant, the herd and the animal. As a form of governing, the commons involves the circulation of life-forms centered around human living labor. It is at once open to all and governed by a set of rights, or at least constraints, concerning access and use (the right to pasture, the right to work the soil, the right to fish). Even before the language of "enclosure" dichotomizes the commons (open versus closed, public versus private, etc.), the tension between freedom and constraint already occupies the concept.

By the time Garrett Hardin published his often-referenced essay "The Tragedy of the Commons"—a notion of tragedy that is not moral, though still very Greek—there was also a parallel debate emerging around so-called postindustrial or post-Fordist economies based on information. The issue of the openness of such information would raise issues similar to those of population growth and the use of natural resources. In the field of digital media, there has been a push for a "digital commons," or its more nuanced variant, the Creative Commons licensing system. In the biological domain, the controversies surrounding the patenting of genetic materials have moved some to promote the idea of a "genetic commons" or, more broadly, of a "biological commons."

Such variants implicitly point back to something shared, or something in common, in each idea of the commons—the commonality of the commons, as it were. This is the notion that a system can sustain itself through a consistent, distributive flow. These two requirements—that everything flow, and that homeostasis be maintained—form the

physics of the common (or should we say metaphysics?). Thus *flow* and *stasis* mutually imply each other in the idea of the commons. Thus, what is at issue is, of course, the production, distribution, and consumption of resources. And issues like these make the commons more than merely a problem about the use of inorganic matter. What is at issue is not just the availability of raw materials, but also and more crucially, the sustainability of the circulation of those materials, the way that they literally feed into and nourish the commons itself—in other words, what is at stake is the "life" of the commons.

What is the life of the commons? To what degree is the commons living? Certainly the notions of a genetic or biological commons imply "life" in a very limited and specific sense: biological, organismic, or genetically based life, the life of species. But the ideas surrounding the digital commons also imply a life of the commons, except here "life" is social, cultural, and political life, a qualified life directly linked to the post-Fordist practices of communicative, symbolic, and affective labor.

The idea of a commons implies not only something shared, but also something that is always present or available in the same way. This field is a commons, one says, because it is open and available for all in the community to use (and here one has to read the fine print, for "community" and "use" are not unproblematic terms). This being available for all has the connotation of being same at different times, at different places, for different people or uses. More than an actual raw material, the commons points to something like a site, the very conditions of possibility for production, labor, sharing, and so on. And it is this condition of possibility that repeats itself in the same way.

But is not the actual material important, even integral, to the commons? Is the actual site of the field, the actual files of information, the actual molecules of the plant or organism simply an afterthought to the act of sharing or distributing? Every commons has its limits; indeed, the commons is in many ways the articulation of limits within a political-economic framework. There is no free and open space of possibility, only a rigorous crafting of the boundaries of a sustainable system.

The commons is an absolutely ancient, and totally medieval, concept. That something is "common" implies that it is at once a single, unified thing (a field, a database, a cell) and also a plurality (a field of crops, a database of files, a renewable cell line). The old problem of the one and the many—exhaustively rehearsed in Plato's *Parmenides*—haunts the idea of the commons. One thing is many things (to many people), and yet this one-many exists by virtue of its being limited, constrained. This dichotomy of the one-many is in turn inflected through a concern that the commons exists as common—that is, as something immanent to an entire field of existence, activity, and labor. The problem of the divinity and the problem of the common share this concern, a concern formalized in the medieval philosophies of Anselm and John Scotus Eriugena: How to be distinct, to exist with a degree of consistency, while at the same time being distinct everywhere, being consistently here-and-there?

Perhaps the most crucial issue raised in this regard is that of origin and generation—or, we might do better to say, of production and productivity. From where does the common emerge? Does the common have its authority from without or from within? If the common is totally immanent to itself, if it derives itself only from itself, does this not still necessitate something outside the common, something that might in fact guarantee the ongoing consistency of the common-as-common? For this reason the problem of the authority is often treated as a problem of transcendence—and thus a problem of sovereignty—whereas the problem of the common raises the problem of immanence—and thus a problem of community.

Life-resistance

From the view of political theory, any thesis concerning sovereign power immediately raises the question of a counterpower—insurgencies, civil strife, dissent, revolt, and resistance. Power, as Foucault has famously stated, always implies resistance. In a 1982 interview, Foucault pushed this thinking farther, suggesting that resistance in fact precedes power:

You see, if there was no resistance, there would be no power relations. Because it would simply be a matter of obedience. You have to use power relations to refer to the situation where you're not doing what you want. So resistance comes first, and resistance remains superior to the forces of the process; power relations are obliged to change with the resistance. So I think that resistance is the main word, the key word, in this dynamic.[1]

Though Foucault's particular context in this interview deals with the gay rights movement, and though it is hard not to read his comments in relation to his late work on the "technologies of the self," what we can glean from this idea—that resistance is prior to power—is that resistance requires its articulation in terms of multiplicities. Foucault is careful to note that there is not simply a free-floating, liberated resistance that exists outside of power, but at the same time he does want at least to hint at the primary challenge of all forms of power: the problem of multiplicities, the challenge of articulating an object of power that, in the right conditions, is able to show itself forth in all its complexity—and, for this reason, to exist as the field of circulation, interventions, and preventions (and preemptions) that is the domain of the apparatus of security.

Resistance, of course, is not only a political concept; it is also a biological concept, widely used in microbiology, virology, and epidemiology. One example is the phenomenon known as antimicrobial resistance. Antimicrobial resistance—also called drug resistance—is the phenomenon in which an excessively widespread or overprescribed use of antibiotics triggers genetic mutations in the bacteria that are targeted by the antibiotics. These mutations enable the bacteria to resist the effects of the antibiotics, in effect

granting them an immunity to the technology of antibiotic action. While a certain but limited degree of antimicrobial resistance has always been a by-product of antibiotic use, it has been only recently that a significant increase in antimicrobial resistance has been identified by public health agencies worldwide. A number of factors contribute to this increase: the presence of emerging infectious diseases, many of which take advantage of global transportation and shipping, the overprescription of antibiotics in human medicine, and the extensive use of antibiotics in agriculture and livestock farming (most notably with mad cow disease). What is, from a biological perspective, most noteworthy about such resistance is that it arises less from generations of gradual evolution and more from horizontal transmission of genetic information between microbes.

In 1999 the U.S. Centers for Disease Control and Prevention (CDC), the Food and Drug Administration (FDA), and the National Institutes of Health (NIH) combined to form the interagency Task Force on Antimicrobial Resistance. One of their reports, "Public Health Action Plan to Combat Antimicrobial Resistance" (abbreviated as the "Action Plan"), proposes increased regulation and control in four main areas: surveillance (the development of systems for monitoring and diagnosing potential antimicrobial resistance trends), prevention (the promotion of "appropriate drug use policies" that limit overuse), research (increased research into the mechanisms of resistance), and product development (new treatments). Initiatives such as this have been echoed on the international level by the World Health Organization (WHO), especially concerning the global character of many emerging infectious diseases.

The problem of antimicrobial resistance is both a very real public health issue and an articulation of microbial "life itself" within the context of threat, security, and preparedness. It is, as Melinda Cooper notes, a set of techniques through which public health agencies are positioning modes of intervention vis-à-vis a concept of "the emergent"—a mode of preempting emergence. As Cooper notes, the late twentieth century saw both the height of genetic engineering developments and the emergence of a new type of epidemic disease:

Pathogenic micro-organisms were proliferating from within and without; friends were turning against us; the immunological self as mis-recognizing itself (the auto-immune disease); our most promising cures (antibiotics) were provoking counterresistances at an alarming rate; the apparent triumph of bio-medicine was generating its own blowback effects (due, for example, to the overuse of antibiotics in the "developed" world and their under-use in the "developing" world).[2]

The long-standing tradition in the history of medicine in which disease is metaphorized as war here takes on a new form in light of the new microbiology of bacterial evolution (e.g., Lynn Margulis's serial endosymbiosis theory), which connects microbes to humans to the environment. In such a connected or networked milieu, public health threats and attacks take on a new, ontological form:

The new public health discourse calls our attention to emerging and re-emerging infectious disease. . . . It defines infectious disease as emerging and emergent—not incidentally, but in essence. What public health policy needs to mobilize against, the new microbiology argues, is no longer the singular disease with its specific etiology, but emergence itself, whatever form it takes, whenever and wherever it happens to actualize.[3]

Here we have the resurfacing of the "problem of multiplicities" that Foucault had identified as one of the main principles of the apparatus of security. Recall that Foucault's primary case studies in his Collège de France lectures have to do with public health: epidemics and controls, food shortages and famine, urban hygiene and political economy. The problem of multiplicities is precisely that biological life itself, microbial life, is understood to be essentially emergent.

What is noteworthy about the "Action Plan" from a public health perspective is that it is caught in a double bind: it identifies a problem, which has to do with the overuse of drugs, but it can pose as a solution only the very thing that is the problem (development of new drugs). Under the section concerning product development, the authors state: "As antimicrobial drugs lose their effectiveness, new products must be developed to prevent, rapidly diagnose, and treat infections."[4] Such initiatives involve working with the pharmaceutical and biotech industries to "ensure that researchers and drug manufacturers are informed of current and projected gaps in the arsenal of antimicrobial drugs, vaccines, and diagnostics and of potential markets for these products."[5]

What results from this picture is a new kind of "drug war," one that is not about the illegalities of narcotics, but rather about the cycles of capital and product development in the pharmaceutical industry (in which the limitations of patents, the production of generics, and the development of new drugs all play a part). In this bizarre microbial drug war, the overuse of drugs inadvertently spurs on antimicrobial resistance to the drugs, which then necessitates the production of new drugs as a sort of counterinsurgency to the antimicrobial resistance, and so on. Inasmuch as the drugs and treatments themselves are the products of microbiology and biotechnology, what we have is a sort of low-level microbial drug war, a new type of biological warfare carried out at the microlevel of transfection and resistance, as well as at the macrolevel of global health concerns.

Resistance-in-theory, resistance-in-biology. Both involve multiplicities that are, in many cases, frustratingly unhuman. And they spread, they propagate, they fan outward. There is a great deal of ambiguity here: life is, on the one hand, what resists. For Foucault, resistance is not secondary to power, and for Deleuze, life is in fact this nonreactionary resistance: "When power . . . takes life as its aim or object, then resistance to power already puts itself on the side of life, and turns life against power."[6] But life is never a simple affair, and its very articulation implies a politics, even if to demarcate "bare

life" from the qualified life. In the age of biotechnology and biomedia, life is also increasingly fashioned and refashioned along several lines, as evolutionary or species life, as a molecular and informatic code, as a set of pathways or systems, even as a set of nanoscale machines.

These forms of life are indelibly tied to the biotech and health care industries, informing everything from new diagnostic devices, to genetic patents, to the circulation of personal health data. There are, then, at least two meanings of "life-resistance": life is what resists, and life is also what is resisted. When the former is the same as the latter, then the politics of life itself enters a zone that is neither simply social nor biological, but an anonymous zone that intensifies politics at the levels above and below that of the individual human subject. The public health and biodefense concerns over emerging pandemics is just one example of this kind of microbial politics.

A New Drug War

In this sense, the rhetoric of war, often deployed in both specialist and popular descriptions of immunity and biomedicine, takes on a new meaning. The war metaphors in medicine are not so much about fighting invading microbes as about fighting the very concept of the emergent in the biological and microbial domains. The disease-as-war metaphor is really a defense against the emergent.

What results is a kind of "microbial security" that operates at several levels. It operates at the level of medical surveillance, where specialized antimicrobial resistance surveillance systems are connected to broader syndromic surveillance initiatives. This kind of security operates at the level of a whole new class of biomedical threats to the population and to public health. The microbial threat expresses the "fear of a bacterial planet" (to quote Margulis and Sagan), or the overdetermination of the role of human life in relation to the biosphere as a whole. The microbial threat is a threat because it is an example of what Deleuze and Guattari call a machinic phylum—a class of nonbiological life that cuts across categories and classifications, that creates transversals that stitch together humans, animals, microbes, technologies, economies, laws, governments, and so on. Species, ecosystems, DNA, and global capital are all part of this machinic phylum that is configured as a microbial threat.

The microbial threat leads to the development of a drug, but a new kind of drug war that is uncannily nonhuman, a very unhuman conflict that takes place above and below the level of the anthropomorphic subject, a mode of exchange that is not just biological but also abstract, an unhuman, "abstract sex": "The distance between the macro and the micro no longer applies to this world of molecular sexes where evolution implies the modifications of content and expression of information . . . through contagion rather than filiation."[7] This unhuman conflict proceeds through several phases that, of course, involve human institutions, economies, and medical practices:

- There is no beginning, really, only a process of identification. A new threat is identified—a microbial threat—that is not so much a public health threat as it is a threat of the life as emergent. Here we see a shift from the identification of discrete public health threats (global pandemic) to the identification of abstract processes that define a new class of threats (emergence or emergent diseases).
- This microbial threat then necessitates the agglomeration of technologies for defending against the threat, resulting in the formation of pharmaceutical stockpiles, syndromic surveillance, and preventive medical practices. In the case of pharmaceutical stockpiling, we see the Cold War mentality of stockpiling weapons which are paradoxical weapons that either combat by curing or that cure by combating.
- However, the overuse of such technologies or weapons instigates the horizontal gene transfer that results in antimicrobial resistance. This is not totally determined by the mere use of pharmaceuticals, for technology does not cause or determine microbial resistance, though it does play a part in canalizing resistance, especially in cases of the overuse of antibiotics.
- The triggering of antimicrobial resistance in turn necessitates the development of newer drugs to overcome the resistance (which implies new investments in R&D, new patents, clinical trials, and so forth). The U.S. TFAR (Task Force on Antimicrobial Resistance) and the WHO are, as of this writing, at a loss as to what the correct response is to this threat, since the standard response (development of new drugs) is precisely the problem.

In the same way that microbes exist in cycles of resistance to drugs, so do the drugs exist in cycles of obsolescence. In a sense, antimicrobial resistance is the schizoid dream of the biotech industry, a cycle of microbial capital that is constantly renewing itself both as threat and as the necessity of response or intervention. The problem of antimicrobial resistance is by definition indeterminate—or, rather, it is determined by the fluxes and flows of the biocapital and the pharmaceutical industry (itself tied to the dominant medical paradigm of drug therapy as a form of medical healing).

Beneath the level of the human world, there is a microbial war taking place between antimicrobial resistance and genetically engineered pharmaceuticals. Capital and microbes are intertwined, with the latter acting as emergent and the former acting as a control, together obtaining a bizarre kind of homeostasis between them. The result is a tension between control and emergence, the latter defined as the (ideal) absence of the former, and the former defined as the ability to regulate the latter.

Antimicrobial resistance is indissociable from the concept of the emergent in relation to microbial life. Not only are naturally occurring global diseases emergent (emerging infectious disease), but the ability to resist medical interventions is also emergent. The concept of emergence in both cases points to the ability of microbial life to develop in complex and unpredictable ways in a multifactorial context.

With antimicrobial resistance, the key factor is that microbes do not develop drug resistance through vertical evolutionary mutation (chance mutations over generations), but horizontally between coexisting microbes. Increasingly, biologists are entertaining the idea that such horiztonality is in fact the rule and not the exception. What biology has traditionally called evolution may in fact be a proliferation of genetic difference across species borders. Instead of the war of selection and division driving biological existence, there is a germinality and propagation, from which *relations* between organisms, between organic and inorganic matter, and between the living and the nonliving take place: "Symbiogenesis brings together unlike individuals to make large, more complex entities. . . . We abide in a symbiotic world."[8]

As Margulis notes, this horizontal gene transfer is of several types: transduction, or the viral infection of bacteria, in which the virus is the mediator of genetic information between bacteria; transformation, in which bacteria directly take up free-floating DNA from the environment (often DNA that has come from a recently lysed or dead cell); and conjugation, the exchange of genetic information between bacteria, mediated by a plasmid, or small, circular strand of DNA. All of these processes have to do not with *infection* but rather with *transfection*, the ability of microbes to exchange, share, and distribute genetic information through a microbial network. This new microbiology suggests that evolution happens horizontally. In this sense *resistance is contagious.*

The lesson from the example of antimicrobial resistance is that at the molecular level, resistance is consonant with emergence. Resistance is precisely this creation of new forms and new relations. Resistance is emergent because it is a form of generative life, life not defined by any sort of quasi-theological essence, nor by any reductive master molecule, but a life defined by its capacity for process and change. This says nothing about any moral definition of resistance—we should not romanticize microbes as miniature revolutionaries—but it does raise political issues that are both complex and, in some cases, without apparent resolution for the benefit of human life.

The Mobilization of Life

In speaking of the "apparatus of security" surrounding eighteenth-century public health practices, Foucault notes that one of the primary concerns of the emerging biopolitical viewpoint was how to control the "problem of multiplicities"—a view of the management of life that points to the naturalness of the population. For Foucault, this problem of multiplicities is also a problem of life. But the problem is not simply defining life's essence, nor is it the command over the cessation of life that defines, for Foucault, juridical sovereignty. Rather, the apparatus of security approaches the problem of life-as-multiplicity, and its central concern is that of circulations: "Circulations understood in the most general sense as displacement, as exchange, as contact, as a form of dispersion, and also as a form of distribution—the problem is: how is it that something circulates or does not circulate?"[9]

However, the shift that demarcates the apparatus of security from other forms of power, such as juridical sovereignty or disciplinary mechanisms, is that security has as its aim the facilitation and regulation of multiplicities, whereas the other forms aim to limit, canalize, and restrict multiplicities (sovereignty, by the delimitation of its rule within a territory; discipline, by carving up the multiplicity into individual subject bodies). If juridical sovereignty instantiates legal codes (the permitted and the forbidden), and if disciplinary mechanisms prescribe practices (training, docility, norm), then the apparatus of security simply "lets things be" (laissez-faire). Its aim is not to limit, but rather to facilitate, emergence. The apparatus of security involves the regulation of a context in which "it is not a matter of fixing limits, frontiers, in which it is not a matter of determining locations, but above all of essentially permitting, of guaranteeing, of assuring circulations: circulations of people, circulation of merchandise, circulation of air, etc."[10] The apparatus of security approaches the problem of multiplicity (which is the problem of "life itself") as the management of flows and circulations:

Now, it seems to me that what one sees appearing through the evidently very partial phenomena that I've tried to outline, is another problem altogether: no longer the fixing and marking of the territory, but the letting be of circulations, the controlling of circulations, the sorting of the beneficial and the harmful, arranging things so that this always moves, so that this is displaced continually, so that this perpetually goes from one point to another, but in a manner such that the inherent dangers to this circulation are annulled.[11]

But this apparent laxity of security is not arbitrary; rather, it is actually the development of a set of techniques (statistics, demographics, political economy, public health) that create the conditions in which the multiplicity of life can bear itself forth, the condition in which life—as multiplicity—will "naturally" emerge. This controlled environment provides the conditions for what will become the legitimized modes of intervention and prevention (which Foucault historically locates in the eighteenth century, with the first inoculation campaigns).

The challenge of sovereignty is how to establish the decision in relation to self-organization, unanimity in relation to complexity, and exception in relation to emergence. The only way to secure human interests is to intervene via ways that are, in effect, nonhuman ways, modes of intervention which by definition question the centrality of human interests. The challenge of sovereignty today is not that it articulates a gray zone or zone of indistinction between sovereign and "bare life," but that it finds *it can concern itself with the human only within a nonhuman context.*

What Foucault identifies as the apparatus of security "lets things be"; it creates the condition in which the sovereign exception is placed not in opposition to or outside of the multiplicity (or emergence) of life, but rather as something that exists internal to it, as a constitutive part of its logic. Exception does not oppose emergence, as if in a top-

down fashion; rather, this biological sovereignty creates the conditions in which exception is internal to emergence—in which it is even necessarily and naturally part of the logic of life itself as multiplicity, as emergence. In a metaphorical sense, the conflict being carried out, the war being fought, is not a conventional one between opposing enemies; rather, it is always an internal conflict, a conflict not between opposing parties but between intersecting processes: multiplicity and control, circulations and regulations, emergence and exception.

It is in this sense that we can perhaps speak—somewhat ambivalently—not just about a political resistance, and not just about antimicrobial resistance, but instead about "life-resistance," a twofold concept that indicates both that life is what resists, and that life is what is resisted. Life is what resists, at the most literal level of microbial transfection, but life is also what resists at the level of engineered responses to this other life, a biological war of life against life, most often in the form of antibiotics, vaccines, or novel genetic treatments. Life is also what is resisted, in that microbial transfection circumvents the workings of molecular antibodies, of the organismic immune system, and of the biospheric regulation of interconnected ecologies. But life is what is resisted in another fashion, in that this twofold character of life-resistance is at once biological and political, at once about sovereignty and about biological "life itself," at once the problem of multiplicities and the control of circulations.

The Calculation of Life

Since 9/11 there have been a number of efforts to develop disease alert-and-response systems that would make use of information networks. The U.S. CDC had begun a number of such projects in the 1990s, with acronyms such as LRN (Laboratory Response Network) and NEDSS (National Electronic Disease Surveillance System). The impetus behind such programs was the alarming number of new and emerging infectious diseases being tracked nationwide by the CDC, and internationally by the WHO. In addition, the 1980s and 1990s saw a number of instances of biological sabotage (often by religious cults), both within the United States and in other countries, such as Japan. Such events, combined with evidence suggesting a Soviet offensive bioweapons program in 1979, collectively made biodefense an increasing concern of both public health and national security within the United States.[12] It became evident that an information network like the Internet could be a crucial tool in enabling health officials to foresee potential outbreaks before they have a widespread effect on a population.

This idea—the use of information networks to monitor, prevent, and counteract epidemics—is called "biosurveillance" by the U.S. government. The systems that are used are variously referred to as "syndromic surveillance systems" or "disease surveillance networks." For the sake of brevity, and following the penchant for acronyms in government agencies, we can broadly refer to them all as disease surveillance networks or simply DSN.

In the wake of 9/11, the U.S. Department of Homeland Security and Department of Health and Human Services have been especially active in promoting the need for a sophisticated, nationwide DSN. Since the late 1990s, prototype DSNs have been activated in multiple cities nationwide.[13]

In early 2003, the Homeland Security BioWatch program was tested in a number of American cities, with the cooperation of state and local governments.[14] The BioWatch system routinely took air samples to test for the presence of biological agents, and was connected to a network, through which it sent the data to be processed. This program became the forerunner of the U.S. Biosurveillance Program, which received a record-setting $274 million for the development of DSNs alone. The program aims to "enhance on-going surveillance programs in areas such as human health, hospital preparedness, state and local preparedness, vaccine research and procurement, animal health, food and agriculture safety, and environmental monitoring, and integrate those efforts into one comprehensive system."[15] Proposals and projects surrounding DSNs are, as of this writing, growing at an exponential rate, and include projects both in the private sector and in government-funded, university-based research.

The overarching aim of such systems is not just monitoring, but an integrated system of monitoring and selectively intervening, or regulating and perturbing. The effect, however, is that of a real-time battle between networks: one, a biological network operating through infection, but abetted by the modern technologies of transportation; the other, an information network operating through communication, and facilitated by the rapid exchange of medical data between institutions. This is a situation of what we can call *networks fighting networks*, in which one type of network is positioned against another, and the opposing topologies are made to confront each other's respective strengths, robustness, and flexibilities. In their analyses of new modes of social organization and conflict, John Arquilla and David Ronfeldt have pointed to the importance of the network paradigm. What they call "netwar" reflects the contemporary integration of information technologies and network-based modes of political action, culminating in a Janus-faced dichotomy between pro-democracy activism on the one hand, and international terrorism on the other:

Governments that want to defend against netwar may have to adopt organizational designs and strategies like those of their adversaries. This does not mean mirroring the adversary, but rather learning to draw on the same design principles that he has already learned about the rise of network forms in the information age.[16]

The take-home message is that network forms of organization are highly resistant to top-down, centralized attempts to control and restrain them. Instead, Arquilla and Ronfeldt suggest that "it may take networks to fight networks."[17] In this case, biosurveillance and DSNs can be seen as initial attempts by governments to reframe public health within the context of information technologies and national security.

However, there are a number of significant differences between what Arquilla and Ronfeldt call netwar and the example of biosurveillance and DSNs. The majority of case studies that are considered under the rubric of netwar—case studies which range from the Zapatista resistance, to the anti-WTO protests in Seattle and Geneva, to al-Qaeda—imply human action and decision-making as a core part of the networks' organization. In fact, one limit of the netwar approach is that it does not push the analysis far enough, to consider the uncanny, unhuman characteristics of such networks. In a sense, the interest in the study of network forms of organization is exactly in their decentralized, or even distributed, mode of existing—and for this reason research in biological self-organization often provides a reference point for netwar analysis (e.g., in studies of crowd behavior, flocking, or swarming).

Yet, as many studies make clear, the result of netwar analysis is, ultimately, to gain a better instrumental knowledge of the how and why of network forms of organization (that many netwar studies have come out of the RAND think tank environment is indicative in this regard). In other words, approaches to studying networks seem to be caught between the views of *control* and *emergence* with respect to networks as dynamic, living entities.[18] On the one hand, networks are intrinsically of interest because the basic principles of their functioning (e.g., local actions, global patterns) reveal a mode of living organization that is not, and cannot be, dependent on a top-down, centralized mind-set. Yet, for all the idealistic, neoliberal visions of "open networks" or "webs without spiders," there is always an instrumental interest that underlies the study of networks, to better build them, to make them more secure, or to deploy them in confronting other network adversaries or threats. At the same time that there is an interest in better controlling and managing networks, there is also an interest in their uncontrollable and unmanageable character.

Health officials warned in late 2003 that the SARS virus may very well make occasional reappearances during the cold and flu season, implying that new and emerging infectious diseases are less one-time events, and more of an ongoing *milieu*. By definition, if a network topology is decentralized or distributed, it is highly unlikely that the network can be totally shut down or quarantined: there will always be a tangential link, a stray node (a line of flight?) that will ensure the minimal possibility of the network's survival. This logic was, during the Cold War, built into the design of the ARPAnet, and if we accept the findings of network science, it is also built into the dynamics of epidemics as well. Though the ideas of totally distributed networks and open networks have become slogans for the peer-to-peer and open-source cultures, the hybrid quality of DSNs and biosurveillance (at once material and immaterial, contagion and transmission) reveal the frustratingly oppressive aspects of decentralization. Furthermore, the network organization of epidemics is, as we've noted, much more than a matter of biological infection; epidemic networks of infection are densely layered with networks of transportation, communication, political negotiation, and the economics of health care.

In DSNs, the tension between control and emergence points to the "nonhuman" character of networks. DSNs are nonhuman networks, *not* because the human element is removed from them and replaced by computers, but precisely because human action and decision-making form constituent parts of the network. This point is worth pausing on. Despite the technophilic quality of many biosurveillance projects, their most interesting network properties come not from the automated detection systems, but from the ways in which a multiplicity of human agencies produces an intentional yet indeterminate aggregate effect. While much time and money is spent on computer systems to model and forecast epidemic spread, such systems are always best guesses. The same is implied in the human involvement—autonomous and conscious—in the epidemics that biosurveillance aims to prevent. As we've noted, the layered quality of networks (infection, transportation, communication) give each particular epidemic incident a singularity that frustrates any sort of reductive, quantitative modeling. In short, for biosurveillance the challenge for the network management of an epidemic is how to articulate control *within* emergence. The nearly paradoxical question posed by biosurveillance with regard to epidemics is this: *Is it possible to construct a network for articulating intention within indeterminacy?*

Notes

1. Michel Foucault, "Sex, Power, and the Politics of Identity," in Paul Rabinow, ed., *Ethics: Subjectivity and Truth* (New York: New Press, 1997), p. 167.

2. Melinda Cooper, "Pre-empting Emergence: The Biological Turn in the War on Terror." *Theory, Culture & Society* 7. 23 (2006): 113–135.

3. Ibid., p. 5.

4. "Action Plan," Executive Summary, http://www.fda.gov/oc/antimicrobial/taskforce2000.html.

5. Ibid.

6. Gilles Deleuze, *Foucault*, ed. and trans. Séan Hand (Minneapolis: University of Minnesota Press, 1988), p. 92.

7. Luciana Parisi, *Abstract Sex* (London: Continuum, 2004), p. 174.

8. Lynn Margulis, *Symbiotic Planet* (New York: Basic Books, 1998), p. 9.

9. Michel Foucault, *Sécurité, Territoire, Population* (Paris: Gallimard/Seuil 2004), p. 67.

10. Ibid., p. 31.

11. Ibid., p. 67.

12. Two events in particular have given the need for such programs greater urgency. One is the 2001 anthrax attacks that occurred within the United States: several letters containing a weaponized strain of anthrax in powder form were sent through the postal system to media and government offices in New York and Washington, D.C. Though the anthrax in the letters did not cause a

nationwide or statewide epidemic, it did cause what one journalist called "mass disruption," triggering a state of public alarm through the elaborate media coverage given to the events. Undoubtedly the anthrax attacks were but one important factor behind the 2002 Bioterrorism Act, which, among other things, restricted the access to and research on approximately fifty "select biological agents"—even within legitimate, university-based biology labs receiving government funding.

The other event which has made the need for alert and response systems more urgent was the 2003 SARS epidemic. While SARS barely deserves the title of "epidemic" in comparison to AIDS and tuberculosis worldwide, the condensed time span in which it spread from China to Canada made it a perfect case study for next-generation alert and response systems. In fact, it was in part thanks to the WHO's Global Outbreak Alert and Response Network that the spread of SARS was limited to the cities through which it traveled. Coordinating among hospitals and clinics in infected areas in Beijing, Singapore, Toronto, Hong Kong, and elsewhere, and making use of a central server to upload and download patient data, the WHO was able to issue travel advisories and suggest countermeasures to the spread of SARS. In a sense, the WHO's network provided a proof-of-concept that information networks could be effectively used in countering epidemic outbreaks.

13. See the 2000 CDC report "Preventing Emerging Infectious Diseases: A Strategy for the 21st Century": http://www.cdc.gov/ncidod/emergplan (article retired).

14. For an example, see Mark Hoffman et al., "Multijurisdictional Approach to Biosurveillance, Kansas City," *Emerging Infectious Disease* 9, no. 10 (October 2003): 1281–1286.

15. U.S. Department of Homeland Security, 2004.

16. John Arquilla and David Ronfeldt, eds. *Networks and Netwars: The Future of Terror, Crime, and Militancy* (Santa Monica, Calif.: RAND, 2001), p. 15.

17. Ibid., p. 327.

18. The challenges put forth in this tension between control and emergence are not just technical problems, but are challenges that raise ontological as well as political questions. From the network perspective, case studies like the 2003 SARS epidemic look very much like a centralized information network counteracting a decentralized biological network. The WHO's outbreak response network coordinated the exchange of data through network servers and conference calls, and health advisories could then radiate from this central node. By contrast, the SARS infection was maximized by moving through the highly connected nodes of airports and hotels. The strategy of DSNs, then, is to canalize transmission in order to fight the decentralization of contagion. If an epidemic is "successful" at its goals of replication and spread, then it gradually becomes a distributed network, in which any node of the network may infect any other node. Thus, the most "successful" epidemic is one that is *virtual* with respect to any *actual* node on the network.

AIDS Activists and People with AIDS

A Movement to Revolutionize Research and for Universal Access to Treatment

Mark Harrington

The HIV/AIDS pandemic provoked a worldwide movement of citizen activists, many living with HIV, who mobilized the skills and learned the scientific and regulatory jargon necessary to carry out a series of targeted campaigns. Through civil disobedience, direct action demonstrations, and dramatic confrontations with leading scientists, government officials, politicians, drug company executives, and the media, AIDS activists transformed the U.S. and global responses to the AIDS epidemic. They demanded rights and legal protections for people living with HIV/AIDS; secured programs to support people with HIV in their medical, supportive care, housing, and support needs; and demanded and achieved radical changes in the way AIDS drugs were developed, approved, and distributed. Activists used a double-pronged "inside/outside" strategy, in which the same activists who challenged the "experts" at science, policy, and drug company meetings, and also led dramatic break-ins, surrounded the headquarters of the U.S. Food and Drug Administration (FDA), the National Institutes of Health (NIH), and drug company headquarters to demand changes in drug regulation, clinical trials, expanded access, accelerated approval, and lower drug prices.

In these campaigns people with AIDS (PWAs) deployed an expertise based on real-world lived experience with the disease against that of the formal professional networks and institutions which were resisting changes. Intellectual and cultural exchanges took place—the activists learned more about science; the scientists learned the human cost of their rigid methods and were able to develop new flexible, but still rigorous, approaches to clinical trials which met both the needs of PWAs and the need for scientifically interpretable information. This work led to a series of key changes by the FDA, NIH, and the drug industry, which in turn led to much more rapid approval of many new drugs for HIV/AIDS. By 1996, with the introduction of triple-combination, highly active antiretroviral therapy and its rapid dissemination throughout the United States and other

developed countries, the death rate from AIDS dropped by 67 percent. Now, activists worldwide are seeking similar changes in research and access. A global movement is demanding universal access to a comprehensive package of HIV/AIDS prevention, care, and support by 2010.

This chapter will review the changing and contested notions of expertise wielded by the activists and the PWAs with that of the scientific experts and government officials. From this cultural clash emerged a new way of doing business for AIDS drug development, leading to a revolution in therapy which is now becoming increasingly accessible to people in developing countries, where 2.5 million HIV-infected persons are now receiving antiretroviral therapy in the world's biggest, fastest, and most ambitious global health emergency campaign ever.

An essential part of the early energy deployed and released in AIDS treatment activism was a powerful, revolutionary, and at first almost utopian strain of activist belief that with enough effort, activists could mobilize sufficient political and scientific support to accelerate the development of a cure for AIDS. Then, it was hoped, most activists could resume their "civilian" lives in an AIDS-free world. The hoped-for cure remains a distant chimera, but since the 1980s, people with HIV/AIDS and treatment activists have become powerful players in the AIDS research, treatment, and policy arenas globally.

"All Power Is the Willingness to Accept Responsibility"

AIDS treatment activism emerged in New York City with the foundation of ACT UP/ New York in March 1987. For forty years Americans had lived inside an "antibiotic bubble" during which many believed that infectious diseases were on the verge of extinction. By the mid-1980s, two decades of gay and lesbian political activism, adapting models from the civil rights and feminist movements, had produced a cadre of experienced gay and lesbian activists able to join a new movement focusing on AIDS. American social and political responses to the new epidemic which emerged in 1981 revealed that despite some political gains, gay men and lesbians remained outcasts for mainstream U.S. politicians and researchers alike. President Reagan refused to discuss AIDS until Rock Hudson died of it in 1985. Many middle-class American gay men were unaware of the depths of society's homophobia until it was made manifest by the abandonment of people with AIDS in the early 1980s.

Early activist efforts in the gay community included the creation in 1982 of service-providing agencies such as Gay Men's Health Crisis (GMHC) to provide care and support to people living with AIDS. In 1982—before HIV was even discovered—three gay men, Richard Berkowitz, Michael Callen, and Dr. Joseph Sonnabend, laid the foundation for safer sex by writing "How to Have Sex in an Epidemic," which proposed that gay men stop exchanging sexual bodily fluids (such as semen) until the cause of AIDS was discovered. In 1983 PWAs from around the United States met for the first time and framed the

Denver Principles, declaring the rights of PWAs to organize on their own behalf and to take part in AIDS research and service delivery. Henceforth, PWAs would speak and agitate on their own behalf.

After the discovery of the human immunodeficiency virus (HIV) in 1984, researchers quickly developed antibody tests to screen blood samples to ensure the safety of the blood supply. Widespread use of the antibody test by people to determine their serostatus (HIV antibody status) created a population of thousands of anxious but still healthy individuals ready to mobilize around AIDS.

New York City was the epicenter of the AIDS epidemic in the United States. By 1987, over ten thousand cases of AIDS had been reported in New York City. Half of these had died. As many as four hundred thousand New Yorkers were thought to be HIV-positive.

The rapid development of the first anti-HIV drug, AZT (azidothymidine, zidovudine), by Burroughs-Wellcome and the approval by the FDA of AZT in March 1987 created a climate of new hope about prospects for treating or even curing AIDS. Yet AZT's price—$10,000 a year—and a limited supply created outrage. Hope and rage made up a potent cocktail.

ACT UP was formed after the playwright Larry Kramer delivered a fiery speech at New York's Lesbian and Gay Community Center on March 10, 1987. Kramer pointed out that AIDS cases had jumped from 1,112 in 1983 to 32,000 in four years.

We have not yet even begun to live through the true horror. . . . The real tidal wave is yet to come. . . . Two-thirds of this room could be dead in less than five years. . . . What does it take for us to take responsibility for our own lives? Because we are *not*—we are not taking responsibility for our own lives. . . . We must immediately rethink the structure of our community. . . . Do we want to start a new organization devoted solely to political action? I want to talk to you about power. We are all in awe of power, of those who have it, and we always bemoan the fact that we don't have it. . . . *All power is the willingness to accept responsibility.* . . . It's easy to criticize . . . It's harder to do things. Everyone here is capable of doing something. Of doing something strong. We have to go after the FDA—fast. That means coordinated protests, pickets, arrests. Are you ashamed to be arrested?[1]

Larry's call was for people to take to the streets in a concerted campaign of direct action—not just traditional lobbying, which had failed so far, but civil disobedience and other forms of direct action—to mobilize the gay community and to agitate politically on behalf of people with AIDS. Taking responsibility for the crisis head-on and using it to gain power was appealing. Service organizations like GMHC provided foundations on which community organizing could take place; without them, many would be completely occupied taking care of loved ones with AIDS. A new generation of younger people affected by the epidemic was ready to be mobilized into activism.

Two nights later, over a hundred people met to consider Larry's question: "Do we want to start a new organization devoted solely to political action?" They formed the AIDS Coalition to Unleash Power (ACT UP). Within two weeks, ACT UP staged its first demonstration, "No More Business as Usual," on Wall Street; seventeen were arrested.

ACT UP attracted an eclectic mixture of gay and lesbian activists, feminists, peace activists, Quakers, and people without previous political experience. Movement veterans passed on activist lore—how to run meetings with a minimum of hierarchy, how to train people for demonstrations while assuring their safety, how to work the legal system—and the newer recruits brought skills honed during the 1980s: media savvy and an irreverent, punky wit.

The exclusive focus on "Drugs into Bodies" favored by Kramer did not satisfy everyone. Too many other issues demanded attention: collapsing health care systems, explosive epidemics among drug users, safer sex campaigns, rising numbers of homeless people with AIDS, and the gamut of federal, state, and local politics.

In the summer of 1987, ACT UP protested President Reagan's inaction at the White House, entered an "AIDS concentration camp" float at the June 1988 Gay Pride Parade in New York City, held a four-day, around-the-clock protest at Memorial Sloan-Kettering Hospital, forced Northwest Airlines to rescind its refusal to accept people with AIDS as passengers, and demonstrated at the first meeting of the new National Commission on AIDS.

ACT UP exploded into national attention at the gay and lesbian March on Washington in October 1987, the first such event since 1979. The Names Project quilt, with its thousands of hand-sewn panels commemorating people who had died of AIDS, was laid out alongside the march route on the Washington Mall. ACT UP's contingent stood out in stark black "SILENCE=DEATH" T-shirts, camaraderie, exuberance, and noisy chants. Something new was afoot. Many who saw them there for the first time returned to their own cities to found ACT UP chapters, each one autonomous.

ACT UP zapped *Cosmopolitan* magazine in January 1988 for claiming erroneously that women were not at risk for AIDS, and sent activists to pester presidential candidates at every primary from New Hampshire on, demanding that they address the AIDS crisis in the presidential campaign. Determined to be as egalitarian as possible, ACT UP evolved a minimal structure.[2] Two facilitators, elected for six-month terms, ran weekly meetings, opening every Monday night with ACT UP's mission statement:

ACT UP is a diverse, non-partisan group united in anger and committed to direct action to end the AIDS crisis. We protest and demonstrate; we meet with government and public health officials; we research and distribute the latest medical information; we are not silent.

Major decisions were made by the entire ACT UP membership at the weekly meetings. Each week a succession of new outrages demanded immediate action, and many were

proposed as immediate targets for "zaps," for which groups would meet in corners to plan small, quick-turnaround, improvised actions.

Seizing Control of the FDA

In 1988 ACT UP began developing long-range objectives and campaigns. It was no longer enough to go to Wall Street and say, "No more business as usual!" or simply to demand "Money for AIDS!" We had to get specific. For each campaign, we needed detailed recommendations ("demands") to make any headway. ACT UP's forthcoming campaign to transform the regulation and approval of AIDS drug development would illustrate the need for detailed negotiating positions. Yet detailed objectives implied negotiation; negotiation implied compromise; and compromise was anathema to ACT UP.

By the summer of 1988 many ACT UP members began to focus on AIDS research and treatment. Treatment + Data (T+D, a subcommittee of the Issues Committee, held an initial teach-in on AIDS drug trials in early June. Frustrated by the complexity of the material, I suddenly found my vocation within ACT UP as a writer on treatment issues, and developed a glossary of AIDS drug trials for ACT UP.[3]

While Jim Eigo and others within T+D began building a case against the FDA for our national demonstration in October, Peter Staley led the first targeted zap of a drug company.

During my first months in ACT UP, I felt that my activism had mainly symbolic value. My life was different, but nothing we'd done so far had been of direct benefit to people with AIDS such as my friend Scott, whose illness had drawn me into ACT UP. I wanted to figure out a way to help Scott and other people with AIDS more directly. Our scattershot, reactive activism was cathartic, but where was it going? How could we do more to help people with AIDS or, as we put it, "to end the AIDS crisis"?

It sounds naïve in retrospect, but at the time we actually believed, or fantasized, that this could be done quickly. Gregg Bordowitz later reminisced, "I used to believe in a secular form of redemption—in redemption through activism."[4] We felt then that if we just worked hard enough for a year or two, we could uncover some sort of cure and get it distributed—while ending legalized homophobia, bringing pharmaceutical capitalism crashing to its knees, obtaining the decriminalization of drugs with nationwide drug treatment on demand, and, just possibly, establishing national health care. These were the early days, infused with a strain of almost utopian treatment activism.

But aside from the very small T+D Collection Subcommittee, there was still no ACT UP-wide focus on these issues. Wave 3, the affinity group I belonged to, decided to focus on research and treatment, and invited T+D's Iris Long, Jim Eigo, and David Z. Kirschenbaum to give us a teach-in early in June. Iris Long was a pharmaceutical chemist who had retired from Memorial Sloan-Kettering Cancer Center. She was a happily married feminist who knew something about research, and needed help communicating her ideas

to the larger group. Jim was a playwright who had stumbled upon an ACT UP meeting in late 1987. David Z. Kirschenbaum was an architect from Brooklyn whose father was a pharmacist.

The three of them focused on trying to gather information about experimental studies of AIDS drugs taking place in New York City. No one knew where these trials were. Thus enrollment into them was very slow; most rejected women and children. T+D developed an ambitious plan for an AIDS treatment registry, a spin-off group to gather information about New York's AIDS drug trials and distribute it to people with AIDS.

The teach-in was confusing. Over two hours we were asked to absorb a daunting array of disparate information couched in obscurely technical jargon. There was HIV, the virus, and the various possible anti-HIV drugs; all the opportunistic diseases which struck people with AIDS, and drugs which might treat them; experimental trials, with their ostensibly scientific rules and regulations; federal bureaucracies, academic research sites, public hospitals, and drug companies. Iris, Jim, and David kept mentioning drugs whose uses we didn't know.

What was Ampligen? What was AL-721? Someone needed to make a skeleton key to the confusing tangle of scientific, medical, and regulatory terminology if we were to advance our vision of AIDS treatment activism.

T+D planned a teach-in for the entire membership of ACT UP on July 7, 1988. It would be just as frustrating as the first one unless people had a reading and reference guide to take home with them. At the Wave 3 teach-in, wholly unexpectedly, I stumbled across something I could do to directly help people like Scott. I could use my research and writing skills to summarize the confusing jargon of AIDS research and drug trials into a document for activists and people with HIV. I decided to take on the task of making a glossary of AIDS research terminology. Late at night, after completing work, I started entering into the computer words I didn't understand, from "accrual," the process of enrolling patients into clinical trials, to "zidovudine," the generic name for AZT.

I got my information from newsletters such as *AIDS Treatment News*, mainstream media such as *The New York Times* and *The Wall Street Journal*, the ACT UP special issue of *October* magazine edited by Douglas Crimp ("AIDS: Cultural Analysis/Cultural Activism,"[5] Randy Shilts's often useful, sometimes sensationalistic *And the Band Played On*, and elsewhere.

In *A Glossary of AIDS Drug Trials, Testing and Treatment Issues*, I described the clinical manifestations of AIDS, the numerous experimental drugs targeting the virus and the opportunistic diseases, and the confusing research bureaucracy, including the FDA and the NIH. I stayed up later and later in the darkened Chelsea loft, working into the early morning hours, filling in definitions and garnishing them with tart activist rhetoric.

I brought the completed first draft to an Issues Committee meeting, where I distributed it to Iris, David, Jim, and Garry Kleinman. I'd never been to T+D or to the Issues

Committee. They looked nonplussed. What was this unexpected manuscript? I hoped they would incorporate the *Glossary* into the upcoming T+D teach-in. After leafing through it, Iris quickly offered editorial assistance. Over the next week, Iris, Jim, and David helped me straighten out and clarify the *Glossary*.[6]

The T+D teach-in July 7, 1988, was sweltering and packed. Interest in research and treatment was high because ACT UP was planning its first national demonstration later that year at FDA headquarters. People wanted to know about AIDS drugs and clinical trials. The teach-in was a success. We distributed the *Glossary* to all of ACT UP's members present.

By writing the *Glossary* I put my my research and writing skills to a more strategic use than the zap-based screeds I'd previously written against New York Senator Alphonse D'Amato, the Museum of Modern Art, and New York City Commissioner of Health Stephen Joseph. As a follow-up I volunteered to work on the *FDA Action Handbook* and began planning for the FDA action.

ACT UP's first national demonstration, "Seize Control of the FDA," on October 11, 1988, kicked off an epic campaign to transform the drug testing system in the United States, a campaign that yielded unexpectedly far-reaching changes. AIDS activists forced FDA, NIH, and drug companies to speed up research and broaden access, and to provide access to new treatments which prolonged the lives of people with AIDS and prevented many opportunistic diseases.

Between 1988 and 1992, in response to demands by AIDS activists, the FDA developed a broad range of programs speeding access to experimental therapies for people with life-threatening diseases, expanding access outside of controlled clinical trials through "parallel track," and approving drugs far earlier than before.

The FDA campaign was the first in which ACT UP did detailed policy work in advance, coming armed not only with chants, banners, slogans, and masses of demonstrators, but also with facts, figures, questions, and detailed policy proposals. As early as March 23, 1987, Larry Kramer had written in *The New York Times*:

Its response to what is plainly a national emergency has been inadequate, its testing facilities inefficient, and access to its staff and activities virtually impossible to gain. . . . the FDA constitutes the single most incomprehensible bottleneck in American bureaucratic history.[7]

We began planning the FDA demonstration in the early summer along with other activists focusing on the FDA's sluggish approach to AIDS drug development, including the attorneys Jay Lipner and David Barr from the Lambda Legal Defense and Education Fund, and Martin Delaney from San Francisco's Project Inform. ACT UP sent two emissaries to a natioanl conference of AIDS activists in July 1988 and persuaded ACT NOW (the AIDS Coalition to Network, Organize and Win) to persuade other ACT UPs to join us in a national demonstration at FDA headquarters in October, following another display

of the AIDS memorial quilt in Washington, D.C., timed to precede that year's presidential elections.

An ad hoc FDA Action Committee met weekly to plan outreach, recruitment, training, logistics, publicity, fund-raising, and educational strategies. Gregg Bordowitz came up with the phrase "Seize Control of the FDA!" We intended to stop business at the FDA for a day, creating both a media event and a moral challenge to force the FDA to change its policies. I worked on the *FDA Action Handbook*, planned FDA teach-ins, and helped draft the demands, which had to go through a complex approval process within ACT UP/New York and then within ACT NOW.

In its first national demonstration, ACT UP was taking on an immensely powerful, monolithic, fanatically secretive, and heavily politicized agency. The FDA is a largely autonomous part of the Department of Health and Human Services (HHS), which also includes the Centers for Disease Control and Prevention (CDC) and the NIH. HHS funded most federal AIDS programs.

The FDA regulates all production, marketing, and advertising carried out by the food, beverage, pharmaceutical, biotechnology, medical device, and cosmetics industries, whose combined sales make up one quarter of the U.S. economy.

The American pharmaceutical industry is the most profitable in the country, averaging 16 percent in annual profits versus 4 percent in other industries. Its lobbying arm, the Pharmaceutical Research & Manufacturers Association (PhRMA), is among the most powerful on Capitol Hill. Drug companies regularly complain that they are hobbled by overregulation, that each drug takes ten years and a billion dollars to develop, and that FDA rules impede the development of life-saving therapies.

The FDA originated in 1906 when, in response to meatpacking scandals uncovered by Upton Sinclair in *The Jungle*, Congress established the Bureau of Chemistry under the Pure Food and Drugs Act to prohibit patent medicine manufacturers from making false claims. The Food, Drug and Insecticide Administration was created in 1927 to enforce the 1906 act, and was renamed the FDA in 1930.

President Franklin D. Roosevelt attempted to expand the FDA's powers, but the drug industry bottled up these reforms until 108 people died after swallowing Elixir of Sulfanilamide, a sulfa-based antibiotic mixed with poisonous chemicals. Reformers utilized the resulting publicity to push through the Food, Drug, and Cosmetic Act of 1938, which required drug sellers to prove to FDA's satisfaction, before marketing a drug, that it was safe.

In the late 1950s, Democratic Senator Estes Kefauver of Tennessee held hearings to publicize pharmaceutical firms' abuse of the market, collusion, false advertising, and outrageous pricing. His bill did not advance until 1962, when the sedative thalidomide, used by pregnant women, caused thousands of babies to be born with deformed or no limbs. The resulting scandal forced Congress to pass the Kefauver reforms (omitting price controls). President Kennedy signed the Drug Amendment Laws on October 10, 1962.[8]

All drugs approved after 1962 had to demonstrate *efficacy*—their usefulness for treating the condition for which they would be prescribed—as well as *safety*. The FDA wrote new regulations governing drug approval. Henceforth, after preclinical development in the test tube and in animals, drugs would be tested in three phases to prove they were both safe and effective.

Phase I trials are small and short; they look for a safe, active dose. Phase II and III trials are larger and longer; they look for safety and efficacy. Phase I trials are usually "open-label," meaning everyone gets the drug, at escalating doses. Phase II and III trials are controlled, either with a placebo (placebo control) or with an established treatment (active control). Patients are assigned to experimental or control arms by chance (randomization). Pills and placebos often look identical, so neither doctor nor patient knows who is getting what (double blind). Phase III trials provide definitive evidence required for approval. Most drugs have to demonstrate efficacy in two comparative studies before approval; good science depends on replication.

This process is slow, careful, and often cumbersome. Sometimes useful drugs are held off the U.S. market although already approved abroad. The FDA's rules help ensure that drug companies do rigorous research on new drugs.

The FDA controlled all four routes for access to potential AIDS drugs. FDA decided which drugs would be licensed and available *by prescription*. FDA approved experimental treatments available *through clinical trials* at medical centers. FDA could allow certain experimental drugs out on *special release programs* such as Treatment IND or "compassionate use." Finally, FDA oversaw the *AIDS drug underground*, and could allow or forbid PWA buyers' groups to import drugs approved abroad, or to sell unlicensed substances to people with AIDS. FDA could easily shut these organizations down, and sometimes did.[9]

In March 1987, the FDA released new regulations it claimed would provide access to experimental therapies for patients in extreme need, while the drugs were still being tested. These regulations formalized a long-term policy of allowing single patients "compassionate use" access to unapproved drugs. FDA could designate a drug as Treatment IND (investigational new drug), and the drug company could give it to people for whom approved therapies weren't working.

The first AIDS drug released under Treatment IND was trimetrexate, an experimental treatment for *Pneumocystis carinii* pneumonia (PCP), the most common fatal HIV-related opportunistic infection in the United States. The FDA would allow trimetrexate only for patients who could not tolerate the approved PCP drugs Bactrim and intravenous pentamidine. To receive trimetrexate, patients must have "serious or life-threatening reactions" to *both* approved treatments. Patients who were failing to respond to the drugs, but had no side effects, were not allowed into the Treatment IND program. You could be dying of PCP, but if you didn't have *side effects from two drugs which weren't working anyway*, you couldn't get trimetrexate. It was a lethal bureaucratic catch-22.

By July 1989, only eighty-nine patients had gotten trimetrexate through the Treatment IND, whereas thousands had died of PCP around the country. Jay Lipner, an attorney who had recently left his firm because he had AIDS and he wanted to put his skills to work lobbying for broader access to experimental AIDS treatments, crafted a legal challenge to the FDA. Lipner was working with a younger lawyer from the Lambda Legal Defense & Education Fund, David Barr, and with Martin Delaney of San Francisco's Project Inform.

Over the course of 1988, the Lambda lawyers negotiated with the FDA about the trimetrexate Treatment IND. In early summer, they met with Dr. Ellen Cooper, the director of the FDA's Division of Antiviral Drug Products, and threatened to sue the FDA. David Barr thought Dr. Cooper seemed brusque and annoyed, as if thinking, "Why do I have to waste my time with these bozos?"

As the FDA caught wind of the impending October ACT UP demonstration, its negotiators became more pliable. In early August, Dr. Cooper and her FDA colleagues told Lipner, Barr, and law student Margaret McCarthy that they would rewrite the trimetrexate Treatment IND so that patients failing to benefit from approved drugs could get trimetrexate.[10]

The FDA could have done it all along. No new data had emerged. But community pressure—both inside legal pressure and growing activist outside pressure—had forced the FDA to change its interpretation of its own rules. The rules were arbitrary; by law the FDA had wide latitude to allow broader use of experimental drugs. Now treatment activists were beginning to force the FDA do what people with AIDS needed.

ACT UP and ACT NOW asked the FDA for a meeting to discuss our demands. FDA officials agreed to a meeting on October 5, six days before the demonstration. ACT UP/New York sent Ortez Alderson, Jim Eigo, Margaret McCarthy, Peter Staley, and me to the meeting.

FDA headquarters in Rockville, Maryland, was located in a tall building that was the very image of a bureaucratic monolith—a colossus, built in the 1960s, housing a range of agencies crammed into a rabbit warren of offices and corridors so narrow it was impossible to pass someone without pressing against the walls.

FDA Commissioner Dr. Frank Young, a glad-handing physician, was out of his depth in the treacherous milieu of federal bureaucratic politics, let alone the AIDS crisis. Young presided avuncularly over the meeting in a slightly shabby, ill-fitting white uniform, and introduced a phalanx of deputies including Ellen Cooper, the main point person for AIDS drugs.

The frame for our discussion was Jim Eigo's linkage of two principles. First, *health care was a right*. Second, because the majority of AIDS drugs were experimental, and thus available only through clinical trials, *drug trials were health care, too*. Jim had a stolid dignity as he spoke calmly and slowly in dense, passionate paragraphs. Placebos must be prohib-

ited in future AIDS drug trials. They were unethical, and they encouraged people to cheat, diluting the results of clinical trials and slowing them down.

FDA officials said that when approved treatments were available for a given condition, they could be used as "active controls"; if they were not, placebos were scientifically necessary—and ethical, too, since new drugs could turn out to be worse than placebos.

I argued that the FDA should require that clinical trials allow people to take preventive medications, such as aerosolized pentamidine or Bactrim to prevent PCP, even though FDA had not approved these specific uses yet.

FDA staff agreed, and said that they would allow it.

Ortez Alderson and Margaret McCarthy criticized the exclusion of women, people of color, injecting drug users, and children from AIDS drug trials.

Frank Young said that while FDA had no authority to force sponsors to allow women or drug users into trials, they supported the idea in principle.

Peter Staley said AIDS drug trials must be shortened to make drugs available faster.

Ellen Cooper replied that lengthy trials were necessary to observe enough "endpoints" (e.g., illness and death) to reach "statistical significance."

Frank Young and Ellen Cooper promised that new programs such as Treatment IND could provide access while research trials continued.

Peter retorted that trimetrexate experience showed that Treatment IND provided neither meaningful access nor faster drug approval.

Then we raised questions about a long list of potential drugs we were concerned about: aerosolized pentamidine, recombinant CD4, ddC, ddI, dextran sulfate, DHPG (ganciclovir) fluconazole, foscarnet, Imreg-1, peptide T, and ribavirin. Their names were like numinous entities to us, remote and powerful, held back only by nameless bureaucratic forces which we were trying to name, summon, and defeat.

Frank Young said that the FDA was prohibited by law from revealing "proprietary information" about those drugs unless the sponsors agreed, so he wouldn't say when the FDA would act on any of them.

Activists and bureaucrats were speaking different languages. We did not yet have a common vocabulary in which to negotiate.

Frank Young tried to placate us, saying that we were "all pulling on the same team," minimizing the differences and exaggerating the little we had in common.

When it came to details, Frank Young left the argument to Ellen Cooper. A pediatrician, she had joined FDA as a virologist in 1982, oversaw the lightning-fast approval of AZT in 1987, and was named head of FDA's new division of antiviral drugs.[11] Though intelligent and spirited, Cooper lacked deep clinical knowledge and had never treated an AIDS patient.

We argued about rigid, restrictive, and excruciatingly slow AIDS drug trials. I complained that a trial of foscarnet, a new drug to fight cytomegalovirus (CMV), which causes blindness in people with AIDS, required people to be hospitalized for a month.

"Foscarnet is dangerous!" snapped Ellen Cooper. "Those patients need to be closely monitored."

At that time we thought Ellen Cooper was the very embodiment of bureaucratic heartlessness, but she wasn't a typical bureaucrat. She was impatient with our ignorance of the fine points of clinical trial design, and quick to show her disdain. One year later, she was just as quick to show interest in our unorthodox ideas, once we had mastered the complexities of her science and regulation.

After Young declared himself to be "on our side" one last time, I retorted, in the kind of rhetorical flourish I used to indulge in, "The last decade has been a shameful one in the history of America, and history will record the names of those who have blocked access to life-saving treatments to thousands of people with HIV and AIDS. At the top of that list will be those regulating AIDS drugs at the FDA."

We thought the FDA might have some concession up its sleeve to defuse media coverage of the upcoming demonstration, but their only stab in that direction was coffee and cookies and a press release they had written before the meeting, saying, "FDA Responds to ACT UP Demands." We were outraged that they had given this to the press prior to the meeting, but learned it was a common organizational tactic.

On the train home, we felt deflated. The FDA hadn't made a single policy concession. It was the first of countless meetings with federal research bureaucrats that brought us from boredom to frustration to fury. These meetings marked points along a long, excruciating process of resistance and change.

In spite of all our work, I could never really believe "Seize Control of the FDA" would ever come off. "Is it going to happen?" I kept asking Gregg Bordowitz.

"It's gonna happen," he kept reassuring me.

"Seize Control of the FDA" marked a high-water point for the messianic, utopian phase of AIDS activism, mobilizing forces from around the country which now planned to swirl around FDA headquarters, hoping that our protest could somehow unlock not only the FDA bureaucracy, but also the cure we all dreamed of.

Friday, October 7, 1988, hundreds of ACT UP members took buses to Washington, D.C. For the first time, hundreds of exuberant AIDS activists from around the country would come together. It was exhilarating. Jim and I gave a ninety-minute teach-in on the FDA. Many of us attended a candlelight vigil beside the Names Project quilt. Thousands marched down the Mall toward the rally at the Reflecting Pool. As the vigil ended, the low roar of ACT UP members chanting "ACT UP, Fight Back, Fight AIDS" rose into the air. Later we marched around the White House, screaming "Shame!" at its absent-minded occupants.

Sunday morning we went to the quilt. Huge and desolate, covering the entire Ellipse on the Mall, the portable hand-crafted memorial carried the names of 8,288 people who

had died of AIDS, a quarter of the national total to date. All day long, speakers read the litany of names aloud. People walked along canvas strips lining each block of six panels. Some 150,000 people, some living with AIDS, some in wheelchairs, saw the quilt that weekend. Annoying attendants ran around thrusting Kleenex as people wept.

Monday morning, we caucused. We were firm in our resolve to risk arrest. We finished our action plan and took the subway to downtown Washington for the rally at HHS headquarters. Outside, before the Hubert H. Humphrey Building, an ugly, late 1960s gridded concrete bunker, a motley, exuberant crowd listened to film historian and veteran gay activist Vito Russo give a beautiful speech:

AIDS is a test of who we are as a people. When future generations ask what we did in the war we have to be able to tell them that we were out here fighting. And we have to leave a legacy to the generations of people who will come after us. Remember that some day the AIDS crisis will be over. And when that day has come and gone there will be people alive on this earth—gay people and straight people—black people and white people—men and women—who will hear the story that once there was a terrible disease—and that a brave group of people stood up and fought, and in some cases died, so that others might live and be free. . . . And after we kick the shit out of this disease I intend to be alive to kick the shit out of this system so that this will never happen again."[12]

Vito made us believe that he was going to survive, and that we might win.

That night, we stayed up late making flags, banners, and props for the next day's action.

We awoke before dawn, dressed, and met in front of a 7-11 store. Artist and PWA Brian Damage did tai-chi in the predawn light. We took the Metro to Rockville. The subway teemed with activists. Bloody-hand palmcards were slapped up in usually spotless Metro stations.

At Twinbrook station we donned our white Wave 3 lab coats, emblazoned with the red Biohazard logo and the words New Center for Drugs and Biologics. FDA headquarters loomed ahead in the mist. Wave 3 provided the day's first arrest. Richard Deagle, who usually confined his graphic impulses to posters and placards, was carried away by the spirit of rebellion and started spray-painting a pink triangle and the letters FDA on the concrete walls of the station. He was accosted, pinned, and handcuffed by Metro police, and shoved into a police car, limp and screaming epithets. We tried to block the car, but it drove right through.

We made our way to the blocklike FDA building. Squadrons of Montgomery County, Maryland, police stood in serried ranks, many wearing rubber gloves, some in riot head-gear. The gloves implied a quarantine attitude toward AIDS activists, and bad training. "Your gloves don't match your shoes," chanted some activists, "we'll see you on the evening news."

Perhaps 1,500 activists surrounded the building. Groups from each city, and affinity groups from ACT UP/New York, clustered together in the street by the front entrance,

before a double row of county cops. Each group had its own visual signature, signs, and themes.

Hyperactive media coordinators, equipped with a rented Sony Watchman TV, cellular phones, and walkie-talkies, based at a press booth brimming with press releases and fact sheets, ran around with bullhorns calling out, "We need a lesbian PWA from California" or "Is there a mother of a PWA from Ohio?"

The Delta Queens surrounded a flagpole, lowered the Stars and Stripes, and raised a SILENCE = DEATH flag, which flew over an effigy of Ronald Reagan. Another banner read 75,000 PEOPLE WITH AIDS FIGHT BACK. Every half-hour another American died of AIDS.

FDA staff who had arrived before 6 A.M. peered through tinted glass, nervous and titil-lated. They'd never gotten so much attention. In a parking lot where bewildered FDA employees awaited a call to return to work which never came, C-FAR (Chicago for AIDS Rights) sold pentamidine for $28 a vial, a quarter of the cost charged by its maker, LyphoMed. ACT UP/New York's Cary Stegall sold dextran sulfate, imported from Japan in blister packs. "Test drugs, not people!" chanted the crowd.

It was a carnival of activism. Queer and Present Danger staged a die-in at the doors of the building, outlining their bodies in chalk. Later, in what became the photo op of the day, appearing on the front page of newspapers around the country, ACT UP/New York's Candelabras (named in homage to Liberace) staged another die-in with tombstones reading I GOT THE PLACEBO—R.I.P.; AZT WASN'T ENOUGH; I DIED FOR THE SINS OF THE FDA; "DEAD—AS A PERSON OF COLOR, I WAS EXEMPT FROM DRUG TRIALS; DEAD FOR LACK OF AEROSOL PENTAMIDINE; DEAD FROM LACK OF AL-721; DEAD FROM LACK OF DEXTRAN SULFATE.

Peter Staley scaled the concrete awning over the main entrance, raising a black banner reading SILENCE EQUALS DEATH and posters of NIH AIDS chief Anthony Fauci with the word GUILTY and the Reagan AIDS/Gate poster.

Wave 3 gathered in the street to erect our New Center for Drugs and Biologics. We built a rickety structure out of cardboard panels, from which we were to distribute edicts Jim Eigo had written announcing the new, enlightened, flexible, proactive, responsive FDA. The structure quickly blew down in the wind. We piled the pieces on the side of the street.

Activists were getting restless. The cops weren't arresting very many people. Some of us decided to try and enter the building. This was impractical. A double line of cops blocked the entrance. Wave 3 huddled with the Delta Queens. Only a few, in the middle, could hear the discussion. We decided to attempt a direct entry, deploying ourselves in a flying wedge and running straight *through* the police.

The Delta Queens were on the left; Wave 3, on the right. We all linked arms and marched forward, chanting, "Seize control! Seize control!"

Wave 3 just broke and ran—directly toward the police, who were blocking the entrance. Months of nonviolence training went in vain.

Our flying wedge became a swirling melee as the cops defended their position with sticks. Richard Elovich crashed into a glass panel near the entrance. The Delta Queens and Wave 3 moved back from the entrance to regroup. Some activists, disillusioned by recklessness, disappeared for the day. Others surrounded the bus, attempting unsuccessfully to prevent the arrestees from being driven away.

Provoked by the assault, the police now dragged Peter off the concrete awning while he ran back and forth setting off smoke bombs, and arrested him.

Around the side of the building, ACT UP/Los Angeles members broke into a ground-level office after someone lobbed a rock through a window. There were a few arrests.

As the demonstration went on, it became increasingly ragged. An irate citizen brandished a chain saw at several ACT UP members who ran across his lawn. A truck driver hurled homophobic abuse at activists who blocked his exit from the FDA parking lot.

The rest was anticlimax. We ran from place to place, looking for a focus, watching small confrontations between activists and police. By 3 P.M., most of the media had left and the cops became more aggressive. The two Richards, Deagle and Elovich, Wave 3's sole arrestees, rejoined us. We decided to leave. One hundred and seventy-six arrests had been made.

Press coverage of the FDA demonstration was overwhelming. We made the front page in Boston, Baltimore, Dallas, Houston, Orlando, and Miami, and were well-covered in Atlanta, Buffalo, Chicago, Detroit, Los Angeles, Memphis, New York, Philadelphia, San Francisco, St. Louis, Tampa, Tucson, and Washington D.C. Wire services ran photos of the Candelabras' die-in with tombstones. The coverage was mostly favorable. AIDS activism had gone national.

The TV news coverage that evening was comprehensive and sympathetic. We were on all local stations: ABC, NBC, CBS, Fox, and CNN. Peter Staley was a guest on CNN's *Crossfire*, debating Pat Buchanan, and demolished his sneering insinuations. Buchanan asked Peter what he would do, if his younger brother were gay, to protect him from AIDS—wouldn't he recommend abstinence? "I'd tell him to use a condom every time he had anal sex," replied Peter matter-of-factly.

Among community newspapers, coverage was euphoric. A turning point in the AIDS epidemic had been reached. In fighting for the rights of people with AIDS, we were at the vanguard of a larger movement for patients' rights. As Robert Massa put it in a front-page story in New York's *Village Voice*:

These activists seek nothing less than a revolution in medical research. They are challenging long-standing assumptions about drug development. For the demonstrators who gathered in Washington, what the researchers call good science is murder—especially in this epidemic, when

experimental drugs may be a patient's last hope. ACT UP's critique rests on a single sentence that became a slogan of the FDA action: "A Drug Trial Is Health Care Too."[13]

Massa recognized what was responsible for the generally favorable media reaction to "Seize Control of the FDA." Most people could understand problems with government red tape and with greedy drug companies. The anxieties about health care released by AIDS and unleashed by ACT UP were anxieties felt by many people around the country.

Kiki Mason, writing in *The New York Native*, was even more euphoric:

In eighteen months, ACT UP and similar militant organizations across the country have turned the tide of AIDS activism and forever changed the traditional gay movement. . . . If militant organizations maintain their pressure on the FDA, the process will move faster, and lives will be saved. . . . In the long war on AIDS this past weekend may be remembered as Gettysburg. We still have much heartache and bloodshed ahead of us. We can take it. The tide has turned. Victory will be ours.[14]

The triumphal optimism unleashed by ACT UP at "Seize Control of the FDA" gave birth, over the next year, to a powerful, revolutionary, and, at first, almost utopian strain of treatment activism. ACT UP returned to New York like a wounded bear, surprised by its strength and unsure of where to go next. A malaise set in during the weeks immediately following. We were stumped about how to infiltrate ourselves into the regulatory process and turn it inside out. How would we keep the pressure on? What kind of follow-up was needed? How could we continue to grow and become more effective?

In 1989, ACT UP cracked the U.S. research system wide open. The energies unleashed in 1987 and tested in a frenzied, scattershot approach throughout 1988 were about to be focused with single-minded intensity on the FDA-regulated, NIH-funded, pharmaceutical-dominated American drug testing system.

When the year opened, just one drug had been approved by the FDA to be sold for treating AIDS—AZT—and no drugs had been approved specifically to treat the AIDS-related opportunistic infections. After six months of relentless activist pressure, in June the FDA would approve the first two drugs for AIDS-related opportunistic infections, aerosolized pentamidine to prevent *Pneumocystis carinii* pneumonia (PCP), which afflicted 60–80 percent of PWAs, and DHPG (ganciclovir) for cytomegalovirus (CMV) retinitis, a viral disease which caused blindness.

In mid-1989, ACT UP would storm the opening ceremonies of the Fifth International Conference on AIDS in Montreal, Quebec, and release our *National AIDS Treatment Research Agenda*, the first attempt to develop a comprehensive agenda for AIDS research. That, in turn, would lead to a new alliance with researchers which paved the way for parallel track and innovative study designs which were far more inclusive and sensitive to the needs of people with AIDS. By the fall, thousands of people with AIDS would be

getting a new antiviral drug, ddI, free through their doctors' offices, on a "parallel track" designed by ACT UP with NIH, the drug industry, and FDA, and controlled studies of ddI were started.

The changes of 1989 were due to a revolution in attitudes at the FDA, radical regulatory shifts, a new alliance between AIDS activists and researchers at NIH, and pressure from the very highest levels of the new Bush administration.

AIDS activists mobilized to become full participants in the research process. In November, ACT UP sent four representatives to the triannual meeting of the AIDS Clinical Trials Group, which conducted the bulk of the federally sponsored AIDS clinical trials. They demanded that activists and people with HIV be allowed to participate in the planning and execution of research protocols. AIDS research would never be the same.

For one brief, tantalizing moment, it seemed that science, prodded by activism, might be on the verge of transforming AIDS from an almost universally fatal condition to a "chronic, manageable disease." If we could prevent PCP with pentamidine, why not try to prevent *each* of the opportunistic infections? Might people not survive far longer then? What if antivirals, used early, could delay or even prevent progression to AIDS? The possibilities were intoxicating. In 1989, ACT UP crested atop a wave of treatment utopianism, spreading hope that perhaps a cure might be just around the corner.

By 1989, AIDS treatment activism had gone national; a turning point had been reached. We were at the vanguard of a larger movement for patients' rights, a movement to revolutionize medical research for all diseases. The triumphal optimism unleashed by ACT UP at "Seize Control of the FDA" gave birth, over the next year, to a powerful, revolutionary, and, at first, almost utopian strain of treatment activism. Henceforth, AIDS activists would demand a seat at any table where AIDS research was under discussion; increasingly, we would succeed in seizing such places. Not only did we want full participation, we wanted to change the research agenda. By the Fifth International AIDS Conference in Montreal, in the summer of 1989, ACT UP had published its first *Treatment Research Agenda*, which we distributed to scientists and the media. Some had objected that we lacked the expertise to publish our own views, infused by the concerns of the HIV community, on what the scientific research agenda should focus on, and how it should proceed. "Those things should be decided by scientists," said one objector. "We're not scientists." But as AIDS treatment activists we had a perspective on the whole AIDS epidemic which the scientists, focusing intensely on narrowly defined research areas, lacked. It couldn't hurt to try.

Notes

1. This and the subsequent quote are from Larry Kramer, "The Beginning of ACTing UP," in Kramer's, *Reports from the Holocaust: The Making of an AIDS Activist* (New York: St. Martin's Press, 1989), pp. 127–139.

2. ACT UP's original Working Document, http://www.actupny.org/documents/firstworkingdoc.html (accessed February 18, 2007).

3. M. Harrington with J. Eigo, D. Z. Kirschenbaum, and I. Long, *A Glossary of AIDS Drug Trials, Testing and Treatment Issues* (New York: ACT UP/New York, July 5, 1988).

4. Gregg Bordowitz, *Fast Trip, Long Drop*, 16 mm film/video (1994).

5. October 43, *AIDS: Cultural Analysis/Cultural Activism*, ed. by Douglas Crimp (Cambridge, Mass.: MIT Press, 1988; also reissued in paperback by MIT Press).

6. Harrington et al., *A Glossary of AIDS Drug Trials, Testing and Treatment Issues*, pp. 26–27.

7. Larry Kramer, "The FDA's Callous Response to AIDS," *The New York Times*, March 23, 1987, also in Kramer's *Reports from the Holocaust*.

8. Section 102 (c) of the 1962 Kefauver-Harris Drug Efficacy Amendment amends the Federal Food, Drug and Cosmetic Act to read:

(5) . . . [If] there is a lack of substantial evidence that the drug will have the effect it purports or is represented to have under the conditions of use prescribed, recommended or suggested in the proposed labeling thereof . . . he [the Secretary of HHS] shall issue an order refusing to approve the application . . . The term "substantial evidence" means evidence consisting of adequate and well-controlled investigations, including clinical investigations, by experts qualified by scientific training and experience to evaluate the effectiveness of the drug involved.

9. In the 1970s, the U.S. Supreme Court held that the FDA could prevent people from importing laetrile, the putative anticancer drug, and could prosecute people for selling or buying laetrile. *U.S.* v. *Richardson*, 588 F.2nd 1235 (9th Circuit, 1978); certiorari denied, 440 US 947 (1979); rehearing denied, 441 US 937 (1979).

10. Margaret McCarthy, transcript of FDA meeting, August 5, 1988.

11. Philip M. Boffey, "At Fulcrum of Conflict, Regulator of AIDS Drugs," *The New York Times*, August 18, 1988.

12. Vito Russo, "AIDS Is a Test of Who We Are as a People," speech delivered in Albany, New York, May 7, 1988, and in Washington, D.C., on October 10, 1988.

13. Robert Massa, "ACTING UP at the FDA: What AIDS Activists Want," *Village Voice*, October 18, 1988, p. 1.

14. Kiki Mason, "FDA: The Demo of the Year. With the Troops in Washington," *New York Native*, October 24, 1988, pp. 13–17.

The Politics of Rationality

Psychiatric Survivors' Challenge to Psychiatry

E. Gabriella Coleman

The moral logos of contemporary biomedical psychiatry, no matter how clearly entrenched in our current medical topography, exists in the midst of various forms of political challenge. Here I will examine the significance of one of the most striking political countercurrents to the new biomedicalization of mental health: the psychiatric survivor movement, also known as "mad liberation." These advocates refer to themselves as psychiatric survivors to underscore the trauma experienced through various forms of forced treatment, such as electroshock therapy, forced drugging, hospitalization, seclusion, and restraints. This movement, whose historical roots extend back to the radical milieu of the 1970s and grew in the 1980s to include a more reformist strain of consumer advocacy, mobilizes the cultural ideal of freedom and self-determination, along with the law of human rights and informed consent, to undermine the moral, scientific, and legal claims furthered by the pharmaceutical companies and other authoritative psychiatric institutions (Morrison 2005; Lewis 2006b; Chamberlin 1990).

The psychiatric survivor movement has significantly contributed to a refiguring of the relationship between madness and rationality via an avenue of engaged, radical, and at times risky politics. While the line drawn in science between experts and non-experts is significant, the disjuncture between psychiatrists and those labeled as mentally ill has existed more like an impassable gulf, for the latter, as one advocate reminds us, "have been assumed to be irrational—to be 'out of their minds' " (Chamberlin 1990: 323). The size of this gulf has diminished as those diagnosed or labeled as mentally ill have forcefully nullified entrenched stereotypes of their incapacity through vibrant political expression, and eventually have been understood to hold a rational capacity to speak credibly about their condition and their treatment, and even to comment on the science of psychiatry.[1] Acting for the first time as a visible collective and in a broader context of social unrest and upheaval, these activists drew upon some of the most culturally charged

discourses of freedom, individuality, and human rights to make their claims bear cultural weight. These discourses still figure prominently in their political messages after thirty years of organizing.

While there are various political positions and critiques launched by consumers, survivors, and ex-patients (sometimes collectively designated by the term "c/s/x movement"), together they affirm a right to self-determination in the face of coercive treatments, and they seek to expose what they see as the scientifically suspect claims put forth by the pharmaceutical industry and institutional psychiatry. They often do so by challenging not the general enterprise of science, but what they see as particular instances of fraudulent science. In this chapter I examine cases and examples that demonstrate how survivors have challenged authoritative psychiatric practices and science in support of their own political project—to establish the right to unconditional self-determination in the face of their subjectivity and rationality being deemed pathological and irrational by medicinal diagnosis. In particular, I seek to understand how these activists have maintained a radical stance in the face of shifting though related contextual conditions—such as the transition from the radical political landscape of the 1960s and 1970s to that of neoliberal materialism in the 1980s, the growing legitimacy of a neurochemical model of mental illness, and a pervasive culture of seeking, prescribing, and taking drugs—that have worked against their ability to sustain a visible articulation of radical politics.[2]

Thus, while the present face of the psychiatric survivor movement challenges the current biological paradigm of mental illness by undermining its presumed certainty, those involved have launched their claims from the foundation of a longer historical engagement with psychiatry at different epistemological moments and in different political climates. And these contexts have significantly facilitated *and* dampened the radical voice of the movement. For example, as I will argue below, the politics of ex-patients and survivors arose in a period in American history ripe for a radical critique of psychiatry, one that was able to communicate with cultural ease due to the broader climate of dissent as well as the more uncertain state of psychiatry.

However, just as these advocates gained a voice, mainstream psychiatry reinvented itself so as to become a more legitimate enterprise, one that provided the public with a morally enticing model of mental illness. As part of this shift, institutional psychiatry came to focus primarily on one object for therapy: the brain. Viewing the brain as an organ existing in isolation from its social environment, mainstream psychiatric practice sought to alter a range of behavioral symptoms, largely exclusively through the psychotropic manipulation of brain chemistry, notably neurotransmitters. It is this limited scientific framing of normalcy and illness, mandating a cocktail of pharmaceutical interventions, which survivors have had to contend with in their struggle to remain radical over time.

Along with these changes internal to psychiatry, survivors faced broader political and economic shifts that facilitated the rise of the more moderate expression of consumer activism. In the mid-to-late 1980s, it seemed that psychiatric survivors and ex-patients

were doomed, like many other political activists from that period, to languish and vanish in an era that championed primarily consumer and lifestyle politics. In these changing social and medical contexts, freedom, the governing rallying call of the movement, seemed capable of communicating only one message: individual choice over treatment options, which, however expansive-sounding, was in reality being narrowed down to choosing from an extensive array of psychiatric drugs. Indeed, at first blush, the ascendancy of consumer advocacy in the 1980s and the marginalization of survivors and ex-patients seem to provide an apt example of David Harvey's recent insight that "[a]ny political movement that holds individual freedoms to be sacrosanct is vulnerable to incorporation into the neoliberal folk" (2005: 41).

However, despite a substantial commitment to individual freedoms and the growing visibility of consumer rhetoric, the radical message of this movement was not, in fact, so easily engulfed by neoliberal logics. Since the mid-1990s, survivors have demonstrated their ability to stand the test of time, remaining relevant by building extensive alliances with more moderate political activists, by reemphasizing more inclusive political vocabularies, such as those of disability rights, by tactically shifting messages, and by entering a territory—the neurochemical basis of mental illness as formulated by mainstream psychiatry—where few others were willing to venture.[3]

As part of this venture, they have been one of the few groups to get the American Psychiatric Association (APA) to address and admit to the uncertainty surrounding the current biological theories of mental illness. After a small group of psychiatric survivors held a hunger strike in the summer of 2003, demanding that various groups, including the APA, "produce scientifically valid evidence" for the biological basis of mental illness, the APA eventually released a statement that admitted "brain science has not advanced to the point where scientists or clinicians can point to readily discernible pathologic lesions or genetic abnormalities that in and of themselves serve as reliable or predictive bio-markers of a given mental disorder or mental disorders as a group."[4] In an era during which biological explanations for behavioral conditions have become part of the largely unquestioned terrain of explanations, this was an exceptionally rare, and thus historic, political admission. The hunger strike represents one of the most potent examples of how psychiatric survivors, often marginalized as "non-experts," "too radical," or "the political fringe," have in fact, via decades of continuous, though continuously shifting, political action, successfully created an arena for critical debate in the medical biosciences.

I raise this striking example as a starting point from which to examine the role, importance, and limits of radical politics for the creation of participatory publics in the biological sciences. What follows, it must be emphasized, is not a straightforward empirical history, much less a detailed account of survivors, American political culture, or transformations in psychiatry. Instead, it proceeds with a more modest and highly selective account of examples drawn from the psychiatric survivors' initial forceful appearance in the early 1970s, tracks the rise of consumer advocacy in the 1980s, and ends with a more

detailed examination of this hunger strike. Since I focus primarily on ex-patients and survivors, who tend to put forth a radical critique, I disaggregate them from consumers, especially in the earlier part of my narrative, before I address the rise of consumer advocacy in the 1980s. I nest these partial examples within some of the most salient political, medical, and economic currents at play during this thirty-year period (especially dominant trends in psychiatry) so as to offer a critical and conceptual appraisal of the moments in which the political message of psychiatric survivors held more widespread cultural and political purchase. In so doing, it is clear that while larger forces enable *and* constrain political activity, these activists' ability to survive as central protagonists in a critique of institutional psychiatry follows from their willingness to shift political message and tactics within a tide of changing conditions.[5]

The Beginnings of Radical Politics of Freedom

The 1960s and early 1970s are recalled as a tumultuous period in American history when the vibrant fire of political dissent burned bright, illuminating and, in some cases, transforming a plethora of social ills, institutions, and legal mandates. From attacks on segregation to feminist clamoring for equality, academic critique was in significant harmony with a blizzard of imaginative political action. In this period, activists and academics alike seized the concept of madness as a means by which to understand the very nature of social injustice, inequality, and political interventions. To take one of the earliest and most forceful examples, in 1955 Martin Luther King delivered one of what were to be many fiery speeches on civil rights, "Montgomery Story," during which he urged his listeners to "keep the ball of civil rights rolling to the end" by adopting a seemingly counterintuitive tactic. In short, he suggested the path toward liberation lay in embracing madness.

In future speeches he would expand on this message, urging audience members to stand maladjusted in the face of racial discrimination and segregation, religious bigotry, militarism, and physical violence.[6] For example, in a speech delivered in 1965 at the University of Western Michigan, he proclaimed, "I am proud to be maladjusted. . . . I say very honestly that I never intend to become adjusted to segregation and discrimination."[7] For African–Americans to adjust to the unquestioned norms and laws of racial segregation was in fact to inhabit the territory of true madness. To achieve justice and freedom, King ostensibly sanctioned the embrace of "madness" and thus, in turn, diagnosed the norms of society as mad. His proclamation is just one important example of how the meanings of normalcy and madness in this period of American history were starting to shift under the weight of vigorous social unrest, academic critique, and legal populism.

In the 1960s, a steady stream of civil rights and anticolonial movements, and other challenges to authority—from the antiwar protests to the countercultural turn—diagnosed society in similar terms, speaking powerfully and collectively about and to the social abuses of power. In particular, this decade saw an efflorescence of academic literature that

deployed "madness" as a means to conceptualize, and thus unearth, abuse, coercion, and injustice. The academic champion of the New Left, Herbert Marcuse, for example, wrote in the late 1960s about the ways the power of social dissatisfaction, and thus potential political dissent, was categorically nullified by being collapsed and associated with insanity, and thus worked to obscure the real locus of sickness: the affluent, wasteful society (1968: 248–252). And of course, most famously, there was body of widely read and influential academic literature by Michel Foucault, Erving Goffman, and Thomas Scheff, as well as critiques put forth by dissent psychiatrists, such as Ronald Laing and Thomas Szasz, that specifically addressed psychiatry, its institutions, and its schemes of classification as modalities of coercion. This literature animated what grew to become a primarily academically oriented yet influential critique that also came to be known more broadly as that of anti-psychiatry (Crossley 2006).[8]

It was within this charged milieu and following in the wake of an extensive academic critique of psychiatry in which a group of people, primarily those who were deemed insane and who shared experiences of abuses of psychiatric power, banded together to initiate what became a grass-roots "mad liberation movement." As Nancy Tomes argues, this new development was historic insofar as "[t]he claim to have special insight into mental illness by having actually experienced it was a novel assertion" (2006: 722). The first step taken was to form organizations and collectives run by ex-patients, such as the Insane Liberation Front, founded in Portland, Oregon, in 1970, followed by groups in New York, Boston, western Massachusetts, and San Francisco. Though activists emphasized the importance of self-determination in the face of psychiatric power, among peers they cultivated a social message of peer support and mutual aid (Chamberlin 1990: 323; Morrison 2005). The publication of the *Madness Network News* in 1972 increased the movement's scope significantly, providing a medium in which to formulate the nascent ideals, and linked people across space and time through the circulation of home-brewed news and art, written and edited by a host of actors who included ex-patients, survivors, dissent psychiatrists, and sympathetic lawyers. In 1973, survivors helped to organize and participate in their first conference, "Committee of Human Rights and Psychiatric Oppression," and similar yearly conferences since then have played an important role in the movement. As a result of these activities, these activists started to build a realistic picture of psychiatric patients as an oppressed group.

These advocates took it upon themselves to challenge the legal regulation of their bodies not only though the law of informed consent and human rights, but also through the regulation of the meanings of mental illness, madness, and rationality. Echoing Martin Luther King's call to stand maladjusted in order to reveal the madness of society, psychiatric survivors challenged authoritative medical institutions by laying bare the irrationalities of psychiatric care and reformulating the meanings of normalcy and madness. Some advocates questioned the state of madness altogether, and others coded it as a real and valid human experience that should not be pathologized, but instead celebrated due to

its deviancy and its ability to provide insight into the human condition.[9] Amid these varied positions, one stance was eminently clear and nearly unanimous: forced treatment, which at the time was entirely buttressed by the law, was a form of violence, for it denied participants the self-determination of their own bodies and often placed them in situations that were experienced as injurious, and thus were traumatic.

As Linda Morrison vividly demonstrates in her extensive account of the mad liberation movement, psychiatric survivors, along with other mental health advocates, through this type of activism not only crafted a "voice" to "talk back" to psychiatry on questions of care, treatment, and harm, but also sought to more fundamentally change the terms of engagement to create an alternative epistemological, material, and moral reality to the one provided by mainstream psychiatry. Eschewing a desire for normalcy as dictated by dominant understandings of mental illness, they sought instead to validate "their local, regional knowledge as *knowledge* and not only as data for the psychopharmaceutical research-industrial complex" (Morrison 2005: 23).

At the time, many of the political claims made by advocates held considerable public sway, in part due to the charged countercultural milieu in which various intersecting antiauthoritarian currents were working in synergy to bolster each other. With society assiduously and so visibly attacked as mad by so many various social groups, there was a political opening by which those deemed mentally ill could communicate a critique of psychiatry more forcefully than ever before.

However, what must be emphasized is that at the time of this political outpouring, the field of psychiatry was also at a crossroads, undergoing significant epistemological turmoil and lacking the types of hard scientific insignias that it now is supposed to bear. For example, the development of neurochemical theories of the brain was in its infancy, only beginning to challenge the authority of psychodynamic approaches—often Freudian in orientation—which had been one of the dominant paradigms in psychiatry until the early 1960s.[10] In the early 1970s, these techniques were increasingly subject to a critical gaze, in part because of their tendency to reduce all phenomena to childhood experience, and thus their propensity to breed an overt moralism that placed heavy blame on the family, usually mothers (Dolnick 1998). In addition, the *Diagnostic and Statistical Manual of Mental Disorder* (*DSM*), now the current diagnostic bible, was considered, even within the field of psychiatry, overly vague and thus unable to shore up the forms of authority it now commands. Finally, and most famously, the institution most closely associated with psychiatry, the asylum, was under sustained attack by the political Right and Left, and in the throes of being torn down due to a complicated host of pressures that included over two decades of critiques and exposés, financial crises, and legal attacks from civil liberties organizations.[11]

A body of mental health law was of course the primary tool used to place and keep those identified as mentally ill within the confines of the psychiatric hospital and subject to various forced treatments. Because of psychiatry's dependence on the law, Foucault

rightly notes that the body of the madman was an "object of juridical interdiction," further clarifying that the "law prevailed over medicine in endowing madmen with a marginal status" (1970: 338). In the United States and most other liberal democracies, legal statutes authorized forced treatments and, until the 1960s, informally coded "madmen" either as non-persons or as criminals by stripping them of their civil rights (to vote, marry, hold licenses, for example) once placed in an institution. With an attack on asylums also came an attack on the web of laws that sustained institutionalization.

By the end of the 1970s, due to significant changes that partly followed patient-driven litigation (including that of survivors), and partly through independent initiatives supported by civil rights activism, the law no longer worked in such seamless service with psychiatry. For example, legal changes that upheld the civil rights of patients made it more difficult to involuntarily commit patients, clarified the right to refuse treatment, and outlawed forced labor within hospitals. These changes worked together to designate psychiatry and its institutional locus of the time, the asylum, as far too powerful and coercive, often to the detriment of the well-being of patients.[12]

One well-known example of the more general shaky position psychiatry and the asylum held during this period was produced and conveyed by an experiment conducted by Stanford University Professor David Rosenhan and published in the prestigious journal *Science*. It is worth briefly recounting the experiment here, for it is one powerful token of a more general skepticism that marked psychiatry and asylums at the time. In 1973 Rosenhan sent eight pseudo patients to various hospitals on the East and West coasts to try to gain admission by claiming they were hearing voices. They were admitted without difficulty, and staff immediately diagnosed them as either schizophrenic or manic-depressive. After admission, they resumed their normal behavior. Although they acted normal, they were never detected by the staff, but many fellow patients easily noticed the deception, and a substantial number challenged them: "You're not crazy, you're a journalist or a professor" (1973: 4).

On the other hand, staff members interpreted seemingly innocuous and ordinary actions, such as taking notes, as the manifestation of aberrant, compulsive behavior. The "patients" were forced to stay on average nineteen days, and in one case, fifty-two days. *Science* published the findings in an article, "On Being Sane in Insane Places," that helped to fuel one popular perception that psychiatric institutions were holding pens for people labeled by the psychiatric profession as deviants, as opposed to a place for healing the genuinely ill.

Biological Psychiatry Gains Respectability Through the *DSM III* in the Era of Neoliberal Economics

Because psychiatry was undergoing significant flux, it was particularly vulnerable to critique, especially in an era that was already championing human rights in the face of what

were perceived as impersonal, dangerous, or overly powerful institutions. However, in the succeeding decades, whatever forms of credibility survivors had forged were shaken and transformed by a newfound confidence in the biological foundations of mental illness. Beginning in the 1970s and reaching a zenith in the late 1980s, a neurochemical model of mental illness was consolidated and strengthened to achieve a state of significant respectability. This came about through the convergence of trajectories that included new federal regulations covering drug research and advertising initiated in 1962, the introduction of psychotropic medication on a widescale basis, and the third edition of the *DSM*. Within and through this convergence, psychiatry formulated what Andrew Lakoff describes as a new technical rationality of specificity, which he dubs "pharmaceutical reason," an idea that "targeted drug treatment will restore the subject to a normal condition of cognition, affect or volition" (2005: 7).

Until new psychotropic drugs were developed in the early 1950s, most psychiatric drugs, such as Valium, were tranquilizers, which carried with them two related perspectives. One was that the public and medical professionals often understood them not as therapeutic, in the sense of returning a patient to well-being, but still worthwhile insofar as they provided a brief respite from the onslaught of symptoms. Second, the media and the public often cast then in a critical hue for being dangerous, overabused, and addictive, notably after the FDA mandated stricter advertising regulations in 1962, as part of sweeping changes to the Food, Drugs and Cosmetics Act following public outcry over a sedative, thalidomide, that caused thousands upon thousands of birth defects, even though originally deemed safe by pharmaceutical companies (Healy 1997). As a number of historians, anthropologists, and critics of psychiatry note, these regulatory pressures worked to place psychiatry and new pharmacological developments on a road toward an exclusive and narrow medical model of disease (Healy 1997, 2002; Lakoff 2005). After the regulatory changes of 1962, drug companies were required to establish that drugs were both safe and effective prior to approval (and thus market release). This necessitated, in other words, a much more intimate correlation between drugs and discrete disease entities than previously necessary.

This regulatory requirement to connect drugs' efficacy to specific diseases helped to accelerate an independent initiative within clinical psychiatry and pharmacology to formulate standard classification schemes. An array of standardized classification schemes was devised following a well-publicized comparative study involving the United States and Europe that demonstrated significant disparities in diagnostic regimes between the two. Under the leadership of Robert Spitzer, a researcher from Columbia University's Psychiatric Institute, new instruments and questionnaires, such as the Research Diagnostic Criteria and the Global Assessment of Psychopathology, were created to achieve greater standardization and, it was hoped, specificity in psychiatry.

Robert Spitzer was also one of the main figures directing and driving an ambitious, six-year project to review, renew, and update the *DSM* from its second to its third edition that,

when completed in 1980, not only provided psychiatrists with more standardized criteria by which to evaluate and diagnose patients, but also described in recipe-like detail more than 292 disorders, over 100 more than had existed previously.[13] Approved by the APA, it signaled a new style of thinking, diagnosing, and treating mental illness that had, by the time of its release, eclipsed a more psychodynamic approach popular in the preceding decades.[14] Touted by many in the profession as a genuine scientific instrument, this new tool equipped the psychiatrist to "become a measurer, not interpreter" (Lakoff 2005: 12).

Though its development was often a drawn-out and contentious affair, once released, the *DSM III* quickly made waves in the general public. "There were splashy stories in the press," writes the journalist Alix Spiegel, "and TV news magazines showcased several of the newly identified disorders" (2005: 62). In the period of its initial circulation, it was translated into thirteen languages and was soon embraced by a wide array of interested parties. For the pharmaceutical industry and the insurance companies, in particular, it provided a professionally agreed-upon artifact for pushing efficiency and tracking outcomes in health service and drug provision. "The creation of a discrete set of disorders, such as panic disorder, social phobia, obsessive-compulsive, and other disorders," David Healy argues, "gave the pharmaceutical industry a set of targets at which to aim its compounds" (1997: 237). Eventually, these compounds were presented as "cleaner" and safer than their predecessors because they arguably targeted a definitive set of neurochemicals, such as dopamine and serotonin, that were increasingly being conceptualized as the heart of emotional disturbance, even though definitive links have yet to be established (Rose 2003; Whitaker 2002; Lacasse and Leo 2005).

In this era, through the close combination of a proliferation of therapeutic agents and new technologies of intervention, visualization, and classification, psychiatry, as Brad Lewis argues, came to acquire "an amazingly idealized notion of 'theory neutrality'" (2006a: 1). The power of science to talk and to compel publics, of course, is not a self-enclosed and self-sustaining engine that transports a new model of mental illness to public acceptance. As with any scientific claim or medical therapy, there are various complicated, though often invisible, forms of labor at work, including moral promise, and the one provided by the new pharmaceutical reason proved to be particularly enticing. The neurochemical model of mental illness was seductive, in part, because it provided a pronounced pledge: a moral alibi that could free human persons from certain forms of responsibility, and thus, it was said, from stigma. As Tanya Luhrmann argues persuasively in her analysis of American psychiatry, "[b]iology is the great moral loophole of our age. If something is in the body, an individual cannot be blamed; the body is always morally innocent" (2000: 8).

The promulgation of this model and its moral implications was voiced by psychiatrists, many patients, and more indirectly but no less powerfully, furthered by the pharmaceutical industry through a considerably fortified advertising apparatus. And perhaps more than by any other group, the biological model was heralded by another stakeholder that

appeared a little less than a decade after the establishment of survivor activism: the National Alliance for the Mentally Ill (NAMI). Founded in 1979, NAMI is a large-scale nonprofit, support, and advocacy organization of families and friends of those with severe mental illnesses. It sits in significant tension with survivors for its uncritical endorsement of drug therapy and the neurochemical model of mental illness (Morrison 2005: 85–87, 149–155; Whitaker 2002: 283). With hefty funding, much of it from Big Pharma, NAMI champions, to the general public and the government, the biological model of illness as a path to orient research and therapy, and especially to pave over the bumpy gravel road of stigma. It states on its Web site: "Mental illnesses are, biologically based brain disorders. They cannot be overcome through 'will power' and are not related to a person's 'character' on intelligence."[15]

If mad liberation politics of the 1970s opened a space in which the "mentally ill" demanded a voice and were to some degree granted this rationality, then the growing acceptance of the neurochemical model of illness, with its moral promise for a possible cure and destigmatization, changed the terms of engagement. Now, to be rational meant to accept this model of mental illness and, as a close corollary, the treatment model it entailed: psychotropic drugs. To do otherwise was seen as a stark rejection of what was being presented as transparent and clear scientific evidence and would implicitly, though no less powerfully, recode a person as lacking in rational capacities.

Despite these changes, the language of freedom initiated by the radicals of the 1970s did not all of a sudden vaporize; instead it mutated. The politics of the mad movement unleashed a discursive genie of self-determination and freedom that, due to its enormous popular appeal in the American cultural imaginary (cf. Foner 1998; Norton 1993) and other liberal democracies, did not vanish. During the mid-1980s, in the face of the dominance of a renewed biological model of psychiatry, the public and radical face of the psychiatric survivor movement wilted. In its stead, the consumer reform movement flourished. It retained a language of freedom which, at times, aligned with and reinforced the neoliberal currents still with us today.

And consumerism it was. The 1980s, and especially the 1990s, saw the rise of a fortified pharmaceutical industry whose dizzying profits were the result of many changes in research and development as well as marketing practices. The pharmaceutical industry aggressively engaged in marketing campaigns, pitching directly to doctors and hospitals. In the United States, new laws sanctioned direct-to-consumer advertising for all classes of pharmaceutical treatment. This helped to secure the rise of a handful of blockbuster drugs targeting the management of a range of chronic health conditions from high cholesterol to depression (Oldani 2004; Goozner 2004; Healy 1997, 2002; also see collections in Elliott and Chambers 2004; Sismondo 2004; and Petryna et al. 2006). These changes helped set into motion cultural changes in self-perception (Rose 2003; Dumit 2003a, 2003b) and fueled a growing cultural acceptance of, and perhaps even a desire for, pharmacological interventions to manage the body and its afflictions (Elliott 2003).

Since the 1990s, the pharmaceutical companies have worked assiduously to connect specific drugs to the discrete disorders outlined in the *DSM* by directly providing doctors and hospitals with recommendations and guidelines, known in some places as medication algorithms (Waters 2005). It was more common than ever to be told that mental illnesses were chronic conditions that often required a lifetime of cocktail drug therapy. Within this changed environment, psychiatric patients more than ever were called consumers and clients, labels that some patients, even those critical of psychiatry, started to actively embrace (Tomes 2006; Morrison 2005; Chamberlin 1990).

Indeed, they were granted the rationality of consumers: by the 1980s they were encouraged to participate to some degree in policy-making and development of local community health clinics and other nationally coordinated programs that replaced the large state institutions; in various mental health settings, they were asked to provide feedback so as to create a collaborative relationship between psychiatrists and clients, in the hope of reaching recovery. Given these allowances, Linda Morrison explains, the self-help consumer movement became the visible public face of the consumer, survivor, and ex-patient movement, and its political strategies were geared primarily toward the reformist goals "of obtaining funding, influence, and the power of negotiations, sitting at the table with professionals and policy makers" (Morrison 2005: 85; Tomes 2006).[16]

In this context, any accusations of forced treatment and human rights violations seemed somewhat anemic and pale, perhaps even mute. How could these claims stand as valid or communicate at all to larger publics when patients were now considered consumers exercising their free will, working in collaboration with mental health workers, managing unwanted symptoms by ingesting pills (verified as safe by the FDA) in the privacy of their homes—and the drugs were touted by doctors and pharmaceutical companies as far more effective than an earlier generation of drugs?

Politics in the Age of the Proliferating Pills

In fact the new biologization of mental health also augured different forms of control and coercion over patients, and it became clear that a united front was necessary to continue organizing effectively (Oaks 2006; Morrison 2005: 96–97). Since the 1990s, an older generation of psychiatric survivors and a new cadre of activists have come together to continue forging a radical yet tactical politics that addresses these new medical and economic contexts. The effect has been a more targeted attack against pharmaceutical science and a conscious move to end the evident strife between reformist and radical positions that had grown markedly in the 1980s, so as to accommodate a spectrum of political sentiments and individual views on the nature of illness/experience.

In the mid-1990s came many renewed efforts to reintroduce practices such as electroshock therapy, and especially forced drugging. For example, since 1997 NAMI has continually proposed, and is seeking federal backing for, a program first developed in the

1970s as part of the shift from deinstitutionalization to community mental health: the Program of Assertive Community Treatment, more commonly known as PACT. Now used in twenty states (and legalized in at least twenty more), it is a medication compliance program that provides at-home drug delivery. The idea is that trained mental health workers visit some clients every day at their homes, even twice a day, to inject them or to confirm they have swallowed their pills. New York State NAMI proudly advertises PACT as "in essence, a hospital without walls."[17]

The radical wing of mad liberation, in part because of this specter of "a hospital without walls," resurfaced with revitalized and tactical vigor. "The organized efforts by NAMI and its sympathizers to introduce PACT model of forced outpatient treatment in every state," writes Linda Morrison, "mobilized a c/s/x activist force in the 1990s that was unprecedented in the history of the movement" (2005: 91). Access to the Internet facilitated organizing and allowed for the immediate transmission of information and personal experiences of trauma, many as a result of serious side effects from drugs that were officially touted as safer than the older generation of drugs.

This new iteration of the mad liberation movement is still primarily against forced treatment and electroshock therapy, but has also had to contend with new, powerful institutional actors, notably the pharmaceutical industry and the reality it helped secure: that of a pervasive culture of prescribing and taking drugs. Psychiatric survivors now direct much of their political energy toward this arena, routinely challenging the pharmaceutical industry for false advertising and for concealing potentially harmful side effects that are discovered in their own clinical trials; and they actively support research that seeks to understand how current psychiatric drugs may produce "chemical lobotomies" by permanently altering brain chemistry.

Part of the revitalized agenda among psychiatric survivors also needs to be read as an attempt to widen the scope of rationality that had been whittled and shrunk into a box of consumerism by the popularity of the neuroscientific paradigm validated through new forms of psychiatric diagnosis and treatment in combination with neoliberal trends, such as privatized science and new techniques for advertising. And the survivons do so largely by destabilizing the current state of psychiatric science and exposing the coercion that marks current drug prescription regimes and new laws that sanction forced drugging.

For example, during a protest at the annual American Psychiatric Association meetings held May 20–23, 2006, in Toronto, psychiatric survivors and other advocates handed out a leaflet titled "In the Name of Mental Health—Psychiatry's Human Rights Violations." The first item on the list—the lack of informed consent in treating patients—forms the bulwark of their critique, past and present. This is followed by "forced drugging," which specifies and expands on the theme of informed consent to include psychotropic medication:

Psychiatrists frequently administer brain-disabling antidepressants and neuroleptics and addictive tranquilizers ("medication") without informed consent of their patients. This is unlawful. Under the Criminal Code of Canada, "unwanted touching" is an assault. Forced drugging is assault. Many psychiatric survivors have been traumatized and disabled (sometimes permanently) by forced drugging (e.g., injections).

While psychiatric survivors do affirm a person's right to take drugs for treatment and have actually moved more than ever before to openly relay and support a pro-choice stance (in part because of the rise of consumer advocacy and in part because some activists do rely on drugs), they also are quick to point to the limits of the current dominant discourse of consumer freedom. For example, the following explanation from The Freedom Center, an advocacy center based in Northampton, Massachusetts, is a fairly common position on drugs among even more radical activists. While they clearly affirm choice, and thus retain a language that is common to a consumer message born in the 1980s, they also, in the same swoop, quickly qualify it so as to demonstrate the limits of this narrative, given an institutional and social context in which there are virtually no alternative treatments and where there is a dearth of clear and honest information on side effects:

Many of our members take some kind of psychiatric medication. We believe in personal choice and empowerment as opposed to paternalism and control. We believe individuals should, with support and true informed consent, find out what works best for them. We believe that the existing "informed consent" of the psychiatric system is basically a sham. For informed consent to be authentic, everyone should have access to accurate information about "mental illness" and the real nature and toxicity of psychiatric drugs; that real alternatives to drugs should be funded and available; . . . The science behind psych meds is corrupted by drug company money, and studies show placebos (sugar pills), counseling, social supports and alternatives are more effective and safer. Medical doctors and pharmaceutical companies must stop spreading misleading and fraudulent propaganda about psych meds and start telling the truth about how dangerous, ineffective, and often counterproductive they can be. Doctors should stop pushing meds—even putting people on six, seven, or eight different drugs at once. This is abuse.[18]

The organization's co-founder further clarifies that "pro-choice is a way to deal with the reality of individuals on medications who feel judged and alienated. We don't want to be shrinks in reverse. We are a harm reduction movement—we are not advocating abstinence and we respect that people make difficult decisions."[19] However, as they recognize, with no other institutional options provided—much less insurance coverage—than to take drugs, many consider consumer choice an empty promise that works to reassert the neurochemical model of illness that is, as far as they see it, still far from scientifically established, only made worse by the nearly blind faith put in pharmaceutical treatments.

Therefore psychiatric survivors, even while working with more reformist consumer advocates, point to the limits of a model of consumerism as freedom. It reveals the power imbalances concealed in a model that has reached the status of nearly unquestionable truth. Given this status, it is not surprising that so many of their political efforts are currently directed at undermining the confidence that in turn underlies the scientific basis of the neurochemical model of mental illness that in turn supports current practices of pharmacological interventions and, given its hegemonic status, is doing so through more extreme political measures.

In recent times, the most distilled and successful of their campaigns was the hunger strike mentioned earlier, held in Pasadena, California, in August and September of 2003. Six psychiatric survivors were joined by survivors all over the country who organized shorter solidarity fasts in order to draw the attention of the American Psychiatric Association, the National Alliance for the Mentally Ill, and the U.S. surgeon general. Their primary demand was "that the mental health industry produce *even one* study proving the common industry claim that mental illness is biologically-based."[20]

The choice of a hunger strike was significant for pragmatic and symbolic reasons. Despite years of consumer input in the field of psychiatry, one topic was behind barbed wire, off-limits to any sort of meaningful debate: the biochemical nature of mental illness. These psychiatric survivors deployed an extreme political tactic to attempt to force a discussion on a reductive biological theory of mental illness, which seemed to lie largely beyond discussion. Additionally, their hunger strike enunciated strong performative elements. These psychiatric survivors, who have suffered under psychiatric care, are willing to inflict suffering on themselves to demonstrate how those very organizations and institutions that assert they are helping them have instead come to stand for the suffering they claim to have endured.

At the time, I was following the strike with keen interest, in part because this move seemed particularly bold. Even while it was clear there was still a high degree of uncertainty surrounding the neurochemical basis of mental illness, it seemed to me that the APA and related parties could probably produce at least *one* source that, if nothing else, seemed, in the greater public eye, to offer "enough evidence" to validate their claims. And if they did, this would significantly, if not indefinitely, mute and silence the position advocated by these protesters. "The protesters faced the possibility," Brad Lewis rightly notes, "of being labeled 'mad' " (2006b: 339). These actions, in other words, seemed to be risky not only because of the physical injury potentially incurred by fasting but also because, if they failed in their quest, the larger movement would be further discredited by some of the most powerful associations and institutions of psychiatry while under the steady gaze of the mainstream media.[21]

Soon after the start of the hunger strike, the APA refused to release a statement. After twenty days, its medical director had a brief telephone conversation with one protester, telling him that mental illnesses were in fact "brain diseases and that this fact is as

irrefutable as the 'earth going around the sun' " (emphasis added). Surprisingly, a few days later, the APA released an official statement that refuted this earlier claim. Though it was insistent that mental illness was biological, it acknowledged that brain science, as they called it,

... has not advanced to the point where scientists or clinicians can point to readily discernible pathologic lesions or genetic abnormalities that in and of themselves serve as reliable or predictive bio-markers of a given mental disorder or mental disorders as a group. Mental disorders will likely be *proven* to represent disorders of intercellular communication; or of disrupted neural circuitry." (emphasis added)

Of course, this revelation neither proves nor fully denies a biological reality for mental illness. More than anything else, it is significant because the APA finally engaged in a debate, as defined by the survivors, on the limits, lacunae, and myopic reductionism of psychiatric science.[22] Specifically, the APA openly admitted to a routine state of any scientific endeavor: being in a state of uncertainty or partial certainty, and the need to orient known variables toward hypothetical future possibilities.[23] As the APA claims, given what we know, it is conceivable that a more sound neurochemical model for mental illness may be found, but as it stands, there are still many pieces missing from this model—too many, perhaps, to warrant the type of uncritical confidence exuded both by institutional psychiatry and, especially, by the pharmaceutical industry. As stated during a media interview with David Oaks, one of the fasting survivors: "They acknowledged that they didn't have the biological evidence [of mental illness], so that's on the record. . . . Now it's time for the APA to implement a far more complex model [of mental illness] that reflects the whole person and not just this narrow, reductionist, biological model."[24]

With an admission of uncertainty there also comes some acknowledgment that treatment may not be as efficacious as routinely presented, and thus there is room for alternative theories, public debate, and ongoing critique. Another way of thinking about the admission of uncertainty is that it places advocates/patients/survivors in a position where they *must* be taken more seriously as experts because so-called experts are operating as much within an uncertain territory as their patients, yet patients are the ones who have to bear the very real consequences of engaging in therapies that, though many personally admit they are helpful and necessary, still carry tremendous, ill-understood risk. In the end, one of the strongest messages this hunger strike conveyed is that many psychiatric survivors are not questioning medical science per se, but are asking for a more open, transparent practice that fully confronts and admits to current uncertainties, verified risks in treatments, and the highly reductionist orientation of current models. This is the only way to end the abuse and unequal power relations so commonly attributed to psychiatry.

One interesting question that follows from the APA admission discussed above is, What sort of treatments should one, or can one, devise in a field of missing pieces? This

question is one that many survivors, consumers, and patients must, and do, confront when they decide to embark on a drug treatment regime whose long-term effects are poorly understood and whose known side effects are often concealed and, when addressed, often grossly underemphasized. But this often is a personal choice that occurs individually, or increasingly collectively among peers on the Internet, or through the support networks of survivor organizations, well outside of open and public debate with mainstream psychiatrists and, most certainly, the pharmaceutical industry.

And what is clear is that while this question is difficult to ask within the context of biomedicine, which eschews uncertainty and, often for good reasons, it is even a more unthinkable question to ask within an industry that works along a curious logic of promise that uses the past as a prop by which to argue for progress, advancement, and thus goodwill. Drawing on the work of Paul Rabinow, Nick Rose distills the nature of today's pharmaceutical-driven psychiatry as one of a tight entanglement between the drive for knowledge and the need to secure high profit margins: "The quest for truth is no longer sufficient to mobilize a production of psychiatric knowledge . . . the profit to be made from promising health has become the prime motive in generating what counts for our knowledge for mental ill-health" (2003: 58). As part of this promise, one claim shines forth unambiguously: that new drugs are a marked improvement, whether in efficacy, in their ability to target more discretely a class of neurotransmitter, or in producing less harmful side effects than their predecessors (Whitaker 2002: 257). Even if they cannot offer a cure, they do offer a narrative of progress prepackaged in good-will.

This polished narrative, however, has lost some of its luster in the last years. There have been disclosures in the mainstream public that have significantly sullied the pharmaceutical industry's fabricated good-will and the intentions that it has striven to promote since the 1980s. The long list is growing, and can be enumerated only in brief. It includes the revelation that the pharmaceutical industry downplayed and hid data on the severity of side effects of a class of anti-inflammatory pain killers, as well as antidepression medications. It also includes two studies, one in the United States and the other in Great Britain, which found that new antipsychotic drugs differ from their predecessors only in price, not safety or efficacy. Most recently, and closest to the politics of psychiatric survivors, *The New York Times*, after obtaining internal documents leaked from an ongoing product liability lawsuit, divulged that Eli Lily systematically downplayed the health risks and side effects of a schizophrenia medication that is best-selling drug, Zyprexa. Many survivors are now involved in a its campaign to circulate and comment on these documents, in the hopes of raising more critical awareness about the dangers of certain psychiatric drugs.[25] Taken together, these revelations have generated increasing critical attention on the FDA's lack of regulatory rigor and integrity in overseeing the scientific testing and market release of these drugs.[26]

Along with this critical media attention on pharmaceutical corporations and the FDA, mainstream medicine and the medication practices it entails, while certainly still

pervasively deployed and admired, have also been met with stiff competition, patient exodus, and often outright suspicion as patients pursue alternative treatments, which have grown exponentially in types and availability since the 1980s (Eisenberg et al. 1998). Patients who remain in mainstream medicine often do so on their own terms, cultivating a pronounced form of self-expertise used in partial self-diagnosis and treatment, often with the aid of new Internet technologies. Both moves are usually accompanied by a vigorous critique of conventional medicine and pharmaceuticals—a message that states treatments, and the power to classify and treat illness, are no longer the exclusive property of established medicine. Thus, amid vigorous public and media scrutiny, the tarnished image of the pharmaceutical industry, and a semi-autonomous zone of peer-to-peer diagnosis and treatment, the critiques heralded by psychiatric survivors regarding the shaky foundations of pharmaceutical science and their call for unconditional self-determination have an opportunity to resonate more profoundly and widely, once again, in the greater public arena.

Conclusion

"The struggle of man against power," wrote Milan Kundera, "is the struggle of memory against forgetting." Though not necessarily one of the best-known sets of political actors, psychiatric survivors, ex-patients, and consumers, by virtue of their persistence and tactical ability to shift messages, have engaged successfully in the struggle against power. As in all social movements, the crucial move is not simply to speak to power, but to cultivate a historical consciousness of this process, for it is by this cultivated memory that a politics is propelled from the present into the future, to respond to changing conditions.

Survivors are well aware of their legacy, and it is made apparent in a number of registers. For example, in current-day speeches, it is common for movement leaders to revive Martin Luther King in reminding their listeners that "[h]uman salvation lies in the hands of the creatively maladjusted" (Oaks 2006). In so doing, the speakers are offering inspirational words about their plight that follows from coercive treatments. The invocation also serves to remind their audience that their movement is a "nonviolent revolution" with historical roots firmly grounded in the civil rights era and with basic goals that remain unchanged.

Starting in the 1980s, however, psychiatric survivors found themselves in a predicament similar to that of a host other radical advocates. The sharp edge of many radical claims, often voiced in a lexicon of freedom and liberty, was blunted by a broader set of economic and cultural shifts that entrenched a new commonsense language of freedom centered on the ideas of lifestyle choice and free market principles. It is also likely that the plethora of laudable legal changes that occured in the 1960s and 1970s bred an unintentional wave of complacency among liberal and progressive publics who were comforted by the fact that the worst forms of segregation, inequity, and mental health abuse were over, for many had been fixed in the law books.

Psychiatric survivors' viability as a radical political movement was also threatened with extinction by a unique set of challenges. They were questioning a set of medical practices that, in the short span of a decade, had changed to become not only more legitimate, but also much more pervasive within the health sciences, the medical profession, and the public at large. The pharmaceutical industry developed and released a wide array of drugs poised to be prescribed by psychiatrists and other health workers (such as family doctors and registered nurses) to people in nearly every age group to manage an equally wide array of proliferating conditions. Along with the multiplication of these medications, a rosy optimism came to mark the field, one in which the past could easily be marshaled to designate the progressiveness and humaneness of the present moment. Because psychiatry's orientation evolved from its psychoanalytic roots, with a firm institutional base in the asylum, to a medical science paradigm, the rhetoric of scientific progress became pronounced. Given this historical dynamic, survivors are easily discredited as fanatical for their inability to accept what is presented as the truth of science. Yet, drawing from their own forms of historical consciousnesses and their legacy built from experiencing, firsthand, treatments that were often provided in the name of care and therapy—and only later acknowledged to be harmful, useless, or even barbaric—survivors approach the field with a skeptic's sword that, when applied in the political sphere, works to make unmistakably clear the risks of *current* treatment and, thus, to disturb this narrative of progress.

Acknowledgments

This article benefited from many helping hands. Genevieve Lakier, Micah Anderson, Praveen Sinha, and the participants in the 2006 Law and Society Summer Institute (especially the workshop leaders, Michele Goodwin and Jonathan Klaaren) provided helpful comments on an earlier draft. Marko Zivkovic, Charles Barbour, Jeff Kochan, Kathleen Lowery, Jonah Bossewitch, Chloe Silverman, Pamela Moss, and Linda Morrison commented incisively on more recent drafts. I extend extra thanks to Will Hall, Rob Wilson, Alex Choby, and Erika Dyck, who each went beyond the call of duty. While many of their most incisive comments are not reflected here, they certainly enriched the article and my larger project.

Notes

1. While the c/s/x movement may historically represent the most visible collectivity protesting mental health abuse, there were certainly a number of antecedents. For a discussion of them, see Morrison (2005: 63–67). There is also a rich first-person literature by survivors and other mental health advocates on their plight, history, recovery, and activism. For an extensive list, see Gail Hornstein's bibliography: http://www.mtholyoke.edu/acad/assets/Academics/Hornstein _Bibliography.pdf.

E. Gabriella Coleman

2. By "radical" I do not mean politically Left, for radical survivors span the spectrum from anarchism to libertarianism. What I do mean is a strong, unconditional, and institutionally independent critique of pharmaceutical science and psychiatric abuse.

3. Currently, the most visible organizational face of this revitalized politics is MindFreedom International. MFI helps to coordinate over one hundred other advocacy and political organizations to fight for human rights for those with psychiatric disabilities. See http://www.mindfreedom.org.

4. http://www.mindfreedom.org/kb/act/2003/mf-hunger-strike.

5. The most comprehensive academic account on the c/s/x movement in the American context is Linda J. Morrison's *Talking Back to Psychiatry* (2005), and this chapter is heavily indebted to her analysis. I also draw on Judi Chamberlin's (1990) assessment of the movement. For an account of mental health critique and advocacy in England, see Crossley (2006), and for an examination of a Canadian case, see Barbara Everett (2000). Nancy Tomes (2006) provides a brief history in order to assess the movement's role in changing mental health policy. Brad Lewis (2006b) situates psychiatric survivors and consumers within the wider field of disability rights.

6. http://www.dartmouth.edu/~towardsfreedom/transcript.html.

7. http://www.wmich.edu/~ulib/archives/mlk/transcription.html.

8. Anti-psychiatry and survivor activism are often incorrectly conflated or collapsed; for two recent examples of this, see Rissmiller and Rissmiller (2006) and Sharfstein and Dickerson (2006). Though ex-patients and survivors drew on the anti-psychiatry literature to formulate their politics (evident, for example, in the early issues of *Madness Network News*), some survivors and ex-patients also differentiated their political goals from what they often saw an elitist enterprise (see, for example, Chamberlin 1990: 324). As survivors have moved to clearly broadcast a pro-choice drug stance, it is also harder to sweep them under the rug of anti-psychiatry, and leaders of the movement reiterate this position in public speeches (see, for example, Oaks 2006). My feeling is that some professional psychiatrists and mental health workers, such as the two sets of authors cited above, label survivors as "anti-psychiatry" in order to portray them as fanatical, and thus delegitimate and obscure their message. They also sharply distinguish them from consumers, whom they tend to designate as "the acceptable activists."

9. For the articulation of these early positions, see Hirsch et al. (1974).

10. To be sure, prior to the development of current neurochemical theories of mental illness, and even during the dominance of psychoanalysis, there was a range of popular somatic theories and treatments that also guided psychiatric approaches. For example, through much of the early-to-mid-twentieth century, most patients diagnosed with "severe" mental illnesses underwent therapies that directly manipulated or altered body physiology, most famously insulin coma therapy, lobotomy, and electroshock therapy.

11. For accounts of the demise of institutionalization and the transition to community care, see Brown (1985) and Grob (1991).

12. The reshaping of mental health law followed from a slew of federal and state cases argued and decided primarily in the 1960s and 1970s. Many of the most famous ones were argued by Bruce

Ennis of the New York Civil Liberties Union. In particular, the Supreme Court case of *Donaldson* v. *O'Connor*, 422 U.S. 563 (1975), which he argued, is regarded as one of the most important. As it regards to civil liberties, the pertinent section reads: "A finding of 'mental illness' alone cannot justify a State's locking a person up against his will and keeping him indefinitely in simple custodial confinement. . . . In short, a state cannot constitutionally confine without more a nondangerous individual who is capable of surviving safely in freedom by himself or with the help of willing and responsible family members or friends." For a further discussion of challenges to mental health law in this period, see Brown (1985: 175–193).

13. Though Spitzer wanted the DSM to classify *diseases*, in the end, the committee settled on the term "disorder" to reach consensus with the APA-member psychologists, many of whom opposed the language of disease.

14. For additional critiques of the *DSM*, see Kirk and Kutchins (1992) as well as Brad Lewis's extension of their critique to include the question of power relations (2006a, esp. chap. 6).

15. http://www.nami.org/Content/NavigationMenu/Inform_Yourself/About_Mental_Illness.htm (accessed October 3, 2007).

16. For a specific account of the tensions between consumers and survivors in the mid-to-late 1980s and the demise of the MNN due to waning support, see Morrison (2005: 80–87).

17. http://www.naminys.org.

18. http://www.freedom-center.org/section/about.

19. Personal communication, November 29, 2006.

20. http://www.mindfreedom.org/kb/act/2003/mf-hunger-strike/hunger-strike-debate.

21. The hunger strike generated pronounced media attention. For two extensive pieces, see http://www.mindfreedom.org/know/mental-health-activism/2003/mf-hunger-strike/hunger-strike-media.

22. To be sure, medical textbooks and drug ads openly address uncertainty. However, these acknowledgments, especially in advertisements, tend to operate socially, as they are in fine print, and thus are often minimized in practice (though certainly not by all psychiatrists). Thus, what is significant about the hunger strike and the APA admission is that, for at least one moment in time, the "fine print" was transformed into unmistakably large print.

23. To date, one of the most interesting and important accounts of the political techniques to transform data and information into perceptible and imperceptible knowledge in medical science and among patients is Michelle Murphy's fascinating analysis of sick building syndrome (2006).

24. http://www.mindfreedom.org/campaign/media/mf/losing-the-mind-david-oaks-and-others-in-the-mad-pride-movement-believe-drugs-are-being-overused-in-treating-mental-illness-and-they-want-the-abuse-to-stop/?searchterm=zoloft%20david%20oaks.

25. Eli Lily has tried to halt circulation of these documents, which have been widely posted on Internet sites and blogs for download. On February 13, 2007, a judge ordered a permanent injunction against a group of named people known to possess the documents, barring them from circulating the documents. But he also ruled that at this point "it is unlikely that the court can now

effectively enforce an injunction against the Internet in its various manifestations, and it would constitute a dubious manifestation of public policy were it to attempt to do so." For ongoing developments, links to the ruling, and the leaked documents, see http://zyprexa.pbwiki.com.

26. In recent times, the media attention placed on the pharmaceutical industry has been nothing short of remarkably critical and extensive. Coverage can be found in publications with a variety of political perspectives, such as those that are squarely liberal (*New York Times* and *Washington Post*), Left-leaning (*Mother Jones, AdBusters, The Nation*), business-oriented (*Forbes, Business Week, The Economist*), academic (*The New York Review of Books*), and even lifestyle/entertainment (*New York* magazine, *People* magazine).

References

Brown, Phil. 1985. *The Transfer of Care: Psychiatric Deinstitutionalization and Its Aftermath.* London: Routledge & Kegan Paul.

Chamberlin, Judi. 1990. "The Ex-Patient's Movement: Where We've Been and Where We're Going." *Journal of Mind and Behavior* 11(3): 323–336.

Crossley, Nick. 2006. *Contesting Psychiatry: Social Movements in Mental Health.* Abingdon, U.K.: Routledge.

Dolnick, Edward. 1998. *Madness on the Couch: Blaming the Victim in the Heyday of Psychoanalysis.* New York: Simon & Schuster.

Dumit, Joseph. 2003a. "Is It Me or My Brain? Depression and Neuroscientific Facts." *Journal of Medical Humanities* 24(1/2): 35–47.

—. 2003b. *Picturing Personhood: Brain Scans and Biomedical Identity.* Princeton, N.J.: Princeton University Press.

Eisenberg, David M., et al. 1998. "Trends in Alternative Medicine Use in the United States, 1990–1997." *Journal of the American Medical Association* 280(18): 1569–1575.

Elliott. Carl. 2003. *Better Than Well: American Medicine Meets the American Dream.* New York: Norton.

Elliott, Carl, and Tod Chambers (eds.). 2004. *Prozac as a Way of Life.* Chapel Hill: University of North Carolina Press.

Everett, Barbara. 2000. *A Fragile Revolution: Consumers and Psychiatric Survivors Confront the Power of the Mental Health System.* Waterloo, Ontario: Wilfrid Laurier University Press.

Foner, Eric. 1998. *The Story of American Freedom.* New York: Norton.

Foucault, Michel. 1970 [1998]. "Madness and Society." In Foucault's *Aesthetics, Method, and Epistemology*, vol 2, ed. James Faubion, trans. Robert Hunley et al. New York: New Press.

Goozner, Merrill. 2004. *The $800 Million Dollar Pill.* Berkeley: University of California Press.

Grob, Gerald. 1991. *From Asylum to Community: Mental Health Policy in Modern America.* Princeton, N.J.: Princeton University Press.

Harvey, David. 2005. *A Brief History of Neoliberalism.* Oxford: Oxford University Press.

Healy, David. 1997. *The Antidepressant Era.* Cambridge, Mass.: Harvard University Press.

—. 2002. *The Creation of Psychopharmacology.* Cambridge, Mass.: Harvard University Press.

Hirsch, Sherry, et al. 1974. *The Madness Network News Reader.* San Francisco: Glide.

Kirk, Stuart, and Herb Kutchins. 1992. *The Selling of the DSM: The Rhetoric of Science in Psychiatry.* Piscataway, N.J.: Aldine.

Lacasse, Jeffery, and Jonathan Leo. 2005. "Serotonin and Depression: A Disconnect Between the Advertisements and the Scientific Literature." *PLoS Med* 2(12): e392 DOI: 10.1371/journal.pmed.0020392.

Lakoff, Andrew. 2005. *Pharmaceutical Reason: Knowledge and Value in Global Psychiatry.* Cambridge: Cambridge University of Press.

Lewis, Bradley. 2006a. *Moving Beyond Prozac, DSM, and the New Psychiatry.* Ann Arbor: University of Michigan Press.

—. 2006b. "A Mad Fight: Psychiatry and Disability Activism." In *The Disabilities Studies Reader,* ed. Lennard Davis, 2nd ed. New York: Routledge.

Luhrmann, Tanya. 2000. *Of Two Minds: The Growing Disorder In American Psychiatry.* New York: Knopf.

Marcuse, Herbert. 1968. *Negations.* Boston: Beacon Press.

Morrison, Linda. 2005. *Talking Back to Psychiatry: The Psychiatric Consumer/Survivor/Ex-Patient Movement.* New York: Routledge.

Murphy, Michelle. 2006. *Sick Building Syndrome and the Problem of Uncertainty.* Durham, N.C.: Duke University Press.

Norton, Anne. 1993. *Republic of Signs: Liberal Theory and American Popular Culture.* Chicago: University of Chicago Press.

Oaks, David. 2006. "Unite for a Nonviolent Revolution in the Mental Health System: What 30 Years in the Mad Movement Have Taught Me." Talk delivered at "Open Minds: Cultural, Critical and Activist Perspectives on Psychiatry," New York University, September 23. On file with the author.

Oldani, Michael. 2004. "Thick Prescriptions: Toward an Interpretation of Pharmaceutical Sales Practices." *Medical Anthropology Quarterly* 18(3): 325–356.

Petryna, Adriana, Andrew Lakoff, and Arthur Kleinman (eds.). 2006. *Global Pharmaceuticals: Ethics, Markets, Practices.* Durham, N.C.: Duke University Press.

Rissmiller, David, and Joshua Rissmiller. 2006. "Evolution of the Antipsychiatry Movement into Mental Health Consumerism." *Psychiatric Services* 57: 863–866.

Rose, Nikolas. 2003. "Neurochemical Selves." *Society* 41(1): 46–59.

Rosenhan, David. 1973. "On Being Sane in Insane Places." *Science,* January 19, pp. 251–258.

E. Gabriella Coleman

Sharfstein, Steven, and Faith Dickerson. 2006. "Psychiatry and the Consumer Movement." *Health Affairs* 25(3): 734–736.

Sismondo, Sergio (ed.). 2004. "Intersections of Pharmaceutical Research and Marketing." *Social Studies of Science* 34 (2).

Spiegel, Alix. 2005. "The Dictionary of Disorder: How One Man Revolutionized Psychiatry." *The New Yorker*, January 3, pp. 56–63.

Tomes, Nancy. 2006. "The Patient as Policy Factor: A Historical Case Study of the Consumer/ Survivor Movement. *Health Affairs* 25(3): 720–729.

Waters, Rob. 2005. "Medicating Aliah." *Mother Jones*, May/June, pp. 50–56.

Whitaker, Robert. 2002. *Mad in America: Bad Science, Bad Medicine, and the Enduring Mistreatment of the Mentally Ill*. Cambridge: Perseus.

Reaching the Limit

When Art Becomes Science

Beatriz da Costa

The politically oriented artist engaged in technoscientific discourses faces significant challenges. She has to be versatile within the theoretical framework developed in disciplinary areas such as science and cultural studies, acquire the technical and/or scientific skill base needed in her chosen area of investigation, and develop an artistic language appealing to peers in her field while remaining accessible to a nonexpert audience. In addition, for the more activist-inclined artists in this area, interactions with other (nonartist) activist groupings are often indispensable, resulting in yet another set of skills and modes of interaction to be acquired.

Given the limited funding opportunities for most artistic endeavors, especially the ones that dare to affirm politicized discourses as part of their creative processes and public manifestations, the acquisition of such a broad range of skills can be difficult. For the privileged few entering a flexible, multidisciplinary Ph.D. program, a long-term research residency, or other kinds of work environments designed to support these types of knowledge acquisition, the in-depth development of such a practice might be a possibility. But let's be realistic. Not only are the above options limited in their capacity but, in addition, most politically oriented artists became "radicalized" through real-life experience, commonly define their place of research outside the walls of academia, and only reluctantly admit their partial dependence on the latter to begin with.

However, given the educational system in the United States, which places art education, with the exception of a few independent art schools, inside the university, members of this more radical strain of artists often find their employment and source of income back in the academy itself, even if preceding activities which led to a mature practice took place in less sanctioned environments. Not only are job opportunities outside the university scarce (even more so than within it), but direct access to the locations where science is being conducted is often a necessity for those who wish to become active players

in the shaping of socioscientific discourses and their (mis)appropriation by cultural, political, and economic forces.

When we ask what type of role the intellectual should assume once she has rejected the impetus to function as the "bringer and master of truth" in our society, Foucault might urge us to consider the distinction between the "universal" and the "specific" intellectual.[1] Unlike the "universal" intellectual, whose duty was to serve as "the consciousness/conscience of us all" and whose primary task was to fulfill this mission through the written word, distanced and removed from the people who were identified as the supposed beneficiaries of such discourses, the "specific" intellectual emerged out of a group of people that was originally not given the status of intellectuals at all. Engineers, mathematicians, physicists, and other scientists were respected for their expertise and specialized knowledge, but were by no means given the role of transcendental context providers. Citing J. Robert Oppenheimer as an example, Foucault identifies a moment in history in which the intellectual was held accountable by political powers, not because of his [sic] discourse, but precisely because of his expertise and specialized knowledge.[2] Oppenheimer himself is described as one of the pivotal figures who simultaneously assumed both roles: the "specific" intellectual, given his knowledge and dedication to the discipline of physics, and the "universal" one, given the affect the nuclear threat had on the world at the time. His discourse became, by necessity, a universal one.

Today, we find ourselves in a university environment filled with "specific" intellectuals. Unlike the philosophers of the past, these individuals are confronted with everyday struggles and share similar adversaries with the working and middle classes outside of the academy: the ideological and economic influence of multinational corporations (on knowledge production, among many other things) and capital at large, as well as the judicial and police apparatuses.[3] Imposed cooperation with the forces described above, combined with the expertise held by the "academic intellectual," has influenced the intellectual's ability and responsibility to participate in the political shaping of society as well as in the "process of politicizing intellectuals themselves."[4] Direct confrontation with an "adversary" at hand is often all that is needed in order to reflect on one's own position of power and ability to act. The conduct of "objective" and "pure" research, independent from the political "outside," becomes a less and less plausible position to hold at a time in which industrial, military, and political interests are directly tied to funding provided by the respective institutions.[5]

What type of role is the artist engaged in the technosciences (certainly ranking among the most vulnerable disciplines subjected to the powers described above) to assume in this context? How can the artist function as an activist intellectual situated between the academy and the "general public" in an age in which global capital and political interests have obtained an ever-increasing grip on the educational and public environments where technical, scientific, and artistic knowledge production occur?

Before we delve into such issues, let us first look at the environment that gave rise to this type of knowledge production and examine more closely the figure that we might call the "political technoscientific artist."

"New Media Art" and the Emergence of the Artist as a "Specific" Intellectual

In the early 1990s we have seen the increased popularity of a new disciplinary area within the visual arts. Sometimes referred to as "new media art," "emergent technology art" or (at worst) "computer art," this area incorporates the use and critical examination of a range of new media, tools, and technologies that have become available with the advent of personal computing and the decrease in costs for anything electronic. "Net art," "interactive art," and "robotic art" are just a few of these recently emerged and newly categorized subfields. Whereas art since modernism has always had members who actively engaged in reexamining and expanding their forms and means of expression (from land art to fluxus, installation art, video art, sound art, etc.), the incorporation of digital technologies represented a shift of significant enough magnitude that entire programs, and by now even departments (rather than just isolated "special topics" classes), dedicated to the examination and expansion of these areas have been established.

Obviously, the willingness of universities and other institutions of higher education to invest in these areas did not stem merely from intellectual curiosity, but from the identified need to educate a generation of students versatile in both the technical and the aesthetic aspects of digital media. Equipped with these skills, they would be able to become active participants in the ever-expanding information society under capital. Parents who might previously have been opposed to supporting education in the arts, a field with dubious career options and a questionable placement record for economic prosperity, were suddenly willing to send their offspring to art school with the hope that their loved ones would one day stake a claim within the digital media and related industries.

Luckily, only a small subsection, if any, of the art faculty engaged in emergent technologies are in the business of educating the next generation of new media entrepreneurs. Rather, most faculty still attempt to equip their students with the same critical abilities that have been part of artistic education for decades. These include not only the rigorous examination of the qualities inherent in any media, but also their current use and status in society outside the realm of artistic production.

For digital technologies this presented a very interesting proposition. After all, students were trained to use, appropriate, and take apart the very machines and their electronic subsections that were in the process of transforming our society with great force and speed. Whereas some simply used their new abilities to further the expansion of artistic disciplines and their attached formulas for aesthetic expression, others attempted to redefine the very site of art itself.[6] In some cases, "site" simply implied venue. The World Wide Web has become one of such newly acquired venues for the arts. In other cases, however,

the usage of digital technologies has meant the exploration of topical areas and social phenomena intimately linked to the status and functionality of these very technologies themselves. Activities such as data categorization, (electronic) information distribution, electronic surveillance, collective action facilitated (at least partially) by electronic media, and collaborative information accumulation and distribution all have become "sites" for artistic investigation and action.

Obviously artists were not the only people present at these newly found sites. Programmers, activists, information theorists, academics, engineers, journalists, and others were involved in exploring and shaping instances of these newly available information technologies. Sometimes members of these fields would work together, at other times in competition, but everyone was certainly fueled by a sense of novelty and excitement.

What emerged among the more politically inclined early explorers of information technologies was a sense that previously established models of "DIY" media[7] had just obtained a whole new tool kit ready to be explored and expanded. Early listservs such as Nettime were dedicated not only to building a new platform for "open" communication,[8] but also to specifically using this arena to facilitate discussions to examine new capitalist formations made possible through the World Wide Web and to exchange information and ideas for potential subversion of this power at play. Other discussion forums and listservs focused on topics such as feminism in the digital age (*faces*)[9] or postcolonial developments under global capital (*undercurrents*),[10] to name just two. We also saw the formation of independent media outlets, such as *Indymedia*,[11] enabling the growing movement of citizen journalism to flourish.

A culmination of this shift in information acquisition and distribution, and thereby the construction of knowledge itself, was the framework developed for *Wikipedia*. Albeit not capable of hosting direct exchanges among people, *Wikipedia*, composed of articles by self-declared experts in given fields, collectively rewritten and edited by other individuals who declare themselves to be the same, is by now one of most frequently consulted encyclopedias of our time. While the contributions in *Wikipedia* may look similar when compared to its more "official" precursors, the open contribution platform—and thereby its contributor profiles—certainly don't. *Wikipedia* has changed the nature of collaboration with respect to knowledge production and greatly challenged the notion, definition, and status of the "expert." What a difference from the carefully nominated contributors to the *Encyclopaedia Britannica*, often carrying the weight of a Nobel Prize or similar award of distinction![12] Whereas opinions regarding the usefulness and/or the positive impact of *Wikipedia* certainly vary (celebrated by some, fiercely disputed by others), one thing is for sure: a resource that has become the one-stop reference for thousands of students and professionals (as well as other individuals) around the world has to be looked at seriously.

Much in the tradition of the "computer hobbyists" and analog electronic artists of the 1970s and 1980s, artist/engineer teams started building their own electronic hardware

tools as well as designing software programs and platforms. In this case the task is slightly more difficult, at least with respect to distribution. The open source approach used in many software initiatives doesn't translate as well into the world of resistors and diodes. The common black box, with its abilities to send software packages anywhere, is suddenly missing.[13] However, as communicative objects, hardware tools and projects have been shown to be very effective.

The Bureau of Inverse Technology (BIT)[14] was one of the early groups to explore the powers a functional tool could hold when being developed for the purpose of raising awareness around social injustice, rather than for commercial exploitation. The BIT Suicide Box[15] consisted of a motion detection video system designed to capture vertical activity. Once it had detected an object falling in front of its lens, it would trigger recording of the motion. The Suicide Box was installed on the Golden Gate Bridge in 1996, one of the most prominent suicide locations in the United States. Another example was the BIT rocket. It was designed to provide a clear video stream at six hundred feet altitude to a ground receiver. Launched from the ground, BIT rocket was used to document crowd attendance during demonstrations at a time when sanctioned news and media outlets appeared to have "accidentally" forgotten to undertake these estimates themselves.

The Institute for Applied Autonomy (IAA)[16] is another group invested in developing artist/activist inspired tools. GraffitiWriter,[17] the project that launched the group's public visibility, was a first instance of exploring the notion of a "contestational robotics." It consisted of an enhanced remote-controlled car equipped with spray cans, a microcontroller, and a type pad. Any message up to sixty-four characters could be typed in, and would be sprayed onto the street at a desired location, without its human controllers being present at the locale. Action could thus be undertaken removed from the eyes of authority and, even more important, individuals who might have had little interest in expressing their opinions publicly in the form of graffiti became involved through mere fascination with this new and unusual interface. For groups ranging from Girl Scouts to police officers, GraffitiWriter was successful in its mission to expand participant demographics and promote the notion of a contestational robotics.

So let us look at what lessons might have been learned by the "political technoscience artist in becoming" from the developments described above. On the one hand, we see increased sophistication in the use of digital and electronic technologies. Skills such as software development and electronic board design, commonly associated with disciplines other than the arts—namely, computer science and engineering—have suddenly become part of the artistic tool kit. With that have come not only an extension of possible media for artistic projects but also a shift in status for the artist herself. The disciplinary families of engineering and computer sciences enjoy a stronger economic foothold in our society than the arts traditionally did, and with that foothold comes a superior power base. Artists working between these disciplinary areas now had a choice, if they desired to obtain their piece of the economic pie; a career within the digital and media industries became a

lucrative option. This is rather different from the "starving artist" life and the never-ending hope to one day turn one's creations into highly traded commodities within the commercial gallery world.

However, for those individuals interested in employing their newly obtained skills in a different manner (which is most likely the case for our "political technoscience artist"), other opportunities were opening up. Armed with the lessons learned from public interventionist art practices of the 1970s and 1980s, artists now realized that with a shift in technology came the increased ability to create new forms of independent project and information distribution. This time not confined in museums or carefully selected sites for "public" art, but artists could infiltrate the very mechanisms designed to be the new interfaces between knowledge production and society outside the arts. In the end, it doesn't matter if *Indymedia* or *Wikipedia* had been brought into existence by artists or not. What matters is that they could have been. And many initiatives and artistic projects emerged on the basis of this realization.[18]

We could argue, then, that artists were put on the path of approaching the role of the "specific intellectual" characterized above. Rather than performing the role of an individual in search of a higher truth that will eventually be revealed and distributed to "the masses" in the form of paintings, sculptures, and other works, artists were now in the position to serve as interdisciplinary "experts" in an area that was considered to hold high economic status.

The Artist as "Dissenter"

When looking at artists' ambition to venture into the scientific realm, things become much more complicated. A common basic yet powerful skill, which allowed for the above-mentioned developments to happen, is now missing: coding.

An artist able to design custom software is by no means a computer scientist, but he or she is able to learn that trade within a couple of years and integrate it almost immediately into artistic production and other projects of choice. The same holds true for basic electronics knowledge. Even without formal training, artists have gained sophisticated enough knowledge to build their own electronic boards and implementations in an effort to design devices that will serve their particular needs. But let's remember here that the important question is not how good or bad a programmer an individual artist is, but the powers that are associated with that particular skill. It is programming under capital that we're interested in.

If we look at the sciences, and in this context I am specifically interested in the life sciences, where might we find the equivalent of "programming," a skill from which to venture out into all kinds of project ambitions? What is the trade of the life sciences that will easily translate across platforms, that puts you in command of the black box in order to conduct your future experiments? The answer is probably that there is no such trade.

Learning how to use a microscope, a pipette, or a polymerase chain reaction (PCR) machine will help you to ease your life around the laboratory, but unless you know what you are looking at, what substances you're about to mix together, or why a specific piece of DNA might be worth amplification, these skills will get you nowhere. Rather than a universal machine, what we find are highly specialized laboratories.

Another issue that must be taken into account is that scientific pursuit requires a very different relationship to time. Little or no immediate feedback is received when you're working in a wet lab, no error message, no debugging software assisting you in correcting your mistakes. While software assisting tools obviously exist and have made both pre- and postproduction in the lab much easier, in the end, organisms still need time to grow and chemical reactions need time to take place. Hours, days, weeks, or even months can pass (in the case of molecular plant biology, for example) before results of an experiment can be observed, analyzed, and the next step be put under way. Recent developments in biology have obviously attempted to "fix" these latency aspects inherent in conducting science. The Human Genome Project would not have been possible without the creation of the appropriate machinery and software applications, and fields such as bioinformatics wouldn't exist. We also have the emergence of synthetic biology, which attempts to push the mechanization of life one step farther by creating desired traits from scratch and to use lower-level organisms (such as bacteria) as input/output devices ready to be assembled into a functional living "circuit."[19]

Increase in time usually means an increase in money as well. Since artists are accustomed to work for free and are often happy not to outsource "lower division" labor tasks to other people, this might not be an issue, but to invest five years for a project to come to completion might be stretching one's involvement with the art world a little bit. Though the tolerance for production time needed has increased over the past years, there are certainly limits to this end.

So how is the artist to navigate these laboratories? How can she acquire the skills necessary in order to do anything meaningful with the organisms, solutions, petri dishes, and instruments found in the lab? How can she get access to a lab to begin with? And finally, how could she possibly finance the exuberant costs involved in conducting science? Is this really the right way to go?

A look at Bruno Latour's influential book *Science in Action* might be helpful in this regard, not only to learn more about the challenges involved but also to reaffirm the laboratory environment as one of the necessary places to investigate for artists wanting to be involved in the shaping of technoscience discourses.

Latour introduces us to the difficulties *any* outsider will encounter in the pursuit of understanding and retracing developments in the sciences. Starting with scientific literature, he reveals how the emergence of a scientific fact is brought to light. Rather than being the "simple" act of publishing a recent discovery, it is only through the careful referencing of related, previously published articles and, even more important, by through

the later referencing and rigorous examination by other members of the scientific community, that the discovery may eventually gain the status of a scientific fact. "When things hold they start becoming true."[20]

For the outsider attempting to retrace the emergence of this newly established fact, a significant problem arises. Not only does she have to familiarize herself with the terminology and language used in the paper, as well as the social and professional context in which the study was being conducted, but she also has to do the same for every referenced paper and every paper that references this paper. The curve is exponential.

Even worse, when research results are controversial, the published literature will become more and more technical. More experts will be asked to give their opinion and will, by mere reference and citation, advance the acceptance of the study in either one direction or the other (depending whether negative or positive modalities are used).[21] This shift toward the technical will make the penetration and understanding of literature even harder for the outsider, and is thereby fulfilling its desired function. Outsiders are to be kept *out* of this discussion. The number of people "allowed" even to formulate an opinion about the controversy at hand is intentionally kept low, until the controversy is resolved and ready to come to the surface as either a confirmed fact or a defeated one. Latour names our outside person, the person coming into the scientific world attempting to retrace as well as challenge a scientific fact, the "Dissenter."

Though challenging a scientific fact might not be the starting point, or even the motivation, for an artist coming into the sciences, an attraction to scientific controversies very well might be. After all, scientific controversies and the aspects of life we simply don't know about are the ones most vulnerable to exploitation in the public media and other interfaces designed to serve as mediators between scientific pursuit and political decision-making.

Eventually, after having followed the endless literature threads, Latour's "Dissenter" will have to enter the place where he believes the published results originated: the laboratory of the lead scientist. Whereas artists might not always be as diligent in reading all the involved literature first, they will find themselves at the same location. After all, science is best understood through practice!

What will the dissenter/artist find at this location? Instruments. Not really that much closer to the actual natural phenomenon being studied, instruments are serving as the interface between "nature" and its human interpreters. Graphs, curves, and images are provided by these devices in order to assist with the task of studying and interpreting, as well as fostering, a scientific claim at hand.[22]

Now instruments (as well as observation skills!) are something that artists are used to dealing with. Be it a scale to balance the right ingredients for paint or sculpture material, or an oscilloscope to observe voltage drops, artists are certainly accustomed to using them. It should come as no surprise, then, that former or current "new media artists" are by no means the only ones who make their way into the scientific laboratory.

Rather, they are being joined by installation artists, video artists, painters, and others, all arriving with the same interest in scientific inquiry and its relevance to their particular practice.[23]

However, as we have seen above, knowing how to operate the instruments found in a laboratory, from simple ones such as pipettes to more complicated ones such as PCR machines, doesn't get you all that far in your ambitions to understand scientific processes—let alone conduct your own science/art experiments. In addition, getting access to a scientific lab for more than a one-time visit can be tricky, and any conduct of science quickly becomes very expensive.

Artists have found a number of responses in order to attack these problems, and many of these are still in the process of being developed. One example is the SymbioticA research lab at the University of Western Australia. Here, a team of artists (Oron Catts and Ionat Zurr) and scientists has convinced officials and administrators within the School of Anatomy and Human Biology to house a collaboratively run research lab dedicated to the development of artistic science projects. Rather than using the facility just for their own research, Zurr and Catts have opened the doors to other interested artists, ready to invest the necessary time and training in order to conduct projects in this arena. Interested individuals can apply for extended residencies in order to achieve their goals.

In addition, Zurr, Catts, and their scientific collaborators have developed cheap do-it-yourself techniques to build usually very expensive lab equipment (such as a laminar flow hood) out of readily available home construction materials, and are conducting workshops around the world in order to spread their knowledge. These types of workshops are contributing to a larger model developed and experimented with by a number of artists in the field.

Public Amateurism

Practicing and theorizing the notion of *public amateurism* is a task that a number of artists have undertaken in recent years. Rather than attempting to achieve expert status within the sciences, artists have ventured to find help in the realm of hobbyism and do-it-yourself home recipes for conducting scientific experiments.

The *Biotech Hobbyist*[24] attempted to combine a hobbyist approach with artistic projects. Available as an on-line as well as a print publication, it consists of contributions from the artists Natalie Jeremijenko, Heath Bunting,[25] Eugene Thacker, and others. The magazine offers descriptions of DIY artistic-scientific experiments combined with step-by-step instructions and advice on how to obtain the necessary materials. The print edition, *Creative Biotechnology: A User's Manual*,[26] includes theoretical writings by the authors. One of these contributions, "Notes Towards a Sociology of Computer Hobbyism,"[27] examines the analogies between computer hobbyism of the 1970s and the proposed biotech hobbyism in the 1990s.[28]

Critical Art Ensemble (CAE) developed its notion of amateurism from its discourse on *Tactical Media* and the lay-expert relationship it observed taking place within ACT-UP. CAE translated this notion into its scientific projects initially with *Cult of the New Eve* (with Paul Vanouse and Faith Wilding)[29] while writing their book *Digital Resistance.*[30] However, the project series that fully merged theoretical discourse with practical implementation was probably its work on the politics of transgenic organisms that culminated in three projects. In their accompanying book *The Molecular Invasion,*[31] the collective developed a seven-point plan meant to serve as a guideline for negotiating the relationship between transgenic production and cultural resistance:[32]

1. Demystify transgenic production and products
2. Neutralize public fear
3. Promote critical thinking
4. Undermine and attack Edenic utopian rhetoric
5. Open the halls of science
6. Dissolve cultural boundaries of specialization
7. Build respect for amateurism.

Points 1 through 4 were certainly enacted throughout all three projects, with *Gen-Terra*[33] being the one most closely looking at point 2. Points 5–7, however, the ones of most interest to us in this context, found their biggest manifestation in *Molecular Invasion*[34] and *Free Range Grains.*[35] *Molecular Invasion*, a project by CAE, Claire Pentecost, and myself, examined the possibilities of reverse engineering Monsanto's highest cash crop, the Roundup Ready (RR) plant line.[36] We attempted to sensitize Roundup Ready crops to Monsanto's herbicide Round Up, the very poison they were designed to resist. Through the application of the compound pyridoxal 5 phosphate (a compound often found in vitamins, harmless to humans and the environment) onto the leaves of RR crops and exposure to sunlight, we undertook this task. Experiments to test our hypothesis were conducted publicly within museum spaces and with the inclusion of interested students and other groups ready to participate in this particular instance of amateur science *in action.*

With *Free Range Grains* (CAE, da Costa, and Shyh-shiun Shyu) we went one step farther, and in addition to conducting scientific experiments publicly, we included a public lab. Specifically designed to test for transgenic reminiscence in processed food products, visitors were invited to bring in recently purchased groceries, and we would test for them. This project was of particular importance in Europe, where foods containing traces of transgenic materials have to be labeled. However, the materials and lab equipment used in *Free Range Grains* were also the ones that contributed to raising initial suspicions by the police and the FBI at the beginning of the still ongoing federal investigation of the group.[37] In this case, enacting amateurism clearly didn't go without punishment.

Claire Pentecost has developed the notion of amateurism in her own right and has been working on theorizing the figure of the *public amateur* for quite some time. She writes:

In such a practice the artist becomes a person who consents to learn in public. It is a proposition of active social participation in which any nonspecialist is empowered to take the initiative to question something within a given discipline, acquire knowledge in a noninstitutionally sanctioned way, and assume the authority to interpret that knowledge, especially in regard to decisions that affect our lives. The motive is not to replace the specialist, but to augment specialization with other models that have legitimate claims to producing and interpreting knowledge.[38]

SubRosa is another group that has embraced practicing amateurism within the life sciences. Though actual engagement with life materials isn't always the case in its projects, the demystification of science and the critical examination of its political repercussions is certainly at the center of its work.

Embracing demystification by and for amateurs was thus one of the ways in which artists approached the difficult task of developing science-based projects.

Lay-Expert Relations

It should be clear by now that by *political* I don't mean local party politics or involvement in "get out the vote" campaigns. Whereas I wouldn't object to these activities, what I believe to be of interest here is not the active involvement in changing the people at play in taking command of the various institutions through which power is executed, but rather the radical undermining and redefinition of these institutions themselves.

Within the life sciences and for our "political technoscience artist," these would be the institutions that provide the contemporary grounding for the "Right of Death and Power over Life"[39] to be enacted. The sites for action now become the research and businesses involved in the agricultural, environmental, and biomedical domains.

Once again, artists obviously are not the only people found at these sites. Next to academic, political, economic, and artistically motivated individuals, we now also find a very different group of people. Namely, those who have in one way or the other been negatively affected by the institutions mentioned above and who are in search of collective organization for means of survival.

This group of people, who often develop an expert knowledge in their own right, tends to act from a position of distrust in whatever governing and decision-making forces might be held responsible for a particular situation of concern—be it available medications and funding for disease research or the environmental conditions in one's own neighborhood. Involvement within the institutions of science and their related policy-making becomes a necessity for those whose concerns aren't adequately addressed by the current social and economic system. Gabriella Coleman's analyses of the psychiatric survivor movement and

Mark Harrington's survey of activities conducted by the Treatment Action Group, found elsewhere in this anthology, provide excellent examples of the types of forces and challenges at play when a group of "dissenters" converges and organizes to resist, negotiate, and change existing governmentalities[40] responsible for the framing and treatment of disease.

The lay-expert relationship and the interfaces used to stimulate participation at these sites vary among the examples cited above. The *Biotech Hobbyist* invites interested individuals to open their own biotech kitchen in a home environment. Either by enhancing existing educational science kits commonly used in high and middle schools (which can now be found even at places like *Toys'R'Us*), or by distributing its own kits, the *Biotech Hobbyist* is clearly a resource developed by practicing amateurs for inspiring new recruits. No top-down approach is to be found, no "outreach" from an academic environment down to the "ignorant" public. The emphasis here is on fun and play.[41]

Though Critical Art Ensemble embraces a similar notion of nonhierarchical interaction with any interested participant, the production and development involved in order to bring these projects into existence are clearly dependent on active cooperation between scientific experts and the group itself. The identification of pyridoxal 5 phosphate as a potential candidate to help render RR crops vulnerable to Monsanto's herbicide would not have been possible without the help of Mustafa Unlu, at the time a Ph.D. student in the department of biology at the University of Pittsburgh. Similarly, we would not have been able to select and order the lab equipment needed in order to run the experiments involved in *Free Range Grains* without the assistance of Shyh-shiun Shyu, at the time a Ph.D. student in biology at the State University of New York, Buffalo. Expertise was needed in both cases in order to select the right materials and learn how to use and operate the equipment.

SymbioticA's research lab goes a step farther. In this case, collaboration between scientists and artists is not a temporary alliance, but the permanent institutionalization of this alliance within the university environment itself.[42]

In a lecture given a few years back in Germany, Latour talked about the eroding boundaries between research conducted within scientific laboratories and experiments taking place on the "outside."

The sharp distinction between scientific laboratories experimenting on theories and phenomena inside, and a political outside where non-experts were getting by with human values, opinions and passions, is simply evaporating under our eyes. We are now all embarked in the same collective experiments mixing humans and non-humans together—and no one is in charge. Those experiments made on us, by us, for us have no protocol. No one is given explicitly the responsibility of monitoring them. This is why a new definition of sovereignty is being called for.[43]

Critical Art Ensemble's public experiments, the *Biotech Hobbyist*'s call for home experimentation, and SymbioticA's promotion of self-designed and cheaply assembled laboratory

equipment all rely on public participation. "Audience" members become active players forced to take responsibility and assume their roles as part of publicly designed collective experiments. In that sense, artists operating at the nexus between the laboratory and the public are staging the new articulation of sovereignty being called for by Latour.

I would like to end this chapter with a personal account of the conception, production, and development of a recent project of mine, which served as a catalyst in getting me to rethink how the "political technoscience artist" might have to act when starting to become identified as a part of the educational system called the university, and associated with the role of the "specific" intellectual. Having myself experimented with various formations of lay-expert relations and their associated places for production, distribution, and creation of knowledge, I have come to ask myself at which point the political potential, so clearly inherent in the arts in their ability to consciously work with matters of presentation and representation, might break apart when approaching the sciences too closely.

PigeonBlog: Interspecies Co-production in the Pursuit of Resistant Action

—a project by Beatriz da Costa with Cina Hazegh and Kevin Ponto

"To make people believe, is to make them act."
—Michel de Certeau.[44]

PigeonBlog[45] was a collaborative endeavor between homing pigeons, artist, engineers, and pigeon fanciers engaged in a grass-roots scientific data-gathering initiative designed to collect and distribute information about air quality conditions to the general public. Pigeons carried custom-built miniature air pollution sensing devices enabled to send the collected localized information to an on-line server without delay (Figure 21.1). Pollution levels were visualized and plotted in real time over Google's mapping environment, thus allowing immediate access to the collected information to anyone with connection to the Internet.

PigeonBlog was an attempt to combine DIY electronics development with a grass-roots scientific data-gathering initiative, while simultaneously investigating the potentials of interspecies co-production in the pursuit of resistant action.[46] How could animals help us in raising awareness of social injustice? Could their ability to performing tasks and activities that humans simply can't, be exploited in this manner while maintaining a respectful relationship with the animals?

PigeonBlog was developed and implemented in Southern California, which ranks among the ten most polluted regions in the country. Its aims were (1) to reinvoke urgency around a topic that has serious health consequences but lacks public action and commitment to change, (2) to broaden the notion of a citizen science while building bridges between scientific research agendas and activist-oriented citizen concerns, and (3) to develop

Figure 21.1 A homing pigeon in the *PigeonBlog* project. Photo copyright 2006 Susanna Frohman, photographer of the San Jose Mercury News. All right reserved.

mutually positive work and play practices between situated human beings and other animals in technoscientific worlds.

When thinking of pigeons, people tend to think of the many species found in urban environments. Often referred to as "flying rats," these birds and their impressive ability to adapt to urban landscapes aren't always seen in a favorable light by their human cohabitants. At least by association, then, *PigeonBlog* attempted to start a discussion about possible new forms of cohabitation in our changing urban ecologies and made visible an already existing world of human-pigeon interaction. At a time where species boundaries are being actively reconstructed on the molecular level, a reinvestigation of human to nonhuman animal relationships is necessary.

PigeonBlog was inspired by a famous photograph of a pigeon carrying a camera around its neck taken at the turn of the twentieth century. This technology, developed by the German engineer Julius Neubronner for military applications, allowed photographs to be taken by pigeons while in flight. A small camera was set on a mechanical timer to take pictures periodically as pigeons flew over regions of interest. Currently on display in the Deutsche Museum in Munich, these cameras were functional, but never served their intended purpose of assisted spy technology during wartime. Nevertheless, this early example of using living animals as participants in surveillance technology systems provoked the following questions: What would the twenty-first-century version of this combination look like? What types of civilian and activist applications could it be used for?

Facilities emitting hazardous air pollutants are frequently sited in, or routed through, low-income and "minority" neighborhoods, thereby putting the burden of related health and work problems on already disadvantaged sectors of the population who have the least means and legal recourse (particularly in the case of non-citizens) to defend themselves against this practice. Recent studies have revealed that air pollution levels in Los Angeles and Riverside counties are high enough to directly affect children's health and development.[47]

With homing pigeons serving as the "reporters" of current air pollution levels, *Pigeon-Blog* attempted to create a spectacle provocative enough to spark people's imagination and interest in the types of action that could be taken to reverse this situation. Activists' pursuits can often have a normalizing effect rather than one that inspires social change. Circulating information on "how bad things are" can easily be lost in our daily information overload. It seems that artists are in the perfect position to invent new ways in which information is conveyed and participation is inspired. The pigeons became my communicative objects in this project and "collaborators" in the co-production of knowledge.

PigeonBlog also helped to provide entry into the health and environmental sciences. The largest government-led air pollution control agency in Southern California is the South Coast Air Quality Management District (AQMD), covering Orange County and the urban areas of Riverside and Los Angeles counties. Despite AQMD's efforts, in addition to major air quality improvements achieved since the 1970s, pollution levels in the region still surpass national regulatory health standards. In 2005 ozone levels exceeded the federal health standard for ozone on eighty-four days, or nearly one quarter of the calendar year.

Besides the actual numbers, it was the way in which air pollution measurements are currently conducted that the project hoped to address. The South Coast AQMD controls thirty-four monitoring stations in its district. These are fixed stations that cost approximately tens of thousands of dollars per station. Each station collects a set of gases restricted to its immediate surroundings. Values in between these stations are calculated based on scientific interpellation models. Stations are generally positioned in quiet, low-traffic areas, not near known pollution hot spots, such as power plants, refineries, and highways. The rationale behind this strategy is to obtain representative values of the urban air shed as opposed to data "tainted" by local sources in the immediate surroundings.

PigeonBlog's birds had the potential to test these interpellation models. Not only were they collecting the actual information while "moving" around, but they also were flying at about three hundred feet, an area that has proven difficult to assess through other means. Most flying targets are themselves sources of pollution. Airplanes in particular have this problem, and obviously cannot fly at such a low altitude.

Recent behavioral studies of pigeons have revealed that in addition to the commonly accepted theory that pigeons orient themselves in relation to the Earth's magnetic field,

they also use visual markers such as highways and bigger streets for orientation.[48] Flying about three hundred feet above the ground, pigeons are ideal candidates to help sense traffic-related air pollution, and to validate pollution dispersion in those regions. Depending on the location of the initial release, the pigeons could also report ground-level information at locations were AQMD-sanctioned monitors were not available.

The pigeon "backpack" developed for this project consisted of a combined GPS (latitude, longitude, altitude)/GSM (cell phone tower communication) unit and corresponding antennas, a dual automotive CO/NOx pollution sensor, a temperature sensor, a subscribes identity module (SIM) card interface, a microcontroller, and standard supporting electronic components. Because of its design, we essentially ended up developing an open platform, short message service (SMS) enabled cell phone, ready to be rebuilt and repurposed by anyone who is interested in doing so. While the development of the basic functionality of this device took us about three months, miniaturizing it to a comfortable pigeon size took us three times as long. After some initial discomfort, many revisions, "fitting sessions," and balance training in the loft, the birds seemed to take to the devices quite well and were able to fly short distances (up to twenty miles).

The pigeons that worked with us on the project belonged to Bob Matsuyama, a pigeon fancier and middle school shop and science teacher, who became a main collaborator in the project. He volunteered his birds for *PigeonBlog* and helped the pigeons train and interact with us.

After many trials and test flights in Southern California with Bob and his birds, we felt ready to introduce the project to a larger audience. Pigeons flew on three occasions, once as part of the Seminar in Experimental Critical Theory, an event sponsored by UC Irvine's Humanities Research Institute, and twice as part of the Inter Society for Electronic Arts (ISEA) Festival in San Jose. All three of these events took place in August 2006 and the observing human audience members got a chance to interact with the birds and retrieve the collected pollution information. The birds that worked with us in San Jose belonged to a local San Jose pigeon fancier.

The reactions to *PigeonBlog* were diverse. The human-animal work was embraced and applauded by many, but there were also critical comments by the People for the Ethical Treatment of Animals (PETA), who accused *PigeonBlog* of animal abuse and conducting nonscientifically grounded experiments. PETA's campaign didn't result in action beyond the public statement issued by the group, but it tainted the experience for a brief moment. Animal abuse was not "practiced" as part of the project, nor was animal rights a topic that the project was hoping to create public dialogue around. *PigeonBlog* was not animal rights in action but political cross-species art in action, and the collaboration with the birds was organic to the project. However, on a more positive note, PETA's critique raised very important questions regarding the legitimacy of arts/science experiments. PETA's accusations were built on the assessment that *PigeonBlog* was not scientifically grounded and should therefore cease its activities. Is human-animal work as part of political action

Beatriz da Costa

380

less legitimate than the same type of activity when framed under the umbrella of science?

In addition to technophile "fans" of the project who simply admired the "coolness factor" of putting electronics on birds, environmental health scientists raised questions about the technology used and wondered if the device could be used for their own research, which for the most part was geared toward tracing personalized pollution exposure to humans.[49] Another group of people who inquired about the project were ornithologists (professional and hobbyists) looking for cheap and feasible ways to track birds of all kinds. Then there were the many e-mails from pigeon fanciers around the country wanting to become involved in *PigeonBlog* itself, as well as green/environmental activists simply being supportive of the project's goals.

All of these inquiries had a logic to them. Whereas the technophile approach to anything electronic was certainly the least interesting or relevant to the project's aim, the technophile community is at least partially linked to the type of work that technoscience artists engage in. The specific questions regarding the technology and its potential usefulness for other research endeavors made sense. After all, the project did produce a very small, lightweight, and inexpensive device that couldn't be purchased commercially.

We also received an invitation to participate in a Defence Advanced Research Projects Agency (DARPA) grant geared toward the development of small, autonomous aerial vehicles designed around the aerodynamics of birds,[50] as well as inquiries regarding the feasibility of "measuring pulmonary artery pressure in birds during flight." How could *PigeonBlog* possibly be of help to these people? Isn't it obvious from this work that a DARPA grant is the last thing its authors would want to be involved in, and that da Costa is neither a biologist nor a veterinarian? Why was I suddenly being associated with areas of expertise that I was in no way qualified to respond to?

PigeonBlog received a lot of media coverage. Major national and international newspapers covered the project, and so had national television news channels. In nearly every instance, I was being referred to as "Beatriz da Costa, *researcher* at the University of California, Irvine." "Researcher" seemed to imply "scientist" in many people's minds, rather than "creative," "social," or "artistic" researcher. Suddenly I was put under a scrutiny and questioning similar to what scientists have to go through after publishing their work, and the association of the "political technoscientific artist" with a "specific" intellectual seemed to have gone one step too far.

This realization and thoughts about the future of *PigeonBlog* made me pause for a while. Did the project lose its political potential by becoming too closely associated with the university and myself being an actor within it? How should *PigeonBlog* continue? Should *PigeonBlog* data be linked to existing air pollution models in order to justify the project's scientific validity to criticism raised by groups such as PETA? And what would this approach entail? Would large amounts of money now have to be raised to conduct a "scientifically sanctioned" study? Would pigeons have to be flown for several years, even-

tually accumulating enough data to publish results in a scientific journal rather than at an arts festival? Wouldn't this end up creating the same trap of eventually developing expertise while becoming less accessible to a nonexpert public?

At this point, *PigeonBlog*'s future remains uncertain. Perhaps the most inspiring and gratifying inquiry came from the Cornell University Ornithology Lab, which asked me to serve on the board of its current "Urban Bird Gardens" project, which is part of its citizen science initiative.[51] The citizen science initiative involves bird observation and data gathering conducted by nonexpert citizens, ranging from the elderly to schoolchildren. Unlike other "outreach" programs conducted by universities around the country, Cornell's citizen science initiative actually uses the collected data as part of its research studies. Several projects conducted under the citizen science agenda, such as "PigeonWatch," "Urban Bird Studies," and now "Urban Bird Gardens," overlap in their aim and audience with the ambitions *PigeonBlog* set out to address.

Rather than dedicate myself to a scientific justification of *PigeonBlog* built within the university research environment and its related publication venues, I am hoping that this approach will be more true to *PigeonBlog*'s original aim in situating itself between the academy and nonexpert participants.

Notes

1. Michel Foucault, "Truth and Power," in *The Foucault Reader*, ed. Paul Rabinow (New York: Pantheon Books, 1984).

2. Ibid.

3. Ibid.

4. Ibid.

5. For more information on this topic, see Jennifer Washburn, *University, Inc.; The Corporate Corruption of American Higher Education* (New York: Basic Books, 2005).

6. For an excellent history on site-specific art and the changing notion of the term "site specificity," see Miwon Kwon, *One Place After Another: Site-Specific Art and Locational Identity*, new ed. (Cambridge, Mass.: MIT Press, 2004).

7. Deep Dish Television and Paper Tiger TV are good examples of pre-www DYI media initiatives. For more information, see http://www.papertiger.org and http://www.deepdishtv.org.

8. Nettime is a moderated listserv. For more information, see http://www.nettime.org.

9. For more information, see http://faces-l.net.

10. Undercurrents is an invitational listserv.

11. For more information, see http://www.indymedia.org.

12. For more information, see www.wikipedia.org. It should also be noted that Larry Sanger,

co-founder of *Wikipedia* and its precursor *Nupedia*, has started to build a *Wikipedia* "fork" project called www.citizendium.org. *Citizendium* will employ "officially" sanctioned experts who will function as editors for the project.

13. Tracing the relationship between open source software and open source hardware is not the purpose of this chapter. However, for recent developments in open hardware, see http://www .opencollector.org/Whyfree.

14. For more information about the Bureau of Inverse Technology, see www.bureauit.org.

15. For more information about *Suicide Box*, see http://www.bureauit.org/sbox.

16. For more information about the Institute for Applied Autonomy, see http://www .appliedautonomy.com.

17. For more information about *GraffitiWriter*, see http://www.appliedautonomy.com/gw.html.

18. For examples, see http://www.howstuffismade.org and http://www.txtmob.com.

19. For more information, see http://syntheticbiology.org.

20. Bruno Latour, *Science in Action* (Cambridge, Mass.: Harvard University Press, 1987).

21. Ibid., p. 22.

22. Ibid., chap. 2.

23. A number of these artists are included elsewhere in this anthology.

24. For more information, see http://xdesign.ucsd.edu/biotechhobbyist.

25. For more information on Heath Bunting's work, see http://www.irational.org.

26. To download available pdfs on-line go to http://www.locusplus.org.uk/biotech_hobbyist .html.

27. Ibid.

28. A good reference for the history of computer hobbyism is Steven Levy, *Hackers: Heroes of the Computer Revolution* (New York: Penguin Books, 2001).

29. Documentation of the project can be found at http://www.criticalart.net/biotech/cone/index .html.

30. *Digital Resistance* is available for free download: http://www.criticalart.net/books/digital/index .html.

31. *Molecular Invasion* is available for free download: http://www.criticalart.net/books/molecular/ index.html.

32. Critical Art Ensemble. "Transgenic Production and Cultural Resistance: A Seven-Point Plan," http://www.criticalart.net/books/molecular/chapter3.pdf. In *The Molecular Invasion* (New York: Autonomedia, 2001), p. 59.

33. Documentation of *GenTerra*, *Molecular Invasion*, and *Free Range Grains* can be found on Critical

Art Ensemble's Web site in the biotech projects section: http://www.critical-art.net/biotech/index.html.

34. Ibid.

35. Ibid.

36. Roundup is a herbicide, made by Monsanto, that is designed to kill any plants the Roundup Ready line. For background materials regarding the Roundup Ready controversy, see publications by the Etcgroup, http://www.etcgroup.org.

37. For more information regarding the case, see www.caedefensefund.org.

38. http://www.clairepentecost.org/publicamateur.org/index.htm.

39. Foucault, "The Right of Death and Power over Life," in *The Foucault Reader,* ed. Paul Rabinow (New York: Pantheon Books, 1984).

40. Michel Foucault, "Governmentality," in his *Power*, ed. James D. Faubion, trans. Robert Hurley et al. (New York: Penguin, 2002).

41. The recent appearance of biotech science kits in toy stores is interesting in this regard. Obviously, sparking the scientific interests of children might be one of the reasons why adults are looking through the science kit shelves at local toy stores. But I wouldn't be surprised at all if playing with forensic DNA and running electrophoresis experiments at home wasn't as intriguing to parents as to the children for whom these kits were originally designed. Similar to the pleasures of cooking one's dinner or fixing up one's house, the act of making, building and simultaneously learning seems to be an appealing and desirable way of spending spare time for those who can afford doing so. So here we have one reason to become involved with scientific knowledge acquisition by nonexperts: pleasure and the desire to "make things." Interestingly, these are often the same motivations which steer young high school graduates toward an education in the arts. However, in addition to "making something," "saying something" with what you make obviously has to become part of this equation very quickly.

42. SymbioticA is now offering a Master of Science degree in biological arts.

43. "What rules of method for the new socio-scientific experiments?" http://www.bruno-latour.fr/poparticles/poparticle/p095.html.

44. Michel de Certeau, *The Practice of Everyday Life*, trans. Steven Rendall (Berkeley: University of California Press, 1984), p. 148.

45. *PigeonBlog* was developed in conjunction with Preemptive Media's (Beatriz da Costa, Jamie Schulte, Brooke Singer) *AIR* project.

46. Another example is the *Zapped*! project by Preemptive Media, www.zapped-it.net.

47. Nino Künzli et al., "Breathless in Los Angeles: The Exhausting Search for Clean Air," *American Journal of Public Health* 93, no. 9 (Spring 2003): 1494–1499.

48. Hans-Peter Lipp, "Pigeon Homing Along Highways and Exits," *Current Biology* 14, no. 14 (July 27, 2004): 1239–1249.

49. Preemptive Media's *AIR* project addressed the pollution exposure to humans in more detail.

For more information, see www.pm-air.net.

50. This inquiry came from the University of Arizona.

51. For more information regarding Cornell's citizen science initiative, see http://www.birds.cornell.edu/LabPrograms/CitSci.

VII

Biosecurity and Bioethics

Critical anthropologists Paul Rabinow and Gaymon Bennett approach our contemporary moment by refusing all attempts to purify overlapping notions of science, ethics, and human dignity. Definitions of scientific truth, and notions of the human, have always constructed each other, they argue. Even well-meaning attempts at addressing "bioethics" today forget this, positioning ethics as exterior to science, constituting it via rules and people-independent moral systems. Well-meaning attempts at protecting people, nature, and the future from admittedly horrific histories (eugenics, capitalist exploitation, colonialism) tend to seek refuge in a metaphysical humanism that neglects to ask: What is the good life today? What is the nature of scientific truth today? What is the human today? Since none of the hypostatized, "eternal" answers are satisfactory, we must pay attention to emerging technical meaning construction and new biosocial practices. To answer these questions in the broadest interdisciplinary sense, they suggest, we need to rethink the meanings of collaboration, equipment, and human–nature ethics without reducing them to instrumental relationships or metaphysical essences.

Biologist Jonathan King invites us to think about biosecurity through lenses that are simultaneously scientific, historical, and political. If, as he argues, current "antiterrorist" biosecurity projects are likely to generate new infectious agents, and to distract us from the real ethical-political issues, how might experts and non-experts forge collaborative public experiments in responsibility? Scientists and citizens would have to work collaboratively to forge the most enduring form of security, he suggests, which involves more than the unthinking implementation of administrative imperatives. Genuine collaboration between scientists and the public must engage with the messy practices of democracy: public workshops, petitions, social policy debates, scientific education for the lay public, social and historical education for scientists, accountability for the implications of one's intellectual positions, and the responsible critique of unsound scientific practices.

Critical Art Ensemble (CAE), a collective of tactical media practitioners, has, since the 1980s, explored the intersections between art, critical theory, technology, and political activism. CAE formulates modes of cultural resistance to the authority of contexts (such as the museum, the lab, and the state) which mark "high" art, technē, and politics by exposing, often parodically, the structures which underpin authoritarian knowledge practices. CAE's contribution to this volume, rather than rehearsing the artwork of the group, helps us understand some of the specific ways in which its historical and intellectual work, and political commitment to social justice, inform its artistic practice. Focusing on the phemonenon of "bioparanoia," CAE's essay takes apart three images of the body—constructed, it is argued—under the sign of fear.

The chapter tracks historical images of the disinfected body, the aestheticized screenal body, and the abused body, arguing that these emerge out of the material conditions of early capitalism and morph under the conditions of late capital in ways that facilitate the coercive power of the state. Through writings such as these, CAE provides historical tools and visual analysis for activists, artists, and intellectuals who wish to forge a society that respects and promotes the value of every living body, the importance of civil liberties, socially responsible rather than wasteful tax policies, egalitarian rather than militarized public health. In this sense its chapter must be understood as being in keeping with the spirit of its artistic practice, as an intervention in the public sphere that creatively reads the "collective illusions and hallucinations that haunt the public imaginary," unmasking them as "constructions designed only to mislead the public and obscure contemporary and historical relationships to production and power."

Women's studies scholar Gwen D'Arcangelis does a close reading of media and scientific disourses around the 2005 SARS outbreak, suggesting that they are both components of a new orientalized medical discourse about transnational security threats. CNN referred to South China, where SARS first emerged, as the "petri dish of the world," signifying, she argues, a contamination of the constructed borders between human and nonhuman, tradition and modernity, public and private, waste and consumption. Diseases emerging from China have become conflated with Chinese people, animals, and cultural practices; the possibility of transnational movement of diseases and people appears to threaten a pristine Western space. D'Arcangelis refers to these interlocking discourses as the new biogeographies of hygiene. The expert discourses of epidemiology and biosecurity draw on, yet render invisible, these older rhetorics of racialization and orientalism while promising to forge a secure global order for transnational consumption.

From Bioethics to Human Practices, or Assembling Contemporary Equipment

Paul Rabinow and Gaymon Bennett

If the various genome sequencing projects of the 1990s were significant in providing a first approximation of the core molecular information about the genome, they were no less significant for the ways in which they contributed to a reconfigured moral imagination and thereby altered relations among biology, ethics, and anthropology. From the outset, the genome projects and the bioethics programs affiliated with them traded on the notion that the genome contained the determinative essence of human identity. The run-up to the announcement of the mapping and eventual sequencing of the human genome was replete with the rhetoric of revelation: in reading our DNA, genomic scientists were uncovering the "blueprint" of life, the "holy grail" of biology. Of course, such rhetoric provoked contestation and rebuttal, yet it was taken seriously and its proponents succeeded in setting the points of debate and communication.[1] Thus, a good deal of anthropological and ethical energy was spent working to imagine and understand the supposed capacities and threats introduced by massive genomic sequencing projects.

Ethics: Technology and Equipment

In a major innovation, federal funds—"the largest ethics project in human history," as one actor put it[2]—were devoted to the design and implementation of legal and cultural methods, procedures, and practices adequate to the challenges posed by the sequencing projects. Like the molecular technologies under consideration, this legal and cultural *equipment* was designed to achieve specified ends.[3] As opposed to technology, what is distinctive about equipment is that its task is to connect a set of *truth claims*, *affects*, and *ethical orientations* into a set of practices. These practices, which have taken different forms historically, are productive responses to changing conditions brought about by specific problems, events, and general reconfigurations.

The first National Commission for the Protection of Human Subjects of Biomedical and Behavioral Research, for example, was established, in part, in response to the abuse of subjects of medical research. It was mandated to develop practices that could protect research subjects. The form these practices took was guided by the following set of considerations: a *truth claim* (human beings are subjects whose autonomy must be respected), an *affect* (outrage at the abuse in such infamous research projects as the Tuskegee experiments), and an *ethical orientation* (human subjects must be protected from such abuse in future through the guarantee of their free and informed consent). With genomics, more than the autonomy of subjects appeared to be at stake for bioethics. For many, human nature, as well as the integrity of nature more generally, appeared to be threatened. Thus the sequencing projects contributed to a growing sense that bioethics urgently needed new equipment designed to protect human beings from violations of their nature. Neither the affect of concern nor the desire to restrict genetic interventions was new, to be sure. What was new, however, was a growing sense that bioethics as it functioned in authorized spaces, such as government commissions, needed to be recalibrated to meet these new conditions.

Whereas the protection of research subjects involved the development of regulations "upstream" from research in the form of institutional review boards and protocols for obtaining informed consent, human genomics appeared to require the design of "downstream" equipment. The objective of this equipment was to mitigate "social consequences" by restricting those directions and applications of research thought to pose a threat to the dignity of human beings. In the United States, equipment of this kind began to be elaborated as part of the Human Genome Initiative ELSI project (ethical, legal, and social implications); it has been most thoroughly developed by the current President's Council on Bioethics. The architect and first chair of that council, Prof. Leon Kass, proposed a truth claim, an affect, and an ethical orientation for the construction of such equipment: (1) bioethics matters precisely because what is at stake in biotechnology is humanization or dehumanization, that is to say, the essence of human being is on the line; (2) this state of affairs should inspire a measure of fear, and vigilance, for in the face of scientific advance the "truly" human might be sacrificed; and (3) given the risk of dehumanization, the task of the ethicist is to discover what is truly valuable about human life in advance of any particular scientific endeavor, and secure it against scientific excess.[4]

At the beginning of the twenty-first century, after two decades of genomics, it is now clear that the significance of biology for the formation of human life is more than molecular; today we are faced with new forms of the challenge of understanding living organisms and their milieus. New developments in the biosciences must be accompanied by the invention of new ethical and anthropological analysis and equipment. Focusing on a new synthetic biology engineering center with which we are associated, SynBERC, we argue that contemporary developments call for new forms of collaboration among ethics, anthropology, and biology. In this chapter we propose the initial steps in that direction.

Paul Rabinow and Gaymon Bennett

Postgenomics: Human Practices

Under the leadership of Professor Kass, the President's Council on Bioethics was oriented to the view that bioethics must begin its work by identifying the "defining and worthy features of human life" so as to determine whether or not those features are put at risk by innovations in biomedical technology. Several characteristics of this orientation are noteworthy. First, these features of human life are universal and ahistorical, that is, they obtain regardless of context or situation. Second, this means that they can be identified without reference to scientific developments. Third, the defining features of human life thus serve as criteria by which particular scientific programs can be judged as threatening, or not, to "truly human" life.[5]

When the design of equipment starts with the supposition that science can only pose threats to the integrity of human nature, it is difficult for ethical understandings of *anthropos* to take into account the knowledge produced by contemporary molecular biology or anthropology. Ethics thereby would be positioned exterior to both biological and human sciences. Such positioning makes it more difficult to incorporate scientific knowledge in formulating the stakes and significance of contemporary human practices. Rather than excluding continuing scientific insight from our understanding of the human, it seems imperative to engage molecular biology and other sciences in order to learn what they can tell us about living beings. If one accepts this dialogic and contingent form of engagement, then scientific developments themselves prompt the question: Are contemporary forms of ethical equipment required today? And what critical stance—in the sense of assessing legitimate limits and forms—is appropriate toward and within it?

Molecular biology demonstrated that DNA is shared by all forms of life and is a remarkably pliable molecule. This means, on the one hand, that if there are questions to be posed about the qualitative distinctiveness of living beings—and there are—such questions must be posed at a different level than the molecular. On the other hand, it also means that DNA can be manipulated without violating any laws of nature or deep ethical principles per se. Longer and longer DNA sequences are being constructed ever more efficiently and economically each year. Sequences are being inserted with increasing precision and forethought into organisms; knowledge and know-how are accumulating about ways to make these organisms function predictably. What is at issue for the science, the ethics, and the anthropology is not the metaphysical purity of nature but the biological function of DNA sequences, the extent to which these sequences can be successfully redesigned, and ways in which these redesigns contribute to—or are harmful to— well-being understood as a biological, anthropological, and ethical question.

Living beings are complex in part because of their evolutionary history; they survived or perished under specific selective pressures in particular environments. Although the products of natural selection demonstrate fitness, this does not mean that this is the only way the organism can function. Quite the contrary—while evolution certainly contains

lessons about organic functionality, for contemporary biologists there is nothing sacred about the evolutionary paths followed to arrive at the functionality. Furthermore, the specific functions themselves are neither inviolable nor immutable. For biologists, there is no ontological or theological reason per se why specific functions—whatever their history—cannot be redesigned. Biologists indeed are making new things. And while this may not violate any sacrosanct ontology of nature, it does not mean that anything goes. It is precisely because we do not think that nature is by essence immutable that these practices and the objects they produce must be carefully examined. The effects of redesign do contribute to a problematization of things (ontology) that must be taken up and thought about (ethics and anthropology).

In 2007, not only are genomes sequenced with regularity and a steady flow of genes inventoried and annotated, but an array of other active biological parts and functions is being identified and cataloged. All of this science and technology proceeds on the basis of a tacit faith in a principle of an economy of nature. That is to say that nature must consist of isolatable and describable units and functions. Many biological functions appear to be irreducibly complex in part because the capacities to analyze them, to break them down into parts, do not yet exist. One strategy to address this impasse is to invent the skills necessary to reconstruct those parts and make them function. It is that path—of analysis and synthesis—that is currently being grouped under the rubric "synthetic biology" that which concerns us here.

Today, in the early years of postgenomic science, the insufficiency of what has been called "the gene myth" is now clearer. It has not been as frequently recognized, however, that the sufficiency of the standard bioethical models that arose alongside the discourse of molecularization must itself be exposed to renewed questioning and reformulation. Questioning and reformulation does not mean jettisoning; much of existing bioethical equipment continues to serve a necessary function. It is simply prudent and consistent with our principles for those of us inventing new ethical forms based in *phronesis* to learn from the strengths and limits of previous practices. Limiting the intersection among ethics, science, and anthropology, however, to either upstream bureaucratic review or downstream impact regulation now appears poorly adjusted to the current situation of dynamic contingency and critical exploration in the biological and human sciences. In sum, loyalty to past practices can inhibit an ability to identify and analyze new challenges. We must take seriously the ways in which current transformations in scientific research modulate past problems as well as the equipment that had been invented to handle them.

Ethical equipment like that developed by the President's Council on Bioethics remains in an ambivalent relation to bioscientific innovations. Strikingly absent from the development of this equipment is any attempt to incorporate the insights of science into definitions of what it means to be human. We hold that bioethics, as currently practiced in official settings, tends to undervalue the extent to which ethics and science can play a

mutually formative role. More significant, it undervalues the extent to which science and ethics can collaboratively contribute to and constitute a flourishing existence (*eudaemonia*). The question of what constitutes a good life today, and the contribution of bioscience and biotechnology to that life, must be constantly posed and re-posed. Which norms are actually in play and how they function must be observed, chronicled, and evaluated.

At the outset, the name was a basically a placeholder or, as some of its critics hold, a hoped-for brand. From our perspective, however, "synthetic biology" is best understood as a development within the tradition of the "engineering ideal in American culture."[7] Unlike the visionaries of the sequencing projects, with their prophecies of the molecular as the "code of codes," synthetic biologists clearly have a feeling for the organism.[8] Synthetic biology aims at nothing less than the (eventual) regulation of living organisms in a precise and standardized fashion according to instrumental norms. There is a feeling of palpable excitement that biological engineering has the capacity to make better living things, in an ongoing fashion. It is plausible that engaged observation stands a chance of contributing positively to emergent scientific formations. It is worth seeing if such observation can be effectively realized by conducting ethical inquiry in direct and ongoing collaboration with scientists, policymakers, and other stake holders. We are persuaded that within such collaborative structures, biology, ethics, and anthropology can orient practice to the purpose of flourishing.

Synthetic Biology

The challenges of functional redesign presented by innovations in molecular biology are being addressed by a next generation of "postgenomic" projects. One such project is synthetic biology. Synthetic biology began as a visionary but minimally defined project:

Synthetic Biology is focused on the intentional design of artificial biological systems, rather than on the understanding of natural biology. It builds on our current understanding although what that would mean beyond efficiency and specification opens up new horizons of inquiry and deliberation.

Today, the engineering project of building parts that either embody or produce specific biological functions, and inserting them in living organisms, is at the stage of moving from proposal to concept. The concept is being synergistically linked to an ever-expanding set of technologies and to increasingly sophisticated experimental systems.[9] There is agreement within the synthetic biology community that a necessary, if not sufficient, initial step required to further this project is to conceive of, experiment with, organize, and reach broad consensus on, standardized measures and processes. The very qualities of living systems that make them interesting to engineering—that they are robust, complex, and malleable—also make them extremely difficult to work with. The extent

to which these difficulties can be productively managed remains to be seen. In any case, at present the hoped-for standards are recognized to be initially crude, and will certainly have to be reworked in an ongoing manner. The important step is to begin to create them and to instill an awareness and sensitivity among practitioners as to their importance.

Synthetic biology arose once genome mapping became standard, once new abilities to synthesize DNA expanded, and once it became plausible to direct the functioning of cells. Its initial projects address a part of the global crisis in public health—malaria. At the same time, the first ethical concerns that it has to deal with arise from the risk of bioterrorism (see below). The synthetic biology community is obliged to bring these heterogeneous elements into a common configuration. Put schematically, synthetic biology can be understood as arising from, and as a response to, new capacities, new demands, and new difficulties that oblige, in an urgent manner, contemporary ways of thinking and experimenting with vitality, health, and the functioning of living systems. Those investing in the development of synthetic biology expect that it will play a formative role in medicine, security, economics, and energy, and thereby contribute to human flourishing. Questions about what constitutes flourishing and the extent to which synthetic biology can indeed contribute to it are basic, and, more important, remain unanswered.

SynBERC

In 2006 a group of researchers and engineers from an array of scientific disciplines proposed a five-year project to achieve such standardization, with the aim of thereby rendering synthetic biology a full-fledged engineering discipline. Representing five major research universities—UC Berkeley, MIT, Harvard, UC San Francisco, and Prairie View A&M—the participants proposed to coordinate their research efforts through the development of a collaborative research center: the Synthetic Biology Engineering Research Center, or SynBERC. SynBERC is highly unusual on a number of counts. In addition to its far-reaching research and technology objectives, it represents an innovative assemblage of multiple scientific subdisciplines, diverse forms of funding, complex institutional collaborations, serious forward-looking reflection, intensive work with governmental and nongovernmental agencies, focused legal innovation, and imaginative use of media. More unusual still, from the start SynBERC has built in ethics as an integral and co-equal, if distinctive, component.

The SynBERC initiative is designed around four core thrusts: (1) Parts, (2) Devices, (3) Chassis, and (4) Human Practices. These thrusts, in turn, are designed to meet specified goals. Thrusts 1 through 3 link evolved systems and designed systems, with emphasis on organizing and refining elements of biology through design rules. Thrust 4 examines synthetic biology within a frame of human practices. It attends to the ways that synthetic

biology may significantly inform human well-being through its contributions to medicine, security, and energy.[10] Critical examination of how synthetic biology will inform these domains constitutes a central concern of thrust 4.

Several core synthetic biology projects were well under way prior to the organization of SynBERC. Two of these were particularly important for the development of thrusts 1–3. The first of these is a project at Berkeley, led by SynBERC Director Jay Keasling. The project's goal is to take a molecule, artemesinin, which is found in the bark of a Chinese tree and is one of a small group of molecules that remain effective against malaria, and to engineer a system in which the molecule can be produced at a cost that is many times less than extraction from the tree. This basic work has been accomplished—it is grown in yeast or *E. coli* through a reengineering of the pathways of these common single-celled organisms. Thus, synthetic biology, at least in this form, exists and works. The major criticisms of the project come from those who have the legitimate concern that too much hope is being invested in a combination therapy based on a synthetic version of artemesinin that is likely to lead to its potential overuse and the consequent acceleration of resistance to it, with tragic results. That is a valid public health argument, and those holding this position do not advocate eliminating this source, only thinking about consequences.

The partner chosen to take Keasling's work out of the lab and into those regions of the world where it is most urgently needed, is a distinctive NGO, OneWorld Health. The concept around which this NGO is organized is that hundreds of millions of dollars have been spent on research and development in the pharmaceutical and biotechnology industries that have yielded scientific insight and technical improvements, but often no commercially viable product. Its strategy has been to acquire (at the lowest possible cost) the intellectual property generated by this investment and work, and to transfer it to countries such as India, where it can be adapted to local circumstances. The goal is to make available therapeutic advances that might be effective but are deemed not to be profitable enough for multinational pharmaceutical companies. The quid pro quo is for those receiving the intellectual property not to compete in the same markets.

Although it is hard to imagine how one could argue that one should not encourage the development of new antimalaria drugs in a world in which several hundred thousand people die each year from the parasite simply because the molecule to be used in therapy would be produced by reengineering pathways in yeast or *E. coli* (artificial, organic, natural, and emergent), this does not mean that no critical questioning should go on. But critical questioning requires knowledge and understanding. Hence, it is valid to argue that an overabrupt use of a monotherapy in a situation where the pathogen is highly adaptive is not a prudent strategy. The synthetic biologists accept that criticism and are seeking to build the molecule so that polytherapies that will reduce the likelihood of swift resistance can be built into the design (artificial, organic, natural, and emergent). Surely,

changing the genome of yeast to produce artemesinin seems prudent and urgent, since it is known full well that it is being designed to be introduced into the bodies of human beings, and will thereby change both their internal milieu, which already consists of multiple genomes, both contemporary and archaic, and the external milieu in which they live.

So, perhaps attention solely to the question of existing cultural understandings of nature and science at times can obscure other, potentially more significant problems and questions. For example, what is perhaps most distinctive about this project is its funding and institutional setting. There is government research money, there is venture capital funding, there is university support, and the artemesinin project is funded in large part by the Bill and Melinda Gates Foundation. This foundation—with the gift of massive funding by the financier Warren Buffet—has the largest endowment of any philanthropy in the world. It, like a few other new foundations—Google now has a for-profit foundation—is seeking to assemble health, science, policy, accountability, profit, delivery systems, management styles, scope, and timing in a distinctive fashion. Here is a very American assemblage with global reach. Its norms of productivity and accountability differ from those of the WHO or other such organizations in which national and international politics play such a distinctive part. This assemblage would certainly seem to be making a difference. And that diagnosis implies that we are obliged to think about its significance.

The second project is located at MIT. It is devoted to building, or learning how to build, or finding out to what it extent it is possible to build, standardized biological parts, devices, and platforms. Its goal is to have a directory of such functional units available for order on-line[11] and to make them available worldwide on the basis of an open source license developed by the nonprofit Creative Commons. The core concept and initial work have taken place at MIT under the leadership of Professors Drew Endy and Tom Knight, core members of the SynBERC initiative. One original organizational contribution, led by Randy Rettberg, has been to organize an international student competition, iGEM (genetically engineered machines), that has grown exponentially since 2004 to include the participation of over a hundred teams.[12]

Whereas one set of ethical and policy problems was raised by the Keasling project, the work at MIT poses a different order of challenge. Recent innovations in synthesis technology vastly expand the capacity to produce ever larger specified sequences of DNA more rapidly, at lower cost, and with greater accuracy. These innovations raise the stakes of the "dual-use" problem (the idea that technologies can be used both constructively and destructively), expanding existing fields of danger and risk. The relation between technical innovation and the expansion of danger has long been identified in the world of genetic engineering. Previously, these trends were framed as issues of safety which could be addressed through technical solutions. To date, a number of reports focusing on the governance of synthetic biology have adopted this framing.[13]

It has become clear, however, that not all challenges associated with synthetic biology can be dealt with through technical safeguards. For instance, changes associated with contemporary political environments, particularly new potential malicious users and uses (i.e., terrorists/terrorism), and increased access to know-how through the Internet exceed technical questions of safety. Such challenges cannot be adequately addressed using existing models of nation-specific regulation. New political milieus produce qualitatively new problems that require qualitatively new solutions. In addition, we must confront the challenge of uncertainty characteristic of all scientific research. Although some risks are presently understood, we lack frameworks for confronting a range of new risks which fall outside of previous categories. Such frameworks would need to be characterized by vigilant observation, forward thinking, and adaptation.

Given these conditions, synthetic biology calls for a richer and more sustained inquiry and reflection than is possible in a study commission model of collaboration, wherein formal interaction ceases with publication of a report. To date, work in bioethics has largely consisted either of intensive, short-term meetings aimed at producing guidelines or regulations, or standing committees whose purpose is limited to protocol review or rule enforcement. By contrast, we are committed to an approach that fosters ongoing collaboration among disciplines and perspectives from the outset. The principal goal of SynBERC's human practices thrust is to design such collaboration. This enterprise aims at giving form to real-time reflection on the significance of research developments as they unfold and the environments within which research is unfolding. The aim of such collaborative reflection would be to identify challenges and opportunities in real time, and to redirect scientific, political, ethical, and economic practices in ways that would, hopefully, mitigate future problems and contribute to human flourishing.

Human Practices: Principles of Design

Within collaborative structures, practice can be oriented and reoriented as it unfolds. This work is accomplished not through the prescription of moral codes, but through mutual reflection on the practices and relationships at work in scientific engagement, and on how these practices and relationships allow for the realization of specified ends. Straightforwardly, ethics and anthropology can be designed so as to help us pause, inquire into what is going on, and evaluate projects and strategies. The goal of the Human Practices thrust is to design, develop, and sustain this mode of collaboration. Given that goal, our wager is that the primary challenge for the Human Practices thrust is the invention of diverse forms of equipment requisite for the task. If the scientific aims of synthetic biology can be summarized as the effort to make living things better and to make better living things, then the principal question that orients our efforts to invent contemporary ethical equipment is this: *How should complex assemblages bringing together a broad range of diverse actors be ordered so as to make it more, rather than less, likely that flourishing will be enhanced?*

We do not yet know what form contemporary equipment will take.[14] At this early stage of our work, however, three fundamental design principles appear worthy of elaboration and testing: *emergence*, *flourishing*, and *remediation*. In initial experimentation these design principles appear to be both pertinent and robust. They are pertinent in that they form part of the research strategies of the biologists and characterize the assemblage of relations within which the research is developing. Initial indications have shown them to be robust in closely related domains (e.g., biosecurity). In these domains they have made visible unanticipated problems and interconnections, thereby opening up new and more appropriate modes of intervention and reflection. One of our initial aims is to test the robustness of these principles in synthetic biology.

Research in human practices is underdetermined. Past bioethical practices often operated as though the most significant challenges and problems could be known in advance of the scientific work with which these challenges and problems were to be associated. Our hypothesis is that such practices are not sufficient for characterizing the contemporary assemblage within which synthetic biology is embedded. This assemblage is a contemporary one: it is composed of both old and new elements and their interactions.[15] While some of these elements are familiar, the specific form of the assemblage itself, and the effects of this form, can be known only as it emerges. We understand *emergence* to refer to a state in which multiple elements combine to produce an assemblage whose significance cannot be reduced to prior elements and relations. Thus, the problems and their solutions associated with synthetic biology cannot be identified and addressed until they unfold. Questions concerning what it means to make life different, what it means to make living beings better, and what metrics and practices are appropriate to these tasks can best be addressed in real time as challenges arise and breakdowns happen. The knowledge needed to move toward the desired near future will be developed in a space of relative uncertainty and contingency. Adopting a vigilant disposition that is attentive to a mode of emergence is at the core of our work. In sum, our equipment must be designed in such a way that it generates knowledge appropriate to states of emergence.

In the 1990s, bioethical equipment was designed to protect human dignity, understood as a primordial and vulnerable quality. Hence its protocols and principles were limited to establishing and enforcing moral bright lines indicating which areas of scientific research were forbidden. A different orientation, one that follows within a long tradition but seeks to transform it, takes ethics to be principally concerned with the care of others, the world, things, and ourselves. Such care is pursued through practices, relationships, and experiences that contribute to and constitute a *flourishing* existence (*eudaemonia*). Understood most broadly, flourishing includes physical and spiritual well-being, courage, dignity, friendship, and justice, although the meaning of each of these terms must be reworked and rethought according to contemporary conditions. The question of what constitutes a flourishing existence, and the place of science in that form of life—how it contributes to or disrupts it—must be constantly posed and re-posed in such a form

that its realization becomes more rather than less likely. In sum, the equipment we are developing must be oriented to cultivating forms of care of others, the world, things, and ourselves in such a way that flourishing becomes the telos of both scientific and ethical practice.

The design challenge is to develop equipment that operates in a mode of *remediation*. The term "remediation" has two relevant facets. First, it means to remedy, to make something better. Second, remediation entails a change of medium. Together, these two facets provide the specification of a specific mode of equipment. When synthetic biology is confronted by difficulties (conceptual breakdowns, unfamiliarity, technical blockages, and the like), ethical practice must be able to render these difficulties in the form of coherent problems that can be reflected on and attended to. That is to say, ethical practice remediates difficulties such that a range of possible solutions becomes available. In sum, our challenge is to design contemporary equipment that will operate in a mode of remediation. This equipment must be calibrated to knowledge of that which is emergent, and enable practices of care which lead to flourishing.

We do not presume to know, in advance of its actual scientific work, how synthetic biology will inform human life. We are persuaded, however, that ethical observation and anthropological analysis are capable of contributing positively to the overall formation of synthetic biology. We think that our contribution can only be effectively realized if this work is conducted in direct collaboration with scientists, policymakers, and other stake holders. Standard approaches have sought to anticipate how new scientific developments will impact "society" and "nature," positioning themselves external to, and "downstream" of, the scientific work per se. The value of collaboration constitutes a synergistic and recursive structure within which significant challenges, problems, and achievements are more likely to be clearly formulated, successfully evaluated, and changed. Following our design principles, our goal is to invent new sets of equipment, put them into practice, and remediate things as they unfold.

Acknowledgment

Thanks to NSF EEC-0540879 for funding; to Drew Endy and Jay Keasling; and to all the readers and ARC members.

Notes

1. This rhetoric still circulates. A summary statement of the significance of the Human Genome Project, on the U.S. National Genome Research Institute Web site, reads, "Completed in April 2003, the HGP gave us the ability . . . for the first time, to read nature's complete genetic blueprint for building a human being." http://www.genome.gov/10001772.

2. Eric Juengst.

3. On the concept of equipment, see Michel Foucault, 1977–8 and 1981–2 courses, *Security, Territory, Population: Lectures at The Collège de France, 1977–1978*, Ed. Michel Senellart, François Ewald, al Alessandro Fontana. Trans. Graham Burchell (NY: Palgrare MacMillion, 2007), *The Hermeneutics of The Subject: Lectures at The Collège de France 1981–1982*, Ed. Frédéric Gros, François Ewald, Alessandro Fontana (NY: Palgrare MacMillion, 2005), and Paul Rabinow, *French Modern: Norms and Forms of Modern Equipment*, (Cambridge, Mass: MIT Press, 1989).

4. See http://www.bioethics.gov/transcripts/jan02/jan17session1.html.

5. See www.bioethics.gov.

6. Synberc strategic plan, unpublished.

7. The phrase is from Philip Pauly, *Controlling Life: Jacques Loeb and the Engineering Ideal in Biology* (New York: Oxford University Press, 1987).

8. David Kevles and Leroy Hood, eds., *The Code of Codes*, (Cambridge, Mass.: Harvard University Press, 1992); Evelyn Fox Keller, *A Feeling for the Organism: The Life and Work of Barbara* McClintock (New York: Time Books, 1984).

9. www.synberc.org.

10. For more details, see www.synberc.org. This chapter treats only the efforts of the fundamental modules of thrust 4.

11. www.parts.mit.edu.

12. See http://parts2.mit.edu/wiki/index.php/Jamboree.

13. See, for example, "National Academies Report on 'Dual Use' Research (the Fink Report)," http://www.fas.org/main/content.jsp?formAction=297&contentId=123

14. For more on the technical meaning of "equipment" in ethics, see the Anthropology of the Contemporary Research Collaboratory, www.anthropos-lab.net.

15. For more on this technical use of the term "contemporary," see ARC, www.anthropos-lab .net.

How Do We Insure Security from Perceived Biological Threats?

Jonathan King

During the Cold War and after, successive U.S. government administrations have mobilized public support for diversion of public funds into military industries, through claims of looming threats to national security. Examples include the "bomber gap" of the 1950s and 1960s and the missile gap" (with the former USSR) of the 1970s, and in 2004–2005, the "weapons of mass destruction" in Iraq. The latest of such threats presented to the public is that of bioterrorism, justified by the deaths of five Americans from anthrax in the fall of 2001. In the name of countering the threat of bioterrorism, billions of dollars are being diverted from desperately needed biomedical research and public health delivery into programs such as Project Bioshield and the Biological Advanced Research and Development Authority (BARDA). As I describe below, these programs are far more likely to generate new and novel infectious agents threatening our communities than to protect us from terrorist threats. Such expenditures also generate, within the biotechnology, scientific, and medical communities, constituencies for the maintenance of public fears and insecurities with respect to the threat of bioterrorism (Fonda, 2006). This maintenance of public fear provides the justification for the continued funding of these programs, as is described in more detail at the end of this chapter.

One of the major sources of authentic national security with respect to the threat of biological weapons has been the resistance of scientists and citizens to unsound programs. As part of this narrative, I recount the role of the scientific and social resistance in retarding the development of hazardous and destabilizing biological weapons and bioterrorism defense programs.

Seymour Melman, Paul Walker, and others have described in detail the "iron triangle" of elected officials, the military, and military contractors who maintained a stream of billions of dollars of public funds flowing to the defense industry during the Cold War. The channeling of great public wealth into weapons development and procurement contracts

was supported by continuing claims that the U.S. public was in great danger from the Soviet Union, and to a lesser extent China, Vietnam, and Cuba (Melman, 1974). Many of these programs, such as the MX missile, almost certainly decreased national security, though they did enrich the missile manufacturers (Phillips, 1969). The diversion of hundreds of millions of federal R&D dollars into bioterrorism defense programs such as Project Bioshield and BARDA represents a similar dynamic.

The Scientific and Social Resistance to Biological Weapons Programs

The most useful context for examining community responses to the current bioterrorism programs is the history of the effort to control biological weapons. Though initiated by the Geneva Convention of 1925, progress remained dormant until the 1970s.

The low level of attention between the world wars reflected the military reality that no nation had effective and reliable "biological weapons." "BW" was a term lacking implementation. The word "weapon" refers to a device that can be controlled by one side in a conflict so that the damage is done to the other side. But the fundamental nature of microbial pathogens is that they spread from one infected individual to another. Since all human beings on Earth are members of a single species, any agent that can effectively cause debilitating disease to an enemy can spread back to one's own troops and civilians. In addition, there are long and variable lag times from initial exposure to evident illness; considerable variation in individual susceptibility; and often considerable sensitivity to environmental conditions.

However, during and after World War II, the United States, Great Britain, the USSR, and other nations developed biological weapons programs. Jeane Guillemin and Leonard Cole describe these in some detail in their books, including the public open-air testing programs with simulants in the 1950s. Nonetheless, despite a few cases, such as the Japanese use of infectious agents against the Chinese (Guillemin, 2005), biological weapons have rarely been used in conflicts between nations, and have not been weapons of choice for military leaders. This reflects the danger to civilian populations, the absence of rapid effectiveness and reliability under battlefield conditions, the social stigma attached to such weapons, and the existence of the Geneva Convention.

The effort to control biological weapons programs was revived—surprisingly, during the Cold War—with President Nixon's announcement that the United States would unilaterally renounce the development of biological weapons. This opened the way for the passage of the Biological Weapons Convention of 1972, ratified by the U.S. Congress in 1975. This was the strongest disarmament treaty in human history, banning use, development, testing, and stockpiling of biological weapons. At that time the major infectious agents being produced at the U.S. BW facility in Fort Detrick, Maryland, the British facility at Porton Down, and probably the Soviet facility at Sverdlovsk, were bacterial pathogens including anthrax, tularemia, and perhaps some pathogens of agriculturally

important plants and animals. The human pathogens were chosen because they were infectious in low dose, caused a temporarily incapacitating illness, and could be stored in forms that retained infectivity. Countries such as the United States, Britain, and the USSR, which maintained stocks of potential BW agents, were called upon to destroy their stocks.

Unfortunately, when the Reagan administration took over the reins of government, it initiated a remilitarization of the economy. One component was the launching of an effort to reactivate a biological weapons program in the name of biological defense. The major program was termed Biological Defense Research Program (BDRP). It included plans to reopen closed facilities for testing of potential BW agents, including the Dugway Proving Grounds in Utah. These infectious agents included the bacterial pathogens formerly under study at Fort Detrick, Maryland, such as anthrax and tularemia. Among the justifications were unsubstantiated charges of the use of biological agents "yellow rain" by the USSR in Southeast Asia. These were eventually thoroughly discredited through the work of the Harvard biologist Matthew Meselson and colleagues (Guillemin, 2005).

During the Vietnam War the United States had employed chemical/biological weapons against crops and vegetation in Vietnam, such as Agent Orange. A considerable group of biological scientists had mobilized in opposition to these programs within the U.S. biological communities. Among the best-known were Arthur Galston of Yale and Ethan Signer, my former colleague in MIT's department of biology. We organized public workshops at the annual meetings of the American Association for the Advancement of Science, circulated petitions, and raised the issue of misuse of biomedical knowledge among our students and colleagues. The network that developed, continued to be active on public issues concerning biotechnology. Many of them remained connected through the Council for Responsible Genetics (http://www.gene-watch.org), which had been established to represent the public's interest in the development of biotechnology. These scientists had become active in social policy issues through their opposition to the U.S. involvement in Vietnam, and were also influenced by the role of physicists in opposing nuclear weapons development. The well-known Harvard geneticist Matthew Meselson also played a leading role in critiquing chemical and biological weapons programs.

When the Reagan administration reactivated the biological weapons programs, a group of us from the CRG board formed the Committee on the Military Use of Biological Research (CMUBR). Its members included the biomedical scientists Barbara Hatch Rosenberg and Liebe Cavalieri (then of the Sloan-Kettering Institute), Richard Novick of the New York Public Health Institute, Nancy Connell of Rutgers, Stuart Newman of New York Medical College, and the scholars Leonard Coles (author of *Clouds of Secrecy*, on the earlier military BW program), Richard Falk, Susan Wright, and a number of others. Combined, we had a very broad experience in BW issues, and considerable expertise in microbiology, genetic engineering, and infectious diseases. We considered the programs very dangerous and destabilizing in the international arena.

The government's plan was to be able to defend our troops from biological weapons, for example, by vaccinating them against infectious agents thought to be candidates for weapons (anthrax, tularemia, hemorrhagic fever viruses, etc.). Of course, if a nation were planning to use biological weapons, this is the exact course they would follow: developing vaccines or other prophylactic treatments to protect their own troops. Thus, from outside the national borders, "defensive" programs are indistinguishable from "offensive" programs (Strauss and King, 1990; Cole, 1997). In addition, developing defenses requires growing and working with the actual infectious agents considered to be potential weapons. This generates serious dangers to the local communities, creating new and novel risks while offering little increase in national or international security.

One of our first efforts was to launch a petition campaign within the scientific community, "The Pledge Against the Military Use of Biological Weapons." We circulated the petition at scientific meetings and by mail. By April 1988 we were able to hold a press conference in Washington and announce the signatories, including fifteen Nobel laureates and five hundred biomedical scientists and scholars. This was widely covered in the national and scientific press with headlines such as "500 Scientists Spurn Work on Biological Arms" (Lichtblau, 1988; Anderson, 1988)

Local Struggles over Biological Weapon Facilities

The public resistance to the BW programs came to a focus in Utah and Massachusetts. In Utah the reopening of the Dugway Proving Grounds as an aerosol testing facility raised local concerns. Utah residents remembered the deaths of thousands of sheep from inadvertent nerve gas releases years before. A group of biological scientists and physicians at the University of Utah Medical Center, including the microbiologists Sherwood Casjens and Naomi Franklin, circulated a petition in opposition, wrote to newspapers and their congressman, and mobilized resistance. More than three hundred residents attended each of the two public hearings held to consider the draft environmental impact statement. I vividly remember flying to Salt Lake City to speak on the issue, and later meeting with elders of the Mormon Church, who were under pressure to address these topics as well. The combination of the scientific critique of the program and the public malaise led to sufficiently high level of resistance that the army scaled down its Dugway initiative.

Another example of community response was in Amherst, Massachusetts. When Nixon deactivated the BW program, some of the scientists moved from Fort Detrick to academic departments. In previous years, research activities with microbial pathogens at Fort Detrick were centered around anthrax. One of the lead investigators, Dr. Curtis Thorne, who worked on anthrax at Fort Detrick, joined the faculty of University of Massachusetts at Amherst as professor of microbiology. He obtained a research grant from the army to continue working on anthrax. The work involved introducing genes that would confer

antibiotic resistance to anthrax, as well as combining these with genes that conferred increased virulence. Undergraduates working in his laboratory raised safety questions, but the university reacted slowly. A number of public health physicians became concerned, including Dr. Meryl Nass, and brought the issue before the Amherst Board of Health. The Board of Health held public hearings, at which I testified. These hearings were covered in the local newspapers. The research was in fact a direct violation of the Biological Weapons Convention, since anthrax that was both pathogenic and antibiotic-resistant would be a potential BW agent. The eroding community and university climate convinced Professor Thorne to change the direction of his research.

Legislative, Analytic, and International Initiatives

A national focus of the campaign noted above, The Pledge Against the Military Use of Biological Weapons, was to strengthen public support for the Biological Weapons Convention. Article IV of the convention required that signatory nations make the treaty part of domestic law. This ensured that every individual, not just government employees, was bound to the treaty. Our CMUBR Committee organized testimony for House and Senate hearings on corrective legislation in 1989 and 1990. We continued to promote the view that security in the arena of biological (and chemical) weapons came from diplomacy, treaties, and negotiation, rather than questionable military programs. We were successful in the legislative effort with the passage of HR901 in 1989, which incorporated Article IV into domestic law (Boyle, 2005).

In addition to the local mobilizations and the petition and legislative campaign, Prof. Susan Wright gathered an impressive group of scientific and political authorities, and published *Preventing a Biological Arms Race*. This remains a leading source of insight and information on these issues, and should be consulted by anyone concerned over bioterrorism and biological weapons issues. The book's chapters provided the material for workshops and forums organized at subsequent conferences of the American Association for the Advancement of Science, the American Society for Microbiology, and the American Public Health Association.

Of course, a treaty without the power of inspection and enforcement has limited impact. In 1991 the Third Review Conference of the Biological Weapons Convention was held in Geneva to address inspection. The CRG sent a strong delegation to Geneva under the leadership of Susan Wright and Barbara Rosenberg, and organized briefings for the delegates (Stark, 1991). The outcome was increased inspection and the prospects of continuing to ensure that the powers of biotechnology were not used for military ends. With the end of the Cold War, it appeared that the Pandora's box was closed with respect to the danger of biological weapons. Given the increasing efficacy of biotechnology to modify microorganisms, this was an important increase in international security.

September 11, 2001, and the Anthrax Deaths

The attack on the World Trade Towers initiated a new stage in the U.S. response to dangers from unconventional weapons. New legislation and budget authorization channeled billions of dollars into homeland security and related programs The mailing of concentrated anthrax preparations to Senators Tom Daschle (D.-S.D.) and Patrick Leahy (D.-Vt.), and the subsequent deaths of five individuals from anthrax infections led to a further focus on countering suspected bioterrorists (Fonda, 2006). Though the anthrax mailings were the events garnering intense publicity, the government response followed a pattern initiated prior to the attacks.

Second Bush Administration Undermines Biological Weapons Convention

The favorable environment created by the Third Review Conference was reversed under the Bush administration. President George W. Bush sent John Bolton as the U.S. representative to the 2001 Fifth Review Conference in Switzerland (prior to his appointment as ambassador to the United Nations). Bolton actively opposed the strengthening of the convention and blocked signatories from reaching a higher level of inspection and enforcement (Olson, 2001). In particular the Bush administration opposed inspections of U.S. biotechnology companies and federal laboratories. It claimed this was to protect trade secrets. Others suspect that the military was engaging in research that would be viewed as violating the BWC.

The Bush/Bolton opposition to strengthening inspection and enforcement of the BWC is closely tied to their promotion of bioterrorism programs. The anthrax powder directly links the former BDRP programs with the current effort. The sequence of the genome of these cells identified them as being derived from the stocks developed as part of the BDRP program and held in one of the four national laboratories where such activities were proceeding. As described in more detail below, the concentrated, refined anthrax powder that killed the five people almost certainly came from one of the U.S. military laboratories. The inability of the FBI to identify the source of the organisms may be incompetence, but it more likely represents an attempt to avoid the extreme embarrassment to the government in revealing that the source was a government laboratory.

Before proceeding further with consideration of the current reincarnation of the effort to militarize biomedical research, we need to explore the question in the broader context of infectious disease.

The Importance of Preventing the Active Development of Novel Infectious Agents

The most extraordinary feature of living creatures is their ability to reproduce themselves. Chemicals, heavy metals, and oil spills have been very damaging sources of pollution in

industrial society. However, once released into the environment, they do not reproduce further. Eventually the oil is degraded and the metals are returned to the mineral forms. Even radioactive contamination and fallout decay over tens or hundreds of years, depending on the isotope.

This is not the case with organisms. Once established in the ecosystem, they can grow, reproduce and mutate, and cannot be called back. Though organisms modified in the laboratory may not be able to compete with their wild relatives in many ecological niches, in modern industrial society there are often niches where the modified organism has the advantage over natural strains. The survival of antibiotic-resistant microorganisms in hospitals is one of many examples. We have an enormous variety of natural examples; some are benign, such as purple loosestrife taking over freshwater ponds; some have been less benign, such chestnut blight and Dutch elm disease; some have been devastating to humans, such as plague, swine flu, SARS, and HIV.

We also have a dramatic and often tragic knowledge of the effects of formerly endemic microbial and viral infections—diphtheria, cholera, tetanus, syphilis, tuberculosis, yellow fever, smallpox, and poliomyelitis. As a result of modern sanitation, biomedical research, and expanded access to health care, most of these are now history.

Though many have been defeated, humans are still ravaged by infectious diseases: HIV most dramatically, SARS, the return of tuberculosis, and the emergence of strains resistant to antibiotics.

We also have known the tragic history of the introduction of infectious agents into populations who haven't been exposed to them previously. Thus the decimation of the indigenous peoples of North and Central America from syphilis, smallpox, and other infectious diseases which were brought by the Europeans. Similarly, we have the history of the influenza epidemic of World War I, and more recent epidemics, such as swine flu and Hong Kong flu strains, which differ from strains we have immunity to. Public health authorities are currently concerned over the possible spread of avian influenza strains to domestic poultry, and possible from poultry to humans.

When Nixon rejected biological weapons, and the United States and more than 150 nations ratified the Biological Weapons Convention of 1972, many of us thought that BW threats had passed. The subsequent review conferences of the parties developed procedures for inspection and verification, increasing confidence in the effectiveness of the treaty. Sadly, the bioterrorism initiatives represent a return to biological weapons research. The Bush administration has, in essence, launched major programs such as Project Bioshield and BARDA, which many believe put the health of our people at far greater risk than the hazard they claim to be responding to. The scale of these programs is larger than any earlier BW program.

Of course such programs are always called "defensive." But, as noted above, with biological weapons, defensive and offensive programs overlap almost completely, with hardly any differentiation (Strauss and King, 1990). Calling them "defensive" or "prophylactic"

or "preventive" does not change the fact that defensive bioterrorism research activities are not distinguishable from offensive bioterrorism research activities (Cole, 1997). The scenario is roughly as follows:

Authorities claim we have to be able to protect ourselves from a terrorist attack with biological weapons. To do that, we will need to be able to diagnose an infection with them, identify them directly, and develop prophylaxis or perhaps a vaccine.

To develop such protections, we will need the actual pathogenic organisms. Do we know what these will be? Biodefense programs thus typically ask bioscientists and Homeland Security agents to imagine the most infectious, most confounding, most dangerous microorganisms they can—easily dispersed, infectious at very low doses, highly contagious—and then create them.

The source of the anthrax mailed to congressmen Daschle and Leahy was a U.S. Biological Weapons Defense Program laboratory (Read et al., 2002). The programs currently under way to explore the properties of novel infectious agents are the most likely source of such agents, which might be used by disenchanted, deranged, or hostile individuals or groups. The existence of the programs in themselves decreases national security and increases the risk of infection by novel or modified infectious agents.

The Boston-Area Residents' Concern over the Boston University Bioterrorism Facility (Biosafety Level 4 Facility)

The third example of combined public and scientific resistance against the proliferation of biological weapons research activities occurred in response to Boston University's announcement that if would construct a bioterrorism research lab in downtown Boston. Supporters referred to it euphemistically as a "biosafety level 4 facility."

Typical research activities for such a facility include the generation and characterization of hybrids, chimeras, or genetically engineered strains that have features not found in any naturally evolved pathogen—agents that might be difficult to detect and diagnose; pathogens that might evade or fool the immune system; or pathogens that might spread with particular efficacy.

For example, let's imagine an airborne strain engineered so that it produced cholera toxin and was antibiotic-resistant, or a tularemia strain—the pathogen the Boston University team was working on secretly at the Boston University Medical Center (Dembner and Smith, 2005). To find out its properties, it needs to be brought into existence; to create a vaccine against it almost always requires growing the organism to titers and concentrations that can cause infection in animals or humans.

Sooner or later it becomes necessary to test the vaccine—if the investigators are claiming it as a defense against such agents. If it is going to be against tularemia or Ebola virus or hemorrhagic fever, the investigators will have to infect (probably) primates to test the efficacy of the vaccine. Finally, to learn if the vaccines can actually protect

people, human subject volunteers—prisoners, for example—would be needed to be infected.

Thus, any endeavor which involves generating new human or animal pathogens needs to be examined with the greatest stringency, care, and skepticism. Carelessness occurs, misunderstandings are transmitted, incorrect assessments accumulate, and accidents happen. Recent examples range from lost plague-infected mice to mistaken shipments of anthrax (Shane, 2004; Margolin and Sherman, 2005). Suspected bioterrorism agents are predominantly new or novel agents, exactly where you would expect misjudgments. A detailed account of unexpected conditions causing serious accidents and breakdowns in a full high-security facility is in Michael Carroll's (2004) account of the breakdown at the Plum Island Infectious Disease Laboratory at the tip of Long Island. Among the events was a strong storm with unexpected flooding that knocked out the electricity needed for the maintenance of safety and security equipment at the laboratory.

Within a community, one of the sources of infectious organisms is medical and research institutions themselves. This is very well documented in hospitals, where some 5 percent of patients pick up an infection from the hospital environment itself, so-called nosocomial infections.

In the case of SARS, by July of 2007 there were 8094 documented cases, with 774 deaths. The source was a small number of infected individuals, who spread this coronavirus to unsuspecting contacts. In the Hong Kong outbreak, one of the clusters of 125 ill in Prince of Wales Hospital were infected through contact with a single individual.

However, this is also true for high containment facilities. The most recent SARS case, Lieutenant Colonel Chan, was an investigator working in a high containment facility at the Taiwan National Defense University in Taipei. (*In August a similar case was reported in the Environmental Health Institute in Singapore, where a lower level of containment was in force*). At the major U.S. bioweapons facility, Fort Detrick, Maryland—where everyone knew about the biological weapons program—there were at least sixty documented accidents involving exposure of lab workers within the facility, with concomitant risk of contamination or release. There were at least two deaths—William Boyle, a lab scientist, and Joel Willard, an electrician (in 1958)—from anthrax-like symptoms. These are underestimates, because national security concerns are used to cover up such incidents whenever possible. In particular, public announcement of accidents with such agents explicitly violates the enabling legislation.

This is precisely why—until the current construction projects—such laboratories were located in very isolated environments: Plum Island, at the tip of Long Island, for hoof-and-mouth and related infectious viruses; Dugway Proving Ground, in the desert of Utah, for the testing of biological weapons when such programs were operative; Fort Detrick, Maryland, a fully militarized and guarded national security facility.

When the first accidents occur, will the people who are ill know what they were infected with? No. It will be denied until it's too late, due to public relations or national

security considerations. Thus Boston University publicly announced that two of its staff had become infected by the potential bioterrorism agent tularemia only long after the outbreak occurred (Dembner and Smith, 2005). Neither the staff nor the surrounding community was informed of these events during the period when it was most important for them to know.

Do terrorists and crazies exist? Yes. Where will they get novel pathogens? The major source will be these bioterrorism labs, where the organisms are being generated! The anthrax that caused the panic in 2001 was the U.S. military strain (Read et al., 2002). The most likely source was one of the U.S. military labs.

These programs do not increase the security of the American people. They bring new risk to our population of the most appalling kind.

Commercial and Political Factors Promoting Bioterrorism Programs

The rate of entry of the commercial sector into bioterrorism research is truly impressive (Fonda, 2006). Regular conferences are held for commercial vendors at which Homeland Security officials describe the kinds of needs and projects that they will be funding. For example, in August 2006 the Cambridge Health Institute hosted the Fifth Annual Systems Integration in Biodefense: Building a Blueprint for Policy & Preparedness. The advertisements that I received regularly boasted of the number of contractors who would be attending, as well as the number of government officials who would describe the latest initiatives and requests for proposals. The expenditures of such funds create a dedicated constituency. Among these constituencies are biotech firms dependent on bioterrorism contracts for their financial health, biomedical researchers receiving such funds, and federal and state Homeland Security staff employed in planning responses to putative bioterrorism attacks. Absent a threat of bioterrorism, their income streams dry up. Thus they are generally promoters of the need to fear such threats. As was well documented during the Cold War military buildup, military contracts are often singularly profitable; competition is limited, and the product will rarely be tested in action to determine its efficacy.

The funneling of bioterrorism, Project Bioshield, and Homeland Security money to biological scientists—for example, at Boston University—also creates a political constituency. Scientists who might previously have spoken out against the war in Iraq, or against the "missile shield" in Alaska, become much more hesitant as they come to understand that their funding depends on maintaining the public fears and concerns of these perceived threats.

Sources of Biosecurity

Where does security come from? From strengthening the Biological Weapons Convention rather than trying to undermine it, and from infectious disease programs characterized

by complete openness and transparency. If the United States had supported the strengthening of the Biological Weapons Convention by insisting on inspection of any facility whenever there was a concern, there would be little danger from disguised or military programs. The facilities required are too substantial to escape detection by professional inspectors.

There are those who will claim such development and growth of infectious agents in weapons form can be carried out in a garage. This is about as accurate as claiming that intercontinental guided missiles can be built in a garage without detection. Production of refined anthrax spores requires very complex equipment, air-handling equipment, very large volumes of sterile media, and sterile procedures. A person trying to do such work in a basement would almost certainly contract the infection long before generating weapon-grade material.

In summary, these bioterrorism and biodefense programs are deeply and fundamentally unsound and should be terminated, and the funds returned to true infectious disease and public health research and programs.

In general, bioscientists and health professionals should reaffirm the scope of the 1972 Biological Weapons Convention, and in particular its prohibition of development, production, and stockpiling of nonlethal as well as lethal biological and toxin weapons, as well as its prohibition of biological and toxin weapons for all hostile purposes. Such purposes include, but are not limited to, the use of biological and toxin weapons to kill or harm humans, animals, and plants, and the use of biological and toxin weapons to degrade materials.

Our nation needs to commit to prohibiting the construction of novel biological and toxin agents with an enhanced offensive potential for any purposes, including biological defense, and to supporting these efforts in the international arena.

References

Anderson, Alun. (1988). "Biological Weapons Research Opposed." *Nature* 334: 279.

Boyle, Francis A. (2005). *Biowarfare and Terrorism*. Atlanta, Ga.: Clarity Press.

Carroll, Michael C. (2004). *Lab 257: The Disturbing Story of the Government's Secret Plum Island Germ Laboratory*. New York: HarperCollins.

Cole, Leonard. (1988). *Clouds of Secrecy: The Army's Germ Warfare Tests over Populated Areas*. Totowa, N.J.: Rowman & Littlefield.

Cole, Leonard. (1997). *The Eleventh Plague*. New York: W.H. Freeman.

Dembner, Alice and Stephen Smith. (2005). "BU Scientists Missed Bacteria-Illness Link." *Boston Globe*, February 5.

Fonda, Darren. (2006). "Inside the Spore Wars." *Time*, January 3.

Guillemin, Jeanne. (2005). *Biological Weapons: from the Invention of State-Sponsored Programs to Contemporary Bioterroism*. New York: Columbia University Press.

Lappe, Mark. (1971). "Biological Warfare." In *The Social Responsibility of the Scientist*, ed. Martin Brown, pp. 96–117. New York: Free Press.

Lichtblau, Eric. (1988). "500 Scientists Spurn Work on Biological Arms." *Los Angeles Times*, July 23, p. 1.

Margolin, Josh, and Ted Sherman. (2005). "Lab Loses Track of Three Mice That Had Plague." *Newark Star-Ledger*, September 15.

Melman, Seymour. (1974). *The Permanent War Economy: American Capitalism in Decline.* New York: Simon & Schuster.

Olson, Elizabeth. (2001). "Conference on Biological Weapons Stalled by Deep Divisons." *New York Times*, December 8.

Phillips, Josepha D. (1969). "Economic Effects of the Cold War." In *Corporations and the Cold War*, ed. David Horowitz. New York: Monthly Review Press.

Read, T. D., Steven L. Salzberg, Mihal Pop, Martin Shumway, Lowell Umayam, Lingxia Jiang, Erik Hotzapple, Joseph D. Busch, Kimothy L. Smith, James M. Schupp, Daniel Soloman, Paul Keim, and Claire M. Fraser. (2002). "Comparative Genome Sequencing for Discovery of Novel Polymorphisms in *Bacillus anthracis*." *Science* 295 (June 14): 2028–2034.

Shane, Scott. (2004). "Live Anthrax Accidentally Shipped from Frederick to California Lab." *Baltimore Sun*, June 11.

Stark, Margo. (1991). "Proposals to the Third Review Conference of the Biological Weapons Convention." *Genewatch* 7, no. 3: 4–5.

Strauss, Harlee, and Jonathan King. (1990). "Hazards of 'Defensive' Biological Weapons Programs." In *Preventing a Biological Arms Race*, ed. Susan Wright. Cambridge, Mass.: MIT Press.

Wright, Susan, ed. (1990). *Preventing a Biological Arms Race.* Cambridge, Mass.: MIT Press.

Bioparanoia and the Culture of Control

Critical Art Ensemble

Imagine a touchable world.
—PURELL HAND SANITIZER ADVERTISING SLOGAN

The subject under capital lives in constant fear that at any moment her body may betray her integrated subjecthood with organic disintegration that will in turn threaten her agency, identity, role, and appearance in the world. Knowing this betrayal is probable, and eventually inevitable, produces an uncomfortable disquietude that fluctuates wildly in its intensity, depending on the degree to which immediate circumstances are working in conjunction with a stimulated, paranoid imaginary. For the subject under capital, the body imaginary is a technology that can be adjusted, fine-tuned, and amplified by external social, political, and economic pressures in order to advance interests that too often are at odds with those of the individual. Capital's general ability to make such adjustments by constructing easily consumed and rapidly internalized apocalyptic fantasies has been honed to a very refined process. The consumer must accept these scenarios as probable, react with relative predictability, and yet avoid complete meltdown (productivity cannot be destabilized). If internalization of the fantasy can occur within a large enough aggregate of individuals, the social, political, and/or economic landscape can be altered by their collective reactions.

Individuals under the influence of artificially created bioparanoia will typically attempt to find ways to reduce the amplitude of a given internalized scenario in order to maintain a functional persona. The means by which psychological equilibrium is approached and approximated varies by scenario. Sometimes a deferment to authority is the solution, such as in the Bush administration's use of the imaginary of terrorists killing scores of American people in an effort to create a citizen-approved shredding of the Bill of Rights. Other times, the purchasing of a product will calm the storm, such as the run on plastic sheets

and duct tape when the U.S. public was encouraged by various government agencies to fear imminent biological attack. And at yet other times, individuals attempt to restore equilibrium by acquiring information readily supplied by the crisis-generating news media as was seen with viewer approval of the excessive reporting of bird flu outbreaks as a major public health hazard.

Hyperstimulating the imaginary of individuals with fears of a loss of bodily integrity is one of capital's most common energizing spectacles. It may not be the only tactic, but it is certainly a favorite. How much power has been consolidated under the sign of fear? We can never know precisely, but we can probably agree it is too much. We cannot hope to count all of the wars, markets, and legislative acts that have been generated in the wake of a fear campaign, but we can examine the typologies and related mythologies that have become grist for the exploitation mill that churns out the spectacle of fear. There are many phantasmagorical bodies to exploit, but three seem to stand out in regard to public bio-paranoia derived from the spectacle of fear: the disinfected body, the aestheticized screenal body, and the abused body. The narratives associated with these constantly mutating icons can carry us into the territories of the abject, the destabilized, and the tortured bodies that have been acted upon by external and internal (i.e., genetic error) forces that can reinscribe the flesh as the site of catastrophe. While some of these narratives may have a fragile connection to history and materiality, others continue simply as collective hallucinations. All types, however, are still perfectly suited for profitable symbolic exchange in the service of extracting individual agency and expanding realms of domination.

The Disinfected Body

The disinfected body, though a relatively new imaginary entity, is the eldest among this collection of phantoms. It emerged directly out of the material conditions of early capitalism in regard to human and public health. Its backstory reveals one of capitalism's greatest gifts to society and one of its greatest curses. To understand the conditions that brought this mythic specter into being, a look back at the emergence of capitalism (particularly ground zero—the United Kingdom) is necessary.

At the beginning of the nineteenth century, the British landscape was rapidly changing. The intensification of urbanization moved in parallel with the intensification of industrialization. Cities exploded in population, and towns turned into cities in a matter of years. In 1750 there were two cities with a population of over fifty thousand people in the United Kingdom, London and Edinburgh. By 1801 there were eight, and by 1851 there were twenty-nine. The factories' immense demand for labor precipitated a massive population shift from the countryside to the cities. For the first time in history, the center of profit and power was situated in the control of manufactured goods. As long as England had a monopoly on modern technology and the knowledge to use it effectively, the British Empire was unassailable.

As labor poured into the cities, opportunities bloomed for all types of small businesses that supported the factory laborers and the growing industrialist class. However, along with opportunity and wealth, a very serious problem emerged: no institution(s) existed that had the function of managing growth. Urbanization at this rate and density had never been seen before. From this lack of management sprang the now familiar modern social problems: pollution, crime, exceptional poverty, and health crises. In the case of public health, the conditions could not have been worse. The poor were packed together. Multi-generational families crowded into tiny apartments. To make matters worse, in the early part of the century there existed only the crudest waterworks and sewage systems. This problem was particularly bad in London, where the flow of the Thames, in conjunction with regular rainfall, was no longer robust enough to carry all the sewage out to sea. The river, which supplied the city's drinking water, became a festering wound running through the city, yet remained the only source for drinking water. Under these conditions, contagions spread like wildfire. Cholera and dysentery were common. Because of the population density, airborne diseases such as smallpox (in the early century) and tuberculosis (consumption) were rampant. All disease spread faster and had higher mortality because laborers were overworked and undernourished, and consequently had weakened immune systems. For babies and children (especially those who were working) the mortality rate was staggering.

Despite this chaos, capitalism—a political economy populated with managers, number crunchers, bureaucrats, and optimizers—sought ways to express rationalization and efficiency in this urban landscape. It did, albeit probably for the wrong reasons. Labor was an abundant resource that was at best a mere force of production, as opposed to being viewed as a dignified human ability. Thomas Malthus suggested as an early management technique letting the poor die (and, if necessary, helping the process along), since there was an inexhaustible supply. After all, from his perspective, their squalor was a matter of moral ineptitude and not economic oppression. Fortunately for the laboring and underclasses, disease does not care about the qualities of its host. The merchant and ownership classes were also caught in the crisis. Not as many died on a per capita basis, but die they did. The problem caused enough public outrage that something had to be done.

In 1837, the National Vaccination Board was created to distribute smallpox vaccinations around the city of London. In 1843, London created its Board of Health. Other cities copied the model. Because of agitation and unrest, labor began getting some very modest relief as well. The Factory Act of 1833 forbade children under the age of nine from working in textile mills. This was followed by the 10 Hour Act in 1847, which banned women and children from working more than ten hours a day. These initiatives and acts were better than nothing at all, but a quick glance at Friedrich Engels's chronicle *The Condition of the Working Class in England* (1844) shows that they did little or nothing to improve the actual situation.

Spurred by a serious cholera epidemic between 1848 and 1854, a real consideration of public health began in 1854. The summer of 1849 was especially bad, and was surpassed only by the summer of 1854. Cholera was one of London's more gruesome diseases—at that time it had a 50 percent mortality rate due to the disturbing speed with which an infected body would dehydrate. Even more gruesome, infected bodies often continued to convulse after death. A physician named John Snow had been seeking the cause of cholera since its appearance at Newcastle in 1832. Snow had no scientific model with which to track cholera, and instead used a quantitative social scientific model. He chronicled and mapped the outbreak, and managed to build a correlation between case distribution and water quality. This lent some credence to his hypothesis that cholera was waterborne (most of his contemporaries believed it to be airborne). In 1854 he discovered that it was better to get drinking water from the north side of the city. South London, a more impoverished district, had a much higher incidence of cholera. The increased rate was due to the Southwark and Vauxhall water companies drawing their water downstream from the many sewer outlets that flowed untreated into the Thames. Unfortunately, this was the only water available, so people were forced to drink the brown, frothy brew.

In September 1854, cholera raged in Soho, with more than six hundred people dying in the first ten days of the outbreak. Snow tracked the outbreak to a pump on Broad Street where most of the victims were getting their water. His solution was to remove the pump handle. The Board of Guardians of the parish concurred, and carried out his advice. The cholera did stop, but whether it was because the pump was disabled is uncertain. Snow himself admitted the cholera epidemic was in decline at the time of the action, so the closing of the pump could well have been too little too late. Still, this moment was of great importance for three reasons. First, Snow had convinced those in power that water and sewer management were key to public health management. Second, the government began to understand what public health really was, and why it was important to pay attention to it. Third, any doubts the city fathers may have had regarding Snow's conclusions were quashed by the uproar over the number and type of people who had died. The six hundred were not the impoverished laborers of South London, but the reasonably well-to-do shopkeepers of Soho. Members of Parliament, led by Benjamin Disraeli, quickly moved to rework the entire sewer and water system, sparing no expense and using the best engineering techniques known at the time. Cholera never returned to London after the system was completed.

The late nineteenth century brought another series of events that would add to the public's mounting interest in the disinfected body. Most significant was the isolation of a number of disease-causing bacteria, which in turn led to uncontestable proof that specific bacteria were the source for specific diseases and infections. Louis Pasteur and Robert Koch proved the germ theory of disease in the 1880s, a decade that truly launched the field of microbiology. The idea that germs caused disease had been around in a crude form since

1546. During that year, Girolamo Fracastoro proposed that disease was caused by agents too small to be seen by the naked eye. He called these agents "seminaria." A century later, with the invention of microscopy, these creatures were finally seen. Even so, the germ theory of disease enjoyed very modest success through the eighteenth and nineteenth centuries. Most physicians and other specialists were sympathetic to the theory of spontaneous generation that stated bacteria were a by-product of disease rather than a causal agent. After the work of Koch and Pasteur, however, germ theory was uncontestable. Pasteur also proved that bacteria were the cause of souring and rotting. As the evidence mounted, the medical establishment grudgingly accommodated this new knowledge and the medical techniques born from it. These new understandings were among the cornerstones of modern medicine.

The appropriation and exploitation of the new knowledge by capitalist opportunists was rapid. Disinfectants and sanitizers poured into the marketplace. A new appreciation for alcohol (both ethanol and isopropanol) boomed in the 1890s. In 1897 Sears and Roebuck listed five types of bleach in its catalog. By 1903, phenol was the standard antimicrobial against which all others could be judged, using the phenol coefficient method of testing. Hospital infection rates plummeted. Eventually, the antiseptic era of medicine gave way to the aseptic era, in which bacterial contamination was intentionally and actively avoided, and antiseptics were used as a second line of defense. This was the upside. The downside was the reactionary but profitable attack on public consciousness regarding germs.

The public in developed countries was worried enough by experiences of epidemics, and very frightened of infection from the newly discovered invisible germs. We must remember that there were no antibiotics yet, and once they came into being, the public could not access them with any ease until after World War II. This meant that any breach of the borders of the body, no matter how small, was an invitation to infection. Once infection began, it could rarely be stopped. In this context, when the news arrived about the link between filth and germs, it was as if a war between humans and bacteria had been declared. Both body and environment were held to a new standard of purity. Cleanliness was no longer a metaphor for spiritual purity, nor was it just a status symbol that few could afford—it was a standard that toed the line between life and death!

In the 1880s and 1890s scientists and doctors showed that germs could be carried in dust. This notion was immediately exploited. In 1899, an ad for Bissell house cleaning supplies read, "Dust, a carrier of disease." Vacuum cleaners emerged as an answer to the scourge of dust. Ideal claimed that its vacuums would "[eat] up germs as well as dust." If that was not scary enough, it also offered to send free to its customers "the truth about TB." In 1912, Lysol claimed that it would "[kill] the germs that cling to rugs." Hygiene was no longer just a social problem in need of government intervention and management; it was a domestic and personal charge with dramatic consequences for those who failed to respond. Manufacturers were quick to understand that selling bioparanoia moves

products. The greater the fear, the better for the household sanitation and disinfectant industries.

The middle-class household was being transformed. The Victorian era created a new kind of domestic—the wife became the servant. She was responsible for the maintenance of the household, but she no longer had to make the supplies for the house, as in the past; she had to buy them. For example, candles were bought rather than made. The wife was quickly transformed into a service worker and a consumer. As capital pushed its models of efficiency in the factory, Taylorism made its way into domestic space as well. Women's magazines such as *Good Housekeeping* showed women how to do their housework with the greatest efficiency, and offered tips concerning everything domestic from time-saving bodily movement to the best designs for an efficient kitchen. Women were also taught how to be good consumers by buying the best products for the best price, just as any factory purchaser would do for his business. This disciplinary logic of the household made for an immediate association between protection of the home from an invasion of anything inferior or impure, and fear of the consequences of failure. Not only would an inability to stem the invasive tide of germs have a physical consequence for the health of the family, it would also cause a collapse of identity and social position. To this end, any support product became desirable—not just as a functional item, but as a means to neutralize the anxiety of a hyperreal biopolitics.

CAE does not mean to argue that the germ frenzy arising in the West was a pure form of bioparanoia; we are only saying that fear and danger were pushed to an inordinate extreme by profits (both real and symbolic), and then institutionalized. The truth of the matter is that the disinfected body (i.e., a germ free organic body or domestic body) is not possible. Humans have a symbiotic relationship with gut *E. coli*; we would die without them. Some bacteria just like to live on us, and plenty live all around us. Humans are bacterial hosts no matter how hard we may try not to be, and the environment is always filled with one of the oldest, most differentiated species on the planet (except under the strictest of "clean room" conditions, which cannot be achieved in domestic space with household products). And this is fine, since the grand majority of bacteria are not a danger to bodily health and are the foundation of every ecosystem. No ecosystem could sustain itself without decay, and bacteria provide this essential function.

Unfortunately, advertisers have kept the public focused on the dangerous bacteria. The germ hysteria that began in the Victorian era has never really subsided. Even after the invention of antibiotics, the fear of bacteria persists. The matter is further complicated by the discovery of viruses in 1911, and their association with the Spanish flu of 1918. Such events and the personal experience of pain, nausea, and the uncontrolled overproduction of a variety of bodily liquids during illness continue to make advertisers' jobs easier.

The market research on household cleaners is a clear indicator that advertisers and the corporations producing the products have done very well at normalizing a hysterical

relationship to bacteria—one in which the illusion of environmental sterility and personal microbe-free purity is an anticipated daily goal. Consequently, the household cleaning market consistently expands. According to the Freedonia market research reports, demand for household cleaning products tops four billion dollars a year.

While some of this success can be explained by product differentiation (packaging what is basically the same product in slightly altered forms) and the ability of companies to develop more convenient means to use the products, Freedonia is quick to note that "concerns over the spread of diseases continue to boost demand for biocides, not only in disinfectants but in a broad variety of cleaning products."

As the market grows, the standards for cleanliness expand with it. A point of diminishing returns emerges when a body or a space can be only so well sanitized, yet the scrubbing continues. In order for the market for disinfectants and sanitizers to grow continually, consumers must engage in wasted activity—cleaning that which no longer needs cleaning. (Ironically, if this obsession with sanitizing continues to intensify, human immune systems may become weaker.) Through this process, the consumers no longer approximate, but believe they have achieved, the disinfected body, and are once again secure from the microbial boundary disrupters and organic trespassers. They can feel confident in their artificially constructed sense of security. To the contrary, however, strong public health programs are the best protectors against disease. Cholera did not disappear due to housecleaning, but rather a public health policy that provided for robust investment in water treatment. As for viruses (the flu in particular), cleaning may help to a degree, but until one is ready to become Howard Hughes and renounce contact with other humans, occasional sickness is simply a fact of life.

The Aestheticized Screenal Body

CAE has no intention of belaboring its analysis of the aesthetcized screenal body, as the critical literature that already exists on the subject is copious, broad, and articulate. Almost every social aggregate (whether based on class, ethnicity, gender, sexuality, and so on) limited to the margins of the socioeconomic sphere of global capital has presented critiques of either the images used to represent them in all forms of spectacle and/or the absence of images with which the these groups could actually identify. CAE's focus for this article when examining the screenal body in this vast spectrum of spectacle are those body images that can exist only on the picture plane, and yet are believed to be more than just visual fiction; they are seen as a copy of organic perfection to which one should aspire, and that some have attained. Much like the disinfected body's inseparable association with purity transformed into guarantees of health and a site of safe communion, the aestheticized screenal body (ASB) and its association with beauty transforms into a guarantee of strength and attraction. Both forms are caught in the black and white of extremity, and are represented in absolute positive or absolute negative forms. The disinfected body is

either a beacon of health or a failed body that is a reckless endangerment to everyone around it. The ASB exists either as the perfect beauty or as repulsively hideous, as brimming with confidence or as suffering humiliation.

Both of these extremes contained in the ASB are of tremendous use to capital. The positive ASB is of such resplendent artifice it would make Des Esseintes envious. This imaginary succubus could be produced only in the perfectly coded environment of the virtual, in order that she be more real than real. Her ethereal liquidity allows her to constantly develop and transform. For all the unfortunate analogue bodies caught in the cycles of order and entropy, their Sisyphean fate is to endlessly attempt to copy the digital model that the ASB sets for all who gaze upon it. One more product might make it possible to capture this illusive image, or at least a respectable approximation. Even a respectable approximation cannot last long, since that which one tries to imitate is in constant flux. To engage the specter thus requires endless amounts of time and money. This costly imperative is the genius of capital: creating the moment when life must imitate art.

For those who dare to doubt the reality of the fashionable icons of the virtual, capital has created the perfect alibi—the aestheticized celebrity. The floating signifier of the ASB grounds itself in the flash appearance of the celebrity. Acting as a living referent for a dead illusion, this glorified abstraction of the code of beauty walks among the mortals. Not only can it be seen, it can be touched. The flesh becomes a point of obsession, yet the relationship to the flesh is unstable, as this body could betray its image. The hope that the boundaries of the subject will rupture in some way is always waiting behind the public adulation. The witnessing of such occurrences is an industry in itself. Here again is the genius of capitalism; it makes a profit even from its failures and shortcomings.

As with most morality narratives, the villains are more interesting. We prefer the horror to the perfection, the *Inferno* to the *Paradiso*. The opposite end of the spectrum is what truly helps to reinforce the disinfected body, and vice versa. The body in crisis is aestheticization at its most effective. This liquid body, unlike its counterpart, leaks, squirts, oozes, drips, excretes, and even gushes. The association between the body in crisis and evil, horror, humiliation, and abjectivity is replayed with unwavering dedication by the brokers of affectivity. The tale generally ends in punishment or death for the offending monster. The fear that the body will autonomously participate in the performativity of the grotesque becomes its own obsession. Fantasies of organic meltdown and its consequences, fueled by vague social anxieties, run rampant in the imagination. Narratives from the image barrage of horror films and teen "gross out" cinema, and the subtext of humiliation and embarrassment from a tide of advertisements, seem to predict an inevitable future that can be changed only by purchasing the right product—one that could stop the revolutionary conspiracy brewing within the flesh. The technology of the body imaginary is at full amplification, pushing the markets to new heights. Products ranging from makeup to diet products to over-the-counter pharmaceuticals benefit from the fear of a public display of broken boundaries.

The driving of markets through the use of collective hallucinations is a socioeconomic disaster. An immeasurable amount of productive energy is wasted appeasing the anxiety inserted by capital through insidious and invasive manipulations of huge sections of the public imaginary, not to mention the misdirection of resources that could function for the public good. Also immeasurable is the extreme psychological damage done to individuals who find themselves unable to approximate the image to the extent they believe is expected of them by an indefinite, unidentifiable, internalized authority; or conversely, the damage to those who have been left only the option of identifying with the monster. These failures and identifications spill into the social sphere, and become the alibi for more authority and new types of markets to transform the deviance back into market desire. However, capital can do worse. The ASB and the disinfected body are the linkages for a third imaginary body that is meaningful to markets, but even more meaningful to the military. It, too, has colonized the blend of these two imaginaries for its own purpose—as a means to expand its domain by advancing on civilian institutions in the hope of making them its own, and as a way to extract more funds for its own useless purposes.

The Abused Body and Its Consequences

The term "the abused body" is a very volatile one, so it behooves us to define precisely what we are and are not speaking about. We are *not* speaking about the billions of people worldwide who are broken and battered by all or some combination of poverty, violence, starvation, and preventable disease; rather, we are speaking about another fantasy body that, like the other two treated in this chapter, is thought to be material even though it resides only in fantasy. This body signifies the fate of the flesh should the crises that ever loom before us reach fruition. This fate is a nightmare worthy of the most extreme gore films—mounds of corpses, burning bodies, adult and infant deformities, radiation sickness, pox and plague, a Dantesque inferno of agony of global proportions.

For this scenario of complete body meltdown to be transformed into a powerful sign of exchange that can reform material and relations to material, those minting this semiotic coin engage a specific set of principles. The scenario must be all-inclusive and totalizing. No point of escape can appear in the crisis narrative—everyone must be at risk. Every physical body within the sphere of deployment must be included in such a manner that "the body" in meltdown is accepted as one's own body in meltdown. The narrative should be framed as global. The threat of becoming an abused body must be everywhere and imminent. The mythology of the "global village" emerging from the collapse of space and time inside the technosphere helps to transform a belief in a possibility of retreat from the crisis into a statement of naïveté.

The only suitable response to the abused body is fear, and once that is established, all contradictions, no matter how intense, can exist simultaneously and without conflict. For

example, in the current U.S. political climate of fear, the Bush administration can say that the crisis of the global war on terror can be resolved by fighting the terrorists elsewhere in the world so Americans do not have fight them on home soil, and simultaneously claim that "home" is a major battle front peppered with those ready to do citizens harm, so that extreme security measures must be taken within the country even if they severely erode civil liberties. In addition, the executive branch should be granted whatever power is needed to secure the besieged state. The administration can command both of these opposing points without worry that the contradiction will be visible to a public blinded with fear.

While the general model for manufacturing societies of fear has remained consistent since the 1950s, the specifics of scenario generation have varied, blowing with the winds of political fashion. Nuclear war is the traditional fear producer. Certainly, the fear in the 1950s is understandable. Weapons of mass destruction were new on the scene. The power to completely destroy civilization as a real material scenario had never before been contemplated. And the Soviets had "stolen" nuclear secrets through the use of espionage and had created a bomb of their own. Under these conditions the abused body emerging out of global nuclear war appeared as a certainty. With the fall of the Soviet Union, this type of narrative was saved for "rogue" states that capital believed needed to be subdued. The events of 9/11 were ideal for establishing a "global war on terrorism" that in turn would put the United States into permanent and immediate crisis mode, but the technique was too tactical. The weaponry (box cutters and planes) was not of a pangeographic variety. In October 2001, the latest fashion in fear debuted with an anthrax incident that killed five people. This weapon, although hardly as effective as boxcutters and planes, had all the right elements to fire the public imaginary.

First, the public was prepped for this narrative of body invasion. The ASB and the disinfected body had already laid the foundation on which a consumer anxiety could be transformed into outright manufactured fear of biological attack. Once germs had become an official weapon of terrorism, all that was required was to create a campaign that would inform the public about how germs could be used as a weapon of mass destruction. Using the 1918 Spanish flu epidemic as a model, the association with a global epidemic was established and reinforced on a daily basis. The hype in the early 2000s over avian flu further reinforced this situation.

The apparatus that manufactured this phantom of threat is a complex network of institutional authority with each node looking to expand or consolidate its power. Each piece in the network does not necessarily need be in collusion with any other piece. Each needs only to see possibility, and act accordingly, knowing that fear is one the most exchangeable and profitable signs in political economy. (Even the slowest of bureaucracies acts quickly in its presence.) Since all parties involved have a stake in taking their fantasy for reality and turning the most improbable into the most probable, the manufacturing process is nearly frictionless, and the rewards are tremendous.

The rewards to the Bush administration for convincing the public that bioterrorism is a real and present threat are threefold. First, it reinforces the administration's argument that executive power should be unchecked, and that the president is above the law in all matters since the country is under a multilayered invasion. Second, a population that is afraid of becoming an abused body is most likely to surrender its civil rights in exchange for the promise of security. Under these conditions any resistance against the administration's repeal of the First and Fourth Amendments would be minimal. Finally, the security issue was Bush's ticket to a second term as president.

The rewards for other agencies are not as profound, but still quite significant. The news media increase their viewer/reader base during times of crisis, which in turn pleases the advertisers. The producers of knowledge increase their funding. The government handed out billions of dollars for biological research with military applications, and even rewarded those who were most cooperative with Regional Centers of Excellence (RCE) for Biodefense and Emerging Infectious Disease Research. The Centers for Disease Control got its share of these research funds as well, and a new research building (Building 33 in Atlanta), at a cost of 186 million dollars. The real winner, however, is the military. Not only did it see its germ warfare program returned to the status and financing that it had in its glory days of the 1950s and 1960s, but it is able to colonize more civilian resources for its own use.

Here is where the fantasy spirals out of control—these biowarfare initiatives are a huge waste of taxpayer dollars. The waste is everywhere. At a cost of nearly one billion dollars, the Bush administration's plan to have 25 million doses of anthrax vaccine, and eventually a dose for every citizen, is a prime example. Vaccines have a very short shelf life (usually around six months) and must continuously be replaced, meaning the overwhelming probability is that they will never be used, but continuously thrown away. The likelihood of a national anthrax attack is actually zero. Air security is such that no terrorists could possibly fly over the United States in a cargo plane full of anthrax and do systematic large area coverage release. Moreover, where would they get enough anthrax and the cargo plane? At best, anthrax could be used only as a tactical weapon, as in 2001. We should also note that anthrax is not contagious, and cannot start an epidemic. This is public health policy from an administration against national health care in a country with an infant mortality rate that is second among developed nations only to Latvia.

While the loss of money to biowarfare programs is infuriating, the loss of life is unconscionable. Resources for combating and researching emerging infectious disease are finite, whether these resources are funds, labs, or the personnel necessary to do the research. The more that is pulled away to research military interests, the less research is being done in the public interest. While HIV, hepatitis C, multidrug resistant TB (and TB itself), malaria, and other diseases are killing millions of people each year, the military prefers to focus on anthrax, Ebola, and smallpox (which should be extinct; it's on Earth only because the U.S. and Russian military keep specimens). Smallpox hasn't killed anyone

since 1977. Since the 1970s, Ebola has killed only 683 people worldwide (that is not even a good minute of death for most of the diseases listed above). There were only 236 cases of anthrax in the United States between 1955 and 1999. None of these are real public health issues. They are all about military fantasy, and come at the expense of real, ongoing, material health crises.

Three Phantoms

The belief in the abused body as a real body (in relation to germ warfare) stands upon the shoulders of three other phantoms that are haunting the public imaginary. The first is the fantasy that a germ warfare attack is highly probable. It's not probable; rather, it is the most remote form of possible attack except nuclear attack. If we examine the history of terrorism, it becomes abundantly clear that terrorists prefer explosives and small arms for reasons of stealth and practicality. Even the U.S. Office of Technological Assessment (OTA) has said that it is extremely improbable that terrorists would use such weaponry (even if they could get it, sustain it, transport it, and deploy it to begin with). The reasons the OTA gives are lack of familiarity, fear of alienating supporters by causing large numbers of casualties, fear of an extreme response by another country, fear of working with biological weapons, prohibition by terrorist groups' financial sponsors, and the need to await someone else's successful use. Terrorists are not deranged humans looking to spread chaos as if they were the Legion of Doom or some other comic book fabrication. They have a political agenda; they are strategically as well as tactically goal-oriented; and thereby they have limits placed upon them by what they desire to achieve.

The second phantom is one that involves the misunderstanding of kill rates. We can say with great assurance that the death toll expected from biological weapons has been overexaggerated by those who will benefit most from the development and maintenance of this specific fear. For example, in 1997, U.S. Secretary of Defense William Cohen made a dramatic appeal by appearing on television holding up a five-pound bag of sugar and declaring that this amount of anthrax sprayed from an airplane would result in the death of 50 percent of the population of Washington, D.C. Not only is such fear mongering irresponsible, since it greatly exaggerates a highly unlikely scenario, but the information itself is incorrect. Even the World Heath Organization (WHO) estimated that it would take fifty kilograms to cause a 20 percent casualty rate in a population of five hundred thousand.

But why trust the WHO? Money could be going its way as well. Instead, CAE suggests looking at the historical record. Two cases of anthrax exposure are available to us. The first occurred in April 1979. The Soviet biowarfare unit Compound 19 at Sverdlovsk (home to a large-scale military weapons manufacturing site and a city of 1.2 million people, now known as Yekaterinaburg) noticed that a neighboring population was experiencing a serious outbreak of anthrax. Soviet émigrés to Germany told local newspapers

that the factory had released a cloud of anthrax spores. This explanation seems likely. Seemingly, sixty-six deaths occurred in a four-kilometer swath downwind from the incident. The U.S. military and various intelligence agencies believed that an anthrax aerosol was accidentally released. Further evidence of the release came from satellite images of roadblocks and what appeared to be decontamination trucks in the area. Later, Soviet doctors who were involved in the event came forward, saying it was an accident, and published details of victim autopsies. Based on the horrific numbers we are given, wouldn't more than sixty-six deaths occur in a populated area? Though the exposure rate was enormously high, the infection and mortality rates were incredibly low.

Perhaps it was just luck that more were not killed. However, if we look at the other incident of anthrax exposure, the results are repeated. The October 2001 anthrax incident in the United States also tells us that the classification of biological weapons as weapons of mass destruction may be a tad overstated. Thousands of people were exposed to this military grade anthrax. Only twenty-two people were infected, and only five or six (depending on whom you want to believe) died. Once again, there was a high exposure rate followed by a low infection rate and an incredibly low mortality rate. The incident did not generate panic, nor were hospitals overwhelmed. None of the nightmare scenario that the public was sold actually occurred, but unlike Cohen's sugar bag simulator, the attack brushed against the real just enough to structure it as plausible in the public's imagination. This was enough for capital's fantasy engine to produce a phantom that could diabolically haunt the public sphere.

Now the third phantom makes its appearance. Once fear is established and is associated with war, government and military alike can argue that the only solution to the problem is a military one. Health policy can and must be dominated by military concerns and values. Such a policy is the only way citizens can remain secure. Unfortunately, when it comes to health crises due to disease, nothing could be further from the truth. The military has little interest in the diseases that are actually killing millions, thus constituting a real ongoing crisis; rather, its interests are in diseases such as smallpox, Ebola virus, tularemia, Marburgh virus, and anthrax. These diseases are killing practically no one (with the historical exception of smallpox; however, it hasn't killed anyone at all since 1977). Yet this is where resources for fighting true dangers are being redirected.

If anyone needs an example of what happens to public health when civilian institutions become militarized, one need look no further than the sad history of the Federal Emergency Management Agency (FEMA). Launched in 1979 by the Carter administration, FEMA was an attempt to unify a number of federal agencies charged with managing a variety of public emergencies. These included natural disasters, nuclear war, enemy attack on U.S. territory, and incidents involving civil unrest. The Reagan administration decided that FEMA would be most useful if it focused on civil unrest. To this end, the administration appointed a former National Guard general and counterinsurgency expert, Louis O. Giuffrida, to the post of "Emergency Czar". He, in turn, appointed more military men

who shared his McCarthyist tendencies. The militarization of FEMA reached its peak in 1982 with the publication of "The Civil/Military Alliance in Emergency Management." This document contained the plans to cement the association between FEMA and the military, and went on to argue for the countermanding of the U.S. Constitution by saying that military force can and should be used in cases of domestic disturbances. The Reagan administration supported this notion with several National Security Decision Directives that bonded FEMA not only to the military, but to the National Security Council as well. During this time, the Civil Security Division of FEMA pursued all kinds of nastiness, including organizing military training for police and opening files on U.S. activists. They collected twelve thousand files in all.

At this point, FEMA was beginning to crowd into other agencies' territories—most notably the FBI's. In retaliation, the FBI launched a full-scale investigation of FEMA, exposing the de facto nepotism and misappropriation of funds. Giuffrida was forced to resign. After this, FEMA fell into relative neglect, and the ties to the military eroded. During this period, an "all hazards disaster preparedness" plan emerged, designed so a single plan could be used to accommodate many types of emergencies. FEMA was reborn after its performance in Hurricane Andrew in 1992. The storm was the worst ever to have hit the United States, and leveled parts of South Florida. Andrew put a scare into both the government and the public, making it abundantly clear that the focus of FEMA should be on natural disasters that were occurring with steady or increasing (depending on whom one wants to believe) regularity. In this climate, the Clinton administration appointed James Lee Witt to be the director of the agency. For the first and only time in its history, FEMA had a director who was a professional emergency manager! Witt committed FEMA to natural disaster preparedness and disaster mitigation—quite a shift from the Reagan/Bush era.

However, this Dr. Jekyll and Mr. Hyde story does not end here. With the 2000 election of George W. Bush, FEMA went retrograde. The Bush administration followed through with very little of Witt's work and appointed cronies with no emergency experience (much like nominating Paul Wolfowitz to head the World Bank even though he has no banking experience, or appointing John Bolton as the ambassador to the United Nations even though he has no diplomatic experience). The Bush administration's choice for director was Joseph Allbaugh, the chief of staff for Bush when he was governor of Texas and the former national manager for the Bush-Cheney campaign. Allbaugh resigned in 2003. His buddy and GOP activist Mike Brown, who had been appointed deputy director when Allbaugh joined FEMA in 2001, succeeded him. Like Allbaugh, Brown had no experience in emergency management.

After 9/11, the administration decided that FEMA was an anachronism, the duties of which should fall under the new Department of Homeland Security. Public protection from natural disasters once again shifted back toward the military, and the only disaster that garnered government attention in the post 9/11 climate was terrorism. Once again,

military paranoia rather than public health became the order of the day. Under Brown, FEMA developed a new "all hazards" plan suitable only for the many types of terrorist attacks that the agency could dream up. Public health emergency equipment was replaced with military first-response equipment for WMDs. Given the catastrophe in New Orleans and the Gulf Coast in 2005, the consequences of this shift are clear. An underfunded and unprepared FEMA attempted to manage the greatest natural disaster in U.S. history. The military was almost completely useless, giving little support until nearly a week after the storm hit. The many casualties were not from the storm, but from the sheer incompetence of the Bush administration to ensure funding for the necessary precautions against such a disaster, in combination with the inhuman negligence of authorities and the lack of preparedness of FEMA. The clear lesson here, once again, is that a militarized relationship to public health serves only to intensify disaster and not to lessen it.

To the contrary, strong civilian preparedness has served citizens very well. The most significant medical victories have come from civilian initiatives. The elimination of small-pox and polio (although now it is back due to criminal neglect), antibiotics, the arrest of SARS, and all other beacons of health policy are fruits of strengthening programs and research initiatives that are in the global public interest. The people who are dying with every passing minute of every day cannot wait in hope that the military will stumble upon a helpful "spin-off" technology that may benefit them. Only an integrated global public health policy can secure anyone from the threats and crises brought about by emerging infectious disease or hostile attack with biological agents. However, until the collective illusions and hallucinations that haunt the public imaginary are revealed and understood as constructions designed only to mislead the public and obscure contemporary and historical relationships to production and power, a pathological bioparanoia will continue to rule public consciousness, much to the delight of authoritarian forces, and the type of health policies needed for a secure and vital world will remain a dream.

Chinese Chickens, Ducks, Pigs, and Humans, and the Technoscientific Discourses of Global U.S. Empire

Gwen D'Arcangelis

Outside the city limits, farmers eat, sleep and work in teeming and cramped quarters with ducks, chickens and pigs in traditional and often squalid conditions, creating a toxic brew that can easily spread to the modern China, and to the rest of the world.
(BRAY 2005)

Some virologists believe traditional farming practices in China help spread new viruses. Chinese farmers raise ducks, pigs, and fish in one integrated system, and the animals may exchange viruses through their feces.
(LOVGREN 2003)

The casual attitude toward health isn't unusual in China. This remains a country where men and women enthusiastically spit in public, even in affluent cities such as Beijing or Shanghai. People eat from common plates and male drivers urinate in plain view by the side of almost any road.
(LYNCH 2003)

These quotations are representative of U.S. news media coverage of China with respect to the SARS outbreak in 2003. Through these narratives of Chinese hygiene—the depictions of animals, waste, consumption, and disease—the news media participate in new forms of Orientalism and race, on the one hand, and new biogeographies of hygiene and geopolitics, on the other. As a site of governmentality, hygienic discourse belies its ideal of scientific neutrality through the selective emphasis on the hygiene, or lack thereof, of some groups rather than others in aiming at a variety of ends, from policing national borders to providing health services. While the State has historically formed the main site governing its subjects through this site of hygiene (Laporte 1978), in current times the news media are a powerful, if subtle, actor in the production of specific modes of hygienic governance. In news media representations, subjects are positioned in direct and indirect

ways that have tremendous influence over the social order (Poster 1990, 1995). In this chapter I examine processes of racialization and Othering promoted by the U.S. news media during the SARS incident, reading them specifically through the representations of Chinese as unhygienic.

Racialization and "Othering"

To begin with, a discussion of the role of the U.S. news media in producing representations of Chinese[1] must be placed within the context not only of global political economy—namely, the relations between the United States and China—but also of U.S. racial formations. U.S. governance continues to be determined through racial (among other) hierarchies. From the construction of natives as racially inferior to white Europeans accompanying the genocidal inception of the United States, to the dehumanization of black Africans as chattel and slave labor for white Americans, racialization has been a bedrock of U.S. governmentality. Processes of racialization continue today, in the regulation of population size, population ratios, and immigration/emigration between the United States and countries external to it. The racialization of Chinese (and other groups that are neither white nor black) in the United States has taken a particularly contradictory form—as neither black nor white, they are similar to native populations and lie completely outside of, or are Other to, a dualistic racial system based on black–white relations; at the same time, however, they lie racially somewhere in the middle of this racial hierarchy between black and white (Kang 2002; Kim 2004).

This historical racialization and "Othering" of nonwhite/nonblack populations has been maintained through myriad intertwining social and scientific discourses. In the past, with respect to Chinese these took on forms such as institutionalized segregation in social spaces and exclusion altogether from settlement in the United States, or post-slavery scientific studies of race and intelligence that demonstrated the fundamental difference between the mind of the Chinese (or "Mongoloid" at the time), and the Western mind, and produced intelligence rankings conveniently fitting with the social order (Gould 1981; Harding 1993). Today, these processes of racialization and Othering continue, albeit in modified form, with different consequences for different groups. Some groups, such as Italians and Irish, initially categorized as nonwhite, eventually became racialized as white; other groups, such as the Chinese, remain nonwhite. I argue, as previous studies of early twentieth-century America have shown (Leavitt 1997; Shah 2001), that current hygienic discourses serve to ensure that the Chinese, whether U.S. citizens or not, firmly remain in their social position as perpetual Other to the United States.

The particular U.S. racial contours today, however, are different from those of the early twentieth century. The "yellow peril"—the threat of Chinese settlement in the United States by many who were fleeing harsh economic conditions in China, and the prolifera-

tion of anti-Chinese sentiment—of that time finds only moderate resonance in the current post-Cold War security climate characterized by the rise of China as a military and economic power rivaling the sole global superpower status of the United States and by the legacy of the struggles of minority ethnic populations to attain equal citizenship status to whites. New contexts of technoscientific authority, neoliberalism, and transnationalism are also key characteristics of the current age. Attention to these contextual factors will inform my analysis of U.S. news media portrayals of Chinese during the SARS outbreak in China.

Humans/Animals and Other Hygienic Nature/Culture Binaries

The relationship between Chinese people and nonhuman animals was heavily scrutinized and problematized with respect to disease emergence in the SARS incident. Despite lack of consensus among public health institutions about whether animals were vectors, which animals were vectors, and what kinds of contact were actually contagious, the general claim that SARS arose in China because of a high density and proximity of animals (especially "wild" ones) and humans became widespread in the United States.[2] The news media played a large role in the dissemination of these public health claims regarding SARS to the larger public in the United States and beyond. While U.S. public health, as a site of (hygienic) governance, is itself undoubtedly influenced by and constructed in part through discourses of racialization and Othering, the U.S. news media act as a primary filter that selects what claims from public health to cover and how to cover them. In this instance, many U.S. news media sources, rather than give evenhanded, carefully contextualized coverage of either the SARS outbreak or the role of Chinese cultural practices in relation to it, instead liberally applied a variety of public health claims to Chinese without regard to consequence, simultaneously feeding medical discourses of Othering and spreading them widely to the general public.

In the first two quotes at the beginning of this chapter, the close relationship of Chinese people with a variety of nonhuman animals is portrayed as unhygienic and "traditional." In addition to criticizing the violation of the proper policing of borders between human and nonhuman, and tradition and modernity, CNN journalist Marianne Bray and *National Geographic* journalist Stefan Lovgren, along with the author of the third quote, *USA Today* journalist David J. Lynch, problematized the lack of separation between public and private, and waste and consumption. These portrayals of China can be read against Edward Said's notion of "Orientalism," wherein the constitution of a homogenized Western identity occurs through the overcharacterization of an equally homogenized Eastern Other as fundamentally different from and opposite to it (Said 1978). Thus, the U.S. news media portrayals of China as unhygienic, traditional, and improperly mixed serves to construct the United States as hygienic, modern, and appropriately vigilant of the boundaries of civilization.

These hygienic discourses of Orientalism work through the production of two interrelated forms of difference—the fundamental racial difference of Chinese as threatening external Other to a homogeneous U.S. population to be protected, and the sacrosanct differences between nature and culture, a difference rooted in Eurocentric Enlightenment traditions, that Chinese seem unable to abide by. These binary logics are pervasive and characterize many U.S. realms, from marriage and population control to agriculture and health (MacCormack and Strathern 1980). I will show how the recent depictions of the violation of nature/culture boundaries by the Chinese result not only in maintaining the distinction between China and the United States, but also in the association of Chinese with the lower category of nature, uncivilized and animal-like. In this way, the distinction between Chinese people and animals becomes blurred, sustaining and elaborating in new ways the racialization of Chinese as inferior to fully human whites in U.S. racial paradigms.

First, as part of discourses of modernity that rely on a dichotomy between tradition and modernity, the Chinese are constructed as traditional, and the traditional is constructed as a health threat. Specifically, the quote at the beginning of the chapter characterizes Chinese farming practices as "traditional," "squalid," "teeming and cramped," and productive of "a toxic brew that can easily spread to the modern China, and to the rest of the world." In this linear narrative of progress from tradition to modernity, the United States, as the most powerful country on the globe, is constructed as the ideal modern country and the model of progress for all (in this case, China) to follow to achieve similar wealth (Smith 2003).

Despite the varying historical and geographical contexts of different countries, their varying positions in the global hierarchy of power, and their respective relationships with the powerful United States—some may even be actively exploited by the United States—all countries are to follow this idealistic narrative of modernist development. In this way, the myriad ways of farming in a country as large as China, with as many ethnic minorities as it has, all get lumped together into the singular inferior category named "traditional." The problematization of traditional farming practices in China as helping to spread new disease to modern and hygienic countries also serves to construct the flow of disease from "traditional" to "modern" countries, with "modern" countries as necessarily hygienic.

This Orientalist rhetoric must be read against current global political economic relations. The climate of U.S. global imperialism and ascending Chinese power form the context of U.S.-based denigrations of Chinese (agri)culture as traditional and threatening to modernity and the world. The present military and economic threat to U.S. superpower status that China poses is constantly muddled into this simplistic linear paradigm of progress, not only displacing onto the more legitimated terrain of science the type of threat China poses, but also obscuring the fact that, rather than the traditional threatening the modern, it is more often that which is cast as modern that has threatened with erasure

and exclusion that which is named as traditional. Historically, in such examples as the ascendance of "modern agriculture," "modern science," and "modern medicine," and the obsolescence of alternative "traditional" practices, the imbrication of these shifts with Euro-American cultural and economic imperialism on a global scale has been subsumed into and obscured by this narrative of progress (McClellan1992; McClintock et al. 1997; Philip 2004; Prakash 1999).

The discourse about the SARS outbreak is also characterized by the scientific discourse of overpopulation, which further serves to implicate China as unhygienic Other to the United States. The narrative of overpopulation has long been used to characterize certain populations both within and outside of the United States for a variety of biopolitical aims: to justify measures of population control, to police increases in nonwhite populations, to shift blame for poverty in poorer countries from more salient causes such as imperialism to the supposedly less civilized breeding behavior of these peoples. Placed in this context, the characterization of the "teeming and cramped quarters" of Chinese farms invokes this causal narrative of overpopulation, the connotation of the underdeveloped "traditional" character of China that accompanies it, and more specifically the view that the overabundance of its nature/culture mixtures (between humans and animals) is unhygienic.

In this narrative, China creates a "toxic brew that can easily spread to the modern China, and to the rest of the world" when it should instead be policing its population, and especially its population of unsanitary mixtures. With this image of an underdeveloped and overpopulated China threatening not only its domestic land but also the world, and the U.S.-dominated world more specifically, China becomes culpable in impeding its own developmental progress, posing a disease threat to the healthy rest of the ("modern") world, and ultimately constructing its own Otherness.

The racialization of the Chinese as animal-like, underdeveloped Other also works through their purported violations of the separation between gendered public and private spheres, and waste and consumption. Upon examination of the last of the three quotes placed at the beginning of this chapter, there surfaces an almost unnoticeable reference to gender difference through its rhetorical lack in the statement that "men and women enthusiastically spit in public, even in affluent cities such as Beijing or Shanghai." What must be read into this casual reference to men *and* women is the fact that, in the context of Euro-American norms of femininity, it is not common (or is not supposed to be) for U.S. women to openly spit in public. In the discourse of hygiene, women have tended to serve as, on the one hand, the guardians of the domestic sphere, policing the waste production which properly belongs in that sphere of the private, and, on the other hand, the guardians of population integrity, forming a barrier between all manner of unhygiene and its entry into a given population.

The extent to which women's bodies—as mothers, domestics, sex partners, sex workers, and so on—have been policed as the primary sites of regulation and surveillance in the

logic of benefiting and protecting group interests (from unhygienic states, racial mixing, etc.) has been elaborated by many scholars (Burton 1999; Butler 1993; Grosz 1994; Levine 1999; Massey 1994; McDowell 1999; Pratt 1999; Shah 1999, 2001; Shohat 1998; Stoler 2002; Whatmore 1999). This gendered policing of bodily fluids has been part of the maintenance of every social order (Douglas 1966). The unwomanly behavior of Chinese women in both failing to safeguard the public/private split and their actual partaking in public waste production serves to highlight the distinctions between private and public in hygienic discourse and—yet again—how the Chinese do not maintain the proper nature/culture separations dictated by U.S. standards.

The apparent inability or unwillingness of Chinese in general to police their bodily orifices in public does not just signal a violation of modernist norms of civilized hygienic behavior maintained through the separation of the private and the public (Anderson 1995); these portrayals of "enthusiastic" spitting and public urination in China convey implicit critiques of both the public *and* the gluttonous nature of Chinese waste production. Chinese are portrayed, through their nondiscreet and nonprivate waste production, as either unconcerned or unintelligent about healthy behavior. This invokes the narrative of traditional versus modern as well as, relatedly, the equally powerful technology and science (referred to in combination as "technoscience" hereafter, due to the frequent imbrication and indistinguishability in this day and age) narratives of progress that accompany it. In this way, portrayals of Chinese as underdeveloped are heightened by the contrast to the concepts of discipline, control, and preventive self-surveillance offered by the idealism of technoscientific discourses. Instead, Chinese are rendered as overpopulated, overly waste-producing, unhealthy embodiments of out-of-control Others against which technosciences should be wielded (as opposed to subjects who can be entrusted to properly wield the power of technoscience).

Just as Chinese are portrayed as gluttonous in terms of waste production, they are also portrayed as having gluttonous consumption tendencies:

Along the highways, ubiquitous farms are lined up next to each other, with farmers tending their ducks, chickens, and pigs in teeming and cramped quarters. In the city's food stalls, meanwhile, vendors keep their meat—alive and dead—in cages and baskets stacked on top of each other. Customers can choose from a menu of rats, cats, dogs, frogs, snakes, and exotic birds. (Lovgren 2003, p.1)

This indiscriminate technoscientific Othering of Chinese consumption patterns is perhaps best demonstrated by the U.S. news media and public health penchant for attributing possible SARS etiology to some sort of ingrained proclivity to eat "exotic" species of animals, even though the definition of "exotic" animals is contested. (Vaguely defined as those animals not frequently encountered in close contact with or eaten by humans, "exotic animals" is an imprecise term because of the variability

of human contact with specific animals across geographical contexts. That is, animals not frequently encountered by U.S. peoples may be frequently encountered by Chinese peoples.)

Further, the technoscientific discourses wherein China forms the Other through its gluttonous consumption tendencies intertwines with neoliberal discourses of individualistic rights, responsibilities, and consumer choice to enlarge the domain of Chinese Otherness. Here I follow Mei Zhan's linkage of consumption-as-eating and consumption-as-spending in neoliberal and Orientalist tropes in viewing the Othering of Chinese consumptive practices in this double sense (Zhan 2005); the gluttonous, indiscriminate, and unhealthy Other also becomes the irresponsible, undisciplined, and wasteful Other to modern self-sufficient consumer subjects and their self-disciplined consumption practices. In this discourse, the Chinese will never become properly consuming neoliberal subjects.

This representation of Chinese as doubly gluttonous and unhygienic consumers is also demonstrated by the media concern with the blurring of the public and the private, on the one hand, and consumption and production, on the other, through the alleged lack of waste policing in Chinese markets. In addition to the above Lovgren quote, consider the following one describing how Chinese customers in outdoor markets "peer at the caged animals before choosing their meal of the day" or "watch as the butcher cuts up the animal with knives and machetes, spreading blood, guts, feces and urine all over the market floor" (Bray 2005). Instead of pointing to a specific etiology of SARS, these media portrayals problematize in an overly general and exaggerated way the Chinese lack of separation between waste production and food consumption, as well as live and dead animals, resulting in their indiscriminate linking with disease production.

As mentioned earlier, in my view the U.S. news media have been irresponsible in their coverage of SARS, particularly in light of the vagaries and causalities of the various theories that point to live animal markets[3] as primary in SARS etiology because of the presence of (waste-producing) live and dead animals for purchase in the same market. In fact, the only conclusive assertion one can make about the implications of this practice is the certain violation of neoliberal norms. Neoliberal discourse emphasizes consumption alone in marketplaces, hiding the unequal logics of technoscientific production they are tied to. In this hygienic version of consumption, the citizenry is able to pay for and consume products without attention to, and regardless of, highly gendered and raced waste-producing production processes embedded in systemic inequalities (gendered waste management and raced geographies of waste disposal). The concern with Chinese waste policing in the markets reveals an anxiety with keeping hidden the contradictions in technoscientific discourses of hygienic neoliberalism. Thus, simply due to Chinese lack of concern with the visibility of waste in public marketplaces, and despite the ironic fact that the U.S. produces a much more substantial amount of waste through consumption, the Chinese are portrayed as a wasteful and gorging population.

Technoscientific Othering in Transnational Context

This technoscientific Othering of Chinese as subjects unable to attain the ideal of hygienic neoliberalism and modernity (as symbolized by the United States) must be contextualized within a global order that is increasingly characterized by transnationalism—the increasing flow and rapidity with which people, goods, animals, ideas, and disease cross national borders. The movements of people across national borders have formed linkages that both break down and refigure norms of national and racial purity, producing new global identities and spaces. The movements of Chinese between China and the United States, for example, reconstruct the United States and China as transnational sites at the same time that a transnational Chineseness becomes constructed (Grewal 1999; Grewal et al. 2005; Gupta 1997; Kang 2002; Pratt and Yeoh 2003). During the SARS incident, the U.S. news media and public health focus on these transnational movements of Chinese from China to the United States, among other destinations, produced a transnational Chinese identity as disease vector.

Revisiting the first quote placed at the beginning of the article, by CNN journalist Marianne Bray, that China houses "a toxic brew that can easily spread to the modern China, and to the rest of the world," one can see that the emphasis on the transnational nature of disease spread during the SARS outbreak[4] must be read against an Orientalist medical discourse that structures the very terms through which transnational bodies are made visible as locations of disease. Transnational movements in current times have become heavily problematized by public health institutions in new disease etiology and spread. Since the late 1980s the new concept of "emerging infectious disease" has been used to label new or reemerging infectious diseases, emphasizing the causal role of globalization and transnational movement, among other consequences of modernity (Smolinski et al. 2003). As part of this discourse, SARS was covered by news media with an inclination toward sensational connections between small disease outbreaks and global consequences, serving to increase to enormous proportions the fear of Chinese germs carried by globally mobile Chinese people (King 2004; Tomes 2002).

Unhygienic and diseased humans are not the only focus of news media concern over transnational disease spread. Just as the media have given ample attention to the threatening ways in which Chinese violate the borders of nature/culture, they have also focused heavily on a wide variety of technoscientific developments that break down nature/culture barriers (such as genetically engineered species mixing or cyborg enhancements and new reproductive technologies that challenge the boundary between life and death). In this context, the ability of microbes to cross from one species to another (particularly between humans and nonhuman animals) has received substantial consideration, as has, consequently, the embodiment of disease by a variety of forms besides human carriers—nonhuman animal carriers, isolated cellular forms as laboratory product or even biological

weaponry—thereby producing the specter of an enlarged array of transnational disease threats.

The U.S. news media have put forth ample depictions of threatening constructions of interspecies and international/ethnic mixing, (re)producing general public anxiety over disease spread across both species and national borders. South China, where SARS first emerged, has been referred to as the "petri dish of the world," where "at least 60 species can be found in any one market—thrusting together microorganisms, animals and humans who normally would never meet" (Bray 2005). This transnational mixing of biological scales unsettles the image of technoscientific control that promises protection against the unhygienic mixtures and practices of Others normally kept out by national borders.

Yet, while the current attention to barrier-breaking technoscientific developments and the lack of control over transspecies and transnational dangers (neither of which are actually new phenomena) may result in an enlargement of the scale of threats, ironically they do not end up detracting from the discursive authority of technoscience to manage and control them (Balsamo 1996; Harpold and Philip 2000). This faith in technoscience can be partially explained by the fact that although a large amount of news space is devoted to all manner of biological threats, fanning rampant public fears, a large amount of news space is also devoted to narratives of technoscientific authority, particularly the notion that we can build the solutions to any problem through more technoscientific development, eventually attaining control over the ever enlarging array of threats. Thus, media depictions of the threat of flesh-eating bacteria and other specters of supergerms, such as "monster mousepox," are met with stories on the development of new technologies such as genetically engineered defenses and immune boost inhalers to produce a generalized immune response to any invading microbe.

The operations of this contradictory narrative of technoscientific control against nature/culture mixing and those who tend to perpetrate them (i.e., Chinese) must also be placed in the context of recent shifts in public health spheres that have been important to processes of new racial and Othering formations. Older forms of racialization and Othering—the maintenance of both internal racial hierarchies and national borders to keep Others out, based on crumbling Enlightenment binaries of nature/culture—are not so much being erased as reconfigured through public health discourse (the terms of which have been taken up, negotiated, and reworked by news media). A technoscientific shift in (U.S.-based) public health has been described by Cindy Patton from a focus on static bodies and borders—the "tropical thinking" common in colonial-era tropical medicine—to "epidemiological thinking." This latter form of disease medicine is characterized by, on the one hand, the mapping of disease vectoral movement of any scale of organism from people to animals to cells, and, on the other hand, numerical risk factors embodying sign, symptom, and disease all in the same field (Patton 2002). While epidemiology's attention to movement in a globalized, transnational world measured in a grid of numerical risk factors seems both aptly expedient and gratuitously neutral, it is the very nature of the

Chinese Chickens, Ducks, Pigs, and Humans

disease vector and risk factor as unmarked that so easily brings objects from different contexts into arbitrary, and newly marked, relations (Armstrong 1995; Foucault 1977, 1978; Patton 2002; Waldby 2000).

In the case of the vectoral movement of SARS, it came to be embodied by anything and everything labeled "Chinese," whether human, animal, or microbe; and "Chinese" became just another risk factor relative to a decidedly nonneutral, racialized norm of hygiene and health. The context of "Chinese" as a category imbricated with the racial hierarchy and Orientalism contexts of the United States became obscured once embodied as a risk factor. Thus, attaching "Chinese" to a diverse array of objects, even to cultural practices such as farming and hygiene behavior, connected all of these as potentially diseased by virtue of their being "Chinese." In this way, diseases emerging from China became conflated with Chinese people, animals, and cultural practices, all measured in their vectoral capacity to move and spread on a global scale.

Thus, multiple changes of scale have effected parallel developments in both public health discourse and news media representations. Both share a capacity to extract objects out of their contexts, canceling the old contexts and creating new ones with new relations between objects. This has only been enhanced by the recent context of transnationalism, with an increasing number of spaces to be extracted from, as well as reached into, and remapped with new relations. Thus, a theory pops up in public health about civet cats and SARS, another one about "traditional" Chinese animal handling practices and disease; U.S. news media grab these theories, throw in a description about Chinese communal eating habits and an intimation that Chinese women break norms of femininity, and then map all of these diverse things in relation to each other with disease as their normative reference point. In this way, news media do not only just (as I argued earlier) filter and transmit public health-produced information, but also, as a site of discursive production in their own right, rework and generate the terms of their Orientalist medical discourse, creating new (sometimes resistant, often not) discourses of hygiene, along with new biogeopolitical formations and formulations of race and Othering.

In the hygienic narrative focusing on China during the SARS incident, norms of hygiene became mapped onto norms of species, race, and nation. This resulted not only in "Chinese" as a disease-bearing risk factor in need of technoscientific control, but also in an enlarging of the scale of Chinese identity in terms of both the racialization of a diverse array of objects as Chinese, and the greater geographical spread of this enlarged global Chinese identity. The scalar increase in the racialization of Chinese in this Orientalist medical discourse has reconfigured nature/culture constructions of Chinese as Others at the bottom end of reworked human/animal, modern/traditional, clean/dirty, hygienically consuming/waste-producing binaries. What has resulted is the persistent representation of Chinese as reified, racialized, and minoritized Others, no matter what nation they live in, along with a U.S. nation-state imagined as perpetually and homogeneously white.

Gwen D'Arcangelis

Notes

1. I might clarify here that though I am focusing in this article on how U.S. sites represent Chinese subjects, I am in no way ignoring the obvious fact that Chinese (and other) sites play a significant role in representing Chinese subjects. Chinese sites—for instance, Chinese news media representations, China's waste policies, and China's attempts to rival U.S. global hegemony and imperialism—are part of a diffuse, multicentered global governmentality, scattered hegemonies of which China and the United States are just two prominent examples (Chambers and Kymlicka 2002; Cohen 1998; Comaroff and Comaroff 1999; Cruikshank 1999; Grewal and Kaplan 2004; Rose 1989; Williams 1996/1997). Yet, in the context of a U.S.-dominated globe, where U.S.-specific modes become both synonymous with "modern" and dominant globally, U.S. sites often act as a hegemonic influence on many sites of governmentality across the globe, such as Chinese ones, and it is for this reason that I focus on them.

2. Again, this is not to minimize the role of Chinese sites in the production of this discourse. For example, the Chinese government banned the sale and consumption of "wild" animals (itself a changing and contentious category) in response to SARS, and also killed thousands of civet cats suspected to be vectors. However, U.S. productions are my focus.

3. Again, there was a particular focus on markets with "wild" or "exotic" animals.

4. The portrayal of transnational movement as an increasing threat is also demonstrated by the emphasis on the rapidity of disease spread and its dangerous consequences signified by the "super-spreader" terminology of SARS.

References

Anderson, Warwick (1995). "Excremental Colonialism: Public Health and the Poetics of Pollution." *Critical Inquiry* 21(3).

Anderson, Warwick (1998). "Where Is the Postcolonial History of Medicine?" *Bulletin of the History of Medicine* 72: 522–530.

Armstrong, David (1995). "The Rise of Surveillance Medicine." *Sociology of Health and Illness* 17: 393–404.

Balsamo, Anne. (1996). *Technologies of the Gendered Body: Reading Cyborg Women*. Durham, N.C.: Duke University Press.

Bray, Marianne. (2005). "Unhealthy Mix of Animals, Humans." *"CNN* May 9, 2005, World Section, Asia edition.

Burton, Antoinette (ed.). (1999). *Gender, Sexuality, and Colonial Modernities*. New York: Routledge.

Butler, Judith. (1993). *Bodies That Matter*. New York: Routledge.

Chambers, Simone, and Will Kymlicka. (2002). "A Critical Theory of Civil Society." In *Alternative Conceptions of Civil Society*, ed. Chambers and Kymlicka. Princeton, N.J.: Princeton University Press.

Cohen, Jean L. (1998). "Interpreting the Notion of Civil Society." In *Toward a Global Civil Society*, ed. Michael Walzer. Providence, R.I.: Berghahn Books.

Comaroff, John, and Jean Comaroff (eds.). (1999). *Civil Society and the Political Imagination in Africa: Critical Perspectives, Problems, Paradoxes*. Chicago: University of Chicago Press.

Cruikshank, Barbara. (1999). *The Will to Empower*. Ithaca, N.Y.: Cornell University Press.

Douglas, Mary. (1966). *Purity and Danger*. London: Routledge.

Foucault, Michel. (1977). *Discipline and Punish*. New York: Vintage.

Foucault, Michel. (1978). *The History of Sexuality: An Introduction*. New York: Vintage.

Gould, Stephen J. (1981). *The Mismeasure of Man*. New York: Norton.

Grewal, Inderpal. (2005). *Transnational America: Feminisms, Diasporas, Neoliberalisms*. Durham, N.C.: Duke University Press.

Grewal, Inderpal, and Caren Kaplan (eds.). (1994). *Scattered Hegemonies: Postmodernity and Transnational Feminist Practices*. Minneapolis: University of Minnesota Press.

Grewal, Inderpal, Gupta, Akhil, and Aihwa, Ong (eds.). (Winter 1999). "Asian Transnationalities: Media, Markets & Migration." Special issue of *Positions: east asia cultures critique* 7: 3.

Grosz, Elizabeth. (1994). *Volatile Bodies*. Bloomington: Indiana University Press.

Gupta, Akhil, and James Ferguson. (1997). "Culture, Power, Place: Ethnography at the End of an Era." In *Culture, Power, Place: Explorations in Critical Anthropology*, ed. Gupta and Feguson. Durham, N.C.: Duke University Press.

Harding, Sandra (ed.). (1993). *The "Racial" Economy of Science*. Bloomington: Indiana University Press.

Harpold, Terry, and Kavita Philip (2000). "Of Bugs and Rats: Cyber-Cleanliness, Cyber-Squalor, and the Fantasy-Spaces of Informational Globalization." *Postmodern Culture* 11(1).

Kang, Hyun Yi. (2002). *Compositional Subjects: Enfiguring Asian/American Women*. Durham, N.C.: Duke University Press.

Kim, Claire Jean. (2004). "Unyielding Positions: A Critique of the 'Race' Debate." *Annual Review of Anthropology* 4(3): 337–355.

King, Nicholas B. (2004). "The Scale Politics of Emerging Diseases." *Osiris* 19: 62–76.

Laporte, Dominique. (1978). *Histoire de la Merde*. Paris: C. Bourgeois.

Leavitt, Judith W. (1997). *Typhoid Mary: Captive to the Public's Health*. Oxford: Oxford University Press.

Levine, Philippa (1999). "Modernity, Medicine and Colonialism: The Contagious Disease Ordinances in Hong Kong and the Straits Settlements." In *Gender, Sexuality, and Colonial Modernities*, ed. Antoinette Burton. New York: Routledge.

Lovgren, Stefan. (2003). "China Is Perfect Breeding Ground for Viruses like SARS, Expert Says." *National Geographic,* May 6, 2003, News Section.

Lynch, David J. (2003). "Wild Animal Markets in China May Be Breeding SARS." *USA Today*, October 28.

MacCormack, Carol, and Marilyn Strathern (eds.). (1980). *Nature, Culture, and Gender*. Cambridge: Cambridge University Press.

Massey, Doreen. (1994). *Space, Place, and Gender*. Minneapolis: University of Minnesota Press.

McClellan, James E. (1992). *Colonialism and Science: Saint Domingue in the Old Regime*. Baltimore: Johns Hopkins University Press.

McClintock, Anne. (1994). *Imperial Leather: Race, Gender, and Sexuality in the Colonial Contest*. New York: Routledge.

McClintock, Anne, Aamir Mufti, and Ella Shohat (eds.). (1997). *Dangerous Liaisons: Gender, Nation and Postcolonial Perspectives*. Minneapolis: University of Minnesota Press.

McDowell, Linda. (1999). "Introduction." In *Gender, Identity, and Place: Understanding Feminist Geographies*, ed. McDowell. Minneapolis: University of Minnesota Press.

Patton, Cindy. (2002). *Globalizing AIDS*. Minneapolis: University of Minnesota Press.

Philip, Kavita. (2004). *Civilizing Natures: Race, Resources, and Modernity in Colonial South India*. New Brunswick, N.J.: Rutgers University Press.

Poster, Mark. (1990). *The Mode of Information: Poststructuralism and Social Context*. Chicago: University of Chicago Press.

Poster, Mark. (1995). *Second Media Age*. Cambridge, Mass.: Polity Press.

Prakash, Gyan. (1999). *Another Reason: Science and the Imagination of Modern India*. Princeton, N.J.: Princeton University Press.

Pratt, Geraldine and Brenda Yeoh (1999). "Geographies of Identity and Difference: Marking Boundaries." In *Human Geography Today*, ed. Doreen Massey, John Allen, and Philip Sarre. Cambridge: Polity Press.

Pratt, G., and B. Y. (2003). "Transnational (Counter) Topographies." *Gender, Place and Culture* 10(2): 159–166.

Rose, Nikolas. (1989). *Governing the Soul: The Shaping of the Private Self*. London: Free Association Books.

Said, Edward. (1978). *Orientalism*. New York: Penguin.

Shah, Nayan. (1999). "Cleansing Motherhood: Hygiene and the Culture of Domesticity in San Francisco's 'Chinatown,' 1875–1939." In *Gender, Sexuality and Colonial Modernities*, ed. Antoinette Burton. New York: Routledge.

Shah, Nayan. (2001). *Contagious Divides: Epidemics and Race in San Francisco's Chinatown*. Berkeley: University of California Press.

Shohat, Ella (ed.). (1998). *Talking Visions: Multicultural Feminism in a Transnational World*. Cambridge, Mass.: MIT Press.

Smith, Neil. (2003). "The Lost Geography of the American Century." In Smith's *American Empire: Roosevelt's Geographer and the Prelude to Globalization*. Berkeley: University of California Press.

Smolinski, Mark, Margaret A. Hamburg, and Joshua Lederberg (eds.). (2003). *Microbial Threats to Health: Emergence, Detection and Response*. Washington, D.C.: National Academies Press.

Stoler, Ann Laura. (2002). "Carnal Knowledge and Imperial Power: Gender and Morality in the Making of Race." In Stoler's *Carnal Knowledge and Imperial Power*. Berkeley: University of California Press.

Tomes, Nancy (2002). "Epidemic Entertainments: Disease and Popular Culture in Early-Twentieth-Century America." *American Literary History* 14(4): 625–652.

Waldby, C. (2000). *The Visible Human Project: Informatic Bodies and Posthuman Medicine*. New York: Routledge.

Whatmore, Sarah. (1999). "Hybrid Geographies: Rethinking the 'Human' in Human." In *Human Geography Today*, ed. Doreen Massey, John Allen, and Philip Sarre. Cambridge: Polity Press.

Williams, Susan H. (1996/1997). "A Feminist Reassessment of Civil Society." *Indiana Law Journal* 72: 417–447.

Zhan, Mei. (2005). "Civet Cats, Fried Grasshoppers, and David Beckham's Pajamas: Unruly Bodies After SARS." *American Anthropologist* 107(1): 31–42.

Interspecies Co-Production

This section examines the mutual process of learning, relating, and collaborating between human and nonhuman animals. Experiences and perspectives provided in this section are rooted in experimental art, veterinary practice, and science and technology studies.

Donna Haraway opens this section with her analytical framework of the "contact zone" inhabited by herself and her dog, Cayenne. Cayenne, an Australian shepherd, and the author are engaged in the sport of agility. Agility, a sport that involves dogs and their human partners in obstacle runs of varying difficulty, demands understanding, training, and communication between both beings. Haraway uses this activity framework to address questions of power, knowledge, and technique in this human-animal contact zone. She describes the process of becoming at ease to occupy the "naturalcultural art of training for a sport with a dog," and revisits aspects of behaviorism she previously rejected.

Artist Kathy High describes the process of developing and presenting her *Embracing Animal* project at the Massachusetts Museum of Contemporary Art. High ordered three transgenic laboratory rats that had been bred to express inflammatory bowel disease, a disease closely related to the author's own autoimmune diseases. In a poetic account, she describes the time she spent with the animals, from the time of their arrival at her office to their life within her installation in the museum. Feelings of initial disgust morphed into feelings of kinship. High employed homeopathic and other holistic medicinal treatment on her animals, treatments similar to the ones she received. She, and later the museum staff, also treated the animals with tender physical contact. Would these animals survive longer than the average life span, given these treatments? How would the public react when confronted with these animals bred for scientific experimentation and medical advancement? *Embracing Animal* eludes definition; it is simultaneously art, therapeutic practice, and resistance. But most powerfully, the rats, Kathy, and the museum staff read

and react to each other, forming a collaborative system that remains open to audience engagement.

Veterinary ethicist Larry Carbone is interested the secular ethics of human-animal interaction. His work as a laboratory veterinarian has caused him to question the means by which distress, suffering, and discomfort in animals are being assessed. While certain behaviors, such as refusal of food or vocally expressed pain, might clearly indicate distress, how do we know that lack of such symptoms indicates comfort and well-being? Carbone identifies a lack of understanding of how animals live, and gives several examples in which human projections onto animals' well-being have led to harmful outcomes for the animals.

Training in the Contact Zone

Power, Play, and Invention in the Sport of Agility

Donna J. Haraway

Paying Attention

Playing agility with my Australian shepherd, Cayenne, helps me understand a controversial, modern relationship between people and dogs—training to a high standard of performance for a competitive sport. Training together—a particular woman and a particular dog training together, not Man and Animal in the abstract—is a historically located, multispecies, subject-shaping encounter in a contact zone fraught with power, knowledge and technique, moral questions—and the chance for joint, cross-species invention that is simultaneously work and play. Tracking only a few threads in a complex fabric, this chapter examines people and dogs working to excel in an international competitive sport that is also part of globalized middle-class consumer cultures that can afford the time and money that must be dedicated to the game. Training together puts the participants inside the complexities of instrumental relations and structures of power. How can dogs and people in this kind of relationship be means and ends for each other in ways that call for reshaping our ideas about and practices of domestication?

Introducing the notion of "anthropo-zoo-genetic practice," the Belgian philosopher-psychologist Vinciane Despret emphasizes that articulating bodies to each other is always a political question about collective lives. Despret studies practices in which animals and people become available to each other, become attuned to each other, in such a way that each party becomes more interesting to the other, more open to surprises, smarter, more "polite," more inventive. The kind of "domestication" that Despret explores, adds new identities; partners learn to be "affected"; they become "available to events."[1] The question between animals and humans here is, "Who are you?" and thus, "Who are we?" So, how *do* dogs and people learn to pay attention to each other in a way that changes who and what they become together?

The Game's Afoot

What is the sport of agility?[2] Picture a grassy field or dirt-covered horse arena about a hundred feet square. Fill it with fifteen to twenty obstacles arranged in patterns according to a judge's plan. The sequence of the obstacles and the difficulty of the patterns depend on the level of play, from novice to masters. Obstacles include single, double, or triple bar jumps; panel jumps; broad jumps; open and closed tunnels of various lengths; weave poles consisting of six to twelve poles in line through which the dog slaloms; pause tables; and contact obstacles called teeter-totters, A-frames (between 5.5 and 6.5 feet high, depending on the organization), and dog walks. These last are called contact obstacles because the dog must put at least a toenail in a painted zone at the up and down ends of the obstacle. Leaping over the contact zone earns a "failure to perform" the obstacle, which is a high-point penalty. Dogs jump at a height determined by their own height at their shoulders or withers. Many of the jump patterns derive from those used in horse-jumping events, and indeed horse events are among the sporting parents of dog agility.

Human handlers get to walk through the course for about fifteen minutes before the dog and human run it; the dog does not see the course beforehand. The human is responsible for knowing the sequence of obstacles and for figuring out a plan for human and dog to move fast, accurately, and smoothly through the course. The dog navigates the obstacles, but the human has to be in the right position at the right time to give good information. Advanced courses are full of trap obstacles to tempt the untimely or the misinformed; novice runs test fundamental knowledge for getting through a course accurately and safely. In a well-trained team, both human and dog know their jobs; but any knowledgeable observer sees that most errors are caused by bad handling on the human's part. The errors may be bad timing, overhandling, inattention, ambiguous cues, bad positioning, failure to understand how the course looks to the dog, or failure to train basics. Qualifying runs in the higher levels require perfect scores within a demanding time limit. Teams are ranked by accuracy and speed, and runs can be decided by hundredths of seconds.

Agility began in 1978 at Crufts, England, when a trainer of working trial dogs, Peter Meanwell, was asked to design a dog jumping event to entertain spectators waiting for the main action at the classy dog show. In 1979, agility returned to Crufts as a regular competitive event. After about 1983, agility spread from England to Holland, Belgium, Sweden, Norway, and France, and it has since moved across Europe and North America, as well as to Asia, Australia and New Zealand, and Latin America. The United States Dog Agility Association was founded in 1986, followed by other organizations in the United States and Canada. In 2000 the International Federation of Cynological Sports (IFCS) was founded on the initiative of Russia and Ukraine to unite dog sport organizations in many countries and hold international competitions. The first IFCS world cham-

pionship was held in 2002.[3] The growth of participation in the sport has been explosive, with thousands of competitors in many organizations, each with somewhat different rules and games.

Workshops, training camps, and seminars abound. Successful competitors not infrequently hang out their shingle as agility teachers, but only a few can actually make a living that way. California is one of the hot spots of agility, and in that state on any given weekend, year round, there will be several agility trials, each with two hundred to three hundred or so dogs and their people competing. Most dog-human teams I know train formally at least once a week and informally all the time. The year I kept count, I spent about four thousand dollars on everything it took to train, travel, and compete; that is considerably less than many humans spend on the sport. In the United States, white women from about forty to sixty-five years old dominate the sport numerically; but people of various hues, genders, and ages play, from preteens to folks in their seventies. In my experience, lots of human players hold professional jobs to pay for their habit, or are retired from such jobs and have some disposable income. Many people also play who make very little money and have hard working-class jobs.

Many breeds and mixed ancestry dogs compete, but the most competitive dogs in their respective height classes tend to be border collies, Australian shepherds, shelties, and Jack Russell terriers. High-drive, focused, athletic dogs and high-drive, calm, athletic people tend to excel and get in the agility news. But agility is a sport of amateurs in which most teams can have a great time and earn qualifying runs and titles—if they work and play together with serious intent, lots of training, recognition that the dog's needs come first, a sense of humor, and a willingness to make interesting mistakes—or, better, make mistakes interesting.

Positive training methods, offspring of behaviorist operant conditioning, are the dominant approaches used in agility. Anyone training by some other method will be the subject of disapproving gossip, if not dismissed from the course by a judge who is on the lookout for any harsh correction of a dog by a human. Having begun her training career with marine mammals in 1963 at Hawaii's Sea Life Park, Karen Pryor is the single most important person for teaching and explaining positive methods to the amateur and professional dog training communities, as well as many other human-animal communities.[4]

Positive training methods are standard behaviorist approaches that work by marking desired actions called "behaviors" and delivering an appropriate reward to the behaving organism in time for the reward to make a difference. That's positive reinforcement. Reinforcement in behaviorism is defined as anything occurring in conjunction with an act that tends to change that act's probability. That bit about "in conjunction with the act" is crucial. Timing is all; tomorrow, or even two seconds after the interesting "behavior," is way too late to get or give good information in agility training. A "behavior" is

not something just out there in the world waiting for discovery; a behavior is an inventive construction, put together by people, organisms, and apparatus all coming together in the history of animal psychology. Out of the flow of bodies moving in time, bits are carved out and solicited to become more or less frequent as part of building other patterns of motion through time. A behavior is a natural-technical entity that has traveled from the lab to the agility training session.

If the organism does something that is not wanted, ignore it, and the behavior will "extinguish" itself for lack of reinforcement (unless the undesired behavior is self-rewarding; then, good luck). Withholding social recognition by not noticing what the other is doing can be a powerful negative reinforcement for dogs and people. Supposedly mild negative reinforcers such as "time-outs" are popular in agility training and human schools. Restraint, coercion, and punishment—such as ear pinching—are actively discouraged in agility training in any situation I have experienced or heard about. Strong negative words such as "no!"—emitted in moments of great frustration, broken-down communication, and loss of human calm—are rationed severely, kept for dangerous situations and emergencies. For unskilled but aspiring lay trainers like me, using strong negative reinforcers and punishments is foolish as well as unnecessary because we get it wrong and do more harm than good. Just watch a dog shut down in the face of a tense or negative human, and hesitate to offer anything interesting with which to build great runs. Positive reinforcement, properly done, sets off a cascade of happy anticipation and inventive, spontaneous offerings for testing how interesting the world can be. Positive reinforcement improperly done just reduces the stock of liver cookies, chew toys, and popular confidence in behavioral science.

It is essential for a human being to get it that one's partner is an adult (or puppy) member of another species, with his or her own exacting species interests and individual quirks, and not a furry child, a character in *Call of the Wild*, or an extension of one's intentions or fantasies. People fail this recognition test depressingly often. Training together is extremely prosaic; that is why training with a member of another biological species is so interesting, hard, full of situated difference, and moving.[5] My field notes from classes and competitions repeatedly record agility people's remarks that they are learning about themselves and their companions, human and dog, in ways they had not experienced before. Learning a new competitive sport played seriously with a member of another species provokes strong and unexpected emotions and preconception-breaking thinking about power, status, failure, skill, achievement, shame, risk, injury, control, companionship, body, memory, joy, and much else.

The human being actually has to know something about one's partner, oneself, and the world at the end of each training day that he or she did not know at the beginning. The dog, in turn, becomes shockingly good at learning to learn, fulfilling the highest obligation of a good scientist.

The Contact Zone

Let us turn to the approximately two-foot-long yellow contact zones painted onto the up and down ends of A-frames. At least one murder mystery I know of features the A-frame as the instrument of death.[6] I understand that plot very well; Cayenne and I came close to killing each other in this contact zone. The problem was simple: we did not understand each other. We were not communicating; we did not yet *have* a contact zone entangling us both. The result was that she regularly leaped over the down contact, not touching the yellow area with so much as a toepad before she raced to the next part of the course, much less holding the lovely two-rear-feet on the zone, two-front-feet on the ground until I gave the agreed-upon release word ("all right") for her to go on to the next obstacle. I could not figure out what she did not understand; she could not figure out what my ambiguous and ever-changing cues and criteria of performance meant. That paint strip is where Cayenne and I learned our hardest lessons about power, knowledge, and the meaningful material details of entanglements.

Then I remembered lessons from other kinds of contact zones. Colonial and postcolonial theorist Mary Louise Pratt coined the term "contact zone," which she adapted

from its use in linguistics, where the term "contact language" refers to improvised languages that develop among speakers of different native languages who need to communicate with each other consistently. . . . I aim to foreground the interactive, improvisational dimensions of colonial encounters so easily ignored or suppressed by diffusionist accounts of conquest and domination. A "contact" perspective emphasizes how subjects are constituted in and by their relations to each other. . . . It treats the relations . . . in terms of co-presence, interaction, interlocking understandings and practices, often within radically asymmetrical relations of power.[7]

I find something eerily apt in Pratt's discussion for dog-human doings at the bottom of the A-frame. Cayenne and I definitely have different native tongues; and much as I reject the analogy of colonization with domestication, and also much as I worry about how thinking about power issues for animals and humans in the same sentence inevitably raises the specter of the animalization of people of color, I know very well how much control of Cayenne's life and death I hold in my inept hands. I also know that is not the end of the matter.

My colleague Jim Clifford enriched my understanding of contact zones through his nuanced readings of articulations and entanglements across borders and between cultures. He eloquently demonstrated how "the new paradigms begin with historical contact, with entanglement at intersecting regional, national, and transnational levels. Contact approaches presuppose not sociocultural wholes subsequently brought into relationship, but rather systems already constituted relationally, entering new relations through

historical processes of displacement."[8] I merely add naturalcultural and multispecies matters to Clifford's open net bag.

I learned much of what I know about contact zones from science fiction (sf), where aliens meet in bars off planet and redo each other molecule by molecule. The most interesting encounters happen when *Star Trek*'s universal translator is on the blink, and communication takes unexpected, prosaic turns. My feminist sf reading prepared me to think about dog-human communication dilemmas and (polymorphously perverse) joys more flexibly than the more hard-boiled imperialist fantasies found in sf. I remember especially Naomi Mitchison's *Memoirs of a Spacewoman*, in which the human communications officer on space explorations had to figure out how to make "non-interfering" contact with quite an array of sentient critters; several curious progeny resulted. Suzette Haden Elgin's pan-species linguist sf, starting with *Native Tongue*, also got me ready for training with dogs. There was no universal translator for Elgin, but only the hard work of species crafting workable languages. And if shape-shifting skill in the contact zone is the goal, no one should forget Samuel R. Delany's *Babel-17*, where intriguing data flow interruptions seem the order of the day.[9]

Tardily in my agility training dilemmas, I remembered that contact zones called edge areas or ecotones, where biological species assemblages come together outside their comfort zones, are the richest places to look for ecological, evolutionary, and historical diversity. I live in north central coastal California, where, on the large geological scale of things, the great ancient northern and southern species assemblages intermix, producing extraordinary complexity. Our house is along a creek in a steep valley, where walking up from the creek on either northern- or southern-facing hillsides puts one dramatically into changing ecologically mixed species assemblages. Naturalcultural histories are written on the land, such that the former plum orchards or sheep pastures or logging patterns vie with geological soil types and humidity changes to shape today's human and nonhuman inhabitants of the land.[10]

Furthermore, as in Juanita Sundberg's analysis of the cultural politics of conservation encounters in the Maya Biosphere Preserve, conservation projects have become important zones of encounter and contact shaped by distant and near actors.[11] Such contact zones are full of the complexities of different kinds of unequal power that do not always go in expected directions. In her beautiful book *Friction*, the anthropologist Anna Tsing explores the people and organisms enmeshed in conservation and justice struggles in Indonesia in recent decades.[12] Her chapter on "weediness" is a moving, incisive analysis of the wealth and species diversity of naturecultures shaped by swidden agriculture into so-called secondary forests, which are being replaced by legal and illegal logging and industrial-scale monocropping in a violent reshaping of landscapes and ways of life. Tsing lovingly documents the threatened collecting and naming practices of her elder friend and informant, Uma Adang. The contact zones of species assemblages, both human and nonhuman, are the core reality in her ethnography. As Tsing puts it in an essay that tracks mushrooms

in order to get a sense of the webs of world history, "Species interdependence is a well known fact—except when it comes to humans. Human exceptionalism blinds us."

Riveted on stories either praising or damning human control of nature, people so blinkered assume that human nature, no matter how culturally various in detail, is essentially—often stated as "biologically"—constant, while human beings reshape others, from molecule to ecosystem. Rethinking "domestication" that closely knots human beings with other organisms, including plants, animals, and microbes, Tsing asks, "What if we imagined a human nature that shifted historically together with varied webs of interspecies dependence?" Tsing calls her webs of interdependence "unruly edges." She continues, *"Human nature is an interspecies relationship."*[13] With Tsing's approval, I would add that the same is true of dogs; and it is the human-dog entanglement that rules my thinking about contact zones and fertile unruly edges in this chapter.

In a sibling spirit, the anthropologist Eduardo Kohn explores multispecies contact zones in Ecuador's Upper Amazon region in which dogs play a key role. Doing ethnography among the Quichua-speaking Runa and the various animals with whom they craft their lives, Kohn tracks naturalcultural, political, and ecological entanglements in species assemblages in which dogs are central actors. He writes:

Amazonian personhood, very much the product of interaction with nonhuman semiotic selves, is also the product of a certain kind of colonial subjection. . . . This essay looks particularly to certain techniques of shamanistic metamorphosis (itself a product of interacting, and in the process blurring, with all kinds of nonhuman selves) and how this changes the terms of subjection (bodies are very different kinds of entities in this part of the world) and delineates certain spaces of political possibility.[14]

Cayenne and I have no access to shamanistic metamorphoses, but reworking form to make a kind of one out of two is the sort of metaplasmic rearrangement we sought.

I also turned for insight to the phenomena of reciprocal induction studied in developmental biology. As a graduate student in Yale's biology department in the 1960s, I studied morphogenetic interactions through which cells and tissues of a developing embryo reciprocally shape each other through cascades of communications. The techniques to track these complex interactions and the imagination to build better theoretical concepts have become very powerful since the 1980s. Scott Gilbert's several editions of *Developmental Biology*, starting in 1985, are a wonderful site to track a growing grasp of the centrality of reciprocal induction, through which mutual co-shaping of the fates of cells structures organisms.[15] Contact zones are where the action is, and interactions change interactions that follow. Probabilities alter; topologies morph; development is canalized by the fruits of reciprocal induction.[16]

Let us consider the relations of authority in the reciprocal inductions of training. Agility is a human-designed sport; it is not spontaneous play. I have good reason for

judging that Cayenne loves to do agility; she plants her bum in front of the gate to the practice yard with fierce intent until I let her in to work patterns with me. We do nothing else in the agility yard but work on the obstacle patterns; that is the yard she wants access to. Spectators comment on the joy Cayenne's runs make them feel because they feel her whole self thrown into the skilled inventiveness of her course. She is a working dog with great focus; her whole mind/body changes when she gets access to her scene of work. However, I would be a liar to claim that agility is a utopia of equality and spontaneous nature. The rules are arbitrary for both species; that is what a sport is: a rule-bound, skilled, comparatively evaluated performance. The dog and the human are ruled by standards that they must submit to and that are not of their own choosing. The courses are designed by human beings; people fill out the entry forms and enter classes. The human decides for the dog what an acceptable criterion of performance will be.

But there is a hitch: the human must respond to the authority of the dog's actual performance. The real dog—not the fantasy projection of self—is mundanely present. Fixed by the specter of yellow paint, the human must finally learn to ask fundamental ontological questions: Who are you, and so who are we? Here we are, and so what are we to become?

Early casualties of taking these questions seriously were some of my favorite stories about freedom and nature. These were stories I wanted Cayenne and me to inhabit for life, but they turned out to produce painful incoherence. Fixing mistakes on the A-frame forced me to confront the pedagogical apparatuses of training, including their relations of freedom and authority. Some radical animal people are critical of any human training "of" (I insist "with" is possible) another critter. They regard what I see as polite manners and beautiful skill acquired by the dogs I know best to be strong evidence of excessive human control and a sign of the degradation of domestic animals. Wolves, say the critics of trained animals, are more noble (natural) than dogs precisely because they are more indifferent to the doings of people; to bring animals into close interaction with human beings infringes their freedom. From this point of view, training is anti-natural domination made palatable by liver cookies.

Behaviorists are notoriously cavalier about what constitutes natural (biologically meaningful) behavior for an organism (human or not); they leave that preserve to the ethologists and their descendants. For behaviorists, if the probability of an action can be changed, no matter how meaningless the bit of action may be to the organism or anybody else, then that action is fodder for the technologies of operant conditioning. Partly because of this agnosticism deep in the history of behaviorism about both functionality (related to adaptation, and thus evolutionary theory) and meaning to the animal (tied to the question of interiority), Karen Pryor and other trainers of so-called wild animals in captivity, such as dolphins and tigers, have been accused either of ruining them by introducing nonnaturalistic behaviors or of making critters into robots by treating them like stimulus-response machines. Pryor and other positive trainers answer that their work improves the lives of

captive animals and should become part of normal management and environmental enrichment.[17] Engaging in training (education) is interesting for animals, just as it is for people, whether or not a "just-so" story about contributing to reproductive fitness can be made to fit the curriculum.

The coming into being of something unexpected, something new and free, something outside the rules of function and calculation *is* what training with each other is about.[18] Training requires calculation, method, discipline, science; but training is also for opening up what is not known to be possible, but might be, for all the intra-acting partners. In "intra-action," partners are in internal relationality that makes them who they are; they do not "inter-act" as already preformed beings.[19]

Throughout my academic life, whether as a biologist or a scholar in the humanities and social sciences, I had looked down on behaviorism as a pale science at best, hardly real biology at all, and an ideological, determinist discourse at heart. All of a sudden, Cayenne and I needed what skilled behaviorists could teach us. I became subject to a knowledge practice I had despised. I had to get it that behaviorism was not my caricature of a mechanistic pseudoscience fueled by niche-marketed food treats, but a flawed, historically situated, and fruitful approach to questions in the fleshy world. I needed not only behaviorism, but also ethology and the more recent cognitive sciences. I had to get it that comparative cognitive ethologists did not operate with a cartoon of animal machinic non-minds whipped into computational shape with math and computers.

Preoccupied with the baleful effects for dogs of the *denial* of human control and power in training relationships, I have so far understressed another aspect of the human's obligation to respond to the authority of the dog's actual performance. A skilled human competitor in agility, not to mention a decent life companion, must learn to recognize when *trust* is what the human owes the dog. Dogs generally recognize very well when the human being has earned trust; the human beings I know, starting with myself, are less good at reciprocal trust. I lose Cayenne and me many qualifying scores because, in the sport's idiom, I "overhandle" her performance. For example, because I am not confident, I do not see that *she* has mastered the difficult correct entries into weave poles at speed, and that I do not need to rush to do a front cross, thereby, as often as not, blocking her path. Indeed, when I trust Cayenne, I do not ever need to rush, no matter the pattern or obstacle. I do not need to be as fast as she is (good thing!); I merely need to be as honest.

Honesty and response to the dog's authority take many forms. True, I do not need to be as fast as she is; but I do need to stay in as good physical condition as I can, practice patterning my body at speed, be willing to learn to make moves on the field that give her better information even if those moves are hard for me to master, and treat her like a full adult by not bending over and hovering at difficult parts of a course. "Stand up straight!" is a mantra that agility teachers repeat endlessly to their recalcitrant human students. I believe this chant is necessary because we do not actually recognize our dogs' authority, and in spite of our best intentions, too often treat them like athletic toddlers

in fur coats. It is hard not to do that when dog culture in America, even in agility, relentlessly refers to human partners as "mom" or "dad." "Handler" is only a little better; that word makes me think that human agility partners imagine they have their controlling hands on the helm of nature in the body of their dogs. Humans in agility are not "handlers" (nor are they "guardians"); they are members of a cross-species team of skilled adults. With an ear to the tones of asymmetrical but often directionally surprising authority in contact zones, I like "partner" much better.

The mixed practices of training require savvy travels in sciences and stories about how animals actually feel and think, as well as behave. Trainers can't forbid themselves the judgment that they can communicate meaningfully with their partners. The philosophic and literary conceit that all we have is representations, and no access to what animals think and feel, is wrong. Human beings do—or can—know more than we used to know; and the right to make that judgment is rooted in historical, flawed, generative cross-species practices. Of course, we are not the "other," and so do not know in that fantastic way. To claim not to be able to communicate with and to know each other and other critters, however imperfectly, is a denial of mortal entanglements for which we are responsible and in which we respond. Technique, calculation, method—all are indispensable and exacting. But they are not response, which is irreducible to calculation. Response is getting it that subject-making connection is real. Response is face to face in the contact zone of an entangled relationship. Companion species know this.

So, I learned to be at ease with the artificiality, the naturalcultural art, of training for a sport with a dog. But surely, I imagined, she could be free off the course, free to roam the woods and visit the off-leash parks. I had taught her an obligatory recall that authorized that freedom, and I was as nasty as any novice trainer feeling her oats about people who had no idea how to teach a good recall and whose clueless dogs gave a bad name to freedom and an unfair fright to fleeing deer. I watched how my fellow agility competitor and friend Pam Richards trained with Cayenne's littermate brother, Cappuccino; and I was secretly critical of how relentlessly she worked with Capp to fix his attention on her, and hers on him, in the activities of daily life. I knew Capp was aglow with pleasure in his doings, but I thought Cayenne had the greater animal happiness. I knew Pam and Capp were achieving things in agility out of our reach, and I was proud of them. Then, Pam took pity on us. Taking the risk to judge that I actually wanted to become less incoherent with Cayenne, she offered to show me in detail what we did not know. I became subject to Pam so that Cayenne could become free and lucid in ways not admitted by my existing stock of freedom stories.

Pam is nothing if not thorough. She backed us up, forbidding me to put Cayenne on the A-frame in competition until she and I knew our jobs. She showed me that I had not "proofed" the obstacle performance in about a dozen fundamental ways. And so I set about actually teaching what the release word meant instead of fantasizing that Cayenne was a native English speaker. I started thinking practically about adding distractions to make

the "two-on, two-off" performance that I had chosen for us be surer in circumstances approximating the intense world of trials. I learned to send her over the A-frame, to the bottom and the magic two-on, two-off paw position, no matter where I was, no matter if I was moving or still, no matter if toys and food were flying through the air and complicitous friends of various species were jumping up and down crazily.

Pam watched us, and then sent us back again with the mordant comment that Cayenne did not yet know her job because I had not yet taught it. Finally, she said I was sufficiently coherent, and Cayenne sufficiently knowledgeable, that we could do the A-frame in competition—if I held the same standard of performance there that had become normal in training. Consequences, that sledgehammer of behaviorism, were the point. If, by letting Cayenne go on to the next obstacle, I rewarded a legally adequate performance in the contact zone, but one that did not match our hard-won criterion, I was condemning her and me to a lifetime of frustration and loss of confidence in each other. If Cayenne did not hold two-on, two-off and wait for release, I was to walk her calmly off the course without comment or glance, put her without reward into her crate, and stroll away. If I did not do that, I had less respect for Cayenne than for my fantasies.

For more than two years, we had not advanced out of novice competition levels because of the A-frame contact zone. Subject to Pam's narratives of freedom and authority, after we had retrained each other more honestly, I walked Cayenne off the course at a real trial once, and got a year of perfect contacts after that. My friends cheered us over the finish line in our last novice event as if we had won the World Cup. "All" we had done was achieve a little coherence. The occasional breakdowns that still happen in that contact zone get quickly fixed, and Cayenne sails through this performance with a gleam in her eye and pleasure written all over her coursing body.

But what about Cayenne's independent animal happiness off the course, compared to the bond of attention between Pam and Capp? Here, I think Pam and I have changed each other's narratives and practices of freedom and joy. I had to face the fact that many more "I pay attention to you, you pay attention to me" games had to fill Cayenne's and my not-so-leisure hours. I had to deal with my sense of paradise lost when Cayenne became steadily and vastly more interested in me than in other dogs. The price of the intensifying bond between us was, well, a bond. I still notice this; it still feels like a loss as well as an achievement of large spiritual and physical joy for both Cayenne and me. Ours is not an innocent, unconditional love; the love that ties us is a naturalcultural practice that has redone us molecule by molecule.

Pam, for her part, tells me she admires the sheer fun in Cayenne's and my doings. She knows that can exact a price on performance criteria. The gods regularly laugh when Pam and I take Cayenne and Cappuccino out to a grassy field and urge them to play with each other and ignore us. Pam's partner, Janet, will even leave a riveting women's basketball game on TV to revel in the unmatchable joy when Cayenne and Cappuccino play together. All too frequently, Cayenne can't get Capp to play; he has eyes only for Pam's throwing

arm and the ball she has hidden away. But when they do play, when Cayenne solicits her littermate long and hard enough, with all the metacommunicative skill at her command, they increase the stock of beauty in the world. Then, three human women and two dogs are in the open, where the world is made new.

Vinciane Despret suggests that "the whole matter is a matter of faith, of trust, and this is the way we should construe the role of expectations, the role of authority, the role of events that authorize and make things become."[20] She describes what has been found in studies of skilled human riders and educated horses. The French ethologist Jean-Claude Barrey's detailed analysis of "unintentional movements" in skilled riding show that homologous muscles fire and contract in both horse and human at precisely the same time. The term for this phenomenon is "isopraxis." Horses and riders are attuned to each other. "Talented riders behave and move like horses. . . . Human bodies have been transformed by and into a horse's body. Who influences and who is influenced, in this story, are questions that can no longer receive a clear answer. Both, human and horse, are cause and effect of each other's movements. Both induce and are induced, affect and are affected. Both embody each other's mind."[21] A good run in agility has similar properties. Mimetic matching of muscle groups is not usually the point, although I am sure it occurs in some agility patterns, because the dog and the human are co-performing a course spatially apart from each other in differently choreographed and emergent patternings. The nonmimetic attunement of each to each resonates with the molecular scores of mind and flesh, and makes someone out of them both who was not there before. Training in the contact zone, indeed.

Playing with Strangers

Agility is a sport, and that kind of game is built on the tie of cross-species work and play. I have said a lot about work so far, but much too little about play. It is rare to meet a puppy who does not know how to play; such a youngster would be seriously disturbed. Most, but not all, adult dogs know very well how to play, too; and they choose doggish or other play partners selectively throughout their lives if they have the opportunity. Agility people know that they need to learn to play with their dogs. Most want to play with their canine partners, if for no other reason than to take advantage of the tremendous tool that play is in positive training practices. Play builds powerful affectional and cognitive bonds between partners, and permission to play is a priceless reward for correctly following cues for both dogs and people. Most agility people want to cavort with their dogs for the sheer joy of it, too.

Nonetheless, astonishingly, a great many agility people have no idea how to play with a dog; they require remedial instruction, beginning with learning how to respond to real-life dogs rather than fantasy children in fur coats. Some even pay handsomely at special seminars to learn how to play with their dogs. Better at getting what someone is actually

doing than people are, dogs can be pretty good teachers. But discouraged dogs who have given up on their people's ability to learn to play with them politely and creatively are not rare. People have to learn how to pay attention and to communicate meaningfully, or they are shut out of the new worlds that play proposes. Not so oddly, without the skills of play, adults of both the canine and hominid persuasion are developmentally arrested, deprived of key practices of ontological and semiotic invention.

I suggest people must learn to meet dogs as strangers first in order to unlearn the crazy assumptions and stories we all inherit about who dogs are. Respect for dogs demands it. So how do strangers learn to play with each other? First, a story.

Safi taught Wister to jaw wrestle, like a dog, and she even convinced him to carry a stick around in his mouth, although he never seemed to have a clue what to do with it. Wister enticed Safi into high-speed chases, and they'd disappear over the hills together, looking for all the world like a wolf hunting her prey. Occasionally, apparently accidentally, he knocked her with a hoof, and she would cry out in pain. Whenever this occurred, Wister would become completely immobile, allowing Safi to leap up and whack him several times on the snout with her head. This seemed to be Safi's way of saying, "You hurt me!" and Wister's way of saying, "I didn't mean it." Then they would resume playing. After they tired of racing, Safi often rolled over on her back under Wister, exposing her vulnerable belly to his lethal hooves in an astonishing display of trust. He nuzzled her tummy and used his enormous incisors to nibble her favorite scratching spot, just above the base of her tail, which made Safi close her eyes in bliss.[22]

Safi was bioanthropologist Barbara Smuts's eighty-pound sheepdog mix, and Wister was a neighbor's donkey. They met in a remote part of Wyoming, and dog and donkey lived near each other for five months. Wister was no fool; he knew his ancestors were lunch for Safi's ancestors. Around other dogs, Wister took precautions, braying loudly and kicking threateningly. He certainly did not invite them into predator chases for fun. When he first saw Safi, he charged her and kicked. But, Smuts relates, Safi had a long history of befriending critters from cats and ferrets to squirrels; and she set to work on Wister, her first large herbivore buddy, soliciting and inviting skillfully and repeatedly until he took the great leap to risk an off-category friendship.

Of course, the kind of predators dogs are, know how to read the kind of prey donkeys are in detail, and vice versa. Both evolutionary history and the history of herding in pastoral economies make that plain. The whole process would not work if sheep did not know how to understand dogs as well as dogs know how to interpret them. But the fully adult Safi and Wister played together by raiding their predator-prey repertoire, disaggregating it, recombining it, changing the order of action patterns, adopting each other's behavioral bits, and generally making things happen that did not fit anybody's idea of function, practice for past or future lives, or work. Dog and donkey had to craft atypical ways to interpret each other's specific fluencies and to reinvent their own repertoires through affective, meaningful intra-action.

Among beings who recognize each other, who respond to the presence of a significant other, something delicious is at stake. As Barbara Smuts put it after decades of careful scientific field studies of baboons and chimps, cetaceans, and dogs, co-presence "is something we taste rather than something we use. In mutuality, we sense that inside this other body, there is 'someone home,' someone so like ourselves that we can co-create a shared reality as equals."[23] In the contact zones I inhabit in agility, I am not so sure about "equals"; I dread the consequences for significant others of pretending not to exercise power and control that shape relationships despite any denials. But I am sure about the taste of co-presence and the shared building of other worlds.

Play is the practice that makes us new, that makes us into something that is neither one nor two, that brings us into the open where purposes and functions are given a rest. Strangers in hominid and canid mindful flesh, we play with each other and become significant others. The power of language is supposed to be its potentially infinite inventiveness. True enough in a technical sense, but the inventive potency of play redoes beings in ways that should not be called language, but that deserve their own names. Besides, it is not potentially *infinite* expressiveness that is interesting for play partners, but unexpected and nonteleological inventions that can take mortal shape only within the non-infinite and dissimilar naturalcultural repertoires of companion species. Another name for those sorts of inventions is joy. Ask Safi and Wister.

Gregory Bateson did not know that fine dog and donkey, but he did have a human daughter with whom he engaged in the risky practice of play. Play is not outside the asymmetries of power, and both Mary Catherine and Gregory felt that force field in their father-daughter contact zone in "Metalogue: About Games and Being Serious."[24] Their play was linguistic; but what they had to say tracks what Cayenne and I learned to do, even if Wister and Safi remain undisputed masters of the art. Here's how this metalogue starts:

Daughter: Daddy, are these conversations serious?

Father: Certainly they are.

D: They're not a sort of game that you play with me?

F: God forbid . . . but they are a sort of game that we play together.

D: Then they're *not* serious!

Then ensues their noninnocent playful investigation into what is play and what is serious, and how each requires the other for their reinvention of the world and for the grace of joy. Loosening the iron bit of logic, with all of its utterly functional ability to follow single tracks to their proper ends, is the first step. Father says hopefully, "I think that we get some ideas straight and I think that the muddles help." He adds, "If we both spoke logically all the time we would never get anywhere." If you want to get something new, you "have to break up all our ready-made ideas and shuffle the pieces."

F and D are playing a game, but a game is not play. Games have rules. Agility has rules. Play breaks rules to make something else happen. Play needs rules but is not rule-defined. You can't play a game unless you inhabit this muddle. D ponders aloud, "I am wondering about our muddles. Do we have to keep the little pieces of our thought in some sort of order—to keep from going mad?" F agrees, "but I don't know *what* sort of order." D complains that the rules are always changing when she plays with F. I know Cayenne and I have felt that way about each other. D: "The way you confuse everything—it's sort of cheating." F objects, "No, absolutely not." D worries, "But is it a *game*, Daddy? Do you play *against* me?" Drawing on how a child and a parent play together with colored blocks, F aims for some sort of coherence: "No. I think of it as you and I playing against the building blocks." Is this Safi's and Wister's playing against the rules of their species heritages? Is it Cayenne's and my playing in the arbitrary swatch of yellow paint that is our contact zone? F elaborates, "The blocks themselves make a sort of rules. They will balance in certain positions and they will not balance in other positions." No glue allowed; that *is* cheating. Play is in the open, not in the glue pot.

Just when I thought I had it, F paraphrases D: "'What sort of order should we cling to so that when we get into a muddle, we do not go mad?'" F continues, "It seems to me that the 'rules' of the game is only another name for that sort of order." D thinks that she now has the answer, "Yes—and cheating is what gets us into muddles." No rest for the wicked is F's motto: "Except that the whole point of the game is that we do get into muddles, and we do come out on the other side." Is that what the playful practice of making mistakes interesting in agility training helps us understand? Making mistakes is inevitable, and not particularly illuminating; making mistakes interesting is what makes the world new. Cayenne and I have experienced that in rare and precious moments. We play with our mistakes; they give us that possibility. It all happens very fast. F owns up, "Yes, it is I who make the rules—after all, I do not want us to go mad." D is undeterred, "Is it *you* that makes the rules, Daddy? Is that fair?" F is unrepentant. "Yes, daughter, I change them constantly. Not all of them, but some of them." D: "I wish you'd tell me when you're going to change them!" F: "I wish I could [he doesn't really]. But it isn't like that . . . certainly it is not like chess or canasta. It's more like what kittens and puppies do. Perhaps. I don't know."

D jumps at this: "Daddy, why do kittens and puppies play?" Getting it that play is not *for* a purpose, F unapologetically, and I suspect triumphantly, brings this metalogue to a close: "I don't know—I don't know." Or, as Wister said of Safi: "I'll give this dog a chance. Her constant bowing might mean I am not lunch. I'd better not be mistaken, and she had better see that I have accepted her invitation. Otherwise, she is one dead dog, and I am one savaged donkey."

So we reach another point to which Bateson takes us: metacommunication, communication about communication, the sine qua non of play. Language cannot engineer this delicate matter; rather, language relies on this other semiotic process, on this gestural,

never literal, always implicit, corporeal invitation to risk co-presence, to risk another level of communication. Back to the "Metalogue." D: "Daddy, why cannot people just *say* 'I am not cross at you' and let it go at that?" F: "Ah, now we are getting to the real problem. The point is that messages we exchange in gestures are really not the same as any translations of these gestures into words."[25]

Bateson also studied other mammals, including monkeys and dolphins, for their play and their practices of metacommunication.[26] He was not looking for denotative messages, no matter how expressive; he was looking for semiotic signs that said other signs do not mean what they otherwise mean. These are among the kinds of signs that make relationships possible, and "preverbal" mammalian communication for Bateson was mostly about "the rules and contingencies of relationship."[27] In studying play, he was looking for things like a bow followed by "fighting" that is not fighting, and is known not to be fighting by the participants. Play can occur only among those willing to risk letting go of the literal. That is a big risk, at least for adults like Cayenne and me; those wonderful, joy-enticing signals like play bows and feints usher us over the threshold into the world of meanings that do not mean what they seem to mean. The world of meanings loosed from their functions is the game of co-presence in the contact zone. Dogs are extremely good at this game; people can learn.

The biologist Marc Bekoff has spent countless hours studying the play of canids, including dogs. Granting that play might sometimes serve a functional purpose either at that time or later in life, Bekoff argues that that approach does not account for play, nor even lead one to recognize its occurrence. Instead, Bekoff and his colleague John A. Byers offered a definition of play that encompassed "all motor activity performed postnatally that appears to be purposeless, in which motor patterns from other contexts may often be used in modified forms and altered temporal sequencing."[28] Like language, play rearranges elements into new sequences to make new meanings. But play also requires something not explicit in Bekoff and Byers's definition in the 1980s; namely, *joy* in the sheer doing.[29] I think that is what one means by "purposeless." Like co-presence, joy is something we taste, not something we know denotatively.

I want to stay with altered temporal sequencing for a moment. Functional patterns put a pretty tight constraint on the sequence of actions in time: first stalk; then run to outflank; then head, bunch, and cut out the selected prey; then lunge; then bite and kill; then dissect and tug. The sequences in a serious conspecific fight or in any other of the important action patterns for making a living are different, but no less sequentially disciplined. Play is not making a living; it discloses living. Time opens up. Play is a dance of rule and invention in the kinesthetic matching of two moving bodies.

In Cayenne's and my experience of playing together, this play of strangers, an altered temporal sense happens to both partners. Inside that jointly altered but still nonidentical sense, time in the sense of sequencing also opens up. Unexpected conjunctions and coordinations of creatively moving play partners take hold of both, and put them into an open

that feels something like a suspension of time, a high of "getting it" together in action, or what I am calling joy. No liver cookie can compete with that! Agility people often joke with each other about their "addiction" to playing agility with their dogs. How can they possibly justify the thousands of hours, thousands of dollars, constant experiences of failure, public exposure of one's foolishness, and repeated injuries? And what of their *dogs'* addiction? How can their dogs be so intensely ready *all the time* to hear their human utter the release word at the start line that frees them to fly in coordinated flow with this two-legged alien across a field of unknown obstacles? There is, after all, a lot that is not fun about the discipline of training, not to mention the rigors of travel and the erosions of confined boredom while waiting for one's runs at an event—for people and for dogs. Yet, the dogs and the people seem to egg each other on to the next run, the next experience of what play proposes.

Besides, joy is not the same thing as fun. I don't think very many people and dogs would keep doing agility just for the fun; fun together is both unreliable in agility and more easily had elsewhere. I ask how Cayenne can possibly know the difference between a good run and a mediocre one, such that her entire bodily being glows as if in the phosphorescent ocean after we have flown well together? She prances; she shines from inside out; by contagion, she *causes* joy all around her. So do other dogs, other teams, when they flame into being in a "good run." Cayenne is pleased enough with a mediocre run. She has a "good time"; after all, she still gets string cheese and lots of affirming attention. Mediocre runs or not, I have a good time, too. I've made valued human friends in agility; I get to admire a great motley of dogs; and the days are uncluttered and pleasant. But Cayenne and I both know the difference when we have tasted the open. We both know the tear in the fabric of our joined becoming when we rip apart into merely functional time and separate movement after the joy of inventive isopraxis. That's why we do it. That's the answer to my question, "Who are you, and so who are we?"

Good players—watch any adept dog—have a sizable repertoire for inviting and sustaining their partners' interest and engagement in the activity and for calming any worries the partner may develop about lapses into the literal meaning of alarming elements and sequences. Bekoff suggests that these animal abilities to initiate, facilitate, and sustain joint "fair" play, in which partners can take risks to propose something even more over the top and out of order than the players had yet ventured together, underlie the evolution of justice, cooperation, forgiveness, and morality.[30] Remember Wister's letting Safi whack him with her snout when the donkey had accidentally caught the dog's head with an overly exuberant hoof? I remember how many times in training with Cayenne, when I am incoherent and hurtful instead of inviting and responsive, I receive the gift of her forgiveness and her readiness to engage again. I experience that same forgiveness in play with her outside formal training when I misinterpret her invitations, preferences, or alarms.

I know perfectly well that I am "anthropomorphizing" (as well as theriomorphizing) in this way of saying things, but *not* to say them seems worse, both inaccurate and impolite. Bekoff is directing our attention to the astonishing and world-changing natural-cultural evolution of what we call trust. I am partial to the idea that the experience of cognitive/affective/sensual joy in the nonliteral open of play might underlie the possibility of morality and responsibility for and to each other—strangers that we always are—in all of our undertakings at whatever webbed scales of time and space.

I said that "play proposes," and I argued that people must learn to meet dogs as strangers, as significant others, so that both can learn the corporeal semiosis of cross-species trust and enter the open of risking something new. Agility is an ordinary game in which the syncopated dance of rule and invention reshapes players. The open beckons; the next speculative proposition lures; the world is not finished; the mind/body is not a giant computational exercise, but a risk in play. That's what I learned as a biologist and a feminist cultural studies scholar; that's what I learn again in the contact zones of agility. People must not explain away by tautology—"just-so" stories of relentless function—what must be understood (i.e., disclosed). If we appreciate the foolishness of human exceptionalism, then we know that becoming is always becoming *with*—in a contact zone where the outcome, where who is in the world, is at stake.

Notes

This chapter is an edited and shortened version of a chapter by the same title in Donna Haraway, *When Species Meet* (*Minneapolis*: University of Minnesota Press, 2008).

1. Vinciane Despret, "The Body We Care For: Figures of Anthropo-zoo-genesis," *Body and Society* 10, no. 2–3 (2004): 111–134. For a feminist environmentalist approach to the history of domestication, see Barbara Noske, *Beyond Boundaries: Humans and Other Animals* (Buffalo, N.Y.: Black Rose Books, 1997). Besides introducing the idea of the "animal-industrial complex," Noske sketches the many thousand years' complexity of human-animal relations in domestication, defined as a situation in which humans alter the other animals' seasonal subsistence cycle, but allowing for animals' altering human patterns in more than a passive way. The historical, natural-cultural ecologies of all the entangled species are at the center of attention in this approach. Noske insists that we regard animals more like science fictional other worlds and less like mirrors or lesser humans.

2. See http://www.cleanrun.com for links to a wealth of agility information. The monthly magazine *Clean Run* is a major resource. For this chapter, see especially *Contacts, Clean Run* special issue (November 2004).

3. Brenda Fender, "History of Agility, Part 1," *Clean Run* 10, no. 7 (July 2004): 32–37.

4. Karen Pryor, *Don't Shoot The Dog!: The New Art of Teaching and Training* (New York: Bantam 1984; rev. ed. 1999); Karen Pryor and Konrad Lorenz, *Lads Before the Wind: Diary of a Dolphin Trainer* (Waltham, Mass.: Sunshine Books, rev. ed. 2004). For a successful agility competitor's

approach, see Susan Garrett, *Shaping Success: The Education of an Unlikely Champion* (Chicopee, Mass.: Clean Run Press, 2005).

5. I owe my understanding of the prosaic to Gillian Goslinga, "Virgin Birth in South India: Childless Women, Spirit Possession, and the Prose of the Modern World" (Ph.D. diss., University of California at Santa Cruz, 2006). I am also indebted to Isabelle Stenger's understanding how the abstractions of science push one to imagine new manifestations which make sense only in prosaic details.

6. Susan Conant, *Black Ribbon: A Dog Lover's Mystery* (New York: Bantam, 1995).

7. Mary Louise Pratt, *Imperial Eyes: Travel Writing and Transculturation* (New York: Routledge, 1992), pp. 6–7.

8. James Clifford, *Routes: Travel and Translation in the Late Twentieth Century* (Cambridge, Mass.: Harvard University Press, 1997), p. 7.

9. Naomi Mitchison, *Memoirs of a Spacewoman* (London: Women's Press and New York: Berkley Books; 1962; 1985); Suzette Haden Elgin, *Native Tongue* (New York: Daw Books, 1984); Samuel R. Delany, *Babel-17* (New York: Ace Books, 1966).

10. See Allan A. Schoenherr, *A Natural History of California* (Berkeley: University of California Press, 1992).

11. Juanita Sundberg, "Conservation Encounters: Transculturaltion in the 'Contact Zones' of Empire," *Cultural Geography* 13, no. 2 (2006): 239–265.

12. Anna Tsing, *Friction: An Ethnography of Global Connection* (Princeton, N.J.: Princeton University Press, 2005).

13. Anna Tsing, "Unruly Edges: Mushrooms as Companion Species," in "Thinking with Donna Haraway," Sharon Ghamari-Tabrizi, ed. (forthcoming, MIT Press).

14. Eduardo Kohn, "How Dogs Dream: Amazonian Nature and the Politics of Transspecies Engagement," *American Ethnologist*, 34 (2007): 3–24. The quotation is from a personal e-mail communication, November 4, 2005. Kohn is preparing a book titled *Toward an Anthropology of Life: Amazonian Natures and the Politics of Trans-species Engagement*.

15. Scott Gilbert, *Developmental Biology*, 8th ed. (Sunderland, Mass.: Sinauer, 2006).

16. Scott F. Gilbert and Steven Borish, "How Cells Learn, How Cells Teach: Education Within the Body," in *Change and Development: Issues of Theory, Method, and Application*, ed. Eric Amsel and Ann Reninger (Mahwah, N.J.: Lawrence Erlbaum, 1997), pp. 61–75.

17. See Amy Sutherland, *Kicked, Bitten, and Scratched: Life and Lessons at the World's Premier School for Exotic Animal Trainers* (New York: Viking, 2006), p. 265.

18. See also Vicki Hearne, *Adam's Task: Calling Animals by Name* (New York: Random House, 1987).

19. For a full discussion of intra-action, see Karen Barad, *Meeting the Universe Halfway* (Dusham, N.C.: Duke University Press, 2007).

20. Despret, "The Body We Care For," p. 121.

21. Ibid., p. 115.

22. Barbara Smuts, "Encounters with Animal Minds," *Journal of Consciousness Studies* 8, no. 5–7 (2001): 1–17, see 13.

23. Ibid., p. 16.

24. Gregory Bateson, "Metalogue: About Games and Being Serious," in his *Steps to an Ecology of Mind* (Chicago: University of Chicago Press, 1972/2000), pp. 14–20.

25. Bateson, *Steps to an Ecology of Mind*, p. 12.

26. Ibid., p. 179.

27. Ibid., p. 367.

28. Marc Bekoff and John A. Byers, "A Critical Reanalysis of the Ontogeny of Mammalian Social and Locomotor Play," in *Behavioural Development*, ed. Klaus Immelmann, G. W. Barlow, L. Petrinovich, and M. Main (Cambridge: Cambridge University Press, 1981), pp. 296–337. See also Marc Bekoff and John A. Byers, eds., *Animal Play: Evolutionary, Comparative, and Ecological Approaches* (New York: Cambridge University Press, 1998).

29. See Marc Bekoff, *The Emotional Lives of Animals* (Novato, Calif.: New World Library, 2007).

30. Marc Bekoff, "Wild Justice and Fair Play: Cooperation, Forgiveness, and Morality in Animals," *Biology and Philosophy* 19 (2004): 489–520.

Playing with Rats

Kathy High

Arrival

03.15.05: The rats arrived today. They were delivered from the lab. A truck with a giant rat painted on the side drove up to the university building. The driver carried them in a plastic tub that had holes in the top, a carrier designed for transporting rats. I signed for the carrier and took them to my office, where I had a cage to transfer them into.

Actually, I didn't sign for them, nor was I there to greet them. I arrived back from a meeting and the department secretary told me that a package had arrived. I went into my office and saw the plastic tub on my side table. The room was cold, and I was worried about the temperature.

I took the tub over to the table with the cage. Two other staff members came to meet the rats. We all worked to get them into the cage with the least amount of trouble—and also with the least amount of contact.

The plastic tub smelled bad. But it was not the rats that smelled, as I had suspected, but the food pellets.

The rats were scared and immediately hid under the hut areas I had provided in the cage. Their long tails were pink and scaly. I always thought their tails looked reptilian. I understand that the tail acts as a thermoregulator for their body. When it is cold, the tail shrinks, constricting blood flow to the tail and maintaining more blood flow for the rest of the body. The opposite happens when it is warm. Also, the tail is used for balance. The rats carry their tails extended slightly off the ground when walking or running. Their tails still creep me out.

Why did I decide to work with these rats? I am afraid of them. And I don't know how to relate to them. They make me nauseous and queasy. They make my skin crawl. I have never touched a rat before except accidentally, when they crawled over me in bed at night

or when they ran by my foot in the alley or the subway. They terrify me. Plague-laden animals, low to the earth, crawlers, sneaky, creepy vermin. . . .

What was I thinking? These rats were *bred* with a small amount of human DNA to give them autoimmune diseases: inflammatory bowel disease for one (this most closely links to mine). My own autoimmune diseases are incredibly complicated. Why did I think the rats would be easy to treat to correct their autoimmune diseases? I have been treated with acupuncture and homeopathy and supplements for twenty years.

Autoimmune diseases are generally considered as the body attacking itself, exaggeratedly responding to intrusions and overreacting: military terminology is most often used to describe the scene (Sontag). But rather than thinking in aggressive terms of *invasion*, *defense*, and *attack*, think in terms of *process*. How does the subject respond to cause and effect? Question the process, examine it, and understand it from a position of alliance, relationship, exchange, rather than one of defense. Better to think of Humberto Maturana and Francisco Varela, and envision a living system, one of *autopoiesis* (self-making). "An autopoietic organization is an autonomous and self-maintaining unity which contains component-producing processes."[1]

I bought them to conduct research and to treat them holistically with alternative medicines, environmental enrichment, good food, and play. I want to relate to them because I, too, have autoimmune problems. I identify with the rats and feel as though we are mirroring each other. The rats and I are all retired breeders. I feel some kind of strange kinship with them. If they ache when being touched, I understand this is from my own fevers. I also know they do not know how to behave as pets. They are not pets. They are extensions, transformers, transitional combined beings that resonate with me in ways that other animals cannot—because of that small addition of human DNA. These rats and I are engaged in like systems and routines of health and sickness.

We will be a closed system—the rats and I—reading and reacting to each other, defining our conditions. We will collaborate and make up our own rules.

3.23.05: The rats adapt quite well to the cage and their new environment. I cover them every night to keep them warm. People stop coming to my office, as it is beginning to smell a bit musty, like straw, food, and shit. I find I am somewhat comforted by the smell and welcome it. We are isolated together.

3.28.05: The rats are eating quite well and starting to gain weight even in their first week. They are actually growing already. They are definitely getting larger.

Their shit stinks. But it is hardening up, at least—turning from the runny, putrid slime that they had at first to harder orbs. I count their shits the way I count my own visits to the toilet, monitoring waste and consistency.

4.15.05: Today we named them. The oldest one was named Star, after the Wistar Institute, one of the oldest rodent lab facilities in the country.[2] The other rats are named Matilda and Tara. (See figure 27.1.)

Figure 27.1 Rat tail, detail.

Transfer-Transplant

The rats were bred to be sick. Just as the psychospiritual state of our country is unwell, and "... the melodramatics of the disease metaphor in modern political discourse assume a punitive notion: of a disease not as a punishment but as a sign of evil, something to be punished ... ,"[3] so these transanimals are a metaphor for a fabricated "alien." In discussing OncoMouse™, a similar rodent creation, Donna Haraway says:

OncoMouse™ is my sibling, and more properly, male or female, s/he is my sister. Her essence is to be a mammal, a bearer by definition of mammary glands, and a site for the operation of a transplanted, human, tumor-producing gene—an oncogene—that reliably produces breast cancer.

Above all, OncoMouse™ is the first patented animal in the world. By definition, then, in the practices of materialized refiguration, s/he is an invention. Her natural habitat, her scene of bodily/genetic evolution, is the techno-scientific laboratory and the regulatory institutions of a powerful nation-state. Crafted through the ordinary practices that make metaphor into material fact, her status as an invention, who/which remains a living animal, is what makes her a vampire, subsisting in the realms of the undead.[4]

These rats—Matilda, Tara, and Star—are also known as the Barbies (to salute their origins as a kind of manufactured production). They are all transgenic (microinjected gene transfer) rats—HLA B27 transgenic rats, to be precise—exhibiting a phenotype similar to humans suffering B27-related rheumatic disorders. They have been microinjected with human DNA that sets them up for a predisposition to be autoimmune challenged. The human genetic material is injected into the pronucleus of the rat embryo, and it is passed from generation to generation ever after. These rats are prone to develop diseases such as reactive arthritis, psoriasis, inflammatory bowel disease, and other things. They are developed for pharmaceutical research studies in systemic inflammation.

Matilda, Tara, and Star are also retired breeders, meaning they were used to give birth to baby rats that carried their added gene (one to two litters each). They came from a laboratory that breeds such rats (and mice, too) and sells them to researchers. Some of their ears have holes, and they have yellow markings on their fur as a kind of numbering system. These marks denoted their identification until they came to live with me.

The rats that were ordered were all about eleven months old. When researching them I looked for a few things: proximity of rodent facility (this place was only a one-hour drive away); they had to be transgenic rats (I had decided to work with rats, as opposed to mice, because they were a more powerful image for me and I reacted to them more strongly than to mice—in other words, I loathed them); and rodents that were developed for work with autoimmune diseases close to my own. (I may not have selected the best "models" of diseased rats. The NIH Autoimmune Rat Repository and Development Center has an entire bank of cryopreserved pedigreed embryos from sixty-three strains of rats.) The rats cost over three hundred dollars each. They were the closest product I could find to conduct treatment like my own. They are bred ill and are not expected to live longer than six months to a year and a half. Generally they were created for research in rheumatoid arthritis.

Rat Histories

Rats are traditionally seen as vermin, pests, gnawing, repugnant, destructive, and disposable. They are also easy to breed, cheap, small, and easy to contain.

Mythic and dark and laden with negative energy—and add to it the fact that these rats are now mutants, transhuman/transgenic, which makes them even scarier. The skeletons of the Black Plague haunt these rats (. . . dirty, disease-carrying rats) and follows them everywhere—even if they are now albino, pure white, brought to us from "clean rooms."

So they now are carriers of my diseases. They have been dealt my condition, my illness. And since they are already "diseased" and "dirty," this contact goes unnoticed and unobjected. And the animal that caused disease is now injected/polluted with disease.

Rats originally came from India and China, where they were honored for their wit and agility and written into mythology, accompanying Ganesh as a companion and heading

up the Chinese astrological signs. They came to Europe, probably via trading boats, sometime in the 1500s, and to the Americas in the 1700s. First to arrive was the black rat. Then the "fancy" rat or Norwegian rat, which is larger and brown in the wild. The "fancy" rat is used in laboratories now. The black rat is the rat that carried the fleas of the Black Plague—now harder to find in the wild.

They are dispensable. They breed quickly. They are pharmed. They are not on the endangered species list.

There are over fifty breeders and vendors of laboratory animals in the United States. The total number of rodents and birds is uncounted, but millions are used in research each year. Over 95 percent of all laboratory research animals used in biomedical research are rodents (mice and rats) or birds.[5]

Interview between artist Kathy High and Joel Taurog, professor of internal medicine and immunology at the University of Texas Southwest in Dallas, who worked with Robert Hammer to invent the HLA B27 rat line.

Joel Taurog: My interest in B27 and its role began in 1973. In the 1980s we were looking at conventional animal models that had arthritis. In the early 1980s technologies were developed for transgenic animals. At the time we had cloned the B27 gene. And everyone was making transgenic mice at the time. But it wasn't so clear what to do. I was actually looking at a conventional animal model in the early and mid-eighties.

Kathy: When you say "conventional model," what, exactly, do you mean?

Joel Taurog: It is a model that has arthritis . . . a model where you give rats a certain concoction of things and they get arthritis, which seemed like it might be a model for reactive arthritis, which was another B27-associated phenomenon. Meanwhile, the technology to make transgenic animals was developed in the early eighties, and Bob Hammer trained in a lab where that was developed—in Ralph Brinster's lab at the University of Pennsylvania. Really, the seminal work that made transgenic animals a reality was due to a collaboration between Ralph Brinster and Richard Palmiter, who was at that time at the University of Washington (I think he still is). So, Bob came from that lab and then I came to Dallas in 1986. What had happened is in 1983 Carl Simmons, who is a very wealthy Dallas businessman, gave a large endowment to the rheumatology division here. Mr. Simmons himself was, I think, suffering from reactive arthritis, so he, I guess, had some interest in having somebody here working on that condition, and there wasn't anybody here at the time . . . so they recruited me—I was at the University of Minnesota at the time. When I came here, it seemed like we had just cloned the B27 gene and it seemed like the making of a transgenic model would be a reasonable thing to do. It seemed like everybody would be making transgenic mice and we knew from a lot of other work that rats are much more susceptible to arthritis than mice. There was a number of experimental models, so it was easy to produce arthritis in rats and much more difficult in mice—or not at all.[6]

Rodents' Rights

Under the U.S. Animal Welfare Act (AWA), rats, mice, and birds do not receive the same protection that other "animals" currently do, even though they make up the bulk of all research animals. Since the 1960s, a battle has been ongoing to exclude these small animals bred for research in the definition of "animals." The addition of rodents and birds under the Act would require further oversight and inspections that would conceivably increase research costs and therefore cut into the profits of the pharmaceutical industry. In 2002, an amendment to the Farm Bill instituting a permanent exclusion of rats, mice, and birds from the AWA was promoted by both the National Association for Biomedical Research and by Jesse Helms prior to his resignation from his position in the Senate. Helms retired due to illness. Perhaps he selfishly supported the amendment to keep his own drug costs down. More likely, as the Senator from North Carolina, Helms was using his senatorial position to champion a burgeoning pharmaceutical industry for his state, similar to what he had done for the textile and tobacco industries.[7]

[May 13, 2002] President Bush signed the farm bill, which included an amendment authored by Sen. Jesse Helms, R-N.C., to exclude rats, mice and birds from the Animal Welfare Act. Lab rodents and birds are already protected to some degree under other laboratory guidelines and researchers claim that more regulations—and more lawsuits—would only hinder research.

"It would mean more paperwork and more cost," says Frankie Trull of the Foundation for Biomedical Research. "And that will ultimately only drive up costs for consumers."[8]

The added costs of routine care and assessment would have cut down on the ways that the pharmacology *machine* profits. However, the costs need not be passed onto the consumer, as the by-line of this newspaper article reports. The real concern here is the hidden costs to the industry itself if regulations concerning animal care and pain management, etc. were enforced. Like many other similar issues currently in play in our corporate-nation, maintaining the low costs of these animal products are imperative for modest labor overhead and high product yield. Consequently, the smaller animals are left to fend for themselves.

Habitat +Play

We need to play—to cuddle up, to bare our fangs, to playfully threaten, to develop our relationship and also the rules of the game.

05:20:06: I drive the rats in my car and in their cage to my exhibition at the Massachusetts Museum of Contemporary Art (MASS MoCA). They are part of the "Becoming Animal" show. They have a towering and rambling housing situation/habitat. There are upper

small huts high along the wall, attached by tubing that loops around and back to the main huts. These upper areas are for hiding and have tunnels running to them for scaling. There is a typical cage with three levels for climbing as well. There are Quonset huts with grass, dirt, rocks, and even a plastic toy barn for sleeping and playing. Metal piping or vacuum cleaner hosing connects all the different housing units. All in all, it is like living in a small village.

The rats will be on exhibit at the museum. Their house will become my artwork. They will no longer be lab products, but art products, again on display, again used as research. Does this shift or change their status in the world? They are still workers and products for sale. In fact, while they may be now considered "art objects" instead of "lab products," the fragility and unpredictability of working with these small creatures makes me aware of my own fragile situation. It does that for all of us as we constantly monitor and check, discuss illnesses, and compare our own bodies to theirs. (See figure 27.2.)

Through a process of empathy, and identification, and in a gesture of revolt, our act of caring for transgenic rats honors our confused relationship. Our exchange with rats was obsessive care. We should make them live forever, cure their diseases in a real transgression, in an exchange unmeasured in power. Their immortality will celebrate our kinship with transgenic animals and the work they do, using their body parts and ours. I will replace their body parts with mine as they continue this passage, this exchange, perpetually.

Play Exercise One: Place treat pellets in mouth and have rat take from you in a small kiss.

Play Exercise Two: Call rats from one end of housing and see if they come to you. Award treat. Then call from other end of housing, and repeat.

Play Exercise Three: Sit in Healing Dome and allow rats to crawl over you. Touch excessively.

07.10.06. Playtime comes at night. The rats chew their teeth and make grinding, gnawing sounds constantly. The sound echoes in their tunnels. They roam and wander, passing back and forth in the space, their little nails hitting the hard surfaces and clicking as they run through the vents and crawl spaces: click click click. They smell musky, like hay and sweat. The smell becomes more pronounced at night—the scents stirred up. (see figure 27.3.)

Imaging: Intimacy and Distances

Modern medical imaging accomplishes what began in the eighteenth century as a desire and a search for illuminating every dark corner, especially for seeing the insides of the human body. Modern man has since been rendered somatically transparent, in gestures that extend into putting into full view not only the hidden but the ultimate microscopical, the DNA fingerprinting, the biochemical profiles, the immune cellular probes and markers. Our times have renewed the visible

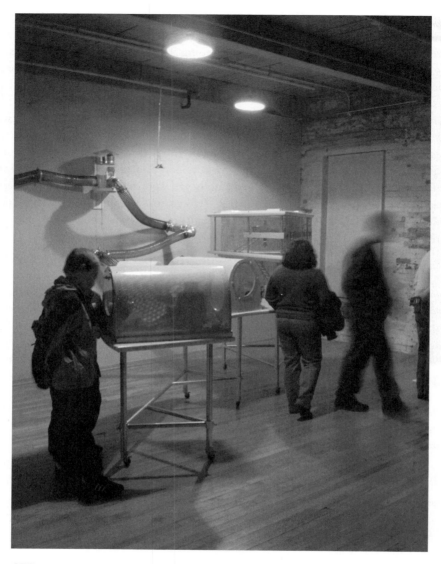

Figure 27.2 Rat habitat in *Embracing Animal* installation at MASS MoCA.

Figure 27.3 Overview of *Embracing Animal* installation. Photograph by Adrian Garcia Gomez.

and the explicit as a preeminent presence, compared with times in which only the rarefied world of pure ideas and Logos was supreme and the image mere appearance. . . .[9]

This installation was a lab environment for observation with large, glowing "tube-scopes"—tall glass tubes with mini LCD monitors at the bottom of the glass—and the extended animal cage housing the three transgenic lab rats. It was an experimental playground to feel the tension of exchanges, transitions, and transplay. It was built for surveillance, to make the unseen, seen. The rats observed us and we observed them.

The staff at the museum gave tours and explained transgenics. They introduced the concepts to the public and also introduced the public to these creatures, whose labor otherwise would have been unseen. The installation honored our relationship and our kinship with transgenic animals (housing our DNA) and made them visible. The staff learned to love the rats. The night watchman, Mike Wilber, and his wife, Peg, enacted the exercises, noted their every ailment, nursed their wounds, and finally adopted the rats. Their love was infectious.

Dirty Room: Autoimmune Metaphor

In an industry/research laboratory setting, these rats are not tested in what I would consider nourishing environments: their cages are small, offering little stimulation; their autonomy is limited. They are not nurtured to develop skills and strength. Thus they are being tested for drug research and development while they are getting increasingly sick. In other words, the starting point for the research is not a good one.

In my lab, the rats grew stronger under what would be considered "improper" conditions for them. They were exposed: they came from clean rooms and were then in a dirty environment. But this only proved to make them stronger. Contrary to common belief that they should be "clean" and quiet and contained, they were "under observation" and under "stressful conditions," with the public nagging and challenging them every day. They were asked to perform for the public, and thus live with constant distractions. To break from the obsessing nature of immunological disorders, and to break the innate immunological tolerance cycle, one must develop the ability to distinguish "self" from "non-self." Extending beyond our mirroring, the rats engaged with distractions, learned new relationships, and developed changing reactions that established a separation of self from non-self, which encouraged tolerance for external aggravations, and perhaps encouraged a similar immune response.

My basic research premises:

1. Lab rats will become ill when confined and not excited or stimulated.
2. Food must be varied and plentiful.
3. Diversions will create new ways of thinking that will increase immunity and strengthen.
4. Movement is good for blood circulation and for immune building.
5. Treat with homeopathic or natural medicines as much as possible.
6. Work closely with a vet who reviews often.
7. Public will not be noticed by rats, as they cannot see very well, but they will sense the warmth of bodies around them.
8. They will be great teachers.

12.05.05 Rat report e-mail from the assistant curator, MASS MoCA

Hi, Kathy,

Sorry for the delay . . . things have been nuts around here. Without further *ado,* here's the rat girl update:

Matilda: Had a seizure while Hilary [the vet who comes every few weeks] was examining her. Her right eye has a mild infection and red tears. We are going to start using eyebright tea daily

for 10 days and will call Hillary with an update. No tumors, chest is great. Overall in good health. Wanted to be touched, and seemed very affectionate.

Tara: She is severely overweight. Her skin condition is probably due to the fact that she is unable to clean herself properly. It's not an infection; that area on her back is just dirty. She said in the meantime we can clean that little spot for her. Need to watch treat intake. Eyebright tea to soothe eyes (no infection, but look a little swollen.) No tumors, chest is great. Overall in good health.

Star: Perfect weight. No tumors and chest is great. Eyebright tea to soothe eyes (no infection, but look a little swollen.) Overall in good health. [See figure 27.4.]

So everyone's doing well, but we need to work on Tara's diet, and Matilda could stand to lay off the treats a bit too. She said that Star is the ideal weight. We are going to start administering eyebright tea on all of them, to see if it helps with the slight swelling of their eyes, but will continue to give them the eye salve if they have infection.

Take care,

Molly O'Rourke

Sentient Life

. . . all becoming is a becoming-minoritarian. . . . Becoming-minoritarian is a political affair and necessitates a labour of power (*puissance*), an active micropolitics.
GILLES DELEUZE AND FÉLIX GUATTARI, *a thousand plateaus*

02.20.06. After the exhibition the rats came to live with me. Then Mike and Peg Wilber begged to take them to their home. They took them, and loved them madly until they died. They had been their real caretakers and would report on their every tick.

They died within two months of each other. They slowly slipped away. Matilda died with me, and the other two, Star and Tara, with Peg and Mike. Each rat was held as she passed. They lived over two years, beyond what was expected of them. They were cremated all together.

09.03.06. Excerpt of e-mail from Dawn Hayman, animal communicator, Spring Farm Cares: postmortem telepathic conversation with the rats.

Here is what I do get from the rats—and I get them as a group:

"The work that we did with people was what was important to us. Being a part of a living exhibit was ok, sometimes stressful, but mostly ok. But the highlight of it all was introducing people to rats in general and us in particular. . . .

Usually, humans do not see rats in a favorable light. . . . so they do not reap the benefit of our genius, heart, love, and observations. We live close to the planet and are aware of many things that

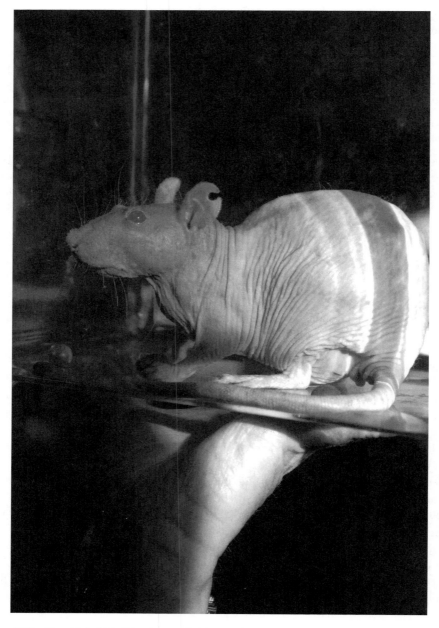

Figure 27.4 Star, HLA B27 albino transgenic lab rat. Photograph by Olivia Robison.

Kathy High

humans are not aware of. In the laboratory setting, of course, we are . . . separated from our natural connection to the Earth and her vibrations. Therefore, as rats, we were also trying to reconnect to our spiritual heritage and truth. . . . much like the humans who came to see us in our exhibit. We are not certain what humans learned from us, but we know that they did learn something. We learned that humans are very closed off from the communications of nature and the Earth. Anything we could do to help them was very good. We were glad for the time we had with you."

Transmission

The lab technician looks down at her hand. She is shaking. She starts sucking her middle finger, which is bleeding.

The rat looks at her with a smirk. The transfer had occurred. She had succeeded. She'd bit the hand that fed her, through the latex gloves. Punctured the skin ever so slightly and then tongued the wound. Transferring genetic material. They would then be blood sisters. Bonded. Twins.

Acknowledgments

Embracing Animal (www.embracinganimal.com) was an installation that was part of the "Becoming Animal" exhibition at MASS MoCA, North Adams, Massachusetts, May 2005–February 2006, curated by Nato Thompson. I would like to extend my thanks to the staff of the museum who worked so hard to keep the rats healthy and happy: Molly O'Rourke, Bridget Hanson, Richard Criddle and crew, vet Hilary Cook, and especially Mike and Peg Wilber. Special thanks to Adam Zaretsky, who is a constant inspiration.

Notes

1. http://pespmc1.vub.ac.be/ASC/AUTOPOIESIS.html.

2. http://en.wikipedia.org/wiki/Wistar_Institute.

3. Susan Sontag, *Illness as Metaphor* (New York: Vintage Books, 1979), p. 79.

4. Donna J. Haraway, *Modest_Witness@Second_Millennium.FemaleMan©_Meets_OncoMouse*[TM] (New York: Routledge, 1997), pp. 79–80.

5. PETA, "Why Include Rats, Mice and Birds? Arguments Against the Exclusion of Rats, Mice, and Birds from the Protection of the Animal Welfare Act," February 2002. http://www.peta.org/feat/carolina/why.html.

6. A significant publication for this discussion is R. E. Hammer, S. D. Maika, J. A. Richardson, J.-P. Tang, J. D. Taurog, "Spontaneous Inflammatory Disease in Transgenic Rats Expressing HLA-B27 and Human Beta2-m: An Animal Model of HLA-B27-associated Human Disorders." *Cell* 63 (1990):1099–1112.

7. David Malakoff, "Senate Says No to New Rodent Rules," *Science* 295 (February 22, 2002): 1439–1441.

8. Amanda Onion, "Lawyers: Animals Should Be Able to Sue," ABC News Original Report, May 13, 2002, p. 2. http://abcnews.go.com/Technology/story?id=97994&page=1.

9. Francisco J. Varela, "Intimate Distances: Fragments for a Phenomenology of Organ Transplantation," *Journal of Consciousness Studies* 8, no. 5–7 (2001): 259–271. http://www.oikos.org/varelafragments.htm.

Animal Welfare in the Laboratory

A Case Study in Secular Ethics of Human-Animal Interaction

Larry Carbone

Expanding our ethics to include the nonhuman world means rethinking ethics at a fundamental level. Much of moral philosophy in the Western world has been based on an ideal of freely acting, rational, equal, autonomous humans interacting with each other in a moral community. How could this possibly apply to plants, cells, animals, and ecosystems, without radically rethinking the basis and nature of morality? In part, it means rethinking words such as *harm, interests*, and *respect* for entities that do not think or feel in ways remotely human.

In this chapter, I discuss the special case of animal ethics. As a veterinarian whose patients are experimental animals living in laboratories, my lifelong biopolitical project has been to develop a consistent, responsible standard for these animals' care. I am convinced that many animals do think and feel in ways terribly close to how humans do, and that this is an excellent starting point for thinking about our ethical responsibilities to them. It requires not so much a rethinking of harms, interests, and respect as a dedication to acting on those concepts. What makes this work political are both the resources that are contested (such as regulatory constraints on animal use, and the impact on medical progress and various medical industries) and the differing goals of various stakeholders (animal users, animal advocates, veterinarians, and, of course, the animals themselves).

What should we do about the animals in our lives, the animals whose lives we touch? People possess and use billions of animals per year for food, fur, companionship, sport, and science. Concurrently, daily human enterprise radically transforms the living environments of those free-living animals outside of actual human possession. We wield such power over animals' lives: Can we wield it ethically? My focus in this chapter is the focus of my veterinary practice: the special case of animals in laboratories.

Though humans impact animal lives in myriad ways and in myriad locations, the ethics of animal experimentation has received the greatest attention from scholars and enormous

energy from activists. Animal welfare laws around the world focus heavily on laboratory animals and ignore most of the rest. The Animal Welfare Act, the most exhaustive legislation on animal welfare in the United States, offers some protections for some laboratory, zoo, and circus animals,[1] but actively excludes farm animals, animals in rodeos, animals sold or kept as pets, and even birds in cockfights (U.S. Congress 1985). This is far out of proportion to the much larger numbers of animals affected by agricultural and environmental activities.

Why this narrow focus from philosophers, activists, and regulators? I see several factors at play. The laboratory is a limited space in which rules of behavior can be analyzed and regulated. Science—unlike meat consumption, fur/wool/leather wearing, keeping pets—is performed by a minority of individuals, and so may appear to be more easily critiqued and regulated without obviously impacting the majority.[2] Moreover, the animal pain and suffering in the laboratory can appear to be more deliberate, premeditated. Unlike the accidental cruelties inflicted by negligent or uninformed pet "owners" or the rough-and-tumble of transforming living animals into supermarket cuts of meat, the cruelties of science are planned, funded, studied, and carefully replicated as medical scientists attempt to model the infections, cancers, and traumas of human illness.

I write about the ethics of laboratory animal use for three reasons: (1) it is important in its own right for those animals currently serving in laboratories; (2) it has been discussed so exhaustively that it can serve as a crucible for thinking more broadly about how human activity affects animals; and (3) it is what I know best, having worked most of the past twenty years as a veterinarian in animal laboratories. The special case of laboratory animal welfare illumines a theoretical framework for exploring the politics of animal ethics, especially the empirical challenges in speaking for animals, and the political constructions of those empirical "facts" about animals.

One starting point for animal ethics is conventional day-to-day human ethics. Indeed, two of the most radical and influential animal liberationist philosophers, Peter Singer and Tom Regan, have made the case for just how nonradical their philosophies are. They describe human ethics in well-established terms of utilitarian consequences (Singer) or basic rights and respect for persons (Regan), ask why animals should be excluded, and argue that the truly rational, reasonable, and consistent position is to include animals in our moral sphere (Regan 1983; Singer 1990). Theirs is a start, but just as feminist scholars have criticized such rationalist philosophies for ignoring power inequalities among humans, even more, any serious discussion of human-animal ethics must recognize the deep inequity in power between modern humans and nonhuman animals (Donovan 1996).

Thus, animal ethics requires consideration of power inequities. Alongside this, and often overlooked, is the need to know the facts about animals: what they want, what hurts them, what causes them pleasure or distress or joy, and to recognize how those facts might differ for such widely differing animals as chimpanzees, mice, squid, and amoebas. In

political struggles to say how humans should treat animals, convincingly controlling the factual information about animals is key.

Start with the most basic question about animal experimentation: Should animals be used in laboratories at all? If not, why not? If it is because they might experience pain and distress, we face empirical questions: What experimental procedures cause pain or distress? Do they distress fish or fruit flies in the way they might distress a monkey or a dog? How do we know? Might it be acceptable to keep animals in a laboratory solely to observe their behaviors? Might it be acceptable to keep the fruit flies and the amoebas in the laboratory if their harm, as they perceive it, is somehow less than that of other animals? And if we spare the fruit flies or the amoebas, does that also mean no plants in the lab, no cells in culture?

I do not introduce amoebas here to mock the question of animal ethics, but to emphasize that pushing outward to include animals in our ethics really does require figuring out just which animals we're talking about. Whether we look for a sharp line delimiting some species of concern (while excluding others), or a graded matrix in which the most sensitive of animals get the greatest protections, I cannot see how we could avoid asking what it is about the animals that allows these distinctions. And not "animals" as a generic category, but particular species of animals, and often specific individuals with their own life stories.

In my own work, I start with the fact that animals *are* in laboratories, and will be there for decades to come, and ask: What should govern how we treat them? This is the question that concerns me daily in caring for such animals, and it also illuminates some of the interesting challenges in developing a human-animal ethic.

Antivivisectionists call for the total abolition of laboratory animal use. Against them, some scientists (though rarely in public) want complete freedom to use animals as their scientific curiosity dictates. In the middle are those who grant some legitimacy to the enterprise of using animals in laboratories, so long as safeguards are in place for the animals' welfare. [Disclosure: I work in research because I am convinced it produces important medical advances that I am not prepared to deny to myself or to people with serious illnesses.] This may play out as setting limits on types of experiments that may be performed. Or it may instead focus on species, allowing experiments on fruit flies or frogs or mice that would not be allowed on dogs or monkeys. Mostly, it plays out as a vague balancing act, the potential benefits of research weighed against the likely suffering and certain death of animals.

Most nonabolitionist writers, most public opinion polls, and all regulations converge on this consensus: *It is wrong to inflict harm on animals without strong justification* (Gallup and Beckstead 1988; Humane Society of the United States 2001; Carbone 2004; Foundation for Biomedical Research 2005). Something of a corollary: Harming animals can sometimes be justified.

Animal Welfare in the Laboratory

Scientists, regulators, and activists find dialogue with each other by first affirming the shared goal: to allow animal research to proceed in ways that cause the least necessary harm to animals. Yet they proceed to some dramatically different prescriptions of how to work with animals. The explanation, I believe, lies in the facts that each actor believes.

With confined animals, we impose our assumptions about their priorities and have total control of their treatment. The authority to say what shall or shall not be done to animals comes from speaking most convincingly of what matters to animals: where their pleasures and pains lie, where their fears and hopes are, what they need and what they want. Only once there is some agreement on the empirical facts about animals can we proceed with the next step, deciding how heavily to weigh those against the proposed benefits of animal experiments.

As David DeGrazia has argued, "The path to the ethical treatment of animals runs through their minds," emphasizing the importance of understanding animals' mental lives—their sentience, intelligence, consciousness, self-consciousness, capacities for pleasure and pain—in judging animal ethics. If an animal's welfare resides in how she or he *feels*, and if those feelings are the function of the mind, then any serious ethical discussion of animal welfare must somehow account for what is in the animal's mind. As DeGrazia puts it: "What sorts of mental capacities we attribute to animals have a great deal to do with how we think they should be treated" (DeGrazia 1996). Different actors (veterinarians, scientists, regulators and "lay" activists) vie to speak most authoritatively for animals' inner lives, and thereby to most powerfully influence how people shall treat animals.

People have often glibly assumed what animals can or cannot think and feel, with little reference to evidence one way or the other. Descartes, Thomas Aquinas, and Kant all based their ethics on what makes humans uniquely human, what attributes separate us from animals (rationality, self-awareness, autonomy, sentience), without much hand-wringing over the accuracy of their facts about animals. I contend that reading animals is not always so easy, even for those of us who try to do so on a daily basis.

Uncertainty arises even for so simple a question as whether a particular experiment causes animals pain. An old debate on whether animals can truly feel pain has, happily, been relegated to obsolescence. Watch your dog yelp and run if you step on his tail, and you'll think it's all pretty obvious. Some early attempts to set guidelines for animal use also made the recognition of animal pain sound simple enough (Committee on the Guide 1963). Animal experiments have often entailed surgery on animals[3]; and 1960s guidelines appear to presume surgical pain is the primary concern in the laboratory. It should go without saying to the researcher that surgery will almost always be painful, and thus requires full anesthesia and unconsciousness for the patient/subject during the procedure. Surgery usually results in residual pain as well, after the procedure has ended and the animal has awakened from anesthesia. For human patients, postsurgical pain can take weeks to diminish. Sometimes postsurgical pain is obvious from an animal's vocalization, disinterest in food, or hunched posture, especially in the first twenty-four hours post-op.

But how reliably can we say an animal not showing such signs is not in pain? This is where controversy arises in the laboratory.

What ethical prescriptions flow from the uncertainty of the empirical assessment of postsurgical animal pain? One conclusion might be to prohibit animal surgery in the laboratory, or to require that animals never be allowed to awaken from such surgery.[4] Another might be to prohibit all painful procedures, though we're back to assessing somehow which procedures those are. Another option: require empirical use of postsurgical analgesics, regardless of whether pain is evident or not; the problem here is how to know the dose and frequency and choice of analgesic are actually helping the animal. Yet another option is to extrapolate from people, requiring the analgesic regimen that people undergoing a similar operation would require.

The cost to the animal of undertreating pain is clear: the animal suffers. The costs in overtreating pain include animal welfare (painkillers can have unpleasant side effects), effort (coming to the lab at midnight to redose short-acting painkillers), and the possibility of inducing research artifacts (data clouded by the effects of the painkillers). But until a researcher and her vet agree on how much pain is to be expected in Mouse #34389 two days after surgery, and how to recognize that pain, we cannot proceed to ethical negotiations (such as whether my researcher will come back to the lab at midnight to redose the mouse's painkillers).

Assessing and managing surgery-associated pain is but one of dozens of challenges in reading animals in the laboratory. There is the potential pain of all sorts of other cancer, toxicology, and infectious disease studies. Laboratory animals are confined to cages, which may lead to distress, fear, and boredom. They may be lonely, or they may quite dislike their cagemate. They may want a cleaner cage, or they may like the comfort of their own smell surrounding them. The more their distress veers from the obviously physical to the psychological, I contend, it becomes more and more challenging to recognize animal distress in the first place and, more, to assess our efforts to help. Thus the creation of "animal welfare science" as a nascent discipline, with debate on the best ways to know animals' welfare: behavioral observation? measurement of stress hormones (such as cortisol and adrenaline) or other physical factors? empathetic extrapolation from how a human might feel? comparison with life in "nature" (where genetically modified albino mice do not roam)? I have yet to find that any one particular modality trumps all the others.

Animal-centered questions about animals' priorities can lead to some surprises. Much has been made of the "battery cages" that egg-laying hens are crammed into for the eggs you eat. In experiments where chickens must work to get to their preferences, they'll work harder to get a chance to peck and scratch in litter than to be near or to avoid their crowded cagemates (Bubier 1996). Decrease the crowding in a grid-floored, no-litter cage, and the average chicken, apparently, will tell you that you've missed the point: this is not what chickens want. Empathy may not have led you to that conclusion. Stress hormone

levels (in crowded birds, in birds deprived of a good dust bath) may or may not correlate. Comparison with unconfined "nature," where chickens are neither crowded nor deprived of the chance to peck the ground, will not reveal what matters most to the chickens. In a situation where animals *will* be confined, *will* be experimented upon—and yet, the impact on them will hopefully be minimized—good intentions plus bad data do not necessarily help the animals.

So I remain convinced that the key challenge in animal ethics is accurately reading how animals live. I must add that it is impossible to discuss human-animal ethics and not talk about killing.[5] That we kill animals in such numbers reflects both the overwhelming power we have over their lives and the beliefs we have about their inner lives. To my mind, the strongest of the weak defenses of meat-eating is the belief that killing animals is morally unproblematic so long as they have lived happy, pain-free lives and died pleasant, stress-free deaths. This belief is what makes animal research acceptable to so many as well; for instance, if I study early, painless stages of cancer and painlessly kill the animals before its progress causes the animal subjects to suffer, perhaps I can believe I have not harmed them in any significant way. Willfulness and rationalization may get us to that conclusion. Can we reach that same conclusion in a more credible way?[6]

The empirical thrust in assessing the ethics of (painlessly) killing animals is this: to discover whether a given animal has a sufficient sense of himself existing through time, with the possibility of hopes, dreams, and plans for the future that are stolen in killing the animal before his time (Cigman 1989; Regan 1989; Carbone 1998). Though there's a vibrant literature on cognitive psychology and animal sense of self (especially in primates, though in others as well), there's far less discourse on how to tie this research to decisions about killing animals. What shall we do if we decide a dog buries a bone, confident she'll be back for it tomorrow? Does that pass the test of sufficient self-awareness and future awareness to say her death would indeed be a harm? What if pigs and monkeys and laboratory mice are all operating at this level of awareness? Perhaps the implications would be too inconvenient for both the scientist and the diner.

Manifesto

The kingdom Animalia covers amazing diversity. Those animals that most resemble us—dogs, primates, dolphins—are so obviously sentient and vulnerable as to force us to expand our ethical norms to include them. They are like us, but they are not us, and the challenge of honestly reading their priorities must not be underestimated. But consider their sensitivity, consider the power we wield over them, and it is obvious to me that we must try. That means doing our best to truly assess what matters to animals themselves, when our ability to hear their voices directly is so limited. There are many valuable routes to knowing about animals—behavioral, physiological, extrapolation from our own

realities—and each has its strengths and weaknesses. My day-to-day veterinary responsibilities are with these sentient, sensitive, all-too-human animals, but. . . .

Having started the project of animal ethics, there is no obvious place to stop. No easy way to draw a sharp line between those animals we consider and those we exclude. If mice are in, why not frogs? If frogs are in, why not fish? coral polyps? oysters? If our closest cousins make us open the door of our exclusive moral club, our further cousins lay the ground for rethinking our ethics for all of life. How to live ethically in a world with those whose awareness—if that is an appropriate word for a one-celled animal—is so very alien from ours? In a world where we live as predators—on plants, perhaps, on some animals, perhaps—or die? How do we go beyond a sentience-based individualistic ethic to respect the biosphere? Seriously addressing those animals who so obviously demand it starts us there; I cannot say where we will end.

Notes

1. The Animal Welfare Act narrows its focus even more in excluding most laboratory-bred mice and rats, as well as fish, frogs, and other nonmammalian vertebrates, from its limited protections.

2. I certainly would challenge this distancing. Antivivisectionism began in the nineteenth century, when the connection between laboratory research and medicine was weak, and when few medicines or procedures had involved study of animals in their development. Nowadays, however, though science is performed by scientists, almost everyone is complicit in its application. There are almost no medications or medical procedures used in humans that are not tainted by the use of laboratory animals. While one could debate the necessity of future uses of animals, or argue that all harmful uses of animals be stopped from this point forward, it would be impossible to receive medical care in the foreseeable years that had no basis in animal studies.

3. As an example, much of physiology in the nineteenth and early twentieth centuries included surgically removing an animal's endocrine organs—such as a dog's pancreas or a rat's pituitary—to discover the organ's function through its absence (such as the diabetes that follows removal of a dog's pancreas).

4. The practice of studying anesthetized animals, then euthanizing them at the end of the experiment, before they could experience postsurgical pain, is a commonplace in the laboratory. It is frequently referred to as either *terminal surgery* or *acute use*.

5. Elsewhere, I have discussed the challenges of minimizing animal pain and distress in the killing of animals (Carbone 1997; Carbone 2004). Those issues are somewhat separable from the killing itself.

6. Another side issue threatens to distract the discussion: whether in human or veterinary medicine we can assess for another whether that individual's life is so diminished and/or so painful as somehow to be no longer worth living to that individual. That, too, is different from the ethics of killing a healthy, happy subject for the killer's benefit.

References

Animal Facilities Standards Committee of the Animal Care Panel (1963). *Guide for Laboratory Animal Facilities and Care*. Bethesda, Md.: U.S. Public Health Service.

Bubier, N. E. (1996). "The Behavioural Priorities of Laying Hens: The Effect of Cost/No Cost Multi-choice Tests on Time Budgets." *Behavioural Processes* 37(2–3): 225–238.

Carbone, L. (1998). "Euthanasia." In *Encyclopedia of Animal Rights and Animal Welfare*, ed. M. Bekoff and C. Meaney, pp. 164–166. Westport, Conn.: Greenwood.

Carbone, L. (2004). *What Animals Want: Expertise and Advocacy in Laboratory Animal Welfare Policy*. New York: Oxford University Press.

Carbone, L. G. (1997). "Death by Decapitation: A Case Study of the Scientific Definition of Animal Welfare." *Society and Animals* 5(3): 239–256.

Cigman, R. (1989). "Why Death Does Not Harm Animals." In *Animal Rights and Human Obligations*, ed. T. Regan and P. Singer, 2nd ed., pp. 150–152. Englewood Cliffs, N.J.: Prentice-Hall.

DeGrazia, D. (1996). *Taking Animals Seriously*. Cambridge: Cambridge University Press.

Donovan, J. (1996). "Animal Rights and Feminist Theory." In *Beyond Animal Rights: A Feminist Caring Ethic for the Treatment of Animals*, ed. J. Donovan and C. J. Adams, pp. 34–59. New York: Continuum.

Foundation for Biomedical Research. (2005). "Poll Shows Majority of Americans Support Animal Research." Unpublished press release.

Gallup, G. G., and J. W. Beckstead. (1988). "Attitudes Toward Animal Research." *American Psychologist* 43: 474–476.

Humane Society of the United States. (2001). "Americans Disapprove of Animal Research." Unpublished press release.

Regan, T. (1983). *The Case for Animal Rights*. Berkeley: University of California Press.

Regan, T. (1989). "Why Death Does Harm Animals." In *Animal Rights and Human Obligations*, ed. T. Regan and P. Singer, 2nd ed., pp. 153–157. Englewood Cliffs, N.J.: Prentice-Hall.

Singer, P. (1990). *Animal Liberation*. New York: Avon Books.

U.S. Congress. (1985). Food Security Act of 1985 (Public Law 99-198), title XVII, subtitle F, "Animal Welfare."

Contributors

Joseph Dumit Director of Science & Technology Studies and Associate Professor, Department of Anthropology, University of California, Davis

Beatriz da Costa Associate Professor, Arts Computation Engineering, University of California, Irvine

Kavita Philip Associate Professor, Women's Studies, University of California, Irvine

Larry Carbone Senior Veterinarian, Lab Animal Resource Center, University of California, San Francisco

Karen Cardozo Visiting Five College Assistant Professor of American Studies, Amherst College

Gaymon Bennett Director of Ethics, Synthetic Biology Engineering Research Center, University of California, Berkeley

Gary Cass Scientific Technician, Faculty of Natural and Agricultural Sciences, University of Western Australia

Oron Catts Artistic Director, SymbioticA; School of Anatomy and Human Biology, University of Western Australia. Co-founder, Tissue Culture and Art Project

E. Gabriella Coleman Assistant Professor, Department of Media, Culture, and Communication, New York University

Critical Art Ensemble Independent artists' collective

Gwen D'Arcangelis Women's Studies Ph.D. Candidate, University of California, Los Angeles

Troy Duster Professor of Sociology and Director of the Institute for the History of the Production of Knowledge at New York University. Chancellor's Professor at the University of California, Berkeley

Donna J. Haraway Professor, History of Consciousness, University of California, Santa Cruz

Mark Harrington Executive Director, Treatment Action Group, New York City

Jens Hauser Curator and Media Studies Scholar

Kathy High Associate Professor, Department of Art, Rensselaer Polytechnic Institute

Fatimah Jackson Professor, Anthropology (Behavior, Evolution, Ecology, and Systematics), Nutrition and Biology, University of Maryland, College Park

Gwyneth Jones Science Fiction Writer

Jonathan King Professor of Molecular Biology, Massachusetts Institute of Technology

Richard Levins John Rock Professor of Population Sciences, Department of Population and International Health, Harvard University

Richard Lewontin Alexander Agassiz Professor Emeritus of Zoology, Harvard University

Rachel Mayeri Assistant Professor of Media Studies, Harvey Mudd College

Sherie McDonald Research Assistant Biologist, Biological Anthropology Research Laboratory, University of Maryland

Claire Pentecost Associate Professor and Chair, Photography Department, School of the Art Institute of Chicago

Paul Rabinow Professor of Cultural Anthropology, Department of Anthropology, University of California, Berkeley

Banu Subramaniam Associate Professor, Women's Studies Program, University of Massachusetts, Amherst

subRosa Cyberfeminist collective of cultural producers

Abha Sur Lecturer in the Program in Women's and Gender Studies, Massachusetts Institute of Technology

Samir Sur Graduate student, Boston University, School of Medicine

Jacqueline Stevens Associate Professor, Law and Society Program, University of California, Santa Barbara

Eugene Thacker Associate Professor, School of Literature, Communication, and Culture, Georgia Institute of Technology

Paul Vanouse Associate Professor, Visual Studies, State University of New York, Buffalo

Ionat Zurr Artist in Residence, SymbioticA; School of Anatomy and Human Biology, University of Western Australia. Co-founder, Tissue Culture and Art Project

Index

The letter "f" indicates a figure, "t" indicates a table.

and Internet, 85–86, 367–370
objectivity, 65, 113
performance as, 91, 109, 235–238
and politics, 53–57, 83–85, 88, 97, 120
versus popular culture, 115
presence and meaning, 83–85, 89
rat exhibit as, 471
robotic, 367
and social utilitarianism, 96
wetwork, 86–89, 93
artemesinin, 395
art history, 132–134
artists
activism, 57, 83, 370–373, 375
bioartist views, 134–135
and biomedia, 88
blacklisting, 98
and capitalism, 113f, 116f
and distributors, 114
education, 115, 367–371, 373–375,
384n42
as intellectual, 366–370
and laboratories, 372–373
and the media, 114, 131, 381
as science amateurs, 373–375
and scientists, 57, 112
Art Orienté Objet, 90
Arts and Genomics Centre, 96
Ashbaugh, Dennis, 55
Asian Americans, 430. See also *All Over
Creation*
Asian Indians, 169
assisted reproduction, 225
Atwood, Margaret, 290
autoimmune diseases, 465–468, 474
automobiles, 40
Avakian, Bob, 5, 17
avian flu, 424

bacteria. *See* microbes
Baker, Steve, 128
Ballengée, Brandon, 91, 108, 119, 123n21
Bamshad, Michael, 207, 209, 211, 214

banding, 177–180
BARDA, 401, 407
Barr, David, 329, 332
Barrey, Jean-Claude, 456
Barthes, Roland, 285
Basic Local Alignment Search Tool (BLAST),
52
Bateson, Gregory, 458
The Bats, 64, 66, 70–73
beauty, 419–421
behavior
and animal models, 11–15, 72, 483
and art, 53–56
of consumers (*see* consumerism)
definition, 447–448
and DNA databases, 171
and gender, 291, 304
and genetics, 10, 38
mental illness origins, 343
behavioral modification, 447–452
Bekoff, Marc, 460, 462
belongingness, 9, 153, 284, 285. *See also*
castes; "Other"
Benjamin, Solomon, 263
Benjamin, Walter, 119
Berkowitz, Richard, 324
Berry, Sara, 251
bias
in CODIS, 183
of early geneticists, 10
and forensic DNA, 160, 164, 166, 170,
173, 182
and racial genetics, 6
of reductionism, 27
and senses, 35–37
binary thinking, 273–276, 280. *See also*
dichotomies
bioart
and capitalism, 110, 113f, 116f, 134
context dependency, 94–98
cost factors, 371
displays (*see* museum exhibits)
and ethics, 151, 153, 184

bioart (cont.)
 funding, 112
 influence, 42
 and neoliberalism, 110–113
 origins, 133–135
 paratexts, 93, 98
 and performance art, 90
 presence and meaning, 83–85, 89, 98
 presence and representation, 91
 and programming, 370–373
 and reality, 89
 rematerialization, 42, 86–88
 and scientific method, 108, 119
 spatial proximity, 90
 taxonomy, 84–88
 terminology, 83, 134–135, 149
 transgenic art, 86, 109, 128, 149
 and truth, 56
 workshop (*see under* SymbioticA)
biodiversity, 253, 271, 277
bioethics, 389–393. *See* ethics
biofiction, 269–274, 284. See also *All Over Creation*
biological determinism. *See* genetic determinism
biologic weapons, 16, 402–410, 423, 424
biology, 128, 131, 133, 273. *See also* molecular biology; synthetic biology
biomedia, 88
bioparanoia
 abused body, 421–424
 aestheticized screenal body, 419–421
 body meltdown scenario, 421–424
 and capitalism, 414–418
 disinfected body, 417–419
 germ panics, 275
 media role, 414, 420, 423, 436–438
 in U.S., 413, 424–427
biopiracy. *See* piracy
biopolitics. *See* politics
biopower, xviii, 111, 222, 239*n*3. *See also* power
bioprospecting, 250–251

biosecurity, 15, 396, 401, 410
biosurveillance, 318–321, 322*n*18
The Biotech Hobbyist, 373, 376
biotech industry
 and bioterrorism, 410
 and documentaries, 64
 and genetically altered food, 277
 investors, 44, 58*n*8
 public relations, 44, 54–55
bioterrorism, 408–410, 421–424. *See also* anthrax
birds
 and Animal Welfare Act, 480
 chickens, 483
 in museum exhibit, 86
 PigeonBlog, 56, 377–382
 as research animals, 470
blood, 7, 201
body
 appearance, 264, 420
 monitoring, 227, 228f, 229f
 usage of, 238
body art, 90–92
body meltdown scenario, 421–424
Bookchin, Natalie, 55
Bordowitz, Gregg, 327, 330, 334
Boyd, Dana, 95
Bray, Marianne, 435, 437
Brinson, Peter. See *It Did It*
Buber, Martin, 117
Bunting, Heath, 373
Bureau of Inverse Technology (BID), 369
Burson-Marsteller, 53
Bush, George W., 97, 421–426, 470
Butler, Octavia, 289
Byers, John A., 460

Callen, Michael, 324
Canada, and HIV/AIDS, 338
cancer, 30, 37
Canguilhem, Georges, 136, 137
capitalism
 and bioart, 110, 113f, 116f, 134

and bioparanoia, 414–418
and biopower, xviii, 111
and biotech industry, 44
and boundaries, 276
and environmentalism, 252
and gender, 221–223, 238, 239n1, 254
and genetically altered food, 277
and improved life, 111
and Internet, 368
and microbial resistance, 315
and perfect body, 420
Carrel, Alexis, 135
Carroll, Michael, 409
castes
and environmentalism, 257
and genetics, 9, 206, 213–215
and information technology, 263
and language, 208, 211
migration impact, 208–214
new elite, 264
oppression history, 213–215
physical appearance, 212
Catts, Oron, 373
Cavalieri, Liebe, 403
celebrities, 420
Celera Genomics, 76. *See also* Human Genome
 Project
cells, 135–138, 150–155, 164, 451. *See also*
 neurons
Certeau, Michel
Chadwick, Helen, 45, 47, 55
Chamberlin, Judi, 341, 345
change
 and epidemiology, 29
 fear of, 275, 277
 prerequisites, 283
 and science fiction, 304
 and sociobiology, 6
Charnas, Suzy, 290
chickens, 483
children
 babies to order, 15
 and biotech science kits, 384n41

gender behavior, 304
and HIV/AIDS, 333
magazine for, 50
playing with, 458
China, 5, 429–438, 468
cholera, 416, 419
chromosomes, 291–301
civil rights, 344. *See also* human rights
Clifford, Jim, 449
Cline, Nathan, 226, 227
clinical trials, 331, 333, 339, 348
Clinton, William J., 426
Cloaca, 95
clones
 Canadian cult, 74
 in *The Eighth Day*, 88
 and environment, 46
 in museum exhibit, 48
 of pets, 56
 in *Stories from the Genome*, 79
 of trees, 46, 57, 109
clothing
 fungal dress, 146f
 self-cleaning, 240n16
 T-shirt, with sensors, 227, 228f, 229f,
 240n16
 of victimless leather, 139f
Clynes, Manfred, 226, 227
co-corporality, 90
CODIS, 170, 180, 183
Coffey, Mary, 47
cogradient selection, 27
Cole, Leonard, 402
Coleman, Gabriella, 375
Collet, Janet, 299
Collins, Francis, 76–79
colonialism, 251, 255
commodities, 36, 265n2
commons, 309–311. *See also* traditional
 knowledge
community(ies), 318, 352, 404–409, 426
community interest, 172
Connell, Nancy, 403

De Menezes, Marta, 89, 91

demographics, xviii, 433. *See also* population genetics

Denver Principles, 323–324

depression, 67–70, 71f

Derrida, Jacques, 87, 281–282

DeSalle, Robert, 47, 48, 49

Despret, Vinciane, 445, 456

Devlin, B., 166, 167, 172

Diagnostic and Statistical Manual of Mental Disorders (DSM), 346, 347

dialectical materialism, 26

dichotomies

 activism/terrorism, 319

 binary thinking, 273–276, 280

 control/emergence, 312, 315, 317–321, 322*n*18

 life/resistance, 314

 one/many, 309–311

 power/counterpower, 311

 traditional/modern, 432

diethylstilbestrol (DES), 271

digestive system, 240*n*16

digitization, 88, 201, 367–369, 367–370, 372

disease. *See also* infectious diseases

 genetic disorders, 172

 of immune system, 465–468, 474

 Parkinsonism, 47

 prediction, 200–202, 215

disinfection, 414–419

dissent, 370–373, 375–376. *See also* activism

DNA

 banding, 177–180

 versus cells, 135–138

 coding regions, 169

 and cultural factors, 189

 databases, 170, 181–183

 in forensics, 159, 164, 166, 170, 173

 and government, 185

 isolation, in workshop, 147

 of mitochondria, 194, 207

 and resistance, 316

 search tool, 52

 and sexuality, 95

 transposition, 180–183, 302

DNA fingerprinting

 accuracy, 181–183, 186, 189

 description, 179–181

 police profiling, 168–171

 in workshop, 148

DNA mania, 126

DNA testing, 80

documentaries

 animation, 66, 69, 70–74

 on Human Genome Project, 76

 parodies, 66–70

 and reality, 63–66

documentation, 85, 92. *See also* science writers

dogs. *See* agility training

Dowling, Anne, 246

Drosophila, 10, 13, 27, 31

Drucker, Peter, 122*n*15

drug approval, 323, 327, 330, 332–334, 339, 348

Duffy blood group, 7

Dumit, Joseph, 80

Duster, Troy, 183, 215

Ebola virus, 423–425

economy

 of experience, 122*n*15

 and improved life, 111

 of knowledge, 11, 115

 of nature, 392

 and Third World, 21

 and women, 251, 254

ecosocial distress, 29

eco-terrorists, 97

Edelman, Murray, 44, 53

The Eighth Day, 85, 89

Eigo, Jim, 327, 332

Elgin, Suzette Haden, 450

Eli Lilly company, 356

emergence, 312, 314–317, 320, 322*n*18, 398

emergencies, 313–318, 321*n*12, 322*n*18, 425–427

labor
 and agriculture, 17, 26
 of bioartists, 371
 and biology, 273
 and bioparanoia, 415
 and castes, 213
 and commons, 309–311
 and ecology, 251
 scientists as, 37
 union role, 18, 19, 22
 and women, 221–227, 239*n*1, 251, 262
laboratories
 as art, 106
 and bioartists, 144–147, 149, 152, 155, 370–373
 for bioterrorism research, 408–410
 for hobbyists, 373, 376, 384*n*41
 human components, 18
 public version, 374
 as real life metaphor, 135–138
 safety, 145, 408–410
 and science fiction writer, 299, 300
Lakoff, Andrew, 348
laminar flow hood, 373
land, 250, 252–257, 253t, 263, 276
Lander, Eric, 76–79
Langlois Foundation, 118, 123*n*16
language
 in *All Over Creation*, 276, 281
 and caste, 208, 211
 and contact zones, 449
 for Derrida, 282
 versus play, 458–460
The Latent Figure Protocol, 186–190
Latinos, 166, 182
Latour, Bruno, 65, 272, 371, 376
Leach, Melissa, 251
leather, victimless, 139f
legal implications, 390
legal systems, 159, 256, 265*n*19
legitimacy, 23
Le Guin, Ursula, 289
Lesney, Mark, 52

Levins, Richard
 activism, 30, 37
 background, 25–27
 on energy industry, 40
 on Human Genome Project, 38
 on large and small systems, 39
 on misuse of work, 39
 on philosophy of science, 36
 selection studies, 27–29
 on social location and science, 35
 systems approach, 31
Lewis, Brad, 349, 354
Lewontin, Richard
 on ancestors, 8
 on animal models, 11–15
 on anthropology, 13
 background, 3–5
 on biological determinism, 9–11
 on biosecurity, 15
 on gene therapy, 14
 on Human Genome Project, 13
 on intellectual property, 20
 and National Academy of Sciences, 30
 on science and politics, 5–8
Liang, Lawrence, 260
Life, 289, 291–299, 304
Lipner, Jay, 329, 332
liver cells, 153
Long, Iris, 327
loop analysis, 31
Lounsbery Foundation, 49
love, 238
Lovgren, Stefan, 434
Lowe, Alex, 167
Luhrmann, Tanya, 349

Majumdar, Partha, 208–211, 214
Majumdar, Sucheta, 212
malaria, 395
males. *See* gender; sex chromosomes
Manglano-Ovalle, I., 55
Marchesi, Eugenio, 151
Marcuse, Herbert, 345

and vulnerability, 28
of women, 248
Orlan, 90
Osborne, Janet, 154
"Other," 430–438, 454. *See also* castes
Out of Africa Replacement, 194, 199
outreach programs, 376
overpopulation, 433
Ozeki, Ruth, 271. See also *All Over Creation*

paratext, 93, 98
Parkinson's Disease, 47
parody, 55, 57, 67–70
patents. *See also* intellectual property
 and documentaries, 64
 in India, 260
 Lewontin view, 20–21
 OncoMouse™, 467
 of rice, 254
 of seeds, 280
 and trade agreements, 122*n*10
 and traditional kowledge, 233, 250, 254,
 260–262
patriarchy, 256, 260, 291
Patton, Cindy, 437
Pentecost, Claire, 97, 374, 375
performance art, 91, 109, 235–238
Perry, Paul, 152–153. *See also* tissue culture art
perspectives, 35
pesticides, 29, 31, 279
PETA, 131, 380, 381
Peterson, Hans, 138
pharmaceutical industry
 and animal models, 470
 and bioparanoia, 420
 efficacy proof, in U.S., 330, 348
 good-will, 356
 and HIV/AIDS, 323, 325, 327, 330
 and media, 348, 361*n*26
 and mental illness, 347–352, 356, 358
 and microbe resistance, 313–318
 and Third World, 253–254
 and trade agreements, 122*n*10

and traditional knowledge, 258–259
phenotypes, 109, 169–171, 194, 201f
philosophy of science, 36
Pichot, André, 126
Piercy, Marge, 290
PigeonBlog, 56, 377–382
piracy, 20, 122*n*10
placebos, 332–333
plants
 cells of, 164
 cloned trees, 46, 57, 109
 and contact zones, 451
 as intellectual property, 250–252, 254, 257
 invasions, 275, 277
 research ethics, 481
 tissue engineering, 153–155
 wild-type alleles, 302
play, 283, 456–462, 471
 games, 55, 459
 sports, 299, 456
politics. *See also* power
 and *All Over Creation*, 274, 280, 283–285
 and art, 53–57, 83–85, 88, 97, 120
 and commons, 311–314
 and databases, 258
 and documentaries, 64–65
 and environmentalism, 245–250
 and genetically altered food, 277
 and genetic identity, 206, 210–214
 of knowledge, 243–246, 360*n*23
 lay-expert relations, 375–377
 and networks, 319
 and psychiatric treatment, 342
 and research, 172, 303, 366
 and science, 5–9, 15–18, 29, 120
 in 'Sixties, 344–347
 of terrorism, 424
 U.S. and China, 432
 and women, 232–237, 256
Pollan, Michael, 272
pollution. *See also* environmentalism
 and automobiles, 40
 Ballengé work, 108

biology *versus* society, 7
and genetics, 6–8, 10, 165–172, 207, 214
and HIV/AIDS, 333
in India, 205–207, 211–214
Müller theory, 211
profiling, 159–165, 169–172
scientized stereotypes, 184, 190
and tissue culture, 91
two-race theory, 211–213
racism
in Africa, 198
and contact zones, 449
in geneticists, 10–11
and genetic markers, 215
and India, 211–213
and lineage pollution, 282
and SARS media coverage, 430–438
in the United States, 8, 199t, 200–202,
 430–438
Raël, 74
Rai, Arti, 258
Rajaram, N. S., 211
rape, 256, 295
rats, 465–475
reality, 63–66, 89
reciprocal induction, 451
Reck, H. U., 84
Red Hat India, 259
reductionism, 95
Regan, Tom, 480
regenerative medicine, 74, 135–137. *See also*
 gene therapy
The Relative Velocity Inscription Device, 179, 185
religion
 in *All Over Creation*, 278, 280–282
 and commons, 310
 creationism, 38, 281–283
 and genetically altered food, 277
 and homunculus theory, 74
 and India, 210, 213
 versus science, 392
 witch hunts, 222–227, 251
rematerialization, 42, 44, 86–88

Reodica, Julia. See *Workhorse Zoo*
reproduction
 in *All Over Creation*, 280–285
 with assistance, 225
 babies to order, 15
 fetus, 74, 282, 451
research. *see also* funding
 animal use (*see* animal models; animals)
 for biological weapons, 402–409
 careers, for women, 292–302
 clinical trials, 331, 333, 339, 348
 controversial results, 372
 and corporations, 30, 96
 and documentaries, 64
 ethics project, 390
 for forensics, 170
 on HIV/AIDS, 327
 and infectious diseases, 423
 open source ethos, 150
 and politics, 172, 303, 366
 and power, 375
 for science fiction, 291–295, 299, 303
 and stem cells, 67
resistance
 to change, 29
 and gene therapy, 318
 to global capital, 251
 of microbes, 312, 315–316, 395, 404
 to transgenic production, 374
Rettberg, Randy, 396
rice, 254, 276
Risch, Neil, 166, 167, 172
robotics, 85, 109, 367, 369
Rockman, Alexis, 55
Ronfeldt, David, 319
Rose, Nick, 356
Rosen, Christine, 184
Rosenberg, Barbara, 403, 405
Rosenhan, David, 347
Rudin, Norah, 181
Rupp, Christy, 56
Russ, Joanna, 289, 290
Russo, Vito, 335

Signer, Ethan, 403

Singer, Peter, 480

Sinha, Suber, 249

skin color, 90, 211–212

Slobodkin, L. B., 276

Slonczewski, Joan, 290

smallpox, 16, 423, 425, 427

SmartMom, 226–230

Smith, Michael, 171

Smithson, Robert, 110

Smuts, Barbara, 457

Snow, John, 416

social criticism, 55–57

social Darwinism, 112, 189

social "othering," 430–438, 454

social roles, 35, 189, 215. *See also* castes

social utilitarianism, 96

sociobiology, 5, 6, 29, 31. *See also* race

software, 259–261, 370–373

Somerville, Siobhan, 284

Sonnabend, Joseph, 324

sovereignty, 311–318, 376

Spitzer, Robert, 348

sports, 299, 456. *See also* agility training

Staley, Peter, 332, 337

Stein, Howard, 45–47, 54, 55

Stelarc, 90

stem cells, 67, 74

stereotypes, 184, 190

sterility, 150

Stevens, Jaqueline, 43

Stories from the Genome, 64, 67, 73–80

Strauss, David, 52

stress, 29, 39

Subramaniam, Banu, 276

subRosa

 and amateurism, 375

 description, 221, 239n4

 SmartMom, 226–230

 Vulva De/ReConstructa, 230–232, 233f

 witch hunts, 222–227

 Yes Species, 235–238

suicide, 369

Sundberg, Juanita, 450

surveillance

 by motion detector, 369

 networks, for disease, 318–321, 322n18

 toxin detectors, 109

symbiosis, 312, 316

SymbioticA, 90–91, 143, 373, 376, 384n42

symbols, 53, 91, 95

SynBERC, 394–397

synecdoche, 91

synthetic biology, 371, 392–399, 406–408

Syracuse University, 46

systems, 31, 39

Taurog, Joel, 469

technoscience, 257–263, 436–438. *See also* science

television. *See* documentaries; media

terminology, 127–130, 149, 194

terrorism, 97, 318. *See also* anthrax; bioterrorism

Thacker, Eugene, 88, 135, 373

Thapar, Romila, 210

Third World. *See also* Africa; Cuba; India

 and environmentalism, 244–251

 and genetic engineering, 21

 and hygiene, 432

 and infectious diseases, 29

 and international law, 265n19

 and pharmaceutical industry, 253–254

 and power, 254–255, 260

 and property rights, 253t

 and trade agreements, 122n10

time sequences, 460

Tiptree, James, Jr., 289

tissue culture art, 88–91, 129–133

tissue engineering

 versus genetic engineering, 127, 129

 workshop course, 150–155

tissues, communication between, 451

Tomes, Nancy, 275, 345